History of the Development of

Building Construction in Chicago

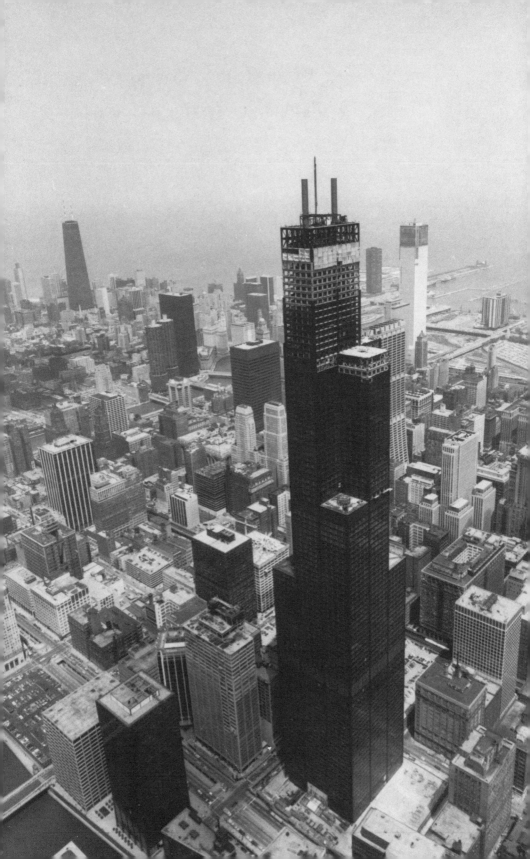

History of the
Development of
Building Construction
in Chicago

FRANK A. RANDALL

Second Edition

Revised and Expanded
by John D. Randall

University of Illinois Press
Urbana and Chicago

Frontispiece: Sears Tower, 1974
(Photograph by McShane-Fleming Studios)

Publication of this book was supported by a grant
from the Graham Foundation for Advanced Studies
in the Fine Arts.

Library of Congress
Cataloging-in-Publication Data

Randall, Frank A. (Frank Alfred), 1883–1950.
History of the development of building construc-
tion in Chicago / Frank A. Randall. — 2d ed. /
rev. and expanded by John D. Randall.
p. cm.
Includes bibliographical references and index.
ISBN 0–252–02416–8 (cloth)
1. Building — Illinois — Chicago — History.
2. Public buildings — Illinois — Chicago — History.
3. Chicago (Ill.) — Buildings, structures, etc. —
History. I. Randall, John D. II. Title.
TH25.C4R35 1999
690′.09773′11 — ddc21
98-8927
CIP

Contents

Appendixes

Illustrations

A map of prominent buildings of the Chicago School from Period III, 1881–1900, is on page 175.

Rand McNally Views

A map locating depots and hotels in the central business district is on page 213.

A map of the central business district locating views 1–24 is on page 251.

A map of the Gold Coast Historic District locating views 25–28 is on page 252.

Preface to the Second Edition

The primary purpose of this edition is to record the change of the status of the thousand buildings in this unique book. It adds some information for almost all of the main entries, including many references to illustrations in some 150 additional publications, where they are usually accompanied by discussions about the buildings. This edition includes about seventy additional buildings that were built before 1950, and several hundred later structures have been described briefly in a new section for Period VI, 1950 to 1998.

Nearly 350 buildings in the first edition have since been demolished. Their demolition dates are often given here in rough ranges of time. New building and parking usages of their sites are noted. The names of about half of some 400 original buildings that are standing at this writing have changed over the years, many several times, largely by the use of the addresses in place of proper names. Minor errors have been corrected in this volume, and a few buildings have been redated. Minor variations in reported construction dates and in the number of stories have not been changed; such information frequently has different bases for reporting.

The geographical boundaries of the original book are broadened significantly here because of the sprawl of important construction in all directions. About thirty buildings beyond the stated boundaries of the original book are now within the geographic limits of this edition. As in the original book, this edition does not include every high-rise building. About 200 buildings within the broadened boundaries are acknowledged in appendix A but with the notation NI (not included in the text).

The listings of buildings are now grouped within each year according to the following geographical areas: Loop and east to Lake Michigan; south of Congress Parkway; west of the south branch of the Chicago River; and north of the river. Many recent major additions to structures are cited with the descriptions of buildings of earlier periods; examples are those to the Builders/now 222 N. LaSalle Street building and those with groups such as the McKinlock/Chicago Campus of Northwestern University. The date for such additions is usually inserted at the year of actual construction.

About a score of post-1949 buildings replaced designated landmarks, most notably the Chicago Stock Exchange, and others that had been cited as

"meritorious" in *Chicago's Famous Buildings*. Of course, some new buildings developed sites that were previously of little importance, replacing insignificant small buildings, or they created higher uses of parking sites. The scores of recent parking structures are not included in this edition. Parking lots remain the principal blemishes on the city scene; most of about 100 parking and vacant sites noted in the text are lots, and many others are noted in appendix A.

The destruction of buildings for intended projects or for new buildings that never materialized is unfortunate. More than fifty "announced" buildings have not been erected. The overbuilding of the 1980s boom and the resulting reduced occupancy of both old and new buildings caused the clearing of many sites, vacancies now most obvious in the Loop. The most notorious evidence of premature destruction is the virtually vacant "Block 37," opposite the Marshall Field store on North State Street. The circumstances of the troubled "Great Street" (State) were exacerbated by the problems of its mall and by the competition of new stores and mixed-use buildings in the lusty development of the Magnificent Mile. "Mag Mile" itself has suffered in character because of a few buildings that compromise the dignity of North Michigan Avenue and by the loss of smaller old buildings of substance, including such places of respite as Diana Court and the tiny Italian Court. Now, the almost vacant and key block at Chicago Avenue awaits reported development — and the shadowing of the revered Water Tower by another hotel.

Frank A. Randall was on the board of the Chicago Building Congress and was involved in many arenas of the city's physical development for about forty years. He referred to problems of the building industry as a whole at the close of his preface. Apparently he felt that elaboration about this related interest was too much of a digression from his subject. I am less reluctant to comment briefly on the implicit importance of greater attention to closer relationships among the principal branches of the building industry and of these with government for the attainment of the highest possible qualities of urban life. The professions of structural engineering and architecture are of course but a part of the big picture. The Chicago Building Congress strives to unite and advance the thinking of construction professionals with others who are not even recognized here. Other engineers; governments; those in the fields of planning, real estate, and management; contractors; manufacturers and material suppliers; and the forces of labor itself are among the principals that are vital in the developments presented here. Formed over a half-century ago, the Chicago Building Congress constitutes the greatest potential resource for those who are interested in the broadest vision to maximize the benefits of construction and design in the community's interest.

Chicago's central business district, the city's early residential-mercantile-industrial core, has been transformed into more of a cultural center by the

multifaceted facilities increasingly woven throughout its heart—to the vast benefit of the metropolitan area as a whole. And many of its plazas, facades, and lobbies have enriched the urban fabric with outstanding works of sculpture, art glass, textiles, murals, and ornamentation.

The original author of this book, as consultant to the City of Chicago, established the cross section of the subway tubes, and he directed a city program of photographing (which resulted in a collection that is apparently no longer available) and assessing the conditions of buildings along the subway routes to determine possible effects of the subway construction on adjoining properties and the needs to mitigate potential claims against the city that might arise due to its construction. His familiarity here and from direct involvement with many structures and with their engineers and architects through several decades provided him with an authoritative core of knowledge. This supplemented his keen interest in the foundation and structural problems of increasingly larger buildings. His long research about earlier construction developments was supplemented by responses to his lengthy basic data listings sent to principals of firms responsible for major works. Information came also through his various chairmanships, including those of committees on soil mechanics and on structural code revision, and from family members who combed various publications.

By contrast, the current compilation, done over several years, was developed by informal inquiries and by tours around the central area. It owes much to the extensive literature of the period and to libraries that have not been thoroughly mined. Although I was for more than fifteen years involved with various Chicago buildings and organization activities and have maintained a strong interest as a native of the city, the most important factors in even approaching such an updating task were my participation on the initial Advisory Committee for the Chicago Commission on Architectural Landmarks and on the Mayor's Committee to Save the Garrick Building, and the inspiration and preservation interest afforded by friendship with the crusading photographer-preservationist Richard Nickel (1928–1972).

The general reader may expect an account of Chicago's great building industry to acknowledge its relevance to the nation's wondrous progress. Chicago's achievements are not those of isolation, but they are more intimate with the rich saga of the country's heartland, the development of the Midwest. In somewhat over 150 years the city flowered from the days of occasional wagon travel and horseback mail delivery across sparsely populated countryside to the era of the World Wide Web. Dories and buggies gave way to bicycles and streetcars, to the coming and passing from prominence of rail travel, to Ford's "model T," to superhighways, and to leadership in the airways. Chicago prospered with a multitude of developments, from Deere's plow and McCormick's reaper to the products of fiery ironworks and steel and cement plants. It enjoyed the proliferation of institutional advancements in diverse fields, including those of the several arts

related to the building industry. Internally, the story of Chicago building would ideally encompass the whole of the city, from the less prominent tilt-up, reinforced brick masonry, ordinary frame, and heavy mill construction barely noted, to advances in long-span, low-rise structures and the many skyscrapers beyond the subject's central area. Appreciation deepens in such a context, all within the nation's growth and its highs and lows of peace and war, recessions and prosperity, uplifting and depressing events, and great strengths in both thought and material matters of real relevance to the art of building in Chicago.

Although shortcomings and incompleteness here are the fault of the writer, debt is acknowledged to many professionals and librarians, particularly Deborah Kosinsky, head of the architecture library at the State University of New York at Buffalo. Timothy Samuelson reviewed early building notes and prevented some errors and omissions, and without his encouragement this edition would not have been carried even as far as it has. Scott Rappe resolved some data questions, delineated the Chicago School map and the tall-building chart, and contributed two biographical sketches. Harold Olin, associate in my Chicago office in the 1950s, contributed the updated building permit data. My brother, Frank A. Randall Jr., and Robert Johnson, both structural engineers, kept me in touch with engineering activity and concerns and with the latter's admirable programs to interest youth in that profession. Larry Viskochil and Jason Aronoff urged me on with their aid.

The Graham Foundation made the book possible through a generous publishing subsidy, and Richard Martin, executive editor at the University of Illinois Press, exhibited great understanding and patience. Through the interest of Mary Woolever, archivist of the Ryerson and Burnham Library of the Art Institute of Chicago, that library has started a Central Area Building Fact File that is described in appendix K. For general benefit the file is intended to increase the accuracy and completeness of recording information about buildings in this book, about others that are not yet listed, and about those that are constructed in the bright future that Chicago will surely enjoy.

—John D. Randall
Buffalo, New York
1998

Frank A. Randall, 1883–1950

Frank A. Randall was a public-spirited engineer who believed that what helped his fellow man was good for him. In this spirit, he wrote this book as a hobby without compensation, his reward lying in its benefit to the members of the building industry and to the general public. This same spirit has motivated this revised edition.

Born in Cambridge, Illinois, he earned his B.S. in civil engineering as 1905 class valedictorian and his C.E. degree from the University of Illinois.

His early engagements included the American Bridge Company; the Chicago Milwaukee and St. Paul Railroad; the Sanitary District

of Chicago; Morey, Newgard and Company; and Robert Black, New York shipbuilder, during World War I. His professional associations as a principal were Randall and Warner, structural engineers, and Berlin, Swern, and Randall, architects and engineers. From 1923 he practiced independently in Chicago, designing actively until his death in the year after this book was first published. His brother Arthur worked with him in the 1920s, as did I in the 1940s, both of us as structural engineers.

Highlights of Frank A. Randall's career include the structural design of the Medinah Athletic Club, the Lawson YMCA, and a multitude of structures of all types in Chicago and many other cities, including the Foshay Tower in Minneapolis. He was a building commissioner for the 1933 Chicago Century of Progress, consultant to the Department of Subways and Superhighways, including superintendence of the Outer Drive bridge, and to mayors' committees for building code revisions. He was instrumental in

establishing, with the University of Illinois, the microfilm collection of the Burnham Library, Art Institute of Chicago.

His professional activities included many engineering organizations, concrete and specification institutes, and marine and honorary societies. He authored a number of technical papers on building construction.

— Frank A. Randall Jr.
Northbrook, Illinois
1998

Foreword to the First Edition

Available in quantity when we wish to understand the nature, the evolution, the dynamics, and the probable future of such population giants as New York City, Chicago, Philadelphia, Detroit, Los Angeles, San Francisco, or St. Louis is a wide variety of documents. These include impressionistic sketches of many aspects of city life, careful studies of urban sociology, analyses of metropolitan markets and real estate practices and tax policies, comprehensive accounts of municipal government and politics.

What we in America have not had hitherto is a detailed history of the structures, the foundation engineering and construction methods, and the planners and builders, in any of our metropolises.

Thanks to Mr. Randall and the research group of which he is a member, we now have such a history. The College of Engineering, and the Engineering Experiment Station, are proud to offer it in published form. It is broad in its generalizations, highly particularized in its presentation of historical data. It deals with that city which it is not mere local pride to call the pioneer in modern urban construction methods. Indeed, not until the picture of building in Chicago is completely delineated can the history of building in America be written. As Dr. Ralph Peck recently said in an Illinois Engineering Experiment Station bulletin which forms a sort of prologue to the present volume: "The history of building foundations in Chicago between 1871, the year of the great fire, and 1915 epitomizes the development of foundation engineering throughout the world. Within less than half a century and within the confines of the small area known as the Loop, the art of constructing building foundations grew to maturity by a process of trial, error, and correction. Seldom in any field of engineering has so much experience been concentrated in so little time and space."

This is not to say that there will be no sequels to the present work. Indeed, it is one of Mr. Randall's achievements that he names in great detail the contemporary sources of information regarding hundreds of structures, and thus urges upon us a further exploration of his wide field. As a matter of fact, several subjects with which he deals are under intensive investigation. But even without the results of these studies, we now have a far clearer and

fuller picture of the physical growth of Chicago than has ever been at our disposal before.

Mr. Randall's researches have not been limited to the period of which Dr. Peck speaks. They have penetrated into the decades before the Great Fire and into the years since World War I. He has spent thousands of hours, and funds of his own, in gathering information never utilized—much of it, in truth, never before known—by either practicing engineers and architects or research specialists. His text, his illustrations, the entries in his bibliography, and his appendixes and indexes all represent a broad contribution to knowledge.

It is not only the architect and the engineer who will find in these pages literally thousands of pertinent and usable facts—facts concerning sites, costs, methods, and the materials used in laying building foundations, constructing the buildings themselves, and decorating and embellishing their interiors. Mr. Randall's specific data, and his generalizations both expressed and implied, will also serve real estate experts and members of the legal profession. They will likewise aid sociologists, historians, and city planners. All of these people will find many of their views buttressed, and others perhaps challenged, by the technological and economic findings set forth in this volume.

Not to anticipate too greatly the reader's own pleasure of discovery, I might call special attention to the biographies of Van Osdel and other leaders of thought and practice; the reproduction of many pages from a book of which there is known to exist, outside one library and the publisher's safe, only the copy that Mr. Randall found after a ten-year search; and the detailed figures on dimensions, costs, and construction methods which stud many of his descriptions of specific buildings.

Though he has included thousands of particulars, Mr. Randall has at the same time been rigidly selective. In making his choices of facts to put in and facts to leave out, he has been guided in large part by years of practical experience as a structural engineer. He has himself contributed greatly to Chicago developments of the past forty years, and knew intimately many master architects of the generation preceding his own. His perspective is therefore wide, and his judgment deep.

In addition his studies have been aided by the Joint Committee on Soil Mechanics and Foundations of the Western Society of Engineers, the Illinois Section of the American Society of Civil Engineers, and the Engineering Experiment Station of the University of Illinois.

We of the University of Illinois College of Engineering, in his association with us as Special Lecturer in Civil Engineering, learned much from him and we are happy too that the Illinois Engineering Experiment Station shares in the production of this volume. We are under great obligations to him for the years of study whose fruits appear in the following pages. We

believe that engineers, architects, businessmen, historians, and students of urban economics and social life will be happy to join us in acknowledging the indebtedness.

—M. L. Enger
Dean, College of Engineering
Director, Engineering Experiment Station
1949

Preface to the First Edition

Over the years, the author has found it necessary to search for information relative to existing buildings, particularly their foundations and type of construction. From 1938 to date, as Consulting Structural Engineer for the Department of Subways and Superhighways of the City of Chicago, he collected data of such nature concerning all buildings along the routes of the State and Dearborn subways. The most important of these buildings were located in the district covered by this volume — from Division Street on the north to Roosevelt Road (Twelfth Street) on the south, and from the north and south branches of the Chicago River on the west to Lake Michigan on the east. This district is commonly referred to as the central business district.

Later a Joint Committee on Soil Mechanics and Foundations of the Chicago area was instituted by the Illinois Section of the American Society of Civil Engineers, the Western Society of Engineers, and the Engineering Experiment Station of the University of Illinois. The members of this committee are Messrs. Albert E. Cummings, Verne O. McClurg, Frederick W. Reichert, Paul C. Rutledge, Chester P. Siess, Karl Terzaghi, Ralph B. Peck, Secretary, and Frank A. Randall, Chairman. Additional information was collected, and the publication of these data is a part of the report of this committee.

Publication limits prevent a complete history of each building; therefore, liberal reference is made to other sources of description and illustration. A chronological arrangement is used to assist the reader in following the development of the construction of Chicago buildings.

The compilation of the data involved the discovery and utilization of many sources other than those listed in the bibliography. Architects, engineers, owners, and contractors responded freely. Grateful acknowledgement is made to them and to the Chicago Historical Society and the Burnham Library.

The many inquiries from architects, engineers, and realtors for such information as is contained herein leads the author to hope that this work will be helpful to these professions and that it will prove of historical interest to many others. Future generations of architects and engineers will

find in the work of their predecessors an inspiration to exercise their inge-
nuity and keep Chicago in the lead in solving the problems of the building
industry.

— Frank A. Randall
Chicago
1949

Abbreviations

The following list of abbreviations for works cited throughout the text functions also as a partial bibliography for this book. Additional bibliographical references appear in appendix J.

A *Architecture* (published 1900–1936)
AA *American Architect* (published 1876–1938)
AAC *All About Chicago,* John and Ruth L. Ashenhurst, 1933
AAH *American Apartment Houses, Hotels and Apartment Hotels of Today,* R. W. Sexton, 1929
ABOV *Above Chicago,* Robert Cameron, 1992
ACMA *Architecture in Chicago and Mid-America,* Wayne Andrews, 1968
ADE *Architecture and Design,* issue on Henry Ericsson, March 1943
AEF *Architectural Engineering,* J. K. Freitag, 1901
AF *Architectural Forum* (published 1916–1974; previously titled *Brickbuilder*)
AGC *AIA Guide to Chicago,* ed. Alice Sinkevitch, 1993
APB *Directory to Apartments of the Better Class on the North Side of Chicago,* Albert J. Pardridge and Harold Bradley, 1917, reprint 1979
AR *Architectural Record* (published since 1891)
ARCH *Architecture* (published since 1983 by American Institute of Architects)
ARV *Architectural Review* (published 1883–1921)
AUS *The Architecture of the United States,* Vol. 2, G. E. Kidder Smith, 1981
AWG *The Architectural Work of Graham, Anderson, Probst & White,* 1933
B *Planning and Construction of High Office Buildings,* William Harvey Birkmire, 1900
BB *Brickbuilder* (published 1892–1916; renamed *Architectural Forum*)
BMT *American Building: Materials and Techniques,* C. W. Condit, 1968, 1993
BOC *Burnham of Chicago,* Thomas S. Hines, 1974
BTC *A Business Tour of Chicago,* E. E. Barton, 1887
BW *A Portfolio of Fine Apartment Homes,* Baird and Warner, 1928
C *Chicago,* comp. Rush C. Butler Jr., 1929
CA *Chicago Architects Design,* John Zukowsky et al., 1982
CAA Corpus of American Architecture, University of Illinois
CAC *Commercial and Architectural Chicago,* G. W. Orear, 1887
CAD *Chicago Architecture and Design,* George A. Larson, 1993
CAJZ *Chicago Architecture: 1872–1922,* John Zukowsky, 1987

CAL *Chicago: Chicago Architectural Landmarks,* Chicago Historical and
 Architectural Landmarks Commission, 1988
CALP Chicago Architecture Landmarks Pending, Department of
 Planning, March 1996
CANY *Chicago and New York: Architectural Interactions,* Art Institute of
 Chicago, 1984
CBF *Chicago before the Great Fire,* Trans-Continental Publishing Co.
 [1890s]
CCNT *Chicago: Creating New Traditions,* Perry Duis, 1976
CCP *Chicago: A Century of Progress, 1833–1933,* Marquette Publishing Co.,
 1933
CCS *Chicago Churches and Synagogues,* George Lane, 1981
CE *Civil Engineering,* American Society of Civil Engineers, published
 since 1930
CFB *Chicago's Famous Buildings,* 1964, 1969, 1993
CGY *Chicago, the Glamour Years (1919–1941),* Thomas G. Aylesworth and
 Virginia L. Aylesworth, 1986
CHALC Chicago Historical and Architectural Landmarks Commission (now
 the Commission on Chicago Landmarks) brochures and
 "Information" typescripts
CHC *Centennial History of the City of Chicago,* Inter-Ocean, 1905
CH10 *Chicago, 1910–1929,* Carl W. Condit, 1973
CH30 *Chicago, 1930–1970,* Carl W. Condit, 1974
CIDL *Chicago Interiors,* David Lowe, 1979
CIJ *Chicago Illustrated,* Jevne and Almini (rare prints), Chicago
 Historical Society, 1866, 1868
CIM *Chicago and Its Makers,* Paul Gilbert and Charles Lee Bryson, 1929
CIS *Chicago and Its Suburbs,* Everett Chamberlin, 1874, reprint 1974
CLSI *Chicago's Landmark Structures: Inventory,* Landmarks Preservation
 Council of Illinois, 1974, 1975
CMAG *Chicago* magazine
CN *Construction News*
CNM *Chicago's North Michigan Avenue,* John W. Stamper, 1991
COF *Chicago on Foot,* Ira J. Bach, 1969 and, as noted, editions of 1987, 1994
CON *Constructing Chicago,* Daniel M. Bluestone, 1991
CPH *Chicago: A Pictorial History,* Herman Kogan, 1958
CPS *Carson, Pirie, Scott,* Joseph Siry, 1987
CRC *Chicago,* Robert Cromie, with A. Lieberman photographs, 1980, 1982
CRT *Chicago and Its Resources Twenty Years After (1871-1891),* Royal L. La
 Touche, 1892
CSA *Chicago School of Architecture,* Carl W. Condit, 1964
CST *Chicago since the Sears Tower,* Mary Alice Molloy, 1988, reprints
CSV *Chicago,* Santi Visalli, 1987
CTCP *Chicago at the Turn of the Century in Photographs,* Larry A. Viskochil,
 1984
CYT *Chicago — Yesterday and Today,* Felix Mendelsohn, 1932
DATA *Dankmar Adler: His Theaters and Auditoriums,* Charles E. Gregersen,
 1990
DHBM *Daniel H. Burnham: Architect,* Charles Moore, 1921

EAR	Manuscript records of Edward A. Renwick, architect, formerly in possession of his son, Ralph Renwick
EN	*Engineering News* (published 1902–16)
ENR	*Engineering News-Record* (published since 1917)
ER	*Engineering Record* (published 1897–1909)
FC	*Feininger's Chicago,* Andreas Feininger, 1980
FNB	*The First National Bank of Chicago,* Guy W. Cooke, 1913
FRAG	*Fragments of Chicago's Past,* ed. Pauline Saliga, 1990
GAPW	*Architecture and Planning of Graham, Anderson, Probst and White, 1912–1936,* Sally A. K. Chappell, 1992
GCA	*Guide: 150 Years of Chicago Architecture,* Museum of Science and Industry, 1985
GCSU	*The Great Conflagration: Chicago: Its Past, Present and Future,* James W. Sheahan and George P. Upton, 1871
GFC	*The Great Fire: Chicago, 1871,* Herman Kogan, Robert Cromie, 1971
GMM	*Chicago: Growth of a Metropolis,* Harold M. Mayer and Richard C. Wade, 1969
HA	*Historic American Building Survey,* 1983
HAAW	*Highlights of Recent American Architecture,* Sylvia H. Wright, 1982
HABS	*Historic American Building Survey: Chicago,* J. W. Rudd, 1966
HB	Hedrich-Blessing Photo Collection: 1930 to 1970, Chicago Historical Society Inventory, 1994
HBF	*History of Building Foundations in Chicago,* Ralph B. Peck, Bulletin 373, University of Illinois Engineering Experiment Station, 1948
HCA	*History of Chicago,* A. T. Andreas, 1885–86, reprint 1975
HCCB	*A Half Century of Chicago Building,* ed. John H. Jones and Fred A. Britten, 1910
HDM	*Here's the Deal,* Ross Miller, 1996
HE	*Sixty Years a Builder,* Henry Ericsson, 1942
HRHR	*Holabird and Roche, Holabird and Root,* Robert Bruegmann, 1991
HSM	*History of the Skyscraper,* Francisco Mujica, 1929, 1977 reprint
IA	*Inland Architect* (published 1883–1908)
IA-C	*Inland Architect* (published since 1957)
IC	*Industrial Chicago,* 2 vols., 1891
ILL	*Illinois Architecture from Territorial Times to the Present,* Frederick Koeper, 1968
ISA	*Handbook of Illinois Society of Architects*
JSAH	*Journal of the Society of Architectural Historians* (published since 1941)
JWR	*The Architecture of John Wellborn Root,* Donald Hoffmann, 1973
LAAM	*Lost America: From the Atlantic to the Mississippi,* Constance M. Greiff, 1971
LC	*Lost Chicago,* David Lowe, Chicago Historical Society, 1975
LO	*Land Owner* (illustrated periodical of late 1860s to early 1870s, Collection, Newberry Library)
LSCS	*Louis Sullivan and the Chicago School,* Nancy Frazier, 1991
LSM	*Louis Sullivan,* Hugh Morrison, 1935, reprints, and new edition
MAC	*Modern Architecture in Color,* Werner Hofmann and Udo Kultermann, 1970
MEA	*Macmillan Encyclopedia of Architecture,* ed. Adolf Placzek, 1982

NR *National Register of Historic Places: 1966 to 1988,* 1989
OBD *Chicago Central Business and Office Building Directory,* Winters
 Publishing Co., issued periodically
OMSM *Old Monroe Street,* Edwin F. Mack, 1914
OYF *One Year from the Fire, October 9, 1871–October 9, 1872 — Chicago
 Illustrated,* J. M. Wing and Co., 1872
PA *Progressive Architecture* (published 1945–1995)
PGC *Paul Gapp's Chicago,* Paul Gapp, 1980
PROC *Process Architecture 102,* Masami Takayama, 1992
RB *Realty and Building* (originally *Economist,* published since 1888)
RG *Railroad Gazette*
RMN *Handy Guide,* Rand McNally and Co., 1893
RMNP *Photographic Views of Chicago,* Rand McNally and Co., 1902
RMNV *Views of Chicago,* Rand McNally and Co., 1893, reprint 1898
RMP *The Spirit of H. H. Richardson on Midland Prairies,* Paul C. Larson,
 1988
RNRC *They All Fall Down: Richard Nickel's Struggle to Save America's
 Architecture,* Richard Cahan, 1994
SCB *Steel Construction,* Henry Jackson Burt, 1914
SCM "Skeleton Construction," William B. Mundie, 1932, ms. (formerly in
 possession of Elmer C. Jensen)
SCS *Second Century of the Skyscraper,* Council on Tall Buildings and Urban
 Habitat (CTBUH), ed. Lynn S. Beedle, 1988
SEA *Award Winning Structures, 1979 through 1994,* Structural Engineers
 Association of Illinois (SEAOI), 1995
SGC *Standard Guide to Chicago,* John J. Flinn, 1892
SM *Skyscraper Management* (periodical formerly published by Building
 Owners and Managers Association)
SRT *Louis Sullivan,* Robert Twombly, 1986
STL *The Sky's the Limit: A Century of Chicago Skyscrapers,* ed. Pauline A.
 Saliga, 1990
T *Architecture in Old Chicago,* Thomas E. Tallmadge, 1941
TAA *Treasures of American Architecture,* J. D. Randall, 1992
TBAR *Tall Building Artistically Reconsidered,* Ada Louise Huxtable, 1984
TBC *They Built Chicago: Entrepreneurs,* Miles L. Berger, 1992
TYF *Two Years after the Fire — Chicago Illustrated,* J. M. Wing and Co., 1873
VO John M. Van Osdel account books, 3 vols., Collection, Chicago
 Historical Society
WA *Western Architect* (published 1903–1928)
WACH *Architecture of the Twentieth Century,* Mary Hollingsworth, 1988
WCWF *Gems of Wonderful Chicago and the World's Fair,* George W. Melville,
 1893
WO *Wild Onions: A Brief Guide to Landmarks and Lesser-Known Structures
 in Chicago's Loop,* ed. Deborah Slaton, Association for Preservation
 Technology, 1989
WSE *Journal of the Western Society of Engineers* (published 1896–1920)

History of the Development of

Building Construction in Chicago

Part 1

Growth and
Early Development
of Chicago

Leadership of Chicago

Chicago's preeminence in many fields is generally known, but its important contributions to the field of building construction may not be so widely recognized. Many advancements in building practices originated in Chicago—balloon construction of frame buildings, fireproof construction, the rational proportioning of the areas of isolated footings, the use of steel grillages to secure shallow footings, the Chicago caisson, the evolution of skeleton construction and wind bracing, and the development of reinforced concrete construction. In the development of the art of building construction, Chicago has consistently led other cities. Only in the height of buildings has it been surpassed.

Great credit must be given to the outstanding engineers and architects whose vision, ingenuity, and inventions led to the development of present-day building construction.

Except for occasional comparatively dormant periods of economic depression, the city has served as a large-scale research and testing laboratory; the detailed history of its buildings represents a continuous and successful battle for improved construction upon soil that has presented difficult problems. This rapid development has of course been aided by an unusual growth in population and increased property values.

One of the factors which contributed largely to the remarkable progress of architectural design and subsequent building construction was the great fire of 1871. This fire, in which 18,000 buildings valued at $192,000,000 were burned, wiped the slate clean, and served as a vivid warning that more permanent construction was required. To date, no other city has had such a

1

stimulus to improved building construction, together with industrial wealth sufficient to finance swift rebuilding.

After the Chicago fire, many structures were quickly rebuilt, but the financial panic of 1873 slowed reconstruction for a period of nearly ten years. Then there came a golden decade of building which culminated in the World's Columbian Exposition. Another relatively quiet period followed the panic of 1893, but by the turn of the century the most important developments had been realized. Skeleton construction, structural steel, and caissons had been proved and accepted, and reinforced concrete was on its way to acceptance. The materials and methods of construction had been devised, and engineers and architects were in a position to meet all demands then current for height of construction.

In order that the reader may appreciate the economic pressures that forced the growth and development of building construction in Chicago, the following sketch of the early history of the city is presented.

Location and Early Growth of Chicago

Beginnings of Chicago

The first structure on the site of Chicago was a log cabin built beside the river near the lake shore in 1779 by Jean-Baptiste Point du Sable, a black settler, who occupied it until 1803. It was sold in 1803 to an individual named Le Mai, and again in 1804 to John Kinzie, the first permanent white resident.

In 1804, Fort Dearborn was built by Captain John Whistler, civil engineer of the U.S. Army, at the location of the southwest corner of N. Michigan Avenue and E. Wacker Drive. It was of log construction, two stories high. On August 15, 1812, the Fort Dearborn massacre occurred, and on the following day the fort was burned by the Indians. It was rebuilt in 1816 by Captain Hezekiah Bradley, also of the U.S. Army, and was torn down about 1875.

In the *Chicago Tribune* of December 29, 1947, is a detailed sketch of the fort and accessory buildings, based upon the official report of Captain John Whistler, Commander, together with a plan from Illinois Street south to Madison Street and from Dearborn Street to the lake. This plan shows the old mouth of the Chicago River near E. Madison Street.

Growth of the City

The first map of the original town of Chicago, by James Thompson, surveyor, is dated August 4, 1830. This date marks the beginning of Chicago as a legally recognized town. The settlement, three-eighths of a square mile in area, was bounded by Madison, State, Kinzie, and Halsted Streets. On March 4, 1837, Chicago was incorporated as a city.

On May 21, 1830, the United States had granted to the State of Illinois alternate sections of land for five miles on either side of a canal to connect the Chicago River with the Desplaines River. Later in the year the Canal Commissioners, appointed by the state, subdivided a part of one section at the fork of the Chicago River. This first subdivision in the city was bounded by the present Madison, State, Kinzie, and Desplaines Streets. The first lots were sold on September 4, 1830.

In 1830 the first bridge was built across the South Branch of the Chicago River near Randolph Street. In 1834 South Water and Lake Streets were graded, and the first drawbridge was built across the river at Dearborn Street.

By 1848, the original incorporated area had expanded until the city limits had reached North Avenue on the north, Wood Street on the west, and Cermak road (22d Street) on the south. By 1871, Fullerton Avenue was the northern boundary, Pulaski (Crawford) Avenue the western, and Pershing

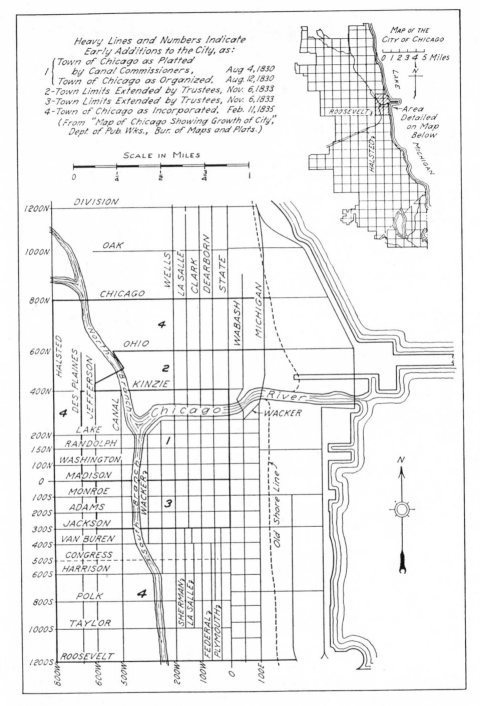

Fig. 1. Street Map of the Central Business District, 1949

4

Table 1.

	Area (sq. mi.)	Population	Density of Population (per sq. mi.)
1830	0.417	100[a]	
1840	10.186	4,470	439
1850	9.311	29,953	3,218
1860	17.492	109,260	6,246
1870	35.152	298,977	8,505
1880	35.152	505,185	14,371
1890	178.052	1,099,850	6,177
1900	189.517	1,698,575	8,963
1910	190.204	2,185,283	11,489
1920	198.270	2,701,705	13,626
1930	207.204	3,376,438	15,862
1940	212.863	3,396,808	15,958
1950[b]	212.900	3,620,962	17,008
1960	228.090	3,550,404	15,566
1970	228.115	3,369,357	14,770
1980	228.116	3,005,072	13,173
1990	228.475	2,783,726	12,184

Sources: 1830–1940 data from *Residential Chicago, Chicago Land Use Survey* (vol. 1, 1942), directed by the Chicago Plan Commission; 1950–1990 data from the Municipal Reference Library.

a. Estimated

b. Approximated; O'Hare airport annexations in the 1950s

Road (39th Street) the southern. The largest annexation (132 square miles) was effected in 1889; and by 1893 the city had reached approximately its present limits, excepting for small areas scattered along the western boundary, as shown in figure 1.

A graphic picture of the swift expansion of the city in the nineteenth century is presented by the data in table 1.

Raising the Grade

Since Chicago's site was low and swampy, the problems of drainage and sewage disposal became more serious as the population grew. The high death rate made a solution of this problem imperative. In line with a comprehensive plan devised by E. S. Chesbrough, the street grades were raised in 1855 and again in 1857. Many buildings were raised correspondingly, one of the first being a block of four-story buildings at the corner of W. Lake and N. Wells Streets, owned by George Smith. Built in 1850, these structures were considered the finest of their period in the city. A photogravure of the buildings at this corner is in CBF, where the site is described as "one of the busiest corners in Chicago" and the first paved with Nicholsen blocks (1855).

The first brick building to be raised to the street grade, in 1857, was the

Jennings building at the northeast corner of Dearborn and Randolph Streets. A view in CIM (p. 108) and in CYT (p. 19) illustrates the condition of sidewalks on Clark Street at that time. In 1861 the famous Tremont House, a five-story brick structure, was raised six feet to grade "without a crack in its walls." George M. Pullman was one of the contractors (HE).

The filling of the streets to the new grade had not been completed at the time of the great fire of 1871 and was brought to a conclusion largely with debris from the fire.

Height of Buildings

The necessary rebuilding after the fire, and the accelerated building program preceding the World's Columbian Exposition in 1893, were marked by many new departures in construction, including the erection of higher buildings than architects had previously considered safe. In fact, before the fire the general height of the buildings in the business district was from four to six stories; after the fire, six-story buildings became more common and buildings of seven and eight stories were erected. The first 10-story building was the Montauk (1882–1902), which was considered a skyscraper; it was followed shortly by the first 12-story building, the Mallers (1884–1920). The 21-story Masonic Temple, erected in 1892, was the marvel of its day.

Table 2.

Name of Building	Height (ft.)	Stories	Architect
Rookery[a]	164	12	Burnham and Root
Monadnock[a]	215	16	Burnham and Root
Northern Hotel	168	14	Burnham and Root
Woman's Temple	n.a.	13	Burnham and Root
Masonic Temple	302	21	Burnham and Root
Ashland	n.a.	16	Burnham and Root
Home Insurance	n.a.	11	Jenney and Mundie
Manhattan[a]	210	16	Jenney and Mundie
Fair	241	17	Jenney and Mundie
Owings	160	13	Cobb and Frost
Cook County Abstract	211	16	Henry Ives Cobb
Athletic Association[a]	146	10	Henry Ives Cobb
Tacoma	165	13	Holabird and Roche
Pontiac[a]	174	14	Holabird and Roche
Caxton	150	12	Holabird and Roche
Venetian	180	13	Holabird and Roche
Unity	210	17	Clinton J. Warren
Auditorium[a]	210	Main 10	
		Tower 18	Adler & Sullivan

a. Standing in 1998.

The marked trend toward tall buildings in Chicago was viewed with alarm by some builders and architects.

"The recent tall building agitation," said one writer, "principally at Chicago, where the nature of the underlying strata appears to have given rise to some apprehension regarding the safety of lofty and correspondingly heavy structures, lends special interest to the appended figures. They give the heights in feet and number of stories of several of Chicago's noteworthy tall buildings" (see table 2).

Evolution of Buildings before the Fire

First Frame Buildings

The earliest non-residential buildings in Chicago were of frame construction. One of these, the Eagle Exchange Tavern, built in 1829 by Mark Beaubien, was enlarged in 1831 to form the Sauganash Hotel, which may be regarded as the first commercial structure in the settlement. At this date, Chicago was a village of only twelve houses.

Another early frame building was Hogan's Store at the corner of W. Lake Street and N. Wacker Drive. One corner of this store served as headquarters for the first postmaster, appointed on March 31, 1831. In 1834 the post office was moved to the corner of N. Franklin Street and W. Wacker Drive, and again in 1837 to the Bigelow Building on N. Clark Street between W. Lake Street and W. Wacker Drive. A further move took the post office to the Saloon building, a three-story structure at the southeast corner of N. Clark and W. Lake Streets, after which it was located in various buildings until 1855.

When Chicago received its charter as a village in 1833, Lake Street was the main street of the town; in this same year the first Tremont House was erected at the northwest corner of Dearborn and Lake Streets. The first store building on Lake Street, a two-story frame structure, was built in 1834 by Thomas Church. The first Court House followed in 1835 and the City Hotel, later the Sherman House, in 1837. From 1837 to 1842 the first City Hall was located in the Saloon building, previously mentioned. All of these early Chicago landmarks were of frame construction.

Balloon Construction

The first major improvement in building practice of the many for which Chicago may claim credit was the balloon construction of frame buildings. Although a discussion of this type of construction is out of place in a history of the development of commercial buildings, the invention was of great practical significance.

First Brick Buildings

One of the first brick buildings in Chicago was built in 1837 on the site of the present 30 N. LaSalle Street building. Ten years later the first brick building on Randolph Street was built by Abram Gale. This four-story structure was demolished in the summer of 1871 for a new building designed by John M. Van Osdel, the city's first architect. It was completed in time to be burned in the great fire.

After about 1845, brick began to replace wood in the construction of

walls, although for many years, even after the fire of 1871, wood continued to be used for the floor framing of buildings in the central business district. The dramatic burning of the Grannis Block (1881–1885) emphasized the vulnerability of this type of construction, and after that date few such buildings were erected in the business district.

Athenian Marble

Lemont limestone, called "Athenian marble," came into use in the early fifties. Approved construction practice was to face the brick walls of the more pretentious buildings with limestone veneer; floor construction remained of wood. Twin Lemont stone buildings were built in 1856 for George Smith and the Burleys by Van Osdel, at the southwest corner of N. LaSalle and W. Lake Streets. Some thirty or forty "marble front" buildings, all six stories high, were erected on State Street in 1869 and 1870.

Cast-Iron Fronts

Another vogue in construction, popular in Chicago from 1855 to 1870, was the use of cast iron for the entire fronts of buildings. Among the first buildings of this type was the Lloyd Block at N. Wells and W. Randolph Streets. A block of buildings with cast-iron fronts was started in 1856 on E. Lake Street by Van Osdel. Five stories and one basement in height, this block extended from N. State Street eastward toward N. Wabash Avenue. A photogravure is in CBF. Other examples of this type of construction were Frederick Tuttle's building at the northeast corner of N. State and E. Lake Streets, which with four other buildings had a frontage of 136 feet. On the opposite side of E. Lake Street the iron fronts extended eastward 135½ feet from the City Hotel. Lining both sides of Lake Street, they gave the appearance of single buildings. A writer of the period declared that "in the late fifties this block was the finest architecturally in the city, with scarcely a rival on the continent."* Two views of E. Lake Street, as it appeared in 1860, are in CIJ. A few more buildings with cast-iron fronts were constructed after the great fire; e.g., the U.S. Express Company building, at 58–60 W. Washington Street.

First Attempts at Fireproof Construction

With all the early types of construction which have been described, fires were not unusual; and their results were disastrous. The inadequacies of the Chicago fire department of the period, as well as the flammable construction, were no doubt responsible for some of these losses. The first serious

*HE (quotation), and CIM (illustrated), p. 362.

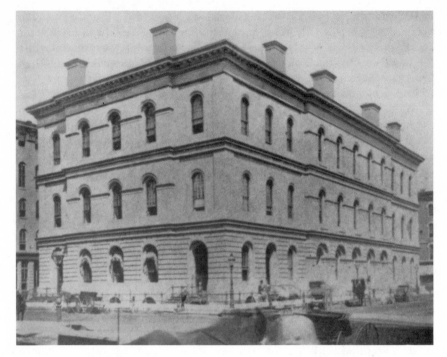

Fig. 2. Federal Building, 1855

attempt to build a structure that would not succumb to fire was made in the erection of the U.S. Post Office and Custom House (Federal Building) in 1855 (fig. 2). Heavy walls were used, but the wrought-iron beams were not fully encased in masonry and were unable to resist successfully the great fire of October 9, 1871.

The Great Fire and Fireproof Construction

History of the Fire

The great fire of Chicago, which began in a barn at the rear of 558 S. DeKoven Street at about 8:45 P.M. Sunday, October 8, 1871, had been preceded by a large fire during the night before. The earlier conflagration had burned the four blocks east of S. Clinton Street to the Chicago River and between W. Adams and W. Van Buren Streets in a north and south direction. The weather had been extremely dry, giving rise to many earlier fires, and after the Saturday night disaster the firemen were exhausted from their efforts. It would have been difficult to select a worse time to combat the colossal fire in which $192,000,000 of property was burned — 30 percent of the total Chicago property value of that date. The population of the city was then 334,270.

The great fire crossed the river at midnight Sunday and by 3:20 A.M. on Monday it had reached the Water Works at E. Chicago and N. Michigan Avenues, a distance of about 2¼ miles from the point of origin.

Buildings in the business district destroyed in this disaster were in general from four to six stories in height. Brick walls of the more pretentious buildings were faced with limestone veneer, but their floor and interior construction was of wood. The fire leveled them to a few feet above the street grade. In all, about 18,000 buildings were destroyed.

Andreas's *History of Chicago* contains a detailed history of the fire, with illustrations and a map of the burned district. Sheahan and Upton's *The Great Conflagration* includes a brief history of Chicago prior to the fire, statistics on the city's business and its population at the time of the disaster, a list and map showing the principal buildings destroyed, illustrations and anecdotes of the fire, and a report of the investigation that followed.

Buildings That Survived the Fire

The frame residence of Mahlon D. Ogden, built in 1837, which stood alone in the block south of W. Oak Street and east of N. Clark Street, was one of the few buildings not burned in the great fire. The block where the Ogden house stood is now occupied by the Newberry Library.

Because of its isolated location the Lind Block (fig. 3) also escaped the fire, and the Nixon building (see fig. 19), under construction, was not seriously damaged.

First Brick Building after the Fire

After a disaster of such magnitude, a delay in rebuilding might have been expected, but the first brick structure after the fire, Central Union Block 1, at

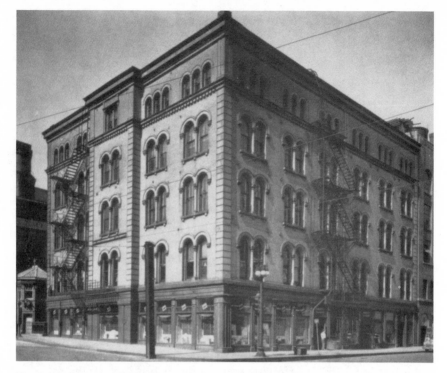

Fig. 3. Lind Block, 1852. (Courtesy of Peter Fish Studios)

the northwest corner of N. Wacker Drive and W. Madison Street, was erected swiftly. In fact, it was completed for occupancy by December 16, 1871.

Fireproof Construction

The principal lesson of the great fire of 1871 was that brick or stone walls, alone, are not sufficient to prevent destruction by fire. The Nixon building (1871–1889) of "fire-resistive construction" was "so little damaged by the fire that it was finished one week later." However, its good fortune may not have been due entirely to its superior construction.

One incident of the great fire left its mark on subsequent building construction. At the time, Van Osdel was superintending the construction of the new Palmer House. As the fire approached, he gathered his plans and record books, took them to the basement, dug a pit, and placed the documents in it. He covered the pit with two feet of sand and a thick layer of damp clay. The records survived the fire, and suggested a method of fireproofing with clay tile that is still used; this procedure was adopted in the construction of the Kendall building (1873–1940), which was considered the first fireproof structure in Chicago. In this building, hollow tile floor

arches were used for the first time. The first flat tile arches were used in the Montauk building (1882–1902).

An amendment to the Chicago building ordinance passed in December 1886 provided that new buildings more than 90 feet high must be of incombustible material, except the trim and flooring, which must rest upon concrete or incombustible material.

The Development of Skeleton Construction

The Rebuilding of Chicago

Chicago's swift recovery from the disastrous fire of 1871 involved construction on an unprecedented scale; the total for new buildings erected from the date of the fire to January 1, 1890, amounted to $257,215,779. In 1890 alone new buildings erected in the city cost $59,000,000, the largest amount for one year to that date; the frontage of these buildings going up in one year was 50½ miles. The tabulation of the total amount of building work in Chicago from the great fire up to 1890 (table 3) is from a report of John M. Dunphy, Building Commissioner.*

Buildings required in order to replace structures destroyed in the great fire, plus the added stimulus of Chicago's rapid growth, made the two decades after the fire an outstanding era in building construction. Advancements during this period entitled Chicago to its position of leadership in building construction in this country. "The construction of enormously high office buildings," said a writer in the *Engineering News* in 1895, "with frameworks of iron and steel carrying the exterior and interior walls and partitions, has become an established feature in nearly all large American cities. This style of construction originated in Chicago, in its practical application, at least, and that city has at the present time more buildings of steel skeleton type than have all other American cities together."

Skeleton Construction

Chicago is the birthplace of modern skeleton construction, a term applying to all buildings in which all external and internal loads are transmitted to the foundation by a skeleton or framework of metal or reinforced concrete, either separately or in combination.

A skyscraper is not necessarily of skeleton construction. The first skyscrapers, it is said, were built in what is now Edinburgh, as early as 200 B.C.; some of these buildings were 10 to 12 stories high in front and 14 to 15 stories in the rear. There are also records of houses of 10 stories in Tyre and Jerusalem. Athens had a law limiting the height of buildings to 10 stories, and the Emperor Constantine limited construction height to 100 feet in Constantinople.

Chicago's claim to the origin of modern skeleton construction lies in the fact that plans prepared in 1883 by William Le Baron Jenney, architect, for a 10-story office building for the Home Insurance Company involved the first clear conception of skeleton construction, although the party walls of this

*Additional data may be found for 1888 in Engineering Record, Jan. 5, 1889; for 1864–70 and 1877–85 in HCA Vol. 3.

Table 3.

From Fire to Jan. 1, 1877	$ 49,239,000
Jan. 1, 1877, to Jan. 1, 1889	176,460,779
For the Year 1889	31,516,000
Total from Fire to Jan. 1, 1890	$257,215,779[a]

a. Additional data may be found for 1888 in Eng. Rec., Jan. 5, 1889; for 1864–70 and 1877–85 in HCA, vol. 3.

structure helped to support the floors. Not until 1889 was a building of this type erected in New York City—the Tower building at 50 Broadway, 10 stories high, which was wrecked in 1914.

In the opinion of Major Jenney, skeleton construction was not a sudden invention, but rather a gradual evolution from old forms of construction. Jenney's partner, Mundie, has recorded that Jenney got his first ideas along this line when as a youth he spent three months in Manila, on a voyage in one of his father's New Bedford whaling ships. The Filipinos used trees as columns and lighter cuts of wood for lateral and diagonal braces, floor supports and partitions, binding them all together at the intersections with thongs and pegs. Baked mud or clay was used for floors and roof coverings. These buildings survived typhoons and earthquakes with slight damage.

Many of the necessary preliminary steps toward skeleton construction had been taken in England and on the continent of Europe. Smeaton used cast-iron beams for the first time in 1775, and in 1801 Boulton and Watt designed a cotton mill of seven stories at Manchester, England, which was the first instance of the successful use of cast-iron beams and columns in a building. The structure also had brick floor arches and floor framing, still typical of wall-bearing construction. Tests of cast-iron beams were made from 1820 to 1830 by Tredgold, Fairbairn, and Hodgkinson, in an effort to determine more economical shapes and design formulas permitting the use of longer spans.

Fairbairn, in *Application of Cast and Wrought Iron to Building Purposes* (1854), reports a series of experiments on the strength of wrought-iron beams conducted in 1845 in connection with the proposed Conway and Britannia Tubular Bridges. He proposes their use for buildings, and in a footnote, written later, states that he had introduced their use in the form of plate-girders in a five-story building at Wolverhampton.

It is less than 150 years since the first successful attempt to analyze the stresses in a framed structure.* The first wrought-iron beams were rolled in Europe in 1850, and in 1851 the Crystal Palace, London, was built of cast iron and wrought iron. In the United States the first wrought-iron beams were rolled in 1854.

*A Work on Bridge Building . . . , by S. Whipple, C.E., Utica, N.Y., 1847, followed by *General Theory of Bridge Construction . . .* , by Gen. Herman Haupt, A.M., Civil Engineer, Appleton & Co., 1851.

In December 1884, while the Home Insurance building designed by Jenney was under construction, Frederick Baumann, architect and author of *The Art of Preparing Foundations for All Kinds of Buildings, with Particular Illustration of the Method of Isolated Piers as Followed in Chicago* (1873), published a three-page leaflet entitled *Improvement in the Construction of Tall Buildings.* "Occupants seek convenience, *secureness* and *light,*" he stated, "all this, of course, combined with a shine of elegance." To achieve these desirable ends he advocated *My Concealed Iron Construction of Tall Buildings,* citing twenty-one properties and arguments in favor of such construction, among them speed and economy of construction, stiffness, and "LIGHT — the most indispensable desideratum with a building is procured even in the lowest, most valuable stories, where otherwise the necessarily broad piers would be a hinderment."

Among the Chicago buildings that exemplify the transition to skeleton construction was the Leiter building, 200–208 W. Monroe Street (1879–1972), characterized by a definite trend from wall-bearing to skeleton construction. Another distinct advance in design was the Montauk Block (1882–1902), considered the first tall building or skyscraper in Chicago. The Home Insurance building, in addition to embodying the first true skeleton construction, was also noteworthy because in it the first substitution of Bessemer steel rolled-beams for wrought-iron beams was made.

The Tacoma building (1889–1929) had street walls of skeleton construction but two interior load-bearing walls in addition to the required party walls; in its construction a few steel beams were used. The Manhattan building, at 431 S. Dearborn Street, built in 1890, is of true skeleton construction, still using wrought iron; the Rand McNally building (1890–1911) was the first of all-steel construction. In 1890, Corydon T. Purdy declared, "The use of cast columns in 16–20-story buildings ought to be prohibited by law."

The New York Life building at 39 S. LaSalle Street, built in 1894, is the first building in which the walls were not built from the ground up, but were begun at several floors.

Eiffel Tower

A striking contemporary of the development in Chicago of skeleton construction was the Eiffel Tower, 300 meters (984 feet) in height, completed in 1889 for the Paris Exposition of that year. Of wrought-iron construction, this structure was for several decades unrivaled in height. A similar tower, proposed and designed by George S. Morison, noted bridge engineer, for the World's Columbian Exposition, was to have been about 1,050 feet high. Another tower of this type was designed by Frank A. Randall for the Century of Progress Exposition — plans called for a height of 2,063 feet to the center of its beacon, and a base 420 feet square.

Elevators

Obviously the high buildings now characteristic of American architecture could not have been developed without similar progress in elevator design. By the middle 1850s steam-powered grain elevators were in use, and in 1857 the first passenger elevator, operated by steam, was installed in New York City. Chicago had a steam elevator in 1864 in the Charles B. Farwell store at 171–75 N. Wabash Avenue. In 1870 C. W. Baldwin of Chicago invented and installed the first hydraulic elevator in a store building for Burley & Company on W. Lake Street. This invention was the first practical elevator, and the passenger elevator of this type came into general use in 1877. It was almost universally used until several years after the first successful electric elevator appeared in 1887.

Party Walls

As stronger walls were required, Chicago became a city of party walls. A building ordinance requiring structures to be wall-bearing was in effect when the first building of skeleton construction, the Home Insurance building, was erected in 1884–85, and also when the first all-steel skeleton building, the Rand McNally, went up in 1890. In the same year the Manhattan building was erected of true skeleton construction, with no party walls, by carrying its north and south walls on cantilevers. The trend toward heavy wall construction reached its peak in the north half of the Monadnock block, built in 1891, the highest and heaviest wall-bearing building.

Steel Columns

In the 16-story Manhattan building (1890) cast-iron columns were used, steel being said to be too expensive; the 16-story Unity building (1892) was one of the last tall buildings to be constructed with cast-iron columns. The Rand McNally (1890), the Caxton (1890), and the Reliance (1890) buildings used steel columns. The Newberry Library building (1892) was the first in which the Larimer steel column was used.

Wind Bracing

Wind bracing was recognized as a necessity for the first time in the Manhattan building (1890), which was also the first 16-story building to be built in Chicago. In the north half of the Monadnock (1891), the first attempt was made at a portal system of wind bracing. The first use of knee bracing, an adaptation of the portal system which has since become popular, was in the Isabella building (1892).

Some Tall Chicago Buildings

Chicago's leadership in the early construction of tall buildings has already been discussed. After the era of steel had arrived in the nineties and the first concrete caissons had been built, buildings rose to even greater heights. This trend, however, was retarded in the decade following 1893, because of the financial depression and the reaction to the accelerated building preceding the World's Columbian Exposition.

The Masonic Temple (1892–1939), the tallest building of its day, was not equaled in height in Chicago until 1905, when the Majestic went up, and was not surpassed until 1909, when the 22-story LaSalle and Blackstone hotels were built. In 1914, the 60-story Woolworth building in New York was constructed. Its height was not exceeded for 15 years. Chicago regained the record for height of buildings when Sears Tower was topped out in May 1973. See chart, "Some Tall Buildings," in appendix G.

Many tall structures were built in the 1920s in Chicago. The Chicago Temple (1923) is 21 stories high, with an 8-story spire; the Continental Companies building (1924) is 21 stories high, with a 9-story tower. In 1926 the Pure Oil building was built with 24 stories and a 17-story tower; the Bankers building erected in 1927 is 41 stories high; and the Mather Tower building reaches a height of 24 stories, with an 18-story tower. The Civic Opera and Medinah Club buildings, both constructed in 1929, are 45 stories high, and One LaSalle (1930) is 49 stories high. The highest point on a Chicago building in 1949 was the tip of the statue of Ceres on the Board of Trade building; it is 605 feet above street level. The Sears Tower antennas reach a height of 1,787 feet.

Corrosion of Structural Iron and Steel

An investigation of the older buildings in Chicago, conducted in 1902, was made "to determine whether or not there is a basis for the alarming reports regarding the corrosion of structural iron in buildings, which have been published so generally throughout the country." Representatives of D. H. Burnham & Company, Jenney & Mundie, and Holabird & Roche, architects; George A. Fuller Company, and the American Bridge Company, contractors; and E. C. & R. M. Shankland, Ritter & Mott, and Purdy & Henderson, engineers, made inspections of the following buildings: Home Insurance (1885–1931), Rand McNally (1890–1911), Caxton (1890–1947), Great Northern Hotel (1892–1940), Masonic Temple (1892–1939), Venetian (1892–1957), and Ellsworth (1892).

The committee reported that "although the most exposed places were looked for, not one single dangerous case was found, and except where water itself had evidently come in contact with the metal, the only traces

of rust found were slight, and in all probability were due to initial conditions."

"All the first buildings constructed with steel frame will endure indefinitely," they concluded, "if reasonable care is exercised to protect the structural material from water. It is true that in those days little care was taken to protect the metal from corrosion as compared with the care ordinarily taken in these days; but in spite of that fact the metal work in these structures is in an excellent condition. The almost perfect appearance of the metal shows clearly that the ordinary hard terra-cotta fire proofing used in covering the columns has protected them from rust wonderfully well, and that the concrete around the grillage beams has likewise served its purpose in a perfectly satisfactory manner."

Examinations of the steel work of the Home Insurance, Great Northern, and Masonic Temple buildings, made at the time of their demolition, have confirmed the conclusions of this investigating committee.

Reinforced Concrete

In the gradual development of building construction in the United States, cast iron gave way to wrought iron and wrought iron to steel. However, by 1890 another structural material — concrete — was coming into use.

The first concrete building in the United States is the Milton House (Milton, Wisconsin), erected by Joseph Goodrich in 1844. This structure involved the use of "cement, sand, broken stone and gravel in a wet mixture and tamping it into forms to construct the walls." Goodrich wanted a building proof against attack and incendiarism by the Indians, and to this end used Portland cement from England, probably in a lean mix in view of the excessive cost of the cement. The main two-story building, 42 feet by 90 feet, has a hexagonal three-story unit at one end, each face of the hexagon having a horizontal dimension of 24 feet. This building was reported to be in almost perfect condition in 1940, but on April 30, 1948, an outer wall and a portion of the roof crumbled. The collapse continued on the next day as the remainder of the roof of the 200-foot wing fell in. The occupants were not seriously injured. The building was a one-time station in the underground railway for fleeing slaves. (*Chicago Tribune*, May 2, 1948.)

Tests of "beton" slabs reinforced with $\frac{5}{16}$-inch rods, and of beams reinforced with 4-inch I-beams weighing 10 pounds per foot, were made in 1871 and 1872 by W. E. Ward, who was seeking fireproof construction for the pretentious dwelling he built near Fort Chester, New York, in 1875. "Not only the external and internal walls, cornices and towers, but all the beams, floors and roofs, were exclusively made of beton, reinforced with light iron beams and rods. Furthermore, all the closets, stairs, balconies and porticoes, with their supporting columns, were molded from the same material. The only wood in the whole structure was in the window-sashes and doors with

their frames, mop-boards and stair-rails."* An illustrated article is in JSAH March 1961, p. 34.

At first reinforced concrete was used more generally in Europe, chiefly in building and highway work. Of several patented systems, some were introduced into this country in a limited way. At the end of the century Considère was making his experiments in France, and a few years later tests were under way at the University of Illinois, the University of Wisconsin, Purdue, and other engineering schools. The use of reinforced concrete in building work, both in conjunction with structural steel and independently in wall-bearing and skeleton construction, then began to be widespread. This advancement in construction was not, however, without its opponents. An editorial entitled "The Concrete Danger," published in 1903, carries this sweeping conclusion: "We have yet to see any system of concrete floor or column construction which in our judgment is fit to be trusted in any building."*

Chicago gained early preeminence in reinforced concrete construction; among its first buildings of this type are Frank Lloyd Wright's 1902 EZ Polish Factory, his 1904 Unity Temple in Oak Park, the Winton (1904), Plamondon (1906), Montgomery Ward & Company (1907), Bauer & Black (1908), and Studebaker (1910). "A survey recently completed [1928] by the Portland Cement Association," stated a writer in the *Engineering News Record,* "shows that there are 647 reinforced concrete buildings over ten stories high in this country, with an average number of stories of 11.9. . . . The tallest concrete building in the United States is the recently completed Master Printers Building, New York City, which has twenty stories and an overall height of 310 feet. Illinois is the leader among states in construction of tall concrete buildings with a total of 110; California is second with 67; Texas is third with 57; and New York fourth with 47." The tallest reinforced concrete building in Chicago now is the 1990 311 S. Wacker Drive building.

*Transactions of the American Society of Mechanical Engineers, IV, 388; illustrated.
*Engineering News-Record, June 1903.

The Development of Foundations

Isolated Footings

Interesting information and sound advice on the construction of foundations were published in 1873 by Frederick Baumann, an architect with twenty years of practice at that date. As is often the case with improved techniques, Baumann's recommendations for locating and proportioning the size of footings were not followed by all builders; indeed, his suggested practice is ignored by some to this day.

His 30-page pamphlet was entitled *The Art of Preparing Foundations for all Kinds of Buildings with particular Illustrations of the "Method of Isolated Piers," as followed in Chicago.* Baumann says modestly in his preface: "The literature upon any subject pertaining to construction of buildings being meager in our country, I venture to advance my limited experience and observation on the matter of foundations, with a hope of inviting better minds to similar and more comprehensive productions."

His fundamental rules represented a great advance in foundation practice, though some of his observations seem outmoded to present-day technicians.

"Concrete work, at best, is random work," Baumann wrote, "that may and may not do good service. Upon hard and practically incompressible ground it is superfluous, as a matter of course. Upon compressible ground it will, under all circumstances, accommodate itself to the deflections of the ground caused by superincumbent loads, and thus may, if circumstances concur, be of positive and very serious damage to the structure under the law of convex deflections as before demonstrated."

And, again, "The Chicago material for bases is: Dimension stone, hard lime rock, of most [*sic*] any dimensions, from eight to twenty inches thick, and with even beds. There can be no better material in the whole world than this dimension stone." (See appendix E.)

The Borden Block (1880–1916) is said to be the first building built on isolated footings.

Shallow Footings

The first isolated footings, of dimension stone as recommended by Baumann, were pyramidal in form. The Montauk Block (1882–1902) was the first building in which a grillage of iron rails was used to reduce the volume of the footings. But in erecting later buildings, architects still followed the practice of using pyramidal footings of stone. The Calumet building (1884–1913) and the Royal Insurance building (1885–1920) designed by Burnham and Root, and the Insurance Exchange building (1885–1912) by W. W.

Fig. 4. Pile Plan for Sibley Warehouse, 1883

Boyington, are typical examples. By 1886, however, the former firm seems to have abandoned the use of pyramidal footings; in the Rookery building (1886) and the Rialto building (1886–1940) not only rails for grillage were used, but also combinations of layers of rails and iron beams.

Wood Piles

Although wood piles had been used at an early date in the foundations of grain elevators along the Chicago River, their first use under a building wall did not come until 1883, when they were driven under the river wall of the Hiram Sibley & Company Warehouse (fig. 4), 315–31 N. Clark Street. From the records of the pile contractors, Fitzsimons & Connell (fig. 5), it appears that three rows were driven with the piles spaced three feet on centers along

Fig. 5. Pile Specifications for Sibley Warehouse

the wall. The oak piles were 30 feet long, with the cutoff about one foot above Chicago City Datum. Hydrographs show that the tops of these piles were then below the water level.

Apparently this use of piles did not bring them into immediate favor; no further record of their use is noted until the construction of the Grand Central Station (1890), followed by the Garrick building (1892), Illinois Central Station (1892), Newberry Library (1892), and Medinah building (1893). Load tests were made prior to the construction of the foundations of the Chicago Public Library, and 50-foot piles were used. Piles of the same length, driven to hardpan, were used in the construction of the Federal building, and from that time on their use became popular.

Caissons

The first "Chicago" caissons, or cylindrical concrete piers extending to either hardpan or bedrock, were used under the west party wall of the Chicago Stock Exchange, 30 N. LaSalle Street (1894–1972). The Herald building adjoined the Stock Exchange on the west, and it was feared that the driving of piles would cause disturbance of the Herald presses. General William Sooy Smith, who had designed the first pneumatic caisson sunk in this country, solved the party-wall problem by the use of open wells to hardpan, filled with concrete.

The first use of caissons as the foundation of an entire building was in the construction of the eleven-story Methodist Book Concern (1899–1990), 12–14 W. Washington Street. In the Electric building (1903–1927), 28 N. Wacker Drive, steel cylinders were used for forms in the lower part of the caissons.

Thereafter the use of caissons became general, especially for the higher buildings. Because of the comparatively low load-carrying capacity of the upper soil strata, the use of spread footings had limited the heights to which buildings could be constructed. The spread footings of the 16-story Monadnock Block, for example, projected as much as 11 feet beyond the building lines into the streets surrounding the building. Lighter buildings could be built a few stories higher. Piles permitted the construction of higher buildings, but the use of caissons to rock has fulfilled all requirements as to load-carrying capacity.

Land Use in the Central Business District

The information in table 4 was compiled from data in *Land Use in Chicago* (Vol. 2, 1943), the report of a survey directed by the Chicago Plan Commission. This survey is divided along section lines, and the areas include the buildings covered by this study.

In table 4 the land uses are segregated in the following way. *Residential* use includes single family (detached and attached), two-family, three- and four-family, and apartment buildings without business uses. *Business* use includes apartment buildings with business use, and business buildings and dwelling units. *Commercial* use includes commercial, commercial and industrial (mixed), and industrial. *Railroad* use includes no other use. *Vacant* use

Table 4. Square Mile Areas

Sq. Mi. Area[a]	Boundaries			
	North	West	South	East
156	W. North Ave.	N. Halsted St.	W. Chicago Ave.	N. State St.
158	E. North Ave.	N. State St.	E. Chicago Ave.	Lake Michigan
174	W. Chicago Ave.	N. Halsted St.	W. Madison St.	N. State St.
176	E. Chicago Ave.	N. State St.	E. Madison St.	Lake Michigan
192	W. Madison St.	S. Halsted St.	W. Roosevelt Rd.	S. State St.
194	E. Madison St.	S. State St.	E. Roosevelt Rd.	Lake Michigan

	Land Use (in sq. ft.)						
	Residential	Business	Commercial	Railroad	Vacant	Public	Total
156	6,781,739	2,832,541	4,011,268	514,256	2,598,356	10,985,240	27,723,400
	(24.5%)	(10.2%)	(14.4%)	(1.9%)	(9.4%)	(39.6%)	
158	2,320,611	595,509	486,878	0	678,010	5,250,727	9,331,735
	(24.8%)	(6.4%)	(5.2%)	(0%)	(7.3%)	(56.3%)	
174	638,917	834,289	8,173,591	4,171,688	2,122,404	12,067,404	28,008,293
	(2.3%)	(3.0%)	(29.2%)	(14.9%)	(7.5%)	(43.1%)	
176	459,899	230,340	5,164,132	4,357,492	1,503,852	10,826,938	22,542,653
	(2.1%)	(1.5%)	(22.7%)	(19.2%)	(6.7%)	(47.8%)	
192	442,921	612,922	7,554,887	6,494,606	2,867,508	10,448,471	28,421,315
	(1.6%)	(2.2%)	(26.6%)	(22.9%)	(10.0%)	(36.7%)	
194	6,539	226,735	2,317,452	1,342,914	368,971	11,773,837	16,036,448
	(0.2%)	(1.4%)	(14.4%)	(8.3%)	(2.3%)	(73.4%)	
Total	10,650,626	5,332,336	27,708,208	16,880,956	10,139,101	61,352,617	132,063,844
	(8.1%)	(4.0%)	(21.0%)	(12.8%)	(7.7%)	(46.4%)	(100%)

a. Corresponds to page number in report.

Table 5.

Residential use	10,650,626 sq. ft.	19.8%
Business use	5,332,336	9.9
Commercial use	27,708,208	51.5
Vacant use	10,139,101	18.8
Total	53,830,271 sq. ft.	100.0%

includes parking and used-car lots, other temporary business, and entirely vacant lots. *Public* use includes parks and playgrounds, cemeteries, other public and institutional buildings, streets and alleys, and waterways.

Eliminating the areas of railroad and public use, the totals for the above six square mile areas are given in table 5.

Cost of Construction

Construction and building cost indexes, from 1913 through 1944, are in ENR for April 5, 1945, p. 113, with an explanation of the basis of each index.

The American Appraisal Company Construction Cost Trend Index (1913 = 100) for Chicago is shown in the same issue (p. 110), from 1914 through 1944.

Yearly indexes of building costs, industrial frame type (Eastern cities), of the American Appraisal Company from 1852 through 1930 are in *The Evolving House, The Economics of Shelter* (Vol. 2, Table W, p. 569), published by the Technology Press, Massachusetts Institute of Technology, 1934. In the same volume (chart 50, p. 280) is shown the Cost of Housing, per family, for the building only, by decades from 1800 through 1930.

The Boeckh Index of Building Costs (U.S. average, 1926–1929 = 100) for the Chicago area is given in the following publications:

> 1926–29, 1939 to 1944, both inclusive — ENR for April 5, 1945, p. 120
> 1926–29, 1935 to 1939, both inclusive — ENR for June 20, 1940, p. 102

Van Osdel says the purchasing value of a dollar was three times as great in 1844 as in 1883. In the latter 1880s his records show the cost of commercial buildings as about five to six cents per cubic foot and the cost of the Grace Hotel as four cents per cubic foot.

Building costs doubled from 1913 to 1926, after World War I. Though not stabilized (1948), building costs doubled, following World War II. The dollar value of the yearly amounts of building construction from 1854 through 1994 is given in appendix C. The Boeckh Cost Index in 1996 was more than four times that of 1948, about 2,000.

Part 2

Noteworthy Chicago Builders

Some Builders from Periods I–V (1830–1949)

A history of the evolution of building construction would be incomplete without added mention of some of the individuals who were prominent in the Chicago scene. John M. Van Osdel, Chicago's first architect, was first a carpenter; his last building was the Monon, 1890, the first 13-story building. Gurdon P. Randall was an architect by training; "down to Burnham's day he had developed the largest clientele anyone had attained outside of Chicago" (HE), and he was the first signer of the published architects' code that antedated the organization of the American Institute of Architects. Maj. William Le Baron Jenney, an engineer by training, is credited with the most important step in the evolution of skeleton construction, and he was architect of the Manhattan, the world's first 16-story building of true skeleton construction. Gen. William Sooy Smith, engineer, was the originator of the Chicago caisson. Charles Louis Strobel, engineer, was the originator of the steel *Pocket Companion* and of standard rolled sections. Daniel Hudson Burnham, famous for his work on the World's Columbian Exposition and the Chicago Plan, extended his practice over the nation. William Holabird was active as an architect in Chicago for half a century, and his firm took a prominent part in the development of tall building construction. Louis Henry Sullivan was famous for the Auditorium and his distinctive architecture. Louis E. Ritter, Corydon T. Purdy, and E. C. and R. M. Shankland were engineers responsible for a great part of the development in steel construction and improved foundation design.

JOHN MILLS VAN OSDEL (1811–1891) (fig. 6), Chicago's first architect, as a young man was a carpenter, which then meant that he was an architect

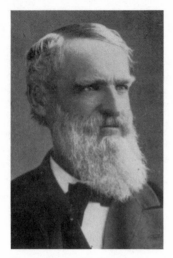

Fig. 6. John Mills Van Osdel

as well; and at the age of 22 he published a book on carpentry. He arrived in Chicago from New York City in June 1837.

Passing from the landing toward Mr. Ogden's office on Kinzie Street, he noticed a block of three buildings, three stories high, the fronts of which had fallen outward, and laid [*sic*] prone upon the street . . . the frost of the preceding winter had penetrated to a great depth below the foundations, and the buildings having a south front, the sun acting upon the frozen quicksand under the south half of the block rendered it inescapable of sustaining the weight of the building. At the same time, the rear or north part of the block, being in shadow, the frozen ground thawed gradually, and continued to support the weight resting on it. . . . The front settled fourteen inches more than the rear, making all floors fourteen inches out of level from front to rear. This movement pressed the upper part of the front wall outward beyond its center of gravity and it fell to the ground.

In 1837 there were not more than one thousand buildings in Chicago. About twenty of these were brick structures. . . . Mr. [George W.] Snow was the inventor of the balloon frame method of constructing wooden buildings (IA, 1883, Recollections of John M. Van Osdel). [Augustine D. Taylor has since been credited as the inventor; see 1830 note, below.]

Van Osdel returned to New York in 1840, where for a year he edited the building department of the American Mechanic, later the Scientific American. In 1841 he returned to Chicago and became the first architect to practice in Chicago or in the west.

In the winter of 1844 when builders were their own architects, some leading builders proposed to me that I open an architect's office, pledging themselves not to make any drawings or construct any building of importance without a plan. With this promise, I undertook to do so, and opened an office on Clark Street between the City Hall and the Post Office, occupying the site of the present Sherman House. No one had ever used an architect and it was difficult to convince the owners of the necessity of such a branch of the building business.

In 1844 Chicago had a population of 8,000, and it is reported that 800 buildings were erected in that year.

In 1848 Van Osdel was commissioned to build the two-story City Hall and

Market in the middle of what is now N. State Street, facing W. Randolph Street; a view is in CYT, p. 12, and in CIM, p. 227.

Two of the first large steamers in Chicago were constructed by him. He also designed grain elevators, among them the first to be erected in Chicago. For two years he was in the iron foundry business.

Van Osdel's original books of account, in three volumes, are preserved in the archives of the Chicago Historical Society. These books cover his work from 1856 until his death in 1891. A double page is assigned to each building. Contracts were awarded by trades, and the names of the contractors are given together with the amount of each contract and the amounts of the individual payments made on each contract as the work progressed (fig. 7). General contracts were let for a few buildings, chiefly residences or small work.

On the inside cover of the book he opened in 1856 is pasted a printed copy of an undated agreement signed by the following architects in order: G. P. Randall, P. A. Nicholson, Robert Schmid, A. Bauer, Edward Burling, John M. Van Osdel, O. S. Kinney, O. L. Wheelock, W. W. Boyington, T. V. Wadskier, and A. Carter. Fees for various kinds of work are enumerated. For a record of their early days and their coming to Chicago, reference is made to *60 Years a Builder* (HE), by Henry Ericsson, who thus eulogizes them: "Indeed, the world, no less than Chicago, remains today under great obligation for what evolved from their trials, the struggles and the conquests of the men who signed the code of 1856. Some men's failures contributed as much or more than did other men's successes."

The method of calculating the safe floor loads is shown by an entry (Volume II, 1869–1886, page 219) as follows: "Safe loads for joists and timbers, being *one-third* of the breaking load, Trautwine's formula. Multiply the breadth by 150. Multiply this product by the square of the depth. Divide this product by the length (in feet) — gives the *center load:* Multiply center load by 2 for distributed load."

This is followed by two tables. The first table is the calculated safe loads per square foot of joists (spaced 12 inches on center) from 2 inches by 6 inches in size to 3 inches by 16 inches and for spans varying from 10 feet to 28 feet for the deeper joists. The second table is the calculated "safe load distributed over the whole length" for girders from 8 inches by 12 inches in size to 14 inches by 16 inches and for lengths varying from 10 feet to 20 feet. The formula is for a unit stress of 1,800 pounds per square inch, considerably higher than present permissible unit stresses for the kind of timber then used.

Van Osdel was a member of the original Board of Trustees of the University of Illinois and served from 1867 to 1873, during which time he built University Hall, the first building there. In his books of account, in the year 1872 is found the entry: "University at Champaign — Contractor — E. F. Gehlman — $113,954." After the Chicago Fire he established the new city grade, served as alderman, was on the building committee, and drafted and

Fig. 7. Page 218 from Van Osdel's Book of Account

secured the passage of Chicago's first building code (HE). His photograph is in IC, Vol. 1.

Van Osdel built a great many of the notable old buildings, including the Tremont and Palmer Hotels. His last work was the Monon building, the first modern building in the world to reach 13 stories, now wrecked on account of the Dearborn Street subway which curves under this site into W. Congress Street. *A Quarter Century of Chicago Architecture — John M. Van Osdel,* by Conrad Bryant Schaefer (in Burnham Library), describes and illustrates a portion of Van Osdel's work.

"GURDON P. RANDALL, one of the oldest of Chicago architects, died on the 20th ult. at his early home in Northfield, Vt., whither he had gone to regain his health, which had been failing for some time. The remains were brought to Chicago and interred at Rosehill. Architect Randall commenced his studies in the office of Asher Benjamin, of Boston, and at the age of thirty removed to Chicago, where, during a term of 34 years, he had become more widely known throughout the west than any other architect. His work was especially in the line of schoolhouses and churches and also court houses of which he built a large number, some in distant states. He was the first architect to build churches in the much favored and copied amphitheatre style, his originating this style in the Union Park Congregational Church in Chicago giving him a wide celebrity as a church architect. Beside [*sic*] being an architect of wide information and an honor to his profession, Mr. Randall was a man of sterling worth, his broad nature and genial temperament drawing to him friends wherever he went, and his upright character securing to him a reputation for honesty and integrity that was always beyond reproach. As an architect of the old school, always true to the principles of his art, and designing with a broad and positive expression, his works will long stand as examples of the thorough work of a thorough man. His upright life will cause him to be deeply mourned by his brother architects, with many of whom he was most intimate in the early days of Chicago. His intelligence and ability is a loss to the entire architectural profession" (IA, October 1884; see also HE).

WILLIAM LE BARON JENNEY (1832–1907) (fig. 8) came of an old Plymouth family and was educated at the Lawrence Scientific School and in Paris. He was engaged in engineering work with Wm. T. Sherman when the Civil War broke out; he served as captain under General Grant down to Vicksburg and then on the staff of General Sherman on his March to the Sea. He retired as major and in 1868 came to Chicago, at which time he opened his office as an architect. In 1869, with his partner, Sanford E. Loring, he published *Principles and Practice of Architecture* (46 plates), a copy of which is in the Burnham Library. From 1876 to 1880 he was Professor of Architecture at the University of Michigan. His photograph is in IC, Vol. 1.

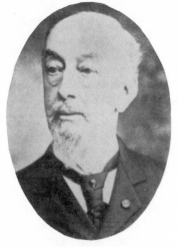

Fig. 8. William Le Baron Jenney

After three short partnerships and intervening periods when he practiced by himself, the partnership of Jenney & Mundie was formed in 1891. In 1905 this became Jenney, Mundie & Jensen until after the death of Mr. Jenney in 1907, when the firm became Mundie & Jensen until 1936; it was then Mundie, Jensen, Bourke & Havens until May 1, 1944, when the name of Mundie & Jensen was resumed. In 1946 Verne O. McClurg entered the firm, and the name became Mundie, Jensen & McClurg.

LE ROY S. BUFFINGTON, architect, of Minneapolis, claimed to be the inventor of skeleton construction under his Patent No. 383,170 dated May 22, 1888, but was unsuccessful in his patent suits. His "Design for 28-story Office Building — Iron Construction" is illustrated in IA (July, 1888) and in HSM.

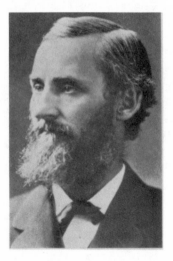

Fig. 9. General William Sooy Smith

WILLIAM SOOY SMITH (1830–1916) (fig. 9) was educated at Athens, Ohio, and at West Point, which he entered in 1849. From 1854 to 1861 he was engaged in teaching and in bridge building. In the late 1850s he practiced in Buffalo as Smith & Parkinson. At the outbreak of the Civil War he was building a bridge across the Savannah River, but when Fort Sumter was fired on, he reenlisted in the army. He resigned in 1864 on account of ill health. His next engineering work was in connection with the lighthouse at the western entrance to the Straits of Mackinac; there he designed the first pneumatic caisson to be sunk in this country, for which he received an award from the Centennial Exposition (WSE, January, 1917). He was the first also to use the Chicago method of caisson construction, under the west party wall of the Stock Exchange building at 30 N. LaSalle Street. See appendix H for his tribute to "The Tall Building."

CHARLES LOUIS STROBEL (1852–1936) (fig. 10) was educated in the public schools of Cincinnati and graduated in 1873 from the Royal Institute

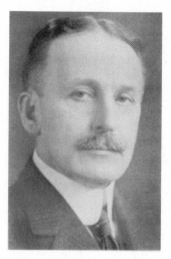

Fig. 10. Charles Louis Strobel

of Stuttgart, Germany, with the degree of C.E. From 1874 to 1878 he was assistant to the Chief Engineer of the Cincinnati Southern Railway, in charge of bridge design. From 1878 to 1885 he was assistant to the president of the Keystone Bridge Company and from 1885 to 1893 its consulting engineer and agent in Chicago, as well as consulting engineer for Carnegie, Phipps & Company, Ltd., the Chicago, Milwaukee & St. Paul Railway Company, Burnham & Root, Adler & Sullivan, architects, and others. He designed standard sections for I-beams and channels and originated the Z-bar column, which was first used on the Kansas City bridge of the C.M. & St.P.R.R. in 1886 and which was first used in a building in Cleveland, Ohio, of which Burnham & Root were the architects (RG, October 30, 1891). He developed and edited, in 1881, *A Pocket Companion of Useful Information and Tables Appertaining to the Use of Wrought Iron for Engineers, Architects and Builders* (see fig. 12). He also edited later editions, containing the properties of steel sections, the forerunners of the *Carnegie Handbook,* which did much to promote the use of steel construction. In 1895, Mr. Strobel designed the first wide-flanged beam sections, which were not adopted by American manufacturers until many years later. Until his retirement in 1926, he operated the Strobel Steel Construction Company, which he had organized in 1905 (WSE, December, 1936).

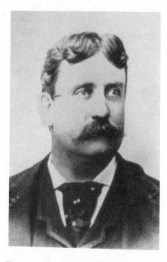

Fig. 11. Daniel H. Burnham

DANIEL HUDSON BURNHAM (1846–1912) (DHBM) (fig. 11) was born in Henderson, New York, and came to Chicago in 1855 with his parents. A photograph is in IA for September 1893. He was educated in the public schools of Chicago and private schools in Massachusetts. In 1868 Mr. Burnham returned to Chicago and spent one year in the office of Loring & Jenney, during which time he built some small houses on his own account. Prior to the Chicago fire of 1871 he also had an architectural partnership with Gustave Laureau. In 1872 he entered the office of Carter, Drake & Wight, where worked JOHN WELLBORN ROOT (1850–1891) (fig. 13), who had followed Peter B. Wight from New York City, where

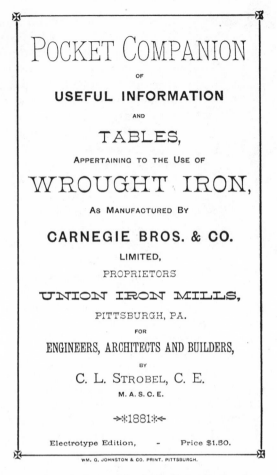

POCKET COMPANION

OF

USEFUL INFORMATION

AND

TABLES,

APPERTAINING TO THE USE OF

WROUGHT IRON,

AS MANUFACTURED BY

CARNEGIE BROS. & CO.

LIMITED,

PROPRIETORS

UNION IRON MILLS,

PITTSBURGH, PA.

FOR

ENGINEERS, ARCHITECTS AND BUILDERS,

BY

C. L. STROBEL, C. E.

M. A. S. C. E.

→∗1881∗←

Electrotype Edition, - Price $1.50.

WM. G. JOHNSTON & CO. PRINT. PITTSBURGH.

Fig. 12. Title Page of Strobel's *Pocket Companion*

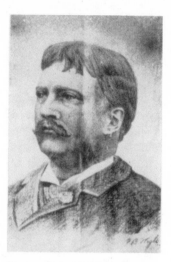

Fig. 13. John Wellborn Root

Root had studied engineering and had gone through his architectural apprenticeship. In 1873 the partnership of Burnham & Root was formed (IA January 1891, with a list of their work). During the years 1891, 1892, and 1893 Mr. Burnham was chief of construction of the World's Columbian Exposition. On March 1, 1894, he reorganized his office as D. H. Burnham & Co. with the following partners: Ernest R. Graham, Edward C. Shankland (to 1900), Charles B. Atwood (to December 1895) and his sons Daniel H. and Hubert Burnham (from 1910). After the death of Mr. Burnham in 1912 the firm became Graham, Burnham & Co., until August 4, 1917, the partners consisting of Ernest R. Graham, Pierce Anderson, Edward Probst, Howard J. White, Daniel H. Burnham Jr., and Hubert Burnham (AR, December 1895, and July 1915). The firm of Graham, Anderson, Probst & White continues under the direction of Robert Surman, succeeding his father, William Surman.

Fig. 14. William Holabird

WILLIAM HOLABIRD (1854–1923) (fig. 14) was born in Dutchess County, New York. He graduated from the St. Paul (Minnesota) High School in 1871, entered West Point in 1873, resigned in 1875, and entered the architectural office of W. Le Baron Jenney in the same year, where he remained until 1880, when with Ossian C. Simonds, landscape gardener, he formed the partnership of Holabird & Simonds. MARTIN ROCHE (1855–1927) was born in Cleveland, Ohio. His family came to Chicago in 1857, where in 1872 he also entered the office of Mr. Jenney, remaining there until 1881, when he joined the above partnership, which then became Holabird, Simonds & Roche. In January 1883, Mr. Simonds withdrew and the firm became Holabird & Roche, which it remained until 1928, when John Wellborn Root Jr., son of John Wellborn Root (1850–1891), who was a partner in the former firm of Burnham & Root, joined with John A. Holabird (1886–1945), son of William Holabird, to form the firm of Holabird & Root. On January 1, 1948, J. Z. Burgee became a mem-

ber of the firm, the name of which was changed to Holabird & Root and Burgee. Edward A. Renwick, who died in 1941, was a member of the firm from 1886 until 1932. Corydon T. Purdy, Purdy & Phillips, and, for the greater part of the time, Purdy & Henderson were consulting structural engineers from about 1892 to 1911, during the latter five or six years of which time Benjamin E. Winslow was employed by the firm as structural engineer. Henry J. Burt was employed in this capacity from 1911 until his death in 1928, during the latter few years as a consultant. Benjamin B. Shapiro and then Frank E. Brown acted as structural engineers until 1928, when Verne O. McClurg became structural engineer, the position he occupied until 1946. The firm continues today as Holabird & Root.

Fig. 15. Louis Henry Sullivan

LOUIS HENRY SULLIVAN (1856–1924) (AR, April 1925) (fig. 15) was born in Boston. After spending one year at Massachusetts Institute of Technology and a short time in the office of Furness & Hewitt, architects, Philadelphia, he came to Chicago in 1873 and worked for about six months in the office of William Le Baron Jenney. In 1874 Sullivan went to Paris, where he studied for about two years before returning to Chicago in 1876. In 1879 he entered the office of DANKMAR ADLER (1844–1900). In 1880, the firm of D. Adler & Co. was established with Sullivan as a partner. In 1883 Sullivan became an equal partner under the firm name of Adler & Sullivan, which was dissolved in 1895. After that time both architects practiced independently. Paul Mueller became engineer for the firm in 1886. The firm achieved its prominence with the Auditorium. It has been internationally acclaimed for the design of the Wainwright building, St. Louis, in 1890 and 1891, and its sister, the Guaranty building, Buffalo, in 1895 and 1896. Sullivan's genius is exemplified best in Chicago by his Carson, Pirie, Scott store, the city's finest architecture and a pinnacle of the Chicago School achievements.

LOUIS E. RITTER (1864–1934) graduated from the Case School of Applied Science in 1886, and after three years in railroad work and three years with the U.S. Engineers on Mississippi River improvements, came to Chicago in 1892. From 1892 to 1899 he was with Jenney & Mundie, architects; from 1899 to 1917, he was a member of the firm of Ritter & Mott, consulting civil engineers; and from 1917 to his death, he continued to practice as a consulting engineer in Chicago. Fondly known as the dean of structural engineers, a list of his engagements would be of historical interest (WSE, August 1934).

Fig. 16. Richard E. Schmidt

RICHARD E. SCHMIDT (1865–1958) (fig. 16) was born in Ebern, Germany, and came to the United States in 1866. He attended the Massachusetts Institute of Technology for two years and practiced in Chicago for seventy years, beginning in 1887. The firm of Schmidt, Garden & Martin was formed in 1906; Carl Erikson succeeded Martin as a partner in 1926 and later became head of the firm. HUGH MACKIE GORDON GARDEN (1873–1961) was born in Toronto, Canada. Before becoming a partner, he was associated with Schmidt in several projects, including the design of the Madlener House, now the Graham Foundation. He was the chief designer for the firm from 1906. Richard Schmidt was a leader among Chicago architects in recognizing the important place of reinforced concrete in major buildings. The work of his office and its Chicago School design influence was diverse, including extensive facilities for the Michael Reese Hospital.

The following tribute of a contemporary engineer, made at the close of the decade ending with the Columbian Exposition, after the lapse of half a century loses none of its poignancy:

> The remarkable enterprise of Chicago has made such great demands upon both architects and engineers that they have been forced to be progressive. The result is that the constructive side of the problem has reached its most perfect development in Chicago practice. Mr. Jenney, Mr. Burnham and Messrs. Holabird & Roche, of Chicago, have taken the most important part in this movement. Chicago's pride is its Auditorium, designed by Messrs. Adler & Sullivan, and other notable work has been done there by other architects, but these three have led the way in the use of steel. . . . Mr. Post, of New York City, whom Mr. Burnham called the father of big buildings, was educated as an engineer and he is, in many ways, as closely identified with the use of steel as these western men. (ER, February 6, 1895, from an address in Boston by Corydon T. Purdy)

Several Period VI (1950–1998) Builders

LUDWIG MIES VAN DER ROHE (1886–1969) was born in Aachen, Germany. After a brief practice in 1907 and from 1912 to 1914 in Berlin, he practiced continually from 1919. He was Director of the Bauhaus from 1930

to 1933 and came to Chicago as Director of Architecture at the Illinois Institute of Technology, teaching from 1938 to 1958. With Ludwig Hilberseimer he planned the campus at which the most celebrated building is Crown Hall of 1956. His buildings and projects in Europe brought him international recognition before he came to America. Among his most highly regarded works there are the 1929 German Pavilion at Barcelona, Spain, and his influential projects of 1919 and 1921 for glass skyscrapers. His 860–880 North Lake Shore Drive Apartments are his greatest Chicago buildings, demonstrative of the clarity of his handling of the steel frame construction. The bronze-clad, 38-story Seagram building of 1958 in New York City is widely considered his finest skyscraper. Mies van der Rohe believed that technology was of central importance in architecture. His structures manifest his concern for orderly and elegant structure and fineness of details. His concepts included the planning of universal space and the necessity that design be based on the integrity of form and material, and their sensitive expression. His tall buildings in many cities and his teaching, based on the importance of understanding fundamental principles, gained him the reputation as the greatest twentieth-century architect of skyscrapers, which he considered America's greatest contribution to world architecture.

SKIDMORE, OWINGS, and MERRILL (SOM), established in 1939 at Chicago, continues today with offices in several other cities. LOUIS SKIDMORE (1897–1962) was born in Lawrenceburg, Indiana; NATHANIEL A. OWINGS (1903–1984) was born in Indianapolis, Indiana; and JOHN O. MERRILL (1896–1975) was born in St. Paul, Minnesota, and became a partner shortly after the founding of the firm. Prominent projects in a number of other cities and abroad, for example, New York's Chase Bank and Lever House, for which Gordon Bunshaft (1909–1990) was the designer, the 1960s "Owings Plan" for Washington, D.C., the Air Force Academy complex in Colorado, and the Bank of America tower in San Francisco, brought the firm very high acclaim for design that manifested much of the theory of Ludwig Mies van der Rohe. Leading SOM Chicago designers, in producing a dominating number of tall office and mixed-use buildings, include Walter Netsch, Bruce Graham, Myron Goldsmith, and Adrian Smith. In Chicago the widest praise has been given for the stainless steel clad Inland Steel building with its column-free office space and its serving tower, and for the John Hancock and Sears towers.

FAZLUR RAHMAN KHAN (1929–1982) was born in Bangladesh. He studied at the Bengal Engineering College in Calcutta and taught at the University of Dacca. Pakistani and Fulbright scholarships brought him to the United States, where he received three degrees from the University of Illinois. He is most remembered for his development at Skidmore, Owings, and Merrill of the bundled tubular framing system, in collaboration with

Bruce Graham. His first use of this system was for the 1963 Plaza On DeWitt apartments. Here, a rigid screen of concrete columns, narrowing as they rise, braces the exterior of the building and helps to minimize the size and frequency of internal columns. This system was modified to become a tube within a tube in the Brunswick building, where a rigid elevator core allowed for column-free internal space. The John Hancock Center represents the translation of this rigid external tube configuration to a steel building. Here the exterior columns and expressive diagonal bracing form a slender tapering volume ideally suited to its function as a mixed-use building. Kahn took the rigid tube concept one step further in the Sears Tower, where nine rigid tubes were bundled together to achieve a structure of unprecedented height. For Onterie Center he developed two reinforced concrete tubes and braced them with diagonals formed by infilling window openings, combining ideas from the previous towers. Kahn left a legacy of engineering masterpieces and distinguished himself as one of the most innovative structural engineers in the realm of modern architecture. (Scott A. Rappe)

HARRY MOHR WEESE (1915–1998) was born in Evanston, Illinois, and studied at MIT, Yale, and Cranbrook, studying city planning under Eliel Saarinen. He established his firm in 1947 after working for SOM for a short time. He believed that the purpose of architecture is innovation and that success comes from eliminating preconceptions about the problem at hand. This innovation characterizes his career. His work consistently shows a debt to Chicago's rich heritage, incorporating elements such as masonry bearing walls, the Chicago bay window, and traditional planning concepts.

Harry Weese was known also for his preservation efforts, including service toward saving the Auditorium from destruction. He distinguished himself in his efforts to revive the appeal of urban living. His leadership in the redevelopment of Printers Row began an urban renaissance in the South Loop area. His conversion of a cold storage warehouse and construction of townhouses at Wolf Point Landing created a cohesive riverfront community.

Contextualism is evident in Weese's larger works. In the Time-Life building, a Cor-Ten steel skin makes use of indented spandrels and bronze glazing to create a lively play of light and shadow on the building's surface. His work balances innovation and self-expression with an understanding of the past and a respect for context, and it represents an individualized approach to modernism. (Scott A. Rappe)

Part 3

Milestones in Building Construction

A Chronological Account of Chicago Buildings

Introduction

From the log construction of Fort Dearborn, rebuilt in 1816, to the 21-story steel and masonry Masonic Temple (1892) was the span of but one lifetime. In fact, it was a period almost identical with the lifetime of Chicago's first architect, John M. Van Osdel (1811–1891), who played one of the most active parts in the Chicago epic of building construction.

The development of building construction in Chicago is indicated in the record of the buildings which follows. In general the arrangement is chronological. It includes buildings over five stories high and smaller buildings of special interest in the area bounded by North Avenue, Lake Michigan, Twenty-third Street in the eastern precincts, and the Kennedy Expressway west of the south branch of the Chicago River. This area includes the original and the present central business districts and has led not only the outlying districts but the nation as a whole in many of the developments in modern building construction.

The names of about 140 noteworthy main-entry buildings are highlighted by italicizing in order to bring them to the reader's attention when scanning this compendium of approximately 1,500 buildings. A dozen structures built between 1873 and 1894 — but demolished before formal landmark designation and preservation programs were formed — are noted as having "special significance." Abbreviations follow the names of those buildings that have been formally recognized as landmark buildings and historic districts by various groups, using the following system: "CAL" refers to Chicago Architectural Landmarks; "CHALC" refers to listings in brochures of the Chicago Historical and Architectural Landmarks Commission, the early

43

name of the present Commission on Chicago Landmarks; "IR" refers to the Illinois Register of Historic Places; "NR" represents the National Register of Historic Places; "NHL" refers to National Historic Landmark; "HABS" refers to the Historic American Building Survey and its reference books containing details, drawings, and photographs; "CFB merit" refers to buildings cited as meritorious in *Chicago's Famous Buildings*. Landmarks Preservation Council of Illinois, a private group, lists noteworthy buildings in its brochure *Chicago's Landmark Structures: Inventory*, some of which are noted as "premier," which reflects LPCI's opinion regarding the buildings most worthy of preservation; hence the names of some buildings in this book are followed by the notation "CLSI" or "CLSI/premier." The buildings included here may express an advanced technology, or may belie it with facades of foreign form. Some may evidence qualities and forms that originated in Chicago and frankly express serious purpose. Others may bow to speculators' needs to gain popular attention, allude to more significant buildings, or simply abandon rational theories such as "form follows function."

Throughout this book, construction dates are given as years of completion and demolition, thus: 1892–1925. Demolition years that are unknown are noted as being before a certain year; for a decade, e.g., "1960s"; or for a longer range, e.g., "(1950 to 1990)." Authorities often vary from one to several years in the dates they give for construction, some probably using the date when construction was begun. In case of doubt an approximate date has been given, thus: ca. 1888, or the date used may conflict with some reports. When neither the date of completion nor that of demolition is certain, but if it is known that the building existed a few years prior to the great fire of 1871, the designation "(prefire)" is used. Extensive remodeling is indicated thus: "1872/1890–1910," which tells that the building was built in 1872, remodeled in 1890, and demolished in 1910. The word "fire" follows the year of demolition when this cause is known. Some major buildings and additions that are recorded with a predecessor building are also referenced at the year of their construction.

The major part that engineers play in the construction of buildings is slighted in most writing. This is also true too often for the identity of the designers. This record also suffers in its effort to attribute credit in this large quantity of buildings, but the firm names of the architect and of the engineer are included when known. These are difficult to ascertain for many of the older buildings and even for some of comparatively recent origin. Biographies containing lists of buildings usually name only a few of the more important structures which the subject designed.

In many cases several bibliographical references have been given, both for the convenience of the reader and because each reference usually contains additional information though only a photograph is noted. Panoramic scene references are occasionally inserted between building entries to bring attention to views of portions of the city at the year noted. Similarly, notes

are inserted at the year of improvements or construction of streets because of their importance in stimulating construction in these sections of the city.

Street Numbers

Old street numbers and names have been changed to the new ones, unless otherwise noted. Where the predecessor building did not occupy the entire area occupied by its successor, this fact is shown generally by the street numbering or by dimensions. Robinson's *Atlas of the City of Chicago* (1886, 5 vols.) shows the name and location of many of the older buildings. The Chicago Title and Trust Company kindly made these volumes accessible to me. *Book of Valuations of the Central Business District of Chicago,* by the Chicago Real Estate Index Company, issued quadrennially for forty years, is generally accessible and, in addition to valuations, contains maps showing the names of buildings, their dimensions, and the street numbering. It also indicates the height and the construction of the buildings; this information has not been repeated here. The last issue of these volumes was for 1939–42.

Appendixes and Indexes

Among the appendixes to this book are a list of all buildings by location (appendix A) and a list of architects and engineers and their works (appendix B). In addition, an index of buildings by name and a general index refer readers to discussions in the text. Many buildings have had several names. The present trend is toward names that incorporate a street number, so that the name indicates the location. All names known to the author have been listed. Occasionally the same name has been used for buildings in different locations. Buildings of the same name on the same site or the continuation of the same ownership or business are distinguished by years and by a number following the name. Thus, Tremont House 1 is the first and Tremont House 2 is the successor building, even though on a different site. See also the introductory statements at the individual appendixes. As noted in the preface to this edition, many buildings are listed in appendix A but designated as NI (not included in the main text).

Floor Areas

Floor areas are not usually given. A tabulation of areas (and the names of developers) of 75 buildings is in *Tall Office Buildings in the U.S.,* Real Estate Research Corporation and the Urban Land Institute (1985).

Period I: From 1830 to October 9, 1871

The building development of Chicago was neither uniform nor continuous. Economic conditions and local and world events divided the history of building construction into six general periods:

1. From the first sale of lots in 1830 to the great fire of 1871
2. From 1871 to 1880, the age of rebuilding after the fire
3. From 1881 to 1900, covering the "golden age" and the World's Columbian Exposition
4. From 1901 to 1920, through the aftermath of World War I
5. From 1921 to 1949, through the aftermath of World War II
6. From 1950 to 1998

In the fall of 1830 the first lots were sold in Chicago and the population was about 100 souls. By 1871 the population was over 300,000.

The first permanent school building, originally called School No. 1 and "Miltimore's Folly," was built in 1845 at 12–24 W. Madison Street. It was two stories high with a basement; it is illustrated in CYT, p. 9, and in CIM, p. 74, with a description.

In 1848 the Galena & Chicago Union was the first railroad to operate into Chicago, 10 miles having been completed to the Desplaines River. The first through train from the east entered Chicago in 1852 over the Michigan Southern & Northern Indiana railroad. A history of the stations occupied by each of the groups of railroads entering the present six downtown stations is in WSE 1937, pp. 78, 81, 124, 127, 250, and 258.

About 1856 the architects signed their first extant professional agreement. The central business district was being developed rapidly with three- to five- and six-story buildings, culminating in Palmer House 2, seven stories high. This hotel was opened in March 1871, about six months prior to the close of this period by the great fire of October 9, 1871, which almost completely destroyed the business district.

In 1856 the Chicago Historical Society was formed and the iron bridge at Rush Street was built. In the same year the first wooden pavement was laid on Wells Street, the first sewers were laid, and the first suburban train was inaugurated, from Chicago to Hyde Park.

The first streetcars ran south on State Street from Randolph Street in 1858, extending during the next year to Thirty-first Street, the city limits. The first paid fire department was also organized in 1858, only 13 years before the end of this period, which terminated in the great fire of October 9, 1871.

Work on the land shaft of the first water tunnel into Lake Michigan was begun in 1865; the tunnel was completed in 1867 and the Chicago Avenue Water Tower in 1869.

TREMONT HOUSE 1, 1833–1839 fire, was a three-story frame building at the northwest corner of N. Dearborn and W. Lake Streets. It is described in HCA Vol. 2, p. 501. An illustration is in the *Chicago Tribune* of March 4, 1937. TREMONT HOUSE 2, 1840–1849 fire, was also a three-story frame building but was at the southeast corner of N. Dearborn and W. Lake Streets; it is described in the same news-story. An illustration from a newspaper advertisement is in CIM, p. 124. TREMONT HOUSE 3, 1850–1871 fire, was on the same site as Tremont House 2 and is described also in the same story. John M. Van Osdel was the architect. This brick building was five stories and attic high, with one basement, cost $75,000 (T, p. 78), and was raised in 1861 to the new street level. The building is illustrated in HCA Vol. 2, p. 739, and a photograph is in CIM, p. 127, and in CYT, p. 30. A description and a fine illustration are in CIJ and in CBF. The three hotels were built by Ira Couch, who developed several business blocks of small buildings. Drawings of the raising of number 3 are in CPH, p. 24, and, of its burning in the fire, in GFC, p. 38, and in CBF. The site of Tremont House 1 is occupied by the 200 N. Dearborn Street apartment building. TREMONT HOUSE 4, 1873–1937, was at 31 W. Lake Street on the same site as No. 2 and No. 3, was designed by the same architect, and was called later the NORTHWESTERN UNIVERSITY LAW SCHOOL building. It was six stories high on spread foundations. It is illustrated in IC Vol. 2, and in HCA Vol. 3. A photograph is in CIM, p. 444; in TYF; and in CYT, p. 83. A view is in RMNV, V20, with a brief description on pages 58 and 148. The ground is now used for parking.

West: GREEN TREE HOTEL, 1833–1902, later called the Chicago Hotel, built by James Kinzie, at the northeast corner of N. Canal and W. Lake Streets, was moved to 33–37 (old number) N. Milwaukee Avenue. An illustration is in CYT, p. 7, and in CIM, p. 46. A photograph is in LC, p. 110.

1833: The boundaries of the new city were from the lake to Jefferson Street and from Ohio Street to Jackson Boulevard.

Balloon framing was first employed for the 1833 St. Mary's Roman Catholic Church near State and Lake Streets. The church is illustrated in CCNT, p. 14. See also CCS, p. 205, for a discussion about the application of the highly influential construction method initiated here and an illustration of the descendant Old St. Mary's Church of 1961 at 29 E. Van Buren Street, for which Belli & Belli were the architects. See also the Plymouth Congregational Church. Augustine D. Taylor is now most frequently credited with the invention of the balloon framing method for rapid, inexpensive, and light lumber construction. Articles are in JSAH, October 1942, p. 3, and December 1981, p. 311.

The first COURT HOUSE was erected in 1835 at the southwest corner of N. Clark and W. Randolph Streets, and was one story and a basement high. It is illustrated in CIM; CYT, p. 12; and IC Vol. 1, p. 177. COURT HOUSE 2 was

built at the northwest corner of N. Clark and W. Washington Streets in 1848, and was one story high. John M. Van Osdel was the architect. The first combined COURT HOUSE AND CITY HALL 3, 1853/1858–1871 fire, was built two stories high, in 1853, in the same block and by the same architect. A third story was added in 1858 by him, after the surrounding grade was raised. The building is illustrated in CIJ and in CBF, with a brief description; in HCA Vol. 2, p. 65; and in CAC, p. 17. A photograph is in CIM, p. 281. The two wings were added after the Civil War. The building burned in the great fire of 1871. A photograph of the Court House, taken in 1855 before the third story was added, is in HCA Vol. 1, p. 176. A photograph taken after the addition of the two wings is in T, p. 101, and in CIM, p. 357. Panoramic views from the Court House dome, taken in 1858, are in CYT, pp. 16 and 17. A photograph of Court House 3 is in GCA, p. 14. The 1911 City Hall and Court House building occupies this site.

North: LAKE HOUSE, 1835–1871 fire, at the southeast corner of N. Rush and E. Hubbard Streets, was three stories high, "elegantly furnished throughout and cost nearly $100,000" (T, p. 47). A photograph is in CPH, p. 24. The hotel was converted to a hospital for Rush Medical College. The Wrigley building includes this site.

South: *HENRY B. CLARKE HOUSE,* CAL/CHALC, HABS, was built in 1836 at S. Michigan Avenue and E. 16th Street. It was moved in the early 1870s to 4526 S. Wabash Avenue, and it was moved in 1977 to 1855 S. Indiana Avenue in the Prairie Avenue Historic District/NR. It was restored as a public museum of the Chicago Architecture Foundation. Photographs are in ABOV, p. 84; COF; GCA, p. 12; AGC, p. 363; T, pp. 43 in the 1840s and 44 in the 1940s; *Smithsonian Guide to Historic America: Great Lakes,* 1989, p. 24, as restored; GMM, p. 23; ILL, p. 42; CFB.

SHERMAN HOUSE 1, 1837/44–1861, was built in 1837 by F. C. Sherman, later Mayor, at the northwest corner of N. Clark and W. Randolph Streets. It was three stories high, 80 feet by 100 feet, and was called the City Hotel until 1844, when Sherman added two stories and changed the name to the Sherman House. In 1861 this building was torn down and a six-story SHERMAN HOUSE 2, 1861–1871 fire, was built on the same site. It is illustrated in CIM, p. 128; CYT, p. 29; GCSU; and HCA Vol. 2, p. 502. A description and a fine illustration are in CIJ and in CBF. W. W. Boyington was the architect. After the fire, and until the new building was completed, the Sherman House occupied the Gault House, a four- and five-story building at the northeast corner of W. Madison and N. Clinton Streets. Called the "Little" Sherman House, it is illustrated in CIM, p. 129, and in LO August 1872. SHERMAN HOUSE 3, 1873–1910, was built on the same site after the fire. It was seven stories on spread foundations. W. W. Boyington was the architect. It is illustrated in HCA Vol. 3, and CAC, p. 49. A view is in RMNV, V16, and in LO

March 1872, p. 33, with a description on p. 38. The frontage was 181 feet on N. Clark Street and 160 feet on W. Randolph Street. The building was replaced in 1911 by 11 stories of SHERMAN HOTEL 4, 100–14 W. Randolph Street, of which a photograph and floor plans are in AR, April 1912. In 1920 six stories were added, the corner building being 17 stories high, with three basements, on rock caissons. The cost of the lower portion, including architects' fees, was 39.445 cents per cubic foot (EAR). Holabird & Roche were the architects. Interior photographs are in ARV, 1913, p. 44. In 1925 an addition to the west at 116–24 W. Randolph Street was built 23 stories high, with three basements, on rock caissons; a photograph is in CAA and in ISA, 1929, p. 648. A photograph of the complete building is in CIM, p. 567. At the same time the SHERMAN HOTEL ANNEX, 125–31 W. Lake Street, was built, eight and nine stories high on hardpan caissons, Holabird & Roche being architects for both additions, and Frank E. Brown the engineer. Sherman House 4 was demolished (after 1950), and the Annex was demolished in 1973. A photograph of Sherman House 3 is in CSA, fig. 65, and a drawing is in RMNV, V16. A drawing of Sherman House 2 is in CBF. Hooley's Theater and the Fidelity building were in this block. The James R. Thompson Center occupies this entire block.

North: WILLIAM B. OGDEN residence, 1837–1850 fire, in the center of the block bounded by N. Rush, E. Erie, and E. Ontario Streets and N. Wabash Avenue, was of frame construction, two stories high. John M. Van Osdel was the architect. It is described in HCA Vol. 1, p. 504; T, p. 50; HE, p. 130; and IC Vol. 1, p. 52. The American College of Surgeons occupied the northeastern part of this site, 55 E. Erie Street, and the Nickerson House.

John B. RICE THEATER 1, 1847–1850 fire, on the south side of W. Randolph Street, "one or two lots" east of N. Dearborn Street, was Chicago's first theater. It was a frame building erected in six weeks. The story of its life is in HCA Vol. 1, p. 484. RICE THEATER 2, 1851–1861, at 125–33 N. Dearborn Street, was a brick building with cornices of galvanized iron, fronting 80 feet on N. Dearborn Street and 100 feet in depth. John M. Van Osdel was the architect. An account is in HCA Vol. 1, p. 490, and Vol. 2, p. 596, with an illustration. An illustration is in CIM, p. 104. The theater was torn down and replaced by the RICE building, 1861–1871 fire, which is shown in the view of N. Dearborn Street in CIJ along with Tremont House 3. The sites of theaters 1 and 2 are in the vacant "Block 37." The Unity building occupied the site of theater 2.

1853: A bird's-eye drawing of the city is in ABOV, p. 8, with a similar contemporary photograph. An 1853 triple fold-out drawing of the city from HCA Vol. 1, is in T, p. 54, and 1858 photographic scenes are on pp. 46, 49, 56, and 58. A bird's-eye view of the city in 1857 is in CAJZ. A quintuple fold-out panoramic photograph of the loop from the Court House is in GMM.

SARGENT building, 1852–1963, at the northwest corner of N. Wacker Drive and W. Randolph Street, was formerly known as the Lind Block. It was known in the 1930s as the (Charles) DeLeuw-Cather (civil engineers) building. Because of its isolated location it was one of the very few buildings in the central business district that escaped the fire of 1871. It was a five-story building, mentioned in the Udall & Hopkins city directory of 1852–53 as being located on Market Street between Randolph and Lake Streets. It appears likewise in the Cass & Gager city directory of 1856–57. In D. B. Cook's city directory of 1859–60 this building is described as being on the northwest corner of W. Randolph Street and N. Market Street (now N. Wacker drive). A photograph is in CIM, p. 181. The Lind Block is shown also in a photograph, "Chicago as seen after the Great Conflagration," in HCA Vol. 2, p. 758. An illustration is in TYF; HCA Vol. 2, p. 753; and LO May 1873, p. 88. When the east face of the building was cut off on account of the N. Wacker Drive improvement in the 1920s, the east wall of the south portion was rebuilt as a facsimile of the original by Arthur Woltersdorf, architect. A view in RMNV, V17, shows a seven-story building. Photographs are in CFB; GFC, p. 174; IA-C, October 1957, p. 13, and No. 5, September 1982. The 150 N. Wacker Drive building occupies this site.

SECOND PRESBYTERIAN CHURCH, 1852–1871 fire, was at the northeast corner of N. Wabash Avenue and E. Washington Street. James Renwick was the architect, and Asa Carter superintended the construction. A description and a photogravure are in CBF. The Garland building occupies this site.

South: A new SECOND PRESBYTERIAN CHURCH, NHL, CAL, CLSI/premier, was built in 1874 at 1936 S. Michigan Avenue. See monograph by Erne R. and Florence Freuh, 1978. A drawing of the 1852 church is in CBF, and a photograph is in T, p. 84. Photographs of the new church are in CCS, p. 32.

ST. PAUL'S (UNIVERSALIST) CHURCH, 1854–1871 fire, was on the southwest corner of S. Wabash Avenue and E. Van Buren Street. A description and a photogravure are in CBF.

U.S. POST OFFICE AND CUSTOM HOUSE building, 1855–1871 fire, at the northwest corner of S. Dearborn and W. Monroe Streets (GCSU) — illustrated in CIM, p. 121; HCA Vol. 2, pp. 385 and 387; and in CYT, p. 19 — was three stories high and was "designed to be fire-proof" (HCA Vol. 2). A description and a fine illustration are in CIJ and in CBF with a view of the five-story Lombard Block to the west on W. Monroe Street. After the fire, the walls were used as part of a building for Haverly's Theater until the site was taken over by the First National Bank in 1881 (OMSM, with illustration). CHICAGO POST OFFICE AND CUSTOM HOUSE, 1879–1896, occupied the block that the Federal Center now occupies. John M. Van Osdel, the architect, was associated with A. B. Mullett, the Supervising Architect of the

U.S. Treasury, Washington, D.C. The building was four stories high, and was supported on a concrete mat covering the ground area. The foundation was very inadequate and the building settled and cracked badly; hence its short life. A description of this foundation is in HBF. A report of the iron work was made by T. L. Condron in WSE 1897, p. 420. An illustration of the building is contained in LO August 1872, pp. 128, 129; AA, July 15, 1876; RMN; RMNV, V3; and HCA Vol. 3, p. 569. A photograph is in CIM, p. 275. The Bigelow House was to have opened on October 9, 1871, the day of the great fire, on the southwest corner of S. Dearborn and W. Adams Streets. After the fire the land was sold to the Government (RMNV, p. 59). The FEDERAL building (fig. 17), formerly the CHICAGO POST OFFICE, 1905–1966, at W. Jackson, S. Clark, W. Adams, and S. Dearborn Streets, for which Henry Ives Cobb was the architect (AR, December 1895) and Gen. William Sooy Smith was the foundation engineer, was a heavy, monumental structure of eight stories, basement, and dome, supported on 50-foot wood piles driven to hardpan about 72 feet below grade. WSE, 1898, pp. 1216 and 1409, gives the plan and details of foundation; AEF, the pile specification. The total cost is said to have been 41 cents per cubic foot (BB, 1903, p. 23). Plans and an illustration are in IA, September 1896. A photograph is in CRT, p. 6; CCP, p. 128; and CIM, p. 277. An artist's sketch is in C, p. 55. CIM, p. 276, gives a photograph of the temporary post office on the east side of N. Michigan Avenue at E. Washington Street, occupied while the Federal building was being built. Photographs of the 1905 Post Office are in HABS and in a CCNT scene, p. 24; a photograph of the dome interior is in LC, p. 214. The Federal Center buildings include this entire block.

West: The 1932 U.S. POST OFFICE, 433 W. Van Buren Street, straddles the Eisenhower Expressway. It is 12 stories high, 200 feet, and about 800 feet by 345 feet. Graham, Anderson, Probst & White were architects and Magnus Gunderson the engineer. It was the largest post office in the world, built on rock caissons in air rights over railroad tracks. It is described and illustrated in WSE, October 1931. Photographs are in AWG; CAA; ISA, 1931-1932, p. 64; PGC, p. 34; COF scene, p. 109; AGC, p. 150; ABOV, p. 42; GMM, p. 315; RB, May 15, 1976, p. 32. See also the General Mail Facility building of 1996. Various proposals were considered for the utilization of the vacated 1932 Post Office building.

RICHMOND HOUSE, 1856–1871 fire, was a six-story building at the north-west corner of N. Michigan Avenue and E. South Water Street. In 1860 the Prince of Wales, later King Edward VII, was entertained here. It was closed before the great fire and converted into a business block. A photograph is in CIM, p. 124. The 300 N. Michigan Avenue building occupies this site.

West: CENTRAL HIGH SCHOOL, 1856–1951, at 740 W. Monroe Street, was demolished for the Kennedy Expressway. It was three stories high with stone walls. A history of the school and an illustration are in HCA Vol. 1, p.

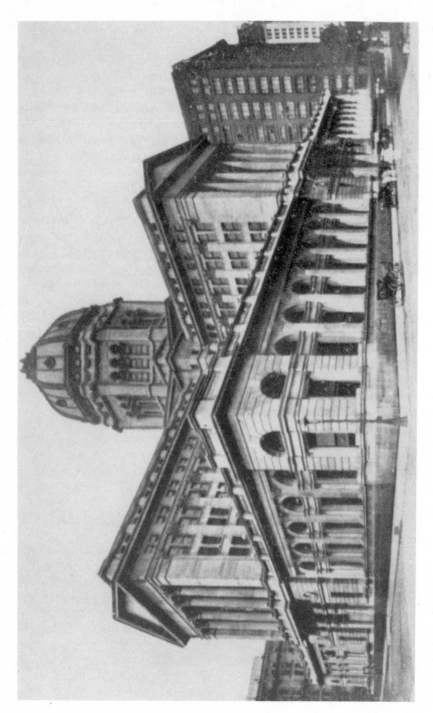

Fig. 17. Federal Building, 1905

218, and an illustration is in CIM, p. 253. It was the first high school in Chicago and the first coeducational high school in the United States (AAC, p. 177).

West: ST. PATRICK'S CHURCH, built ca. 1856, HABS, CLSI/premier, at 718 W. Adams Street, at the northwest corner of (140) S. Desplaines Street. Carter & Bauer were the architects. Photographs are in CFB "merit" and CIM, p. 475. Monograph: *At the Crossroads: Old St. Patrick's and the Chicago Irish,* ed. Ellen Skerrett, 1997; see chapter 6, by Timothy Barton.

North: ST. JAMES EPISCOPAL CATHEDRAL, built in 1856, HABS, CLSI, at 65 E. Huron Street, at the southeast corner of N. Wabash Avenue. A drawing is in RMNV, V24. The bell tower is 135 feet high. It was rebuilt in 1875; Burling & Backus were the architects. Photographs are in AGC, p. 125, interior; CCS, p. 24; T, p. 82; and CIM, p. 471. Monographs: *The Church and the City: A Social History of 150 Years at St. James, Chicago,* Rima Lunin Schultz, 1984, and *History of St. James Church,* 1934.

James H. McVICKERS THEATER building 1, 1857–1871 fire, had been rebuilt substantially just previous to the fire (GCSU). It was a three-story building. It is illustrated in LO February 1871, p. 37; CIM, pp. 103 and 104; CYT, p. 22; HCA Vol. 2; and by photograph in CYT, p. 22. Otis L. Wheelock was the architect. A description and a fine illustration are in CIJ and CBF. A drawing is in CBF, and a photograph is in LC, p. 179. McVICKERS 2 was built in 1872 (HCA Vol. 3). Wheelock & Thomas were the architects. It was four stories high. It is illustrated in LO April 1872, p. 65, with a description on p. 54. A photograph is in LC, p. 179. McVICKERS 3, 1883–1922, at 25 W. Madison Street, was originally four stories high, on spread foundations; two stories were added in 1885. Adler & Sullivan remodeled the theater in 1890. An illustration is in CAC, p. 55; an interior view is in CRT, p. 25, with a description; and also in SGC, p. 36, with a description on p. 127. Photographs are in DATA, p. 57; CSA, fig. 10; LSCS, p. 48; and a drawing is in SRT, p. 155. McVICKERS THEATER 4 was a four-story building, 1923–1934. Newhouse & Bernham were the architects. A photograph is in ISA, 1923, p. 350. Photographs of the two latter buildings are in CIM, p. 435, and CYT, p. 23. The site is used for parking.

MASSASOIT HOUSE 1, 1857–1871 fire, at the southwest corner of Old Central Avenue (now N. Beaubien Court) and E. South Water Street, alongside the old Illinois Central Depot at the foot of E. Lake Street, was built five stories high by David A. Gage and his brother (with W. W. Boyington as architect) and was rebuilt by A. W. Longley after the great fire. It opened in 1873 (HCA Vol. 2, p. 505). The Two Illinois Center building includes this site.

South: WABASH AVENUE METHODIST CHURCH, 1857–1874 fire, was on the northwest corner of S. Wabash Avenue and E. Harrison Street. Boy-

ington and Wheelock were the architects. A description and a fine illustration are in CBF. A drawing is in CBF. This site is used for parking. The Irwin building formerly occupied this site.

ADAMS HOUSE 1, 1858–1871 fire, was a five-story building at the northwest corner of N. Michigan Avenue and E. Lake Street. A photograph is in CIM, p. 125; an illustration is in HCA Vol. 2, p. 504, and in CIJ along with an illustration of the Central Depot. After the fire ADAMS HOUSE 2, at 205–17 N. Michigan Avenue, had a frontage of 188 feet and a depth of 130 feet back to N. Beaubien Court (then Central Avenue) until Michigan Avenue was widened. A drawing is in CBF.

1858: Chicago's streetcar system began operation on State Street.

South: TRINITY CHURCH, 1860–1871 fire, was on the south side of E. Jackson Street between S. Wabash and S. Michigan Avenues with a frontage of 71 feet, near S. Wabash Avenue. A description and illustration are in CBF. The CNA Plaza building occupies this site.

FIRST NATIONAL BANK BUILDINGS: The First National Bank opened July 1, 1863, at 22 (old number) LaSalle Street, near Lake Street, and moved soon afterward into the five-story Exchange building at the southwest corner of N. Clark and W. Lake Streets; a photograph of this building is in CIM, p. 586, and in FNB. In these quarters the bank remained until the end of 1867. FIRST NATIONAL BANK building 1 was at the southwest corner of N. State and West Washington Streets. It was built in 1868, four stories high. Partly destroyed in the fire of 1871, it was rebuilt in December of that year; an illustration is in LO February 1872, p. 19. "The safes and vaults had withstood the heat of the flames; not a security, note or paper of any value was destroyed and the books were intact" (FNB). The building was five stories high, on spread foundations. Burling & Whitehouse were the architects. It is illustrated in HCA Vol. 2, p. 626; LO May 1872, p. 69, with a description on p. 74; and FNB. A photograph is in CIM, p. 342. FIRST NATIONAL BANK building 2, 1882–1902, 38 S. Dearborn Street, at the northwest corner of W. Monroe Street, was six stories high, on spread foundations. For this structure, Burling & Whitehouse were also the architects. It is illustrated in HCA Vol. 3, p. 434; OBD 1901, p. 73; and RMNV, V6. A photograph is in CIM, p. 570; CRT, p. 47; and FNB. FIRST NATIONAL BANK 3, likewise at 38 S. Dearborn Street, 1903–1970, was 17 stories high, with two basements, on rock caissons (EN, December 22, 1904). D. H. Burnham & Co. were the architects. Much information is available in published sources: a description in BB, September 1904, p. 191; an illustration in CHC, p. 122; a foundation plan in EN, December 22, 1904; a photograph in CIM, p. 571, and AWG; photographs and a floor plan in AR, July 1915; and a photograph and a brief description in OBD 1910, p. 79. The west 90 feet of

the First National Bank building, which was the portion at the northeast corner of S. Clark and W. Monroe Streets—formerly called the Fort Dearborn Bank building and originally the American Trust and Savings Bank building—was built in 1906. It was 17 stories high, with two basements, on rock caissons. Jarvis Hunt was the architect. A photograph of the model is in CHC, p. 130; a photograph of the structure itself is in OBD 1916, p. 86, and BB, June 1906. These structures were demolished after the completion of One First National Plaza building, and the site became a plaza. Buildings occupying this block previously include Hawley, Hartford, Morrison Hotel, Chicagoan Hotel, 30 S. Clark Street, and the Montauk.

PRINTERS ROW, ca. 1863–1871 fire, at the northeast corner of N. LaSalle and W. Randolph Streets, was five stories high. A photograph is in CIM, p. 76. The Sherman Hotel and now the James R. Thompson Center include this site.

1861 to 1865: The Civil War affected construction, but see description of activity in *Reminiscences of Chicago During the Civil War,* ed. Mabel McIlvane, 1967.

DIXON building, 1863–1945, at 419–21 S. Wells Street, was a six-story building. It is said to have been the original home of Arthur A. Dixon, founder of the Arthur Dixon Transfer Co., and to have been damaged only in part by the fire of 1871.

S. B. COBB'S "great building," built in 1864, was at the southeast corner of N. Michigan Avenue and E. Lake Street. Van Osdel was the architect. The Doral Michigan Plaza building occupies this site.

CROSBY'S OPERA HOUSE, 1865–1871 fire, at 12–30 W. Washington Street, five stories high (W. W. Boyington, architect), is illustrated and described in HCA Vol. 2, p. 603. A drawing is in CBF. A photograph is in CPH, p. 103. This "Block 37" site is vacant. As Andreas described the opera house:

> The history of this famous temple of art is one without parallel in the West. Its enormous cost ($600,000), its elegance of design, its vicissitudes as a financial investment, its brief existence, and its devotion to grand operatic and dramatic uses, combine to furnish data for a sketch differing in nature from that of any other theater in Chicago or the West. (HCA)

The opening performance in April was postponed on account of the assassination of President Lincoln. Due to financial difficulties in 1866 the theater and its contents were disposed of in a grand lottery; the drawing, which took place on January 21, 1867, was described with great gusto in the newspapers of that time. The theater was repurchased for $200,000 by Uranus H. Crosby from A. H. Lee of Prairie du Rocher, Illinois, the lucky

winner. During the summer of 1871 the theater underwent material alteration and the season was to have been inaugurated on Monday, October 9, the day of the great fire, which ended the checkered existence of the theater. An illustration of the building is in CIM, p. 105; CYT, p. 26; CAA; and T, p. 78. A photograph is in CYT, p. 21. A brief description and a fine illustration are in CIJ; a reproduction of the latter is in CIM, p. 378.

CHAMBER OF COMMERCE building (Board of Trade) 1, 1865–1871 fire, dedicated August 30, 1865, was at the southeast corner of N. LaSalle and W. Washington Streets. It was three stories high. Edward Burling was the architect. It is illustrated in HCA Vol. 2, p. 358; GCSU; and CIM, p. 170. A description and a fine illustration are in CIJ and in CBF. A brief description and a photograph are in T, pp. 90 and 92. A photograph is in GMM, p. 36. CHAMBER OF COMMERCE building (Board of Trade) 2, 1872–1889, was rebuilt to the same height and on the same site. Cochrane and Miller were the architects. It is illustrated in CYF and in LO February 1872, p. 24, with a description on p. 22. A photograph is in LC, p. 165. According to RMNV, it was "once a beautiful temple in which the Board of Trade held its sessions" and "had in its porch four magnificent columns, the pride of the Chicago renaissance, so to speak, of 1872. These columns are all that remain [1898]." The same account continues:

> The building was deserted by the Board of Trade, which moved to W. Jackson street. . . . The walls were raised on screws; a steel and concrete foundation was made; the steel cage was carried down within the walls, and thus there rose another of those remarkable towers that are now attracting universal attention. The quadrilateral interior of this building present [sic], next to the rotunda of the Masonic Temple, the most striking view to be found in any of the great Chicago edifices. Balconies surround the court on each story and brass and mosaic ornamentations are used with fine effect. . . . The cantilever principle has been used to obviate the need of posts under the balconies. . . . The Chamber of Commerce building [3] is a tall box, all of its grandeur being found within.

The first meeting of the Board of Trade was held March 13, 1848, and a room was rented over the flour store of Gage & Haines on S. Water Street (RMNV). Before Chamber of Commerce 1 was erected, the southeast corner of N. LaSalle and W. Washington Streets was occupied by the First Baptist Church; a photograph of this edifice is in CIM, p. 388. *CHAMBER OF COMMERCE building 3,* special significance, 1890–1928, on the same site, was 13 stories, 200 feet high, with cast-iron columns and spread foundations. Baumann and Huehl were the architects; a Mr. Tapper was engineer and superintendent (T, p. 199). Photographs are in OBD 1916, p. 41; CRT, p. 79; CYT, p. 87; CIM, pp. 403, 431, and 582; CSA, fig. 46; CON, pp. 106 and 124. A drawing is in JSAH, December 1959, p. 132. An illustration and a

description are in RMNV, V19. A description is in SGC, p. 570. The American Bank building occupies this site.

South: *PLYMOUTH CONGREGATIONAL CHURCH,* CAL, HABS, 1867–1970, was built at 901 S. Wabash Avenue at the southeast corner of E. 9th Street. Gurdon P. Randall was the architect. A description and a photogravure are in CBF. The building was renamed Old St. Mary's (Paulist) Church. See 1833 note, above, and CCS, p. 205. The church was replaced in 1992 at the southwest corner of S. Wabash Avenue and E. Van Buren Street.

North: SCOTTISH RITE CATHEDRAL, HABS, CLSI, was built in 1867 at 929 N. Dearborn Street at the southeast corner of W. Walton Street, opposite Washington Square Park. This was originally the Unity Church. Theodore V. Wadskier was the architect. It was rebuilt in 1873; Burling & Adler were the architects. A drawing is in RMNV, V25, with the Newberry Library. A photo is in CIM, p. 471.

FIELD & LEITER STORE building 1, 1868–1871 fire, at the northeast corner of N. State and E. Washington Streets, with a frontage of about 145 feet on N. State Street, was a six-story building. It is illustrated in CIM, pp. 105 and 173; CYT, p. 28; GCSU; and HCA Vol. 2, p. 563. FIELD & LEITER STORE building 2, 1873–1877 fire, known as the Singer building, was on the same site. E. S. Jennison was the architect. This building was seven stories high and fronted 160 feet on N. State Street and 150 feet on E. Washington Street. It is illustrated in OYF and in LO June 1872, pp. 92 and 93, with a description on p. 94. FIELD & LEITER STORE building 3, 1878–1905, known formerly as the Singer building and later as Marshall Field and Co. Store building, was a six-story building on the same site. A photograph is in CIM, p. 336. Views are in RMNV, V17; SGC, p. 272; and in CPS, p. 31. See also the 1907 Marshall Field & Co. Store buildings.

ST. JAMES HOTEL, 1868–1871 fire, was formerly the Merchants Hotel (a drawing is in CBF). The Merchants Hotel was destroyed by fire in 1867 and was rebuilt and opened in 1868 as the St. James. It was a six-story building at the northwest corner of N. State and W. Washington Streets. Photographs are in CIM, pp. 105, 175, 265, and in CYT, pp. 21 and 28. A fine illustration is in CIJ and in CBF. This was originally the Stewart House 1. A foreshortened view is in photograph in T, p. 78, with Crosby's Opera House. Stewart building 2 occupied this vacant "Block 37" site.

CHICAGO TRIBUNE NEWSPAPER BUILDINGS: The first issue of the *Chicago Tribune* (June 10, 1847) was printed on the third floor of a four-story building at the southwest corner of N. LaSalle and W. Lake Streets. In 1849 the *Tribune* moved to the second floor over Gray's grocery, a two-story frame building at the northwest corner of N. Clark and W. Lake Streets; in 1850 to

the Masonic building, at 173 (old number) W. Lake Street; and in 1852 to the second and third floors of the three-story Evans Block at the site of the Ashland Block. TRIBUNE building 1, 1869–1871 fire, was at the southeast corner of S. Dearborn and W. Madison Streets (HCA Vol.II, p. 492). The building was four stories high. It is described and illustrated in GCSU. A photograph is in CIM, p. 363. Previously the *Daily Tribune* had occupied the two upper stories of a building in "Newspaper Row," illustrated in CIM, p. 70, and in CYT, p. 11, on the west side of N. Clark Street (old number 50), south of W. Randolph Street. TRIBUNE building 2, 1872–1901, on the same site as Tribune building 1, was five stories high, on spread foundations. Burling and Adler were the architects. The frontage on S. Dearborn Street was 72 feet. A view is in CAC, p. 64, and in RMNV, V6. The Windsor Hotel, with a frontage of 120 feet on S. Dearborn Street, had adjoined Tribune building 2 on the south. A photograph of the hotel is in SGC, p. 44. The 7 S. DEARBORN STREET building, on the same site as Tribune building 2, but with twice the frontage on S. Dearborn Street, was formerly known as TRIB-UNE building 3 and then as the Union Trust building, later owned by the First Federal Savings and Loan Association. It is on the site of the Rumsey School building, which was built in 1844 and which is illustrated in CIM, p. 62, and CYT, p. 9. Tribune building 3 was built in 1902, 17 stories high, on hardpan caissons. Holabird & Roche were the architects. The building is reputed to have been the first in Chicago with two basements. It is illustrated in AR, April 1912. Photographs are in OBD 1916, p. 247; RMNP; CAA; CIM, p. 574; CNM, p. 62; HRHR Vol. 1, p. 308; HB; and *The Builders' Story,* Chad Wallin, 1966, p. 54. An illustration is in OBD 1901, p. 191.

North: *TRIBUNE TOWER building 4,* CAL, CLSI/premier, built in 1925 at 435 N. Michigan Avenue, at the northeast corner of E. Hubbard Street. Howells & Hood were the architects, Holabird & Roche the engineers, and Frank E. Brown, structural engineer. The building is 36 stories, 462 feet high, with four basements, on rock caissons. It is described in WSE, December 1924. Photographs are in CIM, p. 312; CYT, p. 53; A, February 1927; OBD 1941–42, p. 410; CFB "merit"; COF; CANY, p. 63; AUS, p. 169; ACMA, p. 112; AF, December 1973, p. 54; STL, p. 108; WACH, p. 69; FC, frontispiece, showing a detail; HB; SCS, p. 44. Drawings are in TBAR, p. 35; *American Architectural Masterpieces,* Hoak & Church, 1930, reprint 1992, p. 205. Photographs and floor plans are in HSM; AA, October 5, 1925; AR, March 1926; AF, September 1924; WA, November 1925 and January 1926. *Tribune Tower Competition,* published by the Tribune Company, 1923, contains a brief history of the *Chicago Tribune* and of the previous buildings it occupied, together with the story of the competition on the occasion of its seventy-fifth anniversary, and illustrations of many of the designs submitted. *To the Tower,* also published by the Tribune Company, 1924, contains a brief description of the building, illustrations, and a detailed typical floor plan.

On June 10, 1947, the *Tribune* published a Centennial edition, which contains illustrations and descriptions of seven buildings occupied by the paper from 1847 to date. Included also are illustrations of the Wigwam building, several early churches, the Rumsey School (1836), the first jail (1836), the pioneer Kinzie home, State Street before the fire of 1871, Rice's Theater (1847), and bird's-eye views of the central business district in 1853 and 1947, with considerable historical data. See also the adjacent Tribune Plant and WGN Studio buildings, which complete the complex also known as Tribune Square.

SHEPARD BLOCK 1, 1869–1871 fire, at the southeast corner of S. Dearborn and W. Monroe Streets, was five stories high. F. & E. Baumann were the architects. It is illustrated in LO April 1870, p. 90. SHEPARD BLOCK 2, 1872–1880, fronting 32.5 feet on W. Monroe Street and 190 feet on S. Dearborn Street, is illustrated in OMSM and in LO January 1872, p. 7. A photograph is in CIM, p. 418. The building was a pioneer structure on the extension southward of Dearborn Street. The front was of "Athens Marble" designed in the "Modern French style." The Commercial Bank occupied this site until 1933, and the 33 W. Monroe Street building now occupies the site.

CHARLES B. FARWELL STORE building, 1869–1871, at 169–75 N. Wabash Avenue, had a frontage of 72 feet, according to the records of John M. Van Osdel, architect. The Doggett and Medical & Dental Arts buildings occupied this site.

ABRAM GALE building, 1869–1871 fire, on Wabash Avenue, 48 feet by 150 feet, was five stories high. John M. Van Osdel was the architect. According to the architect's records, the contract cost was $43,890, made up as follows: carpentry $16,104; cast-iron $5,237; glass $1,584; gas-fitting $375; draining $188; masonry $14,599; painting $829; cut-stone $4,194; and sidewalk $780. The cost was about 8 cents a cubic foot.

North: *CHICAGO AVENUE WATER TOWER*, NR, CAL/CHALC, HABS, CLSI/premier. It was built in 1869 at 806 N. Michigan Avenue and Chicago Avenue, in the Water Tower Historic District/NR. W. W. Boyington was the architect, Ellis S. Chesbrough, city engineer. The tower is 154 feet high with no basement, on spread foundations, and is one of the few structures that survived the great fire of 1871. The tower is described in HCA Vol. 2, p. 69, and is illustrated in the same volume (p. 742); CHC, p. 48; and GCSU. A photograph is in CIM, p. 226, and RMNP. A description and a fine illustration are in CIJ and CBF. Photographs are in CIM, p. 226; RMNP; CRC; CFB "merit"; ACMA, p. 16; COF; AUS, p. 141; PGC, p. 4; HB. Drawings of the "Waterworks" are in CBF and RMNV, V23, of this book. The nearby Pumping Station includes a Visitors Information Center at 163 E. Pearson Street.

NEVADA HOTEL, 1870–1871 fire, at the southwest corner of N. Franklin and W. Washington Streets, fronting 81 feet on the former and 101 feet on the latter, was five stories high. It was built by William Bross of the Tribune Company. An illustration is in LO January 1871, p. 5. Telephone Square building now occupies this site.

CULVER, PAGE & HOYNE WAREHOUSE building, 1870–1871 fire, at 73–75 W. Monroe Street, five stories high, is illustrated in LO January 1871, p. 10, and HCA Vol. 2, p. 487. The floor loading was heavy, and 16-inch joists were used. F. & E. Baumann were the architects. An illustration of the postfire building is in TYF with interior views. The Bell Savings building occupied this site.

ACADEMY OF DESIGN building, 1870–1871 fire, at 15–23 W. Adams Street, was five stories high, with a marble front. It is illustrated in HCA Vol. 2, p. 558. The Berghoff Restaurant (NL) occupies this site.

South: MICHIGAN AVENUE HOTEL, at the southwest corner of S. Michigan Avenue and E. Congress Street, 1870–1899, six stories high, is illustrated in LO, November 1870, p. 295. This hotel was bought by John B. Drake as the great fire of 1871 was burning, and was renamed the New Tremont House (AAC, p. 57). The Congress Hotel includes this site.

BIGELOW HOUSE, 1871–1871 fire, at the southwest corner of S. Dearborn and W. Adams Streets, 179 feet by 110 feet, was five stories high. John K. Winchell was the architect. It is illustrated in LO July 1870, p. 173. The street facades were of "Athens marble" except that of W. Quincy Street, which was of pressed brick. The formal opening was to have been on October 9, 1871, the day of the great fire. The property was acquired soon after by the government for the Chicago Post Office and Custom House, completed in 1879. The 1905 Post Office/Federal building occupied this block, which is now a part of the Federal Center; see 1964 buildings.

COLONEL RESTAURANT building, 1871–ca. 1960, at 125 N. Clark Street, was five stories high. The Richard J. Daley Center includes this site.

PALMER HOUSE 1, four stories high, was at the northwest corner of S. State and W. Quincy Streets on the site of the 1851 balloon-frame home of John M. Van Osdel, architect of the building. An illustration is in CIM, p. 134. PALMER HOUSE 2, at the southeast corner of S. State and E. Monroe Streets, had opened in the March prior to the fire of 1871, in which it was destroyed. An interesting story is told of the burial and preservation of the architect's records in the clay under the basement floor, where the clay was baked by the fire and suggested a method of fireproofing which is still followed extensively (HE). The building was seven stories high, on spread

foundations. It is illustrated in LO October 1870, p. 267; CIM, p. 155; CYT, p. 29; GCSU; and HCA Vol. 2. PALMER HOUSE 3, 1875–1923/1925 (fig. 18), was located at the southeast corner of S. State and E. Monroe Streets. The architect was John M. Van Osdel, though T, p. 113, names C. M. Palmer. Like Palmer House 2, this building was seven stories high, on spread foundations. It is illustrated in RMNP; CIM, p. 135; CHC, p. 229; HCA Vol. 3, p. 359; LO January 1872, p. 1, with a description; and RMNV, V6. Photographs are in CTCP, p. 54; CPH, p. 134; GCA, p. 16; CYT, p. 84, with an interior photograph of the famous barber shop, in the floor of which silver dollars were inlaid. The building was wrecked in sections to make way for PALMER HOUSE 4, which was completed in 1925 and 1927. Holabird & Roche were the architects and Frank E. Brown the engineer. The present building is 25 stories high, with three basements, on rock caissons. Exterior and interior photographs are in CAA. Photographs are in CIM, p. 443; HRHR Vol. 2, p. 150; HB. An illustration is in ISA 1928, p. 156. A six-story addition was built ca. 1928 at 106–112 S. Wabash Avenue on the south 47 feet of the former site of the Ballard Block and on the site of the seven-story Hoops building. The hotel was renamed the Palmer House Hilton.

MORRISON BLOCK 1, 1871–1871 fire, at the southeast corner of S. Clark and W. Madison Streets, was four stories high. Carter & Drake were the architects. An illustration is in LO February 1871, p. 40, with a description. MORRISON BLOCK 2, 1872–before 1948, of the same height, fronted 100 feet on S. Clark Street and 90 feet on W. Madison Street. It is illustrated in LO January 1873, p. 1, with a description on p. 7. A photograph is in CIM, p. 405. The One First National Plaza building includes this site.

Some "prefire" buildings are cited only under main entries below. Among the most notable was the first Holy Name Cathedral of 1854; its spire was 245 feet high. Others include:

Portland: see Portland
Safety Deposit: see Fidelity
Burch Block: see Doane
City Hall (q.v.)
Heath & Milligan: see replacement of same name
Bryan Hall: see RKO Grand Theater
Barden City Hotel: see Old Marshall Field Warehouse
Grey: see Northern Pacific
McCarthy: see Randolph
Young America Hotel: see McCormick
Marine Bank: see Marine
Foster House/Revere House: see McCormick Hall
Saloon: see Greisheimer
City Hotel: see Loop End/Page Brothers

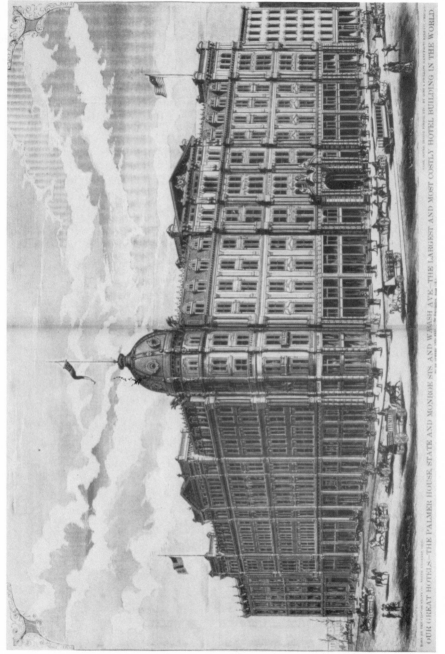

Fig. 18. The Old Palmer House, 1875

Brunswick: see Capitol
Chicago Historical Society (q.v.)
Hale: see Columbus Memorial
Eagle Exchange Tavern: see 333 W. Lake

Similarly, others built after the fire include:

Williams, 1874–ca. 1897: see Williams
Foote Block, 1873–1894: see 105 W. Monroe

Period II: From October 9, 1871, to 1880

A period of intense activity immediately followed the great fire. Many buildings were rebuilt from the original plans, and many others of five and six stories were undertaken. Seven-story buildings became more common. The first "fireproof" building was built in 1873, and more thought was being given to means of preventing another disaster by fire. Elevators came into use during this period, permitting the higher buildings that flourished later. The effects of the financial panic of 1873 slowed up the construction of buildings in the latter part of this period. A near approach to skeleton construction is evident in the framing of the Leiter building (1879).

By one year after the fire over eight miles of building frontage had been rebuilt. Many buildings were under construction on the day of the fire and others had been barely completed. The Nixon building, of "fire-resistive" construction, was nearing completion, and its principal loss was the burning of its wood trim.

A great many buildings were rebuilt to duplicate the prefire construction. The Lind Block, described and illustrated elsewhere, was a typical example of the prefire era. The day of the engineer had not yet arrived; the buildings were largely products of the carpenter and brick mason, with a modicum of planning and embellishment by the architects of the day.

One exception was the rebuilding of the Palmer House. Time was taken for study and travel, and Palmer House 3 was not completed until 1875.

Signs of change were beginning to appear. The Kendall building, 1873–1940, made use of Van Osdel's experience with the baked clay protecting his records in the basement of Palmer House 2, and terra-cotta floor arches and partitions were used. Major Jenney, an engineer by training, returned from the war and carried on for a while in the mode of the day. But his Leiter building, built in 1879, was the forerunner of skeleton construction which culminated in the succeeding period. Many of the young architects who later made distinguished contributions to the art of construction were trained in his office.

Building costs, which had risen during the Civil War, continued high until the panic of 1873 caused a decline to a low in 1879 which remained fairly constant until the end of the century.

Various fire photographs are in LC; GFC; GCSU; *American Apocalypse: The Great Fire and the Myth of Chicago,* Ross Miller, 1981; and GMM with panoramic views on p. 103. Quoting T, "within six weeks 318 permanent brick buildings had been started with a frontage of three and a half miles." Forty-five photographic scenes from between 1871 and 1929 are in CIM, p. 283.

CENTRAL UNION BLOCK 1, 1871–1889, at the northwest corner of N. Wacker Drive (then Market Street, unwidened) and W. Madison Street, fronting 200 feet on each street, three stories high, was completed in 60 days

and occupied on December 16, 1871, as the first brick building built and occupied in the burned district after the fire. F. and E. Baumann were the architects. The building is illustrated in CIM, p. 565; OYF; and LO February 1872, p. 20, with a description on p. 22. Illinois Trust & Savings Bank was a tenant. CENTRAL UNION BLOCK 2, 1890–1926, replaced the above-named building; it was six stories high. L. G. Hallberg was the architect. The frontage on N. Wacker Drive (then Market Street unwidened) was about 200 feet. An illustration and a brief description are in RMNV, V6. A drawing is in GFC, p. 198, and a photograph is in CTCP, p. 40. The Civic Opera building occupies this site.

NIXON building, 1871–1889, was at 128–32 W. Monroe Street, the north-east corner of S. LaSalle Street (fig. 19). It was under construction during the 1871 fire and was of fire-resisting construction. No spans were over 16 feet. The joists were of wrought iron, supporting brick arches. The floors in the halls and prominent rooms were of marble. The tops of the beams were covered with concrete, and the ceilings were protected by nearly an inch of solid plaster of Paris. In the conflagration the floor surfacing and the wood trim were consumed but "the building was so little damaged by the fire that it was finished one week after the fire and occupied at once by leading architects and business men. . . . after the fire it bore an inscription . . . as follows: 'This fireproof building is the only one in the city that successfully stood the test of the Great Fire of October 9, 1871' " (OMSM). The building was six stories high, on spread foundations. Otto H. Matz was the architect. A view of the building is in RMNV, V5, with a brief description. An illustration of the original four-story building is in TYF, and LO April 1873, p. 53, with a description on p. 59; a photograph is in CIM, pp. 392 and 393. A drawing is in CPH. The LaSalle-Monroe building occupies this site.

CLARKE, LAYTON & CO. and WM. DUNNING building, 1872–ca. 1924, at the northwest corner of W. Wacker Drive and N. LaSalle Street, was four stories high. E. S. Jennison was the architect. It is illustrated in LO May 1872, p. 78, with a description on p. 75.

HAMLIN, HALE & CO. WHOLESALE building, 1872–before 1878, at the southwest corner of S. Franklin and W. Madison Streets, fronting 190 feet on the former and 90 feet on the latter, is described and illustrated in LO July 1872, p. 109. The Commercial Trade and Harris Bank buildings oc-cupied this site.

TUTTLE building, at the northeast corner of N. State and E. Lake Streets, fronting 140 feet on the former and 68 feet on the latter, 1872–before 1960, with John M. Van Osdel as the architect. It was five stories high. An illustra-tion is in TYF; CRT, p. 130; and LO March 1873. The 6 E. Lake Street building (NL) occupies this site.

THE LAND OWNER
AN ILLUSTRATED NEWSPAPER.
DEVOTED TO REAL ESTATE INTERESTS, BUILDING, COMMERCIAL PROGRESS, MANUFACTURES AND IMPROVEMENT.

Entered according to Act of Congress in the year 1873, by J. M. Wing & Co., in the Office of the Librarian of Congress, at Washington.

VOL. V.—NO. 4. CHICAGO, APRIL, 1873.—WITH SUPPLEMENT.

A NOTABLE BUILDING.—NIXON'S FIRE-PROOF BLOCK, THE ONLY STRUCTURE IN THE CHICAGO BURNT DISTRICT NOT DAMAGED BY THE FLAMES.
(See Description, page 59.)

Fig. 19. Nixon, 1871

HAWLEY BLOCK, 1872–1892, at the southwest corner of S. Dearborn and W. Madison Streets, was four stories high. John M. Van Osdel was the architect. An illustration and a description are in LO May 1874. This corner—a photograph of which taken ca. 1860 is in CIM, p. 121—is now occupied by the One First National Plaza building. Before the fire of 1871, it was occupied by the four-story Reynolds building, which is illustrated in HCA Vol. 2, p. 53, and by photographs in CYT, p. 19, and CIM, p. 123.

[See appendix L for Portland Block, Stratford Hotel, and Kranz building.]

ROANOKE building 1, 1872–1914, formerly known as the Major Block 2, was at 1–17 S. LaSalle Street on the southeast corner of W. Madison Street, fronting 136 feet on the former street and 66 feet on the latter. It was seven stories high, on spread foundations. Dixon & Hamilton were the architects. A photograph is in CIM, p. 577, as is also (p. 406) one of the four-story Major Block 1—of which T. V. Wadskier was the architect—before the fire. An illustration of Major Block 2 as a five-story building is in TYF; CIM, p. 406; CTCP, p. 49; LO July 1873, p. 114. The present ROANOKE building 2 was built in 1915 as the Lumber Exchange building, 16 stories high, with three basements, on rock caissons. Holabird & Roche were the architects. A photograph is in CIM, p. 586, and an illustration and a description are in OBD, p. 123. Five stories were added later.

Photographs, before and after the addition, are in STL, p. 84. The building, renamed the 11 S. LaSalle Street building, has the same frontage on S. LaSalle Street as did Roanoke building 1 but extends to the east from S. LaSalle Street about 101 feet to include the site of the former Farwell Hall (W. W. Boyington, architect), which was at 131–33 W. Madison Street. A photograph is in CIM. ROANOKE TOWER, adjoining to the east at 125–29 W. Madison Street, on the site of the former DeSoto building, was built in 1926, 36 stories high, with two basements, on rock caissons. Holabird & Roche were the architects, with Andrew N. Rebori associated and with Frank E. Brown as engineer. The building is illustrated in OBD 1941–42, p. 345. A photograph of the 452-foot-high tower is in STL, p. 84.

U.S. EXPRESS CO. building, 1872–1953, at 58–60 W. Washington Street, was six stories high, on spread foundations, with a cast-iron front. John M. Van Osdel was the architect. A photograph is in OBD 1916, p. 252. The Richard J. Daley Center includes this site.

FIDELITY building, 1872–1924, was at 118–20 W. Randolph Street, just west of Sherman House 3. It was four stories high. A view is in RMNV, V16. An illustration is in HCA Vol. 3, p. 665, as the Illinois Trust & Savings Bank. A photograph after the addition of two stories is in CIM, p. 146. This building was preceded by the Safety Deposit building, 1870–1871 fire, four stories high (A. Bauer & Co., architects), illustrated in LO October 1870, p. 261. An interior photograph is in LC, p. 204.

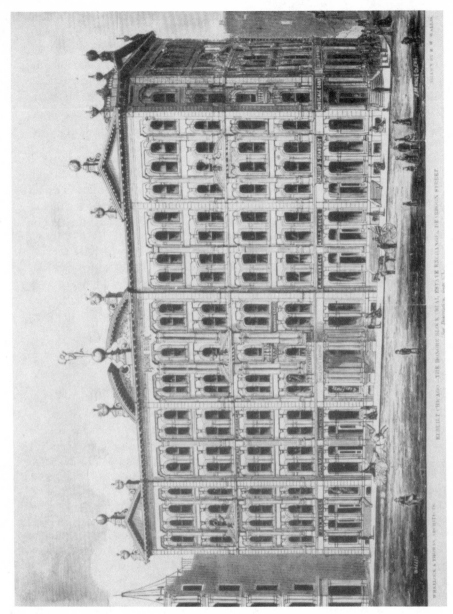

Fig. 20. Honoré Block, 1872

GRANT HOTEL, 1872–1940, was a six-story building at 6 N. Dearborn Street, on the northwest corner of W. Madison Street. It was formerly known as the Inter-Ocean building, a photograph of which is in SGC, p. 144, as a six-story building. This was originally the Chicago Savings Institution and Trust Co. building, four stories high, an illustration of which is in LO March 1873, p. 44, and in TYF. Adler & Sullivan were the architects of the addition. A photograph is in CIM, p. 408, and in OBD 1901, p. 90. A view of the building is in RMNV, V6. A drawing as the Chicago Savings Building is in *Foundations,* Frederick Baumann, 1873, p. 1. The Three First National Plaza building occupies this site.

HONORÉ BLOCK 1, 1870–1871 fire, at the northwest corner of S. Dearborn and W. Adams Streets, fronting 196 feet on the former street, and 114 feet on the latter, six stories high, adjoined the first Honoré Block to the north. Otis L. Wheelock was the architect. An illustration is in LO December 1870, p. 316, with a description. "The block was surmounted by a mansard roof of new and elaborate design, covered with slate. The cornices and dormer windows were entirely of iron and the building was equipped with an Otis patent steam passenger elevator." HONORÉ building 2, 1872–1894, on the same site, was six stories high (fig. 20). The architect was C. M. Palmer (T, p. 113). An illustration and a description are in LO August 1873, pp. 134 and 140; and RMNV, V6. An illustration is in TYF. A description of the construction is in LO April 1874, p. 58. Building 2 was also known as the Old Marquette building. A photograph is in CIM, p. 328. The Marquette building occupies this site.

DOANE building, 1872–1899, known also as the Franklin MacVeagh & Co. building and the Grocers' Block, at the southwest corner of N. Wabash Avenue and E. Lake Street, fronting 170 feet on the former and 115 feet on the latter, was five stories high, "each store having an elevator." T. V. Wadskier was the architect. An illustration is in CAC, p. 212, and LO July 1872, pp. 116 and 117, with a description on p. 118. The five-story Burch Block (photograph in CIM, p. 322) occupied this site previously, and the Lemoyne building later. Franklin MacVeagh & Co. were the original tenants of the corner store; they had been located at 36–38 (old number) River Street until the fire of 1871.

CITY HALL, 1872–1885, was at the southeast corner of S. LaSalle and W. Adams Streets, the site on which the Rookery building now stands. John M. Van Osdel was the architect. The building was two stories high, on spread foundations. It is illustrated in CIM, p. 166; CYT, p. 33; and TYF with interior views of the library. The site had upon it an iron water-tank that belonged to the water works service on the South Side; the building was constructed around this, and the tank was used for the Public Library, founded in 1872, during a short period after the fire. For a description and an il-

lustration of this building see HCA Vol. 3, p. 104. The previous three-story City Hall and Court House in the block bounded by N. LaSalle, W. Randolph, N. Clark, and W. Washington Streets perished in the fire of 1871. The City Hall just mentioned was first occupied in March 1871. It is illustrated and described in GCSU. A photograph is in GFC, p. 200. A drawing of the tank interior used as the Public Library is in CCNT, p. 125.

HOWLAND BLOCK 1, 1869–1871 fire, formerly the Honoré Block and the Real Estate Exchange, at the southwest corner of S. Dearborn and W. Monroe Streets, fronting 189.5 feet on the former and 46.4 feet on the latter, was five stories high, on spread foundations. Otis L. Wheelock was the architect. It is illustrated in CIM, p. 126; HCA Vol. 2, p. 564; and LO for January 1870, p. 8, and December 1870, p. 316, with descriptions. HOWLAND BLOCK 2, 1872–1911, known also as the Honoré Block and the Real Estate Exchange, was built on the same site by Wheelock & Thomas, architects, and was the "most imposing office building erected after the fire." A photograph is in CIM; p. 241. It is illustrated in IC Vol. 1; OBD 1910, p. 101; OMSM; TYF; and LO August 1873, p. 141, with a description on p. 134. The Central Trust Company of Illinois opened its doors here on July 8, 1902 (OMSM). The Xerox Centre occupies this site.

CAMBRIDGE building, 1872–1946, at the northwest corner of N. Wells and W. Randolph Streets, fronting 180 feet on the former and 80 feet on the latter, formerly known as the Garden City Block, built by Henry H. Honoré, was seven stories high. An illustration and a brief description are in RMNV, V18. The site is used for a parking structure.

HEATH & MILLIGAN building, 1872–(before 1924), at 155–59 W. Randolph Street, was five stories high. It is illustrated in LO August 1872. This was the third building of this name on this site; the first was burned in August 1870, and the second in the fire of 1871. The Bismarck Hotel occupies this site.

SENECA D. KIMBARK building, 1872–(before 1949), at 177–87 N. Michigan Avenue, on the southeast corner of E. Lake Street, was five stories high. It fronted 132 feet on N. Michigan Avenue and on the former Central Avenue, and 140 feet on E. Lake Street. An illustration is in CAC, p. 214, and SGC, p. 313. The south portion is illustrated in TYF and LO March 1873, p. 36. This portion was rebuilt on the old site after the great fire.

LORD & SMITH building at 115–17 N. Wabash Avenue, built in 1872 as a six-story building, is now five stories high. It has a frontage of 24 feet and a depth of 163 feet. It is illustrated and described in LO August 1873, p. 148. The facade was of galvanized iron on brick backing, the first instance of such construction in Chicago. A J. W. Reedy elevator was used. Cochrane & Miller

were the architects. It was renamed the 115 N. Wabash Avenue building. A photograph is in T, p. 84, with the Second Presbyterian Church.

BAY STATE/SPRINGER BLOCK, NR, CLSI/premier, HABS/photograph, 1873–1890, at 134–36 N. State Street, at the southwest corner of W. Randolph Street, was six stories high, on spread foundations. Carter, Drake & Wight were the architects. Photographs are in CYT, p. 60; CIM, p. 346; *P. B. Wight,* Sarah Bradford Landau, 1981, p. 32; WO, p. 23; HDM, pp. 69 and 219; and IA-C November 1989, p. 12. A view is in RMNV, V20. Together with the Kranz building, it was remodeled and a top addition made by Adler & Sullivan in 1887. A view of the original four-story building is in TYF, and LO September 1878, p. 157. A photograph in CIM, p. 111, and CYT, p. 60 (taken in 1857), shows the four-story building of Charles Tobey and Brother on this corner. This "Block 37" site is vacant.

RKO GRAND THEATER, 1872/1880–1958, HABS, at 119–21 N. Clark Street, built as the Grand Opera House, six stories high, became Hooley's Opera House, Four Cohans, and then Cohan's Opera House; in 1927 it resumed its maiden name of the Grand Opera House. Photographs are in CIM, pp. 429 and 581. A description is in SGC, p. 123, with an illustration (p. 364) of the interior. Bryan Hall, 1860–1871 fire, occupied this site before the great fire, at which time it had become Hooley's Theater. The Opera House was developed in a series of additions and remodelings, including work by Dankmar Adler and Andrew Rebori; see DATA for plans, discussion, and illustrations. The Richard J. Daley Center includes this site.

OLD MARSHALL FIELD & CO. WHOLESALE WAREHOUSE, 1872– before 1911, built as the Field & Leiter Wholesale building, was at the northeast corner of N. Wacker Drive and W. Madison Street, with a frontage of 190 feet on Market Street (before widening) and 200 feet on W. Madison Street. The building, five stories high, was erected in 100 days. A brief description and an illustration are in RMNV, V12. An illustration is in LO February 1872, p. 25, with a description on p. 23. A photograph is in JSAH October 1978, p. 183. Previous to the 1871 fire the site was occupied by the Garden City Hotel. It was most recently occupied by the Hearst building. The site is vacant.

LEANDER J. McCORMICK BLOCK, 1872–(before 1949), at the northwest corner of N. Wabash Avenue and E. Lake Street, was five stories high. W. W. Boyington was the architect. A photograph is in CIM, p. 322, and CYT, p. 74; an illustration is in LO October 1872, p. 168. The Harold Washington College occupies this site.

M. D. WELLS & CO. building, 1872–1907, at the southeast corner of S. Market and W. Madison Streets, was five stories high. An illustration and a

description are in LO August 1872, p. 141, and OYF. The Hunter building was built on this site now occupied by the One S. Wacker Drive building.

ANDREWS building, 1872–1892, at 19–21 S. LaSalle Street, with a frontage of 55 feet, was a four-story building on the front 66 feet of the site of the present Association building. An illustration is in TYF and in LO December 1872, p. 204, with a description on p. 206. Before the fire of 1871 this site was occupied by the Arcade building, which was built in conformity with the adjoining Major Block. T. V. Wadskier was the architect of both the latter buildings as well as of the Andrews building.

ORIENTAL building 2, 1872–1907, at 12–18 N. LaSalle Street, with a frontage of 75.5 feet and a depth of 122 feet, was five stories high. John M. Van Osdel was the architect. A photograph is in OYF and in LO October 1872, p. 173, with a description on p. 170. A photograph of ORIENTAL building 1, which occupied this site and was destroyed by the fire of 1871, is in CIM, p. 391. The site was occupied by the north 75-foot frontage of the LaSalle Hotel. The 2 N. LaSalle Street building occupies this site.

NORTHERN PACIFIC building, 1872–1929 — known later as the Northern office building — at 151–57 W. Lake Street, 80 feet square, at the southwest corner of N. LaSalle and W. Lake Streets, was six stories high. The building was remodeled in 1891. An illustration is in RMNV, V16, and a photograph is in OBD 1901, p. 138. The Charles F. Grey building, 1868–1871 fire (August Bauer, architect), was on this site (T, p. 96). The Heitman Centre occupies this site.

DOGGETT building, 1872–1925, was at the southeast corner of N. Wabash Avenue and E. Lake Street, fronting 100 feet on the former and 40 feet on the latter, five stories high. Otto H. Matz was the architect. An illustration is in LO July 1872, p. 113, with a description on p. 118. It was known, around 1900, as the Henrietta building. The 1869 Charles B. Farwell Store previously occupied this site. The Medical and Dental Arts/185 N. Wabash Avenue building occupies this site.

OLD FARWELL BLOCK, 1872–(before 1949), at 300–330 W. Monroe Street, from the northeast corner of S. Market Street to the northwest corner of S. Franklin Street, was five stories high. John M. Van Osdel was the architect. An illustration is in RMNV, V12. The east portion of the block, fronting approximately 230 feet on W. Monroe Street and 190 feet on S. Franklin Street, is illustrated in LO April 1872, p. 57, with a description on p. 54. The west addition completed the frontage on W. Monroe Street to S. Market Street, approximately 90 feet, with a depth on S. Market Street of 110 feet. This addition is illustrated in LO September 1872, p. 149, with a description on p. 150. The west portion was demolished before 1949; the

Mutual Trust building occupied this site. The east portion was demolished before 1910; the Hart, Schaffner & Marx building occupied this site. The entire site is now used for parking.

HIBBARD, SPENCER, BARTLETT & CO. BLOCK, 1872–(before 1928), originally known as the Reed Block, at the northeast corner of N. Wabash Avenue and E. Lake Street, fronting 140 feet on the former and 48 feet on the latter, was five stories high. Wheelock & Thomas were the architects. An illustration is in RMNV, V17, and LO April 1872, pp. 54 and 68. An illustration is in CRT, p. 111. The 203 N. Wabash Avenue building occupies this site.

BONFIELD building, 1872–(before 1949), at 208–10 W. Randolph Street, was built four stories high, with a frontage of 54 feet and a depth of 162 feet. L. D. Cleveland was the architect. An illustration is in LO July 1872, p. 120. The ground is now used for a parking structure.

SCHLOESSER BLOCK, 1872–1903, at the northwest corner of S. LaSalle and W. Adams Streets, was four stories high. A view is in RMNV, V5. The site was later occupied by the National Republic Bank building. It is now occupied by the 190 S. LaSalle Street building.

LAFAYETTE building, 1872–1925, was at the southwest corner of N. LaSalle and W. Randolph Streets. It was six stories high, on spread foundations. A view is in RMNV, V19. The Metropolitan Block occupies this site.

MUSIC HALL building, 1872–1949, on the alley at the rear of 66–72 W. Randolph Street, 80 feet wide by 100 feet deep (Burling & Adler, architects), is illustrated in LO October 1873, p. 173, with a description on p. 174. The entrance was 17 feet wide from 169 N. Clark Street. The theater was later called the Olympic Theater and the Apollo Theater, with an entrance through the Ashland Block at 74 W. Randolph Street. Theodore Thomas first played here in October 1873. The Aiken's Museum Theater, 1863–1871 fire, later known as Colonel Wood's Museum, occupied this site where Kingsbury's Hall stood formerly. A photogravure and a description of the museum are in CBF. A photograph of the museum is in CIM, pp. 147, 151, and 152, and in CYT, p. 86. The Kingsbury building, 66–72 W. Randolph Street, five stories high, occupied the front portion of this site, in which was the old Union Hotel, an interior photograph of which is in CYT, p. 76, and in CIM, p. 141. The Music Hall was also known as the New Chicago Theater. Photographs and plans are in DATA, pp. 104 to 109. The J. H. Wood Museum is in a CBF scene.

C. H. FARGO building, 1872–ca. 1876, at the southwest corner of S. Market and W. Madison Streets, was four stories high. It is illustrated and described in LO August 1873, p. 144. The Mullen building occupied this site, and the 1983 Chicago Mercantile Exchange building now occupies the site.

EVENING POST building, 1872–1932, known formerly as the Gardner building, at 173–75 W. Washington Street, five stories and 65 feet high, was built in 1872 and rebuilt in 1891. It had a 40-foot frontage. An illustration is in RMNV, V19. It was renamed the Washington Hotel. The 1975 30 N. LaSalle Street building now occupies this site.

ROBBINS building 2, 1872–(before 1940), was at the southeast corner of N. Wells Street and W. Wacker Drive, fronting 150 feet on the former and 80 feet on the latter. It was five stories high. John M. Van Osdel was the architect. An illustration is in OYF and in LO November 1872, p. 198, with a description on p. 186. A photograph is in CIM, p. 590. The building replaced ROBBINS building 1, 1856–1871 fire, an iron-front building by the same architect. Another ROBBINS building, with an iron front, was built in 1872 by the same architect at the northeast corner of N. Wells and W. Lake Streets, was of the same height, and fronted 150 feet on the former street and 80 feet on the latter; it is illustrated in OYF and in LO November 1872, p. 199, with a description on p. 186. The Builders building occupies the Robbins 1 and 2 site, and the 201 N. Wells Street building occupies the site of the third Robbins building, which was demolished before 1938.

COMMERCIAL HOTEL, 1872–(before 1949), at 50–56 W. Lake Street, five stories high, 150 feet deep, was at the northwest corner of N. Dearborn Street. An illustration is in RMNV, V16. This building was known later as the Commercial building; a photograph is in OBD 1911, p. 57. A photograph of the structure as a four-story building is in CIM, p. 357. Facilities of Northwestern University once occupied this site, which is now occupied by the 200 N. Dearborn Apartment building.

PETER PAGE building 2, 1872–1912, at the southwest corner of N. Wabash Avenue and E. Washington Street, built for occupancy by D. B. Fisk and Co., was five stories high. John M. Van Osdel was the architect. An illustration is in TYF and in LO December 1872, p. 212. PETER PAGE building 1, 1869–1871 fire, was by the same architect. The Marshall Field and Co. Annex building now occupies this site.

JOHN ALSTON & CO. building, built in 1872 at 180–84 W. Randolph Street, is five stories high, with a frontage of 40 feet and a depth of 165 feet. An illustration is in LO September 1872, p. 148, with a description on p. 150. This building has been refaced and is occupied by McDonald's Restaurant, 180 W. Randolph Street. A photograph is in HB.

WINSTON building, 1872–1982, at 124 W. Lake Street, was a five-story loft. F. and E. Baumann were the architects. A photograph is in FRAG, p. 80. The 203 N. LaSalle Street building includes this site.

C. M. HENDERSON & CO. building, 1872–(before 1949), at the southeast corner of S. Franklin and W. Madison Streets, fronting 190 feet on the

former and 50 feet on the latter, was five stories high. Burling & Adler were the architects. An illustration is in OYF and in LO September 1872, p. 145, with a description. "The building was provided with the Davis steam hoisting machines, rendering all the floors equally accessible." The Jewish Federation building occupies this site.

GIBBS building, 1872–1922, originally the Odell Block, was at the northwest corner of S. Wabash Avenue and E. Adams Street, fronting 70 feet on the former and 135 feet on the latter. It was five stories, 85 feet high. Lavall B. Dixon was the architect. There is an illustration in RMNV, V7; OYF; and LO June 1872, p. 97, with a description on p. 94. The site is now occupied by the 30 E. Adams Street building.

166 W. WASHINGTON STREET, formerly (prefire) the Central Bank building, seven stories, 85 feet high, was rebuilt after the fire of 1871. The ornate south facade went through the fire but was modernized in 1892. An illustration is in RMNV, V18.

166–68 W. LAKE STREET building, 1872–1941, was built by William Blair & Co., five stories high, with a frontage of 60 feet and a depth of 144 feet. Burling & Adler were the architects. An illustration is in OYF and in LO October 1872, p. 172, with a description on p. 170. The 200 N. LaSalle Street building includes this site.

WABASH-RANDOLPH building, 1872–1953, formerly known as the Fairbank building, is at the northeast corner of N. Wabash Avenue and E. Randolph Street. It was six stories high. An illustration is in RMNV, V17. This site is used for parking.

DEARBORN BLOCK, 1872–1919, known also as the Sprague, Warner & Co. building, was at the northwest corner of N. Michigan Avenue and E. Randolph Street. The building was five stories high, and fronted 138 feet on N. Michigan Avenue and 129 feet on E. Randolph Street. An illustration is in CAC, p. 218, and in RMNV, V17. John M. Van Osdel was the architect. A photograph is in CNM, p. xxiv. Sprague, Warner & Co. occupied also the five-story building at 72–74 E. Randolph Street, across the alley to the west of the building named above. This building is illustrated in CAC, p. 218. The Crerar Library occupied this site, which is now occupied by the 150 N. Michigan Avenue building.

31 S. STATE STREET building, 1872–1950s, was six stories high, on spread foundations. The entire front had been remodeled. An illustration of the original building, known as the Home Sewing Machine building, is in LO January 1873, p. 11, with a description. The Carson, Pirie, Scott store includes this site.

115–21 N. WELLS STREET building, 1872–(before 1949), formerly known

as the Alexander White Block, was a seven-story building owned by the Eugene S. Pike estate. An illustration of it as a five-story building is in HCA Vol. 3, p. 759. In 1919 the lower two stories were modernized, and in 1939 the five upper stories were removed by W. Gibbons Uffendell, architect, the two lower stories remaining. A photograph is in the *Chicago Tribune*, February 17, 1940. This site is used for parking.

C. H. McCORMICK building, 1872–(before 1960), at 65–69 E. Lake Street, was five stories high. John M. Van Osdel was the architect. It is illustrated in LO October 1872, p. 169. The site is used for parking.

BOWEN building, built in 1872, HABS, at 62–74 E. Randolph Street, now 70 E. Randolph Street, is five stories high. W. W. Boyington was the architect. It is illustrated in TYF and in LO June 1873, p. 105, with a description on p. 99. Photographs are in WO, p. 22, and HB. The west 40 feet of the building was replaced in 1938 by a two-story building, with steel frame, fireproof and air-conditioned, designed for an additional story and having no interior columns. The city's Gallery 37 Arts and Education program is here.

20–22 S. STATE STREET building, built ca. 1872, was six stories high, on spread foundations. In 1942 the two upper stories were removed and the facade was remodeled.

ROYAL PALM building, 1872–1903, later known as the Bennett House, at 16 W. Monroe Street, is described and illustrated in LO January 1873, p. 10. A four-story building, it was a favorite resort, where a large variety of palms were on exhibition. The North American building includes this site.

KEITH BROTHERS building, 1872–(before 1980), at 323–31 W. Madison Street, 55 feet by 170 feet, was five stories high. John W. Roberts was the architect. It is illustrated in OYF and in LO August 1872, p. 132, with a description on p. 130. One story had been added to the west portion. A photograph is in *Rise of the Skyscraper,* Carl Condit, 1952, fig. 99 to the left of the Hunter building. The 1 S. Wacker Drive building includes this site.

WHEELER & WILSON building, 1872–(before 1949), at 29 S. State Street, was five stories high. It was a pioneer in the use of large window openings. It is illustrated in LO September 1873, p. 160, with a description on p. 162. The Carson, Pirie, Scott store includes this site.

WILLIAMS building, 1872–ca. 1896, at 115–21 N. Dearborn Street, with a frontage of 60 feet and a depth of 80 feet, was four stories high. J. R. Willett was the architect. It is illustrated in TYF, and in LO October 1873, p. 177, with a description on p. 178. A Commonwealth Edison substation now occupies this site. The 1889 Chemical Bank building occupied this "Block 37" site, now vacant.

WASHINGTON-DEARBORN building, 1872–1950s, at 56 W. Washington Street, on the northwest corner of N. Dearborn Street, was at one time known as the Beachey & Lawlor building. It was five stories high. John M. Van Osdel was the architect. An illustration of it as a four-story building is in LO May 1873, p. 89, with a description on p. 79. The Richard J. Daley Center includes this site.

LASALLE building, 1872–1908, at the northwest corner of N. LaSalle and W. Madison Streets, was five stories high. It was known also as the Empire Block. The frontage on N. LaSalle Street was 53.25 feet and the depth 81 feet 2 inches. Dixon and Hamilton were the architects. An illustration is in RMNV, V5; TYF; and LO April 1873, p. 57, with a description on p. 58. The Metropolitan National Bank was located in this building. The LaSalle Hotel occupied this site. The 2 N. LaSalle Street building now occupies this site.

RANDOLPH building, ca. 1872–ca. 1964, at the southeast corner of N. Clark and W. Randolph Streets, was six stories high. It was also known as the Batchelder building. It faced 70 feet on Clark and 30 feet on Randolph Street. A prefire photograph of this corner is in CIM, pp. 149 and 387, showing the five-story McCarthy building.

McCARTHY BUILDING, NR, HABS, CLSI, 1872–1990, was at the northeast corner of N. Dearborn and W. Washington Streets, fronting 36 feet on the former and 80 feet on the latter. It was four stories high. It was also known as the Landfield building. John M. Van Osdel was the architect. Articles are in IA-C January 1987, p. 16, January 1990, p. 81, and May 1992, p. 79. Photographs are in CIM, p. 574; HDM, pp. 7 and 18; and WO, p. 12. Photographs of other buildings in vacant "Block 37" are in IA-C November 1989, p. 12. In the early 1880s this building was part of the Williams Block, 101–21 N. Dearborn Street.

FULLERTON BLOCK, 1872–1950s, at 108–14 N. Dearborn Street, was five stories high. John M. Van Osdel was the architect. See also the Washington-Dearborn building. The Richard J. Daley Center includes this site.

AVERILL BLOCK, 1872–(before 1949), was at the northeast corner of S. Wabash Avenue and E. Van Buren Street, fronting 106 feet on the former and 100 feet on the latter. It was four stories high. It is illustrated in LO April 1872, p. 61, with a description on p. 54. The CNA Center building includes this site.

SPAULDING (silverware) building, 1872–(before 1990), a five-story building built by Charles Tobey was at 301–303 S. State Street, the southeast corner of E. Jackson Street. It fronted 40 feet on S. State and 145 feet on E. Jackson. Gurdon P. Randall was the architect. It was later known as the Komiss building. A photograph is in CHC, p. 187; CRT, p. 114; and CIM, pp.

353 and 372. An illustration is in RMNV, V3. Four stories were removed in 1940. A granite facing was added to both street facades in 1947. An illustration of the original building is in LO May 1872, p. 72, with a description on p. 74, and in LO May 1873, p. 83, with a description on p. 87. This site is now a small plaza at the north entrance of the De Paul Center/Goldblatt's Store.

HOOLEY'S THEATER, 1872–1924, at 124 W. Randolph Street, was four stories high, on the site of the west portion of the Sherman Hotel. A photograph is in CIM, p. 146; illustrations are in RMNV, V3, and HCA Vol. 3, p. 665. A description is in SGC, p. 125, with an illustration of the interior (p. 149). In 1903 the theater was remodeled by Wilson & Marshall, architects, and the name was changed to Power's Theater. It had been remodeled in 1882 by Dankmar Adler, architect. Photographs are in LC, p. 181 scene, and in DATA, p. 115 interior. The Richard J. Daley Center includes this site.

BALDWIN PIANO CO. building, 1872–(before 1973), at 323–25 S. Wabash Avenue, formerly the McCormick building, was a five-story building. A sixth story was added. It is illustrated in LO October 1872, p. 176. A photograph is in CAD. The CNA Center includes this site.

VAN BUREN HOTEL, 1872–1972, at the southwest corner of S. Sherman and W. Van Buren Streets, was five stories high. It was formerly known as the Atlantic Hotel. A view is in RMNV, V9. It was also known as the Board of Trade Hotel.

RANDOLPH-FRANKLIN building, at 306–10 W. Randolph Street, built in 1872, was entirely reconstructed in 1927 by Albert Anis, architect. The east third of the building is five stories high; the rest, seven. Photographs are in RB October 29, 1955, p. 5. It was renamed the 310 W. Randolph Street building. A photograph of the adjoining 312 W. Randolph Street Atrium is in RB March 16, 1985, p. 2; VOA were the architects.

FOWLER-GOODELL-WALTERS BLOCK, 1872–(before 1965), was at 133–39 N. Clark Street, with a frontage of approximately 67.5 feet and a depth of 161.5 feet. It was five stories high. W. W. Boyington was the architect. An illustration is in LO March 1872, p. 41. The Richard J. Daley Center includes this site.

S. B. COBB building, 1872–(before 1949), at 165 W. Lake Street, was four stories high. John M. Van Osdel was the architect. A parking structure occupies this site.

LAKE MICHIGAN building, ca. 1872–(before 1980), at 201–15 N. Michigan Avenue, on the northeast corner of E. Lake Street, was six stories high. In 1919 a new front was built, and the first floor was raised to conform with the new street grades created by the Michigan Avenue Improvement. The

north half of the reconstruction was done by Jarvis Hunt, architect, the south half by William Ernest Walker, architect. It was also known as the Lions building. A drawing is in the *Chicago Daily News* ("Line O' Type"), May 29, 1952, as refaced. A photograph is in HB. The Boulevard Towers building occupies this site.

HOYT (wholesale groceries) building, 1872–1921, at the southwest corner of N. Michigan Avenue and E. Wacker Drive, was five stories high, with a frontage of 100 feet on each street. An illustration is in RMNV, V21, and CAC, p. 213. A photograph is in CIM, p. 258. The site was originally occupied by Fort Dearborn. It is now occupied by the London Guarantee building in the Michigan-Wacker Historic District/NR.

STANDARD OIL CO. building, 1872–(before 1924), at the southwest corner of N. Wabash Avenue and E. Wacker Drive, was five stories high. An illustration is in RMNV, V21. The site is now occupied by the Pure Oil building.

CENTRAL MANUFACTURING BLOCK, 1872–1926, later known as the Electric Block, at the southwest corner of N. Wacker Drive and W. Washington Street, was six stories high. It fronted about 190 feet on N. Wacker Drive before the widening of that street. An illustration is in RMNV, V12. An illustration of the structure as a five-story building is in LO March 1874, p. 43, and a photograph as a five-story building is in CIM, p. 357. The Electric building was constructed on the south portion of the site in 1903. The site is now occupied by the Civic Opera building.

25–27 S. WABASH AVENUE building, erected ca. 1872 and extensively remodeled ca. 1925 by Doerr Brothers, architects, is six stories high. It was renamed the 27 S. Wabash Avenue building.

1–3 N. STATE STREET building, 1872–1899, originally the Richards, Shaw & Winslow Store and later the E. H. Sargent & Co. building, at the northeast corner of E. Madison Street, fronting 53 feet on State and approximately 150 feet on Madison, was five stories high. W. W. Boyington was the architect. A photograph is in CPS, p. 23, CIM, p. 264. Illustrations are in HCA Vol. 3, p. 74; SGC, p. 584; LO May 1872, p. 73, with a description on p. 74; and CAC, p. 217. The site was occupied by the Mandel Brothers Store building, which was renamed the 1 N. State Street building.

21–23 S. WABASH AVENUE building, erected ca. 1872, and remodeled ca. 1928 by Graven & Mayger, architects, is six stories high. Frederick Baumann was the architect. It was renamed the 23 S. Wabash Avenue building and the Rae building. It is occupied by the Charette drafting supplies store. A partial photograph is in *Rise of the Skyscraper,* Carl Condit, 1952, p. 24.

1872: Doré Block: see discussion at the 1894 Champlain building.

KENT building, 1872–1892, at 122–26 W. Monroe Street, was six stories high. An illustration is in RMNV, V5. The LaSalle-Monroe/39 S. LaSalle Street building occupies this site.

BRUNSWICK HOTEL, ca. 1872–1910, at the northwest corner of S. Michigan Avenue and E. Adams Street, was six stories high. Burnham & Root were the architects for a remodeling. An illustration is in RMNV, V7. Photographs are in CIM; CRT, opposite p. 12; and CHC, p. 198. A photograph in CIM, p. 454, taken in 1871, shows the home of H. H. Honoré on this corner. The People's Gas building/122 S. Michigan Avenue building occupies this site.

South: WM. B. PIERCE building, 1872–(before 1949), at 512–14 S. Wabash Avenue, was an iron-front building, four stories high. The frontage was not less than 50 feet. It is illustrated in OYF and in LO June 1972, p. 88, with a description on p. 94. This site is used for parking.

North: CLARENDON HOTEL, 1872–1950s, 635 N. Clark Street at the northeast corner of W. Ontario Street, was four stories high. One story had been added. It is illustrated in LO February 1874, p. 21.

North: DAVIDSON & SONS' building, 1872–(before 1949), was five stories high, with a one-story warehouse on the west of the main building, was at the southwest corner of N. Orleans Street and W. Carroll Avenue. An illustration is in RMNV, V22. The Apparel Mart and Holiday Inn building includes this site.

PAGE BROTHERS building/Loop End, NR, CAL, built in 1873 at 177–91 N. State Street, at the southeast corner of E. Lake Street, was formerly known as the Burton building. It is six stories high, on spread foundations. This is one of the very few remaining cast-iron fronts in the city, as is the Berghoff Restaurant building (not listed here) at 17 W. Adams Street. The State Street facade was refaced in 1902 by Hill & Woltersdorf, architects. The internal structure was rebuilt, and the building was converted for usage as part of the Chicago Theater Center (q.v.), 175 N. State Street. A photograph and a description are in OBD 1910, p. 38. Drawings are in AGC, p. 53, and CAJZ, p. 17. Photographs are in CANY, p. 32; WO, p. 22; and PGC, p. 52. An illustration is in LO January 1873, p. 4, with a description on p. 7. John M. Van Osdel was the architect. Stiles Burton had built on this site the City Hotel, "the great brick building of 1848," three stories high, on the site of the former frame inn of the same name.

UNION building 2, 1873–1893, was at the southwest corner of N. LaSalle and W. Washington Streets. It was five stories high and was 101 feet square. Wheelock and Thomas were the architects. The Western Union Telegraph

company's central office was on the third, fourth, and fifth floors. The building is illustrated in LO June 1872, p. 89, with a description on p. 94. An illustration is in RMNV, V19. This Union building was said to have been razed "ruthlessly" for the Chicago Stock Exchange building, just as it too was also razed ruthlessly for the 1974 30 N. LaSalle Street building now here. The site had for a few years been occupied by the four-story UNION building 1, 1868–1871 fire, a photograph of which is in CIM, p. 390. The Union National Bank was in each of the UNION buildings. One of the city's first brick buildings, of two stories, the residence of P. F. W. Peck of Auditorium building fame, was here until 1867. The Chicago Police Department headquarters, with a calaboose in the basement, was here for a time.

STEELE-WEDELES building, 1873–1925, was at the southwest corner of N. LaSalle Street and W. Wacker Drive, on the site of the present Builders building. It was six stories high. A photograph is in CIM, p. 229.

WINDSOR-CLIFTON HOTEL, 1873–1927, formerly the Clifton House, was at the northwest corner of S. Wabash Avenue and E. Monroe Street, on the site of the present Carson, Pirie, Scott & Co. building. It was a six-story structure. John M. Van Osdel was the architect. Photographs are in CIM, p. 325; *Hotel Monthly* June 1912; and CTCP, p. 53. Views are in CAC, p. 46, and RMNV, V7. VO gives the following contract costs: carpentry, $43,840; painting, $2,377; cast iron, $6,750; galvanized iron, $2,400; plumbing, $5,800; draining, $650; masonry, $47,500; plastering, $14,500; and cut stone, $4,000 — a total of $127,817. The first story was 16 feet 2 inches; the second, 15 feet 2 inches; the upper stories, 12 feet 3 inches.

OLD OTIS BLOCK, 1873–1910, at the southwest corner of S. LaSalle and W. Madison Streets, fronting 190 feet on the former and 90 feet on the latter, was four stories high. George H. Edbrooke was the architect. A photograph and a description are in TYF and LO July 1873, p. 121. The Otis building occupied this site; four stories of the facade still remain as part of the Manufacturers Hanover Plaza building now occupying the site.

QUINCY building, 1873–1905, at the northeast corner of S. Clark and W. Adams Streets, was five stories high, fronting 89 feet on Clark and 90.5 feet on Adams. An illustration is in RMNV, V6. The Edison building now occupies this site.

GRAND PACIFIC HOTEL 2, 1873–1895/1921, covered the block bounded by S. Clark, W. Quincy, S. LaSalle, and W. Jackson Streets, on the site of the Continental Illinois Bank building (fig. 21). W. W. Boyington was the architect. The building was six stories high, rebuilt on the spread foundations of the original structure (see below). It is illustrated in HCA Vol. 3, p. 361. A photograph of the exterior and of the dining room is in CIM, pp. 132 and

Fig. 21. Grand Pacific Hotel, 1873

133, and CYT, p. 85. A view is in RMNV, V1. A description is in SGC, p. 354. Photographs are in CIDL, p. 15; CTCP, p. 74; CPH, p. 133; *Thirty-two Picture Postcards of Old Chicago,* David Lowe, 1977 (hotel 2 and the fire ruins of hotel 1); and T, p. 77. The west half of the building was torn down ca. 1895 to make way for the Illinois Trust and Savings Bank building. The east half was remodeled by Jenney and Mundie, architects, and continued in operation as a hotel until demolished to make way for the Continental Illinois Bank building. A photograph is in *Hotel Monthly* June 1912. GRAND PACIFIC HOTEL 1, a six-story building on this site, was being completed when it was destroyed by the fire of 1871. W. W. Boyington was the architect. An illustration, description, floor plan, and cross section of this building are in LO April 1870, pp. 80 and 82; an illustration, drawings, and a description are in LO March 1871, pp. 69, 72, and 73.

LOYAL HOTEL, 1873–(before 1927), at the southwest corner of N. Michigan Avenue and E. South Water Street, was six stories high. An illustration is in RMNV, V21. The site is now occupied by the Carbide and Carbon building.

CHICAGO REAL ESTATE EXCHANGE building, special significance, 1873–1940, at 40 N. Dearborn Street on the southwest corner of W. Washington Street, fronting 90 feet on the former and 40 feet on the latter, was the first "fireproof" building in Chicago. It was first known as the Kendall and then as the Equitable building. It was eight stories high, on spread foundations. A description of the fireproofing is in LO July 1872, p. 115. Photographs are in *P. B. Wight,* Sarah Bradford Landau, 1981, p. 45, and WSE December 1944, p. 115. Terra-cotta floor arches, illustrated in AEF, and terra-cotta partitions were used here for the first time; they are described in LO (above). An illustration of the structure as a six-story building is in CAC, p. 182, and as an eight-story building in CRT, p. 54. In 1854, Orrin Kendall had constructed on this site a four-story bakery building—illustrated in OYF and LO February 1872, p. 17, with a description on p. 20—which remained until 1871, when a new Kendall building (LO October 1871, p. 316) was begun. It perished in the great fire of that year. John M. Van Osdel was the architect both of this building and of its successor, which was demolished in 1940 to make way for a new two-story building. The 69 W. Washington Street building occupies this site.

STATE-RANDOLPH building, 1873–1955, was seven stories high, on spread foundations, at the northwest corner of N. State Street and W. Randolph Street. It was formerly known as the Dyche building. Two stories were added in 1890 by John M. Van Osdel, architect of the original building.

McCORMICK BLOCK 2, 1873–1920, was on the southeast corner of N. Dearborn and W. Randolph Streets, with a frontage of 100 feet on the former and 80 feet on the latter. It was six stories high, on the site of the

United Artists Theater. John M. Van Osdel was the architect. Illustrations are in LO October 1872, p. 169, and in RMNV, V20. A photograph is a CTCP scene, p. 35. A previous McCORMICK BLOCK 1, 1860–1871 fire, had replaced Isaac Cook's Young America Hotel, 1853–1859 (CIM, p. 104, with an illustration) on this site (HE). The Young America Hotel was later called the Revere Hotel. The latter building is illustrated in HCA Vol. 2, p. 596. McCormick Block 1 is illustrated in CIJ, in a view of N. Dearborn Street, with Tremont House 3. This "Block 37" site is vacant.

BRIGGS HOUSE 2, 1873–1928, was at the northeast corner of N. Wells and W. Randolph Streets, the site of the present 188 W. Randolph Street building. It was five stories high. John M. Van Osdel was the architect, as he had also been for BRIGGS HOUSE 1, 1856–1871 fire, on the same site. The first Briggs House is described and finely illustrated in CIJ and CBF. A drawing is in CBF; the building had been raised four feet in 1866 to meet the new street grade. Photographs of house 2 are in CIM, p. 131; CYT, p. 82; and LC, p. 111. A view is in RMNV, V18.

EXPOSITION building, 1873–1891, was on S. Michigan Avenue at the foot of E. Adams Street. It is illustrated in CIM, pp. 168 and 169; OMSM; CAC, p. 59; and HCA Vol. 3, p. 655. W. W. Boyington was the architect. This was also known as the Chicago Opera Festival Auditorium and as the Interstate Exposition building. Photographs are in CPH, p. 138, and LC, p. 135 scene. Adler & Sullivan remodeled the auditorium in 1885; a drawing is in BTC, p. 5; a drawing of the interior is in LSM, p. 69. The Art Institute of Chicago occupies this site.

PIKE BLOCK, 1873–(before 1970), at the southwest corner of S. State and W. Monroe Streets, fronting 80 feet on the former and 120 feet on the latter — also known as the Ayer building. John W. Roberts was the architect. The building, five stories high, was on spread foundations. It was the first home of the Academy of Fine Arts, now the Art Institute (OMSM). An illustration is in OYF and LO October 1872, p. 165, with a description on p. 170. A drawing is in RB May 13, 1972, p. 28 (advert.). The Amalgamated Trust & Savings Bank occupies this site.

T-R building, first known as the Illinois Staats Zeitung building and then as the Firmenich building, at 184 W. Washington Street, on the northeast corner of N. Wells Street, fronting 40 feet on Washington and 110 feet on Wells, is eight stories high. It was built in 1873 with Bauer and Loebnitz as the architects. A photograph is in CIM and CRT, p. 31. A view as a six-story building is in RMNV, V18, and LO June 1872, p. 85, with a description on p. 94. A photograph of the eight-story building is in OBD 1916, p. 79, and CIM, p. 575; a photograph of the six-story building is in CIM, p. 595. A drawing is in CAJZ, p. 17.

TIMES building, 1873–1925, was at the northwest corner of N. Wells and W. Washington Streets, on the site of the present Morton building. It was 80 feet square and was five stories high, on spread foundations. James R. Willett was the architect. A view is in CAC, p. 63, and in RMNV, V18. An illustration is in CIM, p. 595, and LO April 1872, p. 49, with a description on p. 54. The temporary City Hall was here in the early 1900s.

HOBBS building, ca. 1873–1953, at 68 W. Washington Street, was seven stories high, on spread foundations. The Richard J. Daley Center includes this site.

MARINE building, 1873–1928, at the northeast corner of N. LaSalle and W. Lake Streets, fronting 151 feet on the former and 80 feet on the latter, was originally six stories high. A story was added ca. 1890. Twenty feet of the Lake Street frontage was taken in the widening of N. LaSalle Street. Burling and Adler were the architects. An illustration is in RMNV, V16. Before the great fire the corner was occupied by the Marine Bank building, four stories high; an illustration is in CIM, p. 378; CYT, p. 26; CIJ; and CBF, with a description. Photos of this 1856 Marine Bank are in TBC, p. 5; GMM, p. 38; and, under construction, in CAJZ, p. 33. A two-story taxpayer occupied this site for many years. The 203 N. LaSalle Street building includes this site.

AMERICAN EXPRESS COMPANY building, special significance, 1873/96–1930 fire, at 21–29 W. Monroe Street, with a frontage of 90 feet and a depth of 190 feet, was an early work of Charles D. Gambrill and Henry H. Richardson (LO April 1874, pp. 56 and 57). Peter B. Wight was associated with them. Five stories were built in 1873; two were added in 1896. An illustration of the five-story building, then known as the American Merchants Union Express Company building, is in TYF and LO November 1872, p. 197, with a description on p. 186. The building was on spread foundations. A drawing is in RMP, p. 45. An article by J. Carson Webster is in JSAH March 1950, p. 20. The 33 W. Monroe Street building includes this site.

Cyrus McCormick's REAPER BLOCK, 1873–1957, HABS, at 72–84 W. Washington Street, on the northeast corner of N. Clark Street, fronting about 120 feet on Washington and 100 feet on Clark, was nine stories high. It was on spread foundations. John M. Van Osdel was the architect. Photographs are in CIM, p. 577; CHC, p. 83; OBD 1920, p. 206; and CON, p. 117. Views are in LO October 1872, p. 176, and RMNV, V19. The building was "enlarged" and remodeled ca. 1913 by Holabird & Roche. The Richard J. Daley Center includes this site.

36 S. CLARK STREET building, ca. 1873–(before 1970), was six stories high, on spread foundations. The Two First National Plaza building includes this site.

Eli WILLIAMS building, HABS, 1873–late 1960s, 57 E. Monroe Street, at the southeast corner of S. Wabash Avenue, was five stories high. A photograph is in CIM, p. 326. An illustration is in RMNV, V7. The Mid-Continental Plaza building includes this site.

STATE SAVINGS INSTITUTION building, 1873–(before 1949), later known as the Merchants' National Bank building, at 124–26 N. LaSalle Street, was four stories high, with a frontage of 45 feet and a depth of 98 feet. L. D. Cleveland was the architect. An illustration is in TYF and in LO August 1873, p. 132, with a description on p. 134. A photograph is in CIM, p. 565. The 120 N. LaSalle Street building includes this site.

SCHLESINGER & MAYER building, 1873–1903, originally the Bowen building, was at the southeast corner of S. State and E. Madison Streets, fronting 60 feet on the former and 70 feet on the latter. It was seven stories high. W. W. Boyington was the architect. Drawings are in CPS, pp. 25, 71, and 73. An illustration is in RMNV, V6. An illustration of the original five-story building is in TYF, and in LO November 1872, p. 200, with a description on p. 187. This building was replaced by the Carson, Pirie, Scott & Co. building.

STEWART HOUSE buildings: Stewart 1, 1873–1897, was also known as the Stewart-Busby Block. It was five stories high. A photograph is in GFC, p. 26. Stewart 1 was built at the northwest corner of N. State and W. Washington Streets, on the St. James Hotel site (q.v.). Stewart House 2 (q.v.) followed Stewart 1 in 1897. This "Block 37" site is now vacant.

BURDICK HOUSE, 1873–(before 1909), at the southeast corner of S. Wabash Avenue and E. Adams Street, was five stories high. T. V. Wadskier was the architect. A view is in RMNV, V4 to the right of the Stevens Art building. The 207 S. Wabash Avenue building occupied this site, which is now a part of Symphony Center.

BALLARD BLOCK, 1873–1912, later known as the Ely building, at the southwest corner of S. Wabash Avenue and E. Monroe Street, with a frontage of 100 feet on the former and 85 feet on the latter, was five stories high. Victor Roy was the architect. An illustration is in TYF and LO June 1873, p. 104. The Goddard building occupies the north 53 feet of this site. The Palmer House Hilton occupies the rest of this site.

CONTINENTAL HOTEL, 1873–1909, at the southeast corner of S. Wabash Avenue and E. Madison Street, was four stories high. An illustration is in RMNV, V7. The structure was once the home of the Chicago Public Library. The Mallers building occupies this site.

ADAMS-STATE building, 1873–(before 1947), formerly known as the Tobey Furniture Co. building and then as the Leader building, at the northeast

corner of S. State and E. Adams Streets, was four stories high. An illustration is in RMNV, V7. A photograph is in CYT, p. 65. An illustration of the Leader building is in CRT, p. 103, and a photograph is in CIM, pp. 272 and 327. The Baskin Store building was on this site, which is now occupied by the Unicom Thermal Technologies building.

DICKEY building, 1873–1922, six stories high, was at the southwest corner of N. Dearborn and W. Lake Streets. Burling and Adler were the architects. An illustration is in RMNV, V20. A photograph is in OBD 1916, p. 69. The Chicago Public Library occupied the upper floor before moving into the City Hall. The Dickey building was the home also of the Northwestern University Law School before the school moved to the southeast corner of N. Dearborn and W. Lake Streets. The Harris-Selwyn Theaters occupied this site.

1873: A financial panic slowed construction starts.

MERCHANTS building, 1873–1928, at the northwest corner of N. LaSalle and W. Washington Streets, was a seven-story building, on spread foundations, occupying the entire site of the present 100 N. LaSalle Street building. Otis L. Wheelock was the architect. The National Bank of America was located in this building, a photograph of which is in CIM, p. 250. A view as a five-story building is in RMNV, V18. An illustration of the seven-story building is in OBD 1910, p. 130.

HOVEY building, 1873–(before 1949), at the southwest corner of S. Franklin and W. Monroe Streets, was five stories high. A view is in RMNV, V13. A photograph is in RB May 10, 1958, p. 5. A Harris bank building occupies this site.

GALBRAITH building, 1873–1941, was at the northeast corner of N. Franklin and W. Madison Streets, fronting 132.5 feet on the former and 80.9 feet on the latter. It was six stories and 80 feet high, on spread foundations. Cochrane & Miller were the architects. A view is in RMNV, V5. A view as a five-story building is in LO November 1872, p. 181, with a description on p. 186. An illustration of the original five-story building is in TYF. A photograph is in CTCP, p. 47. The 1 N. Franklin Street building occupies this site.

A. C. McCLURG building, 1873–1899, at the northwest corner of N. Wabash Avenue and E. Madison Street, was six stories high. An illustration is in RMNV, V6. The site was occupied by Mandel Brothers Store.

GREISHEIMER building, 1873–1948, originally known as the Saloon building, at 187–97 N. Clark Street, on the southeast corner of W. Lake Street, was five stories high. John M. Van Osdel was the architect. An illustration is in RMNV, V20. The original Saloon building, 1836–1972 fire (CIM, p. 71,

with an illustration) on this corner was a three-story frame building which is described and illustrated in HCA Vol. 1, p. 180, and CYT, p. 33. The three four-story buildings at 173–85 N. Clark Street were removed in 1948. A photograph of all four buildings is in *Chicago Daily News*, July 12, 1947. The Chicago Title & Trust Center building includes the south part of this site; a twin is projected for the north part of the site.

LAKESIDE building 2, 1873–1926, was a six-story building at the southwest corner of S. Clark and W. Adams Streets, fronting 100 feet on the former street and 125 feet on the latter, on the north portion of the site of the present Bankers building. William Le Baron Jenney was the architect. A photograph is in CIM, and a view is in RMNV, V1. An illustration and a description are in LO August 1872, p. 142. A drawing is in BTC, p. 33. A previous building of this name had reached the fifth story when the fire of 1871 occurred. Cass Chapman was the architect. A photograph is in CAJZ, p. 17, showing the building as fire ruins.

COLONNADE building, 1873–(before 1911), at 11–19 N. State Street, with a frontage of 96 feet and a depth of 150 feet, was on a portion of the site of the prefire Book Sellers Row at 111–23 (old number) State Street. This five-story, marble-front building is illustrated in GCSU, p. 89. A photograph of it in 1868 is in CIM, pp. 263 and 264; CYT, p. 63; and TYF. An illustration of the Colonnade building is in LO December 1872, p. 201, with a description on p. 206, and HCA Vol. 3, p. 74. The building was five stories high. Wheelock & Thomas were the architects. A photograph is in CPS, and a drawing is on p. 60. Mandel Brothers Store building included this site.

MERCHANTS HOTEL, ca. 1873–(before 1982), was at 100–104 W. Lake Street, on the northwest corner of N. Clark Street, four stories high. It fronted 40 feet on Lake and 110 feet on Clark. It was also known as the Reed Hotel. The 203 N. LaSalle Street building includes this site.

South: TONTY HOTEL, ca. 1873–(1950 to 1990), at the southeast corner of S. State and E. Eighth Streets, was six stories high, on spread foundations. The site is used for parking.

North: C&NY RAILWAY OFFICE building, 1873–(before 1927), at the southeast corner of N. Orleans and W. Kinzie Streets, was three stories high. An illustration is in LO March 1875, p. 40. The site is occupied by the Merchandise Mart building.

North: McCORMICK HALL, 1873–(before 1949), at the northeast corner of N. Clark and W. Kinzie Streets, 80 feet by 120 feet, was four stories high. The exterior is illustrated in LO October 1872, p. 177, and the interior in LO October 1873, p. 176. W. W. Boyington was the architect. The building

was later known as Jacobs Clark Street Theater. Until the fire of 1871 the site had been occupied by the Foster House, later known as the Revere House. The site is now a parking lot.

North: 400 N. STATE STREET building, built in 1873 at the northwest corner of W. Kinzie Street, is five stories high. It was known as the Newcomb-Macklin building. The lofts were converted to offices in 1982 and renamed the Kinzie/State building; Marvin Ullman, architect.

1874: The fire of July 14 "wiped out 800 buildings on 47 acres between Clark and Michigan and Polk and Van Buren streets." These included the Wabash Avenue Methodist Church (not listed) and the Chicago Historical Society building.

North: HUBBARD HOTEL, 1874–ca. 1949, formerly known as the Revere House, at the southeast corner of N. Clark and W. Hubbard Streets, fronting 100 feet on the former and 120 feet on the latter. It was six stories high. The two upper stories were added at a later date. An illustration as the original Mackin Hotel is in LO January 1875, p. 5. A photograph is in the *Chicago Tribune,* May 24, 1947. The hotel, later known as the Capitol Hotel, suffered a disastrous fire on December 9, 1948 (*Chicago Daily News,* December 10, 1948).

CHICAGO MUSEUM building, 1874–1881, about 60–70 W. Monroe Street, on the "Lombard Lots" where stood the prefire Lombard Block, was a monumental-type building, five stories high. Thomas Tilley was the architect. It is illustrated in LO June 1874. The building fronted 102 feet on W. Monroe Street and was 190 feet deep. Custom House Place then separated it from Haverly's Theater, which occupied the former site of the Chicago Post Office and Custom House.

North: HOLY NAME CATHEDRAL 2, at 733 N. State Street, on the northeast corner of E. Superior Street, was built in 1874–75 by Patrick C. Keeley. An addition was by Henry J. Schlacks, architect. Spread foundations were used, but in 1915 four caissons were built under the spire, which is 210 feet high. Illustrations are in HCA Vol. 3, p. 765, and IC. Photographs are in COF; CCS, p. 36; CTCP, p. 10; CON, p. 93; CIM, p. 199; and CAA. On this site, in 1851, was built a little frame church known as the Church of the Holy Name of Jesus. The first Holy Name Cathedral, 1854–1871 fire, was on the same site, 84 feet by 190 feet. The building was 87 feet to the ridge, with a spire 245 feet high. Burling & Baumann were the architects (T, p. 55).

225–29 S. MARKET STREET building, 1874–1968, formerly known as the Yondorf building, at the southeast corner of W. Quincy Street, was remodeled in 1892. It was 10 stories high. An illustration is in RMNV, V13. Photo-

graphs are in CFB "merit"; CSA, fig. 108; RB August 29, 1964, p. 1. See 1892 note; Yondorf building was attributed to Flanders & Zimmerman, architects. The Sears Tower includes this site.

LUNT building, 1874–(before 1949), at 69–73 W. Washington Street, was four stories high. It is illustrated in LO May 1874, p. 76. The 69 W. Washington Street building occupies this site.

DELAWARE building, NR, CAL, was built in 1874 at 36 W. Randolph Street, on the northeast corner of N. Dearborn Street, part of the building formerly known as the Bryant and as the Real Estate Board building. It is eight stories high, on spread foundations. A photograph is in CIM, pp. 385 and 576. Photographs are in PGC, p. 51; WO, p. 32; 1993 CFB, p. 60; CTCP, p. 28; CAJZ, p. 431; RB November 17, 1951, p. 3, and May 1, 1982, p. 2; and SCS, p. 39. An illustration is in HCA Vol. 3, p. 306, and OBD 1901, p. 151. The original Bryant building, five stories high and fronting 80 feet on N. Dearborn and 120 feet on W. Randolph Street, is illustrated in LO June 1874 (frontispiece), with a description on p. 87. Wheelock & Thomas were the architects.

LORRAINE HOTEL, ca. 1874–(1950 to 1990), at the southeast corner of S. Wabash Avenue and E. Van Buren Street, was six stories high.

GENERAL CLARK HOTEL, ca. 1874–1945, at 215–19 N. Clark Street, was formerly known as the St. Charles Hotel. It was six stories high. On January 16, 1945, a disastrous fire occurred in which fourteen persons lost their lives. Later in the year the damaged building was razed. It was built four stories high. An illustration is in LO April 1874. The 200 N. Dearborn Street apartment building occupies this site.

222 W. MONROE STREET building, 1874–(before 1970), at the northeast corner of S. Franklin Street, was formerly known as the Field building, six stories high. An illustration is in RMNV, V12. The 230 W. Monroe Street building occupies this site.

WASHINGTON BLOCK, built in 1874, now known by its address, 40 N. Wells Street, is five stories high. Frederick & Edward Baumann were the architects. Photographs are in HB; WO, p. 39; and CALP.

PHELPS, DODGE & CO. building, 1874–1911, at 7–9 N. State Street, five stories high, was on the site of the Mandel Brothers Store building. John M. Van Osdel was the architect. An illustration is in HCA Vol. 3, p. 74.

SHOPS building, at 17–25 N. Wabash Avenue, with a frontage of 72 feet, was built in 1875, and was remodeled ca. 1920 by A. S. Alschuler, architect. It is six stories high, on spread foundations. An illustration and a description are

in OBD 1920, p. 216. It is also known by its address, 21 N. Wabash Avenue. A photograph is in WO, p. 20.

CARSON, PIRIE, SCOTT & CO. WHOLESALE building, 1875–1926, was at the northwest corner of S. Franklin and W. Adams Streets. It was six stories high. An illustration is in CRT, opposite p. 84, and in RMNV, V13. The site is now occupied by the 300 W. Adams Street building. It has been speculated (CSA, p. 162) that John M. Van Osdel was the architect.

HADDOCK BLOCK, 1875–(before 1902), at the northeast corner of S. Wabash Avenue and E. Monroe Street, was five stories high. It is illustrated in LO August 1875, p. 120, and HCA Vol. 3, p. 391. A photograph is in CIM, p. 369. The Champlain building occupies this corner.

WALSH building, ca. 1875–(1950 to 1990), at the northeast corner of N. Franklin and W. Lake Streets, was six stories high. The 225 W. Wacker Drive building occupies this site.

PORTER BLOCK, 1875–1899, at the northwest corner of S. Clark and W. Adams Streets, was four stories high. John M. Van Osdel was the architect. An illustration is in RMNV, V5. The site was later occupied by the Merchants Loan & Trust Co. building, 1900–1931, and is occupied by the Field building.

MONROE-LaSALLE GARAGE building, ca. 1875–1959, formerly the Bradner Smith building, at 173–175 W. Monroe Street, was six stories high. It was remodeled extensively for garage use in 1923. A photograph is in the *Chicago Daily News*, August 21, 1959.

BUTLER PAPER CO. building, ca. 1875–(before 1990), at 221–29 W. Monroe Street, was five stories high. One story had been added to the west half. The AT&T Corporate Headquarters building includes this site.

111–19 S. WELLS STREET building was two separate buildings. The north 60-foot portion was built ca. 1875, the south 23-foot portion ca. 1885; both were six stories high. They were demolished in 1959. A photograph is in RB Annual Review, January 31, 1959, p. 123. The site is occupied by a parking structure.

423–29 S. WABASH AVENUE building, ca. 1875–1968, formerly known as the Giles building, was six stories high. HABS. Otis L. Wheelock was the architect. A photograph is in CFB "merit." The Herman Crown Center of Roosevelt University occupies this site.

WABASH-MONROE GARAGE building, 1875–1960s, at 125–29 S. Wabash Avenue, remodeled in 1918 for the use of O. W. Richardson Co., which occupied the building until 1940, when it was remodeled extensively by M. Louis Kroman, architect. The Mid-Continental Plaza building occupies this site.

VICTORIA HOTEL, ca. 1875–1908, at the northwest corner of S. Michigan Avenue and E. Van Buren Street, on the site of the present McCormick building, was known formerly as the Beaurivage Bachelor Apartments. It was six stories high. Photographs are in CTCP, p. 79, and *Chicago: Historical Guide to the Neighborhoods*, Glen E. Holt, 1978, p. 23; RMNP; CYT, pp. 39 and 42; and CIM, p. 294. A view is in RMNV, V8, and in the *Hotel Monthly* June 1912. An illustration as a five-story building is in HCA Vol. 3, p. 55. The frontage on S. Michigan Avenue was the same as that of the McCormick building, but on E. Van Buren Street it was 110.5 feet.

BOYLESTON building, 1875–1925, was at 327–35 S. Dearborn Street, extending through to S. Plymouth Court. It was six stories high, on spread foundations. A view is in RMNV, V3. The Standard Club building includes this site.

201–05 W. MADISON STREET building, ca. 1875–(1950 to 1990), at the southwest corner of S. Wells Street, was six stories high. This site is vacant.

DALEIDEN building, ca. 1875–(before 1980), was six stories high. It was at 218–20 W. Madison Street. The Madison Plaza building occupies this site.

Philip HENRICI RESTAURANT building, ca. 1875–1962, at 67–71 W. Randolph Street. HABS. Holsman & Hunt were the architects. It was six stories high, on spread foundations. Photographs are in LC, p. 188. The Richard J. Daley Center includes this site.

POTTHAST'S RESTAURANT building, 1875–(1950 to 1990), at the northwest corner of S. State and W. Van Buren Streets, six stories high. Pritzker Park includes this site.

South: 500–10 S. STATE STREET building, 1875–ca. 1950, was four stories high. The building was condemned by the Department of Subways and Superhighways.

North: ST. REGIS HOTEL, HABS, CLSI, was built ca. 1875, at the southwest corner of N. Clark Street and (101) W. Grand Avenue. It has been known as the Palace Hotel and as the Grand Palace Hotel. It was renamed One Grand Place, 512 N. Clark Street. The north, corner portion, 54 feet by 80 feet, was formerly known as The Albany. Top additions were made in 1883 and 1884 by Cyrus P. Thomas, architect. It is six stories high, on spread foundations. It was converted to offices in 1985 by Swanke, Haydn & Connell, architects. A photograph is in RB April 27, 1985, p. 76.

UNION TRUST & SAVINGS BANK building, 1876–1905, at 1–17 N. Dearborn Street, on the northeast corner of W. Madison Street, was five stories high. An illustration is in RMNV, V6. Partial photographs as the Manierre

building are in CIM, pp. 407 and 408. The site is occupied by the State-Madison building, formerly known as the Boston Store.

FITCH building, 1876–(before 1923), was at the southwest corner of N. Franklin and W. Randolph Streets. It was five stories high. An illustration is in RMNV, V18. The north end of this site is now occupied by parking and the south end by the Parke, Davis & Co. building.

BURTON ESTATE building, 1876–(before 1916), at 11 W. Lake Street, was on the site of the State-Lake building. John M. Van Osdel was the architect.

DeJONGHE'S HOTEL, 1876–1939, formerly the Chicago Club, 1876–1893, was at 12 E. Monroe Street, site of the Monroe Garage building. It was six stories high, on spread foundations. Treat & Foltz were the architects. Illustrations are in HCA Vol. 3, p. 391; CAC, p. 71; and AA May 6, 1876, with a description in AA August 19, 1876, p. 271. A photograph is in CIM, p. 325. The Columbus Club occupied this building after the Chicago Club moved to its new building. In 1898 the building was rented to DeJonghe, who then had a restaurant in the Masonic Temple. The Carson, Pirie, Scott store includes this site.

North: ROOS, HENSHAW & CO. building, built in 1876, later known as the Liquid Carbonic and then as the LCB building, is a five-story structure at the southeast corner of N. Franklin and W. Illinois Streets. An illustration is in CAC, p. 215. The building is now known as 229 W. Illinois Street.

McCORMICK building, 1877–1926, at the northwest corner of N. Michigan Avenue and E. Lake Street, was five stories high. John M. Van Osdel was the architect. An illustration is in LO October 1872, p. 169. An illustration is in RMNV, V17. The site is now occupied by the 200 N. Michigan Avenue building.

CRILLY building, 1878–ca. 1955, at the northeast corner of W. Monroe and S. Dearborn Streets, known as the 35 S. Dearborn Street building, was built to the height of five stories on spread foundations. Three stories were added in 1888. It was constructed for the printing trades. Photographs are in STL, p. 70 to the left of the Majestic building; SCM; CIM; and OBD 1941–42, p. 383. It was the home of the Stock Exchange, and the building was so called for a time prior to the construction of the 30 N. LaSalle Street building. An illustration is in CRT, p. 32, and RMNV, V6. The Inland Steel building occupies this site.

MULLEN building, ca. 1878–ca. 1950, at the southwest corner of W. Madison and S. Market Streets, was five stories high. An illustration is in RMNV, V12. This building and another of the same height adjoining on the west were occupied later by the New Gault Hotel and later by the Weston Hotel. A

drawing is in BTC, p. 86. The widening of S. Market Street (the extension of N. Wacker Drive) caused its demolition. The C. H. Fargo building previously occupied this site. In 1954 a city parking structure was built on this site, which is now occupied by the Chicago Mercantile Exchange building.

CHICKERING HALL, 1878–1916, formerly known as the Weber Music Hall, at 300–304 S. Wabash Avenue, extending west to the alley, on the southwest corner of E. Jackson Street, was six stories high, on spread foundations. An illustration is in RMNV, V4. The Kimball building, renamed Lewis Center, De Paul University, occupies this site.

COMMERCIAL TRADE building, 1878–(before 1949), at 2–20 S. Franklin and 301–07 W. Madison Streets, on the southwest corner, was five stories high, on spread foundations. An illustration is in RMNV, V12. The 303 W. Madison Street building occupies this site.

QUINCY building, 1878–1930, at 24–30 W. Quincy Street, was eight stories high. The Palmer House Garage once occupied this site. Quincy Street is now the Quincy Court Plaza (pedestrian mall) from State Street to the Dirksen Federal Center building.

Levi Z. LEITER building, 1879 and 1880–1972, CAL, HABS/drawing, was at 200–208 W. Monroe Street, at the northwest corner of S. Wells Street. It is often identified as the Leiter 1 building, and it was also known as the M. D. Wells & Co. (shoes), as the Morris, and as the 208 W. Monroe Street building. William Le Baron Jenney was the architect/engineer. Though not of skeleton construction, it was a distinct advance over the other buildings of its decade. The building permit was issued on August 16, 1879. Five stories on spread foundations; two stories were added in 1888. The design live load was 250 pounds per square foot. Eight-inch by 12-inch cast-iron columns were set flat against the east and west walls and the piers to support the timber girders, which ran east and west. One column at the stairway was set flush in the wall. The joists were 3 inches by 12 inches at 9-inch centers, running north and south. At the north party wall the joists were embedded in the wall. At the south wall the joists were supported on two 7-inch iron beams bearing on the brick piers and on the cast-iron mullions between the triple windows between the piers. The mullions were continuous as columns from the foundations to the roof. Cast-iron lintels, bolted to the columns, supported brick spandrels. Had the wall columns been inserted in the piers and had three more columns been added, the construction would have been essentially skeleton construction. A view is in RMNV, V5. Photographs are in SCM; CFB; CANY, p. 35; IA-C July 1973, p. 9 facade detail; CSA, fig. 4; AF December 1973, p. 58; *Space, Time and Architecture,* Sigfried Giedion, 1941 and reprints. The 200 W. Monroe Street building includes this site.

SARATOGA HOTEL, ca. 1879–(1950 to 1990), at 27 S. Dearborn Street, formerly known as the Chambers building, 21–25 S. Dearborn Street, and the Evening Journal building, 27–29 S. Dearborn Street, was seven stories high, on spread foundations. Photographs are in CIM, p. 368. A view is in RMNV, V6. An earlier home of the Chicago Evening Journal is illustrated in CIM, p. 80, and a drawing of this four-story structure is in CIS, p. 273.

CENTRAL MUSIC HALL, 1879–1901, at the southeast corner of N. State and E. Randolph Streets, on the site of the present "North" building of the Marshall Field & Co. Store, with a frontage of 120 feet on N. State Street and a depth of 150 feet, was six stories high. Burling & Adler were the architects; completed by Dankmar Adler. It is illustrated in HCA Vol. 3, p. 652. Views are in CAC, p. 62, and RMNV, V17. A description is in LSM and SGC, p. 120. Photographs are in CIM, pp. 150 and 350; CYT, p. 67; LC, p. 180; CSA, fig. 4; DATA, pp. 104–9; CHC, p. 46, with the Capitol building; CON, p. 102; and IA-C September 1983, p. 24.

150 N. MICHIGAN AVENUE building, 1879–(before 1980), was seven stories high, on spread foundations. A photograph is in CIM, p. 310 with the Bell building scene. The Doral Michigan Plaza building occupies this site.

ATLAS BLOCK, 1879–1940, was at the northwest corner of N. Wabash Avenue and E. Randolph Street, with a frontage on the latter street of 138 feet. It was five stories high. An illustration is in RMNV, V17. A photograph is in *Chicago Tribune,* February 17, 1940. The site is occupied by a parking structure.

ADAMS building, ca. 1879–ca. 1970, at 315–21 W. Adams Street and 310–18 W. Quincy Street, was seven stories high. The Sears Tower includes this site.

BISHOP building, 1879–(1950 to 1990), formerly the Laflin building, at the southeast corner of N. Wabash Avenue and E. Randolph Street, with a frontage of 48 feet on the former and 81 feet on the latter, was five stories high. An illustration is in RMNV, V17. The two lower stories had been remodeled, and two stories had been added.

FAIRBANKS, MORSE & CO. building, 1879–1925, five stories high, was at the northwest corner of N. LaSalle and W. Lake Streets. An illustration is in RMNV, V16. A photograph of a prefire five-story building on this corner is in CIM, p. 359. The 200 N. LaSalle Street building occupies this site.

South: WABASH HOTEL, ca. 1879–(1950 to 1990), at the southwest corner of S. Wabash Avenue and E. Harrison Street, was four stories high. This site is used for parking.

North: CYRUS McCORMICK residence, 1879–1954, 675 N. Rush Street, on the west half of the block bounded also by E. Huron and E. Erie Streets. Cudell & Blumenthal were the architects. It was remodeled by Louis Sullivan in 1898. It is described in T, p. 119. A view is in RMNV, V24. Photographs are in LC, p. 33, and SFO, p. 31. The Chicago Place building includes this site.

RAND McNALLY building, 1880–1900, at 125 W. Monroe Street, later the site of the Central Trust Company, was five stories high. It is illustrated in OMSM. The Downtown Parking Stations structure and the Harris Bank later occupied this site.

BORDEN BLOCK, 1880–1916, at 50–56 W. Randolph Street, was 80 feet square and six stories high. It occupied the northwest corner of W. Randolph and N. Dearborn Streets. Dankmar Adler was the architect. This is reputed to be the first building on isolated footings. A view is in RMNV, V16. Photographs are in LSM; CIM, p. 385; CSA, fig. 5; LAAM, p. 161; ACMA, p. 48; SRT; SFO, p. 12; and CTCP, p. 29. The Woods Theater building occupied this site, which is now used for parking.

329 W. MONROE STREET building, ca. 1880–ca. 1961, at the southeast corner of S. Market Street, was eight stories high. It is shown in RMNV, V13. The Cleveland building, five stories high (A. J. York, architect), was built on this site in 1872, fronting 50 feet on S. Market Street and 90 feet on W. Monroe Street; it is described and illustrated in LO September 1872, p. 156, and illustrated in OYF. This site was occupied by the U.S. Gypsum building. It is vacant.

HASKEL building, ca. 1880–ca. 1970, at the southeast corner of S. Market and W. Adams Streets, was seven stories high. A view is in RMNV, V13. The Sears Tower includes this site.

CREST building, 1880–ca. 1970, at 227–29 W. Van Buren Street, remodeled in 1909, was seven stories high, on spread foundations. The Sears Tower includes this site.

320–26 W. ADAMS STREET building, ca. 1880–(1950 to 1990), at the northeast corner of S. Market Street, was seven stories high. The 322 W. Adams Street building occupies this site.

320–22 W. JACKSON BOULEVARD building, ca. 1880–1965, at 319–23 W. Quincy Street, was six stories high. M. Randolph Smith was the architect. An illustration is in CAC, p. 206. The building was formerly known as the Garden City Warehouse. The Sears Tower includes this site.

226 S. WELLS STREET building, ca. 1880–(1950 to 1990), formerly known as the Foster building, at the southwest corner of W. Quincy Street, was

seven stories high. An illustration is in RMNV, V13, which shows it adjoining the Owings building on the north. The building was remodeled extensively in 1934 by Graham, Anderson, Probst & White, architects. The 200 W. Jackson Boulevard building occupies this site.

North: 173–77 S. WELLS STREET building, ca. 1880–(1950 to 1990), was six stories high.

North: OHIO building, at 141–49 W. Ohio Street, on the southwest corner of N. LaSalle Street, built ca. 1880, is seven stories high. In the widening of N. LaSalle Street, 20 feet were removed and a new street front was built by Holabird & Root, architects, in 1930. It was renamed the 540 N. LaSalle Drive building. The lofts were converted to offices in 1983; James Peterson was the architect. A photograph is in RB January 21, 1984, p. 3.

North: 6–8 W. HUBBARD STREET building, ca. 1880–ca. 1988, was six stories high, of ordinary construction, on spread foundations. This building was used as a quartermaster's warehouse from which blankets were shipped to the western Indians. M. W. Fairchild & Bros. moved into it ca. 1898. The 6 W. Hubbard Street building occupies this site.

North: DR. V. C. PRICE building, HABS, at the southwest corner of N. Wabash Avenue and E. Illinois Street, built in 1880, is six stories high. It was also known as the Monarch Refrigeration building and as the Addressograph-Multigraph building. It was refaced and renamed the 444 N. Wabash Avenue building.

North: KINZIE building: built ca. 1880 (?)–ca. 1920, at the southwest corner of Pine (now N. Michigan Avenue, extended), and E. Chicago Avenue, was six stories high with a high spire on its corner. Henry L. Newhouse was the architect. A view is in RMNV, V23. The Waller building occupied this site: it is now vacant.

Period III: From 1881 to 1900

This was the "golden age" of building in Chicago. Greater advances were made in this twenty-year period than in any other similar time. The name "skyscraper" was first given to the 10-story Montauk building (1882–1902). The first building of skeleton construction, the Home Insurance, followed in 1885. Structural steel came into use, and wrought-iron beams and cast-iron columns were being replaced. Fireproofing of the columns and floor steel became general. The elevator and skeleton construction now enabled buildings to rise to a height of 12, 13, and 16 stories and then to the 21-story height of the wonder of the world, the Masonic Temple (1892).

The development of S. Dearborn Street began with the building of the Polk Street Station, which was completed in 1883. Then followed the Donohue & Henneberry, Printers Block, Monon, Manhattan, Caxton, Pontiac, Monadnock, Great Northern Hotel, Fair Store, Old Colony, Marquette, Great Northern office building and theater, and the Fisher, all on S. Dearborn Street.

The financial district developed along S. LaSalle Street. Among the buildings built there were the Calumet, Mallers, Gaff, Counselman, Insurance Exchange, Royal Insurance, Board of Trade, Home Insurance, Rialto, Rookery, and New York Life. The Stock Exchange was built at 30 N. LaSalle.

In proportion to population about 80 percent as much building was done in this period as in the five decades that followed. The younger architectural firms availed themselves of the possibilities of skeleton construction, and buildings took on a more modern look.

Chicago was stimulated also by the planning and construction of the World's Columbian Exposition of 1893.

> The use of piles had not been attempted in the loop for the simple reason that no satisfactory method of driving the piles had been discovered. The method then [prior to 1890] in use was to lift a four- or five-ton weight up to the head of the derrick, release it, letting it strike from a distance of twenty-five feet. The resulting vibration was so excessive that adjoining property owners objected and even enjoined the contractor from further driving. A little later a steam hammer for pile driving was devised and put into operation. This gave a light blow with great rapidity, causing the piles to penetrate. (EAR)

The practical limit of height for spread foundations had now been reached, but another type of foundation was being developed, the Chicago caisson, and at the close of this period the first building entirely supported on caissons was erected.

Although many of the buildings mentioned above have been demolished, one hundred nineteenth-century buildings of those recorded here remain

standing in 1998. Half of these are in the Loop area, and about a score were built in earlier periods.

1880 to 1929: Thirty State Street scenes are in CIM, p. 330.

Amos GRANNIS BLOCK, 1881–1885 fire, at 21–29 N. Dearborn Street (Burnham & Root, architects), was seven stories high, on spread foundations. It had a red brick and red terra-cotta front, with wood floor construction. The cast-iron columns were fireproofed with 2½ inches of terra-cotta (BB 1902, p. 147). An illustration is in HCA, Vol. 3, p. 76, showing the Grannis Block south of Portland Block. "The Grannis fire dramatized the passing from the realm of commercial building of the carpenter as a builder" (HE). A drawing is in JWR, plate 6. The Union Bank occupied this site. The Boston Store / 1 N. Dearborn Street building occupies this site.

Milton F. GOODMAN building, 1881–1972, HABS, formerly known as the *Rothschild building,* at 210–12 W. Monroe Street, was five stories high. Adler & Sullivan were the architects. Except for the piers, the front was of cast iron. It was also known as the 210 W. Monroe Street building. It was remodeled for the FBI in 1954. Drawings are in JWR, plate 6, and in RMNV, V5, to the left of the Wells / Leiter building. Photographs are in LSM; SRT, p. 121; SFO, p. 14; AIA Journal February 1966, p. 40; CSA, fig. 6; RNRC, p. 216; HB; and FRAG, p. 127. The 200 W. Monroe Street building occupies this site.

COLUMBIA THEATER, 1881–1900, formerly Haverly's Theater, was at 57 W. Monroe Street, later the site of the Inter-Ocean building and the Iroquois Club. The building was six stories high. The seating capacity was 2,400 and there was a large stage. Oscar Cobb was the architect. The building is illustrated in HCA Vol. 3, p. 403; CAC, p. 54; and CIM, p. 152. A description is in SGC, p. 122. A photograph is in DATA, p. 59. The theater's entrances were remodeled by Adler & Sullivan in 1884. Xerox Centre occupies this site.

323–25 W. ADAMS STREET building, 1881–ca. 1970, running through to W. Quincy Street as 320–22 W. Quincy Street, was six stories high.

West: UNION PASSENGER STATION, 1881–1923, at the northeast corner of S. Canal and W. Adams Streets, was four stories high. W. W. Boyington was the architect. It is illustrated in RMNV, V15, and CAC, p. 38. (See also Chicago Union Station.) A history of the stations of the group of railroads entering this depot is in WSE 1937, p. 258. The 120 Riverside Plaza building occupies this site.

South: IRWIN building, 1881–1975, at the northwest corner of S. Wabash Avenue and E. Harrison Street, was six stories high. Cyrus P. Thomas was the architect and John H. Edelmann the probable designer. A photograph is in

the pamphlet *Collection of Architectural Fragments from Famous Chicago Buildings*, at the Graham Foundation headquarters, the Madlener House. The Wabash Avenue Methodist Church formerly occupied this site, which is now used for parking.

North: ONTARIO HOTEL, 1881–1965, HABS, at the southwest corner of N. State and W. Ontario Streets, was seven stories high, on spread foundations. Treat & Foltz were the architects. An article is in *Chicago Sunday Tribune*, August 23, 1942. A photograph is in CRT, p. 20, with a brief description on p. 17.

North: John M. BRUNSWICK, Julius BALKE, COLLENDER factory, 1881/1883–1989 fire, HABS, CLSI, at 340–68 W. Huron Street in the block bounded also by N. Sedgwick, W. Superior, and N. Orleans Streets, was six stories high. Adler & Sullivan were the architects. It was also known as the Huron & Orleans building. The lofts had been converted to art galleries and shops. Photographs are in CHC, p. 34; SRT, p. 125; and IA-C July 1989, p. 47.

ROBERT LAW building, 1882–1940, at 22–30 S. Market Street, with a frontage of 99 feet and a depth of about 275 feet, was six stories high in the front and four stories high in the rear. John M. Van Osdel was the architect. The architect's record shows a total cost of $93,446.27, divided as follows — carpentry, $22,299.00, and an extra of $2,745.50; stairs, $2,958.00; painting, $1,095.00; sky light, $330.00; glass, $4,396.68; plumbing, $1,950.00, and extras of $175.72 and $252.15; cast iron, $13,237.98; steam heating, $4,975.00; freight hoisting machinery, $4,200.00; roofing, $860.00; passenger elevator, $2,500.00; draining (sewers to river), $126.49; masonry, $18,100.00; asphalt, $1,486.00; wire work, $1,628.30; plastering, $5,600.00, plus $1,226.00; cut stone, $2,850.00, plus $133.45; and two unidentified items of $6.00 and $315.00. This is followed by a notation "2% on full cost," presumably the architect's fee. The Chicago Mercantile Exchange building occupies this site.

MONTAUK BLOCK, special significance (fig. 22), called the Brooks building on the original drawings, 1882–1902, at 64–70 W. Monroe Street, with a frontage of 89 feet, was on the former site of the home of Dr. C. V. Dyer. Burnham and Root were the architects. Considered the first tall building or skyscraper in Chicago and perhaps in the United States, the Montauk Block was 10 stories, 130 feet high, and was a distinct advance in design. Iron rail grillages were used for the first time to reduce the height of some of the individual spread footings. The story is in HBF. Cast-iron columns were used for the interior columns, with wrought-iron floor beams, and heavy exterior bearing walls. This building was distinguished also as being the first to use flat tile floor arches (WSE 1904, p. 458; illustrated in AEF). An illustration of the building is in CRT, p. 51; OMSM, HCA Vol. 3, p. 66; T, p. 135, with a

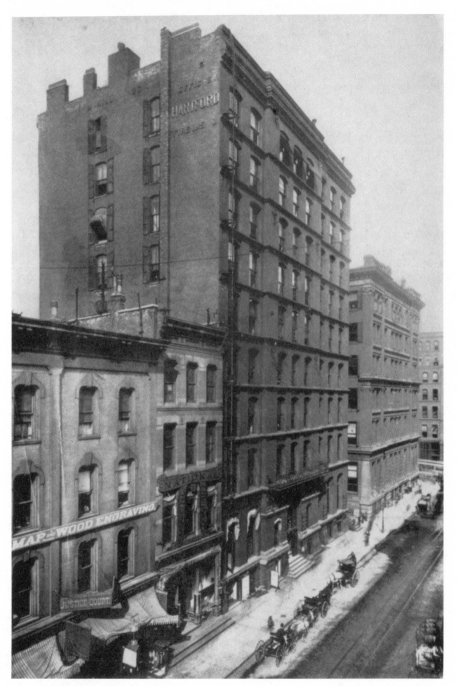

Fig. 22. Montauk, 1883

description; IC Vol. 2; OBD 1901, p. 133; and RMNV, V6. Drawings are in JWR, plate 7; CIDL, p. 51; LC, p. 130. Photographs are in CSA, fig. 15; TBC, p. 31; and CON, p. 134. The building was a project of Peter C. Brooks. The One First National plaza occupies this site.

364–76 W. MONROE STREET building, 1882–1937, was seven stories high.

131–33 S. MARKET STREET building, ca. 1882–(1950–1990), was six stories high. The U.S. Gypsum building occupied this now-vacant site.

JEWELERS building, NR, HABS, CLSI, built in 1882 at 15–17 S. Wabash Avenue, is five stories high. Dankmar Adler was the architect, and Louis Sullivan, associate designer. The building was originally the S. A. Maxwell (stationers) Store and is now known as the 19 S. Wabash Avenue building and as the Iwan Ries (tobacconist) building. The semi-mill constructed building was built for Martin Ryerson. Photographs are in CSA, fig. 7; SRT, p. 122; SFP, p. 14; WO, p. 18 upper stories; and FRAG, p. 129.

South: CARTER HARRISON building, 1882–ca. 1950, at 510–14 S. Dearborn Street, was four stories high, on spread foundations. John J. Flanders was the architect. Second-hand brick was used (HE). This building was condemned by the Department of Subways and Superhighways.

West: Levi ROSENFELD building, 1881/1882–1958, at the southeast corner of N. Halsted and W. Washington Streets, was three and five stories. Dankmar Adler was the architect. A photograph is in *AIA Journal*, February 1966, p. 38. The 659 W. Washington Street building occupies this site.

North: MAJESTIC apartment building, 1882–1942, at the southwest corner of N. Rush Street and E. Walton Place, was seven and eight stories high. A photograph is in APB, p. 104 as the New Majestic Apartments. The site is used for parking.

North: CHARLES B. FARWELL residence, 1882–1950s, was at 120 E. Pearson Street. Treat & Foltz were the architects. The house was occupied by the Chez Louis restaurant in its later years. It is described in T, p. 181, with a photograph. A view is in RMNV, V23. Photographs are in CIM, p. 521, and in LC, p. 34, along with the residence of brother John V. Farwell next door, to the east at the northwest corner of N. Michigan Avenue. Bonwit Teller's and other stores later occupied these sites, which were partially eliminated by the 1920s widening of Michigan Avenue.

North: WELLS STREET STATION, 1882–1927, of the Chicago & Northwestern Railway, at the southwest corner of N. Wells and W. Kinzie Streets, is illustrated in RMNV, V22, and CAC, p. 39. See also Chicago & Northwestern Railway Station. A photograph is in CTCP, pp. 14 and 23, and *Thirty-two*

Picture Postcards of Old Chicago, David Lowe, 1977. The Merchandise Mart includes this site.

North: RALEIGH HOTEL, built in 1882 at the southwest corner of N. Dearborn and W. Erie Streets, originally known as the Vendome Hotel, is seven stories high, on a high English basement. L. G. Hallberg was the architect. The building was renamed the 650 N. Dearborn Street apartments. A photograph is in IA-C May 1972, p. 15, with the old Chicago Historical Society building.

North: CHURCH OF THE ASCENSION, HABS, CLSI, was built in 1882 at 1133 N. LaSalle Drive, at the southeast corner of W. Elm Street. W. H. Wilcox was the architect.

JEWETT building, 1883–1940, 30 S. Wacker Drive at the northwest corner of S. Market and W. Monroe Streets, was six stories high, fronting 99 feet on Market Street and 141 feet on Monroe. John M. Van Osdel was the architect. His records show that piles were used. An illustration is in RMNV, V12. A seventh story was added later. It was also known as the Selz building. The 1983 Chicago Mercantile Exchange building includes this site.

CB&Q OFFICE building, 1883–1926, at the northeast corner of W. Adams and S. Franklin Streets, with a frontage of 122 feet on the former and 199 feet on the latter, was six stories high, on spread foundations. Burnham & Root were the architects. It is illustrated in HCA Vol. 3, p. 208; IA March 1883; and IC Vol. 2. A view is in RMNV, V13. A drawing is in JWR, plate 9. The USG building occupies this site.

DEXTER building, 1883–1961, at 39 W. Adams Street, was eight stories high, on spread foundations. Burnham & Root were the architects and Clinton J. Warren, the designer. A photograph is in CSA, fig. 17. A view is in RMNV, V3. An illustration is OBD 1916, p. 67. The Dirksen Federal Center building includes this site.

BODIE BLOCK, 1883–1927, was a six-story building at the southwest corner of S. Franklin and W. Jackson Streets. A view is in RMNV, V13. The Jackson-Franklin building occupied this site, now occupied by the 311 S. Wacker Drive building.

NORTHWESTERN building, 1883–(1950 to 1990), at the northwest corner of N. Wells Street and W. Lake Street, was five stories high. A view is in RMNV, V22. A photograph is in OBD 1916, p. 181. This site is used for parking.

HUB building, 1883–1947, was at the northwest corner of S. State and W. Jackson Streets. The south half was six stories; the north half, formerly the Pelham Hotel, 234–40 S. State Street, was five stories high. An illustration is

in RMNV, V6. A photograph is in CIM, p. 374. The Bond store/10 W. Jackson Street building occupies this site.

Alexander H. REVELL building, 1883–1968, CAL, CFB "merit," HABS, also known as the Adams-Wabash building, at the northeast corner of S. Wabash Avenue and E. Adams, was six stories high. Terra-cotta slabs were screwed to the bottoms of the wood joists (T, p. 207). Adler & Sullivan were the architects. It was built for Martin Ryerson. Photographs are in LSM; CIM, p. 327; CSA, fig. 8; SRT, p. 124; SFO, p. 14; and RNRC, p. 183. A view is in RMNV, V7. The Mid-Continental Plaza building includes this site.

PARKER building, 1883–1910, at 304–08 S. Sherman Street (later known as the Wheeler building), was seven stories high. John M. Van Osdel was the architect. It is illustrated in OBD 1901, p. 201. Details of the cost of construction are in the architect's books of account (Vol. 2, p. 170). The Insurance Exchange building occupies this site.

MORRISON HOTEL building 1, 1883–1912, was at 71–89 W. Madison Street. It was eight stories high and is illustrated in *Hotel Monthly* June 1912, and CYT, p. 94. It was replaced by MORRISON HOTEL building 2, 1914–ca. 1966, 23 stories high, with four basements, on caissons. Marshall & Fox were the architects. MORRISON HOTEL TOWER, adjoining the hotel at 15–29 S. Clark Street, 1925–ca. 1966, was 45 stories high, with four basements, on rock caissons. Holabird & Roche were the architects and Frank E. Brown was the engineer. Photographs of all three buildings are in CIM, pp. 424 and 578, and ISA 1925, p. 72. The tower replaced an old four-story portion of the hotel. The One First National Plaza building includes this site.

South: DONOHUE building, formerly known as the Donohue & Henneberry building, at 701–21 S. Dearborn Street, was built in 1883 with 200 feet of frontage, eight stories high, on spread foundations. Julius Speyer was the architect. A view is in CAC, p. 231, and in RMNV, V14. In 1913 the south 100 feet of frontage, the Donohue Annex building, at 723–33 S. Dearborn Street, was added, 10 stories high, on pile foundations (A. S. Alschuler, architect). A photograph in OBD 1916 shows both buildings. The original building is heavy timber, and the annex is reinforced concrete construction. The offices were converted to condominiums in 1980, the annex to apartments by Harry Weese and Booth, Hansen, architects.

South: *POLK STREET STATION,* NR, CAL, HABS, CLSI/premier, called also the Dearborn Street Station, on W. Polk Street at the foot of S. Dearborn Street, was built in 1883. It is three stories high, with a tower, on spread foundations. Cyrus L. W. Eidlitz was the architect. It is illustrated in HCA Vol. 3, p. 225. The story of the foundations is in HBF. A history of the stations

of the Dearborn Street group of railways is in WSE 1937, p. 78. Upper portions of the tower and roof were removed after a fire, and the train sheds were demolished in 1976. The building was converted to offices and shops in the late 1980s, and an addition made; Kaplan/McLaughlin/Diaz and Hasbrouck-Hunderman were the architects. It was renamed the Dearborn Station Galleria, 47 W. Polk Street, in the South Loop Printing House Historic District/NR. A view is in RMNV, V14. Photographs are in CAA; CHC, p. 106; CIM, p. 233; LC, p. 56; 1987 COF, p. 150; GCA, p. 29; ABOV, p. 82, with the clock tower and south addition at Dearborn Park; HB; AR March 1980, p. 90; and CFB "merit."

West: 600 W. ADAMS STREET office building, built in 1883 at the northwest corner of (130) S. Jefferson Street, was five stories high. It was also known as the Polk Brothers building. Originally it was the Warder, Bushnell & Glessner (farm implements) building. William Boyington was the architect. It was converted to offices in 1985 and renamed the Glessner Center; Booth, Hansen were the architects.

North: 19 W. CHESTNUT STREET building was constructed in 1883. It was originally a residential hotel. Eight stories high, it was converted to condominiums in 1984 by Jack Berger, architect.

North: HIRAM SIBLEY & CO. WAREHOUSE (fig. 23), 1883–1980s, the Central Cold Storage Warehouse, occupied 315–31 N. Clark Street, at the river. George H. Edbrooke was the architect. The building was divided into three approximately equal portions—the two west portions seven stories high and the east portion nine stories high—and supported on spread foundations except for the river frontage, which is supported on three lines of 30-foot oak piles spaced three feet apart along the wall. This is the first known use of wood or other piles under a building wall, other than in grain elevators along the Chicago River. The building is illustrated in IA November 1883. A photograph is in CIM, p. 320. In 1945 a new concrete dock was constructed, with 45-foot steel sheet-piling, and the river wall was underpinned with concrete, cutting the tops of the piles off at −2.5, C.C.D., the new intended river water level. Fifty wood piles, 50 feet long, were added on the river side of the old dimension-stonewall foundations. Mundie & Jensen served as architects, and Frank A. Randall as engineer. Photographs are also in GMM, p. 136, and CFB "merit." The Quaker Tower building occupies this site.

North: *104 W. OAK STREET/BURLINGHAM building,* NR, was built in 1883 at the northwest corner of (1000) N. Clark Street. Alfred Smith was the architect. It was renamed the Henrotin Health Professionals building. A photograph is in RB April 27, 1985, p. 49. The building is six stories high, of ordinary construction, on spread foundations.

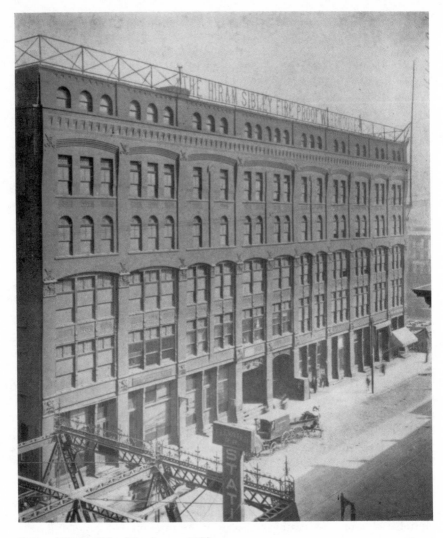

Fig. 23. Hiram Sibley Warehouse, 1883

North: *AMERICAN COLLEGE OF SURGEONS building*, NR, CAL/CHALC, HABS, CLSI/premier, built in 1883 at 40 E. Erie Street, at the northeast corner of N. Wabash Avenue and E. Erie Street, is three stories high. Burling & Whitehouse were the architects. An elevation and a floor plan are in AA February 26, 1881. The building was constructed as a home by Samuel M. Nickerson at a cost of about $450,000 and known as "Nickerson's Marble Palace." John Drury in *Old Chicago Houses* says: "The marble entrance hall, onyx pillars, alabaster balusters, tiled fireplaces, parquet floors, mantels of rare inlaid woods, beamed ceilings, brass, copper and glass chandeliers,

leather paneled walls, and richly carved woodwork . . . are little less than awesome in their grandeur." A general description and a photograph of the building are contained in that book. Interior photographs are in CIM, p. 463, and also an exterior photograph (p. 521). In 1900 the building was sold to Lucius G. Fisher, who occupied it until his death. It was purchased in 1919 by a number of leading citizens and presented to the American College of Surgeons, by whom it is used as their administrative building. No alterations of consequence have been made by succeeding owners, and the building is in a fine state of preservation. The floor construction is of masonry arches supported on iron beams. Adjoining this building to the east and connecting with it, is the John B. Murphy Memorial building, completed in 1926 (Marshall & Fox, architects) and presented to the American College of Surgeons. In the records of the American College of Surgeons is a copy of an interesting letter dated May 22, 1881, from a young architectural draftsman, describing the design of the Nickerson house. George W. Maher was the architect for a 1901 addition. The house was renamed the R. H. Love Galleries. Photographs are in AGC, p. 124, and CFB "merit." A drawing is in RMNV, V24. See also the William B. Ogden residence and the 1963 Surgeons building.

MALLERS building, special significance, 1884–1920, at 224–26 S. LaSalle Street, formerly the Farwell Trust building and the Provident building, was at the southwest corner of W. Quincy Street on the site of the present Federal Reserve Bank building. John J. Flanders was the architect. This was the first 12-story building in Chicago and was on spread foundations. The south and west walls were party walls. The building is illustrated in IA July 1885, and HCA Vol. 3, p. 68. Photographs are in OBD 1916, p. 205; JSAH December 1978, p. 279; and *Chicago Ceramics and Glass*, Sharon Darling, 1979, p. 172. A brief description is in T, p. 148, and RMNV, V1. An illustration is in CRT, p. 52.

RYERSON building, 1884–1939, early known as the Gray, Kingman & Collins building, was a six-story building at 16–20 E. Randolph Street. Adler & Sullivan were the architects. An illustration is in CAC, p. 209. Photographs are in CAA; LSM; AF May 1962, p. 92; and *Louis Sullivan*, Albert Bush-Brown, 1960, plate 11. A bus station was built on the site.

CALUMET building, 1884–1913, at 111–17 S. LaSalle Street, the site of the addition to the present Borland building, nine stories high, on spread foundations (Burnham & Root, architects), is illustrated in OMSM. A photograph is in CIM, p. 572. A brief description is in T, p. 145. "The foundations were commenced about two years ago and slowly and steadily they were laid—sufficient time being given them to settle perfectly, which it may be remarked, is too unusual a custom in Chicago building. These foundations are isolated pyramidal piers—a form which has been found to be the only

thoroughly reliable one for Chicago" (IA February 1884). And yet this "perfect" and "reliable" work endured for less than thirty years. Photographs are in CIM, p. 572, and JWR, plate 14.

PULLMAN (Palace Car Co.) building, HABS, 1884–1956, was at 79 E. Adams Street, on the southwest corner of S. Michigan Avenue. S. S. Beman was the architect. The building was 10 stories high, on spread foundations (see HBF). It is illustrated in HCA Vol. 3, p. 71. A drawing is in CIDL, p. 77. Photographs are in CIM, p. 295; LC, p. 132; SFO, p. 44; CTCP, p. 59; TBC, p. 75; CAJZ, p. 181; STL, p. 67 with the People's Gas building; CHC, p. 107; and RMNP. A view of the building is in OBD 1901, p. 149, and RMNV, V4. A description is in T, p. 146. In its early days the building contained some residential apartments (AAC, p. 77). The famous Tip Top Inn was on the ninth floor for many years; a photograph is in CIM, p. 595, and CYT, p. 46. The Adams residence was on this corner before the fire of 1871; a photograph is in CYT, p. 36, and CIM, p. 455. The Borg-Warner building occupies this site.

DAILY TIMES/A. F. TROESCHER building, 1884–1978, CFB "merit," HABS, CSLI/premier. It was also known as the Chicago Joint Board building, as the 15 S. Wacker Drive building, and as the Louis Sullivan building. It was six stories high. Adler & Sullivan were the architects. Photographs are in LSM; CCP, p. 136; JSAH March 1961, p. 17 drawing; SRT, p. 127; SFO, p. 67; IA December 1884; IA-C No. 5, September 1982, p. 39. The 1 S. Wacker Drive building occupies this site.

OMAHA building, 1884–1913, at the southeast corner of S. LaSalle and W. Van Buren Streets, originally known as the Memory and then the Exchange building, was seven stories high. John M. Van Osdel was the architect. Full details of the construction cost are in the architect's books of account (VO Vol. 2, p. 176). As the Exchange building, in 1892, it was extensively altered by the architect. A brief description and an illustration are in OBD 1901, p. 143, and RMNV, V9. The site is now occupied by the Fort Dearborn Hotel/Traders building.

GAFF building, 1884–1920, was at 230 S. LaSalle Street, on the site of the present Federal Reserve Bank building. It was nine stories high, with a high basement, on spread foundations. Stephen V. Shipman was the architect. It is illustrated in IA April 1885. A view showing the location is in RMNV, V1. A photograph, including the Counselman building, is in RMNP. A photograph is also in OBD 1916, p. 90.

BUCKLEN building, 1884–1933, was a six-story building, on spread foundations, at the southwest corner of S. Michigan Avenue and E. Eighth Street. Oscar Cobb was the architect. An illustration is in CRT, p. 101, and HCA Vol.

3, p. 753. A photograph is in *Chicago Tribune,* February 17, 1940; CIM, p. 298; and CYT, p. 44. The site is now occupied by the Essex Inn.

212–14 S. FRANKLIN STREET building, 1884–1970, at the northwest corner of W. Quincy Street was six stories high. The Sears Tower includes this site.

CHICAGO OPEN BOARD OF TRADE building, 1884–1912, was at 323–31 S. LaSalle Street, on the north portion of the site of the Utilities building. Wheelock & Clay were the architects. The building was six stories high, on spread foundations. It is illustrated in HCA Vol. 3, p. 321, and IA June 1884. It is identified by a sign in RMNV, V1, south of the Phoenix building. The Chicago Stock Exchange Extension building occupies this site.

COMMERCIAL BANK building, 1884–1933, known as the Mohawk building, as the National City Bank building, and later as the Guardian Bank building, was at the southeast corner of S. Dearborn and W. Monroe Streets, with a frontage of 90 feet on the former and 131 feet on the latter. The building was six stories high, on spread foundations. It was designed by Jaffray & Scott, architects. Illustrations are in IA March 1884, and HCA Vol. 3, p. 352. A photograph is in CIM, p. 365; CRT, p. 48; *Chicago Tribune,* February 17, 1940; and OBD 1929, p. 137. A view of the building is in RMNV, V6. Sheppard Blocks 1 and 2 previously occupied this site. The 33 W. Monroe Street building includes this site.

COUNSELMAN building, 1884–1920, 238–40 W. LaSalle Street, was at the northwest corner of W. Jackson Parkway, on the site of the present Federal Reserve Bank building. It was designed by Burnham & Root, architects, and was nine stories, 145 feet high, on spread foundations. It is illustrated in HCA Vol. 3, p. 300, and IA April 1884. A brief description is in T, p. 147, and RMNV, V1. A photograph is in RMNP and OBD 1910, p. 64. Drawings are in JWR, plate 16, and CIDL, p. 55.

South: CHICAGO MANUAL TRAINING SCHOOL, 1884–(before 1949), at the northwest corner of S. Michigan Avenue and E. Roosevelt Road, was four stories high. S. S. Beman was the architect. An illustration is in RMNV, V11; CAC, p. 94; HCA Vol. 3, p. 153; and CIM, p. 459. Charles H. Ham has published a history of this institution. A story of its early organization and history is in SGC, p. 268. The Avenue Motel occupies this site.

West: KNISELY building, 1884–late 1950s, was at 551–57 W. Monroe Street, at the southeast corner of S. Jefferson Street, four and five stories high. Adler & Sullivan were the architects. A photograph is in LSM, plate 6.

West: F. A. KENNEDY & CO. BAKERY, 1884–1972, at 27–33 N. Desplaines. It was six stories high. It was also known as the P. F. Pettibone & Co. building.

Adler & Sullivan were the architects. Photographs are in "A Photographic Documentation of the Architecture of Adler & Sullivan," Richard S. Nickel, 1957 thesis, IIT, and in *Culture and Democracy,* Hugh D. Duncan, 1965, p. 271, facade detail.

CHICAGO OPERA HOUSE BLOCK, 1885–1912, was at the southwest corner of N. Clark and W. Washington Streets, on the site of the present Conway building. Cobb & Frost were the architects. The building was 10 stories, 140 feet high, on spread foundations. It is illustrated in HCA Vol. 3, p. 643, and IA April 1885. A photograph is in CIM, p. 431, and CYT, p. 87. A view of the building is in RMNV, V1. The practice of general contracting is said to have been first employed here by George A. Fuller. A photograph is in CSA, fig. 18. A description of the theater is in SGC, p. 212, with an illustration of the entrance (p. 305). A photograph of the five-story prefire Lombard Block is in CIM, p. 381.

CHICAGO CLUB building 2, 1885–1929, at 404 S. Michigan Avenue, formerly known as the Art Institute building, was the second home of this club (1893–1929); the first was at 12 E. Monroe Street, later known as De-Jonghe's Hotel. The building was originally (1873–1884) two stories high (photograph in CIM). To this structure two stories were added, Burnham & Root being the architects. An illustration and a description of the original building are in LO April 1874. A description is also in T, p. 167. A description of its foundation problems is in ENR November 8, 1928, pp. 684 and 692. A drawing is in BTC, p. 7. Photographs are in CAA; CIDL, p. 39; LSCS, p. 23; JWR, plate 19; STL, p. 18; RMP, p. 55; CIM, pp. 138 and 485; CYT, p. 45; RMNP; and IC Vol. 1. A view is in RMNV, V8. A description is also in T, p. 167. *CHICAGO CLUB building 3,* HABS, CLSI, replaced the above-named building in 1930. It is 10 stories high, on rock caissons. Granger & Bollenbacher were the architects. Its address is 81 E. Van Buren Street, at the southwest corner of S. Michigan Avenue. A photograph is in 1993 CFB, p. 24; see appendix F.

14 N. MICHIGAN AVENUE building, formerly known as the Ward building, having a frontage of 144 feet, was built in 1885, with an addition in 1892. It is eight stories high, on pile foundations. Beers, Clay & Dutton were the architects. Ralph Renwick was the engineer. It was also known as the Lucien Lelong, the Levinson, the John M. Smyth (furniture) Store, and the Illinois State Medical Society building and is known as 20 N. Michigan Avenue. Photographs are in CIM; CYT, p. 51; TBC, p. 399; STL, p. 52 with the Tower building. See appendix F.

VICTORIA HOTEL, 1885–(before 1990) at 330–38 S. Clark Street, with a frontage of about 135 feet on W. Van Buren Street, was formerly known as McCoy's European Hotel, seven stories high, on spread foundations. Greg-

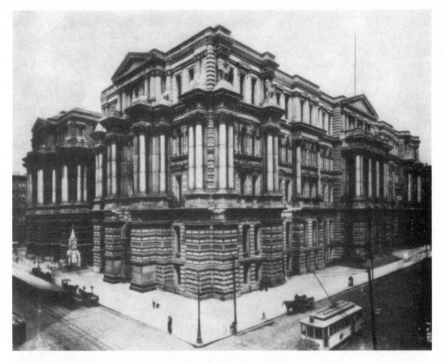

Fig. 24. City Hall and County Building, 1885

ory Vigeant was the architect. A photograph is in CIM, p. 426. A view of the building is in CAC, p. 47, and RMNV, V9. The Chicago Stock Exchange Extension building occupies this site.

The first combined CITY HALL AND COUNTY BUILDING (1882/85–1906/08) after the fire, in the block bounded by N. LaSalle, W. Randolph, N. Clark and W. Washington Streets, was completed in 1885, five stories high (fig. 24). The City Hall (John M. Van Osdel, architect) was on a concrete mat foundation, and the County Building on short wood piles (AEF; see also HBF). A photograph of the combined building is in CAA; CHC, p. 17; T, p. 124; in OBD 1901, p. 62; and IC Vol. 2. A view is shown in CAC, p. 20; CRT, p. 6; RMNV, V19, and CTCP, p. 36. The County Building is illustrated in HCA Vol. 3, pp. 105, 106, and 250. A photograph is in RMN and CIM, p. 479. J. J. Egan and Alex Kirkland were the architects of the County Building, completed in 1882. A photograph of the wrecking of the City Hall is in ER May 15, 1909, and CIM, p. 240. The Public Library occupied the entire fourth floor, except the council chamber, until the present library building was erected. A story of the architectural competition, won by Otto H. Matz, is in T, p. 124, along with a photograph of the building as built. The present *CITY HALL AND COURT HOUSE,* CAL, CLSI, was completed in 1911 (fig. 25). It is 12

Fig. 25. City Hall and Court House, 1911

stories high, with two basements, on rock caissons. Holabird & Roche were the architects. The construction of the foundations of the City Hall portion is described in ER June 12, 1909, and the entire building is illustrated in AR April 1912, with photographs and floor plans. Photographs are in CAA; CIM, p. 478; COF; WO, p. 34; HRHR Vol. 1, p. 255; and HB. The cost of the present Court House building, including architects' fees, was 42.26 cents per cubic foot; and of the present City Hall building, 39.69 cents per cubic foot.

INSURANCE EXCHANGE building, 1885–1912, later known as the Continental National Bank building, was at the southwest corner of S. LaSalle and W. Adams Streets, on the site of the present 208 S. LaSalle Street building. It was nine stories high, on pyramidal foundations. Burnham & Root were the architects. The building is illustrated in RMNP; CRT, p. 55; OBD 1901, p. 60; HCA Vol. 3, p. 464; and IA July 1885. A view is shown in RMNV, V1, which publication reported it as John Root's favorite building. Photographs are in CHC, p. 124; CIM, p. 425; JWR, plate 19; JSAH December 1978, p. 273; and RMP, p. 41.

TRADERS building, 1885–1937, formerly known as the Loan & Trust Co. building, was at 305–15 S. LaSalle Street. It was seven stories high, on spread foundations. Burnham & Root were the architects. Photographs are in CIM; OBD 1929, p. 335; and JWR, plate 20.

McCORMICK building, ca. 1885–1907, also known as the Harvester building and formerly as the Powers building, was at the northwest corner of S. Michigan Avenue and E. Monroe Street, on the site of the present University Club building. It was seven stories high, on spread foundations. A photograph is in CIM, p. 297; CHC, p. 58; and CYT, p. 43. An illustration is in RMNV, V7. Holabird & Roche were the architects.

RICHELIEU HOTEL, at 318 S. Michigan Avenue, built in 1885 and later known as the 318 S. Michigan Avenue building, is a six-story structure on spread foundations. A photograph is in CIM, p. 138, and CYT, p. 39. A view showing the location is in RMNV, V4. It was known in 1918 as the (Solomon) Karpen (furniture) building, with a new facade by Hessenmueller & Meldahl, architects. It was redeveloped in 1982 for the Chicago Department of Housing; Nagle, Hartray, architects. Photographs are also in RB April 30, 1983, p. 15; AF April 1925, p. 225; and STL, p. 116 with the Straus building, and AR April 1912, p. 320, with the McCormick building.

119–23 S. MARKET STREET building, ca. 1885–(1950 to 1990), was seven stories high. The U.S. Gypsum building occupied this site, which is now vacant.

ROYAL INSURANCE building, 1885–1920, was at 160 W. Jackson Street, with a frontage on W. Quincy Street, on the site of the present Federal Reserve Bank building. W. W. Boyington was the architect. The building was 12 and 13 stories high, on pyramidal spread foundations, which are illustrated in ER May 28, 1898. The building is illustrated in HCA Vol. 3, p. 469; OBD 1916, p. 219; and IA September 1884. A photograph is in CIM, p. 559, and a view showing the location of the building is in RMNV, V1. A photograph, including the Continental Bank building, is also in RMNP, and JSAH March 1987, p. 83.

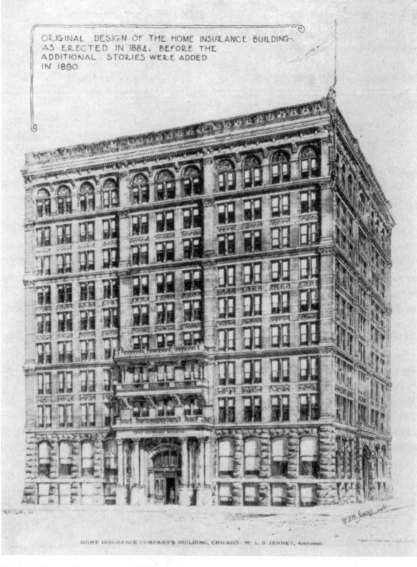

ORIGINAL DESIGN OF THE HOME INSURANCE BUILDING-
AS ERECTED IN 1884, BEFORE THE
ADDITIONAL STORIES WERE ADDED
IN 1890

Fig. 26. Home Insurance, 1885

HOME INSURANCE CO. building, special significance, 1885–1931 (fig. 26),
was at the northeast corner of S. LaSalle and W. Adams Streets on the site
now occupied by the west portion of the Field building. Nine stories and one
basement were completed in 1885. Two stories were added in 1891. William
Le Baron Jenney was the architect. The building housed the Chicago offices
of its owner/builder, a New York–based life insurance company. George B.

Whitney, Major Jenney's engineering assistant, was a graduate of the University of Michigan in civil engineering, and for a few years had been employed as a bridge engineer on the Mississippi River Commission. The building permit was issued on March 1, 1884. The building is illustrated in IA September 1884; HCA Vol. 3, p. 463; CRT, p. 73; and HSM. Discussions are in CE October 1934, p. 505, and *William Le Baron Jenney,* Theodore Turak, 1986, Chapter 10. A drawing is in CCNT, p. 27. Photographs are in LAAM, p. 158; CANY, p. 36; CSA, fig. 45; ACMA, p. 36; IA-C May 1985 Centennial Issue; TAA, with 24 references, p. 23; CIDL, p. 61; CON; WACH, p. 32; LSCS, p. 18; CTCP, p. 67; CPH, p. 150; JSAH March 1985; MEA Vol. 2, p. 495; LC, p. 131; SCS, p. 12; BMT, following p. 112; and CIM, p. 402. A view of the building is in RMNV, V5.

A cross section of a foundation pier and of the upper soil formation in IA Vol. VI, No. 6, p. 100, indicates that the concrete base of the dimension-stone pyramidal foundations was to be from 12 feet 6 inches to 12 feet 8 inches below grade, resting upon a "compact clay called hard-pan."

> Borings were made in some twenty places over the site, and the thickness of the hard pan (about 6 to 8 feet deep) was found sufficiently uniform to allow a uniform weight of two tons per square foot to be used as the permanent load on the foundations.
>
> As it was important . . . to obtain a large number of small offices provided with abundance of light, the piers between the windows were reduced to the minimum, and the following system of construction was adopted.
>
> Iron was used as the skeleton of the entire building except the party walls, and every piece of iron was protected from fire by masonry, excepting only some columns so situated as not to be dangerous if left exposed. A square iron column was built into each of the piers in the street fronts; all columns and mullions were continuous from the bottom plate to the top of the building. (IA December 1885)

The foundations (see HBF) were dimension and rubble stone set on a two-foot bed of concrete, each column, exterior and interior, having its own independent foundation. While all interior columns extended down through the basement to isolated footings, the columns in the two street walls were supported on granite piers just above the second-floor line, the granite first story being preferred by the owners.

The building was set 4 inches high to anticipate settlement. The maximum differential settlement at the end of a year was ¾ inch.

> Square cast-iron columns are built into brick piers and connected at the top of each window by cast-iron lintels. Each floor of beams and girders is tied together and also bolted to the columns, supplemented by heavy hoop-iron, built into brickwork in every place where increased bond or tie is desired, and also every stone is clamped or anchored so that settlement will produce as little displacement as possible. (Jenney)

The interior columns were round and of cast iron. The floors and the fireproofing of the beams were fire-clay tile arches. The flat tile floor arches are illustrated in AEF.

The Building Commissioner ordered the wall columns could not be inserted up to the lot line in the party walls; thus the plan to build the complete unit as a cage with every column on its own isolated pier footing was defeated. Another ruling was, that interior vault tiers against the walls should be of solid brick; this was demanded by the Insurance Underwriters. . . . The expansion and contraction of a column 150 feet high and the extreme variation of temperature . . . from the hot days of summer and the excessive cold of winter [was solved] by supporting the walls and floors of each story independently, story by story, on the columns. . . . (SCM)

Permission was granted to substitute the "first shipment of Bessemer beams" from the Carnegie-Phipps Company in the upper stories for wrought-iron beams. "The columns, of course, were still of cast-iron; other shapes being rolled at that time were considered too expensive" (SCM).

On June 13, 1896, F. T. Gates, president of the Bessemer Steamship Company, wrote the editor of ER asking the name of the architect or engineer to whom "the honor is due of discovering or practically working out the idea of lofty steel construction of buildings" (ER June 27, 1896). Several communications in answer to this question were published, among which were the two following from Chicago and an editorial (ER July 25, 1896).

C. L. Strobel: "A complete iron skeleton was used for the first time [Home Insurance Building] and the floor loads were carried by this. The walls were not carried by the iron but supported themselves, encasing the columns, which were of cast iron, and closing the building. The walls were of sufficient thickness to perform the double duty of carrying their own weight and of staying the building."

D. H. Burnham: "This principle of carrying the entire structure on a carefully balanced and braced metal frame, protected from fire, is precisely what Mr. William Le B. Jenney worked out. No one anticipated him in it, and he deserves the entire credit belonging to the engineering feat which he was the first to accomplish."

Editorial: "Steel Skeleton Buildings.

"The interesting letters regarding the original of steel-skeleton buildings published in our issue of July 11 and in the present issue possess no little historical importance. . . .

"Whether Mr. George B. Post's initiative, in the interior court of the New York Produce Exchange, or Mr. Jenney's completely executed Home Insurance Building in Chicago, is to be considered the first instance of the skeleton system of construction, it would be idle to attempt to decide, or

indeed whether the bare idea may not have been applied elsewhere at some previous time. It is undoubtedly a fact that Mr. Jenney's design was bold, and at the same time well considered, and that its successful execution at once turned attention to the system in a marked manner, and proved to be the stimulus requisite for its general adoption. . . .

". . . It should be stated, as a matter of fairness and justice, that the Chicago practice in these respects is, and has been from the first, far in advance of that of New York City, where cast-iron columns, with all their miserable joints and details that go with them, are still freely employed, and where the necessity of wind bracing is frequently ignored. . . .

"It was thought for a number of years that the supposed difference in rates of thermal expansion and contraction of iron or steel and masonry ultimately would constitute a fatal objection to the steel-skeleton construction, and a prominent engineer of Chicago, in a public address, graphically described the writhing efforts of a steel frame during changes of temperature to free itself from the masonry walls. . . ."

In this connection, Burnham and Root urged in 1888 that "some form of wrought iron should be substituted for cast" (ER September 22, 1888).

On February 13, 1896, Mr. Gates again wrote the editor.

Recalling our inquiry of some months ago . . . we have read with much interest the discussion of the question in your columns. . . . We shall name the new vessel the "W. Le B. Jenney" after the eminent engineer and architect of Chicago, to whom we think the iron and steel trade is most indebted for this great advance in the construction of buildings. (ER Feb. 20, 1897)

In January 1924, there being a question in the minds of some whether the walls were carried by the columns in the piers, an examination was made and "the cast lintels were disclosed, bolted securely to the castings of the columns as shown on the original drawings. . . . The entire weight of the walls and piers, together with the floors, is carried by the iron columns in the piers" (SCM).

For many years before the wrecking of this building in 1931, the question which was the first building of skeleton construction had been a matter of discussion — discussion that sometimes grew heated.

Three committees were appointed to make an investigation of the construction as disclosed during the wrecking operations:

1. A committee appointed by the Marshall Field Estate, owners of the building. The chairman was Thomas E. Tallmadge, architect.
2. A committee representing the Illinois Society of Architects and the Chicago Chapter of the American Institute of Architects. Terrell J. Ferrenz was chairman.
3. A committee of the Western Society of Engineers, consisting of J. C.

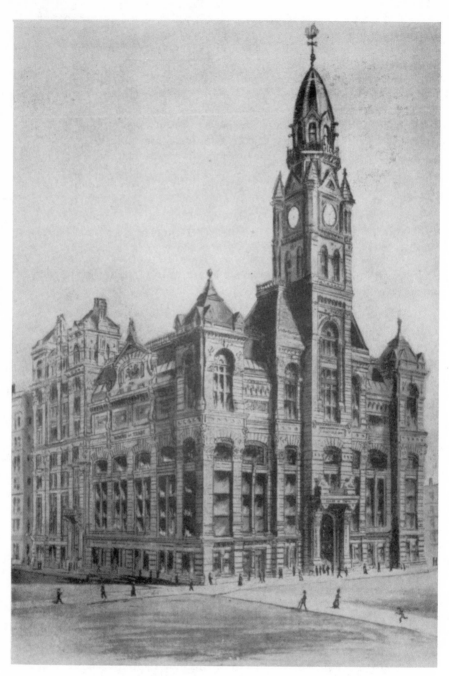

Fig. 27. Old Board of Trade, 1885

Sanderson, J. L. McConnell and F. J. Thielbar. For the report of this committee see WSE February 1932 and AR August 1934.

After extensive studies, their conclusions may be summarized by the following excerpts.

1. The Field Committee: "We have no hesitation in stating that the Home Insurance Building was the first high building to utilize as the basic principle of its design the method known as skeleton construction, and that there is convincing evidence that Major Jenney in solving the particular problems of light and loads appearing in this building discovered the true application of skeleton construction to the building of high structures and invented and here utilized for the first time its special forms." Concerning certain beams above the sixth floor the Committee reports adds that, from a report on "photo-micrographs and chemical analysis and physical tests (ENR, February 18, 1932) . . . this bears out the statement . . . that in this building the first Bessemer steel beams were used, manufactured by the Carnegie-Phipps Company who stated at the time that the Home Insurance Building was the first in the United States to use steel beams in its construction."

2. The Committee of Architects: "We are in complete accord in recognizing the Home Insurance Building as the first tall structure of metal skeleton construction." (The story, with photographs, is in T, p. 193.)

3. The conclusion of the WSE Committee: "The Home Insurance Building was erected during the development period of the skeleton type of building and is a notable example of its type; while it does not fulfill all the requirements of a skeleton type, it was well along in this development and was principally lacking not having curtain walls, no provision in the framing for wind loads, and not having made full provision for starting the masonry above the first floor."

A small assembly of structural members from this great structure, salvaged at the time of wrecking, is held by the Museum of Science and Industry. (A small section of a steel beam used in the building is held by the writer of the revision of this book.) The Field/LaSalle Bank building includes this site.

WILKE building, ca. 1885–(before 1961), at 111 S. Market Street, was seven stories high. This vacant site was occupied by the U.S. Gypsum Co. building.

192 N. CLARK STREET building, 1885–(before 1980), formerly the Ogden building, was eight stories high, on spread foundations. John M. Van Osdel was the architect. A photograph and a brief description are in OBD 1929, p. 241. The James R. Thompson Center includes this site.

BOARD OF TRADE building 3, 1885–1929, was at 141 W. Jackson Street (fig. 27). It was 10 stories high, on spread foundations (see HBF), with a 300-

foot tower that was removed ca. 1895 on account of excessive settlement. For an account of the settlement see HBF. Phoenix columns were used (AEF). W. W. Boyington was the architect. A photograph is in CAA. An illustration of the building is in CIM, p. 171; CHC, p. 142; IC Vol. 2; and HCA Vol. 3, frontispiece. A description is in T, p. 165. A view of the building is in CRT, p. 50; OBD 1901, p. 35 (tower removed); RMNV, V1; and LC, p. 11.

BOARD OF TRADE building 4, NHL, CAL, CLSI/premier, was built in 1930 by Holabird & Root, architects, and Verne O. McClurg, engineer, at a cost of 81 cents per cubic foot of building. (See fig. 44.) It is 45 stories high, 612 feet, on rock caissons. Photographs are in A January 1930; CAA; COF; WO, p. 37; GCA, p. 57 lobby; HRHR Vol. 3, p. 25; AF December 1973, p. 51; ABOV, p. 49; STL, p. 158; AIA Journal May 1983; IA-C May 1983, p. 33; LSCS, p. 32; CTCP, p. 75; and HB. The south "Annex" was built in 1982, 24 stories high. Murphy/Jahn were the architects, Thornton-Tomasetti the engineers, Shaw Associates and Swanke, Hayden, Connell, associated. A drawing is in TBAR, p. 79. Photographs are in *Helmut Jahn*, Nory Miller, 1986, p. 83; CST; STL, p. 160; AGC, p. 77; SEA, p. 80; and see CMAG April 1984. See also the 1997 Stock Exchange Extension building. The Rialto building previously occupied this site.

E. W. GILLETT building, ca. 1885–1921, at 89 E. Wacker Drive, was six stories high, adjoining the Hoyt building, which was to the north. An illustration is in CAC, opposite p. 208. The site is now occupied by the London Guarantee building.

KINSLEY building, 1885–1894, at 62–64 W. Adams Street, was five stories high. A brief description and an illustration are in CRT, pp. 16 and 17, and RMNV, V6. Photographs of the exterior and interior are in CIM, p. 139, and CYT, p. 75. Photographs are in LC, p. 188, and CPH, p. 142. F. L. Charnley was the architect. The Marquette building includes this site.

IMPERIAL building, 1885–(before 1949), at 304–12 S. Clark Street, was four stories high. A view is in RMNV, V9. The 1961 Trans Union building includes this site.

BUTLER PAPER CO. building, ca. 1885–(1950 to 1990), at 231–33 W. Monroe Street, on the southeast corner of S. Franklin Street, six stories high. It was rebuilt in 1901 by Reid, Murdoch & Co. after a disastrous fire. This corner building was originally five stories high and was occupied by Sweet, Dempster & Co. An illustration is in CAC, p. 189. The AT&T Corporate Center includes this site.

PLYMOUTH HOTEL, ca. 1885–(1950 to 1990), at the northeast corner of S. Plymouth Court and W. Van Buren Street, was six stories high. This site is used for parking.

HARDING'S RESTAURANT building, ca. 1885–ca. 1965, at 158–60 W. Monroe Street, was six stories high. The Northern Trust building occupies this site.

South: BALTIMORE HOTEL, ca. 1885–(1950 to 1990), at 503 S. Wells Street, was six stories high. This site is used for parking.

South: PANORAMA buildings, housing the "Jerusalem" and "Battle of Gettysburg" panoramas, occupied the southeast and southwest corners, respectively, of S. Wabash and E. Balbo Avenues in the 1880s. The "Chicago Fire" panorama building was on the Gage building site.

South: HARRIS HOTEL, ca. 1885–(1950 to 1990), at 807–09 S. State Street, was six stories high. This site is used for parking.

West: SCOVILLE building, 1885–early 1970s, at 619–31 W. Washington Street, was five stories high. Adler & Sullivan were the architects. Photographs are in *Prairie School Review*, 3d quarter, 1974.

North: POTTER PALMER residence, 1885–1950, on the east half of the block bounded by E. Schiller and E. Banks Streets and N. Lake Shore Drive. Cobb & Frost were the architects. It is described in T, p. 184. A photograph is in CYT, p. 58, and CIM, p. 521. Illustrations of the exterior and interior are in HCCB, pp. 26 and 27. A drawing is in RMNV, V27. Photographs are in LC, pp. 35–37; LAAM, p. 235; ACMA, p. 29; CIDL, p. 52; LSCS, p. 20; CGY, p. 113; and *Culture and Democracy*, Hugh Duncan, 1965, p. 137. The 1350–60 N. Lake Shore Drive apartment buildings occupy this site.

North: LANDQUIST building, at the southeast corner of N. State and E. Hubbard Streets, 100 feet square, built ca. 1885, is six stories high, on spread foundations. It has been called the Law building.

North: 11–13 E. HUBBARD STREET building, built ca. 1885, is of ordinary construction with cast-iron columns, on spread foundations, seven stories high. The building was remodeled in 1926 by H. M. Seaton, architect. It was renamed the 11 E. Hubbard Street building.

North: 12–16 E. HUBBARD STREET building, ca. 1885–(before 1990), of mill construction, on spread foundations, seven stories high. James R. Willett was the architect. The Courtyard By Marriott hotel includes this site.

RIALTO building, 1886–1940, was at 132–48 W. Van Buren Street, on the northwest corner of S. LaSalle Street, and was known last as the 332 S. LaSalle Street building and earlier as the Postal Telegraph building. It was built nine stories high, on spread foundations, using beam and/or rail grillages. Two stories were added later. The Rialto was so named because of the bridge connecting it with the Board of Trade building. Burnham & Root

were the architects. An illustration is in IA June 1884. A photograph is in BB May 1906; RMNP; CIM, pp. 414 and 425; JWR, plate 21; IA January 1887 supplement. A view is in RMNV, V9, and identified on its roof in View 1. The Board of Trade Annex building occupies this site.

UNION BANK building, 1886–1933, originally known as the Illinois Bank building, at 21–29 N. Dearborn Street, was nine stories high. Burnham & Root were the architects. Photographs are in JWR, plate 30, and OBD 1916, p. 250. The Grannis Block was formerly on this site. An illustration of the National Bank of Illinois building, seven stories high, is in CAC, p. 172.

UNION LEAGUE CLUB building 1, 1880–1927, at 65 W. Jackson Street, was seven stories high, on spread foundations. William Le Baron Jenney was the architect. It is illustrated in HCA Vol. 3, p. 406; RMN; CAC, p. 68; and CIM, p. 466, by photograph. A view is in RMNV, V3, and it is identified on its roof in View 1. A drawing of the 130-foot-tall building is in WCWF. UNION LEAGUE CLUB building 2, on the same site, built in 1928, is 22 stories high, with two basements, on rock caissons. Mundie & Jensen were the architects. A photograph is in CIM, p. 375.

FINE ARTS building, NR, CAL/CHALC, HABS/photo, CLSI/premier, was built in 1886, at 410 S. Michigan Avenue, as the Studebaker Wagon Repository. It was converted in 1895 to arts tenancies principally. It includes the Fine Arts Theaters at 418 S. Michigan Avenue and the five-story north annex. S. S. Beman was the architect. The building is eight stories, 135 feet high, on spread foundations. Formerly there were three spaces here that Frank Lloyd Wright developed: Brown's Bookstore in 1908, Thurber's Art Gallery in 1909, and the Mori Oriental Art Studio in 1914. It is illustrated in HCA Vol III, p. 743, and IA November 1885. Photographs are in CFB; COF; JWR, plate 53; STL, p. 18; LSCS, p. 23; *Chicago Tribune Magazine*, February 6, 1994, p. 20; CTCP, p. 84; HB; OBD 1916, p. 77; IC Vol. 1; CYT, p. 39; and RMNP. A view is in RMNV, V8. A brief description is in T, p. 153. The north 80 feet of this site was occupied previously by the St. Albans Block. A west ANNEX was built in 1924 at 421 S. Wabash Avenue, five stories high. Rebori, Wentworth, Dewey and McCormick were the architects. This was renamed the Musical Arts building. A photograph is in CFB at the left of the Giles building.

ATHENAEUM building, 1886–1929, was at 59 E. Van Buren Street, the site of the present Socony-Vacuum Co. building. It was seven stories, 70 feet high, on spread foundations. A view is in RMNV, V4. An illustration is in OBD 1916, p. 24. A description of the remodeling (1890) for the use of the Chicago Athenaeum is in SGC, p. 265.

MERCANTILE building, 1886–(before 1970), at 305 W. Adams Street, on the southwest corner of S. Franklin Street, formerly known as the Foreman

& Kohn Block. Bauer & Hill were the architects. The building is nine stories high, on spread foundations. It is illustrated in IA December 1886. An illustration is in RMNV, V13. A photograph is in CAJZ, p. 102. The Sears Tower includes this site.

TEMPLE COURT building, 1886–1940, at the northeast corner of S. Dearborn and W. Quincy Streets, was eight stories high, on spread foundations. John M. Van Osdel was the architect. A photograph is in IC Vol. 2; CIM, p. 366; and *Chicago Tribune*, February 17, 1940. A view is in RMNV, V3. Full details of the contract costs are in John M. Van Osdel's books of account (VO Vol. 2, p. 199). The Dirksen Federal Center building includes this site.

F. C. AUSTIN building, HABS, 1886–1957, at 111 W. Jackson Street, known first as the Phoenix and then as the Western Union building, was built 11 stories high, on spread foundations. Burnham & Root were the architects. Two stories were added by the Western Union Telegraph Co. It is illustrated in IA September 1887. A photograph is in CIM, p. 558; CHC, p. 52; OBD 1929, p. 37; and RMNP. A view is in RMNV, V1. An illustration is in CRT, p. 74, and a description is in T, p. 149. Photographs are also in JWR, plates 48–51. The 1961 Trans Union building occupies this site.

ADAMS EXPRESS CO. building, 1886–1934, at 109–19 S. Dearborn Street, was 11 stories high, on spread foundations. George H. Edbrooke was the architect. Its predecessor is illustrated in HCA Vol. 3, p. 352. A photograph is in CRT, opposite p. 12; *Chicago Tribune*, February 17, 1940; CIM, pp. 364 and 365; and OBD 1916, p. 15. The 33 W. Monroe Street building includes this site, which was formerly occupied by a two-story taxpayer.

FARWELL BLOCK, 1886–ca. 1954, covering the block bounded by W. Monroe, S. Market, and W. Adams Streets and the Chicago River, later occupied by Carson, Pirie, Scott & Co. Wholesale, was six stories high, on spread foundations. John M. Van Osdel was the architect. An illustration is in CRT, p. 84. A drawing is in BTC, p. 59. A photograph is in SM January 1954, p. 8. A view is in RMNV, V13. The building was demolished on account of the extension of Wacker Drive. The 100 S. Wacker Drive building occupies a portion of this site.

230 S. WELLS STREET building, 1886–(1950 to 1990), was seven stories high. An illustration is in RMNV, V13. A Federal Reserve Bank building addition occupies this site.

RICHARDSON building, at the northwest corner of S. Wabash Avenue and E. Congress Street, previously known as the George F. Kimball building, was built in 1886; seven stories high. An illustration of it as a six-story building is in RMNV, V8, and CAC, p. 222. A photograph is in CCNT, p. 20, with a view of the Auditorium building. An interior view of the carpeting display loft is

in APB, p. 117. Treat & Foltz were the architects. It was converted to offices and renamed the 434 S. Wabash Avenue building. The south facade was arcaded upon the widening of Congress Parkway.

RYERSON CHARITIES TRUST building, 1886–ca. 1929, at 318 W. Adams Street, was six stories high. Adler & Sullivan were the architects. No photographs are known. The Fashion Trades building occupies this site.

LAW building, 1886–(1950 to 1990), at 434 S. Dearborn Street, originally known as the Zearing building, had a 25-foot frontage. John M. Van Osdel was the architect. It was seven stories high, on spread foundations. This building was operated in conjunction with the LOWELL building, 422 S. Dearborn Street, originally known as the Dale building, which has a 100-foot frontage, and which was built six stories high, in 1885, by the same architect. Later eight stories high, it had cast-iron columns and hollow tile floors, and was on spread foundations. A photograph of the Law building is in RMNP along with the Monon building, which formerly adjoined it to the south. The City of Chicago condemned a right-of-way for the curve of the Dearborn Street subway into W. Congress Street under both the Law and Lowell buildings. The buildings were supported in part by hardpan caissons. This site is used for parking.

BOARD OF TRADE HOTEL, ca. 1886–1971, at 319–21 S. LaSalle Street, was used as a part of the Atlantic Hotel and as a part of the Van Buren Hotel. Originally it was the Commerce (Vault Co.) building. Burnham and Root were the architects. It was nine stories high. Photographs are in CIM, p. 439; JWR, plate 28; and FRAG, p. 87.

West: 118 S. CLINTON STREET building, built in 1886, is seven stories high. The lofts were converted to offices for Baker engineers in 1986, by Eckenhoff, Saunders, architects.

South: CLUETT building, ca. 1886–1947, was at 512–20 S. Wells Street, on the northwest corner of W. Lomax Place, and formerly was known as the Sherman building. It was four stories high, on spread foundations. Burnham & Root were the architects. This building was condemned and removed by the Department of Subways and Superhighways.

South: *John J. GLESSNER HOUSE*, NHL, CAL/CHALC, HABS, CLSI/premier, at 1800 S. Prairie Avenue, at the southwest corner of E. Eighteenth Street, in the Prairie Avenue Historic District, was built in 1886. Henry Hobson Richardson was the architect; it was completed by Shepley, Rutan & Coolidge, architects, in 1887. In the 1950s it was the IIT Lithographic Technical Foundation, then it was operated as a museum and restored by various parties. After many years of operation by the Chicago Architecture Foundation, in 1995 it became a part of Prairie Avenue House Museums; see "Ave-

News" newsletters of PAHM beginning in February 1996. Monographs: John J. Glessner's (1923) *Story of a House*, 1978 and 1992, and Elaine Harrington, 1993. An article is in IA-C March 1988, p. 54. The house is described in T, p. 182. Photographs are in CFB; AUS, p. 143; CSA, fig. 19; PGC, p. 32 interiors; ACMA, p. 24; ABOV, p. 84, bird's-eye view with the Clarke House; LSCS, p. 12; TAA, with 23 references; MAC, p. 85; RNRC, p. 166 detail; HB; and *Architecture after Richardson*, Margaret H. Floyd, 1994. A drawing is in RMP, p. 48.

South: 530 S. DEARBORN STREET building, built in 1886, in the South Loop Printing House Historic District/NR. It is seven stories high, on spread foundations. Edward P. Baumann was the architect. It was converted and renamed the Hyatt on Printers Row Hotel, together with the Morton building (q.v.), also known as the Morton Hotel, and an addition fronting on W. Congress Parkway. It was formerly known as the Duplicator building.

South: MERGENTHALER LINOTYPE building, built in 1886 at 531–37 S. Plymouth Court, is six stories high. Richard E. Schmidt, Garden & Martin were the architects, and Samuel N. Crowen was the associate architect. The frontage is 75 feet and the depth is 101 feet. It is in the South Loop Printing House Historic District/NR. It was renovated in 1917. It was converted to apartments in 1979, Hinds, Schroeder, Whitaker, architects, and renamed the Mergenthaler Loft Condominiums, 531 S. Plymouth Court. A drawing is in CA, p. 157. Photographs are in GCA, p. 91; AGC, p. 148; and *New Chicago Architecture*, ed. M. Casari, 1981, p. 175.

300–308 S. MARKET STREET building, 1887–1950s, at the southwest corner of W. Jackson Street, formerly known as the McCormick building, was eight stories high. An illustration is in RMNV, V13. It was removed on account of the extension of Wacker Drive. A drawing is in JWR, plate 29. A photograph is in RMP, p. 47. The 300 S. Wacker Drive building includes this site.

COMO building, 1887–1938, at 443 S. Dearborn Street, was nine stories high, on spread foundations. John M. Van Osdel was the architect. A photograph of the building is in CRT, p. 117, and a view is in RMNV, V10. The ground was used for a parking lot, but was condemned by the City of Chicago for the Congress Parkway. A photograph is also in CTCP, p. 82.

MARSHALL FIELD & CO. WHOLESALE building, special significance, 1887–1930, covered the block surrounded by S. Wells, W. Quincy, S. Franklin, and W. Adams Streets (fig. 28). It was seven stories high, 130 feet, on spread foundations. Henry Hobson Richardson was the architect. It was completed by Shepley, Rutan & Coolidge, architects. The building is illustrated in CIM, p. 356; RMNP; LSM; CHC, p. 182; IA October 1888 and

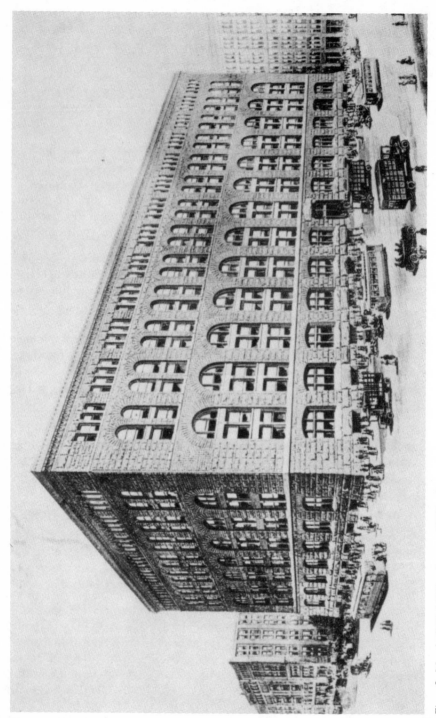

Fig. 28. Marshall Field Warehouse, 1887

March 1889; and in RMNV, V13. A description is in T, p. 168. A drawing is in RMP, p. 46. Photographs are in CAA; LC, p. 133; LAAM, p. 136; CSA, fig. 20; CPS, p. 45; ACMA, p. 23; SFO, p. 69; JSAH October 1978, p. 185 (and predecessor store, p. 67); LSCS, p. 13; CTCP, p. 69; MEA Vol. 3, p. 565; *Art and Life in America*, Oliver W. Larkin, 1949, p. 288; *Architecture through the Ages*, Talbot Hamlin, 1949 and reprints; TAA, p. 25, with 11 references; and LSM, fig. 28. A view of the previous five-story wholesale building of this firm, at the northeast corner of N. Market and W. Madison Streets, is in RMNV, V12. This site is used for a parking structure.

BROTHER JONATHAN (Clark) building, 1887–1911, at 300–302 S. Sherman Street, was on the southwest corner of W. Jackson Street, on the site of the present Insurance Exchange building. It was six stories high, on spread foundations. John M. Van Osdel was the architect. A view is in RMNV, V1, and in OBD 1910, p. 38. The Insurance Exchange building includes this site.

310 W. JACKSON BOULEVARD building, 1887–ca. 1970, eight stories high, on spread foundations. Smith M. Randolph was the architect. The Sears Tower includes this site.

REGAL building, 1887–ca. 1951, at 400 S. Market Street on the southwest corner of W. Van Buren Street, formerly known as the McCormick Block. It was eight stories high, on spread foundations. An illustration is in RMNV, V13. This building was demolished for the Congress Parkway.

WILLOUGHBY building, 1887–1964, at the northwest corner of S. Franklin and W. Jackson Streets, was later known as the 234 S. Franklin Street building. It was eight stories high, on spread foundations. An illustration is in CRT, p. 117. A view is in RMNV, V10. George H. Edbrooke was the architect. Photographs are in CFB "merit"; CSA, fig. 43; and HB. The Sears Tower includes this site.

WORCESTER building, ca. 1887–ca. 1950, formerly known as the Printers Block building, at 501–09 S. Plymouth Court, was six stories high, on spread foundations. This building was condemned and removed by the Department of Subways and Superhighways.

230 S. FRANKLIN STREET building, 1887–ca. 1970, formerly known as the Robert Law building, at the southwest corner of W. Quincy Street, was seven stories high, on spread foundations. John M. Van Osdel was the architect. An illustration is in RMNV, V13. The Sears Tower includes this site.

South: *624–30 S. WABASH AVENUE/WIRT DEXTER building*, CAL, HABS, CLSI, was built in 1887, six stories high, on spread foundations. Adler & Sullivan were the architects. It was renamed the 630 S. Wabash Avenue

building. Photographs are in LSM; CFB; CSA, fig. 12; SRT, p. 240; SFO, p. 203; WO, p. 16; and CALP.

RAWSON building, 1887–1915, at the southwest corner of N. Dearborn and W. Randolph Streets, was seven stories high. An illustration is in RMNV, V20. The site was occupied by the 140 N. Dearborn Street building. The Richard J. Daley Center includes this site.

South: FRANKLIN building, at 519–31 S. Dearborn Street and 518–34 S. Plymouth Court, formerly known as the Conkey building, was built ca. 1887 for the printing trades. It is seven stories high. Baumann & Lotz were the architects. A photograph and a description are in CRT, p. 136. A photograph is in 1987 COF, p. 142. It was converted in 1983 to loft apartments and renamed the Old Franklin building, 525 S. Dearborn Street, in the South Loop Printing House Historic District/NR; Booth, Hansen were the architects.

South: KEUFFEL & ESSER building, ca. 1887–(1950 to 1990), at 516–20 S. Dearborn Street and 519–23 S. Federal Street, was seven stories high, with a frontage of 40 feet and a depth of 67 feet. Henry Ericsson tells an interesting story about the foundations he built in the month of December, which was extremely cold. The architect, Frank B. Abbott, who was also the owner, promised Mr. Ericsson a present if he finished the foundations by Christmas. The lower layer was of concrete about 18 inches thick, and in order not to freeze the concrete it was laid dry and the stone foundation placed upon the dry mixture, with the expectation that the earth would furnish the water. Mr. Ericsson said the experiment was a success. The Hyatt on Printers Row Hotel includes this site.

ROOKERY building, NHL, CAL/CHALC, HABS, CLSI/premier, was built in 1888 at 209 S. LaSalle Street (fig. 29). Burnham & Root were the architects. The building is 11 stories high, 164 feet, on spread foundations using beam and rail grillages. The columns are cast iron. A floor plan, framing plan and foundation plan, and fireproofing details are in ER November 3, 1888. The building is illustrated in IA July 1888; CRT, p. 7; and CAC, p. 183. Frank Lloyd Wright remodeled the lobbies and court in 1907. The building was restored in 1992; Hasbrouck-Hunderman were the architects. Articles are in IA-C July 1992, p. 50, and LSCS, p. 26. A description is in T, p. 149, and a view is in RMNV, V1. Photographs are in CIM, p. 399; AR July 1915; IC Vol. 2; SEA, p. 29 new roof; LC, p. 123; CANY, p. 35; COF; AUS, p. 149; CSA, figs. 21–27; CTCP, p. 65; CAJZ, p. 359; JWR, plates 31–45; ACMA, p. 67 court; SFO, p. 42; CCNT, p. 31 court; STL, p. 22; TAA, with 25 references; CIDL, p. 58; CON; HB; MEA Vol. 1, p. 353, and Vol. 2, p. 606; RNRC, p. 23. The temporary City Hall of 1872 previously occupied this site; a drawing of the namesake rookery and water-tank library is in CCNT, p. 125. Drawings of the City Hall are in TBC, p. 63, CPH, p. 132, and SCS, p. 41.

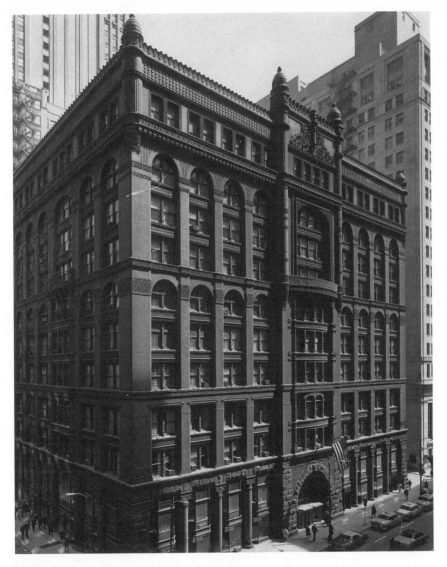

Fig. 29. Rookery, 1888 (Photograph by Richard Nickel)

GIRARD building, 1888–(1950 to 1990), at 412–20 S. Dearborn Street, was seven stories high, on spread foundations. Thomas Hawkes was the architect. It is illustrated in IA May 1888. A view of the building is in RMNV, V10. This site is used for parking.

RYERSON building, 1888–1953, at 200–14 S. Market Street, was designed by Adler & Sullivan, architects. Later known as the *Walker Warehouse,* it

was six stories high, on spread foundations. An illustration is in IA April 1889. A view is in RMNV, V13. Photographs are in LSM; LC, p. 134; CSA, fig. 14; SRT; SFP, p. 70; GMM, p. 136; *Autobiography of an Idea*, Louis Sullivan, 1956 edition, p. 90. The 200 S. Wacker Drive building includes this site.

MAIN OFFICE building of Illinois Bell Telephone Co., 1888–1967, at the northeast corner of N. Franklin and W. Washington Streets, was seven stories high, on spread foundations. J. L. Silsbee was the architect. A photograph is in CIM, p. 567. The building is also illustrated in IC Vol. 2; IA November 1887; and RMNV, V18. In 1899 one story was added and an eight-story addition was built to the east, on wood pile foundations, by D. H. Burnham & Co., architects. A photograph is in CRT, p. 28, and RMNP; an illustration is in CHC, p. 200. This is the first building owned by the telephone company. The first office occupied by it was on the top floor of a building at 21 N. LaSalle Street (WSE, February 1939), shown in a photograph in CIM, p. 155. A photograph is also in RB Annual Review, January 27, 1968, p. 76. A two-story taxpayer occupies this site.

231–39 S. MARKET STREET building, ca. 1888–(before 1970), at the northeast corner of W. Jackson Boulevard, was seven stories high. Burling & Whitehouse were the architects. A photograph is in CFB "merit." The Sears Tower includes this site.

200–206 W. ADAMS STREET building, 1888–(before 1985), CLSI, at the northwest corner of S. Wells Street, formerly known as the Phelps, Dodge & Palmer building, was six stories high. Burling & Whitehouse were the architects. A view is in RMNV, V13. Photographs are in CFB "merit," and RB Annual Review, January 27, 1962, p. 159. The 1985 200 W. Adams Street building occupies this site.

31–33 S. MARKET STREET building, ca. 1888–(1950 to 1990), was six stories high.

J. M. W. JONES building, 1888–1943, at 512–22 S. Sherman Street, was six stories high.

NORTHERN PACIFIC HOTEL, 1888–1948, at 440–44 S. Sherman Street, was four stories high. This building was condemned and removed by the Department of Subways and Superhighways. This site is used for parking, with a plaza above.

STEVENS ART building, 1888–(before 1949), was at 57–59 E. Adams Street. It was seven stories high. Pond & Pond were the architects. A view is in RMNV, V4. A photograph is in *Chicago Architects*, Stuart Cohen, 1976. The Symphony Center includes this site.

CASEY building, 173–77 N. Wells Street, 1888–(before 1949), was six stories high. John M. Van Osdel was the architect. This site is used for parking.

441–43 S. PLYMOUTH COURT building, ca. 1888–(1950 to 1990), with a frontage of about 25 feet, was six stories high. The Harold Washington Library Center includes this site.

South: DEARBORN building, 1888–(1950 to 1990), at 607 S. Dearborn Street, on the southeast corner of W. Harrison Street, fronting 75 feet on both S. Dearborn Street and S. Plymouth Court, was six stories high, on spread foundations. Holabird & Roche were the architects. A photograph is in HRHR Vol. 2, p. 108.

North: HEMLOCK building, at 125–31 W. Hubbard Street, on the southeast corner of N. LaSalle Drive, built ca. 1888, is seven stories high. It was renamed the 415 N. LaSalle Street building. It was also known as the Kress building. It was remodeled in 1986 by the Austin Company.

GRACE HOTEL, 1889–(before 1990), at 75 W. Jackson Street, on the southeast corner of S. Clark Street, was eight stories high, on spread foundations. The records of John M. Van Osdel, the architect, show that a story was added in 1890. A photograph is in CIM, p. 375. A view of the building is in *Hotel Monthly* June 1912, and RMNV, V1. Van Osdel's records show the cost of the original building as four cents per cubic foot. The Metcalf Federal Center building includes this site.

AUDITORIUM THEATER, HOTEL and OFFICE building, NHL, Historic American Engineering Record, CAL/CHALC, HABS/photograph, CLSI/ premier. It is at 430 S. Michigan Avenue, at the northwest corner of E. Congress Parkway, and extends to (431) S. Wabash Avenue. It was dedicated December 9, 1889. Adler & Sullivan were the architects and Paul Mueller the engineer. It was renamed Roosevelt College, later Roosevelt University. Monographs: Edward Garzynski, 1890, and Daniel H. Perlman, 1976. Theater photos are in GCA, p. 23, and IA-C November 1957 and September 1989, p. 41. A description of the building and a copy of the dedication program are in SGC, p. 117, with a full description and a history of its beginning (p. 138). A building of large area, containing both a large hotel and one of the largest opera houses in the world, 10 stories and one basement in height with 18-story tower, 275 feet, it presented special problems for its time. The foundations rest on a timber mat of two thicknesses of 12-inch by 12-inch pine timbers at right angles to each other; they consist of a bed of concrete, and layers of iron beams and rails, on top of which are heavy alternate courses of dimension and rubble stone, with a cap stone carrying the cast-iron bases of the cast-iron columns. The foundations, with construction photographs and details, are described in IA March

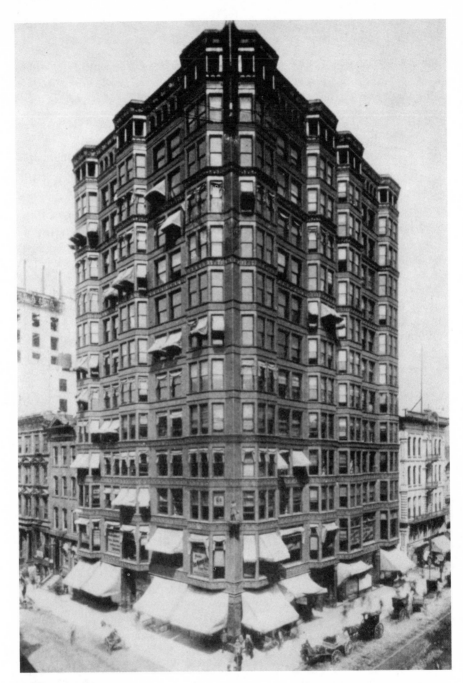

Fig. 30. Tacoma, 1888

1888 (see also HBF). The building is illustrated in IA April 1887, and IC Vol. 2. A cross section is shown in IA July 1888. A cross section of the framing of the theater is shown in ER April 12, 1890; steel details of the trusses in ER November 22, 1890; and steel and cast-iron connections in ER February 21, 1891. The exterior and interior are illustrated in AR May–June 1892. Photographs are in GCA, p. 23; DATA, p. 126; CFB; SRT; AUS, p. 151; CSA, figs. 31–39; ACMA, p. 45; CCNT, p. 21, and p. 23, foundation drawings; STL, p. 26; CFO, pp. 36, 66, and 201; CON; LSCS, p. 39; TAA, with 32 references; RNRC, following p. 128; HB; MAC, p. 89, plan; SCS, p. 40; CAA; CIM, pp. 148, 432, and 433; CHC, p. 36; and A for November 1927. A detailed description, with a longitudinal section and photographs, is in LSM. A view of the building is in CRT, p. 15; CHC, p. 230; and RMNV, V8. The Auditorium Theater was restored as a gift of services by Harry Weese, architect, to the Auditorium Theater Council. Various restoration, ongoing, has been made by others, including Crombie Taylor and John Vinci, architects. The first story was arcaded in 1952 for the Congress Parkway widening. Before the construction of the Auditorium, the northwest corner of S. Michigan Avenue and E. Congress Street was occupied by the Belford, Clark & Co. building, at 434–38 S. Michigan Avenue and 74–84 E. Congress Street.

A 1970 addition: The Herman Crown Center, 425 S. Wabash Avenue, is 17 stories; Mittelbusher & Tourtelot were the architects. A photograph is in IA-C April 1973, p. 11. The 423 S. Wabash Avenue building occupied this site earlier.

WELLS-MONROE building, 1889–1959, 183 W. Monroe Street and 101–03 S. Wells Street, formerly known as the Pancoe building, the Indian building, and the Owings building, was eight stories high, on spread foundations. O. J. Pierce was the architect. The building, of Saracenic design, is illustrated in IA February 1887. Photographs are in *Chicago Daily News*, August 21, 1959, CIM, p. 560, and, as the Pancoe building, RB Annual Review, January 30, 1960, p. 138. This site is used for a parking structure.

CHEMICAL BANK building, 1889–1929, at 115–21 N. Dearborn Street, with a frontage of 60 feet, was eight stories high. Burnham & Root were the architects. A photograph is in OBD 1901, p. 49, and CIM, p. 587. A Commonwealth-Edison Co. substation is now on this site on rock caissons, designed for 18 stories. A photograph of the Chemical Bank is also in CTCP, p. 35. The 1872 Williams building previously occupied this site.

TACOMA building, special significance, 1889–1929, was at the northeast corner of N. LaSalle and W. Madison Streets, fronting 80 feet on the former and 101 feet on the latter (fig. 30). Holabird & Roche were the architects and Carl Seiffert was the engineer. The building permit was dated April 10, 1888. Twelve stories, 165 feet, were erected on spread foundations (see HBF) consisting of 18 inches of concrete on which were laid two layers of 15-

inch wrought-iron beams at right angles to each other, spaced 12 inches on center and embedded in concrete. A grillage of six 20-inch beams was used under each of the eleven exterior and five interior columns. All columns, mullions, and lintels were cast iron. The beams were wrought iron except for the smaller sizes, which were Bessemer steel. The party wall to the north, the alley wall on the east, and the two interior cross-walls, at right angles to each other, were wall-bearing, 32 inches to 36 inches thick in the second story. A discussion of the construction, and a photograph of the building, are in T, p. 197. A photograph of the building is in CIM, p. 401; IC Vol. 2; RMNP; LAAM, p. 37; CANY, p. 37; CSA, fig. 70; ACMA, p. 38; HRHR Vol. 1, p. 11; LSCS, p. 14; CTCP, pp. 45, 49; LC, p. 142; A January 1930; and HSM. The street frontages were truly of skeleton construction, but most of the rest of the framing was wall-bearing. The spandrel section is illustrated in AEF. A view of the building is in CRT, p. 56; OBD 1916, p. 232; and RMNV, V19. This site was occupied previously by the Schweizer Block, 1872–1888, four stories high, an illustration of which is in TYF and LO January 1872, p. 12. The original cost of the Tacoma building, including architects' fees, was 38.93 cents per cubic foot (EAR).

In August 1929 the National Association of Building Owners and Managers published a 20-page report (abstracted in ENR December 26, 1929), titled *Depreciation and Obsolescence in the Tacoma Building,* by Paul Holcombe, research engineer of the association. The report contains a photograph of the building, floor plans, a foundation plan, framing plans, and 36 photographs of construction details exposed during the wrecking of the building, in addition to a history of the building, a description of the engineering features of the design, and a study of the depreciation and obsolescence of the various elements. The first cost of the building is given as approximately $500,000, about 38.9 cents per cubic foot. When the property was acquired by the University of Chicago in 1915, the land value figured at $128 per square foot and "the building was included in this price as of no value." At the time of the wrecking there was no substantial depreciation of the steel, fireproofing, and subfloor construction. An account of the examination of the condition of the metal construction at the time the building was wrecked is in *Chicago Tribune,* May 12, 1929. W. J. Newman, wrecker, said that at the time of demolition the building leaned 11¾ inches to the east into the alley. The One N. LaSalle Street building includes this site.

440–44 S. CLARK STREET building, ca. 1889–1947, was six stories high, on spread foundations. This building was condemned and removed by the Department of Subways and Superhighways. This site is used for parking.

333–35 S. MARKET STREET building, 1889–ca. 1970, as the Adams building, was six stories high, 51 feet 3 inches by 148 feet 6 inches. John M. Van Osdel was the architect. The contract cost — including extras amounting to

$257.28—was $32,529.02, or less than 5½ cents per cubic foot, a cost that was typical of that period for buildings of this sort. Plastering cost 18 cents a square yard. Detailed costs are in the architect's books of account (Vol. 3) at the Chicago Historical Society. The Sears Tower includes this site.

West: Eli B. FELSENTHAL building, 1889–1908, at 63–71 N. Canal Street, was five stories high. Adler & Sullivan were the architects. No illustrations are known. The Chicago Daily News/2 Riverside Plaza building includes this site.

West: MONROE-JEFFERSON building, 1889–(1950 to 1990), at 100 S. Jefferson Street, formerly known as the Frances building, was six stories high, on spread foundations. Treat & Foltz were the architects. The building is pictured in IA February 1889. This site is used for parking.

North: CENTRAL WAREHOUSE, 1889–(1950 to 1990), at the southwest corner of N. Rush and E. North Water Streets, replaced another warehouse (1872–1889 fire). The Sturgess & McAlister wool warehouse occupied this site at the time of the fire. The building was seven stories high. There is an illustration in RMNV, V21.

North: WINSTON APARTMENTS, 1889–1937, at the southeast corner of N. Pine (now N. Michigan Avenue extended) and E. Chicago Avenue, was six stories high and is said to be the first duplex apartment building in Chicago. A photograph is in *Chicago Tribune*, February 17, 1940, and CIM, p. 318. The 777 N. Michigan Avenue building occupies this site.

411–21 S. MARKET STREET building, 1890–(1950 to 1990), was seven stories high.

RAND McNALLY building, special significance, 1890–1911, was on W. Adams Street, west of S. LaSalle Street, with a frontage of 150 feet, adjacent to the Insurance Exchange building, and running through to W. Quincy Street, on the site of the present 208 S. LaSalle Street building. Burnham & Root were the architects, Theodore Starret was their engineer, and Wade & Purdy designed the steelwork. The building was 10 stories high, on spread foundations using beam and rail grillages. The east and west party walls were wall-bearing in accordance with the city building code. The first Z-bar steel columns, invented by Charles L. Strobel, were used in this building; it was the first building of all-steel skeleton construction; and it was the first building to use all terra-cotta facades on the street fronts. A steel framing plan and details are in ER January 9 and 30, 1892, and February 13, 1892. A foundation plan and details are in ER December 12, 1891, and the footings are illustrated in ER July 2, 1898. The building is illustrated in RMN. A photograph is in CIM, p. 425; RMNP; and HSM. A description is in SGC, p.

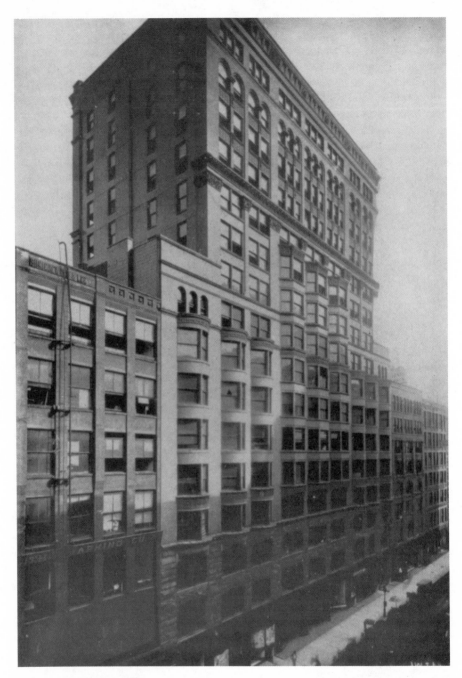

Fig. 31. Manhattan, 1890

575. A view of the building is in RMNV, V1, and OBD 1901, p. 150. A photograph is also in JWR, p. 82.

WELLINGTON HOTEL, ca. 1890–1915, at the northeast corner of S. Wabash Avenue and E. Jackson Street, on the site of the Lyon & Healy building, was six stories high, on spread foundations. Henry Ives Cobb was the architect. Photographs are in SGC, p. 93; CYT, p. 83; and CIM, pp. 373 and 444. An illustration and a brief description are in CRT, pp. 17 and 18. This site was earlier occupied by the old MATTESON HOUSE 2, which was remodeled completely and opened as the Wellington Hotel. Before the great fire of 1871, MATTESON HOUSE 1 was at the northwest corner of N. Dearborn and W. Randolph Streets; a photograph is in CYT, p. 86; CIM, pp. 147 and 151; and CPH, p. 13. A drawing is in CBF.

MANHATTAN building, NR, CAL/CHALC, HABS/photo, CLSI/premier, in the South Dearborn Street Printing House Row Historic District/NHL, at 431 S. Dearborn Street, built in 1890, was the first 16-story (210 feet) building in the world (fig. 31). William Le Baron Jenney was the architect. Louis E. Ritter was assistant engineer to Major Jenney. The permit was dated June 7, 1889. The building is supported on spread foundations with beam and rail grillages. The building is true skeleton construction, with no use of party walls, the north and south walls of tile being supported upon steel cantilevers carrying the load back to the first row of interior columns. The columns are of cast iron, and the beams and girders are of wrought iron with "no steel in the building, Bessemer beams being still too expensive." It was the "first building to recognize a system of windbracing as a necessity" (SCM). The building is illustrated in IC Vol. 2, and IA July 1889. A photograph is in CIM, p. 560; OBD 1901, p. 101; and RMNP. A view of the building is in RMNV, V10. A description is in T, p. 200. It was also known as the Hercules building. It was converted in 1982 and renamed the Manhattan Apartments; Wilbert Hasbrouck, architect. Photographs are also in CFB "merit"; CSA, figs. 52 and 53; TBC, p. 109; GCA, p. 29; CTCP, p. 82; and CSV, p. 104 detail.

RELIANCE/32 N. STATE STREET building, NHL, IR, CAL/CHALC, HABS, CLSI/premier, at the southwest corner of W. Washington Street, was built to the height of four stories in 1890 (fig. 32). Burnham & Root were the architects. Beams and rails were used in the spread foundations. D. H. Burnham & Co., architects, and E. C. Shankland, engineer, added 12 stories in 1895, making the height of the building 200 feet. John Root had designed the earlier building, but Charles Atwood is recognized as the designer of the 1895 building, which was built for William E. Hale, elevator manufacturer and developer. It has been called the Warmington building and was identified for many years as the Karroll (clothiers) building. Gray columns were used with plate and lattice girders for wind bracing. The steel for the upper

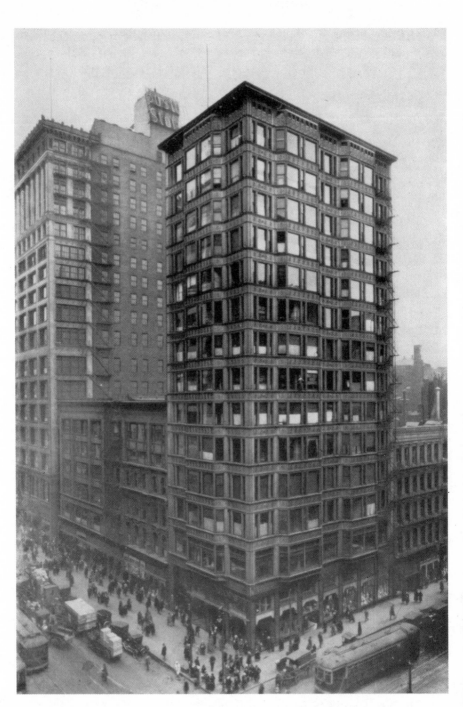

Fig. 32. Reliance, 1890/1895

stories was erected in 15 days, from July 16 to August 1, 1895, while the lower floors were occupied by the tenants. Photographs of the building are in AR November 1895 and July 1915; CFB; AUS, p. 157; CSA, fig. 67; ACMA, p. 43; SFO, p. 108; AF November 1973, p. 57; STL, p. 32; TAA, with 12 references; CIDL, p. 274; CON; WACH, p. 13; TBC, p. 52 under construction; TBAR, pp. 15 and 25; RNRC, following p. 128; MEA Vol. 1, p. 354; SCS, pp. 42 and 129; RMNP; CIM, p. 562; AWG. The building is illustrated also in EN October 17, 1895, and in AEF, which contains also a floor plan, steel framing plan, photographs of the steel erection, and details of the terra-cotta front and piers, spandrel sections, and column splices. Articles are in IA-C September 1988, p. 5, and May 1993, p. 23, and a photograph is in March 1993, p. 23. Photos of facade details are in FGC, p. 26, and CCNT, pp. 12 and 37. The facade was restored in 1996 by T. Gunny Harboe, architect, of the McClier Corporation; see articles in *Chicago Tribune*, December 12, 1995, Tempo section 5, p. 1, by Blair Kamin, and Chicago's *Free Weekly* newspaper, October 11, 1996, p. 1, by Jordan Marsh. It is reported that the Reliance building will be converted to a hotel. The First National Bank building 1 previously occupied this site.

Alexander M. THOMSON & James E. TAYLOR (spices) building, ca. 1890– ca. 1925, at the southwest corner of N. Michigan Avenue and E. Lake Street, was seven stories high. It is described briefly in SGC, p. 329. A photograph is in CRT, p. 110. A drawing is in BTC, p. 82. The Harvester building occupies this site.

439–45 S. CLARK STREET building, ca. 1890–(1950 to 1990), known also as the Feigenheimer and Hofherr building, was six stories high, on spread foundations, with a frontage of 50 feet and a depth of 100 feet. W. W. Boyington was the architect. This site is used for parking.

MONON (Railroad) building, special significance, 1890–1947, at 436–44 S. Dearborn Street, the first modern 13-story (160 feet) building, was the last work of John M. Van Osdel, Chicago's first architect. The building had spread foundations, cast-iron columns, wrought-iron beams, and tile arch floors. It is illustrated in IA October 1889. VO 1889 gives the following contract costs: masonry, $28,000.00; cut stone, $5,500.00; plastering, $4,453.08; terra-cotta, $13,000.00; stone sidewalk, $178.65; sheet metal, $1,400.00; iron stairs, $1,098.00; and excavation, $1,150.00 — a total of $54,779.73, without the cast-iron columns and wrought-iron beams. Extra work was noted as follows: change in foundations, $347.89; flues in the north wall, $275.00; and an extra story (the thirteenth), $1,879.00 — a total of $2,501.89. Photographs are in RMNP; CTCP, p. 83; and CSA, fig. 71 with the Caxton building. A view is in RMNV. The building was condemned and removed by the Department of Subways and Superhighways. This site is used for parking.

BEDFORD building, 1890–1940, at 203 S. Dearborn Street, on the southeast corner of W. Adams Street, formerly called the Owings building, was 14 stories (160 feet) high, on a mat foundation. Henry Ives Cobb and Charles S. Frost were the architects. Cast-iron columns were used. The building is illustrated in IA June 1888, and OBD 1929, p. 43. A photograph is in CIM, p. 366; *Chicago Tribune,* February 17, 1940; CHC, p. 69; CRT, p. 51, and IC Vol. 2. A view is in RMNV, V3, and RMN. The Federal Center includes this site.

JAMES H. WALKER STORE building, 1890–1936, at the southwest corner of S. Wabash Avenue and E. Adams Street, later known as the American Commerce building, was six stories high. Burnham & Root were the architects. A view is in RMNV, V4. This site is used for parking.

West: 600 W. FULTON STREET building, built in 1890 at the northwest corner of N. Jefferson Street, is eight stories high, of mill construction. This was originally the Sears Warehouse. It was also known as the Walter Field (mail order) building and as the Alden Co. building around 1961. The lofts were converted to offices in 1983 for and by A. Epstein & Sons, architects and engineers. Photographs are in RB April 1, 1961, p. 1, and RB Annual Review, January 27, 1962, p. 167, and April 28, 1984, p. 26. A drawing of the five-story Sears, Roebuck & Co. "first Chicago Plant," Adams near Halsted Street, is in *Chicago,* Chicago Board of Education, 1951, p. 195.

South: FIRST INFANTRY ARMORY, 1890–1968, at the northwest corner of S. Michigan Avenue and E. Sixteenth Street, was five stories high. Burnham & Root were the architects. It had been renamed the 131st Infantry Armory. Photographs are in CFB; JWR; CIM, p. 489; and AGC, p. 10.

South: EDWARD HOTEL, ca. 1890–(1950 to 1990), at the southwest corner of S. Federal and W. Harrison Streets, was six stories high.

South: CAXTON building, 1890–1947, at 500–508 S. Dearborn Street, was 12 stories high. Holabird & Roche were the architects. Steel columns were used with grillages of steel beams in the spread foundations. A view of the building is in RMNV, V10. Photographs are in CSA, fig. 71; HRHR Vol. 1, p. 54; and CTCP, p. 83. The original cost of the Caxton building, including architects' fees, was 24.858 cents per cubic foot (EAR). This building was condemned and removed by the Department of Subways and Superhighways.

South: *GRAND CENTRAL STATION,* 1890–1971, HABS, was at the southwest corner of S. Wells and W. Harrison Streets. S. S. Beman was the architect. The building, eight stories high, with five-story wings and a 250-foot tower, was supported on a foundation of 55-foot wood piles (see HBF). The building is illustrated in IA February 1889; CRT, p. 9; and CHC, p. 100. A photograph is in CAA; CIM, p. 234; CCP, p. 117; IA May 1893, *American*

Building Materials, Carl Condit, 1971, p. 47 shed interior; CFB "merit"; LC, p. 57; CSA, fig. 101; CTCP, p. 87; and ILL, p. 54. Drawings are in BTC, p. 58; RMP, p. 65; *Prairie School Review,* 1st quarter, 1974. A view is in RMNV, V9, and SGC, p. 469, with a description on p. 511. The original Bridewell (John M. Van Osdel, architect) was on this site. A history of the stations of the Grand Central group of railroads is in WSE 1937, p. 81. This was originally the (Illinois and) Wisconsin Central Station. This site is used for parking.

North: ALEXANDRIA HOTEL, 1891–(1950 to 1990), at 542 N. Rush Street, on the southwest corner of E. Ohio Street, formerly known as the Granada Hotel, was six stories high, on spread foundations. Edmund R. Krause was the architect. A photograph is in CRT, p. 17, with a brief description on p. 15. An illustration is in *Hotel Monthly* June 1912. A drawing is in RMN, p. 39. Photographs are in RB Annual Reviews, January 28, 1961, p. 2, and January 27, 1962, p. 34. An addition, at 49–53 E. Ohio Street, was built in 1914, seven stories high, of reinforced concrete construction, on spread foundations, except for caissons under the west wall, by Edmund R. Krause, architect. This site is used for parking.

WOLFF building, 1891–(before 1949), at 111 N. Dearborn Street, with a frontage of 28 feet, later known as the Beak building, was eight stories high. An illustration is in OBD 1916, p. 265. A photograph is in CIM, p. 587. This building was reconstructed and three stories added in 1891. This site is used for parking.

CHICAGO COLD STORAGE EXCHANGE WAREHOUSE, 1891–1902, was an eight-story building between N. Market Street (now N. Wacker Drive) and the river and between W. Randolph and W. Washington Streets. Adler & Sullivan were the architects. A photograph is in LSM and in SRT, p. 251. A drawing is in *Louis Sullivan,* Albert Bush-Brown, 1960, plate 28.

MONADNOCK BLOCK, NHL, CAL/CHALC, HABS, CLSI/premier, in the South Dearborn Street Printing House Row Historic District/NHL, at 53 W. Jackson Street, is divided into four equal parts. The north half, known originally as the Monadnock and Kearsarge buildings, was built in 1891. Burnham & Root were the architects. It is 16 stories high, 215 feet, and is the highest and heaviest wall-bearing building in Chicago, and perhaps anywhere. This portion, when built, was set up 8 inches; by 1905 it had settled that and "several inches more" (WSE 1905, p. 687). The total settlement to 1949 was about 20 inches (see HBF). In this building was made one of the first attempts at a portal system of wind bracing (AEF). "When he [Owen F. Aldis as agent] put up the Monadnock on Jackson Boulevard there was nothing on the south side of the street between State Street and the river but cheap one story shacks, mere hovels. Everyone thought Mr. Aldis was insane to build way out there on the ragged edge of the city. Later when he

carried the building on through to Van Buren Street they were sure he was [insane]" (EAR). An illustration of the Monadnock and Kearsarge buildings is in CRT, p. 56. The south half, known originally as the Katahdin and Wachusett buildings, was built in 1893. Holabird & Roche were the architects; Corydon T. Purdy was the engineer. It is 17 stories high and has much smaller piers, enclosing Z-bar columns, used in both sections for interior columns (illustrated in AEF). Spread footings were used throughout, with rails and beams in the north half, and with beams, only, in the south half. The original cost of the Katahdin building, including architects' fees, was 39.247 cents per cubic foot; and of the Wachusett building, 41.077 cents per cubic foot (EAR). The east wall of the entire building is now supported on hardpan caissons, built in 1940 at the time the subway was dug in S. Dearborn Street (ENR, September 16, 1940). The building is described in EN February 16, 1893. It is illustrated in IA November 1889; and by photograph in CAA; CIM, p. 562; RMNP; CHC, p. 87; WSE October 1942; A November 1927; AR April 1912, and July 1915; CFB; AUS, p. 152 detail; CSA, figs. 28 and 72 addition; HRHR Vol. 1, p. 25; STL, p. 40; TAA, with 18 references; JWR, plates 99–103; ACMA, p. 40; CCNT, p. 26; RNRC, p. 155; HB; MAC Vol. 1, with plan; TBAR, p. 14; *Art and Life in America*, Oliver W. Larkin, 1949, p. 290; MEA Vol. 1, p. 353; *Lost America: To Pacific*, Constance F. Greiff, 1972, p. 229; and RB Annual Review, January 26, 1974, p. 15. Articles are in JSAH December 1967; IA-C January 1985 and May 1987. A view is in RMNV, V3. Ongoing restoration is by John Vinci, architect. The Chicago Building Congress, the Landmarks Preservation Council of Illinois, the Western Society of Engineers, and the regional office of the National Trust for Historic Preservation are here.

SEARS, ROEBUCK store, NHL, built in 1891 at the southeast corner of S. State Street and E. Van Buren Street and extending to E. Congress Parkway. Originally it was the Siegel, Cooper & Co. building and later the Leiter Stores building, commonly called Leiter II, the "largest retail store in the world" when it was built. It is skeleton construction, eight stories high, 133 feet, on spread foundations with beam grillages. Jenney & Mundie were the architects. In 1940, caissons to hardpan were built under the west wall, just prior to the construction of the State Street subway. The exterior is of white Maine granite. The building is illustrated in IA August 1889. A photograph is in CIM, p. 354; RMNP; and IC Vol. 1. A view of the building is in CRT, p. 83, with a brief description on p. 19, and RMNV, V8. Drawings are in CPS, p. 43; ACMA, p. 37; STL, p. 38; and CTCP, p. 81. Photographs are also in CFB "merit"; CANY, p. 29; CSA, fig. 48; MAC, p. 95, with plan; and CALP. The south sidewalk was arcaded for the widening of the Congress Parkway. The building was converted in 1985 to offices and shops and renamed One Congress Center, 401 S. State Street, by Louis Weiss, architect. The Robert Morris College is here.

OXFORD building, 1891–1935, was at 116–20 N. LaSalle Street. Clinton J. Warren was the architect. The building was eight stories high, on spread foundations. A photograph is in CIM, p. 576, and a view showing the location is in RMNV, V18. The 120 N. LaSalle Street building occupies this site.

125 S. MARKET STREET building, 1891–ca. 1960, was 10 stories high. The U.S. Gypsum building of 1963 later occupied this site, which is vacant.

KIMBALL HALL building, 1891–1916, was at 306 S. Wabash Avenue near the southwest corner of E. Jackson Street, and on a portion of the site now occupied by the present Kimball building. The building was seven stories high, on spread foundations. Frederick Baumann & J. K. Cady were the architects. A photograph is in IA April 1891. A view of the building is in CRT, p. 127; OBD 1910, p. 105; RMNV, V8; and SCG, p. 505, with a description on p. 399. An illustration of the predecessor Kimball building, six stories high, is in CAC, p. 227. The KIMBALL building, at the southwest corner of E. Jackson Street and S. Wabash Avenue was built in 1917. Graham, Burnham & Co. were the architects. It is 16 stories high, on hardpan caissons. It is illustrated in AA September 1, 1920, and CIM, p. 556. An illustration and a description are in OBD 1916, p. 117. Photographs are in GAPW, p. 128, and RB July 30, 1955, p. 1. The building was renamed Lewis Center, De Paul University, 25 E. Jackson Parkway. See also the Finchley building. The Chickering Hall building previously occupied this site.

WILLOUGHBY building, 1891–1927, formerly called the Western Bank Note building, was at 8 S. Michigan Avenue. It was eight stories high, on spread foundations. Charles S. Frost was the architect. Cast-iron columns were used. A photograph of the building is in IA September 1891, and CRT, p. 138. A photograph and a brief description are in OBD 1916, p. 263. The Willoughby Tower now occupies this corner.

ANDREWS building, 1891–1936, at 161–65 W. Washington Street, formerly known as the Herald building and later as 163 W. Washington Street building, was six and seven stories high. Burnham & Root were the architects. It is illustrated in RMN and RMNV, V19. An illustration is in CRT, p. 30, with a full description on p. 29. A photograph is in OBD 1929, p. 254, and *Chicago Tribune,* February 17, 1940. When the Stock Exchange building to the east was built in 1894, caissons were installed under the party wall, the first used in Chicago. Previously the Chicago Herald occupied the four-story building at 24–26 N. Wells Street, an illustration of which is in CAC, p. 65. Drawings are in CIDL, p. 43, and CTCP, p. 38. A photograph is in JWR, plate 92.

South: *LUDINGTON building,* NR, CLSI, at 1104 S. Wabash Avenue, on the southwest corner of E. Eleventh Street, was built in 1891. Jenney & Mundie were the architects. The building has an all-steel frame; it is eight stories

high, designed for 8 additional stories, on spread foundations. The footings are continuous over almost the entire lot. The illustration of the building in IA August 1892 shows a steam locomotive on the South Side elevated structure. A tiny drawing is in *Master Builders,* ed. Diane Maddex, 1985. Photographs are in CSA, fig. 56; AGC, p. 143; RB Annual Review, January 28, 1961, p. 137; and CALP.

South: GRANT PARK ARMS APARTMENTS, at 1140–44 S. Michigan Avenue, built in 1891 as the Bordeaux Hotel, was seven stories high. Frederick Baumann & J. K. Cady were the architects. It is described and illustrated in RMNV, V11. A photograph is in IA Vol. 18, p. 166, and RB January 7, 1950, p. 4. It was renamed the Chicago Park Avenue Hotel, 1142 S. Michigan Avenue. A story has been added.

South: U.S. APPRAISER'S building, 1891–1950, at the northwest corner of S. Sherman and W. Harrison Streets, was eight stories high. A Mr. Freret was the architect. W. L. Klewer, later City Architect, was superintendent of construction. A photograph is in RMNP, and an illustration is in RMNV, V9.

South: *PONTIAC building,* NR, HABS, HA, CLSI/premier, in the South Loop Printing House Historic District/NR, 542 S. Dearborn Street, at the northwest corner of S. Dearborn and W. Harrison Streets, extending through to S. Federal Street, was built in 1891. It is 14 stories, 174 feet high, on spread foundations, with beam grillages and steel columns. Holabird & Roche were the architects. The original cost of the Pontiac building, including architects' fees, was 29.152 cents per cubic foot (EAR). A view is in RMNV, V10. A photograph is in RMNP; OBD 1916, p. 200; CSA, fig. 73; STL, p. 30; AGC, p. 148; HRHR Vol. 1, p. 93; CTCP, p. 85; and TBC, p. 42. It was for a short time the Chicago Home for Girls.

South: METROPOLE HOTEL, 1891–1994, was at the northeast corner of S. Wabash Avenue and E. Twenty-third Street. It was seven stories high. Clinton J. Warren was the architect. Photographs are in CSA, fig. 113, and CIM, p. 492.

North: OAKLEY building, 1891–1976, 143–51 W. Hubbard Street, at the southwest corner of N. LaSalle Street, was seven stories high. Adler & Sullivan were the architects. The east facade was rebuilt for the LaSalle Street widening. This site is used for parking.

North: VIRGINIA HOTEL, 1891–1929, was at the northwest corner of N. Rush and E. Ohio Streets, 10 stories high, on spread foundations. Clinton J. Warren was the architect. Leander J. McCormick built his home (1863–1871 fire) on this site, and also built and owned the hotel, where he died in 1900. The building is illustrated in RMN. A photograph is in CRT, p. 18, with a brief description on p. 17; CIM, p. 529; *Hotel Monthly* June 1912; *Book of*

Chicago, by the Chicago Evening Post newspaper, 1911, p. 201; CSA, fig. 112; and CAJZ, p. 275. A view is in RMNV, V24.

ATLANTIC HOTEL, 1892–1971, HABS, at 320–28 S. Clark Street, formerly known as the Kaiserhof, Wyoming, and Gore Hotels, was eight stories high, on spread foundations. Max Teich was the architect. A view of the building is in RMNV, V9. An illustration is in *Hotel Monthly* June 1912. In 1915 an 18-story addition was built at 314–18 S. Clark Street, while the hotel was known as the Kaiserhof. This building had two basements and was supported on rock caissons. Marshall & Fox were the architects. Photographs of both buildings are in CIM, pp. 426 and 427. See also the Van Buren building and the Board of Trade Hotel.

VENETIAN building, 1892–1957, HABS, at 15 E. Washington Street, was 13 stories high, 180 feet, on spread foundations with beam grillages. Holabird & Roche were the architects. Steel columns were used; the spandrel section is shown in EN January 2, 1892. The wind bracing is of diagonal rods, portals being used where the rods could not be used (AEF and EN December 26, 1891). The original cost of the Venetian building, including architects' fees, was 43.447 cents per cubic foot (EAR). The building is illustrated in IA August 1891; EN December 5, 1891; and by photograph in CIM, p. 582, and RMNP. A view of the building is in CRT, p. 8, with a brief description on p. 20; and RMNV, V20.

SHEPPARD building, 1892–1912, at the northeast corner of S. Wells and W. Quincy Streets, was seven stories high. A photograph is in OBD 1901, p. 170. The 208 S. LaSalle Street building occupies this site.

David GARRICK building, special significance, CAL, HABS, 1892–1961, 64 W. Randolph Street, originally the Johann C. F. von Schiller building, also known as the (New) German Opera House and, in 1898, as the Dearborn building. The theater was a television studio from 1950 to 1957 and, finally, was a Balaban & Katz movie theater. Adler & Sullivan were the architects. The building was 17 stories high, 250 feet, on pile foundations (see HBF), with Phoenix columns (AEF). A description, with floor plans and illustrations, is in LSM and IA June 1896. Photographs of the tower and the upper stories are in CIM and IA February 1893. An illustration is in RMN and IC Vol. 2. Photographs are in WA April 1920. A view of the building is in CRT, p. 23, with a brief description on p. 24, and RMNV, V16. An illustration is in SGC, p. 121, with a description on p. 123. Drawings are in CANY, p. 100; ACMA, p. 48; SRT, p. 295. Photographs are also in LAAM, p. 161; CSA, figs. 87–89; CFB; TYF, p. 23; SFO, p. 99; *Frank Lloyd Wright: Architecture,* ed. Iovanna Wright, 1962, p. 20; DATA, pp. 160–169; CTCP, p. 20; and RNRC, ten photographs with the story of the preservation campaign led by Richard Nickel. A parking structure occupies this site.

UNITY building, NR, HABS, CLSI, 1892–ca. 1990, at 127 N. Dearborn Street, later known as the American Bond & Mortgage Company building and the 127 N. Dearborn Street building, was on spread foundations, 16 stories, 210 feet high. This is one of the last tall buildings built using cast-iron columns. The bracing was diagonal rods. The brick work was started at the fourth floor; a construction photograph is shown in RG October 30, 1891. Clinton J. Warren was the architect. The south and west walls were supported on caissons to rock; the caisson at the southwest corner, one to the north, and two to the east were built in 1912; the six remaining caissons under the south wall to the east were built in 1927 on account of the uneven settlement up to that time; and the four caissons under the west wall were built in 1940 at the time of the digging of the subway in N. Dearborn Street. There was a substantial lean of the south wall over the alley. An illustration of the building is in RMN and in OBD 1929, p. 24. An illustration of the iron framework is in IC Vol. 2. Photographs are in CRT, p. 22, with a brief description on p. 19; CFB "merit"; PGC, p. 50; WCWF; BMT; CON, p. 121; HDM, pp. 67 and 213; and RMNP. A brief description is in T, p. 200. A view is in RMNV, V20. The Rice Theater previously occupied this now-vacant "Block 37" site.

Daughters of ISABELLA building, HABS, CLSI, at 21 E. Van Buren Street, was built in 1892. Jenney & Mundie were the architects. The building was 11 stories (110 feet) high, with a spread foundation using beam and rail grillages. A knee-brace system of wind bracing was used (AEF). The building is illustrated in IA September 1892, and a description is in EN February 16, 1893. A view of the building is in RMNV, V8. The five uppermost stories were removed after a fire; the remainder is used by St. Mary's Church.

E. J. Lehman's *FAIR STORE,* HABS, 1892/1896–1986, at the northwest corner of S. State and W. Adams Streets and extending to S. Dearborn Street, was nine stories high, to which two stories were added. The eastern half of the 500,000-square-foot building was built in 1896. It was called "the largest department store in the world" when built. Jenney & Mundie were the architects. The spread foundations of concrete, beams, and rails (EN August 8, 1891, illustrated; see also HBF) were set nine inches high in anticipation of that amount of settlement (WSE 1905, p. 687) and were replaced in 1923 and 1924 by hardpan caissons, except under the north wall, where caissons to rock were used. At the same time two sub-basements were added. The wind bracing consisted of diagonal rods and lattice girders between the steel columns. Foundation, column, and beam details are shown in AEF. A feature unique at that time in high buildings was the use of an enclosed steel chimney, on account of the lack of space for the foundation for a heavy masonry chimney (ER November 14, 1891, with illustrations of the chimney, steel, and foundations). A description of the building with

illustrations of the construction is in IA November 1891, and a general illustration is in IA February 1892. An illustration of the construction is in IC Vol. 2, pp. 186 and 842. The building was refaced in 1965 by Perkins & Will, architects; an article is in *Modern Steel Construction*, 1st quarter, 1966, p. 3, including a discussion of the structure and steel framing conditions found. An article is in IA-C May 1986, p. 62. Drawings are in CPS; WACH, p. 10; *Space, Time and Architecture*, Sigfried Giedion, 1941, under construction and framing detail; BMT 1971, p. 4, and 1973, following p. 112, structure; and MAC, p. 97, framing. Photographs are in LC, p. 77, and CIM, p. 351. A view is in RMNV, V6. This site is vacant. Illustrations of various buildings used by the Fair Store are in HCCB, p. 199B.

GREAT NORTHERN HOTEL, 1892–1940, originally the Northern Hotel, was at 237 S. Dearborn Street, on the northeast corner of W. Jackson Street. The hotel was 16 stories high, on spread foundations with iron rail grillages and steel columns. Burnham & Root were the architects. The building was set up nine inches to allow for settlement (ER July 29, 1905). It is illustrated in IA March 1893, and IC Vol. 2. A view is shown in CRT, p. 29, with a brief description on p. 16; and RMNV, V3. A story of the settlement of the building is in HBF. A description and photographs are in IA September 1896. A photograph is in CIM, p. 367; CHC, p. 231; CAA with the adjoining office building; *Chicago Tribune*, February 17, 1940; JWR, plate 88; CSA, fig. 60; and CIDL, p. 38. The wrecking is described in ENR May 9, 1940. The Dirksen Federal Center building occupies this site.

CAPITOL building, special significance, HABS, 1892–1939, at the northeast corner of N. State and E. Randolph Streets, known for most of its life as the *Masonic Temple*, 21 stories, 302 feet high, was the highest building in the world (fig. 33). Burnham & Root were the architects. Spread foundations had grillages of beams and rails. A record of the settlement of this building is in HBF. A foundation plan is in IA March 1896, and steel framing plans and a cross section are in IA April 1896. Steel box columns were used with the wind bracing of diagonal rods (AEF, with an illustration of the building and the spandrel sections). The building and its construction are fully described and illustrated in a series of articles in current architectural and engineering magazines: ER January 21, May 13 and 27, September 2, October 28, November 4, and December 30 1893 (with foundation, floor, and steel framing plans and details), and July 1915 (photograph). A photograph is in CIM, p. 555; CHC, p. 46; CAA; and *Chicago Tribune*, February 17, 1940. It is illustrated also in RMNP; HSM; and IC Vol. 1. A description and a photograph are in T, p. 203. Photographs are in AR July 1916; LAAM, p. 159; JWR, plate 93; CSA, fig. 64; ACMA, p. 42; JSAH December 1978. A view of the building is in CRT, p. 119, with a description on p. 19; SGC, p. 113, with a description on p. 583; and RMNV, V17. Photographs of the wrecking opera-

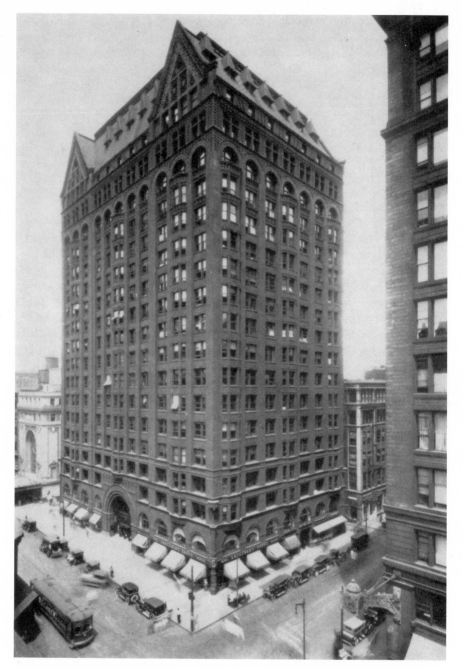

Fig. 33. Masonic Temple, 1892

tions (May and June 1939) are in *Chicago Daily News*, beginning May 5, 1939. The Windett building, fronting approximately 24 feet on N. State Street and 113 feet on E. Randolph Street, previously occupied the south end of this site. It was built in 1872, five stories high, by Dixon & Hamilton, architects, and is illustrated in TYF and in LO August 1873, p. 129, with a description on p. 131. A photograph in CYT, p. 62, and CIM, p. 344, taken in the middle 1880s shows a four-story building immediately north of the Windett building, and then the Brunswick 2, a five-story building. In the late 1860s, Brunswick building 1, also five stories high, occupied the latter site, immediately south of the alley, the north portion of the site of the Masonic Temple. A photograph of Brunswick building 1 is in CIM, p. 266. A photograph of Brunswick building 2 is in CYT, p. 51.

WOMAN'S TEMPLE building, 1892–1926, at 102–16 S. LaSalle Street, on the southwest corner of W. Monroe Street, with a depth of 95 feet, was on the east portion of the site of the present 120 S. LaSalle building. It was 13 stories high, 190 feet, on spread foundations with beam and rail grillages. Burnham & Root were the architects. Steel columns were used; a steel framing plan and spandrel section of the bay window are in EN January 2, 1892. The building is illustrated in IC Vol. 2; IA August 1890; EN December 5, 1891; CRT, p. 80; and HSM. Photographs are in CAA; AR July 1915; WA January 1922; LSM; RMNP; CIM, p. 239; JWR, plate 95; CSA, fig. 63; ACMA, p. 41; CCNT, p. 60; CIDL, p. 64; LSCS, p. 24; CTCP, p. 57; LSM, fig. 48; and LC, p. 143. A view is in OBD 1916, p. 235; and SGC, p. 185, with a description on p. 573. A description is in T, p. 201. A study of the obsolescence of this building was made by the National Association of Building Owners and Managers; an abstract of this report is in ENR July 28, 1927.

KEER building, ca. 1892–(1950 to 1990), was six stories high. It was at 43–45 S. Wells Street. The site is now open space of the adjacent Northern Trust building.

ART INSTITUTE OF CHICAGO, HABS, CLSI/premier, S. Michigan Avenue at the foot of E. Adams Street, the third location of this institution, was built in 1892 on spread foundations, two stories high. Shepley, Rutan & Coolidge were the architects. IA December 1893 contains an illustration of this building and floor plans. A photograph is in CAA; RMNP; CHC, p. 66; CIM, p. 482; CFB; CTCP, p. 58. Monograph: *100 Years: The Art Institute*, by the Institute, 1993. An article is in IA-C May 1989, p. 65. A view is in RMNV, V2. A description and an illustration are in C, p. 35. Additions include: McKinlock Court, 1924, Coolidge & Hodgson; Ferguson Wing, 1958, Holabird & Root & Burgee; Morton Wing, 1962, Shaw, Metz & Dolio; Rice, 1988, Hammond, Beeby & Babka; Administration Wing (CBM, engineers) and Columbus Drive Extension, 1977, both by SOM; the latter includes the reconstructed Stock Exchange Trading Room, Vinci-Kenny; photographs

are in *AIA Journal,* mid-May 1978, p. 125; PA November 1977, p. 62; and *Stock Exchange Trading Room,* John Vinci, 1977. The first location of the Academy of Fine Arts, incorporated May 24, 1879, was in the Pike Block. The name was changed to Art Institute on December 21, 1882. The second location of the Art Institute was at the southwest corner of S. Michigan Avenue and E. Van Buren Street in a two-story building (1873–1884) called the Fine Arts Institute. It is illustrated in CIM, p. 169; CYT, p. 33; CAC, p. 120; and SGC, p. 377, with a description (p. 133) of this building and of the present building, which was then under construction. Burnham & Root were the architects. A photograph of old "Terrace Row," four stories high, extending south on Michigan Avenue from Van Buren Street, is in CYT, p. 36, and CIM, p. 284. Otis L. Wheelock was the architect. The Exposition building previously occupied the present Art Institute site. See also housing facilities of the School of the Art Institute.

ASHLAND BLOCK 2, 1892–1949, at 155 N. Clark Street, on the northeast corner of W. Randolph Street, 16 stories, 200 feet high, on spread foundations. D. H. Burnham was the architect. The spandrel sections are illustrated in AEF, EN January 2 and January 9, 1892, the latter of which shows also a construction photograph. Steel columns were used. An illustration is in CRT, p. 122. A few years later a narrow addition to the north, similar in appearance, was done by John Arthur Rogers, architect. A photograph is in CIM, p. 580, and OBD 1929, p. 30. A view of the building is in AR, Vol. 2, p. 463, and RMNV, V16. Photographs are also in CSA, figs. 61 and 65, and TBC, p. 130. ASHLAND BLOCK 1, built in 1872, was a six-story building on the south portion of the same site. It is illustrated in OYF and in LO August 1872, p. 126, with a description on p. 130. The latter building had a frontage of 140 feet on N. Clark Street and 80 feet on W. Randolph Street. F. & E. Baumann were the architects. This building was purchased by John Alexander Dowie in 1890 and removed in three sections to the east side of S. Michigan Avenue, south of E. Roosevelt Road, where it became the Dowie building. A drawing is in CAJZ, p. 92. It was also known as the Illinois Central building (q.v.). A bus depot replaced Ashland Block 2; the Chicago Title & Trust Center building includes this site, which was occupied by the three-story Evans Block before the fire.

CITY HALL SQUARE HOTEL, 1892–1960s, formerly known as the Rancroft Hotel, and originally known as the Kedzie building, was at 87–91 W. Randolph Street, with a frontage of 50 feet. It was nine stories high, on spread foundations. Edmund R. Krause was the architect. The Richard J. Daley Center includes this site.

30 N. DEARBORN STREET building, 1892–ca. 1962, was formerly known as the Boyce building. Henry Ives Cobb was the architect, and Corydon T. Purdy the engineer. The building was 12 stories high, on spread founda-

tions. It is described in EN February 16, 1893, and is illustrated in RMN and in OBD 1929, p. 325. A photograph is in CIM, p. 576. The 69 W. Washington Street building includes this site.

CHICAGO TITLE & TRUST CO. building, 1892–1962, at 69 W. Washington Street, formerly the Cook County Abstract & Trust Company building. Henry Ives Cobb was the architect. The building was 17 stories high, with spread foundations and steel columns. It is illustrated in IA January 1892; CIM, p. 575; OBD 1916, p. 240; and RMNV, V19. A photograph is in CRT, p. 34, with a brief description on p. 19. The Chicago Title & Trust Co. moved in 1947 into the Conway building, which was remodeled extensively for its use. A drawing is in RMN, p. 91. The 69 W. Washington Street building includes this site.

MARSHALL FIELD & CO. STORE buildings, NHL, HABS, CLSI / premier, 111 N. State Street, between E. Randolph and E. Washington Streets were built in two sections, the north in 1902 on hardpan caissons (EN December 22, 1904) and the south in 1907. Both are 12 stories high, on caissons, the north building having two basements and the south, three. These buildings are illustrated in AR July 1915, and photographs and floor plans are in AWG. A photograph of this block in 1889 is in CIM, pp. 150 and 355. The building at the northwest corner of E. Washington Street and N. Wabash Avenue was built in 1892, nine stories (153 feet) in height, on spread foundations with beam and rail grillages. D. H. Burnham was the architect and E. C. Shankland the engineer. A photograph is in CAA; a view is in RMNV, V17. A description and illustrations are in EN February 16, 1893, which says "it is probably the costliest building of the size and kind in the city." Spandrel sections are in AEF; a photograph is in BB August 1903, p. 169, and AR July 1915. A photograph of these buildings is in RMNP; illustrations are in HCCB, p. 40, and CHC, p. 184. The middle building on N. Wabash Avenue was built in 1906; that at the southwest corner of N. Wabash and E. Randolph Street, in 1914. Both are 12 stories in height, with three basements, on rock caissons. While the building at the southwest corner of N. Wabash Avenue and E. Randolph Street was being erected, the steel sheeting in E. Randolph Street failed and the street dropped several feet. This occurred December 2, 1913, and is described and illustrated in ER December 13 and 27, 1913. Floor plans and photographs are in AWG. The Leander Read building formerly occupied the south 70 feet of the site of the middle building. The ANNEX building at the southwest corner of N. Wabash Avenue and E. Washington Street was built in 1914 and is 20 stories in height, with three basements, on rock caissons. A photograph is in CIM, CPS, and AR July 1915; photographs and floor plans are in AWG. An illustration and a description are in OBD 1916, p. 141. D. H. Burnham & Co. were the architects for all buildings except the 1892 building. The Annex was converted to

offices and renamed the Washington and Wabash building, 25 S. Wabash Avenue.

224-38 S. MARKET STREET building, 1892-ca. 1950, at the northwest corner of W. Jackson Street and the southwest corner of W. Quincy Street, formerly known as the Mallers building, was seven stories high. Flanders & Zimmerman were the architects. A brief description and an illustration are in RMNV, V13. The building was demolished for the S. Wacker Drive extension. The 250 S. Wacker Drive building occupies this site.

West: WOOLENSACK building, 1892-ca. 1926, at the southeast corner of N. Canal Street and W. Washington Street, was seven stories high. A view is in RMNV, V12. The Daily News building occupies this site.

South: KIMBALL building, 1892-(before 1949), at the southwest corner of S. Michigan Avenue and E. 11th Street, was seven stories high, with a clock tower at the street intersection. Flanders & Zimmerman were the architects. The building is illustrated in IA November 1892, and RMNV, V11. The building was used originally as a carriage factory and sales room.

South: TERMINALS building, CLSI, built in 1892, in the South Loop Printing House Historic District/NR, at 537 S. Dearborn Street, was formerly known as the Ellsworth building. J. M. Van Osdel & Co. were the architects, and Corydon T. Purdy was the engineer. The building is 14 stories (170 feet) high, on spread foundations. It is described and illustrated in EN February 16, 1893. A view is in RMNV, V10. An illustration is in OBD 1916, p. 73. Detailed costs are in the architect's account books, Chicago Historical Society. A photograph is in WO, p. 15. It was converted to apartments in 1986; Harry Weese, architect.

South: ILLINOIS CENTRAL RAILROAD STATION, 1892-1974, HABS, east of S. Michigan Avenue and E. 12th Street, with Bradford L. Gilbert as the architect. The building was seven stories high with a clock tower on long wood piles. It is illustrated in IA August 1892. A photograph is in CIM, p. 203; CHC, p. 97; CYT, p. 38; CCP, p. 117, LC, p. 56; *Kindergarten Chats,* Louis Sullivan, 1947 edition, p. 19; and RMNP. A view of the station is in RMNV, V11. A photograph of Park Row, formerly on this site, is in CIM, p. 188. The original Central Depot (1856-1871 fire) was at the foot of E. South Water Street. A photograph is in CIM, p. 97, and CYT, p. 15. A description and a fine illustration are in CIJ and CBF. A history of the passenger stations occupied by the Illinois Central Railroad Co. is in WSE 1937, p. 250.

South: ROWE building, built ca. 1892 (1886?), at 714-16 S. Dearborn Street and 715-17 S. Federal Street (address now 714 S. Dearborn Street), in the South Loop Printing House Historic District/NR, is eight stories high. A

photograph is in WO, p. 13, and CALP with Franklin. It was converted to apartments in 1979; Schroeder, Hinds, Kupritz were the architects.

South: ROOSEVELT HOTEL, built ca. 1892, at the northwest corner of S. Wabash Avenue and E. Roosevelt Road, formerly known as the Meyer Hotel and the Martinette Hotel, is eight stories high. The building is illustrated in RMNV, V11. It was renamed the Roosevelt Budget Hotel, 1152 S. Wabash Avenue.

South: *NEW MICHIGAN HOTEL,* NR, CLSI, 1892–1996, at 2135 S. Michigan Avenue, at the northeast corner of E. Twenty-second Street, was 10 stories high. This was originally the Lexington Hotel. Clinton J. Warren was the architect. Photographs are in CSA, fig. 114; CIM, p. 448; CSV, p. 233 facade detail; RB January 27, 1990, p. 1; and the *Chicago Tribune,* December 28, 1995.

North: PLAZA HOTEL, HABS, 1892–1965, at 1553 N. Clark Street, at the southeast corner of W. North Avenue, was eight stories high, on spread foundations. Clinton J. Warren was the architect. A view is in RMNV, V28. Photographs are in CIM, p. 522; CSA, fig. 115; and CIDL, p. 21. The Latin School of Chicago occupies this site.

North: MILNER HOTEL, 1892–(1950 to 1990), at the northwest corner of N. Rush Street and E. Grand Avenue, formerly known as the Bradley Hotel, was eight stories high, of ordinary construction.

North: NEWBERRY LIBRARY, HABS, CLSI/premier, built in 1892, in the Washington Square District/CAL, is at 60 W. Walton Street, on the northeast corner of N. Clark Street and occupying the entire block. Henry Ives Cobb was the architect. The building is four stories high, on pile foundations. Larimer columns were used here for the first time in Chicago (AEF); they are illustrated in RG October 30, 1891. A photograph of the building is in IA March 1893; CHC, p. 63; CIM, p. 480; and RMNP. A description is in RMNV, V25, and HCCB, p. 58, with an illustration on p. 59. Photographs are also in CFB "merit"; COF detail; GCA, p. 31; and CTCP, p. 7. Library benefactor Mahlon D. Ogden's house, demolished ca. 1890, previously occupied this site; photos are in CIM, p. 163, and ILL, p. 59. The 10-story addition was made in 1982 by Harry Weese, architect.

North: *BOARD OF HEALTH building,* NR, HABS, CLSI, at 70 W. Hubbard Street, on the northwest corner of N. Dearborn Street, formerly the *Criminal Courts building,* was built in 1892. The jail portion was torn down in 1936. The building is six stories high, on spread foundations. Otto H. Matz was the architect. A photograph is in CIM, p. 487. This site was occupied formerly by North Market Hall, which was built in 1851. The first Criminal Court and

County Jail building on this site (illustrated in CAC, p. 21) was completed in 1874, with Armstrong and Egan as architects. The court house fronted 140 feet on W. Hubbard Street and 65 feet on N. Dearborn Street; the jail fronted 141 feet on W. Illinois Street. The former was three stories high; the latter, two stories. An illustration is in HCA Vol. 3, p. 241; TYF; and LO December 1872, pp. 208 and 209, with a description on p. 206. This building was torn down in 1892 to make way for the present building, which is illustrated in IA March 1893. This city office building was converted to rental offices in 1985 and renamed Courthouse Place; Solomon, Cordwell & Buenz were the architects. Photographs are in ABOV, p. 55; CAJZ, p. 19; HB; and RB Annual Review, June 30, 1990, p. 76.

North: *JAMES CHARNLEY HOUSE*, NHL, NR, CAL/CHALC, HABS, CLSI/premier, built in 1892 at 1265 N. Astor Street, at the southeast corner of E. Schiller Street, in the Astor Street Landmark District/CHALC, within the Gold Coast Historic District/NR. Adler & Sullivan were the architects and Frank Lloyd Wright the designer. Articles are in IA August 1891 and in PA April 1989, p. 76. Photographs are in LSM, fig. 42; COF; ACMA, p. 67; SRT; CFB "merit"; *Art and Life in America*, O. W. Larkin, 1949, p. 291; AR April 1925, p. 295; *Architectural Annual*, 1901, p. 68; LSCS, p. 52; *Lost America: Mississippi to Pacific*, Constance M. Greiff, 1972, p. 228, with addition. The house was for years a property of (and restored by, including the removal of the south addition) the Skidmore, Owings & Merrill Foundation. It became the Charnley-Persky (Foundation) house in 1994, and it is now occupied by the national headquarters of the Society of Architectural Historians and is also operated as a public museum.

North: *BRYAN LATHROP HOUSE*, NR, CAL, HABS, CLSI/premier, built in 1892 at 120 E. Bellevue Place, in the Gold Coast Historic District/NR, is three stories high. It was renamed the Fortnightly (Club) of Chicago in 1922. McKim, Mead & White were the architects, with Holabird & Roche, associated. Photographs are in CFB "merit"; CANY, p. 17; IA August 1891; AGC, p. 157; CIDL, p. 103; and *The Fortnightly of Chicago*, a 1972 monograph by Muriel Beadle. A view is in RMNV, V27.

North: (Old) *CHICAGO HISTORICAL SOCIETY building 3*, NR, HABS, CLSI/premier, 632 N. Dearborn Street, at the northwest corner of W. Ontario Street, begun August 13, 1892, is two stories high. Henry Ives Cobb was the architect. It was also known as the Institute of Design, the Podbielnik Institute, the Studio building, and now Excalibur, a nightclub. Photographs are in AGC, p. 129; CTCP, p. 11; CALP; RMP, p. 56; CIM, p. 481; and CAA; an illustration is in HCCB, p. 57. The society originated in 1856. Its first building, on the same site, burned in the great fire of 1871. For several years it had no home. Its collections were burned again in the great fire of July 14, 1874, which was confined to the area south of Van Buren Street. The second

building of the society was completed in 1877, but it was wrecked to make way for the third. It is illustrated in HCA Vol. 3, p. 410. A history of the society is in the latter volume, as well as in C, p. 41.

1892: A quintuple-foldout lithographic view of the city in all directions from the roof of the Monadnock building is in WCWF.

1893: A city ordinance limited building height to 130 feet. Up to the time of the erection of the Masonic Temple building there was no limit, by ordinance, to the height of buildings, but after its erection, and without any publicity, the Chicago City Council considered the reduction of the legal heights of buildings in the city. EAR relates how this affected the office of Holabird and Roche:

> The first intimation of this move came to our office one Thursday morning at eleven o'clock . . . that the Council would pass an ordinance [the next] Monday night limiting the height to 130 feet. . . . We decided to make an offer to some of our clients to make the necessary permit drawings at our expense for several 16-story buildings, providing the owners would pay for taking out the permits. . . . Monday at ten o'clock the sets of drawings [including] basement, first, second, typical floor and roof plans, elevations, sections, steel diagrams and plumbing diagrams were complete.

Four of the five buildings were built later — the south half of the Monadnock (1893), the Old Colony (1894), the Marquette (1895), and the Champlain (1894).

1893: North Lake Shore Drive was built from Ohio Street to Oak Street. The World's Columbian Exposition, a very strong catalyst for erecting many buildings, was held on the South Side. The most noteworthy building was Adler and Sullivan's Transportation building.

179 W. WASHINGTON STREET building, built in 1893, with Handy & Cady as architects, was originally called the Teutonic building and then the Roosevelt building. The building is 10 stories (138 feet) high, on spread foundations using beam-and-rail grillages. It is illustrated in IA August 1892 and is described and illustrated in EN February 16, 1893. A view of the building is in RMNV, V19. A photograph is in RB February 6, 1971, p. 1, and Annual Review, January 27, 1993, p. 20; the building was refaced and converted back to an earlier usage as a parking structure.

ASSOCIATION building, known as the Central YMCA building, at 19 S. LaSalle Street, was built in 1893. It is 16 stories high, on spread foundations with steel-beam grillages. Jenney & Mundie were the architects. A cross section of a heavy Z-bar steel column used is shown in AEF. The building is

illustrated in IA August 1892, and OBD 1929, p. 33. It is described and illustrated in EN February 16, 1893. A view is in RMNV, V5, and a photograph is in RMNP; CTCP, p. 50; and CIM, p. 597, with the Major Block/Roanoke building. It was renamed the 19 S. LaSalle Street building. The 1872 Andrews building previously occupied the front of this site.

15–19 N. LaSALLE STREET building, 1893–1929, known as the Watson building, was a nine-story structure on the site now occupied by the One N. LaSalle Street building. A photograph is in CIM, p. 403, and in CTCP, p. 45, two doors to the left of the Tacoma building.

COLUMBUS MEMORIAL building, 1893–1959, HABS, at 31 N. State Street, on the southeast corner of E. Washington Street, was 14 stories high, on spread foundations. W. W. Boyington was the architect and Corydon T. Purdy the engineer. The building is described and illustrated in EN February 16, 1893, and a floor plan is shown in ER January 5, 1895. A photograph is in CAA; CIM, p. 548; CHC, p. 20; and OBD 1929, p. 89. A view is in HCCB, p. 44, with a description on p. 43, and in RMNV, V17. Photographs are also in CTCP, p. 42; CAJZ, p. 148; CON, p. 126; and LC, p. 144. The Hale building 2, 1872–1891, was on this corner previously, with a frontage of 120 feet on N. State Street and 90 feet on E. Washington Street. E. S. Jennison, the architect, also did the previous six-story Hale building 1, 1870–1871 fire, on this site. The architect was a co-owner with W. E. Hale — the first recorded instance of this kind. An illustration of the postfire Hale building is in TYF and in LO February 1873, p. 28, with a description. A photograph is in CIM (p. 341), taken probably in the 1880s, and in CIM, p. 343. The three-story Old Navy clothing store (NI) occupies this site.

LEES building, 1893–1969, at 15–23 S. Wells Street, 12 stories high (141 feet), was on spread foundations. James Gamble Rogers was the architect. A description is in EN February 16, 1893, and a photograph is in RMNP and in CIM, p. 412. A view is in OBD 1929, p. 168, and RMNV, V5. An article is in IA-C April 1969, p. 22, and a photograph is in RB May 27, 1950, p. 1. The Davidson Block previously occupied this site.

MEDINAH building, 1893–1969, at the northeast corner of S. Wells and W. Jackson Streets, was 14 stories high, on pile foundations. Beers, Clay & Dutton were the architects. Twelve stories were removed in 1931. A photograph of the original building is in *Chicago Tribune,* February 17, 1940; RMNP; and CIM, p. 376. A view is in RMNV, V1. It was also known as the Medinah Temple building. A Federal Reserve Bank building addition occupies this site.

SODEN building of the Illinois Bell Telephone Co., 1893–ca. 1965, at the southeast corner of N. Franklin and W. Randolph Streets, was six stories

high, on spread foundations. D. H. Burnham was the architect. It was re-named the Illinois Bell Telephone building. The 1967 Illinois Bell Telephone building occupies this site.

William MEYER building, CAL, HABS, 1893–1968, at 301–11 W. Van Buren Street, on the southwest corner of S. Franklin Street, was seven stories high, on spread foundations. Adler & Sullivan were the architects. A photograph is in LSM; CFB; CSA, fig. 92; SFO, p. 98; IA April 1892; and RNRC, p. 175. RMNV reported that the "Wilson" building (not listed here) was on this site in 1893. This site is vacant.

CHICAGO ATHLETIC CLUB building, at 12 S. Michigan Avenue, was completed in 1893 after a disastrous fire. It is 10 and 11 stories high, on spread foundations. Henry Ives Cobb was the architect. A photograph is in CAA. The building is illustrated in RMNP and in IA October 1895 and March 1896. A description is in SGC, p. 222. A view is in RMNV, V7. The adjoining addition at 71–73 E. Madison Street was built in 1906, 12 stories high with three basements, steel columns, and rock caissons. Richard E. Schmidt, Garden & Martin were the architects. The cost of this 12-story annex was 46.88 cents per cubic foot. Seven stories were added to this portion in 1926. An illustration showing the addition is in ISA 1925, p. 314, and, for the lower stories, in WO, p. 19. The building was renamed the Chicago Athletic Association building. See appendix F.

SECURITY building, 1893–(1950 to 1990), at 189 W. Madison Street, was 14 stories (200 feet) high, on spread foundations. Clinton J. Warren was the architect. The building is described in EN February 16, 1893. A photograph is in RMNP and in CIM, p. 412. A view is in OBD 1916, p. 223, with a description, and RMNV, V5. The Paine Webber Tower building occupies this site.

MAJESTIC HOTEL, 1893–1961, at 29 W. Quincy Street, was 17 stories high, on spread foundations. D. H. Burnham was the architect and E. C. Shankland the engineer. A photograph is in CHC, p. 232. An illustration is in *Hotel Monthly* June 1912, and CSA, fig. 66. The Federal Center includes this site. The original building on this site was the home of David Morrill Bradley, who purchased the land in 1837.

VAN BUREN building, built in 1893 at 210–14 W. Van Buren Street, is 10 stories high. Flanders & Zimmerman were the architects. A brief description is in RMNV, V9. Photographs are in WO, p. 37; HB; and RB April 28, 1990, p. 64. A plate, as the Kultchar building, is in IA October 1892. It was renamed the 212 W. Van Buren Street building.

HARTFORD building, 1893/1903–1968, at 8 S. Dearborn Street, on the southwest corner of W. Madison Street, was built in two portions, the east

one in 1893 on the site of the former Hawley Block fronting 50 feet on W. Madison Street, and the west 45 feet at 57–61 W. Madison Street, 14 stories and an attic high, 165 feet. The east portion was on spread foundations, and the west portion on caissons (EN December 22, 1904). Henry Ives Cobb was the architect. A description of the building is in EN February 16, 1893, and RMNV, V6. An illustration of the original building is in OBD 1901, p. 84, and a photograph of the same is in CIM, p. 573. In 1940, preceding the building of the Dearborn Street subway, the east wall was underpinned with eight hardpan caissons. An illustration of the completed building is in OBD 1941–42, p. 158, and CTCP, p. 44. The One First National Plaza building includes this site.

South: ILLINOIS CENTRAL RAILROAD CO. OFFICE building, at the southeast corner of S. Michigan Avenue and E. Roosevelt Road, originally Ashland Block 1 at the northeast corner of N. Clark and W. Randolph Streets, was moved ca. 1891 in three sections to S. Michigan Avenue south of E. Roosevelt Road and became known as the Dowie building, the Zion building, and the Imperial Hotel, and was located on a site 85 feet north, having been moved again in 1923. The building, seven stories high, was on spread foundations, and was completed ca. 1893. Baumann & Cady were the architects. A view of the building in its former location is in RMNV, V11. A description of the second moving operation, with photographs, is in WSE January 1924. It was demolished before 1990.

South: CONGRESS HOTEL, at 504 S. Michigan Avenue, formerly known as the Auditorium Annex, was built in 1893. Clinton J. Warren was the architect. It is 10 stories high, on spread foundations. A photograph is in RMNP and CIM. A view is in CHC, p. 230, and RMNV, V8. The south portion of the hotel, formerly known as the CONGRESS HOTEL ANNEX, at 520 S. Michigan Avenue, was built in 1902 and 1907 from plans by Holabird & Roche, architects, and is 14 stories high, on piles and caissons. A photograph of the building is in COF; CSA, fig. 116; HRHR Vol. 1, p. 224; HB; CAA; CIM, p. 446; and ARV 1913, p. 87, with first and typical floor plans and interior photographs shown on pp. 160 and 162. Floor plans are in BB 1903, pp. 31, 50, and 71. See appendix F. The hotel was also known as the Pick-Congress and as the American Congress, and it is now the Ramada Congress Hotel. The north bay was arcaded for the widening of Congress Parkway.

30 N. LaSALLE STREET/CHICAGO STOCK EXCHANGE building, CAL/ CHALC, HABS/drawing, 1894–1972, was at the southwest corner of W. Washington Street, 100 feet deep and a frontage of 180 feet. The building was 13 stories high, 172 feet, carried on pile foundations except for the hardpan caissons under the west party wall, which were the first caissons used in Chicago. For the story see HBF. Adler & Sullivan were the architects and Gen. William Sooy Smith the foundation engineer. The foundations are

described in EN August 31, 1893, and the building is illustrated in LSM; CHC, p. 26; IA February 1893; OBD 1916, p. 46; and AEF with floor plans. A photograph is in CIM, p. 404; RMNP; OBD 1901, p. 52; CFB; CRT; CSA, figs. 95–99; COF; ACMA, p. 53; SFO, p. 104; LSCS, p. 38; CTCP, p. 37; RB Annual Review, January 27, 1973; HB; and RNRC, with 10 photographs and the story of the preservation campaign led by Richard Nickel. The arched entranceway and the Trading Room were reconstructed at the Art Institute (q.v.); articles are in AF November 1972, p. 29, and IA-C November 1972, p. 17. MERCANTILE building 2, at 22–28 N. LaSalle Street, built in 1873, four stories high, 80 feet frontage and 100 feet deep, formerly occupied the south portion of this site; it is illustrated in LO January 1874, p. 4. Burling & Adler were the architects. Here was housed the banking house of Greenebaum & Sons. A partial photograph of the prefire MERCANTILE building 1 is in CIM, p. 391. The Union Block, 80 feet deep, occupied the north portion of this site. The City National Bank building, at 159–65 W. Washington Street, with a frontage of 80 feet, occupied the rest of the frontage on W. Washington Street, and also that of the late Andrews building. The Washington Hotel was on this corner before the great fire. The 1975 30 N. LaSalle Street building occupies this site.

APPAREL building, 1894–ca. 1953, at the southeast corner of S. Franklin and W. Van Buren Streets, was seven stories high, and was remodeled in 1917 by Alfred S. Alschuler, architect. The building was demolished for the Congress Parkway extension.

CHEMICAL BANK building, 1894–1927, later the Iroquois building, was on the site of the present One N. LaSalle building at 21–23 N. LaSalle Street adjoining the alley on the north. It was nine stories high, on spread foundations. A photograph is in CIM, pp. 401 and 403; OBD 1910, p. 104; JWR, plate 89; CTCP, p. 45, third door to the left of the Tacoma building.

OLD COLONY building, NR, CAL/CHALC, IR, HABS, CLSI/premier, part of the South Dearborn Printing House Row Historic District/NHL, at 407 S. Dearborn Street, on the southeast corner of W. Van Buren Street, was completed in 1894. Holabird & Roche were the architects, and Corydon T. Purdy was the engineer. The building is 17 stories (215 feet) high and was built on spread foundations with beam grillages. There are no self-supporting walls.

> Several years before we [Holabird & Roche] built the Old Colony building we [had] built a little one-story tax-payer on the lot. . . . A building had been built immediately to the south and a party wall agreement entered into. . . . Over the signature of Adler and Sullivan it was stated that the wall and foundation would be adequate for any future building that would be built in Chicago. Subsequent developments only proved how far they were

from having any conception of what skeleton construction might lead to. . . . we found that the foundations [of the party wall] were absolutely inadequate. . . . As a matter of fact we found that the party wall had settled so much out of plumb that two or three stories up it was beyond our [lot] line entirely. . . . our problem was to carry the load on cantilever(s) [independent of the party wall].

Later the south end began to settle more rapidly than the north and . . . we were compelled to put caissons there. (EAR)

Four caissons were built by General Sooy Smith to support the south wall in order to stop its settlement. After nine months the average settlement of all foundations was 4³⁄₁₆ inches (EN December 21, 1893). The combined footings, details of the Phoenix columns, and an illustration of the building are in AEF. A description of the building is in EN February 16, 1893; the portal system of wind bracing is illustrated in AEF and ER September 17, 1898. The original cost of the Old Colony building, including architects' fee, was 42.16 cents per cubic foot (EAR). A photograph of the building is in AR April 1912; CSA, fig. 76; STL, p. 46; HRHR Vol. 1, p. 130; CTCP, p. 82; HB; and RMNP. A view is in RMNV, V10. In 1947, preceding the extension of the Dearborn Street subway south of Van Buren Street, hardpan caissons were built under the Dearborn Street columns.

CHAMPLAIN building, special significance, 1894–1916, was at the northwest corner of N. State and W. Madison Streets on the site of the State-Madison building. It was 15 stories high, on spread foundations. Holabird & Roche were the architects. The original cost of the building, including architects' fees, was 40.21 cents per cubic foot (EAR). A floor plan is shown in AEF, and the building is illustrated in IA November 1893. A photograph is in CIM, p. 340; RMNP; HRHR Vol. 1, p. 141; and CTCP, p. 43. A description of conditions found during demolition is in ER August 21, 1915. The Doré Block, a five-story building fronting 65 feet on N. State Street and 105.9 feet on W. Madison Street, occupied this site previously. A photograph is in CIM, pp. 339 and 599. Otis L. Wheelock was the architect. A photograph of the E. F. Doré Block as the Dairy Kitchen Hotel (1872–1893) is in *Chicago: Historical Guide to the Neighborhoods*, Glen E. Holt, 1978, p. 21.

LaSALLE-MONROE building, HABS, at 37–43 S. LaSalle Street, on the northeast corner of W. Monroe Street, formerly the New York Life building, was completed as a 12-story building in 1894. Jenney & Mundie were the architects. The building is now 14 stories high, on spread foundations with beam grillages, two stories having been added at a later date. The east half was built in 1898, 13 stories high, at which time one story was added to the west half. An additional story was added to the entire building in 1903. The building was set 4½ inches above normal grade, 2½ inches to 3 inches settlement being expected during construction with a soil pressure of 3,500

pounds per square foot. A complete steel frame was used with gusset plates for wind bracing. It is claimed that this is the first building in which the walls were not built from the ground up, but were begun at several floors. A description and an illustration of the traveler for setting the stone is in ER October 21, 1893. The building is illustrated in IA October 1894, and AEF, with floor plans. A photograph is in CIM, p. 398; RMNP; OBD 1916, p. 178; and HB. Construction photographs are in CCNT, p. 26. A drawing is in TBAR, p. 23. The building was renamed the 39 S. LaSalle Street building. The Nixon building previously occupied this site.

OTTOWA building, 1894–(before 1949), was at 62–66 W. Madison Street. John M. Van Osdel II was the architect. The site is now occupied by the Three First National Plaza building.

426–28 S. WABASH AVENUE building, ca. 1894–(1950 to 1990), was six stories high. It was called the 428 S. Wabash Avenue building.

North: 46–54 E. HUBBARD STREET building, 1894–(1950 to 1976), was seven stories high, of mill construction, on spread foundations. Fred Ahlschlager was the architect. It is occupied by the Monarch Refrigerating Co. The Downtown Sports Club, 441 N. Wabash Avenue, includes this site.

North: 56–62 E. HUBBARD STREET building, 1894–(1950 to 1976), was seven stories high, of mill construction, on spread foundations. Fred Ahlschlager was the architect. It was occupied by the Monarch Refrigerating Co. The Downtown Sports Club, 441 N. Wabash Avenue, includes this site.

North: 51–53 E. HUBBARD STREET building, 1894–(1950 to 1970), was seven stories high, of mill construction, on spread foundations. Fred Ahlschlager was the architect. The River Plaza apartment building includes this site.

North: 241–43 E. ILLINOIS STREET building, 1894–(1950 to 1990), was five stories high, of mill construction, on spread foundations. Henry Ives Cobb was the architect. This site is vacant.

South: 511–15 S. PLYMOUTH COURT building 1, 1894–1920 fire, was six stories high. The foundations and part of the walls of this building were used (1920) in the construction of building 2, which was rebuilt to the same height. C. A. Eckstorm was the architect.

North: 40 E. HUBBARD STREET building, 1894–(1950 to 1976), at the northeast corner of N. Wabash Avenue, was of ordinary construction with cast-iron columns, six stories high, on spread foundations. Fred Ahlschlager was the architect. Formerly used as a refrigeration building, it had been converted for office use (RB August 31, 1948, with illustrations); Travelletti

and Suter were the architects. The Downtown Sports Club, 441 N. Wabash Avenue, occupies this site.

North: CHICAGO FLEXIBLE SHAFT CO. building, once known as the W. F. McLaughlin & Co. building, at 610 N. LaSalle Drive, on the southwest corner of W. Ontario Street, built in 1894, is eight stories high. A new street front was built in 1936 when N. LaSalle Street was widened. An illustration is in HCCB, p. 148B. The building was converted and renamed Mages Sports Store and Sportmart.

North: *LAMBERT TREE STUDIOS,* NR, IR, CLSI, was built in 1894 at 4 E. Ohio Street, at the northeast corner of (601) N. State Street. It has been called the Fine Arts building. Parfitt Brothers were the architects with Hill & Woltersdorf, architects, associated. Photographs are in CANY, p. 12; AGC, p. 128; CALP; and COF, detail. An addition was made in 1912.

317–19 S. MARKET STREET building, ca. 1895–(1950 to 1990), was six stories high.

105 W. MONROE STREET building, 1895–1957, at the southwest corner of S. Clark Street, was formerly known as the Nixon and the Standard Trust & Savings Bank buildings and originally as the Fort Dearborn building. It was 16 stories high, on spread foundations with beam grillages. Jenney & Mundie were the architects. Plate and angle columns were used for the lower stories, then channels and plates, with latticed channels for the upper stories. Gusset plates on girders were used for the wind bracing. The building is described and illustrated in EN October 17, 1895, and is illustrated in AEF with floor plans, steel framing plan, and spandrel sections. A photograph of the entrance is in IA May 1896. An illustration is in OBD 1910, p. 89. A photograph is in CTCP, p. 56. The 1956 Harris Bank addition occupies this site. The corner site was occupied previously by the Foote Block (1873–1894) with a frontage of 78 feet on S. Clark Street. This building was four stories high; an illustration is in LO February 1873, p. 29. John M. Van Osdel was the architect. The Ingals building, at 110–28 S. Clark Street, adjoined the Foote Block to the south, with a frontage of 110 feet.

MARQUETTE building, NHL, CAL/CHALC, HABS, CLSI/premier, at 140 S. Dearborn Street, on the northwest corner of W. Adams Street, built in 1895, is 17 stories (205 feet) high. It has a frontage of 190 feet on S. Dearborn Street and 140 feet on W. Adams Street. An addition was built in 1905 occupying the west 26 feet of the present Adams Street frontage and a depth of 100 feet. Holabird & Roche were the architects, and Purdy & Henderson the engineers. "The framework is entirely of steel, with Z-bar columns two stories in length, the alternate columns breaking joints, and is carried on steel beam and concrete foundations" (EN, October 17, 1895). The founda-

tions are illustrated in AEF, which shows also a floor plan and spandrel section. In 1940 caissons to hardpan were built under the east wall. Unique provision was made originally at the bases of the columns in the west party wall for hydraulic apparatus to take care of unequal settlement. This arrangement is described in EN October 17, 1895; that article shows an illustration of the building, as does also IA November 1895. The cost of the original Marquette building, including architects' fees, was 31.677 cents per cubic foot; and of the addition, 39.06 cents per cubic foot (EAR). Photographs of the unusual mosaic-tile Indian decorations of the rotunda are in IA March 1896, and AR April 1912, the latter of which contains a photograph and floor plans of the building. A photograph is in CIM, p. 557; CHC, p. 80; and RMNP. An illustration and a brief description are in OBD 1916, p. 136. Photographs are in CFB "merit"; CSA, fig. 74; AGC, p. 11, under construction; STL, p. 48; HRHR Vol. 1, p. 120; CTCP, p. 64; TBC, p. 141; and HB. The Kinsley building previously occupied a portion of this site.

GREAT NORTHERN OFFICE AND THEATER building, 1895–1961, at 20 W. Jackson Street, was 17 stories high, on spread foundations. Daniel H. Burnham was the architect, and Edward C. Shankland the engineer. Photographs are in CAA; CHC, p. 21; and CIDL, p. 38. An illustration is in OBD 1929, p. 136. The Dirksen Federal Center building includes this site.

OCCIDENTAL building, HABS and HA, 1895–1970s, 107–11 N. Wacker Drive, at the northeast corner of N. Wacker Drive and W. Washington Street, John M. Van Osdel II was the architect. The building was eight stories high, on spread foundations. It is illustrated in IA for July 1895. A photograph and a brief description are in OBD 1916, p. 184. Detailed cost records are in the books of account of John M. Van Osdel at the Chicago Historical Society. The 101 N. Wacker Drive building occupies this site.

JARVIS building, ca. 1895–(1950 to 1980), at 18–20 N. Clark Street, was five stories high, operated in conjunction with 10 N. Clark Street building. The 20 N. Clark Street building includes this site.

QUINCY NO. 9, ca. 1895–(1950 to 1990), was eight stories high. The Benson & Rixon store includes this site.

ENTERPRISE building, 1895–(1950 to 1990), at 125–27 N. Wells Street, was 10 stories high, on spread foundations. Howard Van Doren Shaw was the architect. The 120 N. LaSalle Street building includes this site.

South: BRUNSWICK (Balke, Collender) building, CLSI, formerly the Studebaker building, at 629 S. Wabash Avenue, was built in 1895. S. S. Beman was the architect. The building is 10 stories high, on spread foundations. It is illustrated in IA August 1895. Photographs are in CSA, fig. 105; CCNT, p. 30; STL, p. 20; CTCP, p. 90; and RB January 7, 1984, p. 2. The building was

converted in 1987 and renamed Columbia College, Wabash Campus, the 623 S. Wabash Avenue building; Michael Arenson, architect.

South: 830 S. MICHIGAN AVENUE HOTEL, formerly known as the YWCA Hotel, built in 1895, is eight stories high, on spread foundations. John M. Van Osdel II was the architect. A photograph is in CIM. Detailed costs are in VO. It was renamed the Michigan Avenue Hotel, and later it was converted to offices as the (John H.) Johnson Publications building, 820 S. Michigan Avenue building.

North: WESTERN COLD STORAGE CO. building, ca. 1895–(1950 to 1990), at 17–19 E. Illinois Street, was six stories high. Photographs are in IA November 1899. Jarvis Hunt was the architect. The 444 N. Michigan Avenue building includes this site.

North: 225–39 E. ILLINOIS STREET building, 1895–(1950 to 1990), was six stories high, of mill construction, on spread foundations. Henry Ives Cobb was the architect. This site is used for parking.

6 N. CLARK STREET building, 1896–1941, at the northwest corner of W. Madison Street, with a frontage of 63 feet on the former and 80 feet on the latter, was formerly known as the Straus, the H. O. Stone, and (originally) the Atwood building. It was 10 stories and an attic high, on spread foundations with steel beam grillages. Holabird & Roche were the architects, and Purdy & Henderson the engineers. The building, designed for 13 stories, had both portal and diagonal wind bracing and was set up with an allowance of 6½ inches for settlement. The cost of the Atwood building, including architects' fees, was 35.24 cents per cubic foot (EAR). The original building is described and illustrated in EN October 17, 1895. A photograph is in CIM, p. 411, and HRHR Vol. 1, p. 152. An illustration and a description are in OBD 1916, p. 232. The C. O. D. Block, at 2 N. Clark Street, four stories high and with a depth of 80 feet, formerly occupied this site. A photograph is in CIM, p. 410. The Avondale Center building includes this site.

FISHER building, NR, CAL/CHALC, HABS, CLSI/premier, was built in 1896, in the South Dearborn Street Printing House Row Historic District/ NHL, at 343 S. Dearborn Street on the northeast corner of W. Van Buren Street. It is 18 stories, 230 feet high. Charles Atwood was the designer for D. H. Burnham & Co., architects, and E. C. Shankland was the engineer. A unique feature was the use of 25-foot piles under the spread foundations in order to consolidate the soil; and the use on that account of a higher soil pressure, 6,000 pounds per square foot. Gray steel columns were used, and girder wind-bracing. Photographs taken during construction are shown in B. A new record for rapid steel erection was claimed by the erection of 13½ stories of steel work in 14 days. It was built almost simultaneously with this

contractor's (Guaranty Construction Company's) Guaranty building of March 1895–March 1896, the Buffalo masterwork of Adler & Sullivan. A tabulation of certain column loads and pier details is given in AEF. Descriptions and illustrations of the building are in EN October 17, 1897, and IA July 1895, and May 1896. A photograph is in RMNP, and an illustration is in HCCB, p. 59B. The addition to the north at 337–39 S. Dearborn Street was built in 1907, 20 stories high, on rock caissons, with Peter J. Weber as architect and E. C. & R. M. Shankland as engineers. Photographs of the building are in CFB; COF; CSA, fig. 68; WO, p. 27, detail; STL, p. 34; CTCP, p. 77; and HB. Dated construction photographs from late 1895 that were published in Germany in *Baugewerks-Zeitung,* November 7, 1896, appear in *An Early Encounter with Tomorrow,* Arnold Lewis, 1997, p. 65.

ILLINOIS TRUST & SAVINGS BANK building, 1896–1923, was at the northeast corner of S. LaSalle and W. Jackson Streets on the site of the Continental Illinois National Bank & Trust Co. building. It was two stories high with cast-iron columns, on spread foundations. D. H. Burnham & Co. were the architects, E. C. Shankland the engineer, and E. R. Graham the superintendent. It is illustrated in IA June 1896. Photographs and a description are in IA May 1897. Photographs are also in CAA; DHBM; CHC, p. 128; AR July 1915; and RMNP. Photographs of portions of the facade are in CTCP, pp. 65 and 74. An interior photograph is in LC, p. 207. The west portion of the Grand Pacific Hotel previously occupied this site. On July 21, 1919, a small blimp crashed through the skylight, killing and injuring a number of people (AAC, p. 57).

CHICAGO MUSICAL COLLEGE building, HABS, (1896–1960s), was at 64 E. Van Buren Street, formerly called Steinway Hall. Dwight H. Perkins was the architect and Professor Lewis J. Johnson the engineer. The building was 11 stories high, 158 feet to the ridge, on spread foundations, with beam grillages. It is described and illustrated in EN October 17, 1895; exterior and interior photographs are in IA February 1897. A photograph and floor plans are in WA November 1930. An illustration is in OBD 1929, p. 76. This site was occupied previously by the New Jerusalem Temple.

BALTIMORE building, 1896–1930, on the site of the former Palmer House Garage at 18–22 W. Quincy Street, was eight stories high. A photograph is in OBD 1916, p. 27.

South: MORTON building, known later as the 538 S. Dearborn Street building, built in 1896, is 11 stories high, on spread foundations. Jenney & Mundie were the architects. A photograph is in OBD 1916, p. 172, and CSA, fig. 57. It was also known as the Star Insurance building. It is in the South Loop Printing House Historic District/NR. It was converted, with the Duplicator building and an addition, and renamed the Hyatt on Printers Row Hotel,

500 S. Dearborn Street. The 1987 eight-story addition extends to Congress Parkway; Booth, Hansen were the architects. An article is in IA-C September 1988, p. 52. It has been known as the Morton and as the Omni Morton Hotel. The Keuffel & Esser building occupied the north part of this site.

South: NEWBURY building, 1896–(1950 to 1990), known later as the Ninth-Wabash building, at the northeast corner of S. Wabash Avenue and E. Ninth Street, was eight stories high. Jules F. Wegman was the architect.

North: 325 W. OHIO STREET building, 1896, is seven stories high, designed for a live load of 325 pounds per square foot, on wood pile foundations. S. V. Shipman was the architect. It was later known as the Berry building and as the Bowne building. A photograph is in RB Annual Review, January 29, 1966, p. 151.

TRUDE building, 1897–1912, was at the southwest corner of N. Wabash Avenue and E. Randolph Street, on the site of the present "North" building of the Marshall Field & Co. Store. Jenney & Mundie were the architects. The building was 16 stories high, on spread foundations. It is described and illustrated in IA August 1896.

CHICAGO PUBLIC LIBRARY, NR, CAL/CHALC, CLSI/premier, at 78 E. Washington Street, at the northwest corner of N. Michigan Avenue and extending to E. Randolph Street, was completed in 1897, with Shepley, Rutan & Coolidge as architects (AR July 1896). The building is four stories high and is supported on 50-foot pile foundations, which are described in ER June 17, 1893, and EN July 6, 1893. The latter account has a description of the test on four piles. William Sooy Smith was the consulting engineer for the foundations. Photographs, plans, and a description of the building are in IA January 1898. A photograph is in CAA, p. 480; CHC, p. 62; CIM; and RMNP. A description and an illustration are in HCCB, pp. 58 and 59, and RMNV, V17. Photographs are also in AUS, p. 155; COF; PGC, p. 27; CAC; and HB. See appendix F. The building was renamed the Chicago Public Library Cultural Center and is known as the Chicago Cultural Center; it includes a Visitors Information Center. Most of the library materials were relocated to the Harold Washington Library Center (q.v.). The five-story Armour building was on this site formerly; it is illustrated in CYT, p. 14.

STEWART HOUSE building 2, 1897–(1950 to 1990), was at 108 N. State Street, on the northwest corner of W. Washington Street. D. H. Burnham & Co. were the architects. The building was 12 stories high, on spread foundations. A photograph is in CAA, AWG, RMNP, and RB February 3, 1951. An illustration and a description are in OBD 1916, p. 230. STEWART building 1 previously occupied this site. The St. James Hotel (1868–1871 fire) previously occupied this "Block 37" site, which is now vacant.

445–47 S. PLYMOUTH COURT building, ca. 1897–ca. 1949, was seven stories high, on spread foundations. This building was condemned and removed by the Department of Subways and Superhighways for the Congress Parkway widening.

25–27 S. MARKET STREET building, ca. 1897–(1950 to 1990), was seven stories high. T. B. WEBER & CO. building, 1872– , five stories high, formerly occupied this site; it is illustrated in LO September 1872, p. 157, with a description on p. 150. This site is vacant.

PRICE building, 1897–early 1950s, at 319–35 W. Van Buren Street, formerly known as the Hart, Schaffner & Marx building, was eight stories high, on spread foundations. Holabird & Roche were the architects. The cost of the building, including architects' fees, was 11.49 cents per cubic foot (EAR). A photograph is in HRHR Vol. 1, p. 167. A Unicom Thermal Technologies building occupies part of this site.

SILVERSMITH building, CLSI, at 10 S. Wabash Avenue, is 10 stories high, on pile foundations. D. H. Burnham & Co. were the architects and Joachim G. Giaver the engineer. A photograph is in OBD 1941–42, p. 362; CTC, p. 52, scene with sidewall signage; and RB May 27, 1972, p. 1. It was renamed the 10 S. Wabash Avenue building and later the Crowne Plaza Hotel.

WASHINGTON HOTEL, 1897–ca. 1970, at 167 W. Washington Street, originally the Journal building, was 11 stories high, on pile foundations. Jarvis Hunt was the architect. A photograph is in OBD 1901, p. 92.

South: *731 S. PLYMOUTH COURT building*, NR, HABS, CLSI, built in 1897 at the northeast corner of W. Polk Street, formerly known as the Plymouth-Polk building and as the R. R. Donnelley building, is seven stories high. Howard Van Doren Shaw was the architect. It is in the South Loop Printing House Historic District/NR. It was also known as the South Plymouth building, as Lakeside Press, and as Triangle Publications. A drawing is in CA, p. 61. Photographs are in CFB "merit," 1993, p. 81; ABOV, p. 82, at right center with a penthouse addition and arched seventh floor windows; and WO, p. 12. It was converted in 1985 and renamed the Lakeside Loft Apartments; Lisec & Biederman were the architects. In 1993 it was renamed the Columbia College Resident Center.

North: AMANDA APARTMENTS, at 56–60 E. Chicago Avenue, built in 1897, is six stories high, of ordinary construction, on spread foundations. Pond & Pond were the architects.

North: 311 E. ILLINOIS STREET building, 1897–(1950 to 1990), was six stories high, of mill construction, on spread foundations. Henry Ives Cobb was the architect. The site is used for parking.

North: 1210 N. ASTOR STREET apartment building, CLSI, in the Astor Street Landmark District/CHALC, within the Gold Coast Historic District/ NR, at the northwest corner of E. Division Street, was known previously as the McConnell apartment building. Built in 1897, it is seven stories high on an English basement. It is said to be the oldest fireproof apartment building on the North Side. Holabird & Roche were the architects. The building was renamed the Renaissance Condominiums, 1200 N. Astor Street. Photographs are in HRHR Vol. 2, p. 168; HB; and RB October 28, 1972, p. 1.

McKINLOCK building, at 209 W. Jackson Street, on the southwest corner of S. Wells Street, was built in 1898. It is 10 stories high, on spread foundations. Charles S. Frost was the architect. Two stories were added in 1918. A photograph is in OBD 1941–42, p. 218. The facade was remodeled, and the building was renamed the 209 W. Jackson Boulevard building; Altman-Saichek-Adams were the architects. The Wilson building previously occupied this corner.

J. M. WILLIAMS building, CLSI, built in 1898 at 205 W. Monroe Street, on the southwest corner of S. Wells Street, is 10 stories high, of steel-frame fireproof construction, on spread foundations. Holabird & Roche were the architects. The cost, including architects' fees, was 10.626 cents per cubic foot of building (EAR). It was occupied by the Harris Bank. Photographs are in CSA, fig. 82; WO, p. 39; HRHR Vol. 1, p. 172; and RB Annual Review, January 26, 1963, p. 102. This building replaced the Williams Block, built in 1874, which was six stories high and which is illustrated in RMNV, V13.

NEWBERGER building, ca. 1898–(1950 to 1990), at 330–32 S. Franklin and 314–18 W. Van Buren Streets, was seven stories high. A photograph is in HB. The 311 S. Wacker Drive building includes this site.

333 W. LAKE STREET building, formerly known as the Franklin MacVeagh Co. building, built in 1898, is 9½ stories high, on pile foundations. D. H. Burnham & Co. were the architects. Photographs are in RB August 7, 1954, p. 3. Bird's-eye photographs are in ABOV, pp. 33 and 34. This was the site of the Eagle Exchange Tavern, built in 1829 by Mark Beaubien and illustrated in CIM. Abraham Lincoln was nominated for president in 1860 in a temporary structure on this site called the Republican Wigwam. The Wigwam is illustrated in HCA Vol. 2, p. 126; CIM, p. 116; and CYT, p. 18, from a daguerreotype.

GAGE building group, NR, CAL, HABS, CLSI/premier, built in 1898, for David and George Gage (milliners), Edson Keith, and Theodore Ascher. The Gage building was also known as the Stanley P. McCormick building (HA); it was renamed the 18 S. Michigan Avenue building. The Keith and Ascher buildings were, together, renamed the 30 S. Michigan Avenue building. The

eight-, seven-, and six-story buildings were built on piles, at a cost of $175,968. Holabird & Roche were the architects. The facade of the Gage building was designed by Louis H. Sullivan. In 1902 four stories were added to the Gage building at a cost of $95,878. An illustration of the latter is in CHC, p. 186. Photographs are in LSM; CFB; CSA, fig. 80; CPS, p. 84; JSAH March 1990, p. 83; SRT; and SFO, p. 134; *Three Centuries of Notable American Architects*, ed. Joseph J. Thorndike, 1981, p. 195; CALP; and HB. Photographs of the original eight-story Gage building facade are in AGC, p. 38; STL, p. 56; HRHR Vol. 1, p. 181; and *Genius and the Mobocracy*, Frank Lloyd Wright, 1971, p. 216. The Illinois Society of Architects office is at 30 S. Michigan Avenue.

EDISON building, 1898–1931, at 120–22 W. Adams Street, with a frontage of 45 feet, was 5½ to 6½ stories in height. It was wrecked to make way for the Field building. A photograph is in OBD 1911, p. 70. An Edison Co. power house formerly occupied this site. A view of the 1887 Power House is in RMNV, V5.

404–06 S. WELLS STREET building, 1898–(1950 to 1990), was six stories high.

320–22 S. FRANKLIN STREET building 1898–(1950 to 1990), was 10 stories high, on spread foundations. Holabird & Roche were the architects. A photograph is in HB. The 311 S. Wacker Drive building includes this site.

South: 504 and 506–08 S. WELLS STREET buildings, 1898–1947, were each six stories high. The latter building was built ca. 1898. The former building had no stairways or heating plant and was operated in conjunction with the south building. Both buildings were condemned and removed by the Department of Subways and Superhighways.

South: POOLE BROTHERS building, 1898–(1950 to 1990), at the southeast corner of S. Clark Street and W. Harrison Street, was built in two sections. The north portion was built in 1898 and the addition to the south in 1912. The building was six stories high. Holabird & Roche were the architects. The building was on wood pile and caisson foundations. The cost of the north portion was 12 cents per cubic foot (EAR). It was also known as the Wells building. A photograph is in HRHR Vol. 1, p. 186. The site is used for parking.

South: BAILEY building, 1898–1953, HABS, at 529–30 S. Franklin Street, was built in two sections. The north portion was built in 1898; Holabird & Roche were the architects and Purdy & Henderson the engineers. The south portion was built in 1903 (Nimmons & Fellows architects and E. C. & R. M. Shankland engineers). Both portions were 10 stories high, on wood piles. Photographs are in HRHR Vol. 1, p. 180, and CSA, fig. 132. The site is in the Congress Parkway interchange.

South: 1108–10 S. MICHIGAN AVENUE building, ca. 1898–(1950 to 1990), was seven stories high.

North: 18–20 E. HUBBARD STREET building, ca. 1898–(1950 to 1990), of mill construction, on spread foundations, was six stories high. The Court-yard By Marriott Hotel includes this site.

1898: The Union Loop "El" system began operation.

PLYMOUTH building, built in 1899, in the South Loop Printing House Historic District, also known as LaSalle Extension University and 417 S. Dearborn Street, replaced an eight-story building that had burned a short time before. The building is 11 stories high, on spread foundations except for caissons installed under the front wall in 1947. Simeon B. Eisendrath was the architect. A photograph is in OBD 1916, p. 199; CTCP, p. 82; and WO, p. 28, with the Manhattan building. The facade was remodeled in 1945 by W. Scott Armstrong, architect.

57 E. JACKSON STREET/CABLE (piano) building, CAL, HABS/drawing, 1899–1961, was 10 stories high, with pile foundations, except for the party wall, which was supported on caissons. An illustration is in CHC, p. 176, and OBD 1929, p. 64. Holabird & Roche were the architects. The cost of the Cable building, including architects' fees, was 25.84 cents per cubic foot (EAR). Purdy & Henderson were the engineers. It was also known as the Hoops building. Photographs are in CSA, fig. 83; HRHR Vol. 1, p. 191; and *Chicago Architecture: Holabird & Root,* ed. Werner Blaser, 1992, p. 38. The Pierce Block formerly occupied this corner; it extended 160 feet south of the corner, with the same depth as the Cable building on E. Jackson Street. The CNA Center includes this site.

322–26 W. VAN BUREN STREET building, ca. 1899–(1950 to 1990), was seven stories high.

216 W. JACKSON STREET building, 1899– is 10 stories high. It was re-named the Jackson-Quincy Court building. Henry Ives Cobb was the architect.

STOP AND SHOP WAREHOUSE/METHODIST BOOK CONCERN building, 1899–1990, NR, HABS, CLSI, was originally the Methodist Publishing House building, and later the Lincoln and also the Browning building. It was at 12–14 W. Washington Street, 11 stories high. It was the first building supported entirely on caissons. Harry B. Wheelock was the architect; E. C. & R. M. Shankland were the engineers. An illustration is in OBD 1901, p. 123, with a description of the building. Photographs are in PGC, p. 52; IA Vol. 89; HDM, p. 96; and WO, p. 30. This "Block 37" site is vacant.

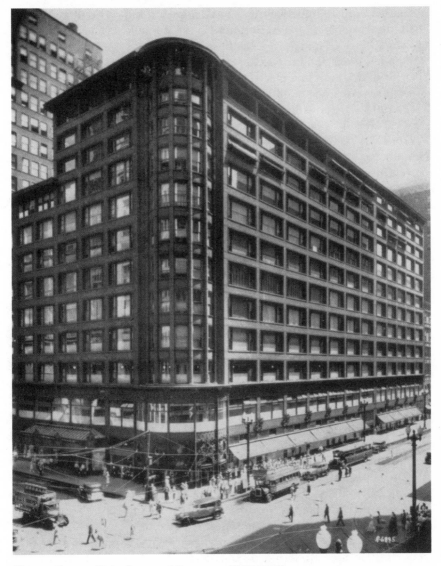

Fig. 34. Carson, Pirie, Scott and Company, 1900/1906

CARSON, PIRIE, SCOTT & CO. STORE, NHL, CAL/CHALC, HABS, CLSI/premier, the principal units built from 1899 to 1906 and 1961, at the southeast corner of S. State and E. Madison Streets (fig. 34). The original ownership was the Leopold Schlesinger and David Mayer store, followed (after several months by Harry G. Selfridge and Otto Young in 1904) by that

of Samuel Carson, John T. Pirie, and George and Robert Scott, and, since 1989, the ownership of P. A. Bergner Co. of Milwaukee. The first unit was built in 1899–1900, at 11–15 E. Madison Street, nine stories high, on 50-foot wood piles. Louis Sullivan was the architect, and Dankmar Adler was associated for mechanical and electrical systems. A photograph is in CPS, p. 96. An addition by Louis Sullivan, at State and Madison Streets, was built in 1903–1904, 12 stories high, with three basements, cast-iron columns, on rock caissons. It is illustrated with a description of the foundations in ER February 21, 1903. A photograph is in RMNP. A description of the construction with structural details and photographs is in BB May 1903, p. 101. An addition at 21–29 S. State Street was built in 1906, 12 stories high, with three basements, steel columns, on caissons. D. H. Burnham & Co. were the architects. An illustration of these buildings is in HCCB, p. 198B, and a photograph is in CPS, p. 113, as the Otto Young building, under construction, and including the four-, five-, and six-story buildings previously occupying the site of a 1961 addition. An addition, at the northwest corner of S. Wabash Avenue and E. Monroe Streets, was built in 1927, 16 stories high, with two basements, on caissons. Burnham Brothers were the architects. The southern addition on S. State Street, eight stories high, was built in 1961. Holabird & Root were the architects. A drawing is in CSA, fig. 129.

Of the store's several occupancies in the block, it occupied the Thomas Church building, built in 1903 at 32–34 S. Wabash Avenue, 13 stories high, on rock caissons. Hill & Woltersdorf were the architects. A photograph is in CTCP, p. 53. The store also converted and occupied the Monroe Garage, at 12 E. Monroe Street (q.v.).

This is the finest commercial architecture in the city. It is of international significance, attracting visitors from throughout the world. In 1948 the cornice was removed, severely compromising the building's character. An understanding of Sullivan's intention and the importance of the cornice is best obtained by studying his theory as expressed in "Tall Building," reproduced in *Kindergarten Chats*, Louis Sullivan, 1947 edition, pp. 202–13, including a photograph. Photographs with the cornice include LSM, plate 60; *Louis Sullivan*, 100th Anniversary Exhibition Art Institute catalog, 1956, p. 11; SRT, pp. 345 and 381; STL, p. 58; *Evolutionary Thought in America*, ed. Stow Persons, 1956, fig. 8 (following p. 396); BB May 1903, reproduced in *Guide to Significant Chicago Architecture of 1872 to 1922*, J. D. Randall, 1958, showing the cornice framing; and *Architecture in America*, John Burchard, 1961, following p. 244. Photographs without the cornice include MAC, p. 149; LSCS, p. 62; RNRC; CFB; SCS, p. 43; *Culture and Democracy*, Hugh D. Duncan, 1965, p. 412; and MAC, p. 148. Photography providing comparison of the architect's conception and the building's disfigurement include SFO, pp. 206 and 127; CPS, pp. 2, 108, 227, and (without the cornice) p. 116; CSA, figs. 123–26; *Louis Sullivan*, Albert Bush-Brown, 1960, plates 72–74; and TAA (includes bibliographic references to fifty photographs). The facade

was restored in 1979 by John Vinci, architect, but the restoration remains to be completed. A new ownership, Proffitts of Tennessee, is planning to lease two or three stories for office use. Buildings previously occupying this block include the 1873 Schlesinger & Mayer building, the Windsor-Clifton Hotel, and DeJonghe's Hotel.

TOWER building, at 6 N. Michigan Avenue, on the northwest corner of E. Madison Street, formerly known as the Montgomery Ward & Co. building, with a frontage of 86 feet on N. Michigan Avenue and 163 feet on E. Madison Street, was built in 1899 of steel frame construction to a height of 12 stories, with a tower of 394 feet, on 50-foot wood pile foundations. The three lower floors were designed for a live load of 200 pounds per square foot, the nine upper floors for 150 pounds per square foot. This made it possible for later owners to add four stories without reinforcing the columns of the lower stories. Richard E. Schmidt was the architect, and Hugh Garden was the designer. The 22½-foot weather vane, *Progress Lighting the Way for Commerce,* was set October 20, 1900. It was modeled by J. Massey Rhine. The street facade of the lower three stories is of carved Georgia marble. The cost of the original building was 36.7 cents per cubic foot. An illustration of the 12-story building is in HCCB, p. 197B, and OBD 1916, p. 242. An addition was made ca. 1923 by Holabird & Roche, architects (Henry J. Burt, engineer), increasing the height to 17 stories and a three-story tower. The building is illustrated in ISA 1923, p. 144; AEF; CAA; CIM; and RMNP. An illustration and a description are in OBD 1929, p. 334. Drawings are in CANY, p. 101, and CCNT, p. 109. Photographs are in STL, p. 52; CNM, p. 42; HB; LC, p. 145; and *Kindergarten Chats,* Louis Sullivan, 1947 edition, p. 19. See appendix F. The weather vane and uppermost stories have been removed, and the building was renamed the 6 N. Michigan Avenue building. The Chicago Athenaeum's Museum of Architecture is here.

North: 319–33 E. ILLINOIS STREET building, 1899–(1950 to 1990), was six stories high, of mill construction, on spread foundations. Henry Ives Cobb was the architect. The site is used for parking.

North: SMITH SHOE CO. building, built in 1899 at 223 W. Erie Street, at the southeast corner of N. Franklin Street, is seven stories high. The lofts were converted to offices in 1980 and renamed the North Branch Center I; James Ohio was the architect.

DOWNTOWN PARKING STATIONS, INC., 1900–ca. 1910, at 121–27 W. Monroe Street, was originally the Chicago National Bank building and later the bank building of the Central Trust Company. It was on the site of the home occupied by Fernando Jones until the 1871 fire, and of the Rand McNally building, 1880–1900. An illustration is in CHC, p. 125. Until remodeled in 1938 into a garage and parking station, the building was three

stories high. Jenney & Mundie were the architects. Photographs are in CIM, p. 577; OMSM; *Chicago Tribune,* February 17, 1940; and Louis Sullivan's *Kindergarten Chats,* 1947 edition, p. 53. A Harris Trust Bank building includes this site.

ILLINOIS THEATER building, 1900–1936, was at 65 E. Jackson Street, four stories high, on spread foundations. Wilson & Marshall were the architects. A photograph is in CAA; CYT, p. 92; BB July 1908, p. 136; CIM, p. 434; *Chicago Tribune,* February 17, 1940; RMNP; and LC, p. 184. The site had been occupied previously by the First Regiment Infantry Armory. A view of the armory is in HCA, Vol. 3, p. 586, and CAC, p. 67. A photograph is in CIM,

Key to map on facing page:

1 Rothschild/Goodman	14 Grand Central Station
2 Montauk	15 Monon
3 Revell	16 Schiller/Garrick
4 Mallers/Farwell Trust	17 Fair Store/M. Ward's
5 Ryerson/Gray, Kingman, Collins	18 Unity
6 Troescher/Daily Times	19 Masonic Temple/Capitol
7 Art Institute/Chicago Club	20 Ashland Block
8 Home Insurance	21 Meyer
9 Austin/Phoenix	22 Chicago Stock Exchange
10 Willoughby	23 Champlain, 1894
11 Ryerson/Walker Warehouse	24 Cable
12 Tacoma	25 Stop & Shop Warehouse/
13 Rand McNally	Methodist Book Concern/

Twelve noteworthy standing structures built after the turn of the century are indicated by solid outlines:

A Reid, Murdoch/Central Office	G Waterman
B Oliver	H Brooks
C Chicago	I John Marshall Law School
D Champlain, 1903	J Dwight
E Lake View	K Lemoyne
F Chapin & Gore/63 E. Adams	L Hotel LaSalle Garage

Other great central-area structures worthy of note include the old Chicago Historical Society and Montgomery Ward riverside buildings, the Graham Foundation/Madlener and Charnley/Persky houses to the north, and Richardson's Glessner House to the south. In addition, there are many within the South Loop Printing House Historic District.

These buildings exemplify the splendid achievements of the Chicago School, which made the city famous throughout the world. Along with the highly innovative work of Frank Lloyd Wright, they manifest the ingenious structural engineering and the revolutionary principles of Chicago building, which exerted great influence on modern architecture.

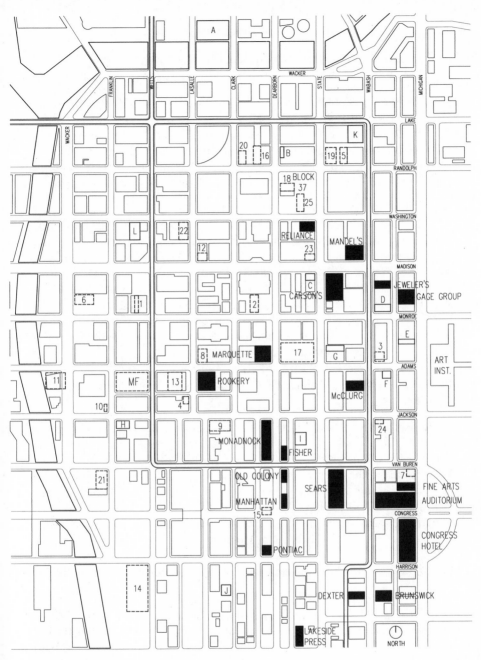

Prominent Buildings of the Chicago School from Period III, 1881–1900

Twenty standing landmarks, indicated by solid black rectangles, are labeled at their locations.

Twenty-five demolished structures, numbered chronologically, are shown on the map by broken outlines. In addition, the site of the Marshall Field Wholesale Store is shown at Adams and Wells by the initials "MF" within a broken outline.

(See key on facing page.)

p. 371. A photograph of Trinity Church, which stood on this site before the fire of 1871, is in CIM, p. 285. This site is occupied by the CNA Center.

INTER-OCEAN building, at 57 W. Monroe Street, 1900–(1950 to 1990), on the former site of the Columbia Theater, was four stories high, on spread foundations. W. Carbys Zimmerman was the architect. It is illustrated in OBD 1901, p. 91. It was remodeled into the Monroe Theater by John B. Fischer, architect. A photograph is in CIM, p. 572, and CHC (frontispiece). A drawing is in CIS, p. 169. The Xerox Centre building includes this site.

218 S. WABASH AVENUE/AYER/McCLURG/CROWN building, NR, CAL/ CHALC, HABS/photograph, CLSI/premier, was built in 1900. It is nine stories high, on pile foundations except for caissons under the south party wall. Holabird & Roche were the architects. The cost of the Ayer building, including architects' fees, was 13.68 cents per cubic foot (EAR). Photographs are in OBD 1916, p. 148; CFB; CAJZ, p. 74; CSA, fig. 85; HRHR Vol. 1, p. 177; and STL, p. 62. See appendix F. It was renamed the Pakula building and was occupied by the Art Institute for a time. This site, with a frontage of 80 feet, was formerly occupied by the A. H. Andrews & Co. building, seven stories high, built in 1890. An illustration is in RMNV, V4; CRT, opposite p. 162; and SGC, p. 548. A photograph is in *Guide to Significant Chicago Architecture of 1872 to 1922,* J. D. Randall, 1958, p. 19, taken from *Standard Guide to Chicago,* Flinn, 1892.

MERCHANTS LOAN & TRUST building, 1900–1933, later known as the Standard Trust building, at 100–16 W. Adams Street, on the northwest corner of S. Clark Street, was on the east portion of the site of the present Field office building. D. H. Burnham & Co. were the architects and Joachim G. Giaver the engineer. The building was 12 stories high, supported on piles. A photograph is in CIM, p. 567; RMNP; CHC, p. 129; and AR July 1915. An illustration and a description are in OBD 1916, p. 159. *Fifty Years of Banking in Chicago, 1857–1907,* by William Hudson Harper and Charles H. Ravell, 1907, published by the Merchants Loan and Trust Company, contains a photograph of this building and of all others occupied previously by this bank.

MANDEL BROTHERS STORE building, at the northeast corner of N. State and E. Madison Streets, was built in three main sections by Holabird & Roche, architects. A nine-story section at the northwest corner of N. Wabash Avenue and E. Madison Street was built in 1900, on piles and rock caissons (described and illustrated in AF May 1901), two stories being added later; the 12-story portion at 14 N. Wabash Avenue was built in 1905 and the 15-story portion at 1–15 N. State Street in 1912, the latter two portions being on rock caissons and having three basements. A photograph is in AR April 1912. An illustration of the various buildings occupied by Mandel Brothers

Store for a period of fifty-five years preceding 1910 is in HCCB, p. 203B. The store was converted to offices in 1986 and renamed the 1 N. State Street building; Perkins & Will were the architects. It was restored in 1992 by Loebl, Schlossman, & Hackl, architects. It had also been known as Wieboldt's Store. The *Wabash Avenue Annex* is in CLSI/premier, and a photograph is in CFB "merit." Photographs are in CSA, fig. 138; CPS, p. 61; HRHR Vol. 1, pp. 198 and 348; and HB. The 1873 McClurg building previously occupied the Wabash Avenue corner site, and the 1872 1–3 N. State Street building the western part of the site.

South: 729–35 S. WABASH AVENUE building, ca. 1900–(1950 to 1990), was seven stories high. It was used as a warehouse by Marshall Field & Co. This site is used for parking.

South: 825–27 S. WABASH AVENUE building, ca. 1900–(1950 to 1990), was six stories high. This site is used for parking.

West: 566 W. ADAMS STREET building, built ca. 1900, at the northeast corner of S. Jefferson Street, is seven stories high. The lofts were converted to offices in 1982; Booth, Hansen were the architects. Photographs are in RB February 27, 1982, p. 9, and June 26, 1982, p. 36.

North: KOHNSTAMM building, built ca. 1900 at 11–15 E. Illinois Street, is six stories high.

North: 920 N. MICHIGAN AVENUE building, 1900–1980s, formerly the Raymond Apartments, was eight stories high, on spread footings. Benjamin H. Marshall was the architect. It was one of the first tall apartments on the near north side. A floor plan is shown in BB December 1903, p. 246. In 1926 the building was remodeled into shops and studios by B. Leo Steif & Co., architects. Photographs are in IA-C No. 5, September 1982, p. 39, and HB. The 900 N. Michigan Avenue building includes this site.

North: CARAVETTA (foods) building, HABS, CLSI, was built ca. 1900, at the southeast corner of N. Dearborn and W. Kinzie Streets, fronting 90 feet on the former street and 45 feet on the latter, four stories and attic high. Henry Ives Cobb was the architect. It is a fine example of Dutch Renaissance architecture. A photograph is in *Chicago Tribune,* November 3, 1946. It has also been known as the Standard Varnish Co. building, Miller's, and Kinzie's Steak House. It was renamed Harry Caray's Restaurant, 33 W. Kinzie Street ("Harry Caray Drive").

North: 444 N. WELLS STREET building, built ca. 1900, at the southwest corner of W. Illinois Street, is six stories high. It was renamed the First Commonwealth building. The lofts were converted to offices in 1985; Howard Conant, architect.

Chicago One Hundred Years Ago

In 1893, Rand, McNally and Company published a unique guide book, reprinted in 1898, entitled *Bird's-Eye Views and Guide to Chicago*. In addition to the usual data that appeared in the company's guide books, this book contained some thirty bird's-eye-view scale drawings of the downtown district, with descriptions of the more important buildings.

Published at an advanced stage in the "golden age" and at a halfway point in the history of the building of the business district of Chicago, this visual record is worth preserving for its historical interest, the original publication being long out of print. Selected drawings follow, with descriptions as originally published.

Though a complete facsimile of those pages of the original which are reprinted has not been sought, a fairly close reproduction has been attained. Discrepancies of spelling and punctuation in the 1893 book have in the main been kept, and the type-font employed in this reproduction resembles that used by Rand, McNally & Company some one hundred years ago.

One of the most interesting studies which a reader might wish to make of the material that follows would deal with occupational groupings and classifications of the tenants in the various parts of the Central Business District.

The Rand, McNally views and descriptions of the original edition have been reproduced in a University of Illinois, Chicago, project in the Internet at Chicago Architecture Imagebase as Bird's-Eye Views. Many important Chicago buildings are illustrated also at various web sites.

Vicinity of the Board of Trade

The region graphically portrayed in view 1 is doubtless the most striking one in the city, for the visitor can not approach it from any direction without adding to the scene many other notable buildings. The "head of La Salle Street," as late as 1868, included no good building of any size whatever. Jackson Street, the avenue in front of the Board of Trade, and Quincy Street, the alley or narrow street one block north, were densely populated with the worst elements of the city. The Van Buren Street Station was then the head of La Salle Street, and La Salle had not been shortened to make a place for the Board of Trade. The Grand Pacific Hotel was built and burned in 1871. It was reproduced in 1872. The grand transformation of this locality came in 1883 and 1884, when the earliest group of Chicago's high buildings was erected. The rise in value of property on Jackson Street was sometimes from one to twenty in a year's time. The block directly to the right of the Grand Pacific Hotel, composed of the Royal Insurance, Mallers, Gaff, and Counselman buildings, made the most rapid progress in 1884. The Rand-McNally building is seen in the foreground. In addition to the

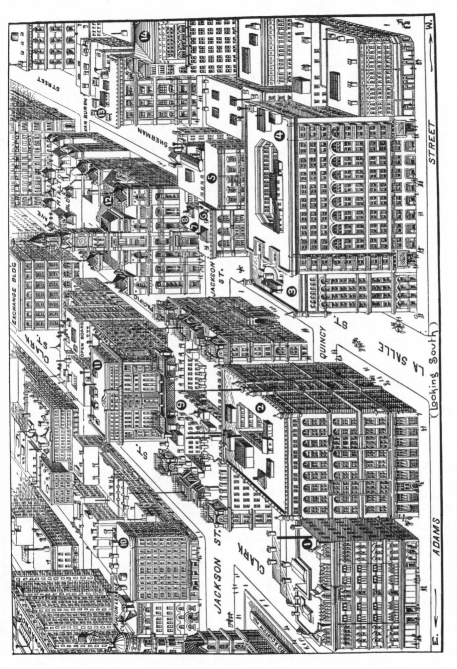

View I. Vicinity of the Board of Trade

179

sterling character of its architecture, it has become very famous as the headquarters of the World's Fair.

1. The Lakeside Building stands at the southwest corner of Clark and Adams streets. It is a populous and busy corner. Here is the home of the Lakeside or Chicago City Directory, a work which grows more ponderous each year. This directory can always be consulted at any drug-store or counting-room. In this building the Lakeside Library began, which was sold to New York publishers and became the Seaside Library, because it was translated from lake to sea. The Lakeside Building is of the days when Chicago imitated Paris, with pavilions, Mansards, gables, and dormers. Its exterior is of stone and iron, and it has 6 stories, is 110 feet high and 125 feet square. It has 65 offices, 3 stores, 2 elevators, carrying 1,600 passengers daily, and its 300 occupants are publishers, printers, and manufacturers' agents. It has always been a publishing center, and here the earliest literary magazines were edited, particularly the *Lakeside Monthly*. It cost $200,000 in 1873.

2. The Rookery stands west of the Lakeside, on Adams Street, and reaches La Salle Street, a remarkable thoroughfare, because of its high skylines, ending with the tower of the Board of Trade. Here stood the water-tank, and here, in 1884, rose this splendid edifice. The Adams Street frontage is 170 feet, the La Salle 180. The height is 165 feet, in 11 stories and basement. The offices — more than 600 in number — surround a large court, and 10 passenger elevators carry 22,000 persons each day. There are 3 freight elevators. The 5,000 occupants may be grouped as financial, but there are many exceptions. D. H. Burnham's offices are on the upper floor. The Corn Exchange Bank and Illinois Trust & Savings Bank are located below, with many offices of brokers, private bankers, and agents. The cost of this structure was $1,500,000. It was built by a joint-stock company.

3. The Insurance Exchange, across La Salle Street from the Rookery, has a handsome façade, the favorite design of the late John W. Root, architect. It extends from Adams Street to Quincy, 165 feet; 60 feet deep. Here are the Columbia and Continental National banks. About 400 tenants are served by 3 passenger elevators; 9 stories and basement, red pressed brick exterior, with coignes of vantage, and elaborate entrance. Erected in 1884; cost $450,000.

4. The Rand-McNally Building is a complete steel 10-story structure occupying Nos. 160–174 Adams Street and Nos. 105–119 Quincy Street, to which it extends. It was erected in 1889, has 10 stories, 16 stores, and 300 offices, but is principally occupied by Rand, McNally & Co., printers and publishers, with 900 employees. The headquarters of the World's Columbian Exposition have been here, and here are the general offices of the Chicago, Milwaukee & St. Paul Railway. Here the Long Distance Telephone Company (Quincy Street side) enables you to call up New York City. Cost, $1,000,000.

5. The Royal Insurance Building, fronting on Jackson Street (Nos. 165–173), reaches through to Quincy. The frontages on both Jackson and Quincy streets are 100 feet, with 9 stories and basement. Here 163 offices surround an impressive quadrangu-

lar, balustraded interior court, and 5 elevators serve 800 occupants. The building is of steel, stone, and red brick, and was built in 1884 to serve Board of Trade operators, insurance men, railroad agents, and cognate interests. The cost was $600,000. The interior is one of the sights of the city.

6. The Mallers Building, occupying a lot but 38 feet on La Salle by 59 on Quincy Street, is 12 stories and basement, or 175 feet high. It has 2 elevators and 200 occupants, who are of all classes of light business. It cost $275,000 in 1884, and was for awhile the highest office building in Chicago. It is all steel, pressed brick, and stone.

7. The Gaff Building is a 9-story steel structure with a frontage of 80 feet and but 60 feet deep, uniting the Mallers and Counselman buildings on La Salle Street, at Nos. 230–36. Here are 2 fine elevators, mail-chute, marble stairs, and nearly 100 attractive offices. Erected in 1884 at a cost of $275,000. It is occupied principally by grain commission merchants.

8. The Counselman Building, occupying but 56 feet on La Salle and 60 on Jackson Street, stands almost at the door of the Board of Trade. It is all steel inside; 9 stories and basement, 145 feet high, and has 78 offices. There are 2 elevators and 300 occupants — grain and insurance men. The building was erected in 1884 and cost $325,000.

9. The Grand Pacific Hotel is an enormous structure fronting Clark, Jackson, La Salle, and Quincy streets. The frontages are 186 feet on Clark, 294 on Jackson and Quincy, and 178 on La Salle. The height is 110 feet, with only 6 stories and basement. This hotel follows the Parisian architecture, with pavilions and Mansard roof. Its grand dining-room is 137 × 62 feet in size. There are 600 rooms for guests, with 2 elevators. This great house contains 35,000 square feet of dimension stone, 7,000,000 brick, 11,000 barrels of cement, 10,000 barrels of lime, 930 windows, 1,070 doors, 250 bath-tubs and closets, 7,500 square feet of tiled flooring, 8,500 square feet of plate glass, 33,500 feet of gas-pipe, 2,698 gas-burners, 47 miles of wire, 30 arc and 760 incandescent lamps. It covers nearly an acre and a half of land, and cost $1,300,000, but costly as it was, the land-value beneath it, by constantly and rapidly rising on a five-year revaluation contract at 6 percent, had completely swallowed the building, which now belongs to the land owners. The western half belongs to the Northwestern University at Evanston, Ill.

10. The Hotel Grace, a European hotel, southeast corner of Clark and Jackson streets; 8 stories, 4 stores, 140 rooms, 1 elevator; 120 feet on Jackson, and 50 on Clark, 100 feet high; hotel office upstairs. It was erected in 1887, and cost $200,000.

11. The Phoenix Building, at the southwest corner of Clark and Jackson streets, has a depth of but 50 feet on Clark, with 217 feet of frontage on Jackson, reaching to Pacific Avenue; 13 stories and basement, 200 offices, 5 elevators, and 1,500 occupants. Built of steel, granite, marble, terra-cotta, and red pressed brick. All offices have marble bases, all corridors are entirely of marble, with bronze railings. High-class tenants have chosen these elegant precincts. The building was erected in 1896, at a cost of $700,000, and with the ground upon which it stands was sold to the Western Union Telegraph Company in 1892 for

$1,500,000. The telegraph company added 2 stories to the height.

12. The Board of Trade Building is at the head of La Salle Street on Jackson, flanked by Sherman Street on the west and Pacific Avenue on the east. This is the principal marketplace of the world, and here cereals and food of all kinds can always be turned into money in a moment's time. The tower is 322 feet high, and the copper weather-vane, a ship, 9 feet long and 8 feet high. The tower contains a large clock, which strikes on a bell weighing 4,500 pounds. The building has 9 stories, and on 3 sides carries aloft walls of Maine granite. Its rear is whitened with 90,000 enameled brick. It is 175 feet wide and 225 feet deep. The hall is 80 feet high, with stained-glass skylight, and walls lined with green and parti-colored pilasters and gorgeous stone balustrades. The cost was $1,800,000. It was erected in 1882–85. The interior is of steel. There are 4 elevators, making 700 trips a day.

13. The Brother Jonathan Building, southwest corner of Jackson and Sherman streets, 100 feet on Jackson and 50 feet on Sherman. It is 100 feet high, with 6 stories and basement, and 70 offices; 2 elevators. Cut-stone and brick exterior. Cost, in 1887, $300,000. Grain commission merchants, brokers, and railroad agents.

14. The Medinah Temple, northeast corner of Jackson Street and Fifth Avenue, erected by the Medinah Temple Company, cost $500,000; 12 stories in height, steel, terra-cotta, and pressed brick. Frontage on Jackson 115 feet, on Fifth Avenue 110. The first 2 stories for stores and shops, the next 8 for manufacturers' agents, 11th and 12th for the use of the shrine which built the Temple.

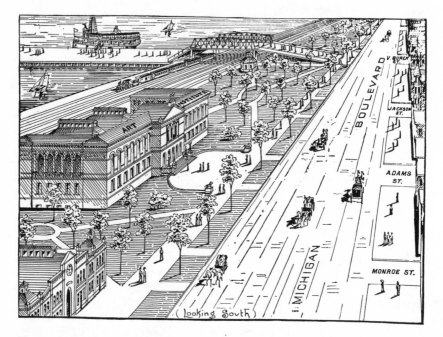

View 2. Art Institute of Chicago

From Adams Street, Looking South

The scene before the reader (in view 3) portrays some of the most remarkable buildings in the world. The Monadnock at the time it was built, and in 1893, contained the largest number of offices. The Great Northern Hotel has 500 rooms for guests. In the distance, on Van Buren Street, are the Isabella, the Siegel-Cooper, and the Old Colony. On the right of the Monadnock can be seen the palatial home of the Union League Club. In front is the celebrated Post Office of Chicago, a property which, at an original cost of $4,000,000, has proved a disappointment to inmates and tax-payers alike. On its left, in front, is the tall Owings Building. The actual views south, west, and north, standing at the intersection of Jackson and Dearborn streets, are perhaps the most striking that can be easily obtained in the city.

1. The National Union Building, at 66–72 Adams Street, is 80 feet wide, 100 feet deep, and 60 feet high, with 3 stories and basement. It is a brownstone front, and its upper stories contain 4 halls for the accommodation of councils or lodges of the mutual insurance association known as the National Union. These rooms are patriotically called Washington, Jefferson, Franklin, and Lincoln halls. It was the method of this society, at first, to unite certain professions in separate councils. But the Press Council, as an instance, beginning with many journalists and printers, has added hundreds of the leading railway men to its membership, greatly to the advantage of all concerned. Erected in 1888.

2. The Dexter Building, at 80–84 Adams Street, is 50 feet wide, 105 feet deep, and 140 feet high, with 8 stories and basement. The structure is of the steel pattern, with heavy brick walls and terra-cotta and tile. There are 2 stores, 140 offices, and 2 passenger elevators. The occupants are insurance companies, real estate dealers, and manufacturers' agents. Erected in 1892, at a cost of $150,000.

3. The Owings Building fronts 50 feet on Adams and 75 feet on Dearborn Street, at the southeast corner. This 14-story structure, on a lot so small, at a corner so conspicuous, produces a monumental effect. The bricks used in this edifice were the first in the Western world to imitate in shape and color the brick used by the ancient Romans in the Eternal City. A tower with cupola, and ornate treatment at the roof, enhance the architectural effect. The history of this peculiar edifice is further given in our chapter on "Notable High Buildings." There are 168 offices and 3 passenger elevators, averaging 900 trips a day. The occupants are financial and coal companies, investors, and professional men. The Owings Building was erected in 1888, at a cost of $475,000, and like the Monadnock, Manhattan, Unity, and others is a genuine Chicago sky-scraper.

4. The Temple Court Building fronts 100 feet on Dearborn and 180 feet on Quincy Street, at the northeast corner, and is 100 feet high, with 9 stories and basement. It is built of stone, brick, and terra-cotta. There are 8 stores, 400 offices, and 3 elevators. The occupants are coal dealers, capitalists, brokers, attorneys, scientific experts, manufacturers' agents, and professional men. Erected in 1887.

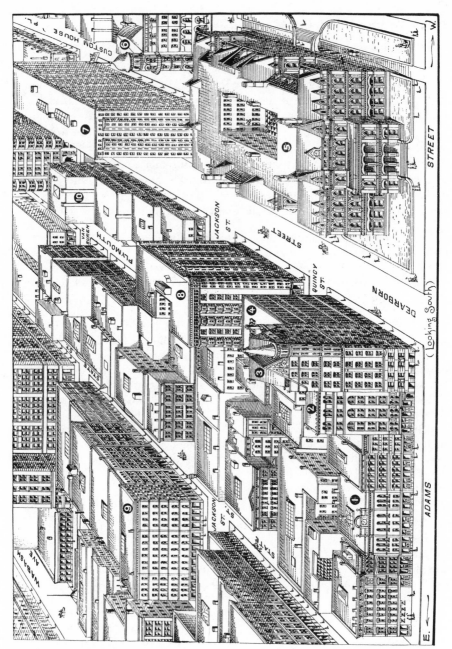

View 3. From Adams Street, Looking South

5. The Post Office and Custom House occupies a square bounded by Adams, Clark, Jackson, and Dearborn streets, but the building, standing in the center of this plot of ground, has a width on Adams and Jackson of only 212½ feet, and a length on Clark and Dearborn of but 305.2 feet. After the destruction of the old Post Office, at the northwest corner of Monroe and Dearborn, there was a strenuous attempt to buy the whole of that square for the Federal Government, but the property was considered too high-priced. Some further history of this institution in Chicago is given in our chapter on "Notable High Buildings." Its weight was too great for the soil, and there has always been an uneven settlement, destructive in character, and at times dangerous to the occupants. To hold it together, heavy rods have been run through the upper walls. The material entering into the construction of this fabric is of the best — Buena Vista sandstone, steel, cement, terra-cotta, brick, and marble. The heavy stone walls rise to a height, with their roof, of 102 feet, and there are 4 stories and basement. On the three upper floors are 65 rooms, occupied by 8 divisions with 20 different departments of the Government service. On the main floor, surrounded by a great lobby, is the Post Office. In the building are 3,500 employees, who use 1 freight, 10 mail, and 4 passenger elevators. Into this house, which never closes, it is estimated that 50,000 persons go every day.

6. The Union League Club, at 110–114 Jackson Street, is the property of the most popular and influential social organization in the city. Its membership is nearly 2,000, and it has exceeded the political bounds and restrictions under which it was founded. Nominally a Republican society, it has become, under the liberal influence of the World's Fair, a potent factor in the every-day life of the city. In its ranks are nearly all the ambitious young successful tradesmen of the city, and professional men have not been slow to ally themselves with a body so active and progressive. The striking and luxurious home of the club fronts 100 feet on Jackson Street and is 60 feet deep, with 5 stories and basement. There are 74 rooms above the street. The walls are 100 feet high with roof, and the material is granite and brick. There are 125 employees. About 400 people enter the club daily. Erected in 1887. Cost, $500,000.

7. The Monadnock Building covers the very long and narrow block bounded by Jackson, Dearborn, and Van Buren streets and Custom House Place (once Fourth Avenue). The front on Dearborn Street is 420 feet; the depth is but 70 feet. The walls, which are among the very heaviest brick constructions in the city, rise to a height of 180 feet, with 16 stories, and exhibit fine specimens of constructive skill. All the strength and security of a steel and tile interior are added to make the Monadnock permanent and popular. In this astonishing edifice there are no less than 1,600 offices and 18 passenger elevators. Great corporations, banks, and professional men are to be found here — among them the Santa Fe, the Michigan Central, and the Chicago & Alton railroads, and the American Exchange National and the Globe Savings banks. Electricians, attorneys, agents, capitalists, and commission merchants also gather here. Erected in 1891–93, at a cost of $2,500,000. (See "Notable High Buildings.")

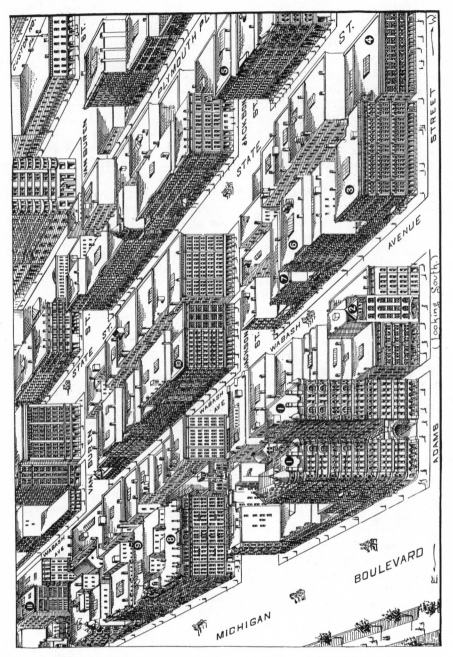

View 4. East End of Adams Street, Looking South

8. The Great Northern Hotel at Dearborn, Jackson, and Quincy streets, on the northeast corner of Jackson and Dearborn, is a high steel structure that preserves many canons of old-style proportions. Like the Rookery, the Siegel-Cooper, and the First National, the Great Northern is impressive on the lines of grace and beauty. The dimensions of this colossal structure are as follows: Front on Dearborn, 165 feet; depth on Jackson and Quincy, 100 feet; height, 185 feet; 16 stories and white marble basement. In this hotel are 500 rooms, 8 dining-rooms, café, and 6 elevators. A prize was publicly offered for a name, and given to the suggestor of the title "The Chicago." This title was abandoned for the present one. The plan of entertainment is strictly European. The appointments and modern character of this hotel give it a conspicuous place among the sights and conveniences of Chicago. The proprietors are Hulbert & Eden, highly experienced and well-known landlords. Erected in 1891, at a cost of $1,150,000.

9. The Spaulding Building fronts 40 feet on State and 147 feet on Jackson Street, at the southeast corner. It is an imposing 6-story building of the style of 1872, with 2 passenger elevators, and 40 offices on the upper floors. The three lower stories are occupied by Spaulding & Co., extensive manufacturers of silverware.

10. The Boyleston Building, at 265–273 Dearborn Street, extends through to Plymouth Place (once Third Avenue) on the east, and is 100 feet wide, 80 feet deep, and 75 feet high, with 6 stories and basement. There are 60 offices and 1 elevator. The walls are of stone and iron. Publishers, printers, agents, and jobbers occupy the premises. Erected in 1875, and owned by the estate that built the Old Colony, opposite.

East End of Adams Street, Looking South

An excellent view of the Pullman Building, and good relative views of the Isabella, the Siegel-Cooper (Leiter), and Old Colony buildings are afforded. Two celebrated hotels, the Leland and the Richelieu, are to be seen; and among popular retail stores, James H. Walker's and the Hub. At the southeast corner of Wabash Avenue and Jackson Street is a remarkable grouping of physicians' offices. Music and art flourish in this part of Wabash Avenue. Here, during war-times, was the fashionable residence quarter of Chicago, and houses with large shaded grounds were to be seen all along Wabash Avenue.

1. The Pullman Building fronts 169 feet on Adams Street and 120 feet on Michigan Boulevard, at the southwest corner. This structure is described fully in our chapter on "Notable High Buildings." Its 10 stories are 125 feet high and its northwest tower rises 162 feet above the street. It has 125 suites of offices and 75 apartments for residence, with 4 passenger elevators. The construction is of steel within, and granite, pressed brick, and terra-cotta outside. Here Mr. George M. Pullman has his offices, and here are the headquarters of the Pullman Palace Car Company. The United States

Army maintains departmental head-quarters here, and many professional men and merchants occupy offices and stores. The Pullman, which is one of the principal edifices of Chicago, as well on account of situation as of intrinsic splendor, was erected in 1884, at a cost of $1,000,000.

2. The Stevens Art Building, at 24–26 Adams Street, is 50 feet wide, 80 feet deep, and 75 feet high, divided in 7 stories and basement. It has 1 store and art-gallery, 28 offices, and 2 passenger elevators. This new style of building has a granite and Roman brick exterior. It is occupied by artists, musicians, and modistes. It was erected in 1888, at a cost of $260,000.

3. The James H. Walker Building (Retail) fronts 80 feet on Wabash Avenue and 225 feet on Adams Street, at the southwest corner, and is 70 feet high, with 6 stories and basement. This is one of the great retail stores of Chicago, and its 7 floors are in themselves a fair, where nearly everything useful and ornamental pertaining to an American home may be seen or purchased. The display in the windows is very fine. There are 4 passenger elevators, 32 departments, and 400 employees. The building is one of the handsomest of the ante-steel era of construction.

4. The Owen Electric Belt Building fronts 142 feet on Adams and 75 feet on State Street, at the southeast corner, and is 80 feet high, with 4 stories and basement. The fittings of the American Oyster House, in the basement, are an example of the magnificence of our contemporaneous architecture. There are 10 store-rooms, 60 offices, and 3 passenger elevators. The offices are occupied principally by manufacturers' agents and jewelers.

The edifice was erected in 1891, at a cost of $130,000.

5. The Hub Building fronts 100 feet on Jackson and 123 feet on State Street, at the northwest corner. It is a 5-story building, 70 feet high, with 2 passenger elevators. It is occupied by the Hub Clothing Company, which employs 100 salesmen. Erected in 1883. Cost, $200,000.

6. The A. H. Andrews & Co. Building, at 215–221 Wabash Avenue, like Kimball Hall, farther south, makes a fine showing on the street, having graceful bays and liberal provisions for light. The building is 80 feet wide, 125 feet deep, and 95 feet high, with 7 stories and basement; has 2 stores, 25 offices, and 3 elevators. The building has a stone and steel front, and is mainly occupied by A. H. Andrews & Co., office and school furniture manufacturers and wholesalers. It was erected in 1890.

7. The Casino was built as the Eden Musee, at 227–229 Wabash Avenue, with a frontage of 54 feet, a depth of 70 feet, and a height of 90 feet, in 5 stories and basement. It is a handsome structure of the old style, erected in 1888, at a cost of $115,000, and is open to the public as a wax-work museum and family minstrel show.

8. The Leland Hotel fronts 180 feet on Jackson Street and 160 feet on Michigan Boulevard, at the southwest corner. Its admirable situation on the Lake Front and the honored name it bears have brought it into widespread popularity. Before the Lelands purchased it it was called the Gardner House, and was always noticeable for the varying bright colors with which its walls were covered. The building is 70 feet high, divided in 6 stories and base-

ment, and has on its main floor 5 stores and a café. There are 275 rooms and 2 passenger elevators. An artesian well flows in the office, which is on the main floor, as are the reception-rooms. The white marble fittings of this hotel are a result of the remodeling in 1890, when Kittredge & Skeels, the present proprietors, took charge. A cheerful public fireplace is a feature which greets the stranger in winter. Originally built in 1872, at a cost of $500,000; remodeled in 1891, at a cost of $200,000. (See "Hotels.")

9. The Richelieu Hotel, next south of the Leland, fronts 125 feet on Michigan Boulevard, and is 125 feet deep. The building is 90 feet high, with 6 stories and basement; brick and terra-cotta walls. There are 125 rooms and 1 passenger elevator. The furnishing of this hotel, the service, and the indefinable thing called "tone" are such as to attract guests of great reputation and large wealth. The article on "Hotels" in this guide mentions some of the characteristics of this hostelry. Erected in 1885.

10. Chickering Hall fronts 100 feet on Jackson Street and 50 feet on Wabash Avenue. It is 65 feet high, with 6 stories and basement, and contains a recital hall of high standing among

musicians, who nearly fill the 35 offices of the building. Here are 2 stores, and here are the headquarters in Chicago of the Domestic Sewing Machine Company. The structure, a fine one, was erected in 1878.

11. The Athenæum Building, at 18–26 Van Buren Street, is the home of one of the noblest of Chicago's semi-public institutions. Here classes in almost all schools of knowledge are maintained, where the adult student may repair the neglect of earlier years. Nor are athletic exercises despised. The Athenæum had its quarters in 1874 where the Peacock Café now is, on Madison Street near Clark, and for many years later was on Dearborn Street near Randolph. Its main apostle was O. C. Gibbs, and Ferdinand W. Peck has been one of its steadfast friends. Here a young man or woman may study foreign languages, elocution, history, or science. He may in some sense enter good society, and here he will form life-long acquaintances. The building is 125 feet wide, 120 feet deep, and 70 feet high, with 7 stories and basement. There are 2 passenger elevators. The walls are of brick and cut-stone. Erected in 1886, at a cost of $107,000; remodeled in 1891, at a cost of $200,000.

From Adams Street, Looking North on La Salle

The tract of valuable and populous territory that falls under the eye in view 5 contains some of the finest business buildings in the world. Conspicuous among these is the Woman's Temple. Some features of the Home Insurance — the cyclopean granite walls of its lower stories — must be closely studied to be appreciated. At the northeast corner of Monroe and La Salle streets is the Nixon Building, which stood unscathed through the Great Fire. Beyond is the Young Men's Christian Association Building, and, dimly beyond, the Tacoma is seen. At the left, on Fifth Avenue, rises the Lees, and still higher beyond it, the Security Deposit. All these are solid steel edifices; and an-

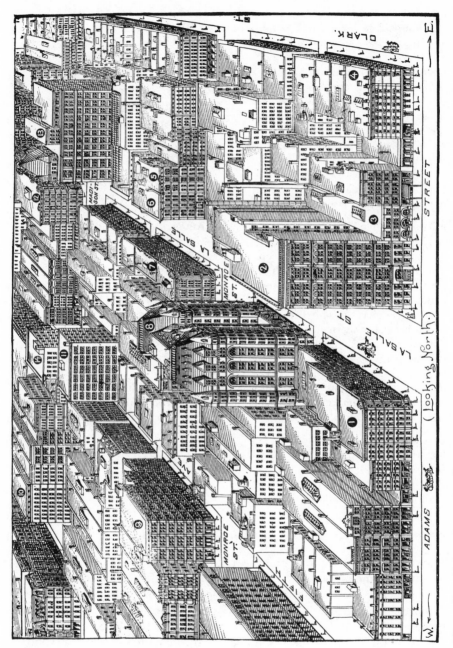

View 5. From Adams Street, Looking North on La Salle

other, the Calumet, is thrown out of view by the presence of the Home Insurance. For twenty years this part of La Salle Street has been given over largely to insurance and real estate.

1. The Schloesser Block, at the northwest corner of Adams and La Salle streets, is a handsome stone-front of the pattern once deemed desirable on La Salle Street. The basement is very high, and there are 4 upper stories. Here the *Current* was born — the most ambitious literary venture of early Chicago — and the Single Tax Club has entertained many accomplished thinkers and writers of different principles. The building, which was erected in 1872, fronts 120 feet on La Salle, 60 feet on Adams, and is 65 feet high. It has 8 stores, 29 offices, and over 160 occupants, who are agents, brokers, and publishers.

2. The Home Insurance Building, at the northeast corner of Adams and La Salle streets, has been described generally in another place. It is a high iron-and-steel building of the first class, and has been increased from 10 to 12 stories in recent years. It fronts 140 feet on La Salle and 97 on Adams, with a height of 180 feet. The walls of the lower two stories are made of one course of granite blocks. The foundations are heavy, and the brick walls of the super-structure are very thick. There are 235 offices, 1,250 occupants, and 4 passenger elevators. The principal tenants are Armour & Co., who have general offices here, and the Union National Bank, of which J. J. P. Odell is president. Insurance agents, manufacturers' agents, publishers, and professional men fill the building. Erected in 1884, at a cost of $800,000, and enlarged in 1891.

3. The Edison Company's Power House, at 139–141 Adams Street, although a small building, contains 16 engines, 32 dynamos, and furnishes power for 100,000 electric lights. Its chimneys have added a chief difficulty to the Chicago smoke problem. Dimensions: Width of Adams, 50 feet; depth, 200 feet; height, 40 feet. The general offices of the Chicago Edison Company are here. Erected in 1887.

4. The Porter Block has 100 feet front on Clark Street and 80 feet on Adams, at the northwest corner. It is 75 feet high, with 4 stories and basement, containing 6 stores and 40 offices. It is occupied by railway ticket offices, agents, and physicians; was erected in 1873.

5. The Kent Block, at 151–153 Monroe Street, is a fine brick front of the old style, 40 feet wide, 60 feet deep, 85 feet high, with 6 stories and basement. There are 2 stores, 44 offices, and 1 elevator in the building, which is occupied by professional men. Erected in 1871.

6. The Nixon Building, at the northeast corner of Monroe and La Salle streets, was in the finishing stages and wet with new plaster on the night of the burning of Chicago. Little or no damage was done to it, and it served as a nucleus around which to gather new business and begin rebuilding. It fronts 46 feet on Monroe and 80 feet on La Salle, with 65 feet of height in 6 stories and basement. There are 48 offices and 1 elevator. The tenants are real estate, insurance, financial, legal, and other professional men. There are about 150 occupants.

7. The Bryan Block fronts 190 feet on La Salle and 50 feet on Monroe, at the

northwest corner. It is 55 feet high, with 4 stories and basement. It is a stone-front of 1872, containing 6 stores, 95 offices, and 1 elevator, and is devoted principally to real estate and insurance.

8. The Woman's Temple, at the southwest corner of Monroe and La Salle streets, is the most conspicuous office building in this part of town. It is described in another chapter. It was erected in 1892, at a cost of nearly $1,500,000. The lot is 96 feet wide on Monroe and 190 feet deep on La Salle. The Temple is 185 feet high, in 12 stories and basement, with 300 offices. Seven passenger elevators carry 15,000 persons daily. The construction is fire-proof, of steel, granite, brick, and terra-cotta, with white marble rotunda, staircases, and wainscoatings. Four banks — the National Bank of America, the Bank of Commerce, the Metropolitan National Bank, and the Bank of Montreal — are to be found here, and Willard Hall may be entered on the ground floor, from Monroe Street. Main entrance on La Salle Street, where the semicircle of elevators should be seen.

9. The Wells Building, at the northwest corner of Monroe Street and Fifth Avenue, has a frontage of 80 feet on both thoroughfares, and is a 7-story structure 110 feet high, with 1 freight elevator. Its walls are of brick and iron, and built with great attention to light and air. It was erected in 1884, just after a destructive conflagration at this corner, and foreshadowed, in the lightness of its walls, the discovery that a building could be made independent of its exterior in the matter of security. M. D. Wells & Co., a great wholesale boot and shoe house, occupy the premises.

10. The Galbraith Building fronts 100 feet on Madison and 200 feet on Franklin Street, at the northeast corner. It is 80 feet high, with 6 stories and basement. It was remodeled in 1892, and is a stone-front of 1873. It has 6 stores and 2 elevators. The tenants are wholesale jobbers and manufacturers' agents.

11. The Lees Building, 147 to 153 Fifth Avenue, is a modern 12-story and basement steel building. The materials used in its construction are pressed brick and terra-cotta, plate-glass being generally used. With a frontage of 80 feet, a depth of 115 feet, and height of 165 feet, the structure presents a substantial appearance, being, it is claimed, absolutely fire-proof and strong enough to resist the heaviest strain. It is the best naturally lighted office building in the city, having a wide alley on three sides. Two hydraulic passenger and 2 steam freight elevators afford ample accommodation to the occupants, who are mainly manufacturers' and importers' agents and jobbers. The building was erected in 1892, at a cost of $325,000.

12. The La Salle Building, fronting 80 feet on Madison and 40 feet on La Salle Street, at the northwest corner, was one of the most sumptuous edifices of the rebuilding era. It is an ornate stone-front of 5 stories and high basement in the La Salle Street style, and runs 2 passenger elevators. There are 5 stores and 30 suites of offices. The height of the stone-front walls is 85 feet. The occupants are financial, insurance, real estate, and professional corporations and persons. Built in 1874.

13. The YMCA Building covers the site of Farwell Hall, in the rear of 150 Madison Street, fronting La Salle

Street on the east side at Arcade Court (an alley). This splendid building is like the Athletic Club's steel building on Michigan Boulevard. The lot is irregular, but has 54 feet front on La Salle, and is 187 feet deep on Arcade Court, with greater width in the rear. The structure is 190 feet high, with 12 stories and basement. Its interior is described in our chapter on "Notable High Buildings." It was erected in 1893, at a cost of $850,000. The skeleton steel method of architecture is here followed, nothing depending on outer walls. Farwell Hall had a notable history. It burned before the Great Fire; it burned in the Great Fire; it was demolished to make way for this steel sky-scraper.

14. The Security Deposit Company Building, as well as the Lees, which stands south of it, has been described in our chapter on "Notable High Buildings." The former fronts 47 feet on Madison and 100 feet on Fifth Avenue, at the southeast corner. It is a sky-scraper of 14 stories and basement, 147 feet high, with 4 passenger elevators. There are 5 stores and 150 offices. It was erected in 1892, at a cost of $500,000, and is occupied by wholesale agents and professional men.

From Adams Street North on Dearborn

The great height of many of the buildings included in view 6 is not apparent at a glance, that of the entire block in the right foreground varying from 100 to 140 feet. The Palmer House, farther to the right, was once, architecturally, the admiration of the West. Near the left foreground may be seen the Montauk Block, the first of Chicago's high steel buildings. In the scene are the First National Bank, the largest financial institution in Chicago; the *Tribune,* and the Hartford. Kinsley's famous restaurant is seen in the foreground, and the Honoré Building, twice burned and restored, has been occupied by the Post Office, the Army, and the Union League Club. This square faces the Post Office on the north.

1. The Quincy Building, at the northeast corner of Clark and Adams streets, fronts 60 feet on Clark and 80 feet on Adams. It is 70 feet high, with 5 stories and basement. There are 45 offices and 1 elevator. The occupancy is miscellaneous, but largely professional. Erected in 1873.

2. The Kinsley Building, at 105–107 Adams Street, is a steel building 65 feet high, with 5 stories and basement. The lot is 55 feet wide and 180 feet deep. This first-class refectory was erected in 1885, at a cost of $500,000, and is wholly occupied by Kinsley, the caterer and restaurateur.

3. The Honoré Building, at the northwest corner of Dearborn and Adams streets, is occupied by the Marquette Hotel. It fronts 185 feet on Dearborn and 100 on Adams Street, is 65 feet high; and has 6 stories and basement, with 12 stores, 10 offices, and 300 rooms. There are 2 passenger elevators. The outer walls are possibly the most ornate that remain in Chicago, if we except the Palmer House. The original building was completed in 1871, burned in 1871, rebuilt in 1872

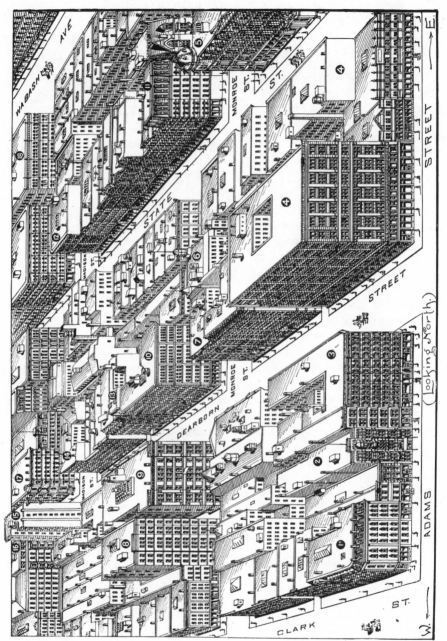

View 6. From Adams Street, North on Dearborn

with much salvage, and gutted by fire early in the eighties.

4. The Fair Buildings occupy the half of a square on State, Adams, and Dearborn streets. The principal structure is a high steel building. Its dimensions are as follows: Front on Dearborn, 200 feet; depth, about 180 feet; height, 9 stories and basement. In the various buildings are 12 passenger elevators. There are 100 departments — that is, 100 different stocks of goods — and 2,500 employees. The annual sales are $8,000,000 at retail. The Fair was established in 1875, by E. J. Lehman. The new building was erected in 1891, and all of the extensive operations on this ground went forward without stopping or decreasing the regular operations of the firm.

5. The Palmer House, which is partly shown at the southeast corner of State and Monroe streets, may be also seen in another view, no. 7. The peculiarities and traditions of this great hotel are noted in our chapter on "Hotels." The main interior is of brick, steel, and tile, and it was the first fire-proof hotel in the West. The State Street front of 275 feet is elaborate and impressive. The total frontages, besides the foregoing, are 300 feet on Monroe and 300 feet on Wabash Avenue. The main building is 9 stories or 100 feet high. There are 15 stores, 700 rooms, and 3 passenger elevators. It was common report in 1873 that this property cost $4,000,000. The rotunda and corridor are 106 feet long, 64 feet wide, and 36 feet high. There are some historical paintings to be seen.

6. The Adams Express Building, at 183–189 Dearborn Street, is probably the most imposing old-style structure in Chicago. Its outer walls are of the cyclopean thickness and weight that came in with the early steel buildings. Particularly noticeable is the magnificent granite arch at its portal. The lot is 100 feet wide and 130 feet deep. The building stands 140 feet high, with 10 stories and basement, and contains 3 stores, 223 offices, 3 elevators, and 700 inhabitants. It is occupied by heavy firms and companies, and has always maintained a first-class standing among tenants. It was erected in 1884, at a cost of $450,000.

7. The Commercial Bank Building, at the southeast corner of Dearborn and Monroe streets, fronts 90 feet on Dearborn and 131 feet on Monroe, and is 100 feet high, with 6 stories and basement. The bank and security vaults occupy the first floor and basement; the upper floors are served by 2 passenger elevators. There are 100 offices, with 300 occupants, who are publishers, lawyers, agents, and insurance and real-estate men. The exterior is granite, brick, and steel, and presents an imposing appearance. The structure was erected in 1884, at a cost of $300,000.

8. The Montauk Building, at 115 Monroe Street, has a frontage of 90 feet and a depth of 180 feet. It is 130 feet high, in 10 stories, of steel construction, on heavy foundations, with thick walls. It has 150 offices, 300 occupants, and 2 passenger elevators. Erected in 1882, at a cost of $325,000; the first high steel building in Chicago.

9. The First National Bank Building, at the northwest corner of Dearborn and Monroe streets, occupies the site of the old Post Office Building. The building offers a spectacle of handsome proportions, combining strength, durability, and great size. It is surrounded on all sides with light

and air. Dimensions: On Dearborn Street, 192 feet to alley; on Monroe Street, 96 feet to alley; 100 feet high, with 6 stories and high basement. There are 3 elevators and 100 offices. It was erected in 1880, and is described among our notable high buildings. The bank inside is a fine sight. The remainder of the building is occupied by corporations, attorneys, leading real-estate operators, promoters, and financial men generally.

10. The Stock Exchange Building, at the northeast corner of Dearborn and Monroe streets, was erected in 1882, and remodeled at great cost in 1889. It is a very large brick structure, with 104 feet front on Dearborn and 120 feet on Monroe, 100 feet high, and 7 stories and low basement. It has 100 offices and 3 passenger elevators, and since its renovation has been a busy building. It is to lose the Stock Exchange, which goes to its new home at Washington and La Salle, but is the rendezvous of many financial men and speculators. The fee of this entire city square is school property.

11. The Mentor Block, at the northeast corner of Monroe and State streets, fronts 26 feet on State and 80 feet on Monroe, 85 feet high, 7 stories. It was erected in 1873.

12. The Schlesinger & Mayer Building, at the southeast corner of State and Madison streets, fronts 200 feet on State and 80 on Madison. It is 75 feet high, with 7 stories and basement, and 2 passenger elevators. Here is one of the popular retail dry-goods stores, with annual sales of $5,000,000. There are 1,000 employees. The building, erected in 1873, has a conspicuous stone front.

13. The Evening Journal Building, at 159–161 Dearborn Street, once boasted a beautiful façade, but this was removed in 1889, when the structure was remodeled. The building has burned twice. It is 40 feet wide, 120 feet deep, and 80 high, with 7 stories. It is occupied by the Saratoga Hotel and the *Journal,* the oldest daily publication in the West.

14. The Tribune Building fronts 120 feet on Madison Street and 72 feet on Dearborn, at the southeast corner, and stands beside McVicker's Theater. The first *Tribune* building was finished in 1869, and its walls were partly saved in the rebuilding of 1872, after the Great Fire. The type of the *Tribune* is set on the upper or fifth floor; the editorial rooms are on the fourth and fifth; the presses are in the basement, and the counting-room occupies the main portion of the lower floor. Tenants of various professions fill the 3 stores and 20 offices which remain for rent to the public. The 5 stories and basement are 65 feet high from the sidewalk. John McDevitt, the billiard champion, was burned to death under the sidewalk on the Madison side October 10, 1871.

15. The Hartford Building is a steel sky-scraper, with 92 feet on Dearborn Street and 50 feet on Madison Street, at the southwest corner. Its 14 stories carry it 165 feet high, and its skeleton construction leaves no weight on the outer walls, which are light. It has 4 elevators and 260 offices and banking quarters; among the occupants are the Chemical National Bank. Real-estate and loan agents and financial corporations gather here. This, the tallest building in the scene, was erected during the busy year 1892.

16. The Inter Ocean Building is nearly concealed behind the Hartford, at the northwest corner of Madison and Dearborn streets. A steel building on

a very small lot rises at the corner, and this lot brought the highest price per square foot that has yet been paid for Chicago real estate. The entire premises front 100 feet on Madison and 50 on Dearborn. The old stone-front was erected in 1873. The steel corner building was built in 1889, when the entire interior was remodeled. There are 2 elevators and 75 offices for the public, with a handsome interior covered court. The portion occupied by the newspaper corresponds with that of the *Tribune* in its building.

17. The Union Trust & Savings Bank Building fronts 50 feet on Madison Street and 75 feet on Dearborn, at the northeast corner, and is 60 feet high, with 5 stories and basement. This is a handsome building of the old style, intended for bankers and professional men. It has 3 stores, 25 offices, and 1 elevator. The bank occupies the corner room. Edison's phonograph was first publicly exhibited in the West in this room. Erected in 1876.

18. The A. C. McClurg Building fronts 150 feet on Madison Street and 72 feet on Wabash Avenue, at the northwest corner. It is a brick block 75 feet high, with 6 stories and basement. It was erected in 1873, and contains one of the largest bookstores in the country.

North from East Adams Street

The scene laid before the eye in view 7 has for its features the Lake Front, the Metropolitan Business College, the high steel building of the Athletic Club, and the Palmer House, at the southeast corner of Monroe and State streets, also portrayed on another page, and there described. Great wholesale and retail shops abound in this region, and many art-stores may be found along Wabash Avenue. Hidden behind the tallest building in the picture is the new steel structure of the Western Bank Note Company, where the Whist Club has its quarters. A highly attractive detail of the view here represented is the portion of Lake Front Park, commanding an unobstructed survey of Lake Michigan, which at early morning or in the afternoon light presents a charming perspective.

1. The Leader Building, at the northeast corner of State and Adams streets, has 34 departments or lines of business, with 475 employees. The building is an old-style stone-front, erected in 1873, fronting 140 feet on State and 120 on Adams Street, 4 stories and basement, or 55 feet high, with 2 passenger elevators for the public.

2. The Gibbs Building, at the northwest corner of Wabash Avenue and Adams Street, was erected in 1874. It has frontages of 90 feet on Adams Street and 40 feet on Wabash Avenue. It is higher than the Leader Building (85 feet), having 5 stories and basement, and is occupied by music-sellers, wholesale jewelers, and manufacturers' agents. There is an elevator.

3. The A. H. Revell Building is at the northeast corner of Wabash Avenue and Adams Street. This edifice, which now presents within an appearance so distinguished, has had an eventful history for years past. It was once filled with a retail stock of dry goods by Gage Brothers, and later by Carson,

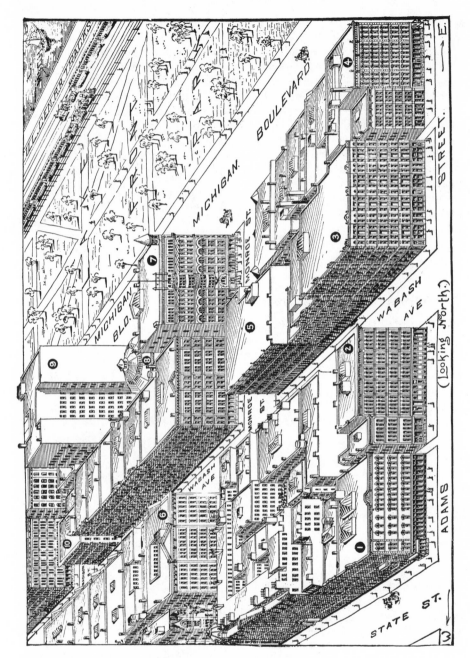

View 7. North from East Adams Street

Pirie, Scott & Co.; it stood vacant at
the time of the Siegel-Cooper fire in
September, 1891, and that firm
moved in and occupied it while the
Leiter Building was finishing at Van
Buren and State, and at last Revell
placed it among the sights of Chicago.
This 6-story structure is a stone-front
of 1873, modernized by Revell in
1891, 100 feet on Wabash Avenue, 160
on Adams, 75 feet high, with 2 pas-
senger and 3 freight elevators.

4. The Hotel Brunswick has an envia-
ble frontage directly at the com-
mencement of the famous lake shore
façades of Michigan Boulevard. It is
opposite the Pullman Building, being
situated at the northwest corner of
Adams Street, with 100 feet on Adams
and 40 feet on the boulevard. The
structure, which is of the later period
(built in 1883), has 6 stories and base-
ment, 85 feet high, 100 rooms, 2
stores, and a passenger elevator. The
walls are of brick, iron, and terra-
cotta. The house is kept on the Ameri-
can plan.

5. The Williams Building is diagonally
opposite, at the southeast corner of
Monroe Street and Wabash Avenue.
Here is the wholesale millinery-store
of Edson Keith & Co., one of the
largest in the world, which all women
visitors should see, and Lyon, Potter &
Co.'s music-house. The building
stretches along no less than 160 feet
on Wabash Avenue and 180 on
Monroe Street, with 5 stories, 75 feet
high, 3 passenger elevators and 2
freight elevators. The style is that of
1873, with considerable elegance of
exterior.

6. The Clifton House is at the north-
west corner of Wabash Avenue and
Monroe Street. Here stands one of
the oldest of the family hotels, noted,

under various managements, for the
elegance of its belongings and the ex-
clusive quality of its family guests. Vast
sums have several times been ex-
pended on the furnishings of the
Clifton. The building has 160 feet on
Monroe Street and 80 on Wabash Ave-
nue. It is 75 feet high, with 6 stories
and basement, 155 rooms, and 6
stores. There are 2 elevators. The style
is that of 1873.

7. The Powers Building rises to 7 sto-
ries at the northwest corner of Michi-
gan Boulevard and Monroe Street,
and represents some beautiful little
shops on each thoroughfare. While it
has 172 feet on Monroe, there are
only 38 feet on the boulevard. The
building is 100 feet high, in 7 stories,
and has the Metropolitan Business
College for its principal tenant, along
with wholesale jewelers, tailors, and
small shopkeepers. There are 2 eleva-
tors. The construction is that of the
year 1890, stone, steel, brick, and
terra-cotta, at a cost of $200,000. (See
"Notable High Buildings.")

8. The Chicago Fire Cyclorama, at
127–132 Michigan Avenue, receives
some description and comment in
our chapter on "Amusements." The
building was erected in 1892, and oc-
cupies a lot 120 feet wide by 180 feet
deep. The height is 60 feet. It is said
that 144,000 people view the circular
painting each year.

**9. The Chicago Athletic Association's
Building** is conspicuous in our draw-
ing, and has a history singular among
all the genuine steel buildings so far
built in the world. No sooner was the
colossal structure under roof than, on
October 31, 1892, fire damaged it to
the extent of $200,000. It stands at
124–126 Michigan Avenue, 80 feet
front, 172 feet deep, 165 feet high, 10

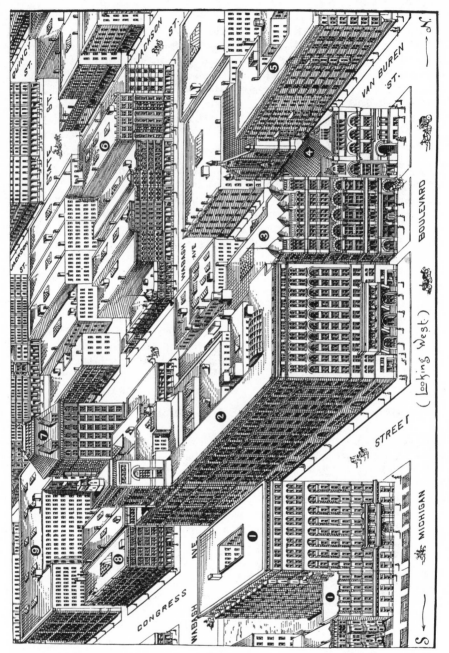

View 8. Looking West from Michigan Boulevard

stories and basement, and boasts the largest number of athletic conveniences that have been arranged together. The architecture follows the order set down in our chapter on "Steel Construction," or the description of Rand-McNally's in the chapter on "Notable High Buildings." It cost $600,000, and was repaired and finished in 1893.

10. The Continental Hotel, southeast corner of Wabash Avenue and Madison Street, carries us to the end of the picture, and to a building which was once the home of the Chicago Public Library; and here Librarian Hild began as a lad to learn his profession. The store-rooms are occupied by the Woman's Exchange and a large millinery establishment. The building is a stone-front of 1873, 120 feet on Madison Street, 100 feet on Wabash Avenue, 60 feet high, 4 stories, 150 rooms, 3 stores, and 1 elevator.

Looking West from Michigan Boulevard

The scene in view 8 offers two structures of the first rank among the edifices of the city, the nation, and perhaps the world. These are the Auditorium and the Leiter, or Siegel & Cooper Building. The façades of the foreground look upon the Lake Front Park, and are but a portion of the famous row that, beginning with the Public Library, extends well south toward the new station of the Illinois Central Railroad. The Public Observatory of the Auditorium (admission 25 cents) is here seen, and in its cupola is the station of the United States Signal Service. The new Isabella Building stands beyond. The only church that remains down-town and retains the form of a church is the New Jerusalem (Swedenborgian), on Van Buren Street. It would be well to especially note that the South Side Elevated Terminal is at the south end of No. 9, the Siegel & Cooper Building.

1. The Auditorium Extension fronts 178 feet on Michigan Boulevard and 173 feet on Congress Street, at the southwest corner. It is a part of the Auditorium Hotel, and is connected therewith by a tunnel under Congress Street. The building, which conforms in appearance with its ante-type, is 152 feet high, in 11 stories and basement, and has 500 rooms. There are 3 passenger elevators. It is among the notable high buildings which elsewhere have a chapter in this guide, and is constructed of steel, New Bedford stone, marble, tile, mosaic, and terra-cotta. It was erected in 1892, at a cost of $1,000,000, and a small addition has already been made on the south. This addition is 4 stories high and 60 feet wide on the boulevard.

2. The Auditorium fronts 362 feet on Congress Street, 187 feet on Michigan Boulevard, and 161 feet on Wabash Avenue. This celebrated and magnificent structure, the chief architectural spectacle in Chicago proper, has received attention in our chapters on "Hotels," "Amusements," and "Notable High Buildings." It covers 1½ acres, and the height of the main building is 145 feet, with 10 stories and basement. The spacious tower, however, is 17 or more stories in height, and measures 270 feet from the ground. The walls are of granite

and Bedford stone to the top, and the interior is of iron, steel, terra-cotta, and other non-combustible materials. A hotel (to which the Extension belongs), the largest theater in the world, a recital hall, 4 stores, and 136 offices go to make up the building. There are 13 passenger elevators, and 3 entrances to as many parts of the structure. It is estimated that in the mosaics of this great fabric are 50,000,000 pieces of marble, all placed by hand. The builders used 17,000,000 bricks, 25 miles of pipes, 60,000 square feet of plate-glass, and 12,000 electric lights. The theater will admit 8,000 people at a convention, 6,000 at a lecture, 5,000 at an opera. The dining-hall of the hotel is 175 feet long. The Auditorium was the conception of Ferdinand W. Peck, who, as president of the Chicago Auditorium Association, brought it to commercial success. Ground was broken in 1887. The Republican National Convention of June, 1888, was held in the theater, and the finished building was dedicated by President Harrison during the holidays of 1889–90. Cost, $3,200,000.

3. The Studebaker Building, at 203–206 Michigan Boulevard, doubtless influenced the architecture of its newer neighbor, the Auditorium, for there is a resemblance in color, height, and general effect. This carriage repository and manufactory has a frontage of 107 feet, a depth of 170 feet, and a height of 135 feet, in 8 stories and basement. It belongs to the class of notable high buildings of Chicago, and receives some description elsewhere. The exterior walls are heavy, and built of red syenite granite and Bedford stone. The two granite columns at the main entrance, 3 feet 8 inches in diameter and 12 feet 10

inches high, are said to be the largest polished monolithic shafts in the country. The first 4 floors display a selection of 2,000 fine carriages. The remaining floors are used as a manufactory of the same class of goods. Erected in 1884 by the famous wagon-makers of South Bend, Ind. Cost, $750,000.

4. The Chicago Club Building fronts 90 feet on Van Buren Street and 75 feet on Michigan Boulevard, at the southwest corner, and is an ornate structure which was erected and occupied by the Art Institute. From 1886 until 1892 it was the home of this association, when the property was sold to the Chicago Club, and remodeled to meet the needs of that society. The edifice is 95 feet high, in 4 stories and basement, and is made of steel, Connecticut brownstone, and brick. There are 2 passenger elevators. Cost, $200,000.

5. The Victoria Hotel Building fronts 102 feet on Michigan Boulevard and 172 feet on Van Buren Street, at the northwest corner, and was once the Beaurivage, Chicago's first "French flats," or fashionable apartment building. The structure is 80 feet high, in 6 stories and basement, with 2 passenger elevators. It was erected about 1878, and burned in 1882. It was rebuilt and stood until 1892, when it was remodeled for the Victoria Hotel, with 278 rooms. Cost, $600,000. (See "Hotels.")

6. Kimball Hall, at 243–253 Wabash Avenue, is an imposing structure, which is devoted largely to music. It is 150 feet wide, 100 feet deep, and 80 feet high, in 7 stories and basement. There are 75 offices for musicians and other professional men, a recital hall, and the ware-rooms of the W. W. Kim-

ball Company, pianos and organs. The building was erected in 1882.

7. The Isabella Building, at 44–48 Van Buren Street, is one of the very latest of the steel sky-scrapers. It is 46 feet wide, 78 feet deep, and 165 feet high, with 11 stories and basement. Copper enters conspicuously into its exterior construction. There are 4 stores, 100 offices, and 2 passenger elevators. The Daughters of Isabella have their society halls on the upper floor. Erected in 1893, at a cost of $200,000.

8. The Richardson Building fronts 80 feet on Wabash Avenue and 200 feet on Congress Street, at the northwest corner, and its 6 stories have a height of 85 feet. The building is a brick one of the old style, with 1 passenger and 2 freight elevators, and is occupied in the lower parts by the carpet company after whom it is named. On the upper floors are some of the heaviest subscription-book firms in the world. Here the Encyclopedia Britannica was photographed and cheaply reproduced, and Stoddard's Views of the World and other popular hits had their origin. Erected in 1886. Cost, $250,000.

9. Siegel, Cooper & Co.'s Building fronts 402 feet on State, 144 feet on Congress, and 144 feet on Van Buren Street. It is 123 feet high, and has 8 stories and basement. It is more fully described in our chapter on "Notable High Buildings," and stands as an example of good taste, munificence, and wisdom on the part of its builder, L. Z. Leiter. It is a steel edifice, with heavy walls of Bedford stone, and has a floor area of about 15 acres. There are 12 passenger and 6 freight elevators. The tenants do a retail business, with 2,000 employees, and practically offer all the conveniences of a small city, with 65 different kinds of stores, a bank, restaurant, butcher-shop, telegraph-office, employment bureau, dentist's office, doctor's office, barber-shop, and a hairdresser for ladies. It is claimed that this is the largest retail establishment in the world. Cost, $1,500,000.

Vicinity of Van Buren and Grand Central Stations

The scene presented in view 9 is notable, first of all, for the presence of two of the six railway passenger depots of Chicago. The first in sight (No. 5) is the Van Buren Street Station, and the farthest (No. 9) is the Grand Central Station. Reference should be had to our chapter on "Arrival," where both of these edifices are described. The Grand Central is mentioned also in the chapter on "Notable High Buildings." The block in the foreground of the picture contains two capacious hotels — McCoy's and Gore's, the latter being a steel structure. Another matter to be known concerning the streets of Chicago may be here adverted to. Van Buren Street is the southernmost street on the South Side that is a thoroughfare to the West Side, and it is in this region that the surface railroads narrow the South Side to a few blocks of width, finally leaving only State Street, Wabash Avenue, and Michigan Boulevard free. But by going west on Van Buren Street, and turning south on Fifth Avenue, Harrison Street may also be utilized as an exit, and many street-cars go still farther south on Fifth Avenue and reach a river-crossing at Twelfth Street.

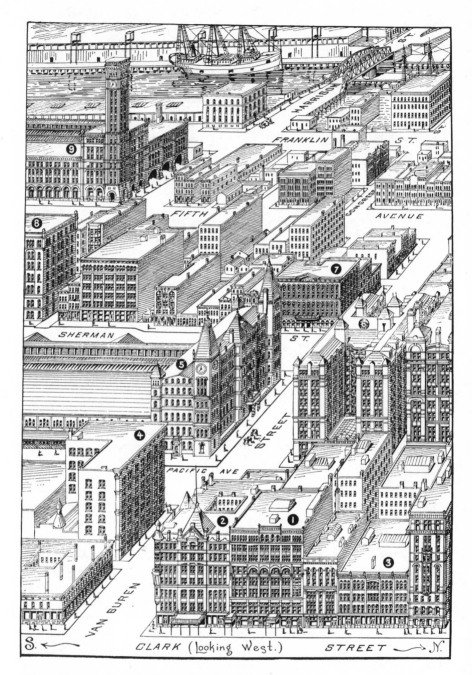

View 9. Vicinity of the Van Buren and Grand Central Stations

1. Gore's Hotel, at 266–274 Clark Street, occupies a steel building, with stone, brick, and steel exterior. It has 100 feet frontage, and is 110 feet high, with 8 stories and basement. There are 5 stores, 200 rooms, and 2 passenger elevators. The wrought-iron work of the office on the main floor is handsome, and the hotel is regarded as safe and popular by a large class of traveling men and visitors. There is a café in the basement. (See "Hotels.")

2. McCoy's European Hotel, at the northwest corner of Clark and Van Buren streets, is celebrated in Irish circles as the rendezvous of prominent Hibernians. It has a massive brick, cut-stone, and iron exterior, with 80 feet on Clark, 100 feet on Van Buren Street, and a height of 100 feet, in 7 stories and basement. There is 1 elevator. The lower part of the building is divided into 6 store-rooms, and there are 250 rooms in the hotel, which is strictly European. The office is upstairs. There is an excellent café on the main floor. Erected in 1884 for William C. McCoy.

3. The Imperial Building, at 252–260 Clark Street, presents a double floor at its entrance, and in this respect is unique in Chicago. It is 100 feet wide, 80 feet deep, and 55 feet high, with 4 stories and basement. It is a small but first-class building, and was long a favorite place for sporting men. There are 5 stores, 20 offices, and 1 passenger elevator. The occupants are the Postal Telegraph Cable Company, the Ives Billiard Hall, grain merchants, and stock operators. Erected in 1885.

4. The Omaha Building, at the southeast corner of Van Buren Street and Pacific Avenue, is a fine building, in which trade papers find light and agreeable quarters. It fronts 90 feet on Van Buren Street and 80 feet on Pacific Avenue, is 80 feet high, and has 7 stories and basement, with 6 stores, 65 offices, and 2 passenger elevators. The exterior is of brick, steel, and terra-cotta. Other occupants are ice companies and manufacturers' agents. Erected in 1884.

5. The Van Buren Street Station fronts 180 feet on Van Buren Street, and 400 feet on both Sherman Street and Pacific Avenue. Before the building of the Board of Trade this depot headed La Salle Street, and was a conspicuous land-mark of the city. In the Great Fire it stood for many hours as a protection to the eastern part of the South Side. It was rebuilt in 1873, and its dedication in June of that year was made a civic musical festival. In 1887 the front was built 2 stories higher, and tower-clocks were added as public conveniences. Fifty-two Rock Island trains, and 56 Lake Shore trains arrive here daily, and 4,500 passengers arrive and depart daily by the Rock Island and 3,500 by the Lake Shore. There are large and well appointed waiting-rooms. The front of the depot is 85 feet high, with 6 stories and basement, and is built of Joliet limestone. It cost $700,000. (See "Arrival in Chicago.")

6. The Rialto Building, bounded on three sides by Van Buren Street, Sherman Street, and Pacific Avenue, is so called because of a bridge which connects its upper floors with the main hall of the Board of Trade, directly north. The Rialto was one of the early high iron-and-steel buildings of Chicago, and its architects planned with special reference to light and air. Its frontage on Van Buren Street is 175 feet, and on Sherman Street and Pacific Avenue 144 feet. It is 160 feet high, with 9 stories and basement, 420

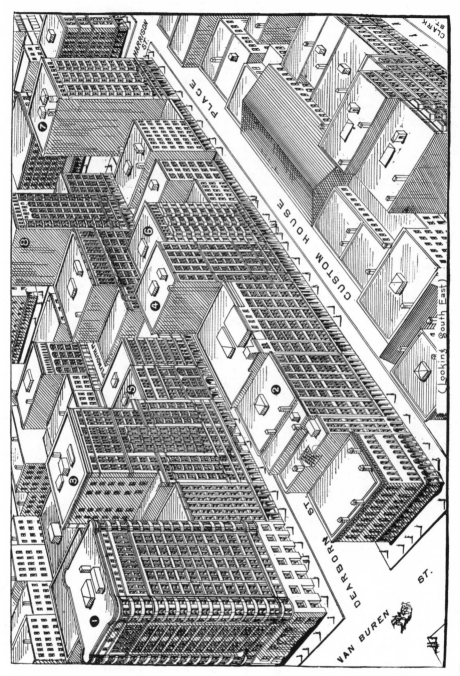

View 10. Printing House Row, from Van Buren Street

offices, and 5 passenger elevators. It is occupied by grain, commission, and insurance companies; and the Drainage Commission, in itself a government, has its headquarters on an upper floor. Erected in 1886 at a cost of $700,000. (See "Notable High Buildings.")

7. The Atlantic Hotel is a well-established hostelry at the southwest corner of Van Buren and Sherman streets, with frontages of 60 feet on Van Buren and 120 feet on Sherman Street, 90 feet high, 5 stories and basement, 100 rooms, office on main floor, and 1 passenger elevator. The building is an old-style stone front, erected in 1872.

8. The United States Appraiser's Building is a steel building which fronts 60 feet on Harrison Street and 80 feet on Sherman Street, at the northwest corner; 100 feet high, with 7 stories and basement. The fronts are of Connecticut brownstone. Excepting the World's Fair exhibits, all foreign goods consigned to the port of Chicago are received, examined, and delivered here. Erected in 1891.

9. The Grand Central Station fronts 228 feet on Harrison Street and 482 feet on Fifth Avenue, at the southwest corner, where its square tower rises to a height of 242 feet, and holds a clock-bell weighing nearly 6 tons. The arches open for carriages, which may

themselves enter the building, and the equipment of the whole edifice is regarded with pride by all railroad men and architects. The fore building is 100 feet high, with 7 stories and basement, constructed of Connecticut brownstone, brick, terra-cotta, and steel. There are 3 elevators. This station is the terminal of the Chicago & Northern Pacific (Wisconsin Central), Chicago Great Western, Baltimore & Ohio, Chicago Central, and Chicago & Southwestern railroads. The seating capacity of the waiting-rooms is 1,800, and 77 trains carry 10,000 passengers daily. The open train-shed, which is 560 feet long, covers 7 tracks, each accommodating 7 coaches and locomotive. This magnificent improvement was completed in 1890, and to serve the depot and not close Fifth Avenue the approach to Polk Street bridge, south of Harrison Street, was turned sidewise, and made architecturally a part of the station. (See "Arrival in Chicago.")

10. The Van Buren Building, at 187–191 Van Buren Street, is a very new steel sky-scraper, 130 feet high. It stands on a lot but 50 feet wide and 80 feet deep, and rises to 10 stories above the basement. Its front is of cut-stone and brick. It contains 100 suites of offices, and has 1 freight and 2 passenger elevators. It is occupied by manufacturers' agents and wholesale jobbers. Erected in 1893.

Printing-House Row, from Van Buren Street

View 10 portrays faithfully the extraordinary double row of high buildings which lines Dearborn Street between Van Buren and Harrison streets. This is Printing-house Row — so called from the large number of printing-offices included within its limits. Among the high structures of this group, described elsewhere, are the Old Colony, the Manhattan, the Pontiac, the Como, the Caxton, the Monon, and the Ellsworth.

1. **The Old Colony Building** is one of the latest of the high steel buildings, and fronts three streets at Dearborn, and Van Buren, and Plymouth Place, on the southeast corner of the two streets. Its frontages are 148 feet on Dearborn Street and Plymouth Place and 68 feet on Van Buren Street. The building is 210 feet high, of 17 stories and basement, with 6 passenger elevators. It is built with tower bays at the corners, and presents an ornate appearance. The first four stories are of light-blue Bedford stone and for the upper part Old Colony pressed brick and white terra-cotta are used. There are 5 stores and 600 offices. The corridor floors are laid in mosaic tile, and the modern appurtenances and luxuries are seen in profusion. The Old Colony was erected by Francis Bartlett of Boston in 1893, at a cost of over $900,000.

2. **The Girard Building,** at 298–306 Dearborn Street, has 100 feet frontages on Dearborn Street and Custom House Place. It is 60 feet deep and 80 feet high, with 7 stories and basement; 1 passenger elevator, 1 freight elevator, 15 offices, and 4 stores; brick, stone, and iron exterior. Occupied by printers, publishers, engravers, and photographers. Erected in 1888.

3. **The Manhattan Building,** at 317–321 Dearborn Street, was the first 16-story building erected in America, beating the Unity only by a neck. It has shoulders like a grain elevator, and at the time of its inception and construction was regarded with awe and fear. It has frontages of 150 feet on Dearborn Street and Plymouth Place, and is 68 feet deep, with a height of 200 feet. There are 3 stores, 600 offices, and 5 passenger elevators. The exterior is of granite, Roman brick, and terra-cotta. The interior is of steel, tile, and cement. The building is tenanted by manufacturers' agents and publishers. It cost $850,000, and was erected in 1890.

4. **The Monon Building,** at 320–326 Dearborn Street, extends through to Custom House Place, with frontages of 75 feet. It is 67 feet deep and 160 feet high, in 13 stories and basement. It is one of the fine high steel buildings of New Chicago, and was built principally for the general offices of the "Monon" Route. There are 4 stores, 125 offices, and 3 passenger elevators. The exterior is of brick and terra-cotta, the interior, steel and tile. Patent lawyers and publishers fill the offices which are not occupied by the railroad company. The Monon was erected in 1890 at a cost of $285,000.

5. **The Como Block,** at 323–325 Dearborn Street, has frontages of 40 feet on both Dearborn Street and Plymouth Place. It is 80 feet deep, 95 feet high, and is divided into 8 stories and basement. It was among the first of the better class of structures for publishers, and was built with steel frame and heavy walls of stone, brick, and terra-cotta. There are 2 stores, 25 offices, and 2 passenger elevators. The building is occupied by printers, publishers, engravers, artists, and manufacturers' agents. It was erected in 1888.

6. **The Caxton Building,** at 328–334 Dearborn Street, has frontages of 80 feet through to Custom House Place. This is a great hive of industry with printers, binders, and publishers on each one of its 12 stories. The building rises to a height of 150 feet, and has 3 passenger elevators, which carry 3,000 persons daily. There are 110 offices and 5 stores. The construction is

steel, fire-proofing, brick and terra-cotta exterior. Erected in 1890; cost $270,000.

7. The Pontiac Building is a still larger structure of the same high architectural character, at the northwest corner of Dearborn and Harrison streets, with 100 feet frontage on Dearborn and 70 on Harrison. It has 14 stories and basement, 260 offices, and 2 passenger elevators. The exterior construction is of brick and terra-cotta, with steel and tile interior. It is occu-pied by publishers and printers, and cost $375,000.

8. The Ellsworth Building, at 353–359 Dearborn Street, extends through to Plymouth Place, with frontages on both streets of 71 feet, and a depth of 60 feet. The building, of steel, with exterior of brick and terra-cotta, was erected in 1892. It is 170 feet high, in 14 stories and basement. There are 4 stores, 200 offices, and 3 elevators. The tenants are manufacturers' agents, publishers, and printers.

Region of Twelfth Street Railway Station

View 11 presents the new and magnificent Illinois Central Station, at the south end of the Lake Front Park, and graphically gives the relative situations of the world-famous Michigan Boulevard (elsewhere fully described) and Wabash Avenue, once the aristocratic thoroughfare of Chicago, but now a rapidly extending business street. The general view in this region is very beautiful, either looking toward the blue lake or westward on the throngs of fine carriages and well-dressed pedestrians continually passing northward and southward. The remarkable Twelfth Street viaduct may be seen to begin at Wabash Avenue. This elevated thoroughfare crosses twelve or more great trunk railway lines ere it descends to grade at Canal Street, on the West Side. The Manual Training School is also in sight, and the World's Fair may be seen from any point south of Van Buren Street along the lake shore. The visitor arriving at this station should note the location of several good hotels near by, all of which are described below. The great boulevard hotels are but a few blocks north.

1. The Twelfth Street Station fronts on Lake Park Place, formerly Park Row, which is the southern boundary of Lake Front Park. For 22 years the Illinois Central depot was the only ruin of the Great Fire, and many fruitless efforts were made by the railroad company to buy property from the city on which to erect a new station at the foot of Washington Street. The Supreme Court's decision in 1892 went against the company, and it withdrew to its own property at Twelfth Street. The present station was erected during the winter of 1892–93. The height of the main building is 9 stories, or 157 feet, the clock-tower being 13 stories, or 225 feet high. The exterior is a beautiful combination of Milford granite and Pompeian brick, with terra-cotta moldings to match. There is a frontage of 212 feet on Lake Park Place, and a depth of 178 feet to the baggage-court, on the Twelfth Street end of the station. The main waiting-room on the second story, 100 × 125 feet, is reached from the carriage court, or from the out-

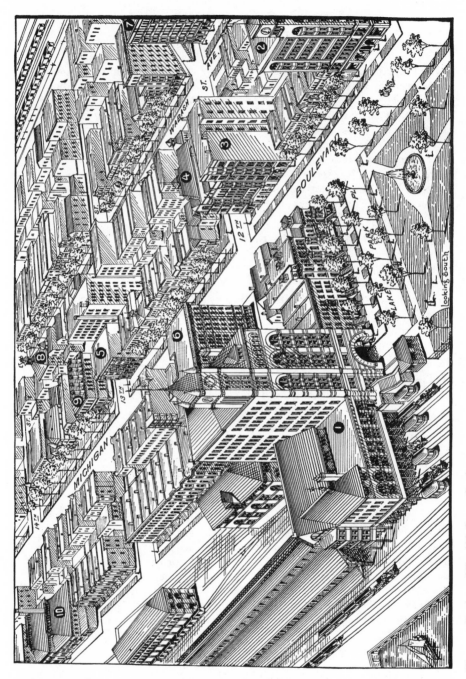

View 11. Region of Twelfth Street Station

side entrance. It has a bay-window, 25 × 50 feet, on the east side, giving a view of the lake through numerous plate-glass windows framed to represent pictures. There are spacious smoking-rooms, a woman's waiting-room, 50 × 75 feet, a restaurant, and private dining-rooms, all arranged and furnished in modern style; 3 high-speed elevators convey passengers to the general offices on the upper floors. The train-shed, over 600 feet long, is equipped with 8 tracks, and has accommodation for 110 passenger coaches at one time. The 3 detached buildings south of Twelfth Street are for baggage, incoming and outgoing, and for express. The emigrant-rooms are located over the baggage-rooms, on the second floor. The total cost of this building was upward of $1,000,000. The Illinois Central, Michigan Central, the "Big Four," and the Chicago & West Michigan railway lines occupy this station as their Chicago passenger terminal.

2. The Kimball Building, a conspicuous feature of Michigan Boulevard, stands at the southwest corner of Harmon Court, with frontages of 160 feet on the court and 80 feet on the boulevard. The structure is 7 stories high, or 115 feet, the clock-tower rising to the height of 140 feet. Granite, pressed brick, and terra-cotta form the exterior, the construction being thoroughly steel and fire-proof. There are 3 elevators — 1 passenger and 2 freight. This building was erected in 1892, and is entirely occupied by the owners, C. P. Kimball & Co., as a repository and factory for high-grade carriages, sleighs, and harness.

3. The Bordeaux Hotel has 60 feet frontage at 339 Michigan Boulevard, with a depth of 120 feet, and is 7 sto-

ries high. Its exterior is of pressed brick and terra-cotta. Erected in 1891, it has since been occupied as a hotel on the European plan, with a first-class French café in connection.

4. The Chicago Manual Training School, situated on the northwest corner of Twelfth Street and Michigan Boulevard, was erected in the spring of 1884. The materials used in its construction are cut-stone, red brick, and terra-cotta. It has a frontage of 60 feet on Michigan Boulevard and 160 feet on Twelfth Street. There are 4 stories and a large basement, all properly fitted up as a model training school for education in all branches of manual labor, with proper intellectual instruction. A history of this successful institution has been written and published in book form by the Hon. Charles H. Ham, United States Appraiser.

5. The Hotel Stamford, on the northwest corner of Michigan Boulevard and Thirteenth Street, has a frontage on Michigan Boulevard of 100 feet, depth 171 feet. The handsome exterior is of light-colored pressed brick, and terra-cotta. It is thoroughly fireproof, and has 300 rooms, reached by 2 passenger elevators. This building was erected in 1892, and has since been occupied as a European hotel.

6. The Hotel Imperial, located near the Twelfth Street Station, on the southeast corner of Michigan Boulevard and Twelfth Street, has a frontage of 100 feet on the former and 135 feet on the latter. It is 7 stories high, or 105 feet, equipped with 2 hydraulic passenger elevators. The exterior is of cut-stone, brick, and terra-cotta, the interior being handsomely decorated and finished in modern style. There are 300 guest-rooms, and all the con-

Location of Depots and Hotels

Our map shows with clearness and fidelity the twenty-five railroads entering
the city, with the location of their respective depots (black numbered rec-
tangles), together with that of sixty-three hotels situated in or near the
business district.

Railroads

6 Atchison, Topeka & Santa Fe
7 Baltimore & Ohio
3 Chicago, Burlington & Quincy
7 Chicago Central
7 Chicago Great Western
3 Chicago, Milwaukee & St. Paul
4 Chicago, Rock Island & Pacific
3 Chicago & Alton
6 Chicago & Eastern Illinois
6 Chicago & Erie
6 Chicago & Grand Trunk
7 Chicago & Northern Pacific
 (Wis. Cent.)
2 Chicago & North-Western

7 Chicago & Southwestern
6 Chicago & Western Indiana
8 Chicago & West Michigan
8 Cleveland, Cincinnati, Chicago
 & St. Louis (Kankakee Line)
8 Illinois Central
4 Lake Shore & Michigan Southern
6 Louisville, New Albany & Chicago
8 Michigan Central
9 New York, Chicago & St. Louis
3 Pittsburg, Cincinnati, Chicago
 & St. Louis
3 Pittsburg, Fort Wayne & Chicago
6 Wabash

Hotels

 1 Atlantic Hotel
 2 Auditorium Hotel
 3 Auditorium Hotel
 Annex
 4 Bradford Hotel
 5 Briggs House
 6 Brown's Hotel
 7 Brunswick Hotel
 8 Burke's Hotel
 9 Clifton House
10 Commercial Hotel
11 Continental Hotel
12 Crescent Hotel
13 Dowling House
14 Gault House
15 Germania House
16 Goldston's Hotel
17 Gore's Hotel
18 Granada Hotel
19 Grand Central Hotel
20 Grand Central Station
21 Grand Pacific Hotel

22 Grand Palace Hotel
23 Grand Union Hotel
24 Great Northern Hotel
25 Hamburg House
26 Hotel Bordeaux
27 Hotel Brevoort
28 Hotel Brewster
29 Hotel Cortland
30 Hotel Grace
31 Hotel Henrici
32 Hotel Imperial
33 Hotel LaFayette
34 Hotel Lansing
35 Hotel Le Grand
36 Hotel Midland
37 Hotel Queen
38 Hotel Stamford
39 Kuhn's Hotel
40 Leland Hotel
41 McCoy's Hotel
42 McEwan's Hotel
43 Madison House

44 Marquette Hotel
45 Merchants' Hotel
46 Neef's Hotel
47 Niagara Hotel
48 Nicollet Hotel
49 Ogden House
50 Old Metropolitan Hotel
51 Oxford Hotel
52 Palmer House
53 Revere House
54 Richelieu Hotel
55 Saratoga Hotel
56 Sherman House
57 Tremont House
58 Victoria Hotel
59 Virginia Hotel
60 Washington Hotel
61 Wellington Hotel
62 Windsor Hotel
63 Wood's Hotel

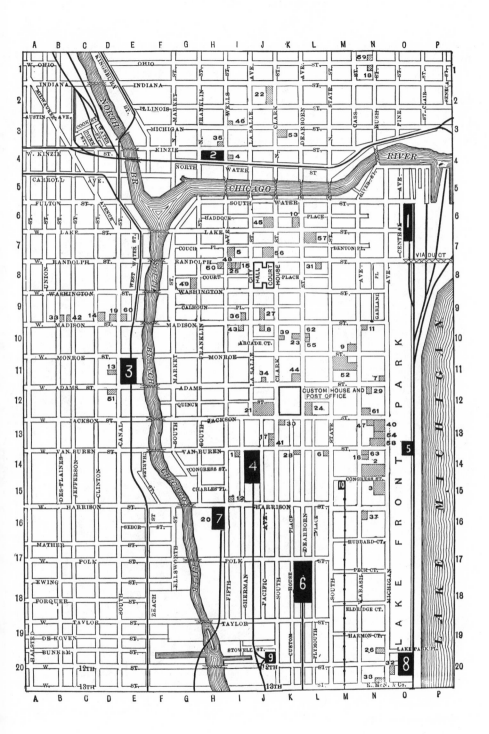

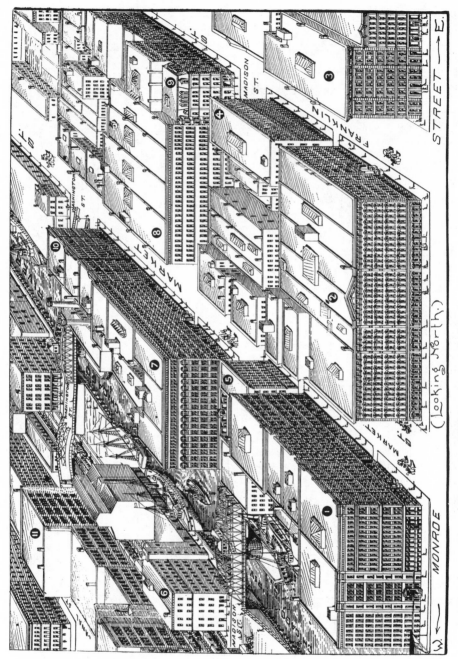

View 12. The Wholesale District, North on Market Street

veniences of a first-class hotel. This structure cost $200,000 in 1891.

7. The Hotel Martinette, situated on the northwest corner of Wabash Avenue and Twelfth Street, has frontages of 50 feet on Wabash Avenue and 100 feet on Twelfth Street. The exterior is of dark pressed brick and cut-stone. The building is 8 stories high, or 115 feet. The European plan has been adopted by the management of this hotel, there being 200 rooms and a first-class restaurant. Erected in 1892.

8. John Brown's Fort, 1339–1343 Wabash Avenue. The outer building is 50 feet in height, 80 feet deep, having a frontage of 75 feet. The old fort within is a low 1-story brick structure, containing 2 rooms and surmounted by a wooden tower 12 feet high. It was originally constructed as a part of the United States arsenal at Harper's Ferry, W. Va.; during the war it was occupied as a hospital by both the Federal and Confederate armies. Brown's personal rifles, pikes with which he proposed to arm the negroes, personal letters, accouterments, swords,

portraits, etc., of prominent generals, and many other relics of the great war are shown in connection with the old fort. It was removed from Harper's Ferry August, 1892, and erected in Chicago September, 1892.

9. The Veteran Protective Association occupies the 2-story building on the southwest corner of Michigan Boulevard and Thirteenth Street. It has a frontage of 80 feet on Michigan Boulevard and 100 feet on Thirteenth Street, and is constructed of cut-stone and brick. The basement is occupied by a medium-priced restaurant. Erected in 1875.

10. The Fourteenth Street Pumping Station was erected in 1892, and contains the engines and pumps that furnish the water obtained from the new 4-mile crib. The building is 2 stories high, and has an exterior of cut-stone and red brick. It occupies the northwest corner of Indiana Avenue and Fourteenth Street. There are 3 high-pressure pumps, with room for another whenever a demand is made for more water in that district.

The Wholesale District, North on Market Street

View 12 is especially notable and instructive on account of the presence of the river, and shows the facilities for loading and unloading that are offered to lake shipping. There are over 25 miles of similar dockage within the city limits, without reference to the Calumet River and Calumet Lake region — for Chicago now has two harbors on Lake Michigan. The bridge at Madison Street is of the largest and latest pattern, with steam motor. The Washington Street bridge has been but lately put where it is, for the structure is an old one displaced from Madison Street. Beneath the bridge and the river runs the Washington Street tunnel, through which pass many millions of people annually, on the cars of the West and Northwest cables. The foreground of the picture is in the heart of the wholesale district. After the Great Fire, the heavy wholesale men moved hither from Lake Street.

1. The Jewett Building, at the northwest corner of Market and Monroe

streets, is an old-style 6-story structure, erected in 1874, 95 feet high,

with 3 freight elevators. Its exterior is of brick and iron, and its great area may be understood by the statement that it has a frontage of 220 feet on Monroe and 100 on Market Street. It is partly occupied by the well-known wholesale clothing firm of Kohn Brothers, and partly as a warehouse.

2. The Old Farwell Block is a still larger edifice of similar history, fronting the whole of the north side of Monroe Street between Franklin and Market. It was built after the Great Fire, to accommodate one of the two largest dry-goods houses in the West, and fronts 189 feet on Franklin, 320 on Monroe, and 120 on Market. It is a 5-story stone-front, 85 feet high, with 8 freight elevators, and, since its relinquishment by the Farwells, has been occupied by wholesale clothiers, wholesale dealers in hats and caps and boots and shoes, and manufacturers and manufacturers' agents. The year of its erection was 1873.

3. The Field Building, at the northeast corner of Monroe and Franklin streets, is a 6-story stone-front of the old style, with 100 feet on Monroe and 185 on Franklin, 80 feet high. It has 3 freight elevators, and is occupied by wholesale clothiers and jewelers. It was erected in 1874, and is only one of very many similar Field buildings on the South Side.

4. The Commercial Trade Building, at the southwest corner of Madison and Franklin streets, is a striking piece of old-style architecture, the designer having secured many novel effects with the simple material at command. The frontages are 50 feet on Madison and 185 on Franklin, with a height of 90 feet in 5 stories and basement. The exterior is of brick and iron, showing long rows of arches at the sidewalk.

One passenger elevator and 2 freight elevators. The occupants are the Ames Sword Co., and wholesalers of boots and shoes, jobbers, agents, and others. It was erected at the close of the panic times, in 1878.

5. The Mullen Building, at the southwest corner of Madison and Market streets, occupies 40 feet on Madison and 100 feet on Market, 75 feet high, 5 stories and basement, brick exterior, with iron beams, and follows generally the description of an old-fashioned city business block. It is occupied by wholesale jobbers and manufacturers' agents. Erected in 1878.

6. The Norton Mill, at the west end on the north side of the Madison Street bridge, is 40 feet wide, 80 feet deep, and 60 feet high. It shows many cracks in its walls, yet sturdily defies the tooth of time. The elevator which is seen in its rear actually did collapse in 1892, with a large loss of grain.

7. The Central Union Block, at the northwest corner of Madison and Market streets, is one of Chicago's most creditable structures. After the Great Fire a brick building was hastily erected, and here, on the river front, the Chicago Board of Trade held its daily sessions for several years. Here the celebrated Sturges corn corner broke. Market Street is in reality a plaza, and taking advantage of their opportunities, the owners of the ground, in 1890, erected a fine brick and stone edifice of 6 stories and basement, with 220 feet on Market and 180 feet facing an inclined surface along Madison Street going up to the bridge. There are 12 stores, 622 offices, and 4 passenger elevators, with about 1,900 occupants, who are engaged in various industries and trades. The Central Union is also

mentioned in our chapter on "Notable High Buildings."

8. The Old Marshall Field Wholesale Building, at the northeast corner of Madison and Market streets, was hurriedly erected in 1872, to serve the owner's great dry goods houses, both wholesale and retail. On its site, before the Great Fire, stood the Garden City Hotel. The frontages are 240 feet on Madison and 180 on Market Street, and the 5-story building is remarkable for the number of its solid iron shutters, which have always been closed at the end of business hours. The value of the goods which have passed through this house would doubtless reach ten figures. It possessed the unusual convenience of a loading-place on Market Street, where traffic could never be engorged. The exterior is of the plainest brick. There are 4 freight elevators, and it is still largely used as a warehouse for the firm, which moved first its retail business to the splendid quarters at Washington and State streets, and after many years the wholesale to the granite structure at Adams Street and Fifth Avenue. A part of the old store is occupied by jobbers, manufacturers, and other denizens of the wholesale district.

9. The Abt & Fautl Building, at the northwest corner of Madison and Franklin streets, is a 4-story and basement structure with Mansard roof. It is a stone-front of 1874, with frontages of 80 feet on Madison and 25 on Franklin, 85 feet high. The building is occupied by wholesale jewelers, manufacturers, and manufacturers' agents.

10. The Central Manufacturing Block, at the southwest corner of Washington and Market streets, is a long and high block, given over completely to machinery, and haunted by inventors and machinists of all kinds. It fronts 240 feet on Market and 60 feet on Washington, is 65 feet high, and has 6 floors in all. It was built in 1872.

11. The Woolensack Building, at the southeast corner of West Washington and South Canal streets, can be seen only from the rear, but is here mentioned because it was erected as lately as 1892. Its dimensions are 120 feet on Washington, 80 feet on South Canal; height, 95 feet, with 7 stories and basement. The exterior is brick, stone, and iron. There are 2 freight elevators. It is occupied by manufacturers.

Within the Heavy Wholesale District

No greater transformation ever befell a locality than the changes wrought by the Great Fire in the region of Chicago which is portrayed in view 13. On the night of October 8, 1871, there lived on these squares a closely settled colony of the very poor, the vicious, and the criminal. Franklin Street did not extend south of Madison. At Market Street, on the north side of Adams, were the gas-works. On the south side of Adams, the Armory Police Court Building had just received the finishing touches of an all-summer's remodeling, whereby its walls had been lifted a story. Fifth Avenue was then Wells Street, and though it boasted the best buildings of the quarter, they were all low frame shops and sheds. Sidewalks were sometimes seven feet higher in

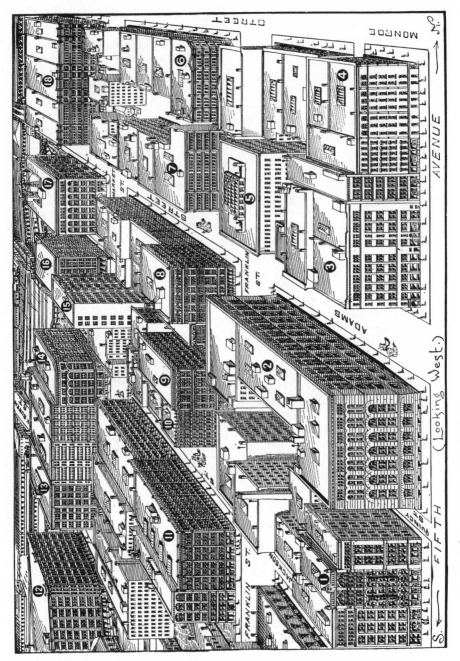

View 13. Within the Heavy Wholesale District

one place than in another, and such grogshops as the Dew Drop Inn made the section notorious as well as disreputable. Into this "Conley's Patch," as it was called, ran the then terrible Quincy and Jackson streets, and it is not likely that there is in Chicago today a purlieu so low. Not a vestige of this former criminal life remains. Neither buildings, monuments, landmarks, nor topography hint of the old Chicago of Conley's Patch. In its place are the trading-rooms and store-rooms of the leading wholesalers, who are now happily freed from the restrictions once laid on traffic in a narrower part of the city. On the left side of Monroe Street, at Franklin, is the site of Brother Moody's Tabernacle in 1876. The wholesale stores of Field, Farwell, Carson, Pirie, Scott & Co., Walker, and Phelps, Dodge & Palmer, and the office building of the Chicago, Burlington & Quincy are included in the scene.

1. The Owings Building, at 232–236 Fifth Avenue, now owned by Mandel Bros., is 80 feet wide, 100 feet deep, and 120 feet high, with 7 stories and basement. The front is of cut-stone and steel. There is 1 passenger and 2 freight elevators. The occupants are wholesale jobbers. Erected in 1886.

2. The Marshall Field & Co. Building (Wholesale), one of the most impressive structures in the whole world, is described in our chapter on "Notable High Buildings," although the building is an exception in that category of edifices. While only partial attempts were made to fire-proof its interior, the outer walls have no equal for solidity in the city. Great monoliths of red granite compose the exterior to the cornice of the upper or seventh story. Inner partitions of iron, shutters of iron, and a well-disciplined watch, add to the security of the colossal house. It fronts on the south side of Adams 325 feet, on Franklin Street and Fifth Avenue 190 feet, and is 130 feet high with 7 stories and basement. There are 13 elevators, 12 acres of floor space, and 1,800 employees. The visitor may enter and look about for a moment, beholding a wonderful hive of actual, time-saving trade. Erected in 1886.

3. Phelps, Dodge & Palmer Building fronts 80 feet on Adams Street and 180 feet on Fifth Avenue, at the northwest corner. It is 95 feet high, with 6 stories and basement; pressed-brick and terra-cotta exterior; 2 passenger elevators and 3 freight elevators. It is occupied by Phelps, Dodge & Palmer, wholesale jobbers and manufacturers of boots and shoes, and by wholesale jobbers of clothing. Erected in 1888 after a destructive fire.

4. The Williams Block fronts 180 feet on Fifth Avenue and 100 feet on Monroe Street, at the southwest corner. It is 95 feet high, with 6 stories and basement. There are 3 freight and 2 passenger elevators; brick and cut-stone exterior. The structure is occupied by wholesale jobbers of clothing and woolen goods. Erected in 1874.

5. The CB&Q Railway Building fronts 120 feet on Adams and 176 feet on Franklin Street, at the northeast corner. It is one of the fire-proof buildings of the new era, and has a fine quadrilateral interior court with balconies. It is 96 feet high, in 6 stories and basement. There are 65 offices and 3 passenger elevators, with about 400 occupants. The heavy walls are made of pressed brick with stone for trimmings. Here are the general of-

fices of the "Q." Erected in 1882, among the pioneers of the better buildings.

6. The Hovey Building fronts 160 feet on Franklin Street and 40 feet on Monroe Street, at the southwest corner. It is 90 feet high, with 5 stories; cut-stone and iron exterior; 3 freight elevators. The structure is occupied by wholesale jobbers of clothing, and manufacturers' agents. Erected in 1873.

7. Carson, Pirie, Scott & Co.'s Building fronts 160 feet on Franklin Street and 140 feet on Adams Street, at the northwest corner. It is 105 feet high, with 6 stories; cut-stone and iron exterior; occupied by the wholesale dry-goods house of Carson, Pirie, Scott & Co. Erected in 1875.

8. Mercantile Company Building, leased by Clement, Bane & Co., fronts 125 feet on Franklin Street and 100 feet on Adams Street, at the southwest corner. It is 125 feet high, with 8 stories; cut-stone, brick, and terra-cotta exterior; 2 passenger and 3 freight elevators. It is occupied by wholesale jobbers of shoes, clothing, and dry goods. Erected in 1886.

9. The Robert Law Building fronts 90 feet on Quincy Street and 80 feet on Franklin Street, at the southwest corner. It is 110 feet high, with 7 stories; rough-hewn stone and brick exterior; 1 passenger and 2 freight elevators. It is occupied by wholesale jobbers of clothing, boots, and shoes. Erected in 1887.

10. The Willoughby Building fronts 30 feet on Jackson and 75 feet on Franklin Street, at the northwest corner. It is 100 feet high, with 8 stories and basement; 1 passenger elevator; cut-stone and iron exterior. Occupied by

wholesale jobbers and importers. Erected in 1887.

11. The Boddie Block fronts 120 feet on Franklin and 160 feet on Jackson Street, at the southwest corner. It is 95 feet high, with 6 stories; cut-stone, brick, and terra-cotta exterior. Erected in 1883; remodeled in 1893.

12. McCormick Block is a very conspicuous structure that appears across the head of Market Street at Van Buren Street, because of the eastern division of the river. The building fronts 160 feet on Market Street and 95 feet on Van Buren Street, at the southwest corner. It is 100 feet high with 8 stories, and the walls are of cut-stone, brick, and terra-cotta. There are 2 freight and 1 passenger elevators. The occupants are wholesale jobbers and manufacturers of clothing. Erected in 1887.

13. The Chalmers Building fronts 75 feet on Van Buren Street and 50 feet on Market Street, at the northwest corner. It is 90 feet high, with 7 stories; cut-stone and brick exterior; 2 freight elevators, 1 passenger elevator. Occupied by wholesale jobbers of clothing. Erected in 1889.

14. The McCormick Building fronts 100 feet on Jackson Street and 80 feet on Market Street, at the southwest corner. It is 95 feet high, with 8 stories and basement; brick and terra-cotta exterior; 2 passenger elevators, 4 freight elevators. Occupied by wholesale jobbers and importers. Erected in 1887.

15. The Yondorf Building fronts 40 feet on Market Street and 100 feet on Quincy Street, at the southeast corner. It is 135 feet high, with 10 stories; 1 passenger elevator and 2 freight elevators; brick and iron exterior. Occu-

pied by wholesale jobbers of clothing. Erected in 1874; remodeled in 1892.

16. The Mallers Building fronts 140 feet on Jackson and 160 feet on Market Street, at the northwest corner. It is 95 feet high, with 7 stories; pressed cream-brick and cut-stone exterior; 3 passenger and 4 freight elevators. The building is occupied by wholesale jobbers of clothing, shoes, and silks. Erected in 1892.

17. The Ryerson Building, a magnificent structure whose Norman arches of granite are the first architectural exhibit of Chicago to be seen by the visitor who arrives at the Union Passenger Station, and comes over the Adams Street bridge near by, resembles the Grand Central Station in its outer walls. The interior follows the plan of wooden pillars, adopted in Marshall Field's wholesale store. The Adams Street front is on an incline of 152 feet, leading to the bridge on the south side of the street. The Market Street front is 166 feet. The building is 98 feet high, with 6 stories and basement. It is occupied as the wholesale dry-goods store of James H. Walker & Co., with 300 employees. There are 5 elevators.

18. The Farwell Block stands on Market, Adams, and Monroe streets and the river bank, presenting an imposing front from the Adams Street bridge. Its frontages are 180 feet on Adams and Monroe streets and 340 feet on Market Street and the river. The block is 95 feet high, with 6 stories; brick and cut-stone exterior. It is occupied by wholesale jobbers of clothing, hats and caps and dry goods. There are 2 passenger and 6 freight elevators. Erected in 1886.

Two Great Railway Stations

In views 14 and 15 are presented two of the seven great stations of Chicago. View 14, at the top of the page, is the scene at the Dearborn Station, on Polk Street, at the head of Dearborn Street, from which the terminal takes its name. In front of the Dearborn Station is the large Donohue & Henneberry aBuilding. View 15 shows the Union Passenger Station at Canal and Adams streets. The Adams Street bridge divides this structure. Beyond is the South Branch of the Chicago River.

1. The Dearborn Station, a beautiful building, was upon its erection one of the principal architectural spectacles of the town, and its Flemish tower and brazen dragon still attract the visitor's eye. It stands in front of Dearborn Street, which in 30 years has been extended clear from Madison Street. The fire-places of the interior and other ornate and useful appointments should be noticed. The frontages are 212 feet on Polk Street, 446 feet on Plymouth Place, and 188 feet on Custom House Place. It is 80 feet high, with 3 stories and basement; height of tower 166 feet. The trainshed is 600 feet long, with 8 tracks, each accommodating 12 coaches and engines. One hundred and twenty-two trains arrive and depart daily, and 17,000 suburban and through passengers are carried daily. The Chicago & Eastern Illinois, the Chicago & Erie, the Atchison, Topeka & Santa Fe, the Louisville, New Albany & Chicago, the Wabash, the Chicago & Grand Trunk,

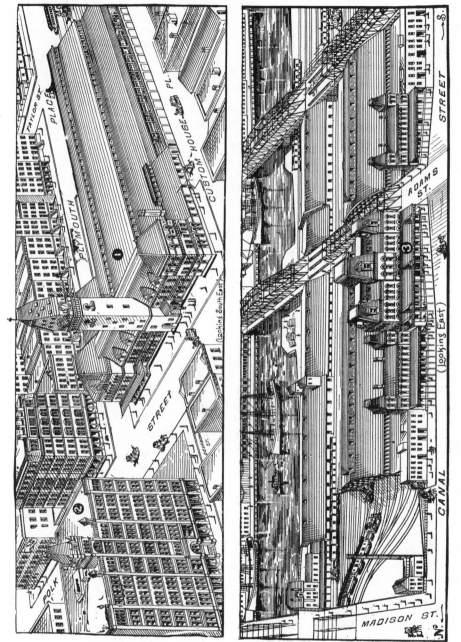

Views *14 and 15*. Two Great Railway Stations

and the Chicago & Western Indiana railroads all enter this station. It was erected in 1885, and cost $325,000. This station is treated in the chapter on "Arrival."

2. The Donohue & Henneberry Building stands in front of the Dearborn Station, near the northeast corner of Dearborn and Polk streets, at Nos. 407-425 of the former street. It has frontages of 180 feet on Dearborn Street and Plymouth Place, and is 71 feet deep and 120 feet high. It has 8 stores, 30 offices, 1,700 inhabitants, and 1 passenger elevator; stone, brick, and terra-cotta exterior; occupied by printers, publishers, book-binders, and printers' supply houses. Erected in 1886.

3. The Union Passenger Station, at Canal and Adams streets, on the West Side, near the South Branch of the river, has a frontage of 200 feet on Canal Street. This great depot is well described in our chapter on "Arrival." Architecturally it is a handsome red-brick series of three pavilions, with the larger one in the center. This part is 65 feet high, with 4 stories and basement, and cut-stone and brick exterior. The length of the train-shed is 1,000 feet, and its 8 tracks accommodate 20 passenger coaches and engines. Here 251 trains arrive and depart daily, carrying 30,000 passengers. The seating capacity of the waiting-room is 600. The station is used and occupied by the Chicago & Alton; Chicago, Burlington & Quincy; Pittsburg, Cincinnati, Chicago & St. Louis; Chicago, Milwaukee & St. Paul; and Pittsburg, Ft. Wayne & Chicago railways. Erected in 1881.

North of the Court House

The locality presented to the eye in view 16 is chiefly remarkable for the presence of the high Ashland Block, the high and narrow Schiller Theater, and the famous Sherman House, all of which stand in the nearest street, or in the foreground. Full half of the heavy wholesale business of the city was once done within these eight or nine blocks. The Great Fire caused a change of location to the region west of La Salle Street and south of Madison.

1. Hooley's Theater occupies a street frontage on Randolph of only 20 feet, but widens within, giving a stage 50 feet wide and 65 feet deep, the rear door being 180 feet from the entrance of the building, at 149 Randolph Street. This building has an exterior of cut-stone and iron, and is 4 stories and basement in height, with lodge-rooms on the upper floors. The theater seats 1,500 persons, but crowds them. The management is famous for presenting a line of first-class attractions, that command the admiration of all who patronize the drama. The best New York companies often play here. Erected in 1872.

2. The Fidelity Building, at 143–147 Randolph Street, stands just east, or lakeward, of Hooley's Theater, with 60 feet front, 60 feet of height, and 50 feet of depth, 4 stories and basement. It has a cut-stone exterior, and numerous safety vaults, visible from the street. This was once the home of the Fidelity Savings Bank, which failed in the hard times of 1877. The building is now occupied by steamship ticket-

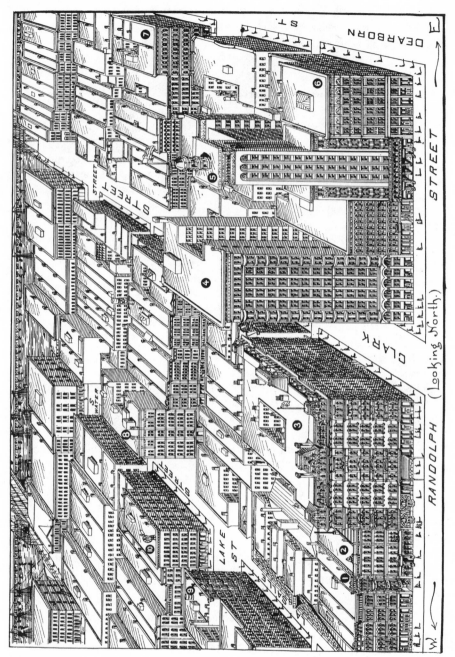

View 16. North of the Court House

agents, bankers, and costumers. It was erected in 1872.

3. The Sherman House, at the northwest corner of Clark and Randolph streets, or exactly north of the northeast corner of the Court House, presents a front of 150 feet to Randolph Street, and a still broader façade of 160 feet on Clark Street. It is 85 feet high, with 6 stories, basement, and Mansard roof, and has 300 rooms and 2 elevators. Its exterior is of cut-stone, and it was erected in 1872, while the Sherman House temporarily occupied the building now known as the Gault House, on the West Side, at the northeast corner of Madison and Clinton streets. The Sherman House, like the Tremont House, the Grand Pacific Hotel, and the Lakeside Building, retains its magnificent appearance in the presence of the colossal structures which have come with the steel era. The reader is referred to our chapter on "Hotels."

4. The Ashland Block is at the northeast corner of Clark and Randolph streets, and is the larger of the two high buildings seen in the picture on the opposite page. In our chapter on "Notable High Buildings" we have referred to some of the phenomena attending its construction. It was erected in 1892 at a cost of $850,000, and supplanted a block as high, and nearly as large, as the Sherman House. In the old Ashland Block, Charles J. Guiteau had his office, and the Chicago *Tribune* and Rand & McNally did business on this lot at 51 Clark Street, touching the alley. The new Ashland Block occupies 140 feet on Clark Street and 80 on Randolph. It is 200 feet high, with 16 stories and basement. It is all steel, with terracotta coverings and fire-proofing. Its

7 elevators serve 480 offices, 9 stores, and over 1,000 occupants. These are largely attorneys, brokers, real-estate dealers, bankers, and financial agents.

5. The Schiller Theater, at 103–109 Randolph Street, is 211 feet high, 80 feet wide, and 180 feet deep, 16 stories and basement, in which is a café. It has, besides the theater, 2 stores, 204 offices, 1 freight and 5 passenger elevators. It was erected in 1892 by the German Opera House Company at a cost of $750,000, and contains a cozy and entirely safe theater that seats 1,286 people, with a stage 74 feet wide and 32 feet deep. The assembly and club rooms of the association are on the twelfth and thirteenth floors. The construction is of steel, with terracotta and brick exterior. The tenants are attorneys, architects, and professional men.

6. The Borden Block, at the northwest corner of Randolph and Dearborn streets, was counted a wonder in its day, when its builder thus commemorated his good fortune in the silver mines of Leadville. It was almost the forerunner of the box-like structures which sacrifice beauty to larger supplies of light and air. It stands on the site of the Matteson House of other days, where Captain Carver, Carmé, Rudolphe, McDevitt, Goldthwaite, Tom Foley, Budd Doble, and the sportsmen of the city loved to congregate. The frontages of the Borden Block are 80 feet on Randolph Street and 90 on Dearborn. The building is 100 feet high, with 6 stories and basement. It has 65 offices, 6 stores, and 2 passenger elevators. It has a cut-stone exterior, and is occupied by professional men, largely attorneys. It was erected in 1880.

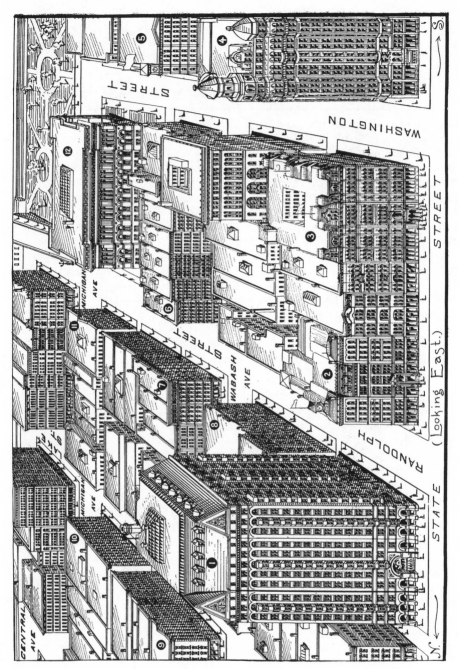

View 17. From State Street, Looking East

7. The Commercial Hotel, at the northwest corner of Lake and Dearborn streets, has 150 feet on Lake and 200 feet on Dearborn Street, but the hotel impinges on the upper floors of adjoining buildings. Our article on "Hotels" discusses the characteristics of this popular inn. The building is 65 feet high, 5 stories and basement, 300 rooms, 9 stores, and has a steam elevator. It is a stone front of the ancient pattern, and was built in 1872.

8. The Marine Building is a large structure of the era of 1873, at the northeast corner of La Salle and Lake streets, which has been affected in value by the presence of the La Salle Street tunnel entrance on its south. The frontages are 100 feet on La Salle and 80 feet on Lake Street. It is 85 feet high, and has 6 stories and basement, with 45 offices, 8 stores, and 60 occupants. There is an elevator. The front is of stone. Bankers, financial companies, and attorneys are the tenants.

9. The Northern Pacific Building is at 30–36 La Salle Street, with frontages of 80 feet on both La Salle and Lake streets. It is 6 stories and basement, or 70 feet in height, and has 8 stores, 93 offices, over 100 occupants, and 2 passenger elevators. It has a pressed-brick exterior, was erected in 1872, and was remodeled in 1891. It is tenanted by attorneys, financial companies, manufacturers' agents, and people who have business among manufacturers and wholesalers.

10. Fairbanks, Morse & Co.'s Building, at the northwest corner of La Salle and Lake streets, shares some of the disadvantages of having the La Salle Street tunnel entrance near by, as may be seen in the picture. The building has a wide front of 100 feet on La Salle and 80 feet on Lake Street. It is 75 feet high, in 5 stories and basement. The outside walls are of brick and iron, and were erected as late as 1879. The entire structure is occupied by Fairbanks, Morse & Co., who, as their sign on the roof purports, are manufacturers of windmills, scales, and other machinery.

From State Street, Looking East

The unexampled structures rising before the eye in view 17 attest the fact that the wide portion of State Street has not lost its priority in the good opinion of Chicagoans. Here, where so many hundreds of thousands of promenaders, buyers, and sight-seers pass, stand the Masonic Temple, Central Music Hall, Marshall Field & Co.'s retail store, and the Columbus Memorial. The new Field rises behind the old Field Building, and the Public Library still farther eastward at the Lake Front. At the farther left corner of the library may be seen an approach to the Randolph Street viaduct, by which one may reach the outer piers and docks. The Venetian Building is hidden from view by the Columbus Memorial. State Street is here very wide, because it was once a market-place.

1. The Masonic Temple fronts 170 feet on State and 114 feet on Randolph Street, at the northeast corner.

This building occupies the place of honor in our chapter on "Notable High Buildings," and is there fully de-

scribed. Its 21 stories carry it to a height of 302 feet. There are 10 stores, 543 offices, many lodge-rooms, and a public observatory. The exterior walls are heavy, of granite and yellow pressed brick. The rotunda on the main floor is open to the skylight at the top, and is nearly surrounded by 14 passenger and 2 freight elevators. In the basement and under the street are 2 Corliss engines, each of 500 horse-power; 8 steel boilers, 6 dynamos, and 8 large pumps. The electric apparatus weighs 60 tons, and includes 53 miles of wire. It is not possible to classify the tenants of a building which is a city in itself; and again, the edifice has not yet developed its characteristics. The upper floors are fitted for Masonic lodges, chapters, asylums, and councils. The first ten floors are expected to accommodate merchants. Professional men already favor the office floors. The observatory offers a very high point of view, to be obtained for a small fee and without climbing. This wonderful edifice was erected in 1890–92, at a cost of $3,500,000.

2. Central Music Hall fronts 125 feet on State and 150 feet on Randolph Street, at the southeast corner, and is 90 feet high, with 6 stories and basement, and 2 elevators. When this building was promoted by the late George B. Carpenter, it was regarded as an outright speculation, and a stock company was necessary — the forerunner of many hundred similar architectural undertakings. The building is a fire-proof structure, with 12 stores, 75 offices, and an auditorium with 2 balconies capable of seating 1,800 persons. There is a good organ, but no scenery, although spacious dressing-rooms are to be found under the stage. In this hall many of the most-

distinguished people of the world have appeared publicly. Here Beecher fell unconscious on the stage, Tilton lectured, Patti sang, Lowell spoke, Edwin Arnold read, and many other celebrities have greeted great audiences. Among the most notable successes were the Stoddard lectures, which for many years crowded the hall for a month at a time, and kept ticket-buyers standing all night at the box-office. Nor has the business part of the building been less successful. Here the Chicago Musical College, under Dr. Florence Ziegfeld, has for 14 years increased, throwing off branches and rival "conservatories," and music-teachers have daily made an unceasing din. Erected in 1879.

3. The Marshall Field Buildings occupy the whole north side of Washington Street, between State Street and Wabash Avenue, fronting 260 feet on State Street, 340 feet on Washington Street, 108 feet on Wabash Avenue. The old building is a remarkably handsome structure of the Parisian style, which is the third of a like appearance that has risen on this site since 1868, when it was first opened by this firm. It is 125 feet high, with 6 stories and basement, ornate stone front, and many pavilions. There are 6 elevators. The windows are dressed with the latest, richest, and most beautiful goods, and the interior presents an animated and entertaining spectacle. The new building was erected in 1892, at the northwest corner of Washington Street and Wabash Avenue, of steel, granite, terra-cotta, tile, and marble, in the latest style of fire-proof construction. It has 9 stories, 90 suites of offices, and no less than 13 elevators. The four lower floors have been added to the retail quarters, and the whole gives to Field & Co. a vast

accommodation for their retail dry-goods business.

4. The Columbus Memorial Building fronts 100 feet on State and 90 feet on Washington Street, at the southeast corner. The example of this building, it is expected, will introduce a still larger use of the metals and artistic ornament into Chicago's principal architectures. The edifice has 14 stories, and rises to a height of 251 feet. Its two fronts are elaborately treated both at base and summit, and it is the richest-looking of the high steel structures of the city. Sculpture, paintings, cupolas, and bronze enter into its interior and exterior furnishings, and these are more fully described in that part of this guide which is devoted especially to buildings of the new style. The Columbus Memorial takes the place of a handsome old-style stone front, which was filled with physicians and dentists, and it is expected that they will return to this corner, where a free library and reading-room has been prepared for their use. Erected in 1892, at a cost of $1,000,000.

5. The Tobey Furniture Company's Building fronts 120 feet on Wabash Avenue and 160 feet on Washington Street, at the southeast corner; is a 6-story stone front, of the style of 1872; 75 feet high, with 4 elevators. It is occupied with a retail furniture exhibit that has few equals in the world, 180,000 square feet of floor space being covered with fine and beautiful products of the cabinet-makers' and house-furnishers' arts. This square was the scene of the costly Farwell and Field fire of September 12, 1870, when several millions of property were burned.

6. The Laflin Building fronts 200 feet on Randolph Street and 40 feet on Wabash Avenue, at the southeast corner. It is 85 feet high, with 5 stories, and 2 freight elevators. Its walls are built of brick and steel. The occupants are wholesale chemists, tobacconists, the American Whip Company, and manufacturers' agents. Erected in 1879.

7. The Fairbank Building fronts 80 feet on Randolph Street and 80 feet on Wabash Avenue, at the northeast corner. It is a 6-story brick building, 70 feet high, with stone trimmings, 3 stores, 20 offices, and 1 elevator; occupied by stove manufacturers and others. Erected in 1872, and remodeled on new interior lines in 1890.

8. The Atlas Block fronts 169 feet on Randolph Street and 228 feet on Wabash Avenue, at the northwest corner. It is 75 feet high, and is a 5-story brick building. There are usually about 375 occupants, who are wholesale jobbers and agents. Erected in 1879.

9. Hibbard, Spencer, Bartlett & Co.'s Block fronts 120 feet on Wabash Avenue and 160 feet on Lake Street, at the northeast corner. It is a 5-story brick building, 85 feet high, with 4 freight elevators. It is occupied by the above firm with the largest general hardware business so far developed in Chicago. There are 325 employees. Erected in 1877.

10. The McCormick Building fronts 60 feet on Lake Street and 100 feet on Michigan Avenue, at the northwest corner. It is a 5-story brick structure, 75 feet high, with 1 freight elevator; occupied by John A. Tolman & Co., importers and wholesale grocers. Erected in 1876.

11. The Dearborn Block fronts 160 feet on Michigan Avenue and 150 feet

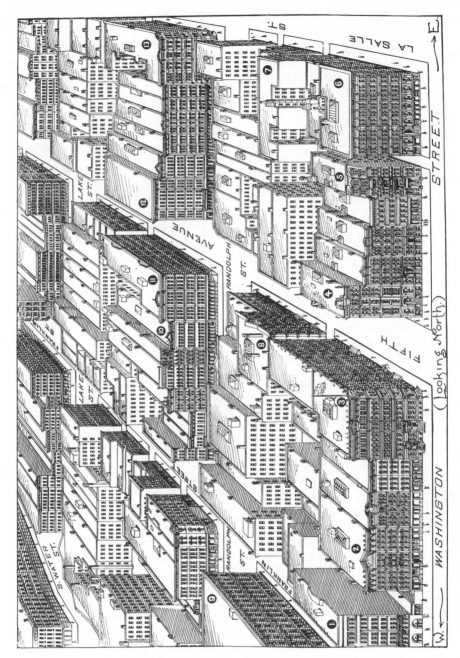
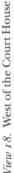

View 18. West of the Court House

on Randolph Street, at the northwest corner. It is a 5-story building, 75 feet high, with 2 freight elevators, and fronts the north end of the Public Library. It is occupied by the great grocery house of Spragues, Warner & Co., one of the heaviest firms of the kind in the world. Erected in 1872.

12. The Public Library occupies Dearborn Park, and is on ground that has never before been permanently covered. (See "Notable High Buildings.") A brief history of the Public Library is as follows: Begun in 1872 from the gifts of the world; occupied a water-tank in the Rookery; at the southeast corner of Madison Street and Wabash Avenue; at the southwest corner of Lake and Dearborn streets; in the City Hall. The first librarian was William F. Poole; the second, Frederick H. Hild, who is now in charge, under an appointive board of trustees. The new building fronts on Michigan Avenue, Washington, and Randolph streets; frontages, 354 feet on Michigan Avenue, 147 feet on Washington and Randolph streets, 95 feet high, in 3 principal stories, 2 intermediate floors, and a basement; 8 passenger elevators; total area, 50,367 square feet; weight, 72,000 tons; 146,000 cubic feet of stone and 1,955 tons of iron were used in construction. There is to be room for 900,000 volumes. Blue Bedford stone, granite, and limestone exterior, with large arches and columns after designs suggested by the ancient gateway at Athens which divided the Roman from the Grecian section of the city. The colonnade is Ionic, with solid piers interspersed, the frieze bearing the names of historic writers. The Washington Street entrance is treated in the Roman method, with coffers and appropriate ornamentation, while the Randolph Street entrance is in classic style, massive columns and entablature being employed. The roof is of copper. A stone balustrade surmounts the walls. The halls and corridors are finished in marble mosaic, cream-colored terracotta in artistic designs being used on the ceilings. The G.A.R. organizations of Cook County will occupy 18,500 square feet of the north section, known as Soldiers' Memorial Hall, for a term of fifty years. Estimated cost, $1,200,000. Erected in 1893–94.

West of the Court House

The eye here surveys a district into which the high steel building has not yet invaded. At the left in view 18, in the distance, South Water Street may be seen rounding into Lake Street at Market Street, and at that point stood the Wigwam wherein Abraham Lincoln was nominated for President of the United States in 1860. Among the most notable of the buildings so accurately portrayed in this picture are the Times, Staats-Zeitung, Telephone, and Metropolitan.

1. The Telephone Building, northeast corner of Franklin and Washington streets. In this handsome home of steel, granite, and terra-cotta the great monopoly beholds the expiration of some of its important patents, but relies as firmly on the public concessions which those patents brought to its use and possession. This very elegant building stands at the descent

into the Washington Street tunnel, the cynosure of thousands of West Side travelers. It is 100 feet high, in 7 stories and basement, 40 feet on Washington Street, 90 on Franklin, and has 2 elevators for its employees. The granite arch and tiling at the entrance are notable. It was erected in 1888, and is occupied by the Chicago Telephone Company.

2. The Forbes Block was erected in 1872 at 191–197 Washington Street. It has 80 feet of front, is 100 feet deep, and is 55 feet high, with 4 stories and basement. It is a stone front of the old style, and is given over to light manufactures, publishers, printers, and manufactures' agents.

3. The Times Building is at the northwest corner of Washington Street and Fifth Avenue. Before the Great Fire, Fifth Avenue was called Wells Street, and still bears that name north of the river. The structure was erected by Wilber F. Storey, under the direct supervision of Franc B. Wilkie, a writer famous as "Poliuto," and for his many valuable books. The history of the building is given in Wilkie's "Recollections." While it was uprearing, in 1872, the *Times* occupied a long one-story shed near the river south of Adams Street on the West Side, where the Union Passenger Station's immigrant room now stands. The Times Building is exceptional in its advantages of light, heat, and elevator service, which have been continuous, night and day, for twenty years. The edifice was a valuable and elegant one in its day, and its hardwood finish has given it an enduring character, though the wear and strain on the interior of a daily newspaper office are great. There are 5 stories, and the presses are in the basement; 80 feet on Washington Street, 189 feet on Fifth Avenue, 75 feet high, 2 steam

passenger elevators, 36 offices, 4 stores, counting-room of the *Times,* and offices of the daily *Freie Presse.* The editorial rooms and composing-room are on the upper floor, and many of their conveniences were for fifteen years the best in Chicago.

4. The Staats-Zeitung Building is a prominent and tasteful structure of the old style, across from the Times, at the northeast corner of Washington Street and Fifth Avenue. Various statues adorn the façades, and the prosperity of the oldest German daily newspaper of the West has lent its mark to the surroundings. On Washington Street there are 40 feet; on Fifth Avenue, 110 feet. The 6 stories carry the cornice to a height of 90 feet, and the presses may be seen in the basement. There are 30 offices, with 1 elevator. The building was erected by A. C. Hesing, who, before the Great Fire, was called "Boss of Chicago," owing to his paramount political influence. The paper is now conducted by his son, Washington Hesing. The buildings just east of the *Staats-Zeitung* have long been famous as lodge-rooms and meeting-places of all kinds of societies, but particularly of workingmen with political aspirations, Knights of Labor, and others.

5. The Central Bank Building, at 155–157 Washington Street, next the alley, on the west, was rebuilt in 1872, and is shown as it was previous to its renovation in 1892, when a beautiful sculptured façade was destroyed to make light and give air. This stone façade stood alone after the Great Fire, and was then regarded as an important salvage. The same fate has befallen the building of the *Evening Journal,* on Dearborn Street. This structure is 40 feet wide, 102 feet deep, 85 feet high, 7 stories and basement, and has 50 offices. There is an elevator. At-

torneys and professional men occupy the offices, with banks and financial operators on the lower floor.

6. The Merchants' Building stands on the valuable property at the northwest corner of La Salle and Washington streets; 100 feet square, 60 feet high, 5 stories and basement, 60 offices, 3 stores, and 2 elevators. On the top floor have long been the headquarters for spiritualists and persons interested in psychic research. Here were the offices of the Mutual Union Telegraph while it fought its losing battle with Jay Gould. The edifice is a sumptuous stone front of the ancient era, when Chicago got its architecture, as it still gets its women's gowns, from Paris. Bankers, real-estate agents, attorneys, and Court House people generally occupy the building.

7. The Oxford Building, 84–86 La Salle Street, was remodeled in 1891. Its dimensions are: Width, 43 feet; depth, 165 feet; height, 80 feet; 8 stories and basement, with 140 offices. There are 2 elevators. Old-style stone front, with modern adjuncts. The tenants here, as on La Salle Street generally, are of classes that are similar in nature — law, real estate, finance, architecture, claims, and insurance.

8. The Greenebaum Building, at 76–82 Fifth Avenue, in its early days held the abstract offices. It is now devoted to publishers, printers, and light manufactures, but has a well-known lodge hall above. There are 4 stores and 20 offices; dimensions, 80 feet wide, 100 feet deep, 65 feet high, 4 stories and high basement. It was erected in 1872.

9. The Fitch Building, southwest corner of Franklin Street and Randolph, was erected in 1876 for the use of the M. J. Fitch Paper Company, and cognate interests. It has 140 feet on Franklin and 80 feet on Randolph. It is 90 feet high, with 5 stories and basement; 2 freight elevators.

10. The Bonfield Building, at 199–203 Randolph Street, was erected in 1872 for wholesale jobbers; 4 stories, 50 feet wide, 120 feet deep, 50 feet high, and stone front.

11. The Garden City Block, at the northwest corner of Randolph Street and Fifth Avenue, was once A. H. Revell's headquarters, and was remodeled in 1892. It is now a vast building, with 200 offices, 9 stores, and 3 elevators. Dimensions, 80 feet on Randolph, 180 on Fifth Avenue, 90 feet high, 7 stories. It is a stone front of the year 1873.

12. The Briggs House has a place in our chapter on "Hotels." It occupies the northeast corner of Randolph Street and Fifth Avenue, with 80 feet on the former and 140 on Fifth Avenue. It is 95 feet high, in 6 stories, and has 8 stores, 150 rooms, and 2 elevators.

13. The Metropolitan Block, before the Great Fire, was conspicuous as Library Hall. It is a 5-story stone front of the year 1872, at the northwest corner of Randolph and La Salle, with 200 feet on the latter street and 80 feet on Randolph. There are 2 elevators, 106 offices, and 8 stores, for brokers, agents, publishers, and small firms.

From Randolph Street, Looking South on La Salle

View 19 covers some of the most remarkable buildings in Chicago, including the great old-style structure commonly called the Court House, and such steel edifices as the Chamber of Commerce, Tacoma, Teutonic, Herald,

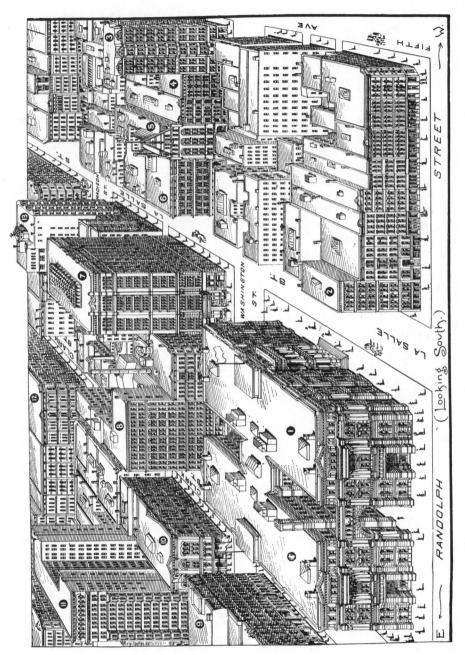

View 19. From Randolph Street, Looking South on La Salle

Title & Trust, and Chicago Opera House. At the time of the Great Fire there were residences along Madison Street west of La Salle, and private houses had been gone but a few years from the west side of La Salle, opposite the Court House. Randolph Street, in 1871, was the most brilliant thoroughfare of the city after dark.

1. The City and County Buildings are generally described on another page. The architect intended that a dome should rise in the center of the plan, and the abandonment of his ideas has disturbed the effect of the edifice. Nevertheless, the "Court House," as the block is called, is impressive in appearance. It occupies the original court-house square, bounded by Washington, La Salle, Randolph, and Clark streets, and is 337 feet long on La Salle and Clark by 214 feet wide on Washington and Randolph. It is no less than 120 feet high, in but 4 stories and basement, and has 14 passenger elevators, which are nearly always well filled. The county side is on Clark Street, and the exterior is built of local limestone, which has disintegrated in places. On the La Salle, or city side, the material is Bedford stone and granite, more durable substances. Many blocks of the limestone have fallen from the Clark Street front, owing to the action of frost. On that side are various local courts, the law library, and county offices. The La Salle Street building contains the headquarters of the mayor, police, fire department, and other city service. The handsome Council Chamber is on the upper floor. The Public Library is on the same floor, pending the completion of its own building. This colossal pile was erected in the years between 1878 and 1885. Many political scandals and some litigation attended its construction.

2. The Lafayette Building is a handsome old-style structure at the south-west corner of Randolph and La Salle streets, with the following dimensions: On La Salle, 100 feet; on Randolph, 40 feet; height, 70 feet, in 6 stories and basement; 2 elevators. There are 35 offices, with about 225 occupants, who are bankers, steamship agents, real-estate agents, editors, architects, and attorneys. The building, which dates from 1872, was renovated in 1890.

3. The Teutonic Building, at the southeast corner of Washington Street and Fifth Avenue, is one of the newest of the notable high buildings of Chicago, and has a place in another chapter. Its frontages are 80 feet on Washington Street and 60 feet on Fifth Avenue. It is 130 feet high in 10 stories and basement, being but 10 feet higher than the 5 stories of the Court House. It has 4 stores, 125 offices, and 3 passenger elevators. Its exterior is of brick and terra-cotta. Its interior is of steel and fire-proof tile. It is occupied by real-estate and investment brokers, attorneys, and others. It was erected in 1892–93.

4. The Evening Post Building, at 164–166 Washington Street, next east of the Teutonic, was erected in 1872, but was rebuilt in 1891. It is 40 feet wide, 181 feet deep, and 65 feet high, in 5 stories and basement; cut-stone front. Beside furnishing a home to the *Evening Post,* the building has 35 offices and 2 passenger elevators. The latter are approached from a handsome counting-room, making an attractive interior scene.

5. The Herald Building, at 154–158 Washington Street, is faithfully shown, its gabled front rendering it conspicuous. It is 61 feet wide, 181 feet deep, and 124 feet high, in 7 stories and basement. The construction is of steel, granite, brick, tile, and terra-cotta, and the newspaper establishment which it shelters is described elsewhere. The scene on entering the counting-room is beautiful. Erected in 1891.

6. The Union Building, at the southwest corner of Washington and La Salle streets, gives way to the Stock Exchange, a sky-scraper of steel described in the chapter on "Notable High Buildings." The old structure is historical as the telegraph headquarters of the West. Here all the news of the Associated Press and all the private dispatches of the Western Union were received. The old building, which was erected in 1872, was 80 feet square and 90 feet high, with 4 stories and a high basement, in which was the telegraph office. Upstairs were the Atlas and International banks.

7. The Chamber of Commerce Building, at the southeast corner of Washington and La Salle streets, has an extended description elsewhere. It is 185 feet long on La Salle and 95 feet wide on Washington, 190 feet high, in 13 stories and basement, and has 8 passenger elevators, that carry 30,000 people in 10 hours. The 600 offices of this structure are occupied by professional men of all kinds, and some great financial institutions here have their Western offices — among them the Equitable Life Assurance Association of New York. There are 4,100 electric lamps, miles of bronze railing, acres of tiling and mosaic, and 3,300 tons of steel in the edifice, which is

one of the principal high steel buildings of the city, and a sight to be seen. It was erected in 1890, at a cost of over $1,000,000.

8. The Chicago Opera House Block is to be seen at the southwest corner of Clark and Washington streets. It was one of the first of the buildings erected on the joint-stock plan, and the success of its promoters led to the erection of the Auditorium. It fronts 187 feet on Clark and 107 feet on Washington, the regular theater entrance, with its handsome canopy, opening on the latter thoroughfare, and presenting a fine illumination at night. The 10 stories are 130 feet high, and the unrelieved brick exterior gives to the edifice a plain appearance. Its 240 offices and 12 stores and its theater are among the most popular places in the city, and its 4 elevators are constantly run at their full capacity. The main entrance of the office building is on Clark Street. Lawyers and professional men crowd the premises. The Appellate Court sits here. Erected in 1885.

9. The Reaper Block is an imposing Parisian pile of the old style, with Mansard and stone front, at the northeast corner of Clark and Washington streets, fronting 90 feet on Clark and 75 feet on Washington, 6 stories high, or 65 feet, with basement, 6 stores, 80 offices, and 1 elevator. It was erected in 1873, and is occupied by a desirable class of tenants, on account of its nearness to the courts.

10. The Methodist Church Block, at the southeast corner of Clark and Washington streets, is the last remaining ecclesiastical reminder of these corners, for 3 churches with steeples once stood in a row on the sites of the

Chamber of Commerce, the Chicago Opera House, and this block. The congregation still owns this property, and in the large auditorium of the building holds regular religious services. The building is in the stone-front style of 1872, 130 feet on Clark, 80 feet on Washington, 55 feet high; 4 stories and basement, with 7 stores, 16 offices, and a hall, with stage, gallery, organ, etc., seating 1,000 people.

11. The Title & Trust Building, at 98–102 Washington Street, is described among our notable high buildings. It is 16 stories high, on a lot 80 feet wide by 165 feet deep. It has 425 offices and 7 passenger elevators. It was erected in 1892, at a cost of $600,000, and is occupied by real-estate and loan agents, attorneys, and architects. The Phenix Insurance Company is also a tenant. This edifice is one of the few sky-scrapers that have been erected on interior lots in the heart of the city.

12. The Willoughby, Hill & Co. Building, at the southeast corner of Madison and Clark streets, occupies a lot that for about 30 years has been considered very valuable, though con-

stantly increasing in its appraisal. In 1872 the Government, then in search of a site for the Post Office, withdrew from offering $2,500 a front foot. The present 4-story stone front was built in 1872, and has been remodeled, but it remains ancient and ill-suited to the realty on which it stands. The lot is 100 feet wide on Clark and 90 feet deep on Madison, giving to the clothiers and restaurateurs who occupy it a valuable advantage over two competitors who surround but do not reach two of the other corners.

13. The Tacoma Building is a remarkable steel structure at the northeast corner of La Salle and Madison streets, with frontages of 101 feet on Madison and 80 on La Salle. Its 13 stories are 165 feet high, and it has 4 stores and 156 suites of offices. Its 5 passenger elevators are under the charge of a chief, and carry 8,000 persons daily. It was erected in 1888, at a cost of $500,000, and is occupied by lawyers, real-estate operators, and insurance agencies. It was the first building to discard heavy outer walls, and has a place in our chapter on "Notable High Buildings."

Looking South from Lake Street

The scene presented in view 20 includes some very prominent structures, which are delineated and described in another picture covering a portion of the same locality. The conspicuous buildings, going southward by cross-streets, are the Tremont House, on Lake; the Ashland Block, Schiller Theater, and Masonic Temple, on Randolph; the Unity, half-way to Washington, on Dearborn; the Title & Trust, Columbus Memorial (not fully shown), Venetian, and new Field, on Washington. Two of the buildings — the Tremont and the old Marshall Field, retail — are fine examples of the rich and handsome Parisian architecture which was displaced by the Age of Steel. Although not the very largest of Chicago's principal structures, these buildings, in many of their details and in general plan, are among the finest in the city, as well as the best known to the public. The designs are as varied as the

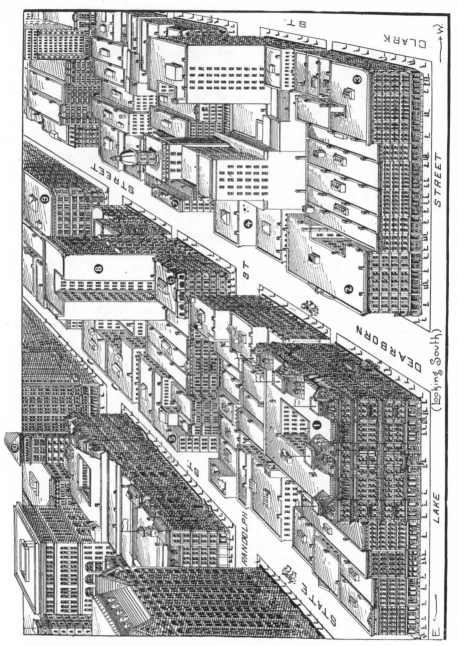

View 20. Looking South from Lake Street

objects for which they were erected, and, it may be added, harmonize with the surrounding of this imposing neighborhood.

1. The Tremont House fronts 200 feet on both Lake and Dearborn streets, at the southeast corner. This historic inn is treated in our chapter on "Hotels." The building is 100 feet high, a stone front, and its 6 stories are capped with ornate pavilions, giving an air of splendor that the Newer Chicago is totally denied. There are 8 stores and 250 rooms. The hotel office is on the main floor, and 2 passenger elevators are at the service of the guests. There are 200 employees. Theatrical and commercial people frequent the Tremont, and many families reside there. Tremont houses were built in 1840, 1850, 1853, and 1872. One of the old Tremont houses was among the first brick buildings to be raised to a higher street grade.

2. The Dickey Building fronts 200 feet on Dearborn and 75 feet on Lake Street, at the southwest corner. Here, in the upper story, the Chicago Public Library had its home before it removed to the City Hall. The building is an old-style stone front, 60 feet high, with 5 stories and basement, 12 stores, 30 offices, and 1 passenger elevator. It is occupied by the Northwestern University Law School, the Illinois College of Pharmacy, and the Irish-American Club. (See "Clubs.") It was erected in 1873.

3. The Greisheimer Building fronts 80 feet on Clark and 100 feet on Lake Street, at the southeast corner. It is an old-style 5-story structure of 1873, 80 feet high, but its lower windows present a brilliant appearance at night. The upper rooms are tenanted by publishers, printers, binders, and manufacturers' agents.

4. The Real Estate Board Building fronts 70 feet on Dearborn and 100 feet on Randolph Street, at the northeast corner. It was completely remodeled in 1889, heightened to 8 stories, and its interior made to meet modern requirements, and to present a striking appearance. There are 6 stores, 140 offices, and 2 elevators. About 200 people occupy the premises. The walls are built of artificial stone, brick, and steel, 85 feet high. The Real Estate Board, financial corporations, real-estate dealers, and insurance agents are the tenants. Cost, $200,000.

5. The Bay State Building fronts 106 feet on State and 35 feet on Randolph Street, at the southwest corner. In 1888 the old-style building of 1873 was completely remodeled, enlarged, and transformed into fashionable offices for doctors and other professional men, who may be found here in unusual numbers. Much white marble was used in the interior. There are 6 stores, 110 offices, and 2 passenger elevators. The building is now 6 stories, 78 feet in height, with a well-lighted front.

6. The McCormick Block fronts 120 feet on Randolph and 100 feet on Dearborn Street, at the southeast corner, and is a 6-story, Mansard roof, stone-front building, of the ancient style. It is 75 feet high, with 5 stores, 100 offices, and 1 elevator. The tenants are attorneys, real-estate dealers, and manufacturers' agents. Erected in 1873.

7. The Rawson Building fronts only 20 feet on Randolph and 100 feet on Dearborn Street, at the southwest cor-

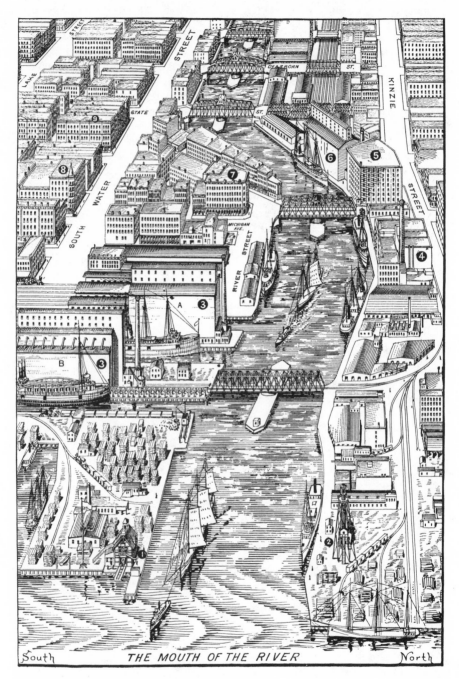

View 21. At the Mouth of the Chicago River

ner. Its 7 stories are 65 feet high. There are 3 stores, 12 suites of offices, and 1 passenger elevator. It is a stone front of the old style, although erected as late as 1887, and is occupied by doctors, dentists, real-estate dealers, and insurance agents.

8. The Unity Building, at 75–81 Dearborn Street, is described in our chapter on "Notable High Buildings." Having a frontage of 80 feet, and a depth of 150 feet, it rises to a height of 210 feet, with 16 stories and basement. Its corridors are paved with tile and ceiled with white marble, and its structure was conceived wholly with regard to economy and security from fire. Six elevators carry 6,000 people daily, and are usually crowded uncomfortably. There are over 800 occupants, covering all manner of professions and vocations. Cleveland's Western headquarters were here in 1892. Erected in 1892, at a cost of $600,000.

9. The Portland Block fronts 75 feet on Dearborn and 100 feet on Washington Street, at the southeast corner. It is an old-style brick building with somewhat eccentric architectural treatment of materials. There are 6 stories and basement, 65 offices, and 2 passenger elevators. The occupants are bankers, attorneys, agents, and architects. The Portland was rebuilt in 1873, and remodeled in 1885. Its height is 80 feet.

10. The Venetian Building, at 34–36 Washington Street, is a steel skyscraper of the latest period, with windbraces, and provision against elastic action. It is 50 feet wide, 110 feet deep, and 181 feet high, having 12 stories and basement, 290 offices, and 3 passenger elevators. The exterior is covered with Roman brick and terracotta. The Venetian was one of the group of skeleton steel constructions that sprang up on account of the World's Fair, and was built for the use of physicians and dentists. The building was erected in 1892, and cost $425,000.

At the Mouth of the Chicago River

Before us, in view 21, is presented the interesting commercial scene which is offered in the main channel of the Chicago River and its immediate lateral regions. On the left is the South Side of Chicago; on the right the North Side. On the left stretches South Water Street, the market-place of the city, to which fruit-laden vessels may gain almost perfect access. On the right is Kinzie Street, leading to the Kinzie Street Station, with many railway-tracks uniting the North-Western Railway system, by means of the first bridge (in the foreground), with the Illinois Central tracks on the lake shore; serving also the Big Four, the Michigan Central, and a line at Sixteenth Street connecting the Union Passenger Station on the West Side. As the latter station has tracks reaching the Kinzie Street Station, it may be seen that an inner railway belt exists in Chicago.

The Bridges The first bridge is a private railway crossing at a low level, and is held open when not in use. All these bridges are pivotal, and turn on the piers which stand under them in the river. Some are moved by hand and

some by steam. Common towing tugs can pass beneath, all save the railway bridge, without turning the structures. The rapid and seemingly easy movement of these bridges is one of the sights of the city, but their frequent opening in summer is no trifling annoyance to the landsmen. The second bridge is at Rush Street, serving both Michigan Boulevard and River Street on the South Side, River Street being the diagonal way that skirts the left bank of the river at its bend. The third bridge is at State Street. The fourth is at Dearborn, serving Dearborn Avenue on the North Side and Dearborn Street on the South Side. The fifth is at Clark Street. The famous Goodrich docks are on the left between the first two bridges.

Commerce Tugs towing schooners are shown, and a small propeller lies near the grain elevator in the left foreground. Through this narrow and obstructed channel, on its journey to twenty-five miles of similar dockage, goes the entire naval commerce of Chicago and the Southwest. Into this doorway have entered riches of almost fabulous amount, and out of this harbor has sailed a goodly portion of the crops and manufactures of the West.

1. The United States Life-saving Station is at the mouth of the river, on the left. It was established in 1874, and the crew, consisting of 7 men and a keeper, are housed in a structure of wood and iron 45 × 25 feet, 2 stories high. The equipment consists of 2 surf-boats, 1 life-boat, 1 whitehall-boat for quick and ready work, complete life-car, beach gear and gun, life and shot lines for landing people from wrecks that cannot be reached with boats.

2. The Chicago River Light-house is on the north at the mouth. This is the oldest light on the lake shore, and was built and established in 1859. The skeleton tower is but 83 feet high, of iron construction. The light is lit at sunset and burns till sunrise the year round. The lenses illuminate an arc of 285 degrees, and may be seen for 16 miles into the lake. There are range-lights, and in fogs a bell is struck by automatic machinery. Three keepers and 2 laborers reside in a frame house near by.

3. The Central Elevators stand on slips at the left near the mouth. The fee of this entire property and much more was taken from the Illinois Central Railroad Company by the United States Supreme Court decision of 1892. The elevator known as "A" has a capacity of 1,000,000 bushels of grain, and was re-erected in 1872. It is 200 feet long, 100 feet wide, and 150 feet high. "B" is 300 feet long, 100 feet wide, and 150 feet high, and will hold 1,500,000 bushels, with a crib annex for 400,000 bushels. This was one of three buildings left unhurt by the Great Fire, the other two being the Lind Block at Randolph and Market, and the Nixon Building at the northeast corner of La Salle and Monroe. Both elevators are built with iron and brick exteriors, and can fill either cars or vessels.

4. James S. Kirk & Co.'s Building, northeast of Rush Street bridge, on the north side of the river. The general opinion of a soap factory once was, that it was an unclean place, but the perfuming and the packing of soaps have been carried to fine arts, and this great establishment will be

found to offer a model of cleanliness. It is 520 feet long, 175 feet deep, and 80 feet high in 5 stories, with brick exterior. There are 475 employees.

5. The Central Warehouse, on Rush Street, just beyond the second bridge, on the North Side, occupies a site with a history. Here was the slip of the rope-ferry, the oldest landing-place on the river. At the time of the Great Fire the Sturgess & McAlister wool warehouse stood here. In 1872 there was erected on this site, a warehouse for the exclusive use of dealers in tea and coffee. It was destroyed by fire in the spring of 1889, involving a loss of over $1,250,000, and was at once rebuilt, on plans approved by the board of underwriters. Dimensions: 100 feet on Rush Street, 125 feet deep, 95 feet high in 7 stories and basement, brick and iron exterior, and mill construction.

6. The Galena Elevator is just southwest of the Central Warehouse, between Rush and State streets, northside river-bank. It was erected on the site of the old Galena Elevator in 1872. It holds 700,000 bushels, and ships by boat or rail. It is 76 feet wide, 300 feet long, and 130 feet high, with brick and iron exterior.

7. The Hoyt Building stands on an irregular lot at the juncture of River Street and Michigan Avenue. The frontages are 100 feet on River Street, 40 facing the bridge, and nearly 100 on Michigan Avenue. There are 5 stories, with 75 feet of height, and 1 freight elevator. This building, erected in 1872, occupies the site of Fort Dearborn, and bears a tablet whose inscription is copied at the beginning of our North Side Drive. Wholesale grocer.

8. The Loyal Hotel Building, southwest corner of Michigan Avenue and South Water Street, was erected in 1873. This is a 6-story building with 50 feet on the avenue and 120 on South Water Street, 85 feet high, brick walls. The hotel has 360 rooms and a restaurant.

9. The Standard Oil Building is at the southeast corner of Wabash Avenue and South Water Street, with frontages of 140 feet on Wabash Avenue and 40 feet on South Water Street, 65 feet high in 5 stories and basement, and brick and iron exterior. Here there are 1 passenger elevator and 2 freight elevators. The vast monopoly has its offices here, and shares its building with manufacturers' agents and wholesale jobbers. The building, which was erected soon after the Great Fire of 1871, was remodeled in 1889.

"Wolf Point" in 1893

The familiar and celebrated picture called "Chicago in 1830" deals with the forks of the Chicago River that are seen in view 22. The general region was then called "Wolf Point." As early as 1778 Guarie lived on the West Side, and gave his name to the North Branch, which was called "Guarie's." The South Branch was known as "the Portage." In the days of the pioneers there were small taverns on all three peninsulas. Besides the historical significance of this scene, the reader should note the presence of the Wells Street Station in the right foreground, and ascertain its position relative to points on the

View 22. "Wolf Point" in 1893

South Side, at the left. See, "Arrival in Chicago." The North, South, and dWest sides are here delineated, and no literal description could bring them so fully before the reader's mind. Wells Street on the North Side becomes Fifth Avenue on the South Side. South Water Street, the grocers' market of the city, is seen skirting the river at the left. On the point where South Water unites with Lake Street, at Market, stood the Wigwam, in which Lincoln was nominated in 1860.

1. The North-Western Building fronts 180 feet on Fifth Avenue and 80 feet on Lake Street, at the northwest corner. It is 95 feet high, or 5 stories and basement, with 2 passenger elevators. The general offices of the Chicago & North-Western Railway are in this structure, and much has been done to conform the interior to the requirements of the day. The exterior is of brick and granite. Erected in 1883.

2. The Wells Street Station, at the southwest corner of Wells and Kinzie streets, is the terminal of the Chicago & North-Western Railway system, and it is the only one of the six great depots that accommodates the trains of a single company exclusively. Suburban residents at Austin, Oak Park, Maywood, etc., arrive here in large numbers daily. It is only in recent years that the West Side depots of the North-Western have been abandoned and all North-Western trains brought to West Street. The handsome station (see "Arrival in Chicago") fronts 188 feet on Wells and 280 feet on Kinzie Street, with a general height of 80 feet; but the central tower on Wells Street rises to 188 feet, and holds a large clock. The building has 5 floors, one of which is on the level of the railway-tracks. The exterior is of red brick and Ohio sandstone, and the 5-story structure stands in front of a train-shed which covers 12 tracks, accommodating 90 passenger coaches and 12 locomotives. About 200 passenger trains arrive and depart each day, carrying about 32,000 people. The station was erected in 1881–82.

3. The Hotel Le Grand fronts 80 feet on Kinzie and 40 feet on Wells Street, at the northwest corner. It is 75 feet high, divided in 5 stories. The exterior is brick and cut-stone, with modern light ornamentation. There are 125 rooms for rent without board, and a restaurant is run in the building. Erected in 1889.

4. The Air Line Elevator, west of the Kinzie Street Station, holds 700,000 bushels of grain. It is 260 feet long, 90 feet wide, and 130 feet high, and was erected in 1872 on the site of the Munger & Armour Elevator, which burned soon after the Great Fire. The exterior is of brick, slate, and iron.

5. The Lumbermen's Exchange Building fronts 80 feet on South Water and 30 feet on Franklin Street, at the northeast corner. It is an old-style brick, 50 feet high, 3 stories and basement. This part of the river was for years the lumber market, and here lake craft tied up, awaiting a sale, hence, the Lumbermen's Exchange. Erected in 1873.

6. The Garrett Building fronts 140 feet on Lake and 200 on Market Street, at the southeast corner. It is an old-style brick, 65 feet high, with 4 stories, and is occupied by iron and steel dealers, flour merchants, and other heavy firms. It was erected in 1871.

7. The Lind Block, celebrated for its escape from the Great Fire of 1871, fronts 82 feet on Randolph and 94 feet on Market Street, at the northwest corner. It is 90 feet high, with 7 stories and basement, and is a building of the style of the sixties. Its history has been uncommonly variable, and it has been by turns the center of active trade, and then the secure retreat of manufacturers, machinists, and patent-makers. The *Arbeiter Zeitung* is published here, and it was this paper which printed the word "Ruhe" in its columns as a signal for the Haymarket bomb-throwing.

8. The Ullman Building fronts 80 feet on Lake and 120 feet on Market, at the southwest corner, and stands well in view at the foot of the Lake Street bridge. It is an old-style 4-story brick building, 70 feet high, occupied by manufacturers, labor agents, shipchandlers, and manufacturers' agents. It was erected in 1875.

9. Davidson & Sons' Building is on the North Side, at the foot of North Market Street. It fronts 150 feet on the latter street, and is 80 feet deep, with a warehouse of the same dimensions one story in height. The main building is a 5-story brick, 75 feet high, the first three floors and warehouse being occupied by Davidson & Sons, manufacturers and importers of marble, granite, etc. On the fourth floor are the offices of the Peabody Coal Company, the fifth being occupied by Smith & Webster, plumbers' supplies. Erected in 1872.

10. The Fulton Elevator, across the North Branch, on Canal Street, is 78 feet wide, 150 feet deep, and 100 feet high. It holds 400,000 bushels of grain, and ships by rail and water. The exterior is of brick, slate, and iron. It was erected in 1873.

11. The St. Paul Elevator, next south on Canal Street, is 100 feet wide, 200 feet deep, and 135 feet high, with a capacity of 1,000,000 bushels. Its exterior is of brick and iron. These elevators are as high as 10-story buildings. Erected in 1879.

12–13. Produce Cold Storage Exchange occupies two buildings at 1–13 West Lake Street. The new building, No. 12, is 85 feet wide, 200 feet deep, and 95 feet high. The walls are of pressed brick and steel. This building marked an improvement in modern methods of refrigeration, and vastly reduced the cost of keeping meats, fruits, and vegetables. Erected in 1890. To the front of this stands the old building, No. 13, 70 feet square and 6 stories high.

14. The Star and Crescent Mills, established 1868, at the west end of Randolph Street bridge, on the south side of the street, are 90 feet wide, 122 feet deep, and 72 feet high, with 6 stories. This property is a landmark on the street, and for many years has been the scene of unending industry, night and day. Wheat, oats, corn, and buckwheat are ground. Cost, $300,000.

The Rand McNally Views

The arrows and view numbers on the maps on pages 251 and 252 show the location and direction from which the drawings for Rand McNally views 1–28 were made. Construction activity at the time of the drawings was not as

quiet as the views suggest. Some buildings presented had been demolished. Several buildings in the scope of the drawings were under construction, for example, the LaSalle-Monroe building (site of the Nixon, demolished 1889), which appears in view 5, and the Stock Exchange (site of the Union building, demolished 1893), in view 6.

Of about 225 buildings that are identified and described, the following were standing in 1997: Rookery, in V1 (and the Monadnock is identifiable); Monadnock, in V3 (Leiter and Old Colony are identifiable); Association/ YMCA, in V5; Chicago Athletic Club, in V7; Congress Hotel, Auditorium, Richardson, Fine Arts, and Isabella, in V8; Old Colony, Manhattan, Pontiac, Terminals, in V10 (Plymouth, Old Franklin, Duplicator are identifiable); Dearborn/Polk Street Station, Donohue, in V14; and Marshall Field store and Public Library, in V17. These are indicated on the map by small solid circles.

Rand McNally views 23–28, showing scenes to the north of the river, did not appear in the 1949 edition of this book, but they are added to this edition. In these drawings the following important structures are shown: the "Waterworks" and Kinzie in V23; Nickerson House/American College of Surgeons, Virginia Hotel/Leander McCormick Apartments, and the St. James Episcopal Cathedral in V24; Unity Church (now Scottish Rite Cathedral) and Newberry Library in V25; Plaza Hotel and the Archbishop's House in V26; Bryan Lathrop House/Fortnightly Club in V27; Potter Palmer House (building no. 100) in V28.

Street names changed after the Rand McNally drawings were made include: Pacific Avenue to S. LaSalle, Custom House Place to S. Federal, Fifth Avenue to Wells, Michigan Street to Hubbard, Indiana Street to Grand, Market Street to N. and S. Wacker, South Water-River Street to E. and W. Wacker, Pine Street to N. Michigan, Cass Street to N. Wabash, Hubbard Court to E. Balbo, Eldridge Court to E. Ninth; Twelfth Street is also Roosevelt Road.

The Gold Coast

The schematic map on page 252 delineates the extent of the Gold Coast Historic District on the National Register of Historic Places. The district extends roughly north from Oak Street to North Avenue and west from North Lake Shore Drive to Clark Street. The small open circles indicate the approximate locations of about a hundred high-rise buildings listed in appendix A in the present volume; there are others as well. The small solid circles indicate the locations of some Period VI buildings. The Astor Street Chicago Landmark District extends from Division Street to North Avenue. The mapping and listing of the Astor Street high-rise buildings are incomplete.

Map location "A" is the site of four houses on the Illinois Register of Historic Places. These four and the three houses at location "B" comprise

View 23. Vicinity of "The Waterworks"

View 24. Looking West from Michigan Avenue at Ontario Street

View 25. Vicinity of Washington Square, Newberry Library

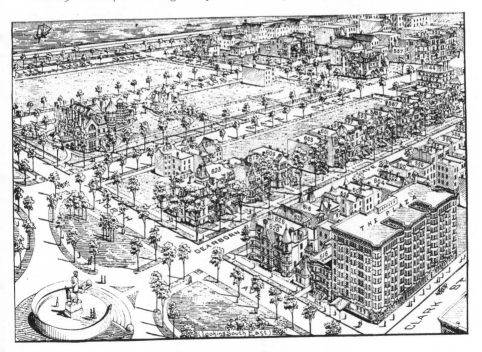

View 26. Looking South from North Avenue at Clark Street

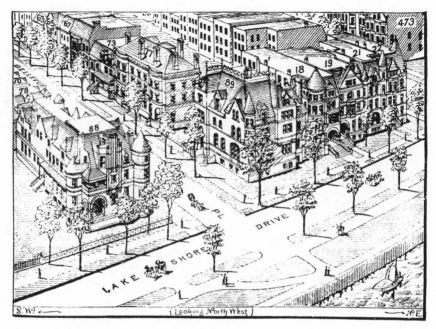

View 27. Looking West from Lake Shore Drive at Bellevue Street

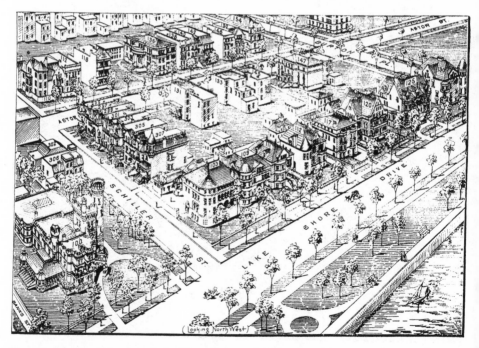

View 28. Looking West from Lake Shore Drive at Schiller Street

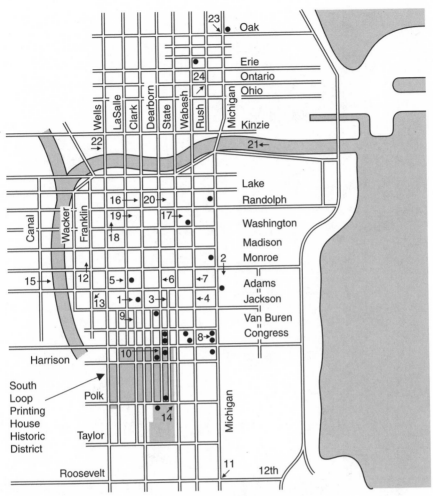

Central Business District, Rand McNally Bird's-Eye Views 1–24

Key: 1. Vicinity of the Board of Trade; 2. Art Institute of Chicago; 3. From Adams Street, looking South; 4. East End of Adams Street, looking South; 5. From Adams Street, looking North on La Salle; 6. From Adams Street, North on Dearborn; 7. North from East Adams Street; 8. Looking West from Michigan Boulevard; 9. Vicinity of the Van Buren and Grand Central Stations; 10. Printing House Row, from Van Buren Street; 11. Region of Twelfth Street Station; 12. The Wholesale District, North on Market Street; 13. Within the Heavy Wholesale District; 14–15. Two Great Railway Stations; 16. North of the Court House; 17. From State Street, Looking East; 18. West of the Court House; 19. From Randolph Street, Looking South on La Salle; 20. Looking South from Lake Street; 21. At the Mouth of the Chicago River; 22. "Wolf Point" in 1893; 23. Vicinity of "The Waterworks"; 24. Looking West from Michigan Avenue at Ontario Street.

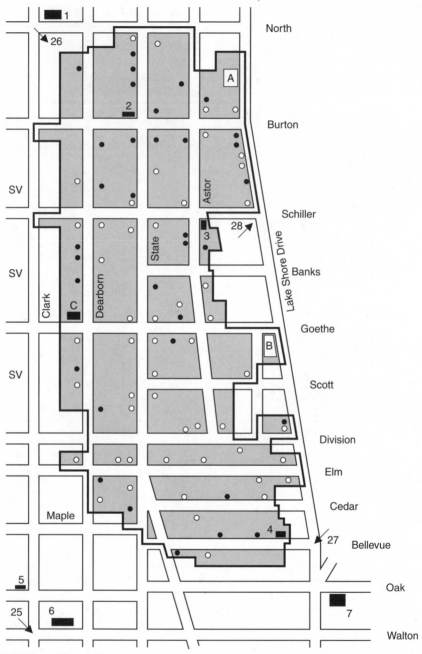

Gold Coast Historic District, Rand McNally Bird's-Eye Views 25–28

Key: 25. Vicinity of Washington Square, Newberry Library; 26. Looking South from North Avenue at Clark Street; 27. Looking West from Lake Shore Drive at Bellevue Street; 28. Looking West from Lake Shore Drive at Schiller Street.

the Seven Houses on Lake Shore Drive Chicago Landmark District. These are not described in the text, but their addresses are given in appendix A. Location "C" indicates Holabird & Roche's Three Arts Club, noted in appendix A but not discussed in the text.

The buildings located by number on the map and described in the text are:

1. Chicago Historical Society
2. The Graham Foundation/Madlener House
3. The Charnley-Persky House
4. Bryan Lathrop House/Fortnightly of Chicago
5. 104 West Oak Street/Burlingham
6. Newberry Library
7. Drake Hotel

The Drake Hotel and the seven apartment buildings to the east, also described in the text, comprise the East Lake Shore Drive Chicago Landmark District.

The "SV" notations indicate the general locations of the extensive Sandburg Village buildings.

Numbers 25–28 show the general location and direction of those Rand McNally views.

In addition to the historic districts mentioned here, a few others are referenced in the general index. Of course, there are buildings in the historic districts that are intrusive to the higher qualities of those for which the districts were designated. More than fifty of the many buildings cited in the text as part of the Gold Coast Historic District alone could be considered intrusive. The designation of landmarks is sometimes based on significance for reasons other than architectural/structural qualities (e.g., importance related to persons, institutions, and/or events). Landmarks designations offer varying degrees of protection, according to the varying (and sometimes changing) nature of programs of city, state, and nation. Federal landmark status confers virtually total protection from any compromise of such buildings' character — or their demolition — by any federal agency.

Period IV: From 1901 to 1920

During the preceding period, 1881–1900, the first skyscraper was erected, wood piles began to replace spread footings, and the first building was built on concrete caissons. Bessemer steel was replacing cast iron and wrought iron.

Financial and labor difficulties slowed up construction after the World's Columbian Exposition of 1893 and it remained at a low for over a decade. The century opened with a new confidence, however, and strengthened building activity reached several record peaks, except for the relative weakness of the World War I years. The developments of the last period became more generally adopted; open-hearth steel superseded Bessemer steel and sub-basements came into use. More tall buildings were built, and the utilization of land in the central business district became more intense.

In connection with the construction of the first sub-basement, a number of extracts from notes prepared in 1932 by Edward A. Renwick (EAR), of the firm of Holabird & Roche, tell the story of the difficulties in venturing below the stiff crust about 15 feet below sidewalk grade. The extracts are given in appendix D.

The Chicago business district was constrained by troublesome circulation in earlier days because of the Chicago River. The main river divides the district into two approximately equal parts. The bridge crossings are vital to commercial and industrial growth. During this period the greatest development in bridge building took place.

Earlier, nearly all the bridges had been swing bridges with center piers. During the early part of this period, however, bridges of the rolling lift type replaced many of the swing bridges. This trend was followed by the more extensive adoption of the modern trunnion bascule bridge, which had its early development in Chicago. Here this bridge type has been brought to its highest perfection, and it has been used in many parts of the world.

The Michigan Avenue bridge, completed in 1920, was the most unusual one built up to that time. The upper level provides six lanes of traffic; the lower level, four lanes. A later notable structure is the Outer Drive bridge. The distance center to center of trunnions is 264 feet, and the width is 108 feet. The bridge at State Street, dedicated on May 28, 1949, is also 108 feet wide.

A paper by Donald N. Becker in the *Transactions of the American Society of Civil Engineers*, Vol. 109, p. 995 (1944), entitled "The Development of the Chicago Type Bascule Bridge," contains a history of Chicago bridge building from the earliest days.

14 N. FRANKLIN STREET building, 1901–(1950 to 1990), was eight stories high, on spread foundations. Russell Wolcott was the architect. The front-

age on N. Franklin Street was 54 feet and the depth 80.8 feet. This site is used for parking.

LORRAINE HOTEL ANNEX, at 419 S. Wabash Avenue, ca. 1901–(1950 to 1990), was six stories high. The frontage of this building on S. Wabash Avenue was 33.6 feet.

North: CHICAGO-CLARK building, formerly known as the Bush & Gerts building and the Bush Temple of Music, at the northwest corner of N. Clark Street and W. Chicago Avenue, built in 1901, is six stories high. A photograph is in CHC, p. 244; CIM, p. 523; OBD 1929, p. 73; CTCP, p. 9. John O. E. Pridmore was the architect. The frontage on N. Clark Street is 100 feet; that on W. Chicago Avenue is 150 feet. It was renamed the 800 N. Clark Street building.

North: 22–24 E. HUBBARD STREET building, ca. 1901–(1950 to 1990), was six stories high, of mill construction, on spread foundations. Fred Ahlschlager was the architect. The Courtyard By Marriott hotel includes this site.

North: BOOTH COLD STORAGE CO. building, 1901–1989, was at 109–21 W. Kinzie Street, seven to 10 stories high. D. H. Burnham & Co. were the architects. The frontage of this building on W. Kinzie Street was 133.33 feet. This site is used for parking.

EQUITABLE building, at 29 S. LaSalle Street, formerly known as the National Life building, built in 1902, is 12 stories high, on spread foundations. Jenney & Mundie were the architects. The Equitable building was renamed Barrister Hall. A photograph is in CTCP, p. 50; HB; and OBD 1916, p. 175. An illustration is in HCCB, p. 43B, and CHC, p. 138. In 1940 a new street facade and other major alterations were made by Holabird & Root, architects. A photograph of the remodeled building is in CAA and in OBD 1941–42, p. 106. The front portion of this site was previously occupied by the first Republic Life building, built in 1870, five stories high, illustrated in LO June 1870, p. 144. George H. Edbrooke was the architect. The rear portion was occupied by the Farwell building. Both were destroyed in the fire of 1871. As rebuilt in 1872, they are illustrated in LO April 1872, p. 53, and May 1872, p. 80, with descriptions on pp. 54 and 80. The Republic Life building was used by the Custom House and United States Courts for several years after the fire of 1871, until the new government building was completed.

75 W. VAN BUREN Street building, ca. 1902–ca. 1970, was seven stories high, on spread foundations. Charles Palmer was the architect. The Chicago Metropolitan Correctional Center includes this site.

South: 515–21 S. FRANKLIN STREET building, 1902–1947, at the northeast corner of W. Lomax Place, formerly known as the Lesher building, was

eight stories high, on pile foundations. Nimmons & Fellows were the architects, with Horace S. Powers as associate architect. This building was condemned and removed by the Department of Subways and Superhighways for the Congress Street superhighway.

South: BOARD OF EDUCATION building, at 646–50 S. Clark Street, built in 1902, is seven stories high. It is occupied by the Spectralith Co., 650 S. Clark Street. A photograph is in HB.

South: BOSCH building, ca. 1902–(1950–1990), at 521–27 S. Wabash Avenue, was seven stories high. Doerr Brothers were the architects. The building was supported on 40-foot wood piles, except the south party wall, which was on spread footings.

South: MANDEL BROTHERS WAREHOUSE, 1902–early 1950s, at the northwest corner of S. Franklin and W. Harrison Streets, formerly known as the Clow building, was seven stories high, on pile foundations except for three caissons at the northeast corner. Holabird & Roche were the architects. The cost of the Clow building, including architects' fees, was 13.50 cents per cubic foot (EAR). An illustration is in HCCB, p. 139B. A photograph is in HRHR Vol. 1, p. 213. The warehouse was demolished for the Congress Parkway interchange.

South: 618–20 S. SHERMAN STREET building, 1902–1939, was an eight-story building owned by James A. Patten. The site is now a parking lot.

South: 624–32 S. SHERMAN STREET building, 1902–1938, was a six-story building owned by James A. Patten. This is now a parking lot.

North: 12–14 E. KINZIE STREET building, ca. 1902–(1950 to 1990), was six stories high. The frontage of this building was 50 feet and the depth 100 feet. This site is used for parking.

North: GROMMES & ULLRICH building, at 108–14 W. Illinois Street, with a frontage of 80 feet, was built in 1901. It is four stories high, of heavy timber construction with a floor load of 200 pounds per square foot, designed for an additional four stories. Richard E. Schmidt was the architect and Hugh Garden the designer. The cost of the building was 8.36 cents per cubic foot. It was also known as the W. H. Long building and was renamed the 114 W. Illinois Street building. Photographs are in AR April 1905, p. 341; *Prairie School*, H. A. Brooks, 1974, p. 51; AGC, p. 133; and the *Prairie School Review*, 1st quarter, 1966.

North: *ALBERT F. MADLENER HOUSE*, NR, CAL, HABS, CLSI/premier, built in 1902 at 4 W. Burton Place, at the northwest corner of N. State Parkway, in the Gold Coast Historic District/NR, is three stories high.

Richard E. Schmidt was the architect and Hugh Garden the designer. It was renamed the Graham Foundation for Advanced Studies in the Fine Arts and restored by Brenner, Danforth & Rockwell, architects. Photographs are in a monograph by Carter Manny, 1988; CFB "merit"; COF; *Prairie School*, H. A. Brooks, 1974, p. 52; ACMA, p. 87; AR June 1905, p. 491; and HB. An undated brochure (late 1980s) illustrates ornament and various buildings from which artifacts are on display in the courtyard here. A drawing of the house is in CANY, p. 93.

North: 337–51 E. ILLINOIS STREET building, 1902–(1950 to 1990), was six stories high, of mill construction, on spread foundations. Henry Ives Cobb was the architect.

ELECTRIC building, 1903–1927, at 28 N. Wacker Drive, was a part of the Electric Block, at the southwest corner of N. Market and W. Washington Streets. It was eight stories high, supported on caissons. Shepley, Rutan & Coolidge were the architects. Steel cylinders were used in the lower parts of the caissons (EN December 22, 1904). The Civic Opera building includes this site.

415–23 S. FRANKLIN STREET building, 1903–early 1950s, formerly known as the Kent building and the Kuppenheimer building, was 10 stories high, on wood piles. Pond & Pond were the architects, and E. C. & R. M. Shankland the engineers. Photographs are in AR January 1905, p. 66. The building was demolished for the Congress Parkway interchange.

STONER'S RESTAURANT building, ca. 1903–ca. 1960, at 24–28 N. Dearborn Street, formerly the Press Club building and the University Club building, was eight stories high, on spread foundations. Photographs are in CIM, p. 576. The site was previously occupied by the Hansen building. The 69 W. Washington Street building includes this site.

HIBBARD, SPENCER, BARTLETT & CO. building, 1903–1924, was at the northeast corner of N. State and E. South Water (now E. Wacker Drive) Streets. Charles S. Frost was the architect. The building was 10 stories high, with two basements, on pile foundations, and was removed to make way for the Wacker Drive improvement. A photograph is in HE and in CIM, p. 348.

CHAMPLAIN building, formerly known as the Powers building, at 37 S. Wabash Avenue, on the northeast corner of E. Monroe Street, was built in 1903, 13 stories high, and is carried on piles, except for the north wall, which is on caissons. Holabird & Roche were the architects. The cost of the Powers building, including architects' fees, was 17.118 cents per cubic foot (EAR). A photograph is in CIM, p. 326; BB February 1904, p. 42; OBD 1929, p. 71; CLSI/premier, CSA, fig. 131; HRHR Vol. 1, p. 216. The Champlain building was renamed the School of the Art Institute, 1990; the conversion was by

Decker & Kemp, architects. The Haddock Block previously occupied this site.

COLONIAL THEATER, 1903–1925, formerly known as the Iroquois Theater, was at 24–28 W. Randolph Street, on the site of the 32 W. Randolph Street building. It was four stories high, on spread foundations. Benjamin H. Marshall was the architect. A photograph is in CIM, p. 435; CYT, p. 92; and CTCP, frontispiece and p. 27. A photograph of the fire-damaged auditorium is in CPH, p. 182. The Iroquois Theater fire here in 1903 caused the death of about 600 people of an audience of 2,300. The tragedy brought about extensive new fire protection requirements for theaters.

LaSALLE STREET STATION, 1903–1982, at the southwest corner of S. LaSalle and W. Van Buren Streets, was the third station on this site. The building had 12 stories with wood pile foundations, which are described in EN August 6, 1903. Frost & Granger were the architects and E. C. & R. M. Shankland the engineers. A description and details of the building are in ER September 12, 1903. An illustration is in HCCB, p. 12B. A photograph is in CTCP, p. 80; LC, p. 55; RMNP; CCP, p. 116; CHC, p. 104; and CIM, p. 439. Also in CIM, p. 440, and in TYF there is a photograph of the Lake Shore and Michigan Southern Depot and the Chicago, Rock Island, and Pacific Railway Depot, 1866–1871 fire, formerly on this site. A description and a fine illustration of the latter depot are in CIJ. A brief description and an illustration of the second station on this site are in RMNV, V9, and LO November 1872, pp. 184, 185, 192, and 193. W. W. Boyington was the architect for this station and the one that preceded the fire of October 9, 1871. The frontage of the station built after the fire was 182 feet on W. Van Buren Street, with a depth of 601 feet. The central tower was 108 feet high; the two side towers, 96 feet. A history of the stations occupied by the LaSalle Street Station group of railroads is in WSE 1937, p. 124. A drawing of the earlier Michigan Southern depot is in RMN, p. 36. The One Financial Place building occupies the station headhouse site.

1903: Church building: see Carson, Pirie, Scott store.

South: BROCK & RANKIN building, at 615–27 S. LaSalle Street, built in 1903, is seven stories high, of fireproof construction. The frontage is 140 feet and the depth 105 feet. Holabird & Roche were the architects. The cost was $255,000. It was renamed the 619 S. LaSalle Street building, in the South Loop Printing House Historic District/NR. A photograph is in HRHR Vol. 1, p. 206.

South: WILSON BROTHERS building, 1903–early 1950s, at 528–36 S. Wells Street, was 10 stories high, on pile foundations. W. W. Clay was the architect. The building was demolished for the Congress Parkway interchange.

West: KELLEY-MAUS WAREHOUSE AND FACTORY, 1903–(1950 to 1990), HABS, was at 405 W. Lake Street. It was renamed the Graham Paper Co. building. It was eight stories high, of mill construction. Jarvis Hunt was the architect. An article is in AA February 1904, p. 133.

North: CARPENTER building, at 430–40 N. Wells Street, formerly known as the Liquid Carbonic building, built in 1903, is eight stories high, of mill construction, on pile foundations. Holabird & Roche were the architects. The cost of the Liquid Carbonic building, including architects' fees, was 11.36 cents per cubic foot (EAR). It was renamed the 440 N. Wells Street building and converted to offices in 1983; Hammond, Beeby & Babka were the architects. Photographs are in HRHR Vol. 1, p. 231; HB; RB Annual Review, January 27, 1968, p. 122, and April 30, 1983, p. 29 (advert.). A photograph of the former George B. Carpenter & Co. building at the northeast corner of N. Wells and W. South Water Streets is in CRT, p. 85.

RAILWAY EXCHANGE building, NR, CLSI/premier, built in 1904 at 80 E. Jackson Street, was renamed the Santa Fe (railroad) Center, 224 S. Michigan Avenue. D. H. Burnham & Co. were the architects, with Frederick F. Dinkelberg the designer and Joachim G. Giaver the engineer. The building is 17 stories high, on hardpan caissons (EN December 22, 1904). Photographs are in CFB "merit"; CSA, fig. 69; ACMA, p. 44; AR May 1905, p. 422, and December 1981, p. 64; STL, p. 66; BOC, p. 276; CSV, p. 185, facade detail; and HB. See appendix F. Photographs are also in AWG, and in BB July 1907, p. 130. A photograph and floor plans are in AR July 1915. A photograph and a description are in OBD 1916, p. 207. The north 55 feet of this site were occupied previously by the Palmer House Stables, at 216 S. Michigan Avenue, and the corner by Kadish's Natatorium, an illustration of the interior of which is in CIM, p. 153, and by Burnham & Root's Argyle Apartments (not listed here). The Chicago Architecture Foundation office and shop are located here.

325 W. JACKSON STREET building, 1904/1911–(1950 to 1990), formerly known as the McNeil building, was 10 stories high. Holabird & Roche were the architects. Piles were used except under the south and east walls, which were supported on caissons. The cost of the original McNeil building, including architects' fees, was 16.827 cents per cubic foot; and of the 1911 addition, 18.637 cents. Photographs are in CFB "merit"; CSA, fig. 133; HRHR Vol. 1, p. 248; and RB Annual Review, January 30, 1971, p. 154. The 311 S. Wacker Drive building includes this site.

COMMERCE building, 1904–1947, at 500–508 S. Franklin Street, on the southwest corner of W. Congress Street, was eight stories high, on spread foundations. F. W. Southard was the architect. This building was condemned and removed by the Department of Subways and Superhighways. This site is in the Congress Parkway interchange.

CHICAGO & NORTHWESTERN RAILWAY OFFICE building, at 226 W. Jackson Street, on the northeast corner of S. Franklin Street, built in 1904, is 14 stories high, on rock caissons. Frost & Granger were the architects and E. C. & R. M. Shankland the engineers. A description is in BB September 1904, p. 192. Photographs are in AR November 1905, p. 396, and in CTCP, under construction. The building was renamed the Chicago City College, 226 W. Jackson Parkway building.

63 E. ADAMS STREET building, NR, CAL, HABS, CLSI/premier, originally known as the *Chapin & Gore* building, built in 1904, is eight stories high, on 50-foot wood piles. The three lower floors are of heavy timber construction designed for a floor load of 250 pounds per square foot. The upper floors are designed for 100 pounds per square foot. Richard E. Schmidt was the architect and Hugh Garden the designer. Photographs are in CFB; CSA, fig. 148; GCA, p. 42; ACMA, p. 86; WO, p. 18; and BB September 1908, p. 218. The cost of the Chapin & Gore building was 16.36 cents per cubic foot. The cornice was removed in 1958. The building was also known as the Nepeenauk, the Labrador, and the Union Life building. It was converted in 1996 for the Symphony Center complex; see Orchestra Hall listing, below.

HAMILTON building, 1904–(1950 to 1980), at the southeast corner of S. Clark and W. Van Buren Streets, originally the Weber Department Store, 100 feet by 100 feet, was five stories high. Holabird & Roche were the architects. The Pacific Block formerly occupied the north half of this site. The Chicago Metropolitan Correctional Center includes this site.

South: MARQUETTE PAPER CO. building, 1904–1947, at 517–25 S. Wells Street, formerly the Paper Mills Co. building, was nine stories high, on pile foundations. George L. Harvey was the architect. This building was condemned and removed by the Department of Subways and Superhighways for the Congress Street superhighway. This site is used for parking.

South: 500–10 S. SHERMAN STREET building, 1904–1947, formerly known as the Patten building, was eight stories high, on spread foundations. This building was condemned and removed by the Department of Subways and Superhighways. This site is in the Congress Parkway right-of-way.

South: 500–502 S. WELLS STREET building, 1904–1947, at the southwest corner of W. Congress Street, formerly known as National Woolens building, was eight stories high, on spread foundations. A. J. F. Bennett was the architect. This building was condemned and removed by the Department of Subways and Superhighways. This site is in the Congress Parkway right-of-way.

South: POPE building, at 633–41 S. Plymouth Court, built in 1904, is 12 stories high. H. G. Hodgkins was the architect. The lofts were converted in 1985 and renamed the Pope Loft Apartments, 633 S. Plymouth Court, in the

South Loop Printing House Historic District/NR; Lisec & Biederman were the architects. A photograph is in RB February 11, 1950, p. 8.

South: 1006–12 S. MICHIGAN AVENUE building, built in 1904, is eight stories high. Edmund R. Krause was the architect.

South: 731–41 S. WELLS STREET building, 1904–(1950 to 1990), at the northeast corner of W. Polk Street, was seven stories high. Jarvis Hunt was the architect. A photograph is in HB. The site is a parking lot.

North: MANIERRE WAREHOUSE, 1904–(1950 to 1990), at 219–23 E. Illinois Street, was six stories high, of mill construction. This site is vacant.

Ca. 1905: Major landfilling was initiated for Grant Park.

South: *WINTON building,* at the northeast corner of S. Michigan Avenue and E. Thirteenth Street, was built in 1904 as a three-story reinforced concrete building designed for seven stories, using the Monier system. James Gamble Rogers was the architect; E. Lee Heidenreich was the engineer. The exterior walls are wall-bearing, the interior supports being reinforced concrete columns on spread foundations. A description of the construction and illustrations of the structural details are in ER June 4, 1904. The building is occupied by the Peota Graphx Co., 1255 S. Michigan Avenue.

MAJESTIC building, at 16–22 W. Monroe Street, built in 1905, is 20 stories high, on caissons. Edmund R. Krause was the architect. A photograph is in OBD 1929, p. 182; AR June 1906, p. 476; STL, p. 270; and CFB with the Inland Steel building. The Shubert Theater is here, at 22 W. Monroe Street. The Bennett House, at 16 W. Monroe Street, was on the east third of this site.

CHICAGO building, formerly the Chicago Savings Bank building, NR, IR, CAL, CLSI/premier, at 7 W. Madison Street, on the southwest corner of S. State Street, was built in 1905. Holabird & Roche were the architects. The building is 15 stories high, with two basements, on rock caissons. The cost of the Chicago Savings Bank building, including architects' fees, was 47.71 cents per cubic foot (EAR). A photograph is in AR April 1912; OBD 1916, p. 44; WO, p. 24; CSA, fig. 135; AGC, p. 58; STL, p. 64; IA July 1905; IA-C January 1990, p. 88; RB April 28, 1990, p. 22; and CALP. An illustration is in CHC, p. 37. A description is in BB September 1904, p. 191. The Otis building was on the north half of this site. The building was converted in 1997 to student housing for the School of the Art Institute.

ORCHESTRA HALL, originally THEODORE THOMAS MUSIC HALL, NHL, CLSI, at 220 S. Michigan Avenue, was built in 1905. D. H. Burnham & Co. were the architects and Joachim G. Giaver the engineer. The building is

10 stories high, on pile foundations. Floor plans, construction photographs, and steel foundation details are shown in EN November 3, 1904. Photographs of the building are in CAA; AWG; BB March 1906; CIM, pp. 303 and 545; AR July 1915; GCA, p. 41; AR August 1904, p. 162, drawing. See appendix F. A description is in BB September 1904, p. 102. It was renamed Symphony Center in 1995, with a new western lobby Rotunda and Rehearsal Center, a six-story addition and conversion of the 63 E. Adams Street building to form the Eloise W. Martin Education Center. These were completed in 1997; Skidmore, Owings & Merrill were the architects. Drawings and construction photographs of the complex are in *Chicago Tribune Magazine,* September 21, 1997, pp. 14–19; acoustical diagrams and drawings of the auditorium are in *Chicago Tribune,* September 28, 1997, pp. 1, 5. Until 1996, the Cliff Dwellers Club occupied the building's 1908 top addition, by Howard Van Doren Shaw, architect (restored by Wilbert Hasbrouck, architect). The south 65 feet of this site was occupied previously by the Palmer House Stables, at 216 S. Michigan Avenue.

NORTHERN TRUST CO. building, CLSI, 50 S. LaSalle Street, at the northwest corner of S. LaSalle and W. Monroe Streets, was built in 1905, four stories high, with two basements, on rock caissons. Frost & Granger were the architects. A photograph is in CAA; CIM, p. 397; WO, p. 35; AR January 1907, p. 52; and HB. C. F. Murphy was the architect for a 1967 addition. Harding's Restaurant building previously occupied part of this site. An illustration is in CHC, p. 13. The structure was not designed for additional stories, but in 1928 two stories and a large two-story penthouse were added. Frost & Henderson were the architects and Max Rosner the engineer. A photograph of the building is in CIM. A description of the method of adding the upper floors is in ENR March 27, 1930. The preceding building on this site was the Bryan Block 2, 1872–1904, a four-story building (F. & E. Baumann, architects), described and illustrated in RMNV, V5, and in LO April 1872, pp. 52 and 55. A photograph of the Bryan Block is in OBD 1901, p. 40. Bryan Block 1 was completed a few months before the fire of October 9, 1871. The Northern Trust Co., founded August 12, 1889, first occupied space on the second floor of the Rookery building.

HEYWORTH building, CLSI, renamed 29 E. Madison Street, was built in 1905. D. H. Burnham & Co. were the architects and Joachim G. Giaver the engineer. The building is 18 stories high, with two basements, on caisson foundations. Photographs are in AWG and AR July 1915. A description is in BB September 1904, p. 191. A description and an illustration are in OBD 1929, p. 145. A drawing is in BOC, p. 279.

UNION TERMINALS building, 1905–(1950 to 1990), at 367 W. Adams Street and 372 W. Quincy Street, originally known as the Ryerson Warehouse and known as the Palmer building, was 10 stories and two basements

high, on pile foundations except for caissons under the east wall. Holabird & Roche were the architects. A photograph is in BB August 1906, and HRHR Vol. 1, p. 251. A description is in BB September 1904, p. 191.

KRESGE building, at 10–14 S. State Street, originally known as the Mercantile building, was completed in 1905, six stories and two basements high, on caissons. Holabird & Roche were the architects. Photographs are in CLSI; *Rise of the Skyscraper,* Carl Condit, 1952, fig. 91; and STL, p. 64, under construction, with the Chicago building. The cost of the Mercantile building, including architects' fees, was 26.32 cents per cubic foot (EAR). The frontage on S. State Street is 72 feet and the depth is 120 feet.

220–24 N. STATE STREET building, ca. 1905–(1950 to 1990), was built as a six-story building. In 1940 four stories were removed by Mundie, Jensen, Bourke & Havens, architects, and for a short time the building was known as the Rhumba Casino. The Stouffer Reviere Hotel includes this site.

CHICAGO GARMENT CENTER building, 1905–(1975 to 1990), later known as the Hirsch-Wickwire building, at the northeast corner of S. Franklin and W. Van Buren Streets, was 10 stories high, on pile foundations. Jenney, Mundie & Jensen were the architects. This site is used for parking.

REPUBLIC building, 1905–1961, originally known as the Strong building, at 209 S. State Street, on the southeast corner of E. Adams Street, was 12 stories high. Seven stories were added in 1909. Holabird & Roche were the architects. The 19-story building, with two basements, was on rock caissons. The cost of the original 12-story Republic building, including architects' fees, was 32.04 cents per cubic foot, and the cost of the seven-story addition was 48.60 cents per cubic foot (EAR). A photograph is in CAA; BB June 1906; AR April 1912; HRHR Vol. 1, p. 234; CSA, fig. 136; CTCP, p. 54 as 12 stories; IA March 1905; IA-C June 1969, p. 45, facade detail; STL, p. 10; TBAR, p. 15; and RNRC, p. 120. A description is in BB September, 1904, p. 191. The W. W. KIMBALL building, built in 1873, four stories high, was formerly on this corner, with a frontage of about 80 feet on each street. It is illustrated in TYF; LO September 1873, p. 156; and by photograph in CYT, p. 65, and CIM, p. 186. About 1890 the Owen Electric Belt building, four stories high, was built on this corner; a photograph is in CRT, opposite p. 147. The Home Federal Savings & Loan/LaSalle Talman Bank building occupies this site.

BOSTON STORE, at N. State, W. Madison, and N. Dearborn Streets, was built from 1905 to 1917. Holabird & Roche were the architects. The building is 17 stories high, with three basements, on rock caissons. A photograph is in CLSI; HRHR Vol. 1, p. 277; GMM, p. 217, under construction; RB Annual Review, January 28, 1950, p. 77; AR April, 1912; and CIM, p. 555. An

illustration is in HCCB, p. 200B. Preceding the Boston Store, the five-story Manierre building, 1876–1905 (q.v.), fronted 162.86 feet on N. Dearborn Street and 80 feet on W. Madison Street; the Hershey Music Hall, four stories high, at 20–24 W. Madison Street, later known as Madison Hall and as Sam T. Jack's Theater, fronted 80 feet on W. Madison Street; the Crystal Block, five stories high, and later seven stories high, at 12–16 W. Madison Street, had a frontage of 50 feet; and the Champlain building occupied the northwest corner of N. State and W. Madison Streets, the former site of the Doré Block. A photograph of this block of buildings is in CIM, pp. 340, 407, and 599. A photograph of the prefire Speed building is in CIM, p. 248; a view is in CIJ, with an illustration of Tremont House 3 and of N. Dearborn Street north of W. Madison Street. Otis L. Wheelock was the architect of the Speed building. On July 31, 1948, a liquidation sale of the merchandise of the Boston Store was completed. A special news bulletin of RB (September 27, 1948) announced the change in name of the building to the State-Madison building and its conversion to a multiple occupancy commercial use. It was renamed the 1 N. Dearborn Street building, later 4 N. State Street. In early 1998 a major retail store is said to be interested in occupying the lower floors.

LAKE VIEW building, NR, at 116 S. Michigan Avenue, originally known as the *Municipal Court building*, was built in 1906, 12 stories high, on caissons; five stories were added later. Jenney, Mundie and Jensen were the architects. A photograph is in CIM, p. 545, and BB September 1907, p. 170. An illustration of the completed building is in OBD 1929, p. 166. Photographs are also in WO, p. 7; CTCP, p. 51; HB; and RB Annual Review, January 28, 1950, p. 65 (advert.), and April 28, 1984, p. 21. See appendix F. The Lake View building was renamed the 116 S. Michigan Association building and converted in 1986 from a school to offices; Pappageorge & Haymes were the architects.

BORLAND building, 1905/1914–ca. 1975, 105 S. LaSalle Street, on the southeast corner of W. Monroe Street, on the site of the former Hampshire building, 1872–1905, was six stories high, a photograph of which is in CIM, p. 572. The addition to the south at 111–17 S. LaSalle Street (frontage 78 feet) was on the site of the former Calumet building. The building is 18 stories high, with two basements, on rock caissons. Shepley, Rutan & Coolidge were the architects of the original building, and Charles S. Frost was the architect of the addition. A photograph is in BB June 1909, p. 130. A photograph of the completed building and of its predecessor on this site is in CIM, p. 572. An illustration and a description of the building are in OBD 1929, p. 46. The 1977 Harris Bank addition occupies this site.

PATTEN building, NR, was built in 1905 at 161 W. Harrison Street, at the southwest corner of S. Sherman Street, in the South Loop Printing House Historic District/NR. It is 12 stories high, on 50-foot wood piles and rock

caissons. C. A. Eckstorm was the architect. A description is in BB September 1904, p. 192.

South: HENNEBERRY building, at 1139–43 S. Wabash Avenue, built ca. 1905, is eight stories high. Howard Van Doren Shaw was the architect. A photograph is in BB October 1906, p. 215; IA June 1905, p. 47; and RB Annual Review, January 27, 1973, p. 124. The Henneberry was renamed the Norbart building, 1139 S. Wabash Avenue.

North: PUGH WAREHOUSES, at 365–589 E. Illinois Street, are six stories high, on spread foundations. C. A. Eckstorm was the architect. They are illustrated in HE. The first unit was built in 1905 and the last unit in 1920. The original frontage on E. Illinois Street was 1,663.5 feet. The portion in the right-of-way and to the east of N. Lake Shore Drive was demolished, as was the site for the North Pier Apartment building adjoining the drive on the west. This Cityfront Center building was converted to mixed uses, including the Festival Market, 435 E. Illinois Street, on the north bank of Ogden Slip, containing restaurants, offices, apartments, and parking facilities. It was renamed North Pier Chicago; Booth, Hansen were the architects, and the Austin Co. associated. An article is in IA-C September 1990, p. 48. A photograph is in AGC, p. 118. Bird's-eye views are in TBC, p. 385, in a scene with Lake Point Tower, and in RB Annual Review, January 30, 1965, p. 14, in a Streeterville scene.

MENTOR building 2, at 39 S. State Street, on the northeast corner of E. Monroe Street, built in 1906, is 17 stories high, with two basements, on rock caissons. Howard Van Doren Shaw was the architect. A photograph is in BB January 1908, p. 19; OBD 1916, p. 155; CIM, p. 334; WO, p. 25; STL, p. 72; CAJZ, p. 321; and RB Annual Review, January 28, 1967, p. 122. An illustration is in HCCB, p. 58B. This building succeeded the MENTOR building 1, 1873–1905, a seven-story building 26 feet wide on the same corner. An illustration of the latter is in RMNV, V6. The building was vacant in 1996.

BREVOORT HOTEL 2, at 120 W. Madison Street, with a frontage of 50 feet, built in 1906, is 13 and 15 stories high, on spread foundations. H. R. Wilson and Benjamin H. Marshall were the architects. It was also known as the New Brevoort Hotel. The facade was replaced by a curtain wall, the building converted to offices and renamed the 120 W. Madison Street building: Shaw, Metz were the architects. Photographs are in CTCP, p. 45; HB; RB April 20, 1963, p. 1, and November 23, 1963, p. 1; and CIM. BREVOORT HOTEL 1, built in 1872, was four stories high, with one basement. It is illustrated in LO April 1874, p. 53. A photograph is in CIM, p. 401.

162 N. FRANKLIN STREET building, built in 1906, is six stories high, on spread foundations. Hill & Woltersdorf were the architects.

310–14 W. WASHINGTON STREET building, built ca. 1906, is six stories high, on spread foundations. A photograph is in CIM, p. 589, and RB March 10, 1951, p. 1.

MAURICE L. ROTHSCHILD STORE building, at 300–306 S. State Street, on the southwest corner of W. Jackson Street, was built in 1906 and 1910, eight stories high, with two basements, on rock caissons. Holabird & Roche were the architects. In 1928 four stories were added, together with an adjacent 12-story addition at 308 S. State Street. A. S. Alschuler was the architect, and Lieberman & Hein were the engineers. A photograph during construction of the addition is in ISA 1931–32, p. 80. The addition is also on caissons. A photograph is in HRHR Vol. 1, p. 285. The John Marshall Law School occupies this building as well as the 315 S. Plymouth Court building.

79 W. MONROE STREET building, at the southeast corner of S. Clark Street, fronting approximately 90 feet on the former and 189 feet on the latter street, was formerly known as the Chicago Trust building and originally as the Rector building. It was built in 1906, 13 stories high, on 50-foot wood piles and hardpan caissons. Jarvis Hunt was the architect. A description is in BB September 1904, p. 192; a photograph is in BB July 1909, p. 132, and OBD 1916, p. 213. In 1924 an addition, to the south, was made by Holabird & Roche, architects, and Henry J. Burt, engineer. The addition was carried on wood piles except for the south and east walls, which are on hardpan caissons. An illustration of the completed building is in OBD 1941–42, p. 360. Photographs are also in AR February 1905, p. 155, and HB. The building was renamed the Bell Savings building. The entire site was occupied previously by Constitution Block, a four-story building, built in 1872 by Otto H. Matz, architect. An illustration of the latter building is in LO March 1872, p. 40, with a description on p. 38. The Culver, Page & Hoyne building was here before the great fire.

CLOCK building of the Illinois Bell Telephone Co., 1906–1971, at 211–19 W. Randolph Street, was eight stories high, on spread foundations. Edmund R. Krause was the architect. This site was occupied formerly by the Sibley building, known originally as the Slosson building, built in 1873, with 80-foot frontage and 180-feet depth, four stories high; it is illustrated in LO May 1874.

South: RED CROSS building, at 529–31 S. Wabash Avenue, formerly the Hoops building, built ca. 1905, is eight stories high. Jenney, Mundie & Jensen were the architects. This was renamed the 531 S. Wabash Avenue building.

West: PLAMONDON building, 1906–(1950 to 1985), at the northwest corner of S. Clinton and W. Monroe Streets, seven stories high, on spread footings, was distinguished as being one of the earliest reinforced concrete

buildings, and was an addition to a mill-construction building to the north, built ca. 1901. The north and west walls were party walls; otherwise the building was of skeleton construction. Steel sections were used in the lower column stories to reduce their size. The floors, of beam and slab construction, carried 250 pounds per square foot. Fc is 700 pounds per square inch and fs is 16,000 pounds per square inch. Leon E. Stanhope was the architect and engineer. The Presidential Towers buildings include this site.

South: *FAIRBANKS, MORSE & CO. building,* NR, at the southwest corner of S. Wabash Avenue and E. Ninth Street, built ca. 1906, is seven stories high, on pile foundations. Holabird & Roche were the architects. It was converted to apartments and renamed the Fairbanks Lofts, 900 S. Wabash Avenue. A photograph is in HRHR Vol. 1, p. 291.

North: HENROTIN HOSPITAL 1, 1906–1933, at the southeast corner of N. LaSalle and W. Oak Streets, was six stories high, of reinforced concrete construction, on spread foundations. Richard E. Schmidt was the architect. HENROTIN HOSPITAL 2, at the southeast corner of N. LaSalle and W. Oak Streets, completed in 1935, is of reinforced concrete construction, on piles. The architects were Holabird & Root, and the engineer was Verne O. McClurg. A drawing is in HRHR Vol. 1, p. 291.

EDISON building, at 72 W. Adams Street, on the northeast corner of N. Clark Street, formerly the Commercial National Bank building, was built in 1907. D. H. Burnham & Co. were the architects and Joachim G. Giaver the engineer. The building is 18 stories high, with two basements, on rock caissons. Photographs and floor plans are in AWG and AR July 1915. A photograph is in CAA; CIM, p. 567; and BB August 1907, p. 150. An illustration is in CHC, p. 126, and OBD 1916, p. 71. The Kentucky building and the Quincy building, 1873–1906, five stories high, previously occupied the west 90.5 feet of this site, the former at 125–33 S. Clark Street and the latter on the corner.

STRATFORD building, 1907–early 1950s, at 418–24 S. Wells Street, was eight stories high, on spread foundations. Nimmons & Fellows were the architects. It was demolished for the Congress Parkway interchange.

South: OHIO building, 1907–early 1950s, at 509 S. Wabash Avenue, on the southeast corner of E. Congress Street, was four and five stories high, on spread foundations. Holabird & Roche were the architects. The cost of the building, including architects' fees, was 16.766 cents per cubic foot (EAR). It was also known as the Chicago Portrait building. A drawing is in HRHR Vol. 1, p. 289. It was demolished for the Congress Parkway widening.

South: FAIRBANKS-MORSE building, at 606 S. Michigan Avenue, on the southwest corner of E. Harrison Street, formerly known as the Harvester building, was built in 1907, 15 stories high, on pile foundations. C. A. Eck-

storm was the architect. A photograph is in CIM, pp. 299 and 549. A description and an illustration are in OBD 1929, p. 142. The building was renamed Columbia College, 600 S. Michigan Avenue. A photograph is in CYCP, p. 91, and HB.

South: 501–09 S. FRANKLIN STREET building, 1907–1947, formerly known as the Brooks building and the Oxford building, was 10 stories high, on wood piles except for caissons under the party wall. Holabird & Roche were the architects. This building was condemned and removed by the Department of Subways and Superhighways for the Congress Parkway interchange. It was also known as the Kohn building.

North: 1100 N. LAKE SHORE DRIVE apartment building, 1907–late 1970s, originally known as the Marshall Apartments, at the northwest corner of E. Cedar Street, was eight stories high. Benjamin H. Marshall was the architect. A photograph and a typical floor plan are in BW, p. 20, and APB, pp. 10 and 11. A photograph is in CAJZ, p. 277. The 1100 N. Lake Shore Drive condominium building, of 1980, occupies this site.

North: 431–51 N. ST. CLAIR STREET building, 1907–late 1980s, at the southeast corner of E. Illinois Street and the northeast corner of E. North Water Street, built for the James H. Rice Co. and occupied by the Pittsburgh Plate Glass Co., was six stories high, of mill construction. C. A. Eckstorm was the architect. The NBC Tower includes this site.

North: 340–48 N. DEARBORN STREET building, 1907–(1950 to 1990), at the northwest corner of W. Carroll Avenue, was six stories high. This site is used for parking.

North: Aaron MONTGOMERY WARD complex, NHL, HABS, CLSI/premier, 618 W. Chicago Avenue and N. Larrabee Street, at the east bank of the Chicago River, was completed in 1907. Richard E. Schmidt, Garden & Martin were the architects and engineers. This eight-story building was one of Chicago's first large reinforced concrete buildings of skeleton construction. It is carried on piles, 40 feet to 50 feet in length. A description, with construction photos, is in ER May 11, 1907. An illustration is in HCCP, p. 197B. Photographs are in CFB "merit"; CSA, fig. 151; Prairie School, H. A. Brooks, 1974, p. 100; ABOV, p. 60; Space, Time and Architecture, Sigfried Giedion, 1941; GMM, p. 230, air view; and RB Annual Review, January 30, 1965, p. 18, river scene. A. Montgomery Ward, who also campaigned against building on Grant Park lands, began business on the fourth floor at 823 N. Clark Street (C, p. 114).

HUNTER building, CAL, 1908–1978, at 337 W. Madison Street, at the southeast corner of S. Wacker Drive, was known as the Liberty Mutual building.

C. A. Eckstorm was the architect. It was 12 stories high, with a frontage of 65.5 feet on W. Madison Street and a depth of 100 feet. A photograph is in HE and *Chicago Tribune,* March 23, 1947. An illustration is in OBD 1916, p. 108. Photographs are in CSA, fig. 140, and in RB Annual Review, January 28, 1961, p. 121. The M. D. Wells building previously occupied this site. The 1 S. Wacker Drive building is now on this site.

ILLINOIS ATHLETIC CLUB, at 112 S. Michigan Avenue, was completed in 1908. It is 12 stories high, with two basements, on hardpan caissons. Barnett, Haynes & Barnett were the architects. A photograph is in CAA; CIM; and CTCP, p. 51. The building was renamed the Illinois Athletic Association building and then became the Charlie Club and Resort building in 1985, at the time of a six-story top addition with a concrete facade; an article is in *Concrete Construction,* October 1985, p. 868. Also see appendix F. A photo is in CFB, p. 14. Swan & Weiskopf were the engineers for the addition. The building was converted for the School of the Art Institute in 1993; Weese, Langley, Weese were the architects. It was renamed Wollberg Hall.

PRINCESS THEATER building, 1908–1941, was at 319 S. Clark Street and was three stories high, on piles. Kirchoff & Rose were the architects. A photograph is in CIM, p. 434; CYT, p. 89; and LC, p. 185. The site is now a parking lot.

MUELLER building, at 318–22 W. Randolph Street, built in 1908, is seven stories high, on spread foundations. Iver C. Zarbell was the architect. It was renamed the Wellington building, 318 W. Washington Street. The lofts were converted to offices by Edward M. Cohen, architect.

NATIONAL REPUBLIC BANK building, 1908–ca. 1985, formerly known as the Corn Exchange Bank building, at 122–36 S. LaSalle Street, on the northwest corner of W. Adams Street, with a depth of 75 feet, was 17 stories high, on rock caissons. Shepley, Rutan & Coolidge were the architects. A photograph is in CIM, p. 590, and BB April 1909, p. 85. An illustration is in OBD 1929, p. 232. The Schloesser Block previously occupied this site, which is now occupied by the 190 S. LaSalle Street building.

ARTHUR DIXON building, at 411–15 S. Wells Street, built in 1908, is 10 stories high, on pile foundations. Nimmons & Fellows were the architects and E. C. & R. M. Shankland the engineers.

OLIVER (typewriter) building, NR, CAL, at 159–67 N. Dearborn Street, later known as the 159 N. Dearborn Street building, built in 1908, is seven stories high, on pile foundations. Holabird & Roche were the architects. Photographs are in HRHR Vol. 1, p. 294; WO, p. 33, partial facade; RB Annual Review, January 31, 1970, p. 152; FRAG, p. 97; and HDM, p. 187.

TOLL building of the Illinois Bell Telephone Co., 1908–1967, at 111–15 N. Franklin Street, was eight stories high, on wood piles. Pond & Pond were the architects. It was also known as the Illinois Bell building. A photograph is in RB Annual Review, January 27, 1968, p. 76.

VOGUE building, at 412 S. Wells Street, built in 1908, is 10 stories high, on spread foundations. Sidney H. Morris was the architect. A photograph is in RB June 30, 1990, p. 76.

South: BAUER & BLACK building, 1908–(1950 to 1990), at 2500 S. Dearborn Street, three stories high, was on spread foundations, with Holabird & Roche as the architects. It was an early reinforced concrete building, designed by the "Kahn system." A photograph is in HRHR Vol. 1, p. 194.

South: BORN building, 1908–1953, at 540–52 S. Wells Street, on the northwest corner of W. Harrison Street, was of flat-slab reinforced concrete frame. It was 12 stories high, supported on wood piles. Holabird & Roche were the architects and Purdy & Henderson the engineers. An illustration is in HCCB, p. 86B. Photographs are in CSA, fig. 134, and HRHR Vol. 1, p. 316. An addition was built in 1927. A. S. Alschuler was the architect. Photographs are in ISA 1922, p. 130.

South: BLUM building, at 624–30 S. Michigan Avenue, originally known as the Musical College building and then as the Barnheisel building and the Grant Park building, was built to the height of eight stories in 1908, on pile foundations. C. A. Eckstorm was the architect. An illustration is in OBD 1916, p. 93. In 1922 seven stories were added by A. S. Alschuler, architect. A photograph is in CIM, p. 296, and WA January 1910. An illustration of the completed building is in OBD 1941–42, p. 38. Photographs are also in STL, p. 74, as eight stories, with the Blackstone Hotel; 1993 CFB, p. 19; CTCP, p. 91; HB; RB August 11, 1990, p. 3; and Annual Review, January 28, 1967, p. 157, as the MRCA building; and ISA 1923, p. 148. The frontage on S. Michigan Avenue is 80 feet and the depth is 172 feet. The Blum building was also known as the Torco building and was renamed the 624 S. Michigan Avenue building of Columbia College, with the conversion by Shayman & Salk, architects.

South: PRINTERS building, built in 1908 at 732 S. Sherman Street, in the South Loop Printing House Historic District/NR, is eight stories high. H. B. Wheelock was the architect. Photographs are in CIM, AR March 1910, p. 252, and RB April 28, 1990, p. 21. The lofts were converted to apartments.

South: REGAL building, at 643–51 S. Wells Street, built ca. 1908, is eight stories high. The building was converted and renamed the Regal Apartments, 651 S. Wells Street, in the South Loop Printing House Historic District/NR.

South: 515 S. WELLS STREET building, 1908–1947, with a frontage of about 46 feet, was eight stories high, on spread foundations. This building was condemned and removed by the Department of Subways and Superhighways for the Congress Street superhighway. This site is used for parking.

West: NORTH AMERICAN COLD STORAGE WAREHOUSE, built in 1908, is seventeen stories high. Frank Abbott was the architect. It was converted in 1981 to offices and condominiums and renamed the Fulton House, 345 N. Canal Street, at W. Fulton Street and the west bank of the Chicago River; Harry Weese was the architect. A photograph is in STL, p. 236.

North: HALL PRINTING CO. building, 1908–(1950 to 1990), later known as the Chanock Industrial building, was at 440–72 W. Superior Street, on the northeast corner of N. Kingsbury Street. It had a frontage of 341 feet on W. Superior Street and a depth of 128 feet. The building was seven stories high, of heavy mill construction, and was supported on wood piles. Paul Gerhardt Sr. was the architect. This site is used for parking.

North: 160 E. ILLINOIS STREET building, at the northwest corner of N. St. Clair Street, built in 1908, formerly known as the Brokers building, is six stories high, of mill construction, on spread foundations. Samuel N. Crowen was the architect.

North: McCLURG building, 1908–1960s, at 330–52 E. Ohio Street and 329–53 E. Ontario Street, was of mill construction and was built in three sections. Marshall & Fox were the architects. The four-story portion, fronting 240 feet on E. Ohio Street, was built on spread foundations. The west 130-foot frontage on E. Ontario Street was six stories high, with spread foundations. The east 110-foot frontage on E. Ontario Street was six stories high, built in 1914 on pile foundations. A photograph is in HB. The McClurg Court Center Apartments, 333 E. Ontario Street, with McClurg Court Sports Center and McClurg Court Theater, 330 E. Ohio Street, occupies this site.

CORT THEATER building, 1909–1934, at 126–32 N. Dearborn Street, 80 feet square, was five stories high. A photograph is in CIM, p. 579, and *Chicago Tribune,* February 17, 1940. The Richard J. Daley Center includes this site.

321 S. PLYMOUTH COURT building, ca. 1909–(1950 to 1990), at 317–25 S. Plymouth Court, was six stories high. A photograph is in RB Annual Review, January 30, 1960, p. 135. The Chicago Bar Association building occupies this site.

Robert, Cavalier de LASALLE HOTEL, 1909–1977, was at the northwest corner of N. LaSalle and W. Madison Streets. Holabird & Roche were the

architects and Purdy & Henderson the engineers. The building was 22 stories high, with two basements, on rock caissons. The cost of the LaSalle Hotel building, including architects' fees, was 43.978 cents per cubic foot (EAR). The construction is described in ER November 28, 1908, and the steel-work in ER June 5, 1909. Photographs and floor plans are in AR April 1912 and in ARV 1913, p. 88. A photograph is in CAA; CIM, p. 400; HRHR Vol. 1, p. 304; CTCP, p. 46; CH10; and HB. The Oriental buildings and the LaSalle building previously occupied this site. The 2 N. LaSalle Street building occupies this site, reusing the LaSalle Hotel foundations. Interior photographs are in ARV 1913, pp. 89, 163, and 169. On the early morning of June 5, 1946, the hotel suffered a disastrous fire resulting in the loss of 61 lives. The fire originated in a cocktail lounge at the north of the LaSalle Street entrance. The frontage of the hotel on N. LaSalle Street was 178 feet and the frontage on W. Madison Street, 161 feet.

McCORMICK building, at 332 S. Michigan Avenue, on the northwest corner of E. Van Buren Street, was built in 1909 and completed May 1, 1910, with an addition in 1912. Holabird & Roche were the architects. The building is 20 stories in height, with two basements, on rock caissons. The total cost of the McCormick building, including architects' fees, was 37.19 cents per cubic foot (EAR). A photograph is in CAA; CIM, pp. 543 and 544; HE; STL, p. 78; and HRHR Vol. 1, p. 322. A photograph and floor plans are in AR April 1912. An illustration is in HCCB, p. 57B. A photograph and a brief description are in OBD 1910, p. 125. See appendix F. The building was renamed the 332 S. Michigan Avenue building, a part of the CNA Center. It is reported that a few of the upper floors have been converted to The Residences of 330 S. Michigan Avenue.

UNIVERSITY CLUB building, HABS, CLSI, at 74 E. Monroe Street, on the northwest corner of S. Michigan Avenue, was built in 1909. Holabird & Roche were the architects. The building is 14 stories high, on pile foundations. The cost of the building, including architects' fees, was 40.65 cents per cubic foot (EAR). A photograph is in CAA; CIM, p. 306; SCB; AR April 1912; BB April 1909, p. 84; ACMA, p. 39; CSV, p. 204; STL, p. 76; AR July 1910; HRHR Vol. 1, pp. 268 and 379. See appendix F. The 1885 McCormick/Powers building previously occupied this site.

South: 501 S. LASALLE STREET building, 1909–1947, formerly known as the Buzzell building, was eight stories high, on pile foundations, and had a frontage of about 100 feet. This building was condemned and removed by the Department of Subways and Superhighways for the Congress Street superhighway.

South: *BLACKSTONE HOTEL*, NR, CLSI, at 636 S. Michigan Avenue, on the northwest corner of E. Balbo Avenue (Seventh Street), the site of the

home of John B. Drake, was built in 1909. It is 22 stories high, with three basements, on rock caissons. Marshall & Fox were the architects. A photograph is in CIM, pp. 296 and 298; CYT, p. 44; WA January 1910; BB December 1909, p. 261; ARV 1913, p. 58, with floor plans at p. 59 and interior photographs at pp. 42, 43, 59, 61, 163, 165, and 172; CFB "merit"; WO, p. 11; GCA, p. 49; STL, p. 74; CTCP, p. 91; TBC, p. 152; and HB. It was also known as the Sheraton-Blackstone and as the (John B. and William M.) Drake-Blackstone Hotel. See also the adjoining Blackstone Theater.

South: MOSER building, at 621–31 S. Plymouth Court, built in 1909, is nine stories high, on pile foundations except under the north wall, which is supported on rock caissons. Holabird & Roche were the architects. The cost of the Moser building, including architects' fees, was 10.485 cents per cubic foot (EAR). It was converted to condominiums in 1985 and renamed the Moser Lofts, 631 S. Plymouth Court, in the South Loop Printing House Historic District/NR; Lisec & Biederman were the architects. A photograph is in HRHR Vol. 1, p. 351.

South: MUNN building, built in 1909 at 815–23 S. Wabash Avenue, is eight stories high. C. A. Eckstorm was the architect. It was also known as the Stone-Cole building. The lofts were converted to offices in 1986 and renamed The Loftrium, 819 S. Wabash Avenue; Kenneth W. Folgers was the architect.

North: RAILWAY TERMINAL building, at 454–58 W. Grand Avenue, built in 1909, is six stories high, on pile foundations. Nimmons & Fellows were the architects. It is of mill construction, with laminated floors having a capacity of 300 pounds per square foot. It is known as the Wallace Co. building, 454 W. Grand Avenue. A photograph is in *Chicago Industrial Guide*, Public Works Historical Society, 1971, p. 37.

North: STEELE-WEDELES building, 1909–(1970 to 1985), was at 312 N. Dearborn Street, on the north bank of the Chicago River. Henry L. Ottenheimer was the architect. The building was nine stories high, with one to five basements, on hardpan caissons. It is described and illustrated in ER December 12, 1908. A photograph is in CIM, p. 228, and an illustration is in HCCB, p. 226B. The caissons under the river wall are reputed to be the first in Chicago built in water; five caissons 6 feet in diameter were built, using 35-foot steel interlocking sheet piling of the George W. Jackson type, under the supervision of Edward J. Fucik, engineer. The Hotel Nikko occupies this site.

1909: "The Burnham Plan": *The Plan of Chicago* was published by the Commercial Club; it was reprinted by Da Capo Press in 1970. See also *Plan of Chicago*, Robert Bruegmann et al., 1979. The present street numbering system was instituted.

1910: North Michigan Avenue (formerly Pine Street) was widened.

HART, SCHAFFNER & MARX building, 1910–1983, at 36 S. Franklin Street, on the northwest corner of W. Monroe Street, was 12 stories high, on pile foundations except for rock caissons under the party wall. Holabird & Roche were the architects. The cost of this building, including architects' fees, was 18.44 cents per cubic foot (EAR). Photographs are in HRHR Vol. 2, p. 318, and RB March 2, 1963, p. 1. This site is used for parking. The east part of the Old Farwell Block previously occupied this site.

MALLERS building, built in 1912 at 5 S. Wabash Avenue, on the southeast corner of E. Madison Street, is 21 stories high, on caissons. C. A. Eckstorm was the architect. A photograph is in OBD 1916, p. 131; HB; and RB February 8, 1964, p. 1. The address was changed to 67 E. Madison Street in 1983. The Continental Hotel previously occupied this corner.

215 S. MARKET STREET building, 1910–(1950 to 1990), formerly known as the Dry Goods Reporter building, was 12 stories high, on hardpan caissons. Peter J. Weber was the architect. A photograph is in OBD 1941–42, p. 416, and HB. This site is used for parking.

5 N. WABASH AVENUE building, at the northeast corner of E. Madison Street, with a frontage of 56 feet on Wabash and 163 feet on Madison, was formerly known as the Kesner building. It was built in 1910 and is 17 stories high, on rock caissons. Jenney, Mundie & Jensen were the architects. A photograph is in OBD 1929, p. 158. A photograph of the previous building on this corner is in CIM, p. 336.

207 S. WABASH AVENUE building, 1910–1995, at the southeast corner of E. Adams Street, had a frontage of 80 feet on Wabash and 50 feet on Adams. It was formerly known as the Mayer building, the Chicago Business College building, and the Adams-Wabash building. It was eight stories high, on rock caissons. D. H. Burnham & Co. were the architects and J. G. Giaver the engineer. A photograph is in CAA; CLSI; and CSA, fig. 14. The Burdick House and Root & Sons' Music House, a four-story building, formerly occupied this site. The Symphony Center includes this site.

STEGER building 2, at 28 E. Jackson Street, on the northwest corner of S. Wabash Avenue, built in 1910, is 19 stories high, with two basements, on rock caissons. Marshall & Fox were the architects. A photograph is in CIM, p. 374, and RB Annual Review, January 25, 1958, p. 45. An illustration is in HCCB, p. 81B, and OBD 1910, p. 189, with a description. A partial photograph of the preceding four-story Steger building 1 is in CIM, p. 373. It was renamed the 28 E. Jackson Boulevard building.

BROOKS building, CLSI/premier, at 223 W. Jackson Street, on the southeast corner of S. Franklin Street, built in 1910, is 12 stories high, on piles.

Holabird & Roche were the architects. A photograph is in OBD 1941–42, p. 51. The cost of this building, including architects' fees, was 20.389 cents per cubic foot (EAR). Photographs are also in CSA, fig. 139; WO, p. 38; STL, p. 80; HRHR Vol. 1, p. 340; RB December 8, 1990, p. 1; and CALP.

HARDING HOTEL, ca. 1910–(1950 to 1980), at 19 N. Clark Street, formerly known as the Planters Hotel, was nine stories high. John O. E. Pridmore was the architect. A photograph is in CIM, pp. 422 and 445; *Hotel Monthly* June 1912; and GMM as the Planters Hotel. The Morrison building, at the northeast corner of N. Clark and W. Madison Streets, with 169-foot frontage on the former street and approximately 160 feet on the latter, formerly occupied this site. The frontage of the Harding Hotel was 100 feet and the depth 120.4 feet. The Three First National Plaza building includes this site.

456 S. STATE STREET building, ca. 1910–ca. 1950, was six stories high. The building was condemned and removed by the Department of Subways and Superhighways.

South: STUDEBAKER building, 1910–(1950 to 1990), was at the northwest corner of S. Michigan Avenue and E. Twenty-first Street. William E. Walker was the architect and Condron & Sinks the structural engineers. This building was designed for seven stories, with provisions for future stories, and was the first building in which flat-slab construction with shallow girders was used in Chicago for floors. Steel columns were used below the seventh floor, supported on caissons to rock. For a description of the building and details of the construction see ER January 22, 1910. A photograph is in *Factories and Warehouses of Concrete*, American Portland Cement Manufacturers, 1911.

South: BELOIT building, at 527 S. Wells Street, built in 1910, is eight stories high, on spread foundations. The frontage on S. Wells Street is 50 feet and the depth is 94 feet. It was renamed the Hunter building.

South: BORLAND MANUFACTURING buildings, at 610–732 S. Federal Street, were built on piles. The building at no. 610 and that at no. 626 is eight stories tall and was constructed in 1910. The building at no. 638, nine stories, was built in 1910; and those at no. 712 and at no. 732, 12 stories, were erected in 1913. Charles S. Frost was the architect. In 1928 an addition of three stories, on spread foundations, was made to no. 732 by Charles C. Henderson, architect. The buildings were converted to apartments in 1983 by Louis Weiss, architect, and renamed Printers Square, 700 S. Federal Street, in the South Loop Printing House Historic District/NR. A partial photograph is in STL, p. 86, with the Franklin building. Photographs are in RB September 17, 1955, and in HB.

South: WABASH EXCHANGE building of the Illinois Bell Telephone Co., at 514–20 S. Federal Street, built in 1910, is seven stories high, on rock

caissons. Holabird & Roche were the architects. In 1928 a five-story addition was built at 522–34 S. Federal Street, with two basements, on rock caissons, designed for 12 additional stories; Holabird & Root were the architects.

North: 1130 N. LAKE SHORE DRIVE apartment building, at the northwest corner of E. Elm Street, built in 1910, is nine stories high. The architect was Howard Van Doren Shaw. The entrance is at 90 E. Elm Street, in the Gold Coast Historic District/NR. A photograph is in CAJZ, p. 284. See appendix F.

North: CRERAR ADAMS WAREHOUSE building, 1910–(1950 to 1990), at the southwest corner of (259) E. Erie Street and N. Fairbanks Court, was seven stories high, on concrete piles. The architects were Ottenheimer, Stern & Reichert. It was also known as the Rembrandt building.

North: LAKE SHORE & OHIO building, at 473–85 E. Ohio Street and 538–48 N. Lake Shore Drive, built in 1910, is seven stories high, on concrete piles. Frank E. Davidson was the architect and engineer. It was converted and renamed, together with the Borg building, the 540 N. Lake Shore Drive Apartments, at the southwest corner of E. Ohio Street. A photograph is in RB December 1, 1951, p. 12.

North: CHANDLER APARTMENTS building, built in 1910 at 33 E. Bellevue Place, is in the Gold Coast Historic District/NR. Schmidt, Garden & Martin were the architects. A photograph is in HB.

North: ORLEANS PLAZA building, built in 1910 at 414 N. Orleans Street, at the southwest corner of (350) W. Hubbard Street and extending to N. Kingsbury Street, is eight stories high, of mill construction. The lofts, known earlier as the Bradley building, were converted to offices and stores in 1985 by Frye, Gillan & Molinaro, architects. A photograph is in RB April 27, 1985, p. 103.

North: 343 W. ERIE STREET building, built in 1910 at the southwest corner of (644) N. Orleans Street, to W. Ontario Street, and known also as Christie's (auctioneers) building, is seven stories high. Originally a warehouse, by Rapp & Rapp, architects, it was converted to offices in 1985; Pappageorge & Haymes were the architects. A photograph is in RB March 18, 1950, p. 3, and April 27, 1985, p. 32.

HAMILTON HOTEL, 1911–(1950 to 1968), at 14–26 S. Dearborn Street, formerly the Hamilton Club building, was 10 stories high, with a frontage of 102 feet, on hardpan caissons. S. S. Beman was the architect. In 1920 six stories were added by E. E. Roberts, architect, and Condron & Co., engineers. Photographs are in CCP, p. 153. The Fuller Block, previously on the front 50 feet of this site, was built in 1872 by John M. Van Osdel, architect. The One First National Plaza building includes this site.

BLAKELY building, 1911–(1950 to 1990), at 418–32 S. Market Street, was eight stories high, on wood piles except for the north and south walls, which were on rock caissons. Perkins, Fellows & Hamilton were the architects.

FEDERAL LIFE building, built in 1911 at 168 N. Michigan Avenue, is 12 stories high, on caissons. Marshall & Fox were the architects. Photographs are in OBD 1916, p. 75, and CNM, p. 30, shown with the Crerar Library. A drawing is in RB January 25, 1958, p. 75. It was renamed the Arnold Maremont (automotive products) building, and it is now the 168 N. Michigan Avenue building. It is also known as the National Bank of Greece building.

HEARST building, 1911–(1975 to 1990), at 326 W. Madison Street, was 10 and 11 stories in height, with two basements, on rock caissons. James C. Green of New York was the architect. A photograph and a description of the building are in AR April, 1912, and a photograph is in CIM, p. 570. A description and a photograph are in OBD 1916, p. 103. An article is in AR April 1912, p. 406. A photograph is in RB February 4, 1961, p. 1. It was also known as the Chicago American (newspaper) building. A five-story Field-Leiter Wholesale building previously occupied this site; a drawing is in JSAH October 1978, p. 183. This site is vacant. A three-story addition at 316 W. Madison Street was done by Paul Gerhardt, architect, and Lieberman & Hein, engineers.

HARRIS TRUST building, at 111–19 W. Monroe Street, built in 1911 on the site of the former six-story Taylor building, is 20 stories high, with three basements, on rock caissons. Shepley, Rutan & Coolidge were the architects. A photograph is in OBD 1941–42, p. 156; CLSI; and HB. Additions were made in 1960, 23 stories high, at the southwest corner of W. Monroe Street and S. Clark Street, and in 1976, 38 stories, 498 feet high, at the southeast corner of W. Monroe and (115) S. LaSalle Streets, of steel frame construction, by Skidmore, Owings & Merrill, architects and engineers. Photographs are in STL, p. 184; *SOM,* Christopher Woodward, 1970, plates 40 and 41; and PROC, p. 67. The 105 W. Monroe Street and the Borland buildings occupied the sites of the additions.

JOHN MARSHALL LAW SCHOOL building, built in 1911, HABS, HA, CLSI, at 315 S. Plymouth Court, formerly known as the City Club building, is six stories high, on pile foundations. Pond & Pond were the architects. See also the Maurice Rothschild Store building.

PEOPLE'S GAS CO. building 2, NR, at 122 S. Michigan Avenue, on the northwest corner of E. Adams Street, was completed in 1911. D. H. Burnham & Co. were the architects and Joachim G. Giaver the engineer. The building is 20 stories high, with two basements, on hardpan caissons. The exterior walls on the two street fronts, above the ornamental monolithic

granite columns, are supported on steel cantilever girders. Photographs and floor plans are in AWG. Photographs are in STL, p. 67, and HB. The building was renamed the 122 S. Michigan Avenue building. An article is in AR July 1915. An illustration is in HCCB, p. 18B. An illustration and a description are in OBD 1916, p. 193. PEOPLE'S GAS CO. building 1 was a six-story building, built in 1883 as the Brunswick Hotel, and wrecked in 1910 to make way for the present building. Burnham & Root were the architects. A photograph is in CHC, p. 198. Photographs of both buildings are in CIM, pp. 294 and 305. The People's Gas Light & Coke Co. moved to this location on August 7, 1898.

325 S. MARKET STREET building, 1911–(1950 to 1990), formerly known as the Chamberlain building, was 10 stories high, on spread foundations. D. H. Burnham & Co. were the architects. The 311 S. Wacker Drive building includes this site.

TEXTILE building, at the northeast corner of S. Wells and W. Adams Streets, built 1911, is eight stories high. Samuel N. Crowen was the architect. The frontage on S. Wells Street is 40 feet, on W. Adams Street 90 feet. A photograph is in RB November 14, 1964, p. 14. The Textile building was renamed the 180 W. Adams Street building.

South: STANDARD OIL CO. building, at 910 S. Michigan Avenue, on the southwest corner of E. Ninth Street, was originally known as the Karpen building. It was built in 1911 to a height of 13 stories, on rock caissons. Marshall & Fox were the architects. An illustration and a description are in OBD 1929, p. 114. In 1927, Graham, Anderson, Probst & White, architects, added seven stories. A photograph of the building is in AWC and in CIM, p. 443. An illustration and a description of the completed building are in OBD 1929, p. 302. The building was renamed the 910 S. Michigan Avenue building.

South: TRANSPORTATION building, at 608 S. Dearborn Street, on the southwest corner of W. Harrison Street, built in 1911, is 22 stories high, on rock caissons. Fred V. Prather was the architect. A photograph is in CIM, p. 561, and in OBD 1916, p. 144, with a description. Photographs are in AR March 1980, p. 93; WO, p. 14; *All About Old Buildings*, ed. Diane Maddex, 1985, p. 384; TBC, p. 111; and RB November 13, 1954, p. 3. The Transportation building was converted to apartments and renamed the Transportation Apartments; Harry Weese was the architect. It is in the South Loop Printing House Historic District/NR, at 600 S. Dearborn Street.

South: 1132–34 S. WABASH AVENUE building, formerly known as the Ryerson building, built in 1911, is six stories high, on spread foundations. Holabird & Roche were the architects. It is occupied by the Advance Uniform Co., 1132 S. Wabash Avenue. A photograph is in HRHR Vol. 1.

South: *DWIGHT building,* NR, HABS, CLSI, at 626–36 S. Clark Street, built in 1911, is 10 stories high, of reinforced concrete construction, with a floor-load capacity of 250 pounds per square foot, on rock caissons. Schmidt, Garden & Martin were the architects. The cost of the Dwight building was 15 cents per cubic foot. Photographs are in CFB and in CSA, fig. 154. It was renamed the 626 S. Clark Street building, in the South Loop Printing House Historic District/NR.

South: BLACKSTONE THEATER building, at 60 E. Balbo Street, built in 1911, is five stories high, on spread foundations. Marshall & Fox were the architects. A photograph is in CAA; CYT, p. 89; CIM, p. 434; CLSI; STL, p. 75; CGY, p. 130; and HB. See also the adjoining Blackstone Hotel. The theater is now De Paul University's Merlo Reskin Theater.

West: CHICAGO & NORTHWESTERN RAILWAY station, 1911–1984, was at 500 W. Madison Street, at N. Canal, W. Madison, and N. Clinton Streets. Frost & Granger were the architects and E. C. & R. M. Shankland the engineers. A description of the pneumatic caissons to rock is in ER May 8, 1909. Descriptions, illustrations, and plans of the building are in ER August 15, 1908, and June 18, 1910. A photograph is in CAA; CCP, p. 115; CIM, p. 438; and CH10, p. 254. A drawing is in IA-C May 1988, p. 71. Guastavino tile vaulting was used extensively. A monograph published by the Chicago & North Western Railway Company in 1910 contains five foldout plans. For an illustration of the preceding Wells Street Depot, built in 1881 on the southwest corner of N. Wells and W. Kinzie Streets, at the Chicago River, see HCA Vol. 3, p. 199. W. W. Boyington was the architect. Elevations and a plan are in AA February 19, 1881. A photograph is in RMNP and in CIM, p. 437. Also in RMNP; CIM, p. 94; C, p. 164; and CYT, p. 13, is a photograph of the first railroad station in Chicago. This was a one-story frame building of the Galena & Chicago Union railroad, built in 1848 at the southwest corner of W. Kinzie and N. Canal Streets. It was replaced in 1852 by a "pretentious" two-story brick station, the Wells Street Depot, a photograph of which is in CIM, p. 95. Two stories were added to this depot in 1863, which was burned in the great fire of 1871. A photograph is in CYT, p. 12. After the fire the Kinzie Street Depot, just north of W. Kinzie Street along the west bank of the Chicago River, was used until the Wells Street Depot of 1881 was occupied, when it was razed. An illustration of the Kinzie Street Depot is in CYT, p. 13, and in CIM, p. 96. A history of the stations occupied by this railroad and its predecessors is in WSE 1937, p. 127, with photographs. See also RMNV, V22. A photograph of the 1848 building is in LC, p. 48. The Gault House (hotel) and the Grand Central Hotel previously occupied this site. The Northwestern Atrium Center occupies the site of the headhouse; rail service continues.

West: BURLINGTON NORTHERN building, built in 1911 at 547 W. Jackson Parkway, at the southwest corner of S. Clinton Street, is six stories high.

Marshall & Fox were the architects. A photograph is in RB May 20, 1978, p. 4.

North: AMERICAN MEDICAL ASSOCIATION building, 1911/1922– (1950 to 1990), at 535 N. Dearborn Street, was a six-story building with one and two basements, on wood piles and hardpan caissons. Holabird & Roche were the architects. In 1936 two stories were added by Holabird & Root, architects. A photograph of the completed building is in ISA 1938–39, p. 396. The limestone facing was added in 1936. In 1941 Holabird & Root were architects for a three-story wing on W. Grand Avenue to house printing facilities. In 1949 five additional stories were added to this wing, with Holabird & Root & Burgee the architects; a photograph is in CN August 31, 1948. The total frontage was 100 feet on Dearborn Street and about 242 feet on Grand Avenue. Photographs are in HRHR Vol. 1, p. 338, Vol. 2, p. 222, and Vol. 3, p. 273.

North: WINSTON building, 1911–(1950 to 1990), at 341–49 E. Ohio Street, was six stories high, of reinforced concrete construction, with a frontage of 100 feet and a depth of 109 feet. Another Winston building, at the southwest corner of N. McClurg Court and E. Ohio Street, adjoining the 1911 building, was built in 1916. It was seven stories high, of flat-slab construction, with concrete exterior walls. This building had a frontage of 250 feet on E. Ohio Street, 218 feet on N. McClurg Court, and 50 feet on E. Grand Avenue. The two buildings were connected with a bridge across a private alley. A photograph is in the *Tribune*, October 27, 1946, where it was reported that the two buildings would be known as the Chicago Scientific Center. Paul Gerhardt Sr. was the architect. The Winston buildings were renamed the Vesicol Chemical building. Photographs are in HB and in RB November 14, 1964, p. 14. The site is vacant.

North: ST. CLAIR building, 1911–(1950 to 1990), at the northwest corner of N. St. Clair and E. Erie Streets, was six stories high. Samuel N. Crowen was the architect. The frontage on N. St. Clair Street was 109 feet and that on E. Erie Street was 143 feet 9 inches. Photographs are in HB and RB Annual Review, January 28, 1967, p. 118. The 676 St. Clair building occupies this site.

BELL building of the Illinois Bell Telephone Co., at 212–26 W. Washington Street, built in 1912, is 20 stories high, on rock caissons. Holabird & Roche were the architects and Purdy & Henderson the engineers. The cost of the Bell building, including architects' fees, was 33.91 cents per cubic foot (EAR). A photograph is in AR April 1912. The Forbes building formerly occupied the west 80 feet of this site.

OTIS building, 1912–1987, at 10 S. LaSalle Street, was designed by Holabird & Roche, architects. The building was 16 stories high, with two basements,

on rock caissons. The cost of the Otis building, including architects' fees, was 47.80 cents per cubic foot (EAR). A photograph and a floor plan are in AR April 1912, and a photograph is in CIM, p. 577. An illustration and a brief description are in OBD 1916, p. 188. The frontage on S. LaSalle Street is 189 feet and on W. Madison Street 110 feet. The first four stories of the facade were incorporated in the design of the 1989 Manufacturers Hanover Plaza building now occupying this site. Photos are in HRHR Vol. 1, p. 352; STL, p. 85; and RB July 11, 1964, p. 1.

STEVENS STORE building, at 17 N. State Street and 16–18 N. Wabash Avenue, was built in 1912. The building is 19 stories high, with two basements, on hardpan caissons. D. H. Burnham & Co. were the architects. A photograph and floor plans are in AR July 1915. An illustration and a description are in OBD 1916, p. 228. A photograph of the lower stories is in 1987 COF, p. 37. Photographs are in GAPW, p. 113; CAJZ, p. 148; HB; AWG; and RB June 13, 1964, p. 1. The Stevens Store building was renamed the 17 N. State Street (and 16 N. Wabash Avenue) building. The Enos Slosson building, formerly at 16–18 N. Wabash Avenue, built in 1873, was five stories high, with a frontage of 48 feet and a depth of 150 feet. It is illustrated in LO May 1874, p. 69, with a description on p. 74.

CITY HALL SQUARE building, 1912–(1950 to 1965), known as 139 N. Clark Street building, was 21 stories high, with two basements, on caissons. C. A. Eckstorm was the architect. A photograph is in CIM, p. 581, and an illustration is in OBD 1916, p. 49. This site was occupied in part by the Fowler-Goodell-Walters Block, later known as the Superior Block, 1872–1911, a five-story building for which W. W. Boyington was the architect and which is illustrated in LO 1872, p. 41, and OYF. A drawing is in ADE.

INSURANCE EXCHANGE building, at 175 W. Jackson Street, on the southeast corner of S. Wells Street, was built in 1912. D. H. Burnham & Co. were the architects and Joachim G. Giaver the engineer. The building is 21 stories high, with two basements, on rock caissons. Floor plans and a photograph are in AR July 1915. An illustration is in OBD 1916, p. 109. In 1928 the ANNEX to the south was added by Graham, Anderson, Probst & White, architects. Magnus Gunderson was the engineer. A photograph is in AWG and CIM, p. 443. An illustration and a description of the complete building are in OBD 1929, p. 152. Drawings are in GAPW, pp. 45 and 91, and CH10, p. 95. Buildings previously on this site include Brother Jonathan and Parker.

DOUGLAS building, at 18–22 E. Jackson Street, formerly known as the U.S. Annuity & Life building and originally as the Gibbons building, was built in 1912. It is 16 stories high, on rock caissons. Marshall & Fox were the architects. An illustration and a description are in OBD 1929, p. 342. It is now 20 E. Jackson Boulevard.

NORTH AMERICAN building, 36 S. State Street, at the northwest corner of W. Monroe Street, was built in 1912. Holabird & Roche were the architects. The building is 19 stories high, with three basements, on rock caissons. The cost of the North American building, including architects' fees, was 39.45 cents per cubic foot (EAR). A photograph and floor plans are in AR April 1912, and a photograph is in CIM, p. 554. An illustration and a brief description are in OBD 1929, p. 237. A photograph of the previous six-story building on this corner is in CIM, p. 335. An illustration of the preceding four-story building, occupied by Lyon & Healy, is in HCA Vol. 3, p. 671. A photograph is in HRHR Vol. 2, p. 7. The Royal Palm building previously occupied this site. The office of the Greater State Street Council was here in early 1998. Probable conversion of the building to a Red Roof Inn has been reported.

MONROE building, HABS, at 104 S. Michigan Avenue, on the southwest corner of E. Monroe Street, was built in 1912. Holabird & Roche were the architects and Ritter & Mott the engineers. The building is 16 stories high, on rock caissons. The cost of the Monroe building, including architects' fees, was 38.711 cents per cubic foot (EAR). A photograph, floor plans, and illustrations are in AR April 1912. A photograph is in CAA; SCB; and CIM, p. 545. A photograph and a description are in OBD 1916, p. 170. Photographs are in ACMA, p. 39; STL, p. 76; HRHR Vol. 1, p. 379; and CSLI. See appendix F. The Monroe building succeeded a two-story building on this corner, a photograph of which is in CYT, p. 43.

225 N. WABASH AVENUE building, at the southeast corner of E. South Water Street, formerly known as the D. B. Fisk & Co. building, was built in 1912. It is 13 stories high, on caissons. George L. Harvey was the architect. A photograph of the upper stories is in STL, p. 112, with the Jewelers/Pure Oil/35 E. Wacker Drive building. The lofts were converted and renamed the Oxford House hotel in 1960; Edward Steinborn was the architect.

GOLDBLATT'S STORE building, NR, CLSI, at the northeast corner of S. State and E. Van Buren Streets, formerly known as Rothschild's and the Davis Store, was finished in 1912. Holabird & Roche were the architects. The building is 10 stories high, with three basements, on rock caissons. The cost of the Rothschild building, including architects' fees, was 33.12 cents per cubic foot (EAR). A photograph is in CIM, p. 353; AR April 1912; CPS, p. 58; and HRHR Vol. 1, p. 356. It was converted in 1992 to university usage, city offices, and shops and renamed De Paul Center, 333 S. State Street (and 1 E. Jackson Parkway); Daniel Coffey was the architect. The site was previously occupied by the Rothschild store, 1894–ca. 1910, which was seven stories high; Holabird & Roche were the architects.

14–16 W. LAKE STREET building, 1912–(1950 to 1990), formerly known as the DeVoe & Raynolds building, was six stories high, on rock caissons. Hill &

Woltersdorf were the architects. The building was designed for an additional four stories. Photographs and floor plans are in WA July 1913, and a photograph is in WA April 1917. A photograph is in CAJZ as the DeVoe building.

WESTMINSTER building, 1912–ca. 1980, at 110 S. Dearborn Street, on the southwest corner of W. Monroe Street, was 16 stories high, on rock caissons. A. S. Alschuler was the architect. An illustration and a description are in OBD 1929, p. 356. Photographs are also in HB as 100 S. Dearborn Street, and in RB March 28, 1959, p. 2. The Xerox Centre building includes this site.

GREAT LAKES building, at the southwest corner of N. Wacker Drive and W. Lake Street, built in 1912, is six stories high, on wood pile foundations. Holabird & Roche were the architects. An illustration and a brief description are in OBD 1916, p. 94. The Ullman Block was formerly on the north portion of this site, with a frontage of about 120 feet on N. Wacker Drive (then Market Street, not widened). Photographs are in HRHR Vol. 1, p. 377, and RB April 24, 1992, p. 32. The Great Lakes building was renamed the 180 N. Wacker Drive building and converted ca. 1981 to offices; George Schipporeit as the architect.

EDISON PHONOGRAPH SHOP, CAL, HABS, 1912–1967, at 229 S. Wabash Avenue, was four stories high. It was also known as the Babson Brothers building and, finally, as the Hung Fa Village Restaurant. Purcell, Feick & Elmslie were the architects with George Grant Elmslie the designer. Photographs and drawings are in WA January 1913, p. 28, and January 1915, p. 58, reprinted by the Prairie School Press, 1965. Photographs are in LC, p. 209; CFB; CSA, fig. 145; *Guide to Significant Chicago Architecture of 1872 to 1922,* J. D. Randall 1958, p. 52. This site is used for parking.

TOBEY FURNITURE CO. building, ca. 1912–(1950 to 1970), at 119–23 S. Wabash Avenue, was seven stories high. Samuel N. Crowen was the architect. The Mid-Continental Plaza building includes this site.

South: ROGERS & HALL CO. building, at 124 W. Polk Street, later known as the W. P. Dunn building, was built in 1912. It is eight stories high, with two basements, on spread foundations. A. S. Alschuler was the architect. In 1914 two stories were added. A photograph is in RB Annual Review, January 30, 1960, p. 121. The building was converted and renamed the 124 W. Polk Street Lofts, at the northwest corner of S. Clark Street, in the South Loop Printing House Historic District/NR. The 1989 conversion was by R. E. McBride.

South: RAND McNALLY building, at 538 S. Clark Street, on the northwest corner of W. Harrison Street and extending through to S. LaSalle Street,

was built in 1912. Holabird & Roche were the architects. The building is 10 stories high, with two basements, on piles and rock caissons. The floor loads are 250 pounds per square foot except on the fourth floor, where they are 375. The cost of the Rand McNally building, including architects' fees, was 23.84 cents per cubic foot (EAR). A photograph and floor plans are in AR April 1912. An illustration and a description are in OBD 1916, p. 209. Photographs are in HRHR Vol. 1, p. 354, and APB, p. 126. The building was acquired by the United States by condemnation, after leasing since 1952, and renamed the Federal building, 536 S. Clark Street, in the South Loop Printing House Historic District/NR.

South: RUMELY building, built ca. 1912, at 117 W. Harrison Street, at the southeast corner of S. LaSalle Street, is eight stories high. It was renamed the 601 S. LaSalle Street building, in the South Loop Printing House Historic District/NR.

South: *Marshall FIELD MUSEUM OF NATURAL HISTORY/CHICAGO MUSEUM OF NATURAL HISTORY,* NHL, CHALC, CLSI/premier (Grant Park at E. 14th Street), was completed in 1912 by D. H. Burnham & Co., architects, and Joachim G. Giaver, engineer. The building is three stories high, with two basements, on wood piles. Photographs and floor plans are in AWG, and in AR July 1924. A photograph is in CAA and in CIM, pp. 320 and 482. A description and illustrations are in C, p. 29. Photographs are also in GAPW, pp. 7 and 86, and CH10, p. 190.

South: *THE FRANKLIN building,* at 718–36 S. Dearborn Street, built in 1912, is 13 stories high, on caissons. George C. Nimmons was the architect. Photographs and floor plans are in WA January 1916. The frontage on S. Dearborn and S. Federal Streets is 122 feet 6 inches, and the depth is approximately 62 feet. The lofts were converted to condominiums in 1987 and renamed the New Franklin building, also called the Second Franklin building, at 720 S. Dearborn Street, in the South Loop Printing House Historic District/NR; Lisec & Biederman were the architects. A photograph is in STL, p. 86; CLSI; and CALP.

South: GUNTHER building, at the northwest corner of S. Wabash Avenue and E. Eleventh Street, built in 1912, is eight stories high, on rock caissons. George Beaumont was the architect. A photograph is in *Chicago Tribune,* July 8, 1945; RB February 18, 1961, p. 1; and Annual Review, January 27, 1962, p. 161. The building was renamed the Flomor building, 1018 S. Wabash Avenue, and later Scribcor.

South: POLK-WELLS building, at 801 S. Wells Street, on the southeast corner of W. Polk Street, built in 1912, is 10 stories high, on caissons. D. H. Burnham & Co. were the architects. It was converted in 1990 (R. E. McBride,

architect) and renamed the 801 S. Wells Lofts Apartments in the South Loop Printing House Historic District/NR. A photograph is in RB April 28, 1990, p. 83.

West: 600 W. JACKSON PARKWAY building was built in 1912, eight stories high. It was originally the Otis Elevator Co. building. Daniel H. Burnham was the architect.

North: 180–98 E. CHESTNUT APARTMENT building, 1912–mid-1960s, at the northwest corner of N. Seneca Street, was three stories high, with an English basement, on concrete pile foundations. The piles were rectangular in section, reinforced, and about 15 feet long. They were cast on the site and jetted into place. Schmidt, Garden & Martin were the architects. The John Hancock Center building includes this site.

North: JOHN R. THOMPSON building, at 350 N. Clark Street, on the southwest corner of W. Kinzie Street and extending to W. Carroll Avenue, formerly known as the Commissary building, was built in 1912. It is seven stories high, on pile foundations. A. S. Alschuler was the architect. Also known as the 350 N. Clark Street building, it was converted to offices in 1982; Metz, Train & Younggren were the architects. It is now the Mesirow building. A photograph is in RB March 31, 1984, p. 1. The Uhlich Block formerly occupied this site.

North: 242 E. WALTON PLACE building, 1912–ca. 1970, formerly the Dudley apartment building, was five stories high, on concrete piles. The architect was William Ernest Walker. A photograph, floor plan, and description are in APB, p. 28. The 990 N. Lake Shore Drive condominium building occupies this site.

North: JOHN MOIR TRUST building, at 325 N. Wells Street, built in 1912, is nine stories high, with two basements, on rock caissons. L. G. Hallberg was the architect. It was also known as the Exhibitors and as the 325 N. Wells Street building. The lofts were converted to offices in 1984, with a top-story addition, and renamed the Helene Curtis (hair care products) building; Booth, Hansen were the architects. A partial photograph is in STL, p. 166, with the Merchandise Mart. Photographs are in ABOV, p. 157, and in RB Annual Review, January 1979, p. 129.

North: 1200 N. LAKE SHORE DRIVE apartment building, formerly known as the Stewart Apartments, at the northwest corner of E. Division Street, is 12 stories high. It was built in 1912 by Benjamin H. Marshall, architect. A photograph and a typical floor plan are in BW, p. 42. Photographs are in HRHR Vol. 1, p. 356, GMM, p. 398, and HB. See appendix F. In the Gold Coast Historic District/NR. Holabird & Roche are reported as the architects in HRHR.

North: MEDINAH TEMPLE building, at the northwest corner of E. Ohio Street, at 600 N. Wabash Avenue, built in 1912, is four stories high, on spread foundations and piles. Huehl & Schmid were the architects. A photograph is in CAA and CIM, p. 534. Photographs and floor plans are in WA May 1913. An article is in AR April 1913, p. 339. Photographs are also in AGC, p. 123; HB; CLSI.

North: BOYCE building, at 510 N. Dearborn Street, was built in 1912 by D. H. Burnham & Co., architects. Six stories were added in 1913. The original north building was four stories high on caissons, and the addition to the south is on spread foundations. A photograph is in AR July 1915 and in HB. A partial view is in ABOV, p. 55, scene to the left of the Illinois Bell building. The building is also known as 500 N. Dearborn Street, at the northwest corner of W. Illinois Street.

North: 213–17 E. ILLINOIS STREET building, 1912–(1950 to 1990), was six stories high, of mill construction. C. A. Eckstorm was the architect. This site is vacant.

North: 999 N. LAKE SHORE DRIVE building, built in 1912, is 10 stories high, on pile foundations. Marshall & Fox were the architects. A photograph is in AA July 22, 1914, and in CYT, p. 59. A photograph, floor plan, and description are in APB, pp. 14 and 15. Photographs are in AGC, p. 111; GMM, p. 398; and HB. See appendix F. Ogden T. McClurg, son of A. C. McClurg, pioneered building construction in this north Streeterville area at the time of the extension of N. Lake Shore Drive; this is in the East Lake Shore Drive District/CHALC.

North: FOURTH PRESBYTERIAN CHURCH, NR, CLSI/premier, was built in 1912 at 126 E. Chestnut Street and (866) N. Michigan Avenue. Cram & Goodhue were the architects. Howard Van Doren Shaw was the architect for the 1925 parish house. The parish house and the sanctuary were restored in 1995 by Thomas Beeby, architect, with the McClier Corp. associated. Photographs are in CFB "merit"; AGC, p. 110; CNM, p. xxiii; IA-C May 1987, p. 17; AR September 1914, p. 177; 1987 COF, p. 190; CCS, p. 133; and CIM, p. 474.

1913: Panoramic views of the loop are in CAJZ, p. 366, and in GMM from the roof of the Transportation building (quintuple foldout).

CONWAY building, NR, at 111 W. Washington Street, on the southwest corner of N. Clark Street, was built in 1913. D. H. Burnham & Co. were the architects, with Frederick P. Dinkelberg the designer and Joachim G. Giaver the engineer. The building is 21 stories high, with two basements, on rock caissons. Photographs and floor plans are in AWG and in AR July 1915. A photograph is in CIM, p. 586, and an illustration is in OBD 1916, p. 59. The building was sold in 1944 to the Chicago Title & Trust Co. The company

filled in the interior court to a height of six stories and moved its offices there on November 29, 1947, from its old location at 69 W. Washington Street. The structure was renamed the Chicago Title and Trust building and was later renovated and renamed the Burnham Center; Jack Train was the architect. A drawing is in ADE. Photographs are in WO, p. 34; STL, p. 92; and GAPW, p. 99. The Chicago Opera House Block previously occupied this site.

UTILITIES building, 1913–1994, at 327 S. LaSalle Street, on the northeast corner of W. Van Buren Street, was formerly the Webster building. It was 12 stories high, with two basements, on hardpan caissons, by A. S. Alschuler, architect, and Lieberman & Hein, engineers. An illustration of the 12-story building is in OBD 1929, p. 352. In 1929 five stories were added. A photograph is in CIM, p. 439, and an illustration of the completed building is in OBD 1941–42, p. 427. A photograph is in RB Annual Review, January 28, 1961, p. 115. Also known as the American Union building, the Utilities building was renamed the 327 S. LaSalle Street building. The 1997 Stock Exchange Extension building includes this site. The north 100 feet of this site was occupied previously by the Chicago Open Board of Trade and the south (approximately) 96 feet by the Mendel Block at the corner.

LYTTON building, at 14 E. Jackson Street, on the northeast corner of S. State Street, built in 1913, is 19 stories high, with three basements, on caissons. Marshall & Fox were the architects. A photograph is in CIM, p. 556, and RB March 22, 1975, p. 1. The building was renamed the 14 E. Jackson Parkway building.

MADISON SQUARE building, at 119–23 W. Madison Street, with a frontage of 45 feet, was built on caissons, in 1913, to a height of 16 stories, with two basements, as the Advertising building. It was known later as the Union Fuel building. An illustration is in OBD 1916, p. 17. In 1929 six stories were added by Eric E. Hall, architect. A photograph is in STL with the Roanoke building. The building was refaced and renamed the 123 W. Madison Street building. This site was occupied formerly by Burke's European Hotel, 1873–ca. 1911, five stories high, illustrated in LO April, 1874, p. 53.

GODDARD building, at 27 E. Monroe Street, on the southwest corner of S. Wabash Avenue, built in 1913, is 13 stories and two basements high, on rock caissons. D. H. Burnham & Co. were the architects and Joachim G. Giaver the engineer. The Ely building formerly occupied this site and that of the Palmer House addition to the south. A photograph is in RB November 20, 1948, and HRHR Vol. 2, p. 151 with the Palmer House.

CONSUMERS building, at 220 S. State Street, on the northwest corner of W. Quincy Street, built in 1913, is 21 stories and three basements high, on

rock caissons. Mundie & Jensen were the architects and Lieberman & Hein the engineers. An illustration is in OBD 1929, p. 92. The five-story Gunther building, built in 1875, previously stood on this corner; a photograph of it is in CYT, p. 71, and CIM, p. 331. The late Hyde W. Perce, realtor, said that in the 1890s the building was occupied by a clothing store in the two lower floors and that the three upper floors were divided into single rooms for light housekeeping, renting for from five to ten dollars a month. It was renamed One Quincy Court, 202 S. State Street building. A photograph is in *Chicago Tribune*, February 21, 1996, as 220 S. State Street (auction advert.).

CHICAGO ENGINEERS' CLUB building, demolished after 1950, at 314–16 S. Federal Street, remodeled for its present use in 1913 by George Awsumb, architect, was six stories high. St. Hubert's Grill, established in 1887, occupied the two lower floors (AAC, p. 62). This site is used for parking.

ALFRED DECKER & COHN building, 1913–(1950 to 1990), at 416 S. Franklin Street, on the northwest corner of W. Congress Street, known as the Society Brand building, was 13 stories high, on pile and caisson foundations. Graham, Burnham & Co. were the architects and Joachim G. Giaver the engineer. It was also known as the 416 S. Franklin Street building. Photographs are in CSA, fig. 142; GAPW, p. 94; and HB.

South: PETROLEUM building, at 616–20 S. Michigan Avenue, formerly known as the Dennehy building and the Arcade building, built in 1913, 80 feet square, is 10 stories high, on pile foundations. Zimmerman, Saxe & MacBride were the architects. A photograph is in OBD 1929, p. 28; CTCP, p. 91; and RB April 22, 1972. The building was also known as the Barnheisel building. It was converted and renamed the Spertus College of Judaica, 618 S. Michigan Avenue; Shayman & Salk were the architects.

South: CRANE CO. building, at 836 S. Michigan Avenue, on the northwest corner of E. Ninth Street, built in 1913, is 12 stories high, on rock caissons. Holabird & Roche were the architects, and Henry J. Burt the engineer. A photograph during construction is in SCB. The cost of the Crane building, including architects' fees, was 34.42 cents per cubic foot. It was renamed the 836 S. Michigan Avenue building. Photographs are in HRHR Vol. 2, p. 19, and HB.

South: 701–03 S. LaSALLE STREET building, ca. 1913–(1950 to 1990), formerly known as the Linden building, was seven stories high.

West: BUTLER BROTHERS buildings, at the southeast corner of N. Canal and W. Randolph Streets, were built in 1913, 14 stories high, with two basements, on hardpan caissons. D. H. Burnham & Co. were the architects and Joachim G. Giaver the engineer. In 1920, the eastern building was demolished to make way for the Union Station track improvement, the building at

111 N. Canal Street remaining. Another building, identical with the one wrecked, was built in 1922 at 165 N. Canal Street, across Randolph Street to the north. The latter building was renamed Randolph Place and converted to mixed uses, largely lofts. A photograph of the two first buildings is in AR July 1915. Photographs of the two present buildings are in A November 1927; CAA; CIM, p. 598; AWG; GAPW, pp. 73 and 147; BOC, p. 283; and ABOV, p. 39. The building at 111 N. Canal Street was also known as the John Plain Co. building; it was renamed the River Center building. The building at 165 N. Canal Street, for which Graham, Anderson, Probst & White were the architects, was also known as the Canal-Randolph building; it was renamed the One Northwestern Center building; Perkins & Will converted it to offices. The Woolensack building was previously here.

North: 936 N. LAKE SHORE DRIVE building, 1913–ca. 1970, at the northwest corner of E. Walton Street, was 10 stories high, on concrete piles. William Ernest Walker was the architect. A photograph is in WA April 1917. A photograph and a typical floor plan are in BW, p. 30, and APB, pp. 12 and 13. Photographs are in GMM, p. 398, and RB January 27, 1968, p. 117. The 990 N. Lake Shore Drive building includes this site.

North: *REID, MURDOCH (foods) building*, NR, CAL, HABS, CLSI/premier (fig. 35), at 320 N. Clark Street, extending to (321) N. LaSalle Street on the north bank of the Chicago River, built in 1913, is seven stories high, plus a three-story tower and two basements, on piles. George C. Nimmons was the architect. One bay was removed when N. LaSalle Street was widened. The frontage on the Chicago River is 320 feet. The depth of the building is 188.3 feet. Photographs and floor plans are in WA January 1916; photographs are in CAA; CIM, p. 439; CFB; CSA, fig. 144; RB October 3, 1953, p. 1; and HB. Known also as the Monarch Foods building, it was renamed the City of Chicago Central Office building in 1955. The Commission on Chicago Landmarks office is here.

North: BOYLSTON building, at 116–22 W. Illinois Street, built in 1913, is seven stories high. Huehl & Schmid were the architects.

North: REMIEN & KUHNERT building, at 57–63 W. Grand Avenue, built in 1913, is eight stories high, of steel-frame fireproof construction, on wood piles. Huehl & Schmid were the architects. It was renamed the 57 W. Grand Avenue building.

North: 1550 N. STATE PARKWAY building, at the southwest corner of W. North Avenue, built in 1913, is 12 stories high. Benjamin H. Marshall was the architect. A photograph and a typical floor plan are in BW, p. 22, and APB. Photographs are in STL, p. 97; AGC, p. 165; CGY, p. 112; AA August 26, 1914; TBC, p. 165; and RB April 24, 1982, p. 16.

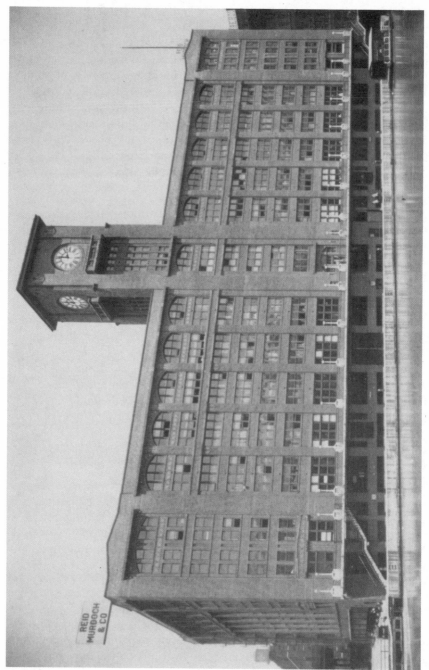

Fig. 35. Reid, Murdoch and Company, 1913

North: 215 W. SUPERIOR STREET building, built in 1913, is seven stories high. The lofts were converted to offices in 1982; Irving Addis, architect. A photograph is in RB April 30, 1983, p. 55.

109 N. DEARBORN STREET building, 1914–(1950 to 1990), formerly known as the New Brede building, the Lutheran building, the Daniel Hayes building, and the Beak Annex, with a frontage of 56 feet, was 13 stories high, on wood piles and caissons. George S. Kingsley was the architect. An illustration is in OBD 1916, p. 35. A photograph is in RB January 28, 1978, p. 109. This "Block 37" site is vacant.

WELLS-QUINCY building, 1914–1959, at the southeast corner of S. Wells and W. Quincy Streets, formerly known as the Lombard Hotel, was 11 stories high, on pile foundations except for hardpan caissons in the rear. D. H. Burnham & Co. were the architects and Morey, Newgard & Co. the engineers. A Federal Reserve Bank addition includes this site.

166 W. JACKSON STREET building, 1914/1922–(1950 to 1990), was 15 stories high, on caissons. C. A. Eckstorm was the architect. A photograph is in OBD 1941–42, p. 293. A Federal Reserve Bank addition includes this site.

MICHIGAN BOULEVARD building, at 30 N. Michigan Avenue, on the southwest corner of E. Washington Street, formerly known as the People's Trust and Savings Bank building, 15 stories high, was built in 1914. Five stories were added in 1923. It is 20 stories high, with two basements, on rock caissons. Jarvis Hunt was the architect. A photograph is in CIM, pp. 307; STL, p. 138; CRC; and HB. A photograph and a description of the original building are in OBD 1916, p. 162. The building was renamed the 30 N. Michigan Avenue building. See appendix F. An illustration and a description are in OBD 1929.

RANDOLPH-WELLS building was originally erected as an office building for the State of Illinois and formerly known as the City State Bank building, later as the People's Life building. It was built in 1914 at the southwest corner of N. Wells and W. Randolph Streets. It was 17 stories high, on caissons. Dibelka & Flaks were the architects and Morey, Newgard & Co. the engineers. An illustration is in OBD 1916, p. 197. The Albany Hotel was formerly on this corner. It is illustrated in *Hotel Monthly*, June 1912. In 1928 an addition, 23 stories high, by Burnham Brothers, architects, was made to the south, at 120–28 N. Wells Street, on the site occupied formerly by the Greenebaum building. The Greenebaum, four stories high and 80 feet square, is illustrated and described in LO July 1872, p. 121, and OYF. Burling & Adler were the architects. A photograph of the completed Randolph-Wells building is in OBD 1941–42, p. 377. It was renamed Phillips College of Chicago, 205 W. Randolph Street. Before the great fire of 1871 the corner

was occupied by the Metropolitan Hotel, of which W. W. Boyington was architect.

208 S. LaSALLE STREET building, built in 1914, formerly known as the Continental National Bank building, is 20 stories high, with two basements, on rock caissons. D. H. Burnham & Co. were the architects and Joachim G. Giaver the engineer. Photographs and floor plans of this building are in AR July 1915; a photograph is in CIM; and an illustration is in OBD 1916, p. 55. Photographs are in GCA, p. 48; GAPW, p. 96; BOC, p. 292; and HB. The building was also known as the City Bank building. The Sheppard and Monroe buildings previously occupied this site.

FORT DEARBORN HOTEL, NR, at 117 W. Van Buren Street, on the southeast corner of S. LaSalle Street, was built in 1914. Holabird & Roche were the architects and Henry J. Burt the engineer. The building is 17 stories high, with two basements, on caissons. It is illustrated in SCB, which contains floor plans, steel framing plans, cross sections, elevations, and a description of the engineering design. The cost of the Fort Dearborn Hotel building, including architects' fees, was 45.60 cents per cubic foot (EAR). Photographs are in STL, p. 89, and HRHR Vol. 2, p. 20. The hotel building was converted to offices in 1985 and renamed the Traders building, 401 S. LaSalle Street: Booth, Hansen were the architects. The Memory office building, 1884–1913, seven stories high, was formerly on this site. John M. Van Osdel was the architect.

South: EMPIRE PAPER building, at 725 S. Wells Street, built in 1914, is eight stories high, on caissons. Marshall & Fox were the architects. The 725 S. Wells Street building is in the South Loop Printing House Historic District/NR.

North: WESTERN NEWS building, at 21–29 E. Hubbard Street, on the southwest corner of N. Wabash Avenue, was built in 1914, of mill construction, seven stories high. Speyer & Speyer were the architects. In 1926 an addition was built at 17–19 E. Hubbard Street, of reinforced concrete construction, to the same height and by the same architects. It was also known as the Great Western News building. The lofts were converted to offices and renamed the 420 N. Wabash Plaza building in 1984; Pappageorge & Haymes were the architects. A photograph is in RB April 30, 1983, p. 4. It has been reported that the building was built in 1906.

North: E. H. SARGENT & CO. building, at 165 E. Superior Street, on the southwest corner of N. St. Clair Street, built in 1914, is six stories high. The frontage on E. Superior Street is 150 feet, and on N. St. Clair Street, 109 feet. It was renamed the Archdiocese of Chicago, 155 E. Superior Street building. Photographs are in HB, and in RB January 12, 1963, p. 5, and August 1, 1964, p. 1.

1914 to 1918: World War I slowed new construction activity.

CENTURY building, at 202 S. State Street, on the southwest corner of W. Adams Street, formerly known as the Buck & Rayner building, built in 1915, is 16 stories high, with two basements, on rock caissons. Holabird & Roche were the architects and Henry J. Burt the engineer. A photograph is in CIM, p. 557, The frontage on S. State Street is 42.5 feet and on W. Adams Street, 101 feet. Photographs are also in HRHR Vol. 2, p. 32; ADE; and RB Annual Review, January 31, 1976, p. 113. The Century building was renamed the 202 S. State Street building.

NORMAN building, 1915–(1950 to 1990), at 106–10 W. Lake Street, was eight stories high, on spread foundations. Ottenheimer, Stern & Reichert were the architects. The frontage is 40.2 feet and the depth is 90 feet. The 203 N. LaSalle Street building includes this site.

GARLAND building, at 58 E. Washington Street, on the northeast corner of N. Wabash Avenue, with a frontage of 163 feet on the former and 97 feet on the latter, was built in 1915, with an addition in 1925. It is 21 stories high, on rock caissons. C. A. Eckstorm was the architect. An illustration is in OBD 1916, p. 91, and a photograph is in ADE. The Garland building was renamed the 111 N. Wabash Avenue building. The Garland Block, a six-story building, 80 feet by 140 feet, formerly occupied a portion of this site; it is illustrated in CAC, p. 219.

LEMOYNE building, at the southwest corner of N. Wabash Avenue and E. Lake Street, built in 1915, is eight stories high. Mundie & Jensen were the architects. Photographs are in CSA, fig. 143; FC, p. 37; HB; and RB September 14, 1963, p. 1. Originally a mixed-use building housing a hotel, shops, parking, and offices, it was renamed the 180 N. Wabash Avenue office building. The Grocers Block previously occupied this site.

South: *YMCA HOTEL*, NR, at 826 S. Wabash Avenue, built in 1915, is 19 stories high, on rock caissons. Robert C. Berlin was the architect, and Randall & Warner were the engineers. The cost of the structural steel frame was forty-five dollars per ton, erected and painted. The south portion, an addition of the same height, was made in 1926 by Berlin & Swern, architects. An illustration of the completed building is in ISA 1926, p. 328. A photograph is in AGC, p. 144. James Gamble Rogers was the consulting architect. The building was converted to mixed uses and an eight-story addition was made in 1988. It was renamed the Burnham Park Plaza building, 40 E. 9th Street, at the northwest corner of S. Wabash Avenue; Schroeder, Murchie, Laya were the architects.

North: 942 N. LAKE SHORE DRIVE, 1915–ca. 1970, was 10 stories high, on concrete piles. William Ernest Walker was the architect. A photograph is in WA April 1917. A photograph, floor plan, and description are in APB, pp. 18

and 19. A photograph is in GMM, p. 398. The 990 N. Lake Shore Drive building includes this site.

North: 199 E. LAKE SHORE DRIVE building, known also as the Breakers building, built in 1915, is 11 stories high, on pile foundations. Benjamin H. Marshall was the architect. A photograph and a typical floor plan are in BW and APB. A photograph is in CYT, p. 59, and CIM, p. 319. See appendix F. The building is in the East Lake Shore Drive District/CHALC.

North: 200 E. DELAWARE PLACE apartment building, 1915–(1950 to 1990), at the northeast corner of N. Seneca Street, was three stories and English basement high, on concrete piles. Chatten & Hammond were the architects. A photograph, floor plan, and description are in APB, pp. 32 and 33. The 1972 200 E. Delaware Place condominium building occupies this site.

North: 730 N. FRANKLIN STREET building, built ca. 1915, at the northwest corner of W. Superior Street, is seven stories high. The lofts were converted to offices in 1983 and renamed the Central Arts building.

140 N. DEARBORN STREET building, 1916–ca. 1962, at the southwest corner of W. Randolph Street, formerly known as the Cunard building, was 14 stories high, on caissons. A. S. Alschuler was the architect. A photograph is in CIM, p. 579, and an illustration is in OBD 1916, p. 66. The Richard J. Daley Center includes this site.

176 W. WASHINGTON STREET building, with a frontage of 40 feet, formerly the Elks Club building, built in 1916, is 15 stories high, on caissons. Ottenheimer, Stern & Reichert were the architects. A photograph is in CIM, p. 575. The building was renamed the "I Am" Temple.

ADAM SCHAFF building, 1916–ca. 1970, at 319–21 S. Wabash Avenue, was six stories high, on piles. George C. Nimmons was the architect. Photographs are in WA April 1917. The CNA Center building includes this site.

PORTER building, at 123–25 N. Wabash Avenue, built in 1916, with a frontage of 48 feet, is six stories high, on spread foundations. Otis & Clark were the architects. Photographs are in WA April 1917 and in HB. The Porter building is occupied by the Eddie Bauer store, 125 N. Wabash Avenue.

LYON & HEALY building, at 243 S. Wabash Avenue, on the northeast corner of E. Jackson Street, built in 1916, is 10 stories high, on hardpan caissons. Marshall & Fox were the architects and Lieberman & Hein the engineers. An illustration and a description are in OBD 1929, p. 174. Photographs are in CIM, p. 563, and RB August 8, 1964, p. 1. The building was renamed the De Paul University Administrative Center, 243 S. Wabash Avenue. The Wellington Hotel previously occupied this site.

SPALDING building, at 211–17 S. State Street, built in 1916, was five stories high. Three stories were added in 1926. It was incorporated with the 1949 Woolworth store building.

North: CENTRAL COLD STORAGE WAREHOUSE, 1916–(1950 to 1990), at 350 N. Dearborn Street, on the southwest corner of W. Kinzie Street, was 14 stories high, on caissons. B. K. Gibson was the architect. The Hotel Nikko occupies a portion of this site.

North: PELOUZE building, at 218–30 E. Ohio Street, built in 1916, is seven stories high, on spread foundations. A. S. Alschuler was the architect. An illustration of the four-story Pelouze building, at 232–42 E. Ohio Street, is in HCCB, p. 191B. Building no. 218–30 was renamed the 230 E. Ohio Street building; no. 232–242 was renamed the 232 E. Ohio Street building. Photographs are in RB April 27, 1985, p. 30; AR February 1910, p. 197; and IA November 1908, p. 66.

North: 200 E. PEARSON STREET APARTMENTS, at the northeast corner of N. Seneca Street, built in 1916, is six stories high, on concrete piles. Robert S. De Golyer was the architect. A photograph, floor plan, and description are in APB, pp. 68 and 69. Ludwig Mies van der Rohe lived here.

North: 217–23 E. DELAWARE PLACE building, built in 1916, is six stories high, of reinforced concrete construction, on concrete piles. The frontage is 100 feet.

North: 191 E. WALTON PLACE building, 1916–(1950 to 1990), at the southwest corner of N. Mies van der Rohe Drive, was seven stories high, on concrete piles. Howard Van Doren Shaw was the architect. A photograph, floor plan, and description are in APB, pp. 26 and 27.

North: *MUNICIPAL PIER/NAVY PIER*, NR, CAL, was built in 1916 at 600 E. Grand Avenue, 200 Streeter Drive, projecting about 2,500 feet into the lake; it is about 400 feet wide. Charles S. Frost was the architect and Edward C. Shankland the engineer. Portions of the surface structure have been demolished. Various occupancies included warehouses and ship docking facilities and a University of Illinois branch facility. Revitalization and new surface structures of mixed uses were constructed in 1995: Benjamin Thompson, architect, with VOA, associated, and Rubinos, Mesia the engineers. Articles are in ARCH March 1977, p. 107, and March 1992. Photographs are in COF; CIM, p. 486; PGC; ABOV, p. 19; SEA, p. 12; LC, p. 87; and *Navy Pier: A Chicago Landmark*, Douglas Bukowski, 1996.

STATE-LAKE building, at 190 N. State Street, on the southwest corner of W. Lake Street, was built in 1917. Rapp & Rapp were the architects and Lieberman & Hein the engineers. The building is 12 stories high, on hardpan

caissons. The lower stories are of steel frame construction and the six upper stories are of reinforced concrete. The theater had 2,800 seats. Photographs and illustrations are in A for November 1927. An illustration is in OBD 1929, p. 310. The frontage on N. State Street is 180.8 feet and on W. Lake Street, 160.3 feet. The theater was converted to broadcasting facilities, and it was renamed the ABC/WLS building. The Burton Estate building previously occupied this site.

WOODS building, 1917–1989, at 50–56 W. Randolph Street, on the northwest corner of N. Dearborn Street, formerly known as Woods Theater, was 10 stories high, on wood piles. Marshall & Fox were the architects. A photograph is in OBD 1941–42, p. 440; CIM, p. 587; and HDM, p. 40. The Borden Block formerly occupied the south 80 feet of this site; the Athenaeum building was on the north 100 feet. A photograph during demolition is in WO, p. 43. The site is used for parking.

FRANKLIN EXCHANGE building of the Illinois Bell Telephone Co., at 311–27 W. Washington Street, built in 1917, 11 stories and two basements high, is on rock caissons. Holabird & Roche were the architects and Henry J. Burt the engineer. In 1930 seven stories were added by Holabird & Root, architects, and Frank E. Brown, engineer. A photograph is in HRHR Vol. 2, p. 80.

DISTRIBUTORS building, 1917–(1950 to 1990), at the southwest corner of N. Clark Street and W. Wacker Drive, was eight stories high, of steel frame construction with reinforced concrete floors, on caissons. Huehl, Schmid & Holmes were the architects. A photograph is in STL, p. 94, showing a scene a block east of the LaSalle-Wacker building. The site is used for parking. The Horatio G. Loomis Block, five stories high, was located on this corner prior to the great fire of 1871; a view is in CYT, p. 24.

South: PETERSON building, at 523 S. Plymouth Court, built in 1917, is 11 stories high of reinforced concrete construction, on rock caissons. Schmidt, Garden & Martin were the architects. The building cost 27 cents per cubic foot. It is in the South Loop Printing House Historic District/NR.

North: JOHN SEXTON building, at 500 N. Orleans Street, on the northwest corner of W. Illinois Street, is six stories high. The west portion is of mill construction and was built in 1917; the east portion, on the corner, is of reinforced concrete construction, built in 1929, and is designed for additional stories. Alfred S. Alschuler was the architect. Photographs are in AGC, p. 134, and RB January 27, 1968, p. 1.

North: 60–70 E. SCOTT STREET building, HABS, at the northwest corner of N. Stone Street, was built in 1917 and is nine stories high. Fugard & Knapp were the architects and Lieberman & Hein the engineers. A photograph and

a typical floor plan are in BW, p. 17. Photographs are in RB Annual Review, January 31, 1970, p. 124, and Annual Review, January 26, 1974, p. 132. These two buildings are in the Gold Coast Historic District/NR.

North: COMMERCE MART WAREHOUSE, 1917–(1950 to 1990), at 251–315 E. Grand Avenue, was seven stories high, of mill construction. C. A. Eckstorm was the architect.

North: 6–12 E. SCOTT STREET building, at the northeast corner of N. State Street, built in 1918, is seven stories high. William Ernest Walker was the architect. A photograph and a typical floor plan are in BW, p. 21, and APB, pp. 50 and 51. The building is in the Gold Coast Historic District/NR.

West: PENNSYLVANIA FREIGHT TERMINAL building, 1918–(1950 to 1990), was at 323 W. Polk Street, extending through to W. Taylor Street. The design of the building was prepared by the engineers of the Pennsylvania Lines and turned over to the architects, Price and McLanahan, who designed the exterior. The building, 420 feet by 750 feet, was four stories high, with a tower 50 feet square extending 180 feet above street level. The tracks were in the basement at main track level. A partial sub-basement housed the heating and other mechanical equipment. The construction was steel framing with reinforced concrete floors, carried on 40-foot wood piles. The first floor was designed for a 300-pound live load, the second floor for a 250-pound, and the third and fourth floors for a 200-pound live load. Track, steel framing, and foundation plans, with details, a description, and construction photographs, are in EN January 25, 1917. A description, track layouts, floor plans, cross sections, and exterior photographs are in *Transactions of the American Society of Civil Engineers* for 1924, p. 861. A photograph is in CH10.

North: *257 E. DELAWARE PLACE apartment building*, NR, completed in 1918, is 10 stories high, of reinforced concrete construction, on concrete pile foundations. John A. Nyden was the architect. A photograph and a typical floor plan are in BW, p. 58, and APB, pp. 38 and 39. Photographs are in HB and in RB April 7, 1979, p. 1. The apartment building is now condominiums.

North: 229 E. LAKE SHORE DRIVE, built in 1918, known also as the Shoreland building, is 12 stories high, on concrete piles. Fugard & Knapp were the architects and Lieberman & Hein the engineers. A photograph and a typical floor plan are in BW, p. 39. A photograph is in CYT, p. 59. The building is in the East Lake Shore Drive District/CHALC. See appendix F.

North: UNION SPECIAL MACHINE CO. building, at 400 N. Franklin Street, on the northwest corner of W. Kinzie Street, built in 1918, is six stories high, on pile foundations. George C. Nimmons was the architect. It

was renamed the 400 N. Franklin Street building. The lofts were converted to offices and shops in 1987; Jack Train, architect. A photograph is in *Chicago Industrial Guide*, Public Works Historical Society, 1991, p. 37.

WESTERN UNION TELEGRAPH COMPANY building, at 427 S. LaSalle Street, was built in 1919, seven stories high with provision for an addition of six stories. The building is supported on piles and caissons. Graham, Anderson, Probst & White were the architects. Photographs of the building are in AWS and GAPW, p. 71.

HOTEL LaSALLE GARAGE was built in 1919 at 217–219 W. Washington Street. The address is now 217 W. Washington Street. It was also known as the Washington Warehouse. It is five stories high. Holabird & Roche were the architects for the original building and a 1923 addition. A photograph is in HRHR Vol. 2, p. 101.

North: BORG building, at 451 E. Ohio Street, built in 1919, is seven stories high, of mill construction, on pile foundations. The Borg building at the southwest corner of N. Lake Shore Drive and E. Ohio Street, known also as the Lake Shore–Ohio building, built in 1918, adjoining the building named above, is seven stories high, of mill construction, on pile foundations. Samuel N. Crowen was the architect. It was also known as Columbia College. It was renamed the 540 Lake Shore Drive Apartments. It was converted, together with the Lake Shore–Ohio building, in 1983; Booth, Hansen were the architects.

North: AMBASSADOR WEST building, 1300 N. State Parkway, at the northwest corner of N. State and W. Goethe Streets, formerly known as the Ambassador Hotel, built in 1919, is 12 stories high, on concrete piles. Schmidt, Garden & Martin were the architects. A photograph is in CIM, p. 530. The building was renamed the Radisson Plaza Ambassador West Hotel. It is in the Gold Coast Historic District/NR.

North: 500–512 W. HURON STREET building was built in 1919. It was renamed the Stiffel (Lamp Co.) building. A photograph is in *Chicago Industrial Guide*, Public Works Historical Society, 1991, p. 36.

North: 220 E. WALTON PLACE, built in 1919, is 11 stories high, on concrete piles. Fugard & Knapp and Ralph C. Harris were associated as architects, and Lieberman & Hein were the engineers. A photograph and a typical floor plan are in BW, p. 26, and a photograph is in ISA 1921, p. 272, and HB. The building was renamed the Two-Twenty Walton Condominium building.

WATERMAN building, at 127–29 S. State Street, built in 1920, is seven stories high, on hardpan caissons. Holabird & Roche were the architects and Henry J. Burt the engineer. A drawing is in HRHR Vol. 2, p. 160.

Fig. 36. Drake Hotel, 1920

HENRY CHANNON building, 1920–mid-1980s, at the southeast corner of N. Wacker Drive and W. Randolph Street, was seven stories high. Alfred S. Alschuler was the architect. A photograph is in ISA 1921, p. 122, and *Chicago Daily News,* July 15, 1949. The Channon building was also known as the Gunthorp-Warren building, 149 N. Wacker Drive. The 123 N. Wacker Drive building occupies this site.

RIALTO THEATER, 1920–1991, at 336 S. State Street, was four stories high, on wood pile foundations. Marshall & Fox were the architects. This site is occupied by the (interim) Pritzker Park.

JOHN CRERAR LIBRARY building, 1920–1981, at 86 E. Randolph Street, on the northwest corner of N. Michigan Avenue, was 16 stories high, on rock caissons. Holabird & Roche were the architects and Henry J. Burt the engineer. A photograph is in ISA 1926, p. 486; *Chicago Daily News,* March 29, 1947, with other Chicago libraries, old and new; CNM, p. 30; HRHR Vol. 2, p. 36; 1987 COF, p. 23; IA-C No. 5, September 1982, p. 38; RB Annual Review, January 27, 1962, p. 109. The library collections were moved to a new building at the University of Chicago campus in 1963. The Dearborn building previously occupied this site. The Stone Container building occupies this site.

North: 222 E. WALTON PLACE, built in 1920, is 12 stories high, on concrete piles. Fugard & Knapp were the architects and Lieberman & Hein the engineers.

North: *THE DRAKE HOTEL,* NR (fig. 36), 140 E. Walton Place, in the East Lake Shore Drive District/CHALC, at the southeast corner of N. Michigan Avenue and E. Lake Shore Drive, was built in 1920. It is 13 stories high, on pile foundations. Marshall & Fox were the architects. A photograph is in CIM, p. 447; CYT, p. 59; ISA 1921, p. 90; PGC, p. 35; CNM, p. 118; CIM, p. 319; STL, p. 96, in a general view, and p. 36. See appendix F. An article is in *Chicago Architectural Journal,* No. 2, 1982.

North: TRIBUNE PLANT building, at 430–38 N. St. Clair Street, on the southwest corner of E. Illinois Street, at the rear of the Tribune Tower, was built in 1920. It is five stories high, on wood pile foundations. Jarvis Hunt was the architect. Photographs are in CNM, p. 65; ABOV, p. 30; and CAJZ, p. 305.

Period V: From 1921 to 1949

In the latter part of the preceding period, World War I had slowed down building construction. With the close of the war, the increasing demand and a shortage of materials brought a swift increase in building costs, which in 1920 reached a peak of approximately double the costs preceding the war. A "buyers' strike" brought a quick recession in costs, and building construction increased. For a period of some six years Chicago enjoyed another building boom, but this was cut short by the financial crash in 1929 and the depression of the 1930s.

Building costs and permits reached their nadir in 1932–33. Although the total amount of building construction in Chicago during the five-year period 1932–36 averaged less than 3 percent of the average for the six-year period 1923–28, the cost of building decreased only an average of about 15 percent.

The defeatist attitude of the 1930s is reflected in an address given in October 21, 1940, by J. Soule Waterfield before the Chicago Building Congress, entitled "Should We Give the Loop Back to the Indians?" The following quotations from this address are of interest:

> Seventy per cent of the properties, by area, in the district north of Van Buren street and east of Wells street are owner-occupied or capable of earning at least three percent net, after taxes and allowing at least one percent depreciation of the Assessor's full valuation of land and buildings. . . . Sixty percent of the properties in the entire area of the Central Business District north of Roosevelt road and east and south of the Chicago river are owner-occupied or capable of earning at least three percent net. . . . In the entire Central Business District [supra] . . . 42.41% of the area is either used for parking lots or improved with buildings which were built before the elevated loop was built [ca. 1898], and during the time of horse and cable cars and before the advent of the automobile.

Very few new buildings were built in the central business district in the 1930s and 1940s. The Century of Progress, 1933–34, while one of the most successful of world's fairs, did not turn out to be the stimulant to building construction that the fair of 1893 had proved.

World War II was followed by another rapid rise in building costs.

CHICAGO THEATER, NR, CAL, at 175 N. State Street, built in 1921, is seven stories high, of steel frame construction, on rock caissons. Rapp & Rapp were the architects and Lieberman & Hein the engineers. There are 3,900 seats. A photograph is in CIM, p. 436, and CYT, p. 92. Photographs are also in PGC, p. 52; AF June 1925, plate 75; and in *American Picture Palaces* David Naylor, 1991, p. 46. The theater was restored and connected with the Loop

End/Page Brothers building in 1987 to create the Chicago Theater Center; Daniel P. Coffey was the architect and Don Belford the engineer. An article is in ARCH May 1988, p. 106.

ROOSEVELT THEATER building, 1921–ca. 1990, at 110 N. State Street, was four stories high, on spread foundations. Rapp & Rapp were the architects. A photograph is in CIM, p. 436. Drawings are in AF June 1925, p. 360, and in ADE. This "Block 37" site is vacant.

UNITED ARTISTS THEATER building, 1921–ca. 1990, formerly known as the Apollo Theater, at 31–45 W. Randolph Street, on the southeast corner of N. Dearborn Street, was four stories high, on spread foundations. Holabird & Roche were the architects and Henry J. Burt the engineer. A photograph is in CIM, p. 434. A photograph is also in HRHR Vol. 2, p. 167. This "Block 37" site is vacant. The McCormick Block 2 building previously occupied this site.

KELLEY building, 1921–ca. 1950, at 460–68 S. State Street, was eight stories high, on caisson foundations. George C. Nimmons & Co. were the architects and Latimer & Dunlap the engineers. This building was condemned and removed by the Department of Subways and Superhighways. The Harold Washington Library Center includes this site.

South: VITAGRAPH building, 1921–(1950 to 1990), at 839–43 S. Wabash Avenue, was three stories high. The frontage is 41.5 feet and the depth 101.7 feet. This building was built for the storage of films, under a then new ordinance, at a cost of $101,549, or 74.06 cents per cubic foot, unusually high for that time. Holabird & Roche were the architects. A drawing is in HRHR Vol. 2, p. 185.

South: 831–33 S. WABASH AVENUE building, 1921–(1950 to 1990), formerly known as the Scown Film building, was six stories high, on spread foundations.

1921: The construction of the Michigan Avenue bridge was the catalyst for extensive construction to the north of the Chicago River. A photograph is in CCNT, p. 52. A panoramic scene of North Michigan Avenue and Streeterville in 1922 is in an RB "Magnificent Mile" article, December 1, 1951, p. 47.

North: WRIGLEY building, CLSI/premier, at 400 N. Michigan Avenue, was built in two sections. Graham, Anderson, Probst & White were the architects, with Charles Beersman the designer and William Braeger the engineer. The south building, at the southwest corner of E. North Water Street, was built in 1921, 17 stories high plus an 11-story tower, 398 feet high. The north building, at 422–28 N. Michigan Avenue, on the southwest corner of E. Hubbard Street, was built in 1924, 19 stories high. Both buildings are

supported on rock caissons. Photographs are in AF October 1921; CAA; CYT, p. 52; CIM, p. 312; ISA 1924, p. 120; HSM; CFB; CANY, p. 61; COF; AUS, p. 167; AF December 1973, p. 49; STL, p. 98; CNM, p. 33; IA-C Vol. 26, No. 5, 1982 cover, July 1988, p. 7 (advert., shown at night), and June 1995; GAPW, pp. 52 and 123; WACH, p. 46; CRC, pp. 59 and 64. Photographs and floor plans are in AWG and in AF October 1921. An illustration and a description of the completed buildings are in OBD 1929, p. 362. The Samuel Bliss building, at 117–21 E. Hubbard Street, on the southwest corner of N. Michigan Avenue, formerly occupied a portion of this site. An illustration is in CAC, p. 199. The Lake House hotel was also on this site.

North: 230 E. WALTON PLACE, at the northwest corner of N. DeWitt Place, built in 1921, is 11 stories high, on concrete piles. Fugard & Knapp were the architects and Lieberman & Hein the engineers. A photograph and a typical floor plan are in BW, p. 66. The building was renamed 232 E. Walton Place. Photographs are in WA December 1921 and in HB.

North: ILLINOIS LIFE building, 1921–1966, at 1208–24 N. Lake Shore Drive, on the southwest corner of E. Scott Street, later known as the United States Appellate Court building, was three stories high. Holabird & Roche were the architects and Henry J. Burt the engineer. Photographs are in HRHR Vol. 2, p. 201, and IA-C No. 5, September 1982, p. 39. The 1212 N. Lake Shore Drive building occupies this site.

North: CASS-SUPERIOR office building, 720 N. Wabash Avenue, at the southwest corner of E. Superior Street, built ca. 1921, is seven stories high. Walter W. Ahlschlager was the architect. A photograph is in ISA 1921, p. 274. A photograph is in RB Annual Review, January 27, 1968, p. 167.

FEDERAL RESERVE BANK building, at 230 S. La Salle Street, on the northwest corner of W. Jackson Street, was completed in 1922. Graham, Anderson, Probst & White were the architects and William Braeger the engineer. The building is 14 stories high with three basements, on rock caissons. An illustration is in ISA 1921, p. 120. Photographs are in AWG; CIM, p. 566; STL, p. 115; and GAPW, p. 130. Naess & Murphy were the architects for a southwest addition in 1957. Holabird & Root were the architects for a northwest addition in 1989. Both of these are 14 stories high. Buildings previously occupying this site include the Royal Insurance, Medinah, Wells-Quincy, 230 S. Wells Street, 1884 Mallers, and Gaff buildings.

10 N. CLARK STREET building, 1922–(1950 to 1980), at 8–16 N. Clark Street, formerly known as the Putnam building, was 16 stories and two basements high, on caissons. Walter W. Ahlschlager was the architect and Lieberman & Hein were the engineers. An illustration and a brief description are in OBD 1929, p. 280. The 20 N. Clark Street building includes this site.

32–34 S. STATE STREET building, built ca. 1922, is seven stories and two basements high.

TELEPHONE SQUARE building of the Illinois Bell Telephone Co., at the southwest corner of N. Franklin and W. Washington Streets, built in 1922, is 13 stories high, on rock caissons. John Archibald Armstrong was the architect, R. H. Maveety the engineer. An illustration is in ISA 1923, p. 484. The Nevada Hotel previously occupied this site.

North: 219 E. LAKE SHORE DRIVE, built in 1922, is 12 stories high, on concrete piles. Fugard & Knapp were architects, Lieberman & Hein the engineers, and Horace Colby Ingram the associate architect. A photograph and a typical floor plan are in BW, p. 11. The building is in the East Lake Shore Drive District/CHALC. See appendix F.

North: 233 E. WALTON PLACE building, at the southwest corner of N. DeWitt Place, built in 1922, is 14 stories high, on concrete piles. Kenneth Franzheim was the architect. A photograph and a typical floor plan are in BW, p. 15. This is now a cooperative apartment building.

North: CHURCHILL APARTMENTS, at the southeast corner of N. State and E. Goethe Streets, built in 1922 (H. L. Stevens & Co., architects), is nine stories high. A photograph and a typical floor plan are in BW, p. 80. An illustration is in ISA 1922, p. 152, and RB Annual Review, January 30, 1960, p. 117. The apartment building was renamed the Churchill Hotel, 1255 N. State Parkway, in the Gold Coast Historic District/NR.

South: THOM building, 547 S. Clark Street, at the northeast corner of W. Harrison Streets, built in 1922, is 10 stories high, on pile foundations. Davidson & Weiss were the architects and Lieberman & Hein the engineers. A photograph is in ISA 1923, p. 152, and RB Annual Review, January 26, 1963, p. 113. The Thom building was renamed the Columbian building. It is in the South Loop Printing House Historic District/NR.

North: WALLER building, 1922–1996, at the southwest corner of N. Michigan and E. Chicago Avenues, also known as the Alliance building, was six stories high with a penthouse apartment, of reinforced concrete construction. Robert T. Newberry was the architect. It was also known as the Ray-Vogue School (?) and as the 750 N. Michigan Avenue building. Photographs are in RB September 1, 1951, p. 31, and December 1, 1951, p. 1. The Kinzie building previously occupied this site.

North: POPULAR MECHANICS building, 1922–(1950 to 1990), at the northeast center of N. St. Clair and E. Ontario Streets, was seven stories high, of flat-slab reinforced concrete construction. Marshall & Fox were the architects. It was also known as the 200 E. Ontario Street building. Photographs

during construction are in GMM, p. 308. A photograph is in RB Annual Review, January 26, 1963, p. 107. The 633 St. Clair building includes this site.

North: 231 E. DELAWARE PLACE, built in 1922, is 12 stories high, on concrete piles. Fugard & Knapp were the architects and Lieberman & Hein the engineers. A photograph and a typical floor plan are in BW, p. 65. The building was renamed the 237 E. Delaware building. It is at the southwest corner of N. DeWitt Place.

1923: A new zoning ordinance liberalized the 260-foot height limitation; see the Straus/Continental Companies building.

HARRIS-SELWYN THEATERS, CAL, at 170–86 N. Dearborn Street, on the southwest corner of W. Lake Street, built in 1923, is three stories high, on spread foundations and hardpan caissons. Crane & Franzheim were the architects. The caissons were built just prior to the construction of the curve in the Dearborn Street Subway under the building. Photographs and floor plans are in WA January 1923. The Dickey building previously occupied this site. The building was renamed the Michael Todd and Cinestage Theaters, and it was also known as the Dearborn Cinemas. Photographs are also in WO, p. 33; CIDL, p. 40; HB; AF January 1928, p. 13 and plate 10; and HDM, p. 109. It is reported (early 1998) that the theaters will be rebuilt, maintaining the original facades, for the relocated Goodman Memorial Theater.

CHICAGO TEMPLE building, at 77 W. Washington Street, on the southeast corner of N. Clark Street, was completed in 1923. It is 21 stories high, with an eight-story spire, 568 feet, on rock caissons. Holabird & Roche were the architects. Henry J. Burt was the engineer. The building is illustrated in ENR April 17, 1924; CIM, p. 578; OBD 1929, p. 80; STL, p. 102; COF, with the Brunswick building; ABOV, pp. 43 and 44; and HB. An article is in A for November 1924, on the tallest church tower in the United States. The Methodist Church Block previously stood on this site; an illustration is in RMNV, V19. It was four stories high, built in 1873. Burling & Adler were the architects. A photograph is in DATA, p. 98. The Methodist Episcopal Church of Chicago erected a church on this site in 1845. John M. Van Osdel was the architect. It was succeeded in 1858 by the First Methodist Episcopal Church of Chicago building, a four-story marble structure, illustrated in HCA Vol. 2, p. 423; CIM, p. 196; and CIJ with the Chamber of Commerce building 1.

COVENANT CLUB, at 10 N. Dearborn Street, built in 1923, is 11 stories high, on rock caissons. Walter W. Ahlschlager was the architect and Lieberman & Hein were the engineers. The building was converted to commercial usage and renamed the 10 N. Dearborn Street building.

30 E. ADAMS STREET building, at the northwest corner of S. Wabash Avenue, fronting 100 feet on Adams and 116 feet on Wabash, was formerly

known as the Hartman building. It was built in 1923 and is 12 stories high, on pile foundations. A. S. Alschuler was the architect. A photograph is in ISA 1925, p. 128. The Gibbs building previously occupied this site.

400 S. STATE STREET building, ca. 1923–(1950 to 1990), at the southwest corner of W. Van Buren Street, formerly known as the Childs building, was seven stories high. The Harold Washington Library Center includes this site.

LONDON GUARANTEE building, CAL, at 360 N. Michigan Avenue, on the southwest corner of E. Wacker Drive, was built in 1923. A. S. Alschuler was the architect, and E. C. & R. M. Shankland were the engineers. The building is 21 stories high, rising 325 feet, on rock caissons. A photograph and floor plans are in HSM and in AF September 1924. A photograph is in CIM, p. 311, and CYT, p. 54. An illustration is in OBD 1929, p. 170. A pamphlet describing and illustrating this building is on file at the Chicago Historical Society. A photograph of the building and a story of its sale by the original English owners are in *Chicago Tribune,* November 5, 1946. Photographs are also in CANY, p. 66; AF December 1973, pp. 52 and 55; CALP; STL, p. 104; CNM, p. 52; AA August 27, 1924; and HB. It was also known as the Stone Container building, and it was later renamed the 360 N. Michigan Avenue building. It is in the Michigan-Wacker Historic District/NR. Fort (Henry) Dearborn and the Hoyt building previously occupied this site. Drawings of the fort are in T, p. 7.

South: SWIGART building, at 723 S. Wells Street, built in 1923, is 10 stories high, on wood piles. Shankland & Pingrey were the architects and engineers. It was renamed the 723 S. Wells Street building; it is in the South Loop Printing House Historic District/NR.

North: LAKE SHORE DRIVE HOTEL, at 181 E. Lake Shore Drive, completed in 1923, is 19 stories high, on concrete piles. Fugard & Knapp were the architects and Lieberman & Hein the engineers. A photograph is in CIM, p. 319, and CYT, p. 59. A photograph and a typical floor plan are in BW, p. 49. The hotel was known as the Lake Shore Drive Hotel and as the Mayfair-Regent Hotel, and it returned to use as apartments in 1993. It is in the East Lake Shore Drive District/CHALC. See appendix F.

North: 844 N. RUSH STREET building, at the northwest corner of E. Pearson Street, formerly known as the America-Fore building, built in 1923, is 12 stories high, on wood piles. Herman Hanselmann was the architect. A photograph is in OBD 1941–42, p. 17. It occupies the full block that is bounded also by N. Wabash Avenue and is known also as the Railroad Retirement Board building. A photograph is in HB.

North: AMERICAN FURNITURE MART building, at 666 N. Lake Shore Drive, was built in two sections. The east portion, built in 1923, 16 stories

high, is on wood piles. Henry Raeder was the architect, with N. Max Dunning and George C. Nimmons as associate architects. An illustration is in ISA 1923, p. 128. The west portion, built in 1926, 20 stories high plus a 10-story tower, rising 474 feet, is on caissons. George C. Nimmons and N. Max Dunning were the architects and Lieberman & Hein the engineers. A photograph is in CIM, p. 551, and ISA 1929, p. 676. When completed, the building was reputed to have the largest floor area of any multistory building. A description, with an illustration of the completed building and a floor plan, is in WA, April 1925, with numerous interior photographs. The building was converted to mixed usage — residential, offices, and shops — in 1982 and renamed 666 Lake Shore Place; Fitch-Larocca were the architects. Photographs are also in STL, p. 118; RB May 5, 1979, p. 1; and CSV, p. 27 detail.

North: PEARSON HOTEL, 1923–1971, at 190 E. Pearson Street, was 12 stories high, on concrete piles. Robert S. DeGolyer was the architect; Smith & Brown were the engineers. A photograph is in CIM, p. 529. The Ritz-Carlton Hotel, Water Tower Place, includes this site.

North: ARMORY building of the 122d Field Artillery, 1923–1993, at 234 E. Chicago Avenue at N. DeWitt Place, was on concrete piles. Edgar D. Martin was the architect. In 1938 an addition was done by S. Milton Eichberg, architect. It was renamed the Illinois National Guard Armory. Photographs are in CIM, p. 536; ABOV, pp. 20 and 22; and *Chicago Tribune,* June 8, 1993, during demolition. The Museum of Contemporary Art occupies this site.

CONTINENTAL ILLINOIS BANK building, at 231 S. LaSalle Street, formerly known as the Illinois Merchants Bank building, was completed in 1924. Graham, Anderson, Probst & White were the architects and William Braeger the engineer. The building is 19 stories high, with two basements, on rock caissons. An illustration is in ISA 1923, p. 120. Photographs and floor plans are in AWG. A photograph is in HE and in CIM, p. 566. Photographs are in WO, p. 36; STL, p. 115; GAPW, p. 47; and ADE. The building was renamed the Bank of America (*Chicago Tribune,* August 31, 1994, "Business" section). Buildings previously on this site include the Illinois Trust and Savings Bank and the Grand Pacific Hotel.

CONTINENTAL COMPANIES building, at the southwest corner of S. Michigan Avenue and E. Jackson Street, formerly the 310 S. Michigan Avenue building and originally the Straus building, was built in 1924. Graham, Anderson, Probst & White were the architects, and Magnus Gunderson the engineer. The building is 21 stories high, with a nine-story tower, reaching 475 feet, supported on rock caissons. A description and an illustration are in AF April 1925, and AR May 1925. Photographs and floor plans are in AWG. A photograph is in CAA; HSM; and CIM, p. 544. An illustration is in OBD 1929, p. 319. Photographs are also in STL, p. 114; GAPW, p. 159; and HB.

See appendix F. The building has also been known as the Britannica (Encyclopedia) Center. It was one of the first buildings to take advantage of the more liberal height limitations of the 1923 zoning ordinance. An article is in AF April 1925, p. 225. The CNA Financial Corp. includes this, the McCormick building, and its 1962 and 1973 buildings, as the CNA Center. The Stratford Hotel previously occupied this site.

BUTLER building, at 162 N. State Street, built in 1924, has 16 stories and is carried on hardpan caissons. C. A. Eckstorm was the architect. An illustration is in OBD 1929, p. 63; ISA 1926, p. 166; and RB April 1951, p. 1. It was renamed the Illinois Medical Training Center building.

PARKE, DAVIS & CO. building, at 130 N. Franklin Street, built in 1924, is 10 stories high, on caissons. Fugard & Knapp were the architects and Lieberman & Hein the engineers. A photograph is in HB. It was renamed the 130 N. Franklin Street building. The Fitch building previously occupied this site.

129 S. MARKET STREET building, 1924–ca. 1960, was eight stories high. The U.S. Gypsum building later occupied this now-vacant site.

FABRICS building, 1924–(1950 to 1990), at 323 S. Franklin Street, was 12 stories high, on pile foundations. The site is used for a parking structure.

BURNHAM building, at 160 N. LaSalle Street, also known as the State of Illinois building, on the northwest corner of W. Randolph Street, was built in 1924. It is 20 stories high, supported on caissons. Burnham Brothers were the architects and E. C. & R. M. Shankland the engineers. A photograph is in CIM, p. 588, and an illustration and a description are in OBD 1929, p. 58. It was renamed the 160 N. LaSalle Street and, in 1991, the State of Illinois Judicial and Office building. Details of the sale of the Burnham building to the State of Illinois for state offices, and a photograph of the building, are in Chicago Tribune, October 18, 1946. Photographs are in IA-C September 1990, p. 20, and ABOV, p. 45, during forecourt infilling construction by Holabird & Root, architects. This site was previously occupied in part by the Metropolitan Block, 1872–1923, a five-story building, fronting 180 feet on N. LaSalle Street and 80 feet on W. Randolph Street. That block is described and illustrated in RMNV, V19, and LO August, 1872, p. 133, with a description on p. 130. F. & E. Baumann were architects of the Metropolitan Block, which replaced a building of the same name (William J. Boyington, architect) destroyed by the great fire of 1871, containing Metropolitan Hall, which had opened in 1854. A photograph of this latter building is in CYT, p. 11, and CIM, pp. 76 and 389.

West: CHICAGO UNION STATION, CLSI, concourse demolished in 1969, at 210 S. Canal and W. Adams Streets, was completed in 1924. Graham, Burnham & Co. were the architects and William Braeger the engineer. The

building is five stories high with provisions for 16 additional stories, and is on hardpan caissons. It is described in WSE September 1922 and December 1925. Foundation tests on the caissons are described in WSE February 1924. The proposed station was illustrated in AR July 1915. Photographs and floor plans of the completed station are in AWG. Exterior and interior photographs are in CAA. Photographs are in ISA 1929, p. 494; C, p. 167; CIM, p. 438; CCP, p. 115; WA January 1926; CANY, p. 55; COF; WO, p. 42; GAPW, p. 150; and GCA, p. 50, showing the waiting room. An article is in AF February 1926, p. 85. A full description with floor plans and numerous views is in AF February 1926. The former Union Passenger Station (q.v.), adjacent to this site, is illustrated in HCA Vol. 3, p. 229, and by photograph in CIM, p. 437.

See appendix L for additional 1924 buildings.

North: AMERICAN DENTAL ASSOCIATION building, at 222 E. Superior Street, built ca. 1924, five stories high, on spread foundations, was remodeled in 1943 by Childs & Smith, architects, for occupancy by the National Offices of the ADA. The ADA is now in its 1966 building just to the north at 211 E. Chicago Avenue. The building was renamed the Northwestern University Medical Faculty building. A photograph is in HB.

North: SUPERIOR EXCHANGE building of the Illinois Bell Telephone Co., at the southeast corner of N. Dearborn and W. Erie Streets, built in 1924, is three stories high, on caissons. Holabird & Roche were the architects, and Frank E. Brown was the engineer. A photograph is in ISA 1925, p. 458, and HRHR Vol. 2, p. 263. A partial fourth story was added in 1941 by Holabird & Root, architects. The Superior Exchange building was renamed the Illinois Bell building.

North: LANSING APARTMENTS building, at 1036 N. Dearborn Street, on the southwest corner of W. Maple Street, built in 1924, is 10 stories high, of reinforced concrete construction, on wood piles. Oldefest & Williams were the architects. It was renamed the 1036 N. Dearborn Street Apartment Hotel building. A photograph is in RB Annual Review, January 26, 1963, p. 104.

North: 220 E. DELAWARE PLACE apartment building, 1924–(1950 to 1990), was seven stories high, of reinforced concrete construction, on spread foundations, with a frontage of 100 feet. Eckland, Fugard & Knapp were the architects and Lieberman & Hein the engineers. A photograph and a typical floor plan are in BW, p. 59. An illustration, floor plan, and description are in APB, pp. 34 and 35.

North: 230 E. DELAWARE PLACE, built in 1925, is 10 stories high, reinforced concrete construction, on spread foundations. Eckland, Fugard & Knapp were the architects. A photograph, floor plan, and description are in APB, pp. 36 and 37. The building was renamed the 900 N. DeWitt Place building.

BELL building, at 307 N. Michigan Avenue, was built in 1925. It is 24 stories high, on hardpan caissons. Vitzhum & Burns were the architects. A photograph is in CIM, p. 310, and CYT, p. 54. An illustration is in OBD 1929, p. 44, and ISA 1924, p. 158. Photographs are in STL, p. 133; CNM, p. 101; and HB. The Bell building was renamed the Old Republic building.

THREE SISTERS building, at 26 S. State Street, formerly known as the Kresge building, built in 1925, is seven stories high, with two basements, on caisson foundations. The two lower stories were remodeled in 1941 for the present occupancy. Photographs are in HB and in *Culture and Democracy*, Hugh D. Duncan, 1965, p. 567, shown with the Carson, Pirie, Scott Store entrance.

GOODMAN MEMORIAL THEATER, 200 N. Columbus Drive, east of the Art Institute on the southwest corner of E. Monroe Street, was built in 1925, one story above grade. Howard Van Doren Shaw was the architect. A photograph is in CYT, p. 45, and CIM, p. 485. It is planned that the theater will relocate to the Harris-Selwyn Theaters by the year 2000.

South: HARRISON GARAGE building, at 606–12 S. Wabash Avenue, built in 1925, is seven stories high, on wood pile foundations. The architect was F. Foltz. A photograph is in ADE. The building was renamed South Loop Parking, 610 S. Wabash Avenue.

South: CONGRESS BANK building, at 500–14 S. Wabash Avenue, on the southwest corner of E. Congress Street, formerly known as the Congress-Wabash building, built in 1925, is seven stories high, on pile foundations. A. S. Alschuler was the architect. A description and an illustration are in OBD 1929, p. 91. A sidewalk arcade was constructed under the north bay of the building when E. Congress Street was widened. Photographs are in RB Annual Review, January 25, 1958, p. 136, January 27, 1962, p. 128 (advert.), and May 13, 1978, p. 1. The building was renamed the 33 E. Congress Parkway building and MacCormac College, 506 S. Wabash Avenue.

North: 180 E. DELAWARE APARTMENTS building, 1925–(1950 to 1990), was 11 stories high, on wood piles. B. Leo Steif & Co. were the architects and Samuel Klein the engineer. A photograph and a typical floor plan are in BW, p. 32. A photograph is in RB Annual Review, January 26, 1963, p. 98. The building was occupied by the University of Chicago Graduate School of Business until the school moved into its 1994 building.

North: 201 E. DELAWARE PLACE, built in 1925, is 17 stories high, of reinforced concrete, on wood piles. Fugard & Knapp were the architects and James B. Black the engineer. A photograph is in AF September 1930; HB; and RB January 30, 1971, p. 122. At the southeast corner of N. Mies van

der Rohe Drive, the building was also known as Hampshire House. It was renamed the Raphael Hotel.

North: 1120 N. LAKE SHORE DRIVE, at the southwest corner of E. Elm Street, built in 1925, is 18 stories high, on piles. Robert S. DeGolyer and Walter T. Stockton were the architects. Photographs and a floor plan are in WA April 1926, and a photograph and a typical floor plan are in BW, p. 43. Photographs are in CAJZ, p. 285; ABOV, at center with steep gable; and CSV, p. 265. See appendix F. The building is in the Gold Coast Historic District/NR.

North: 20 E. CEDAR STREET building, built in 1925, is 19 stories high, on a reinforced concrete mat. Fugard & Knapp were the architects and Samuel L. Klein the engineer. It is reported that one corner has a settlement of 12 inches and an adjacent corner a settlement of 20 inches, and around 1949 there was an annual settlement of about $\frac{3}{16}$ inches uniformly under the building. Photographs and a brief description are in BW, p. 55. Photographs are in RB Annual Review, January 26, 1963, pp. 98 and 157. The building was renamed the 20 E. Cedar Condominium building, in the Gold Coast Historic District/NR.

North: CASS HOTEL, at 640 N. Wabash Avenue, at the southwest corner of E. Erie Street, built in 1925, is 16 stories high, on caissons. Oldefest & Williams were the architects.

North: 18 E. ELM STREET building, built in 1925, is 10 stories high, on spread foundations. William P. Doerr was the architect. Photographs are in ISA 1925, p. 158, and RB July 4, 1964, p. 1. The building was renamed the Elms apartments, in the Gold Coast Historic District/NR.

North: FURNITURE EXHIBITION building, at 433 E. Erie Street, 1925–(1950 to 1990), was 11 stories high, on pile foundations. A. S. Alschuler was the architect. The Onterie Center occupies this site.

North: 820 N. MICHIGAN AVENUE building, built in 1925, is 17 stories high, on rock caissons. Schmidt, Garden & Erickson were the architects. Photographs are in CNM, p. 104; RB December 1, 1951, p. 31; IA-C May 1993, p. 27 (advert.); and HB. The building was converted and renamed Frank Lewis Towers, Loyola University Water Tower Campus.

North: JOHN R. THOMPSON building, 1925–1995, later known as the Michigan-Ohio building, at the northwest corner of N. Michigan Avenue and E. Ohio Street, was eight stories high, on spread foundations. A. S. Alschuler was the architect. A photograph is in CIM, p. 317; OBD 1941–42, p. 236; CNM, p. 104; RB December 1, 1951, p. 12; and *Chicago Tribune,*

October 13, 1994, Tempo section 5, p. 13. The 600 N. Michigan Avenue building includes this site.

North: 1540 N. LAKE SHORE DRIVE building, built in 1925, is 16 stories high. Huszagh & Hill were the architects and J. W. McCarthy the consulting architect. A photograph and a typical floor plan are in BW, p. 13. See also AF for September 1930. A photograph and details of the sale of the building to its tenants as a cooperative project are in *Chicago Tribune*, February 2, 1947. A photograph and floor plan are in AAH, pp. 46 and 49. Photographs are in CH10 and in HB. See appendix F. This cooperative apartment building is in the Gold Coast Historic District/NR.

1925: Tribune Tower: see 1864 Tribune building. Sherman Hotel: see 1837 Sherman House. Morrison Hotel Tower: see 1883 Morrison Hotel.

1926: The two-level Charles H. Wacker Drive improvement included the demolition of many three- to five-story buildings along the south bank of the Chicago River on the former South Water Street. Many of these are in photographs in *Guide to Significant Chicago Architecture of 1872 to 1922*, J. D. Randall, 1958, p. 44 (along with a 1957 view), and in IA-C No. 5, 1982, p. 36. The brochure *Souvenir of Wacker Drive*, by the Mid-Continent Construction Company, 1926, includes many views of the riverfront and of the Loop. A drawing of prefire South Water Street is in CBF. T. Arthur Evans was the Wacker Drive chief engineer.

RICHMAN BROTHERS building, at 114–18 S. State Street, 1926–(1950 to 1990), was six stories and two basements high.

METROPOLITAN BLOCK AND BISMARCK HOTEL, at the southwest corner of N. LaSalle and W. Randolph Streets, extending along the latter to N. Wells Street, was built in 1926, of steel frame construction, on rock caissons. Rapp & Rapp were the architects and Lieberman & Hein the engineers. The office portion is 22 stories high and the hotel 16 stories. The Palace Theater, in the W. Randolph Street portion, had 2,500 seats. A photograph is in OBD 1941–42, p. 228. The Randolph Hotel, at 179–85 W. Randolph Street, a four-story building, later called the Bismarck Hotel, formerly occupied the N. Wells Street corner. A photograph is in *Hotel Monthly*, June 1912. Interior photographs are in CIM, p. 140. The Metropolitan portion of the building is also known as the 134 N. LaSalle Street building. The Bismarck Hotel (now the Allegro) address is 171 W. Randolph Street. The Lafayette building previously occupied the LaSalle Street corner.

STANDARD CLUB building, at 320 S. Plymouth Court, built in 1926, is 10 stories high, on rock caissons. Albert Kahn of Detroit was the architect. An illustration is in ISA 1925, p. 318. A photograph is in CIM, p. 370, and a photograph and floor plans are in WA February 1928. An illustration of the

home of the club from 1870 to 1889 is in CIM, p. 459, and at p. 198 there is a photograph of the building next occupied by the club. The Boyleston building previously occupied the south part of this site.

32 W. RANDOLPH STREET building, NR, formerly known as the Chicago Real Estate Board building, and originally as the New United Masonic Temple and Oriental Theater, known also as the Civic Tower building, was built in 1926. It is 22 stories high, of steel frame construction, on rock caissons. Rapp & Rapp were the architects and Lieberman & Hein the engineers. A photograph is in CIM, p. 435, and photographs of the building and the theater are in WA December 1926. The theater lobby was converted to commercial usage.

Isaac M. SINGER (sewing machine co.) building, NR, at 120 S. State Street, built in 1926, is 10 stories high, on rock caissons. Mundie & Jensen were the architects. Photographs are in HB. The Singer building was renamed the 120 S. State Street building and later the Singer on State building, upon conversion to condominiums in 1997 by Wilbert Hasbrouck, architect.

PURE OIL building, CAL, at 35 E. Wacker Drive, on the southwest corner of N. Wabash Avenue, formerly the Jewelers building, was built in 1926. Giaver & Dinkelberg were the engineers and architects, and Thielbar & Fugard the supervising architects. The building is 24 stories high, with a 17-story tower, 523 feet, and three basements, supported on rock caissons. A photograph is in CAA; C, p. 57; HSM; OBD 1929, p. 277; CIM, p. 315; PGC, p. 33; GCA, p. 56; CSV, p. 134, details; AF December 1973, p. 52; STL, p. 112; and TBC, p. 176. The building was renamed the American Life Insurance building and later the 35 E. Wacker Drive building. The 1872 Standard Oil building previously occupied this site.

North: DUNHAM building, at 450 E. Ohio Street, built in 1926, is eight stories high, on wood piles. Burnham Brothers were the architects and Charles Harkins the engineer. An illustration and a description are in *Herald Examiner,* November 11, 1925. A photograph is in AF July 1927, p. 61; HB; and RB January 26, 1963, p. 1. The Dunham was renamed the 450 E. Ohio Street building.

North: PORTLAND CEMENT ASSOCIATION building, at 29–35 W. Grand Avenue, on the southeast corner of N. Dearborn Street, is five stories and two basements high, of concrete construction, on caisson foundations, designed for 10 stories. It was built in 1926 by Holabird & Roche, architects, and Frank E. Brown, engineer. An illustration is in ISA 1925, p. 62. A photograph is in WA September 1927; HRHR Vol. 2, p. 338; and A December 1926. The building was refaced and renamed the Chicago Medical Society building, 515 N. Dearborn Street. The PCA relocated in Skokie. The first

Rush Medical College building was erected on this corner in 1844. It was a one-story brick structure and cost $3,500 (CIM, p. 73, illustrated).

North: 1209 N. ASTOR STREET condominium building, built in 1926, is 13 stories high. A. S. Alschuler was the architect. It is in the Astor Street Landmark District/CHALC, within the Gold Coast Historic District/NR.

North: WACKER HOTEL, at 109 W. Huron Street, built in 1926, is 12 stories high, on pile foundations. Levy & Klein were the architects and A. Epstein the engineer. A photograph is in ISA 1927, p. 322. The hotel building was converted and renamed the Wacker Apartments, 111 W. Huron Street, at the southwest corner of N. Clark Street.

North: SENECA HOTEL, at 200 E. Chestnut Street, on the northeast corner of N. Seneca Street, built in 1926, is 16 stories high, on pile foundations. Burnham Brothers were the architects and Smith & Brown the engineers. A description is in *Herald Examiner,* August 2, 1925. A photograph is in GMM, p. 397. The building was renamed the Seneca apartments.

North: MARYLAND HOTEL, at 900 N. Rush Street, on the northwest corner of E. Delaware Street, built in 1926, is 17 stories high, on pile foundations. Louis Guenzel was the architect. Photographs are in RB December 1, 1951, p. 25, and August 1, 1981, p. 1. The building was converted to apartments in 1982 and renamed the 40 E. Delaware apartment building; Milton Zic was the architect.

North: BERKSHIRE HOTEL, at 15 E. Ohio Street, built in 1926, has 15 stories, on rock caissons. Bailot & Lauch were the architects. It was renamed the Ohio East Hotel.

North: ELIZABETH ARDEN building, at 70 E. Walton Place, built in 1926, is 12 stories high. Hiss & Weeks were the architects and Andrew N. Rebori the consulting architect. Smith & Brown were the engineers. A photograph is in RB March 2, 1963, p. 1.

North: 1320 N. STATE STREET apartment building, built in 1926, is 15 stories high, of reinforced concrete construction on pile foundations. The frontage is 124 feet. Robert S. DeGolyer and Co. were the architects and Smith & Brown the engineers. Photographs and floor plans are in AAH, pp. 60–63. A photograph is in A for May 1927. The building is in the Gold Coast Historic District/NR.

North: METHODIST BOOK CONCERN building, at 740 N. Rush Street, on the northwest corner of E. Superior Street, built in 1926, is seven stories high, on wood piles. Thielbar & Fugard were the architects and Lieberman & Hein the engineers. It was also known as the Western Methodist Book

Concern building. It was renamed the Crain Communications building in 1974. A photograph is in HB.

North: EASTGATE HOTEL, at 162 E. Ontario Street, built in 1926, is 15 stories high, on wood piles. Oman & Lilienthal were the architects and Samuel Klein the engineer. Photographs and floor plans are in WA March 1927. An illustration is in ISA 1925, p. 304, and in RB November 7, 1964, p. 1. The Eastgate was renamed the Richmont Hotel and later Motel 6 Chicago, at the northwest corner of N. St. Clair Street.

North: MOZART APARTMENT HOTEL, at 100 E. Chestnut Street, on the northwest corner of N. Ernst Court, built ca. 1926, is of reinforced concrete construction, 14 and 15 stories high. It was renamed the Tremont Hotel.

North: HIBBARD, SPENCER, BARTLETT & CO. building, 1926–(1970 to 1990), later the Mandel-Lear building, at 211 E. North Water Street. Graham, Anderson, Probst & White were the architects. It was 14 stories high, on piles and rock caissons. Photographs are in AWG; WA April 1927; and A for April and November 1927. A photograph and details of the sale by the original owners are in *Chicago Tribune,* November 8, 1946. Photographs are also in GAPW, p. 168; RB December 1, 1951, p. 26; and RB Annual Review, January 29, 1966, p. 15, in Streeterville scene; SEA, p. 26; ADE. The address had been changed to 425 N. Michigan Avenue. The University of Chicago Graduate School of Business occupies a part of this site.

North: 20 E. DELAWARE PLACE APARTMENTS building, at 16–22 E. Delaware Place, built in 1926, is 16 stories high, of steel frame and reinforced concrete construction, on rock caissons. John Archibald Armstrong was the architect. Photographs are in RB February 19, 1972, p. 1, and Annual Review, January 27, 1973, p. 87. Known also as Delaware Towers, the building was renamed the Talbott Hotel.

North: 240 E. DELAWARE PLACE building, 1926–(1950 to 1990), at the northwest corner of N. DeWitt Place, was 10 stories high, of reinforced concrete construction. Leichenko & Esser were the architects. A photograph is in HB. The 900 N. Lake Shore Drive building includes this site.

North: DeWITT HOTEL, at 244 E. Pearson Street, on the northeast corner of N. DeWitt Place, built in 1926, is 19 stories high, on pile foundations. Robert S. DeGolyer was the architect. The building was redesigned around the original structure in 1983, converted to nurses training and staff residential usage, and renamed Worcester House, Northwestern University; VOA were the architects. A drawing is in RB April 30, 1983, p. 15.

North: 1366 N. DEARBORN PARKWAY building, built in 1926, is 14 stories high. McNally & Quinn were the architects. A photo of the condominium building is in HB.

North: McKINLOCK CAMPUS of Northwestern University, in 1950 bounded by N. Lake Shore Drive, E. Chicago Avenue, N. Fairbanks Court, and E. Superior Street, included the following buildings: MONTGOMERY WARD MEMORIAL, built in 1926, 14 stories high with a five-story tower, illustrated in WA February 1927 (F. William Seidensticker, engineer); WIE-BOLDT HALL OF COMMERCE, built in 1926, eight stories high; LEVY MAYER HALL OF LAW, and the GARY LAW LIBRARY (Lieberman & Hein, engineers), built in 1927, four stories high; and GEORGE R. THORNE HALL (F. William Seidensticker, engineer), built in 1932. All are on wood piles. James Gamble Rogers was the architect, and Childs & Smith were the associated architects. These buildings are described and illustrated in A June 1927; CIM, p. 551; AA July 20, 1927, pp. 77–115; AF November 1927; and *Power* for February 1927. Photographs of the various buildings are in CAA; C, pp. 79 and 90; and (ca. 1927) STL, p. 122. Bird's-eye views include (1929 and 1991) ABOV, pp. 20 and 21, and (ca. 1978) CRC McGaw Medical Center and Prentice Hospital. A photograph of Abbott Hall, by Holabird & Root in 1939, at Lake Shore Drive and Huron, is in RB December 1, 1951, p. 31. In 1996 the Chicago Campus bounds extended to buildings on E. Pearson Street and N. St. Clair Street, as following or described elsewhere. The 1975 PRENTICE WOMEN'S HOSPITAL, 333 E. Superior Street; Bertrand Goldberg, architect. It is seven stories high, reinforced concrete construction. Photographs are in COF, p. 210; AR July 1976, p. 109; IA-C January 1974, p. 16; CST; and *Sourcebook of Contemporary American Architecture*, Sylvia Hart Wright, 1987, p. 37. The 1979 HEALTH SCIENCES BUILDING; Gerald Horn, architect, with Holabird & Root, associated architects. It is seven stories high. The 1984 ARTHUR RUBLOFF LAW AND AMERICAN BAR CENTER building, 750 N. Lake Shore Drive and 375 E. Chicago Avenue; Holabird & Root, architects, with Gerald Horn, designer. It is 13 stories high. Photographs are in 1987 COF, p. 212; CST; SEA, p. 77; and AGC, p. 114. See appendix F. The 1989 MONTGOMERY WARD MEMORIAL building addition; Perkins & Will, architects, with Ralph Johnson, designer. A photograph is in STL, p. 123. The 1990 GEORGE W. AND EDWINA TARRY MEDICAL BUILDING, 300 E. Superior Street, at the northeast corner of N. Fairbanks Court; Perkins & Will, architects. It is 16 stories high. Photographs are in AGC, p. 114, and CST. Other facilities include the Lake Shore Center/former Lake Shore Club, Medical Faculty building/former American Dental Association, Worcester House/former DeWitt Hotel, Passavant Hospital, Wesley Memorial Hospital, and Northwestern Memorial Hospital (1999 planned completion).

CHICAGO EYE, EAR, NOSE, AND THROAT HOSPITAL, 1927–1980s, at 231 W. Washington Street, on the southeast corner of N. Franklin Street, was 10 stories high, on rock caissons. A. S. Alschuler was the architect, and Lieberman & Hein were the engineers. The 225 W. Washington Street building occupies this site.

BUILDERS building, at 228 N. LaSalle Street, was built in 1927. Graham, Anderson, Probst & White were the architects. The building is 22 stories high, 342 feet, on rock caissons. Photographs and plan are in AWG. An illustration is in OBD 1929, p. 52. A photograph is in ISA 1927, p. 138; CIM, p. 590; STL, p. 134; CST; ABOV, p. 35; and HB. A drawing is in GAPW, p. 188. An article is in IA-C January 1988, p. 50 and cover. A west addition was made in 1986; Skidmore, Owings & Merrill were the architects, with Adrian Smith the designer. It was renamed the 222 N. LaSalle Street building, now extending to the southeast corner of N. Wells Street. The 1873 Steele-Wedeles building previously occupied the site of the original building; the Robbins buildings 1 and 2 occupied the site of the Builders building addition before the parking lot that was here for many years.

CHICAGO MERCANTILE EXCHANGE building, at 110 N. Franklin Street, on the northwest corner of W. Washington Street, was built in 1927. A. S. Alschuler was the architect, and Lieberman & Hein were the engineers. The building is 17 stories high, on rock caissons. It is illustrated in A for March 1927, and by photograph in CIM, p. 589, and in ISA 1929, p. 394. An illustration and a brief description are in OBD 1929, p. 211. The Ogden House, a four-story building, occupied this corner formerly, with a frontage of 80 feet on each street. A special news bulletin of RB October 21, 1948, contains a photograph and description of the present building. A photograph is in WO, p. 42. It was renamed the Illinois Bell building. The Chicago Mercantile Exchange is in its 1983 building.

MORTON building, at 208 W. Washington Street, on the northwest corner of N. Wells Street, was built in 1927. Graham, Anderson, Probst & White were the architects; Magnus Gunderson was the engineer. The building is 23 stories high, 332 feet, on rock caissons. Photographs are in ADE; ISA 1926, p. 510; AWG; and HE. An illustration and a description are in OBD 1928, p. 226. The Morton building was renamed the Illinois Bell building. The Times building previously occupied this site.

200 N. MICHIGAN AVENUE building, at the northwest corner of E. Lake Street, formerly known as the Tobey building, was built in 1927. Holabird & Root were the architects, and Frank E. Brown the engineer. The building is six stories high, on wood pile foundations. A photograph is in CIM, p. 309; ISA 1926, p. 148; A for January 1930; WA September 1927; CNM, p. 148;

HRHR Vol. 2, p. 249; STL, p. 144; and HB. The 1877 McCormick building previously occupied this site.

ADAMS-FRANKLIN building, 1927–(1950 to 1990), at 222 W. Adams Street, was 16 stories high, on pile foundations. A. S. Alschuler was the architect. A photograph is in ISA 1927, p. 364, and an illustration is in OBD 1941–42, p. 13. Photographs are in RB January 29, 1972, p. 1, and March 9, 1963, p. 1. The Butler Bros. building, at 212–16 W. Adams Street, six stories high, was formerly on the east portion of this site; it is illustrated in CAC, p. 198. The USG (Gypsum) building includes this site.

300 W. ADAMS STREET building, at the northwest corner of S. Franklin Street, built in 1927, is 12 stories high, on pile foundations. Jens J. Jensen was the architect, and Lieberman & Hein were the engineers. A photograph is in ISA 1929, p. 310, and RB June 30, 1990, p. 84 (advert.). An article is in SEA, p. 31, showing the Holabird & Root bridge in the court, and IA-C March 1983. The Carson, Pirie, Scott Wholesale building previously occupied this site.

MADISON-LaSALLE building, at 173 W. Madison Street, 1927–(1950 to 1990), was 16 stories high, on hardpan caissons. Frank D. Chase was the architect and engineer. An illustration and a description are in OBD 1929, p. 179. The Paine Webber Tower building includes this site.

100 W. MONROE STREET building, at the northwest corner of S. Clark Street, built in 1927, is 22 stories high, on caissons. Frank D. Chase was the architect and engineer. The west bay uses air rights over a cow path, reserved in an old deed (AAC, p. 54). A photograph is in OBD 1941–42, p. 281; ISA 1926, p. 496; and HB.

BANKERS building, at 105 W. Adams Street, on the southwest corner of S. Clark Street, completed in 1927, is 41 stories high, 476 feet, on rock caissons. Burnham Brothers were the architects and Charles Harkins the engineer. An illustration is in ISA 1926, p. 152, and an illustration and a description are in Chicago Tribune, April 1, 1926. Photographs are in CIM, p. 564; CAA; and in OBD 1941–42, p. 35. A photograph and floor plans are in WA June 1928. The Lakeside building previously occupied this site.

HARVESTER building, at 180 N. Michigan Avenue, on the southwest corner of E. Lake Street, formerly known as the Lake-Michigan building, was completed in 1927. It is 23 stories high, on rock caissons. A. S. Alschuler was the architect, and Lieberman & Hein were the engineers. A photograph is in CIM; ISA 1926, p. 380; WA October 1927. An illustration is in OBD 1929, p. 164; CNM, p. 107; HB; RB Annual Review, January 28, 1967, p. 155. The building was renamed the 180 N. Michigan Avenue building.

PITTSFIELD building, CLSI, at 55 E. Washington Street, on the southeast corner of N. Wabash Avenue, with a frontage of 163 feet on the former and 120 feet on the latter, is on the site of the Drake-Farwell Block 3, which was previously the home site of John B. Drake. The building was completed in 1927 by Graham, Anderson, Probst & White, architects, and William Braeger, engineer. It is 21 stories high, with a 17-story tower, reaching 557 feet, supported on rock caissons. A photograph is in ISA 1927, p. 150; HE; AA December 5, 1928; STL, p. 136; and GAPW, p. 185. A drawing is in GFC, p. 24. Photographs and floor plans are in AWG, and an illustration is in OBD 1929, p. 268. The first Drake-Farwell building, seven stories high, was completed and burned in 1870; it is illustrated in LO March 1870, p. 55. The second, five stories high, was completed in 1871 (LO April 1871, p. 114) and burned in the great fire of 1871; it is illustrated in GCSU and in HCA Vol. 2, p. 574. The third, built in 1872, was a duplicate of the second, and was known later as the Tobey Furniture Co. building. A photograph is in CIM, p. 321. One story was added by John M. Van Osdel, architect, in 1890; a photograph is in CIM, p. 324. A view of the building is in RMNV, V17, and in GFC, p. 24. John M. Van Osdel was the architect of the three buildings.

MEDICAL AND DENTAL ARTS building, now known as the 185 N. Wabash Avenue building, at the southeast corner of E. Lake Street, was built in 1927. It is 23 stories high, on rock caissons. Burnham Brothers were the architects and Charles Harkins the engineer. A photograph, floor plans, and a description are in *Chicago Tribune*, May 2, 1926. A photograph is in OBD 1941–42, p. 219; HB; RB March 25, 1972, p. 1. The Doggett building and the Charles B. Farwell store previously occupied this site.

STARCK PIANO CO. building, at 234 S. Wabash Avenue, built in 1927, is seven stories high. Graven and Mayger were the architects and Lieberman & Hein the engineers.

STARCK building, at 230 S. Wabash Avenue, built in 1927, is 10 stories high, on pile foundations. Frank D. Chase was the architect and engineer. An illustration is in OBD 1929, p. 305. Morton L. Pereira was associated architect. A photograph is in RB August 12, 1950, p. 1.

MIDLAND HOTEL, at 176 W. Adams Street, formerly known as the Midland Club building, built in 1927, is 22 stories high, with two basements, on caissons. Karl M. Vitzhum was the architect. A photograph of the lobby is in ISA 1929, p. 662. An illustration is in OBD 1929, p. 218; CIM, p. 564; and RB April 15, 1961, p. 3.

INSURANCE CENTER building, at 330 S. Wells Street, on the northwest corner of W. Van Buren Street, built in 1927, is 16 stories high, on caissons. David Saul Klafter and James G. Ludgin were the architects. An illustration

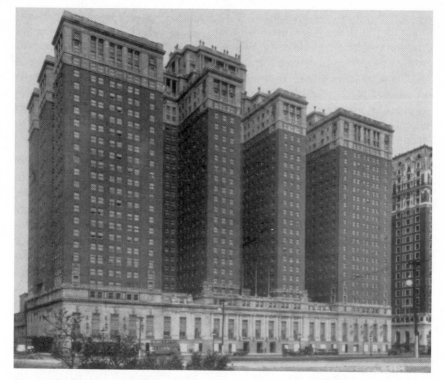

Fig. 37. Stevens Hotel, 1927

is in OBD 1941–42, p. 166, and *Chicago Tribune,* August 10, 1974, section 3, p. 6, as the 206 W. Van Buren Street building. It was renamed the 330 S. Wells Street building. On March 2, 1947, an explosion occurred directly across Van Buren Street, beneath the sidewalk. Considerable damage was caused to the interior of this building.

South: SOUTH LOOP GARAGE building, at 318 S. Federal Street, 1927–1988, was 10 stories high, on pile foundations. A. S. Alschuler was the architect. The 12-story South Loop Self Park garage, built in 1989, occupies this site.

South: STEVENS HOTEL, at the southwest corner of S. Michigan Avenue and E. Balbo Street, was completed in 1927, by Holabird & Roche, architects, Frank E. Brown, structural engineer, and Henry J. Burt as consulting engineer (fig. 37). Benjamin Shapiro has also been reported as the engineer. The largest hotel in the world at the time it was built, it is 25 stories high with a four-story tower, 340 feet, from two to five basements, supported on rock caissons. A description, with photographs and floor plans, is in WSE for December 1926. A photograph and floor plans are also in HSM. A

photograph is in C, p. 146; CAA; CIM, p. 449; STL, p. 124; HRHR Vol. 2, p. 240; and HB. An article is in AF August 1927, p. 97. The building was renamed the Conrad Hilton Hotel in 1957 and, later, the Chicago Hilton and Towers Hotel, 720 S. Michigan Avenue. The STEVENS HOTEL SERVICE building, at 723 S. Wabash Avenue, was completed in 1926. It is 12 stories high, with two basements, on rock caissons, and was designed by the same architects. A photograph of the two-story Arcade building, formerly on the site of the Stevens Hotel, is in CYT, p. 44, and CIM, p. 298.

South: PLYMOUTH COURT GARAGE, at 701–09 S. Plymouth Court, built in 1927, is six stories high. Lewis E. Russell was the architect. A photograph is in 1965 CFB with the 731 S. Plymouth Court building. The garage was renamed the Plymouth Court Self Park, 711 S. Plymouth Court, in the South Loop Printing House Historic District/NR.

North: 70 E. CEDAR STREET apartment building, built in 1927, is 13 to 17 stories high. McNally & Quinn were the architects and engineers. A photograph and a typical floor plan are in BW, p. 45. Photographs are in HB and in RB January 6, 1951, p. 1. The building is in the Gold Coast Historic District/NR.

North: KNICKERBOCKER HOTEL, at 163 E. Walton Place, formerly the Davis Hotel, built in 1927, is 14 stories high, of reinforced concrete, on wood piles. Rissman & Hirschfield were the architects and Samuel Klein the engineer. Photographs are in HB and in RB Annual Review, January 28, 1967, p. 127. The building was also known as the Towers Hotel. It was renamed the Knickerbocker-Chicago Hotel.

North: 1400 N. LAKE SHORE DRIVE apartment building, at the northwest corner of E. Schiller Street, built in 1927, is 21 stories high, on a concrete mat foundation (fig. 38). Hooper & Janusch were the architects and Frank A. Randall the engineer. The construction is all reinforced concrete (fig. 39), with steel H-beam cores in the lower stories of the columns. An illustration is in ISA 1926, p. 298, and a photograph and a typical floor plan are in BW, p. 24. Photographs are in RB November 7, 1964, p. 5; *Chicago Tribune,* September 10, 1993, p. B22; CGY, p. 113, with the Palmer residence; IA-C March 1985, with 1418 Lake Shore Drive. In the Gold Coast Historic District/NR, the building has been known as the Touraine Apartments. Franklin MacVeagh's house, by Henry Hobson Richardson, occupied this site from 1886 to 1922; photographs are in CAJZ, p. 437, and RMP, p. 50. A view is in RMNV, V27.

North: CATHOLIC CHARITIES building, built in 1927 at 721 N. LaSalle Drive between W. Superior and W. Huron Streets, is seven stories high. Holabird & Roche were the architects. A photograph is in HRHR Vol. 1, p. 238.

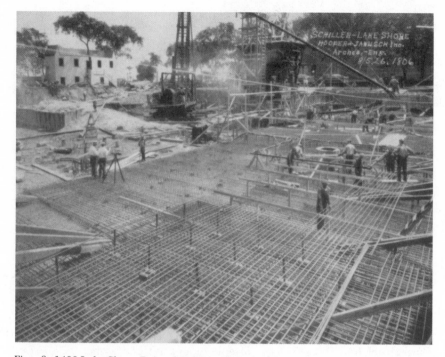

Fig. 38. 1400 Lake Shore Drive: Mat Foundation, 1926

North: FARWELL building, at 664 N. Michigan Avenue, on the northwest corner of E. Erie Street, was built in 1927. Philip Maher was the architect. The building is 11 stories high with 1½ basements, on piles. It is illustrated in A for May 1928 and February 1929; OBD 1929, p. 113; CNM, p. 108; CST; CIM, p. 317, under construction in Michigan Avenue scene; and HB. It was converted to galleries along with alterations to the 666 N. Michigan Avenue building (Helena Rubinstein, 1926, five stories high, not listed here), for the Daniel J. and Adeline Terra Museum of American Art, 1987; Booth, Hansen were the architects. An article is in IA-C July 1987, p. 27.

North: 1448 N. LAKE SHORE DRIVE apartment building, at the southwest corner of E. Burton Place, built in 1927, is 18 stories high. Childs & Smith were the architects. A photograph and a typical floor plan are in BW, p. 14. Photographs are in TBC, p. 266, and HB. The building is in the Gold Coast Historic District/NR.

North: AMBASSADOR EAST building, at the northeast corner of N. State and E. Goethe Streets, built in 1927, is 16 stories high, on wood piles. Robert S. DeGolyer & Walter T. Stockton were the architects and Smith & Brown the engineers. A photograph is in ISA 1927, p. 326. The Ambassador East

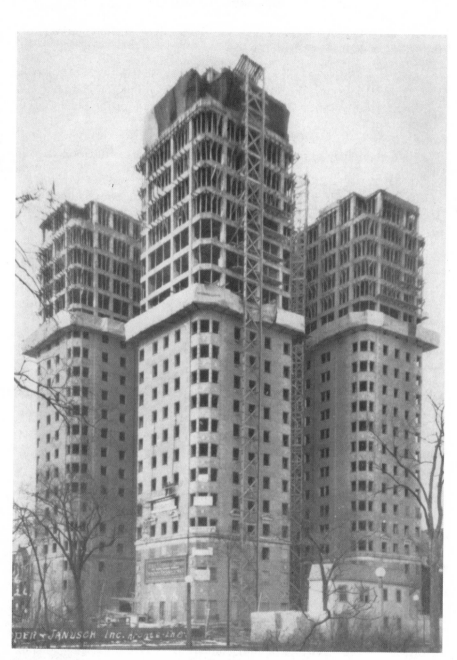

Fig. 39. 1400 Lake Shore Drive: Under Construction, 1927

was renamed the Omni Ambassador East Hotel, 1301 N. State Parkway, in the Gold Coast Historic District/NR.

North: WILMAR HOTEL, at 11 W. Division Street, built in 1927, is 12 stories high. Harry Dalsey was the architect. It was built on pile foundations, but hardpan caissons were installed in 1940 on each side of the State Street subway, which now curves under the building. Photographs are in RB Annual Review, January 29, 1966, p. 123. Known also as the Abby Residential Hotel, the building was renamed the Chicago East Apartment Hotel.

North: DEVONSHIRE HOTEL, at 19 E. Ohio Street, built in 1927, is 15 stories high, on pile foundations. Ralph C. Harris was the architect, and Lieberman & Hein were the engineers. It was renamed the Tokyo Hotel.

North: 210 E. PEARSON STREET building, built in 1927, is 16 stories high, of reinforced concrete frame on spread foundations. Huszagh & Hill were the architects. An illustration is in AF September 1930, p. 327. A photograph and a floor plan are in AAH, pp. 47 and 48. Photographs of this condominium building are in RB Annual Review, January 31, 1959, p. 116, and January 29, 1966, p. 158.

North: 1117 N. DEARBORN STREET building, built in 1927, is nine stories high, with no basement, on spread foundations. Morris L. Bein was the architect.

North: CROYDON HOTEL, at 616 N. Rush Street, formerly known as the McCormick Hotel, built in 1927, is 16 stories high, on wood piles. Edmund J. Meles was the architect and Frank A. Randall the engineer. It was renamed the Lenox House, at the southwest corner of E. Ontario Street. Photographs are in HB and in RB April 27, 1985, p. 42.

North: 900 N. MICHIGAN AVENUE building, 1927–1984, at the northwest corner of E. Delaware Street, was nine stories high. Jarvis Hunt was the architect and Lieberman & Hein were the engineers. The north wall is supported on rock caissons, the rest of the building on wood piles. The building is designed for 20 stories and a tower. Photographs and a brief description are in BW, pp. 40 and 41. A photograph is in CIM, p. 591; ISA 1926, p. 628; CNM, p. 130; RB December 1, 1951, p. 59; IA-C No. 5 September 1982, p. 39; and HB. The 900 N. Michigan Avenue building of 1989 occupies this site.

North: 14 W. ELM STREET building, built in 1927, is 18 stories high, on pile foundations. William Bernhard was the architect. An illustration is in ISA 1929, p. 652; RB January 5, 1963, p. 1, April 20, 1963, p. 6, and July 22, 1972, p. 4. It was renamed the 14 W. Elm Apartments, in the Gold Coast Historic District/NR.

North: DELAWARE TOWERS building, at 25 E. Delaware Street, on the southwest corner of N. Wabash Avenue, built in 1927, is 17 stories high, on wood piles. Hooper and Janusch were the architects and Frank A. Randall the engineer. A photograph and a typical floor plan are in BW, p. 57. The apartment building was converted to an apartment hotel.

North: 211 E. DELAWARE PLACE building, built ca. 1927, is 16 stories high, of reinforced concrete construction. Oldefest & Williams were the architects. It was renamed the Delaware Apartments.

MATHER TOWER building, at 75 E. Wacker Drive, later known as the Lincoln Tower and now by its address, was completed in 1928. It is 24 stories high, with an 18-story tower (521 feet, total height) and two basements, on rock caissons. Herbert H. Riddle was the architect, and Lieberman & Hein were the engineers. Because of the large ratio of height to width it was necessary to anchor the columns into the caissons. A photograph is in CIM, p. 311; CYT, p. 54; ISA 1927, p. 136; COF, p. 91; STL, p. 146; AGC, p. 52; and HB. The site is 65 by 100 feet. A photograph and a description of the building, with steel framing plan and details, are in ENR November 24, 1927.

1928: Insurance Exchange Annex: see Insurance Exchange.

120 S. LaSALLE STREET building, formerly known as the State Bank building, was completed in 1928. Graham, Anderson, Probst & White were the architects, and William Braeger was the engineer. The building is 22 stories in height, with three basements, on rock caissons. It is illustrated in A for March 1927, and in AWG, with floor plans. An illustration also is in OBD 1929, p. 306. Photographs are in ISA 1929, p. 158; CIM, p. 588; AF September 1927, p. 195 under construction; GAPW, p. 197; and HB. The Woman's Temple building previously occupied this site.

203 N. WABASH AVENUE building, formerly known as the Old Dearborn Bank or the Dearborn State Bank building, at the northeast corner of E. Lake Street, was built in 1928, 22 stories high, with two basements, of steel frame construction, on rock caissons. Rapp & Rapp were the architects and Lieberman & Hein the engineers. An illustration is in OBD 1929, p. 245. A photograph is in CIM, p. 571, and RB April 25, 1959, p. 1. This was for a time the Loop College building. The American Society of Civil Engineers, the Structural Engineers Association of Illinois, the Illinois Society of Professional Engineers, and the National Council on Structural Engineering Associations were here in 1998. This site was occupied previously by the Reed Block, a five-story building, built in 1872 (Wheelock & Thomas, architects), an illustration of which is in LO April 1872, p. 68, with a description, p. 54. See the 1872 Hibbard, Spencer, Bartlett Block.

TIMES building, at 211 W. Wacker Drive, the Sun-Times building and formerly known as the Chicago Evening Post building, was built in 1928. Known also as the YMCA Community College building and as the Central Standard Life (Insurance Co.) building, it was renamed the 211 W. Wacker Drive building. Holabird & Root were the architects and Frank E. Brown the engineer. The building is 19 stories high, with two basements, on hardpan caissons. It is illustrated in A for October 1927, and OBD 1929, p. 74. A photograph is in CIM, p. 590; STL, p. 142, with the Engineering building; and ABOV, p. 35. Drawings are in HRHR Vol. 2, p. 386.

ENGINEERING building, at 205 W. Wacker Drive, on the southwest corner of N. Wells Street, was completed in 1928, with Burnham Brothers as the architects and Frank D. Chase as the engineer. The building is 23 stories high, with two basements, on hardpan caissons. It is illustrated in WSE April–May 1927. A photograph is in CIM, p. 590; STL, p. 142; ABOV, p. 35; and HB.

447–511 S. CLARK STREET building, 1928–1947 (Holabird & Roche, architects) was built for the temporary use of the Board of Trade while its building at the southwest corner of S. LaSalle and W. Jackson Streets was being demolished and the present building was being erected. The west portion of the second floor was used as the board room; it was three stories high. The east portion of the building was four stories high. A basement under the entire building was used for a ramp garage. The building was condemned and removed by the Department of Subways and Superhighways in connection with the Congress Street widening. A portion of this site is used for parking.

333 N. MICHIGAN AVENUE building, CLSI/premier, was completed in 1928. Holabird & Root were the architects, and Frank E. Brown the engineer. The building is 35 stories, 394 feet high, with four basements, on rock caissons. Photographs are in CAA; CANY, p. 66; AR December 1973, p. 55; STL, p. 128; CNM, p. 150; HRHR Vol. 2, p. 401; LSCS, p. 33; *100 Years of Architecture in America*, 1957, p. 73; HB; CALP; CIM, p. 311; A for January 1930; and ISA 1929, p. 492. A photograph and floor plans are in HSM. Exterior and interior illustrations are in AR February 1929, and an illustration is in OBD 1929, p. 330.

DE PAUL UNIVERSITY building, 64 E. Lake Street, 1928–(1950 to 1990), was 16 stories high, with two basements, on rock caissons. Vitzhum & Burns were the architects. It is illustrated in CIM, p. 549, and OBD 1941–42, p. 97. This site is used for parking. See the Blackstone Theater and the Finchley, Kimball, and Lyon & Healy buildings for other De Paul University facilities.

MILLINERY MART building, at 65 E. South Water Street, on the southwest corner of N. Garland Court, formerly the Millinery building, was built in

1928. It is 24 stories high; Rissman & Hirschfield were the architects and Samuel Klein the engineer. The building is of steel skeleton construction with reinforced concrete floors and is supported on hardpan caissons except on the lot lines, where they are to rock. An illustration is in OBD 1941–42, p. 364; STL, p. 144, to the right of the Carbide and Carbon building; RB Annual Review, January 28, 1967, p. 149, under its present name, 65 East Southwater building.

FINCHLEY building, at 23 E. Jackson Street, built in 1928, is 15 stories high, on caissons. A. S. Alschuler was the architect and Lieberman & Hein were the engineers. Photographs are in HB and in RB January 7, 1961, p. 1. The building was converted and renamed the O'Malley building, De Paul University. See also the Kimball and Lyon & Healy buildings for other De Paul facilities.

DEARBORN-LAKE GARAGE, at 30 W. Lake Street, 1928–1983, was 10 stories high, on caissons. D. D. Meredith was the architect. The Leo Burnett building includes this northeast corner of N. Dearborn Street.

30 W. WASHINGTON STREET building, 1928–(1950 to 1990), formerly known as the Stop and Shop building, was 17 stories and two basements high, on rock caissons. Schmidt, Garden & Erikson were the architects. An illustration and a description are in OBD 1929, p. 328. This "Block 37" site is vacant.

120 W. LAKE STREET building, 1928–(1950 to 1990), was 10 stories high, on pile foundations. Hall, Lawrence & Ratcliffe were the architects and Samuel L. Klein the engineer. The 203 N. LaSalle Street building occupies this site.

NORTH LOOP GARAGE, 1928–(1950 to 1990), at 70 W. Lake Street, on the northwest corner of N. Garvey Court, was 10 stories high, on pile foundations. Nimmons, Carr & Wright were the architects and E. J. Branson the engineer. The Chicago Title & Trust Center building occupies this site.

WOOLWORTH building, at 20–30 N. State Street, built in 1928, is 10 stories high, on caissons. Walter W. Ahlschlager was the architect. Photographs are in ACMA, p. 43, and STL, p. 43, where the building is shown to the left of the Reliance building. The north portion of the building is four stories high and fronts also on W. Washington Street (nos. 9–21). The building was vacant in early 1998. Hillmans Store, a five- and six-story building, formerly occupied this site. A photograph is in TBC, p. 15.

South: CENTRAL POLICE STATION AND COURTS building, at 1121 S. State Street, built in 1928, is 13 stories high, with two basements, on rock caissons. Graham, Anderson, Probst & White and Argyle Robinson were the

architects, and Magnus Gunderson was the engineer. A photograph is in CIM, p. 488. It has been reported that a new facility is to be built.

South: CHICAGO WOMEN'S CLUB building, at 72 E. Eleventh Street, was built in 1928, six stories high, on wood piles. Holabird & Roche were the architects, and Frank E. Brown was the engineer. Photographs are in A for January 1930; CIM, p. 593; AGC, p. 141; HRHR Vol. 2, p. 394; and *Architectural Annual: Chicago*, 1930, p. 71. The building was converted and renamed the Columbia College, Getz Theater Music Center.

North: 10 W. ELM STREET APARTMENTS building, at the northwest corner of N. State Street, built in 1928, is 20 stories high, on wood piles. B. Leo Steif & Co. were the architects and Samuel Klein was the engineer. An illustration and typical floor plan are in BW, p. 76. A photograph is in RB May 18, 1963, p. 1. A photograph of the building's terra-cotta detail is in *Chicago Ceramics and Glass*, Sharon Darling, 1979, p. 201. It is in the Gold Coast Historic District/NR.

North: 222 E. CHESTNUT STREET building, built in 1928, is 19 stories high, of reinforced concrete, on wood piles. Rissman & Hirschfield were the architects and Samuel Klein the engineer. An illustration and a floor plan are in AAH, pp. 50 and 51. A photograph is in HB and a drawing is in CA, p. 86.

North: 1301 N. ASTOR STREET APARTMENTS, at the northeast corner of E. Goethe Street, built in 1928, is 15 stories high. Philip B. Maher was the architect. An illustration is in AF October 1936, p. 296, and ISA 1930–31, p. 358. Illustrations and a description are in AR March 1932, pp. 167–98. Photographs are in AGC, p. 163; *Architectural Annual: Chicago*, 1931; CAD, p. 123; and HB. The building was renamed the 1301 N. Astor Street Co-Op Apartments. It is in the Astor Street Landmark District/CHALC, within the Gold Coast Historic District/NR.

North: ST. CLAIR HOTEL, at 162 E. Ohio Street, on the northwest corner of N. St. Clair Street, built in 1928, is 22 stories high, on wood piles. Oman & Lilienthal were the architects and Samuel Klein the engineer. An illustration is in ISA 1927, p. 114, and a photograph and a typical floor plan are in BW, p. 48. Photographs are in WA August 1928; RB Annual Review, January 29, 1966, p. 105, and February 5, 1966, p. 1. The St. Clair was renamed the Best Western Inn of Chicago.

North: 1430 N. LAKE SHORE DRIVE apartment building, built in 1928, is 23 stories high. Robert S. DeGolyer & Co. were the architects and Smith & Brown the engineers. Photographs and a floor plan are in AAH, pp. 66 and 67. A photograph is in TBC, p. 183. The building is in the Gold Coast Historic District/NR.

North: 215 E. CHESTNUT STREET building, built in 1928 and known also as the Chatelaine Tower Apartments, is 21 stories high, on caissons. Roy France was the architect. Photographs are in RB October 15, 1944, February 5, 1966, p. 1, and Annual Review, January 28, 1967, p. 120.

North: 40 E. OAK STREET building, built in 1928, is 20 stories high, on pile foundations. Morris L. Bein was the architect. Photographs are in ABOV, p. 24, in a 1937 scene, at the right edge; RB December 23, 1972, p. 1, and December 21, 1963, p. 1. The building was renamed the 40 E. Oak Condominium building.

North: CANTERBURY COURT APARTMENT HOTEL, at 1214–18 N. State Street, built in 1928, is 17 stories high, of reinforced concrete construction, on wood piles. Ralph C. Harris was the architect and S. J. Branson the engineer. It was renamed the Canterbury Court Apartments, 1220 N. State Parkway, in the Gold Coast Historic District/NR.

North: 73 E. ELM STREET building, built in 1928, is 13 stories high, on spread foundations. McNally & Quinn were the architects and engineers. An illustration and a typical floor plan are in BW, p. 23. It was renamed the 73 East Elm Condominiums, in the Gold Coast Historic District/NR.

North: *WOMAN'S ATHLETIC CLUB,* CAL, at 626 N. Michigan Avenue, built in 1928, is seven and nine stories high, on pile foundations. Philip B. Maher was the architect. A photograph is in CIM; ISA 1930–31, p. 434; AGC, p. 104; and CNM, p. 135. The building is at the northwest corner of E. Ontario Street.

North: WHITEHALL APARTMENTS building, at 105 E. Delaware Place, built in 1928, is a 21-story reinforced concrete building (235 feet high), on 60-foot wood piles. Eugene H. Klaber and Ernest A. Grunsfeld Jr. were the architects, with Loewenberg & Loewenberg associated, and Benjamin B. Shapiro as engineer. The concrete superstructure was erected in 56 full working days (ENR June 7, 1928). A description, framing plan, and photograph of the building are in ENR August 30, 1928. Illustrations and a description are in AR March 1929, pp. 213–215. The building was converted and renamed The Whitehall (a hotel).

North: 1140 N. LaSALLE DRIVE apartment building, at 152–62 W. Elm Street, built in 1928, is eight stories high. A photograph is in RB February 28, 1959, p. 1. The building is at the northwest corner of E. Elm Street.

1928: Union League Club: see its 1886 building. Insurance Exchange building: see its 1912 building.

100 N. LaSALLE STREET building, at the northwest corner of W. Washington Street, was formerly known as the Lawyers building. Completed in

1929, it is 25 stories high, on hardpan caissons. Graven & Mayger were the architects and Lieberman & Hein the engineers. The steel superstructure was erected in 36 working days (ENR June 7, 1928, with construction photograph). An illustration and a description are in OBD 1929, p. 250. The Merchants building previously occupied this site. A photograph is in HB.

180 W. WASHINGTON STREET building, formerly known as the Equitable building, is now called the 180 W. Washington Office Center building. It was built in 1929, 12 stories high. Hyland & Corse were the architects. An illustration is in OBD 1929, p. 111, and ISA 1926, p. 322. A photograph of the four-story building previously on this site is in CIM, p. 575. A drawing of the lower stories is in RB September 18, 1993, p. 1.

CHICAGO MOTOR CLUB building, CLSI, at 66 E. South Water Street, was built in 1929. Holabird & Root were the architects and Frank E. Brown the engineer. The building is 17 stories high, with two basements, on rock caissons. Photographs are in A for January 1930; CIM, p. 550; CYT, p. 54; OBD 1929, p. 75; STL, p. 129; HRHR Vol. 2, p. 387; and ADE. An article is in RB April 28, 1990, p. 61. The Motor Club building was renamed the Wacker Tower Office Center, 68 E. Wacker Drive; conversion to condominiums is reported, as well as a renaming as Wacker Tower.

AMERICAN NATIONAL BANK building, formerly the 33 N. LaSalle Street building and originally the Foreman National Bank building, at 33 N. LaSalle Street, on the southeast corner of W. Washington Street, was built in 1929. It is 38 stories high, 479 feet, on rock and hardpan caissons. Graham, Anderson, Probst & White were the architects, and Magnus Gunderson was the engineer. The building is illustrated in HSM and A July 1928; photographs and floor plans are in AWG. Photographs are in CIM, p. 583; STL, p. 164; GAPW, p. 213; and *Architectural Annual: Chicago,* 1930, p. 18. Foreman Brothers Bank building, at 117–25 W. Washington Street, was a four-story building between the old Chamber of Commerce and the Chicago Opera House buildings; a photograph is in CYT, p. 87, and CIM, p. 431. The Chamber of Commerce building previously occupied this site.

CIVIC OPERA building, CLSI, at 20 N. Wacker Drive, occupying the block bounded by W. Madison Street, N. Wacker Drive, W. Washington Street, and the Chicago River, was finished in 1929. The architects were Graham, Anderson, Probst & White, with Alfred P. Shaw as designer, and Magnus Gunderson the engineer. The building is 45 stories high, rising 555 feet, on hardpan caissons. Photographs and floor plans are in AWG. Photographs are in CAA; A for January 1930; GCA, p. 54; STL, p. 152; ABOV, p. 36; GAPW, pp. 15 and 219; HB; and HSM. Exterior and interior illustrations are in AF April 1930, and in C, p. 67, with a description. A description with a photograph and steel framing details is in ENR November 14, 1929. Photographs during construction are in CIM, p. 592. The building was also known

as the Kemper Insurance building. The Civic Theater is here. Buildings previously on this site include the Electric, Central Manufacturing Block, and the Central Union Block.

JACKSON-FRANKLIN building, 1929–(1950 to 1990), at 309 W. Jackson Street, on the southwest corner of S. Franklin Street, was 22 stories high, on rock caissons. A. S. Alschuler was the architect, and Lieberman & Hein were the engineers. An illustration is in OBD 1929, p. 156, and RB November 11, 1950, p. 1. The Bodie Block previously occupied this site. The 311 S. Wacker Drive building includes this site.

CARBIDE AND CARBON building, CAL, CLSI, at 230 N. Michigan Avenue, on the southwest corner of E. South Water Street, built in 1929, is 40 stories high, with two basements, on rock caissons. Burnham Brothers were the architects and Charles Harkins the engineer. An illustration and a description are in *Chicago Tribune*, May 1, 1928. Photographs are in CAA; CYT, p. 54; CIM, p. 547; and OBD 1929, p. 68; WO, p. 4; AF December 1973, p. 52; STL, p. 94, under construction, and p. 144; IA-C January 1990, p. 61; *Architectural Annual: Chicago*, 1930, p. 13; HB; CALP; and CSV, p. 221, detail. Known also as the Union Carbide building, it was renamed the 230 N. Michigan Avenue building. It is reported in early 1998 that Lucien Lagrange is converting the building from offices to condominiums. The Loyal Hotel previously occupied this site.

188 W. RANDOLPH STREET building, at the northeast corner of N. Wells Street, formerly the Steuben Club building, built in 1929, is 27 stories, 465 feet high, with a 15-story tower, on rock caissons. Vitzhum & Burns were the architects. A photograph is in CIM, p. 583. An illustration is in OBD 1929, p. 312; ISA 1929, p. 582; STL, p. 133; and RB April 24, 1982, p. 17 (advert.). The building was renamed the Randolph Tower building. The Briggs Houses 1 and 2 previously occupied this site.

WILLOUGHBY TOWER, at 8 S. Michigan Avenue, on the southwest corner of E. Madison Street, built in 1929, is 36 stories high, reaching 448 feet, on caissons. Samuel N. Crowen was the architect. A photograph is in CIM, p. 547; CYT, p. 51; STL, p. 138; and HB. See appendix F. An illustration is in ISA 1929, p. 286, and OBD 1929, p. 359. The eight-story Willoughby building previously occupied this corner.

HOOPS building, 1929–31, at 106–12 S. Wabash Avenue, was seven stories high. It was replaced by the present six-story addition to the Palmer House, built in 1931 by Holabird & Root, architects. A drawing of a "replacement" building is in HRHR Vol. 3, p. 97.

CHICAGO REAL ESTATE BOARD building, at 105 W. Madison Street, on the southwest corner of S. Clark Street, formerly known as the Loop Center building, was built in 1929. It is 23 stories, 300 feet high, on rock caissons.

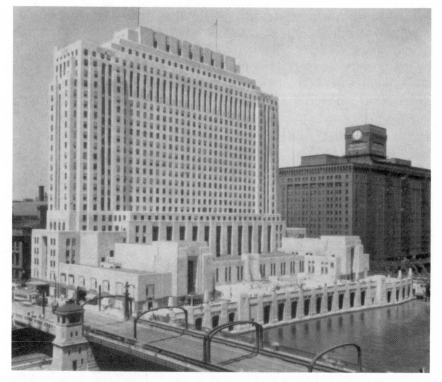

Fig. 40. Chicago Daily News, 1929

Burnham Brothers were the architects and Charles Harkins the engineer. An illustration is in OBD 1941–42, p. 185; HB; and RB June 8, 1963, p. 1. The building was renamed the 105 W. Madison Street building.

WELLS-JACKSON GARAGE building, at 326 S. Wells Street, also known as the Junior Mart building, built in 1929, is seven stories high. Frederick Foltz was the architect.

South: *John G. SHEDD AQUARIUM,* NHL, CLSI/premier, on the Outer Drive at E. Roosevelt Road, was built in 1929. It is founded on wood piles. Graham, Anderson, Probst & White were the architects, and Magnus Gunderson was the engineer. A photograph is in CAA and in A January 1930; an illustration is in CIM, p. 483; and photographs and floor plans are in AWG. A description and an illustration are in C, p. 39. Photographs are in CAD, p. 219; ABOV, p. 13, bird's-eye view; and CRC, p. 39. A drawing is in GAPW, p. 11, and a photo, p. 230. Articles are in IA-C May 1991, p. 50, and AR February 1992, p. 86. An Oceanarium addition was made in 1991; Dirk Lohan was the architect and Rittweger & Tokay were the engineers. A photograph and discussion is in SEA, p. 28.

West: CHICAGO DAILY NEWS building, CLSI, at 400 W. Madison Street, occupying the block bounded by W. Washington, N. Canal, W. Madison Streets, and the Chicago River, was completed in 1929 (fig. 40). Holabird & Roche were the architects and Frank E. Brown the engineer. The building is 26 stories high, rising 302 feet, with three basements, on rock caissons. It is described and illustrated in WSE for January 1929. A photograph and floor plans are in HSM. Photographs are in CAA; C, p. 119; ENR August 1, 1929; and A for January 1930. An illustration is in CIM, p. 593; CANY, p. 64; HRHR Vol. 2, p. 311; AF December 1973, p. 55; WA August 1929; and SCS, p. 45. An article is in AF January 1930, p. 21. The building was renamed the 2 N. Riverside Plaza building. The Felsenthal building and a Washington Hotel previously occupied this site.

The *Chicago Daily News* was started at 15 N. Wells Street in a building constructed soon after the fire of 1871. From its beginning to October 1891, the Daily News progressively filled one four-story building, three stories of a second, and two stories of a third. In a special new-building edition of October 12, 1891, the *Daily News* is described as moving into its new brick building on Wells Street, a four-story brick structure with a high half-basement, 81 by 84 feet, designed by Burnham & Root. The address of this building was also 15 N. Wells Street. In later years the *Daily News* expanded to take in all or parts of the buildings from the alley on Wells Street to the LaSalle Hotel on Madison Street. Some of these were wrecked in 1931; the last of the old buildings were wrecked in 1935 (Thomas V. Sayers, Librarian, *Chicago Daily News*). A photograph of a corner of the old building is in CIM, p. 413. The Wadsworth building, built in 1873 at 166–72 W. Madison Street, with an 80-foot frontage, adjoined the LaSalle Hotel.

North: MERCHANDISE MART building, CLSI, at Merchandise Mart Plaza, occupying the block bounded by N. Wells, W. Kinzie, N. Orleans Streets, and the Chicago River, was completed in 1929 as the world's largest building (fig. 41). It was more than twice the size of its nearest commercial rival and has about four million square feet of floor area. Graham, Anderson, Probst & White were the architects, and Magnus Gunderson was the engineer. The building has 25 stories, 340 feet high, and is supported on rock caissons on air rights over the Chicago and Northwestern Railroad, whose terminal formerly occupied this site. Photographs and floor plans are in AWG. An illustration is in C, p. 140, and CIM, p. 356. A photograph is in CAA; ENR June 5, 1930; WA December 1930; CFB; COF; ABOV, p. 33; CANY, p. 57; AF December 1973, p. 54; STL, p. 166; and CRC, p. 69. The C&NW Railway Office and Wells Street Station previously occupied this site. The Chicago chapter of the American Institute of Architects (AIA) is in the Merchandise Mart building.

North: HARRIET H. McCORMICK MEMORIAL YWCA, at 1001 N. Dearborn Parkway, completed in 1929, is 10 stories high, with a two-story tower

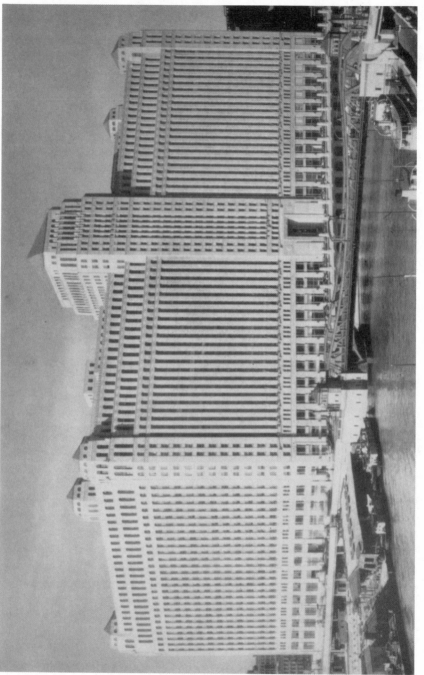

Fig. 41. Merchandise Mart, 1929

and two basements, on pile foundations. Berlin & Swern were the architects. An illustration is in CIM, p. 193, and a photograph is in CCP, p. 152. The building was renamed the Scholl College of Podiatric Medicine.

North: McGRAW-HILL building, 1929, 520 N. Michigan Avenue, on the southwest corner of E. Grand Avenue, was 17 stories high, with two basements, on wood piles. Thielbar & Fugard were the architects and James B. Black the engineer. A photograph is in A for October 1929. Empberger cast-iron cores were used in the reinforced concrete columns. A description and a photograph of the building are in ENR July 25, 1929. An illustration is in OBD 1929, p. 204. The building was renamed the 520 N. Michigan Avenue building. Photographs are also in AGC, p. 103; CNM, p. 180; CALP; *Architectural Annual: Chicago*, 1930, p. 21; RB December 1, 1951, p. 9; and HB. See *Chicago Sun-Times*, February 5, 1997, "Metro" section, and February 6, 1997, "News" section, about commercial redevelopment of the site in which salvaged portions of the McGraw-Hill facade are to be reused in a new building.

North: 1100 N. DEARBORN PARKWAY building, built in 1929, is 20 stories high, of reinforced concrete frame, on pile foundations. McNally & Quinn were the architects and Smith & Brown the engineers. An illustration is in AF September 1930, p. 321. It was renamed the 1100 Dearborn Apartments, at the northwest corner of W. Maple Street.

North: STERLING building, 1929–(1950 to 1990), 737 N. Michigan Avenue, at the northeast corner of E. Superior Street, was five and six stories high. Andrew N. Rebori was the architect. A photograph is in RB December 1, 1951, p. 9. The Olympia Center building includes this site.

North: DEARBORN PLAZA building, at 1032 N. Dearborn Parkway, built in 1929, is 15 stories high, on piles. Morris L. Bein was the architect. A photograph is in RB June 17, 1978, p. 1. The building was renamed the 1030 N. Dearborn Parkway building.

North: DRAKE TOWER APARTMENTS, at 179 E. Lake Shore Drive, was built in 1929. Benjamin H. Marshall was the architect. The building is 29 stories high, supported on piles. It is illustrated in A for May 1928. An illustration and a typical floor plan are in BW, p. 19, and AAH, pp. 264 and 265; a photograph is in CYT, p. 59. A photograph and details of the proposal to change the ownership to a cooperative are in *Chicago Tribune*, January 26, 1947. A photograph is in RB December 1, 1951, p. 33. See appendix F. The building is in the East Lake Shore Drive District/CHALC.

North: PALMOLIVE building, CLSI/premier, at 919 N. Michigan Avenue, on the southeast corner of E. Walton Street, was completed in 1929. Holabird & Roche were the architects and Verne O. McClurg the engineer. The

building is 22 stories high, rising 468 feet, with a 14-story tower topped by an 83-foot beacon, now inoperative, and two basements, and is supported on rock caissons. Photographs are in CAA; C, p. 54; and A for January 1930. A photograph and floor plans are in HSM. Exterior and interior views and a floor plan are in AF May 1930. An illustration and a description are in OBD 1929, p. 259. An illustration is in CIM, p. 594, and a photograph of the Lindbergh Beacon, atop the tower, is in CYT, p. 55. Photographs are in CFB; AUS, p. 171; HRHR, p. 414; AF December 1973, p. 48; ATL, p. 139; CNM, p. 158; and HB. An article is in AF May 1930, pp. 655 and 730. Known also as Playboy Towers, the building was renamed the 919 N. Michigan Avenue building.

North: MICHIGAN-CHESTNUT building, 1929–(1950 to 1990), 840 N. Michigan Avenue, at the southwest corner of E. Chestnut Street, of reinforced concrete construction, was seven stories high. Holabird & Root were the architects and Frank E. Brown the engineer. Photographs are in CNM, p. 170; RB December 1, 1951, p. 10; and HRHR Vol. 2, p. 407. The Plaza Escada building occupies this site.

North: 1325 N. ASTOR STREET building, a cooperative apartment building at the southeast corner of E. Banks Street, built in 1929, is 14 stories high. Andrew N. Rebori was the architect. A photograph and a typical floor plan are in BW, p. 18. A photograph is in ISA 1930–31, p. 108, and HB. Renamed the 1325 Astor Co-Op and the Astor Banks Condominium building, it is in the Astor Street Landmark District/CHALC, within the Gold Coast Historic District/NR.

North: MUSIC CORPORATION OF AMERICA building, 1929–ca. 1960, later known as the 430 N. Michigan Avenue building, was 13 stories high, on pile foundations. Loebl & Schlossman were the architects and Lieberman & Hein the engineers. Photographs are in CNM, p. 186; RB December 1, 1951, p. 12; and Annual Review, January 28, 1961, p. 111. The 430 N. Michigan Avenue building of 1963 occupies this site.

North: PASSAVANT HOSPITAL, HABS, at 303 E. Superior Street, on the southeast corner of N. Fairbanks Court, 1929, is 14 stories high, on pile foundations. Holabird & Root were the architects and Frank E. Brown the engineer. A photograph is in CAA; CCP, p. 141; ISA 1930–31, p. 584; HRHR Vol. 3, p. 335; *Architectural Annual: Chicago*, 1930, p. 53; *Logic of Modern Architecture*, R. W. Sexton, 1929, p. 53. It was also known as Northwestern University Memorial Hospital, Passavant Pavilion. See also Wesley Memorial Hospital. A three-story Passavant Hospital of 1885–1959, HABS, was at 145 W. Superior Street.

North: AMERICAN BANKERS INSURANCE building, at 43 E. Ohio Street, on the southeast corner of N. Wabash Avenue, built in 1929, is 12 stories

high, on wood pile foundations. Childs & Smith were the architects and F. William Seidensticker the engineer. It is illustrated in AA February 1929, and in *Buildings and Building Management* for October 1929, with a full description. A photograph is in OBD 1941–42, p. 18; RB December 1, 1951, p. 12; Annual Review, January 27, 1962, p. 116; and HB. Known also as the Illinois Agricultural Association building, the building was renamed the American Red Cross building.

North: 1242 N. LAKE SHORE DRIVE building, built in 1929, is 27 stories high. Robert S. DeGolyer was the architect; Smith & Brown were the engineers. An illustration is in ISA 1930–31, p. 128, and HB. See appendix F. The building is in the Gold Coast Historic District/NR.

North: 1420 N. LAKE SHORE DRIVE building, built in 1929, is 19 stories high. Hooper & Janusch were the architects. An illustration and a typical floor plan are in BW, p. 25. Photographs are in IA-C March 1985, shown with 1418 N. Lake Shore Drive, and in HB. The building is in the Gold Coast Historic District/NR.

North: 1260 N. DEARBORN PARKWAY apartment building, built ca. 1929, in the Gold Coast Historic District/NR, is 12 stories high. A photograph is in HB.

North: MEDINAH CLUB building (fig. 42), at 505 N. Michigan Avenue, on the northeast corner of E. Illinois Street, was later the Chicago Towers building, the Continental Hotel, and the Sheraton Hotel. It was finished in 1929. Walter W. Ahlschlager was the architect and Frank A. Randall the structural engineer. The building is 45 stories high, 512 feet, on rock caissons. It is illustrated in A for February 1929. A photograph is in CIM, p. 546; CYT, p. 53; ISA 1930–31, p. 576; ACMA, p. 112; AF December 1973, p. 52; STL, p. 148; CNM, p. 140; and WACH, p. 69. An article is in IA-C November 1991, p. 46. There is a monograph by H. G. Phillips, ca. 1929. Known also as the Radisson Hotel, the building was renamed the Hotel Inter-Continental. See also the connected Forum Hotel of the same ownership.

North: *MARSHALL FIELD APARTMENTS,* NR, in the block bounded by W. Blackhawk, N. Sedgwick, W. Siegel Streets, and N. Hudson Avenue, built in 1929, is six stories high, of reinforced concrete construction. Andrew J. Thomas was the architect, and Graham, Anderson, Probst & White were the architectural consultants. An illustration is in AF September 1930, p. 356, and AGC, p. 177. The group of ten buildings was renamed the Town and Garden Apartments, 1448 N. Sedgwick Street. It was also known as Old Town Gardens.

North: 1211 N. LaSALLE DRIVE apartment hotel, built in 1929, is 19 stories high. Oldefest & Williams were the architects. It was also known as

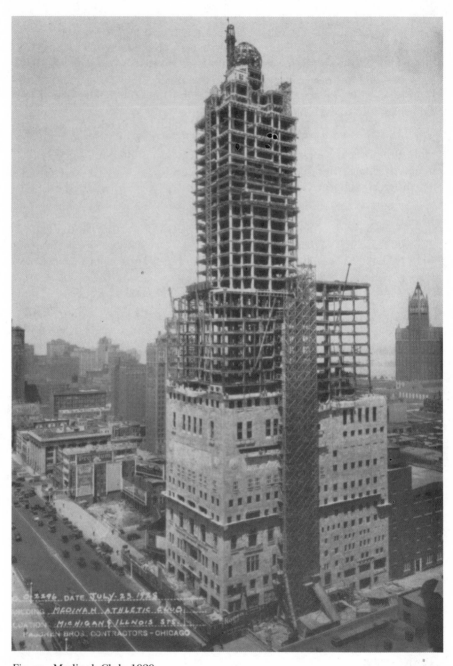

Fig. 42. Medinah Club, 1929

LaSalle Towers. It was converted to apartments in 1980; Weese, Seegers, Hickey, Weese were the architects, and Richard Haas was the facade artist. A photograph is in AGC, p. 167.

1929: The stock market collapsed in October. The ensuing Great Depression virtually stopped new construction, and many buildings were destroyed in order to reduce property taxes; one- and two-story buildings were erected to provide enough income to pay the taxes on the ground.

ca. 1930: The LaSalle Boulevard widening project caused the razing or the cutting back and refacing of many buildings.

ONE N. LASALLE STREET building, CAL, CLSI, built in 1930, is 49 stories high, 530 feet, on rock caissons. Vitzhum & Burns were the architects. An illustration is in CIM, p. 546; OBD 1929, p. 248; STL, p. 132; and HB. It was renamed the American National Bank building. The Tacoma, Chemical Bank, and 15–19 N. LaSalle Street buildings previously occupied this site.

201 N. WELLS STREET building, at the northeast corner of W. Lake Street, formerly called the Trustees building, completed in 1930, is 20 stories high, with an eight-story tower, 336 feet, on hardpan caissons. Thielbar & Fugard were the architects and James B. Black the engineer. Empberger cast-iron columns were used in the 20-story portions as cores for spiraled concrete columns. Steel columns were used under the tower portion. An illustration is in ISA 1930–31, p. 570, and OBD 1941–42, p. 420. In 1949 the name was changed to Corn Products building and was sometimes identified as the Corn Exchange. Photographs are in STL, p. 163; AGC, p. 83; *Architectural Annual: Chicago,* 1930, p. 31; and HB. A photograph of a tower detail is in *Chicago,* Finis Farr, 1973, p. 245. A drawing is in CA, p. 11. The building was renamed the 201 Tower building. It has been converted to apartments. A Robbins building previously occupied this site, as did a John Sexton building earlier.

PALMER HOUSE GARAGE, 1930–early 1960s, at 20 W. Quincy Street, was 25 stories high, on rock caissons. Walter W. Ahlschlager was the architect. The Quincy building previously occupied this site. The Dirksen Federal Center building includes this site.

LaSALLE-WACKER building, CLSI, at 221 N. LaSalle Street, built in 1930, rises 491 feet. It has 23 stories and three basements, with an 18-story tower, on rock caissons. Holabird & Root were the architects (Andrew N. Rebori, associate architect) and Smith & Brown the engineers. A photograph is in CAA, and an illustration is in OBD 1929, p. 167. Photographs are in STL, p. 154; HRHR Vol. 2, p. 365; ABOV, p. 35; and HB. The LaSalle-Wacker building is at the southeast corner of W. Wacker Drive.

SOCONY-VACUUM CO. building, at 59–67 E. Van Buren Street, formerly known as the Buckingham building, built in 1930, is 27 stories, 306 feet high, on rock caissons. Holabird & Root were the architects and Verne O. McClurg the engineer. A photograph is in OBD 1941–42, p. 366; HRHR Vol. 3, p. 22; RB February 2, 1963, p. 6; and Annual Review, January 29, p. 103. A description of the construction is in ENR March 27 and November 27, 1930. The structure was also known as the New Athenaeum building; the Athenaeum building previously occupied this site. It was renamed the 59 E. Van Buren Street building.

FASHION-TRADES building, at 318 W. Adams Street, built in 1930, is 19 stories high, on pile foundations. The street facade is of cast stone. Loebl & Schlossman were the architects. A photograph is in RB Annual Review, January 26, 1963, p. 118. The building was renamed the 318 W. Adams Street building. The Martin Ryerson building previously occupied this site.

ATLAS building, at 226 S. Wabash Avenue, built in 1930, is 10 stories high, on caisson foundations. Eric Hall was the architect. It was renamed the 228 S. Wabash Avenue building. A sliver of this building shows in STL, p. 62, to the left of the McClurg building. A Hartman building (not listed) previously occupied this site. It was renamed Brainstorm Communications.

South: HARRISON HOTEL, at 65 E. Harrison Street, on the southeast corner of S. Wabash Avenue, was built in 1930. A. S. Alschuler was the architect, and Lieberman & Hein were the engineers. The building is 12 stories high, supported on piles. It is illustrated in HE; ISA 1930–31; and ADE. It was renamed the Harrison Motor Hotel. The Queen Hotel previously occupied a portion of this site.

South: ELECTRIC GARAGE, at 615 S. Wabash Avenue, built in 1930, is 21 stories high, on pile foundations. A. S. Alschuler was the architect, and Lieberman & Hein were the engineers. It is illustrated in ISA 1930–31, p. 104. It was renamed Harrison Parking.

South: ADLER PLANETARIUM, NHL, CLSI/premier, at E. Roosevelt Road and Lake Michigan, is described and illustrated in AF February 1931. Ernest Grunsfeld was the architect, and Lieberman & Hein were the engineers. The circular planetarium chamber is 72 feet in diameter, and the exterior diameter of the building is 160 feet. The dome is 68 feet high. The building, the first planetarium building in America, was opened May 12, 1930. A description and an illustration are in C, p. 50. A photograph is in CAA; CFB; AGC, p. 44; Architectural Annual: Chicago, 1930, p. 63; ABOV, p. 11, bird's-eye view; CH10, p. 202; and CRC, p. 45.

South: EAST SEVENTH STREET HOTEL, built in 1930 at 1 E. Balbo Street, is five stories high. Michaelson & Rognstad were the architects. It was also known as the Carter Hotel and as the South Loop Club.

North: MICHIGAN SQUARE building, 1930–1974, was at 540 N. Michigan Avenue, covering the block bounded by E. Grand Avenue, N. Rush Street, E. Ohio Street, and N. Michigan Avenue except for a frontage of approximately 23 feet on N. Rush Street at E. Grand Avenue. Eight stories and three basements high on N. Michigan Avenue, and one story high on N. Rush Street, on caissons, it was designed for 15 stories. Holabird & Root were the architects and Smith & Brown the engineers. A photograph is in OBD 1941–42, p. 238; AF December 1973, p. 53; TBC, p. 184; CNM, p. 165; HRHR Vol. 3, p. 48; RB December 1, 1951, p. 10; AR October 1931, p. 257, and December 1973, p. 53; HB; *Architectural Annual: Chicago,* 1930, p. 25; and LC, p. 215, Diana Court. Of many names, the building was also known as the Time-Life building. The Marriott Hotel occupies this site.

North: 700 N. MICHIGAN AVENUE building, ca. 1930–(1950 to 1990), formerly known as the Judah building, was five stories high. Holabird & Root were the architects and Verne O. McClurg the engineer. It is illustrated in OBD 1941–42, p. 355, and by photograph in A for January 1930; CNM, p. 17; *Architectural Annual: Chicago,* 1930, p. 29; CAD, p. 136; and RB Annual Review, January 25, 1958, p. 68. A drawing is in HRHR Vol. 3, p. 45. The Chicago Place building occupies this site.

North: ORLEANS-HURON building, at 325 W. Huron Street, on the southeast corner of N. Orleans Street, built in 1930, is eight stories high. H. A. Anderson was the architect. An illustration is in OBD 1941–42, p. 304. A photograph is in RB Annual Review, January 27, 1968, p. 115. A drawing is in RB March 23, 1985, p. 1. The building has been known as the Helix Co., a photo lab. The lofts were converted to offices and renamed the 325 W. Huron Street building.

North: 1100 N. LaSALLE DRIVE apartment building, at the northwest corner of W. Maple Street, built in 1930, is 16 stories high. Louis Guenzel was the architect. A photograph is in RB June 23, 1973, p. 1. The structure was renamed the Maple Apartments building.

North: 1500 N. LAKE SHORE DRIVE building, at the northwest corner of E. Burton Place, completed in 1931, is 23 stories high. McNally & Quinn were the architects, and Rosario Candela was the associate architect; Smith & Brown were the engineers. A photograph and a typical floor plan are in BW, p. 12. An illustration is in ISA 1929, p. 308. Photographs are in *Architectural Annual: Chicago,* 1930, p. 68; HB; and RB July 14, 1951, p. 8. The building is in the Gold Coast Historic District/NR.

North: CHICAGO HISTORICAL SOCIETY building, 1601 N. Clark Street, at the northeast corner of W. North Avenue, was built in 1931 and opened to the public in 1932. Graham, Anderson, Probst & White were the architects, and Magnus Gunderson was the engineer. The building is three stories

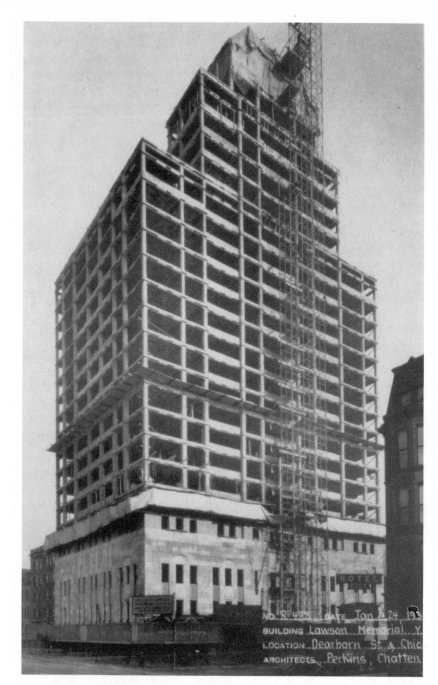

Fig. 43. Lawson YMCA, 1931

high, on spread foundations. A photograph is in HE and in CCP, p. 105. Photographs and floor plans are in AWG. This is the fourth home of the Chicago Historical Society, the three former buildings having been located at the northwest corner of N. Dearborn and W. Ontario Streets. A photograph of the third building is in CAA, CIM, and RMNP. Alfred P. Shaw was the architect for a 1971 addition. Holabird & Root were the architects for a 1988 addition; Gerald Horn was the designer. Articles are in ARCH November 1988, p. 82, and IA-C May 1989, p. 59. Photographs are in AGC, p. 171, and HB. A drawing is in GAPW, p. 245.

North: LAWSON YMCA building (fig. 43), at 30 W. Chicago Avenue, on the northeast corner of N. Dearborn Parkway, was completed in 1931. It is 24 stories high, with two basements. Chatten & Hammond were the architects and Frank A. Randall the structural engineer. Because of a large, deep, city water tunnel that diagonally crosses the lot, a heavy reinforced concrete mat foundation was used, supported on piles, with rock caissons under the north and east walls. Lightweight aggregate was used in all concrete floor construction and fireproofing. A photograph is in CCP, p. 152.

North: 1260 N. ASTOR STREET apartment building, at the southwest corner of E. Goethe Street, built in 1931, is 11 to 16 stories high. Philip B. Maher was the architect. Photographs are in CAD, p. 123; *Architectural Annual: Chicago*, 1931; and HB. The building is in the Astor Street Landmark District/CHALC, within the Gold Coast Historic District/NR.

1930: Board of Trade building (fig. 44): see the 1885 Board of Trade for discussion.

1931: The Commonwealth Edison Substation, at 117 N. Dearborn Street, is the only structure standing in the otherwise vacant "Block 37." Photographs of the substation are in ABOV, p. 43; HRHR Vol. 3, p. 88; and CAD, p. 247. See 1889 Chemical Bank.

Marshall FIELD building, CAL, CLSI, at 135 S. LaSalle Street, on the northeast corner of W. Adams Street and northwest corner of S. Clark and W. Adams Streets, was completed in 1932 and 1934. Graham, Anderson, Probst & White (Alfred P. Shaw, designer) were the architects, and Magnus Gunderson was the engineer. The building is 23 stories high, with a 19-story tower, on rock caissons. Photographs and floor plans are in AWG. A photograph is in CAA; COF; AF December 1973, p. 50; STL, p. 170; GAPW, pp. 60 and 215; IA-C January 1990, p. 63; CE October 1934, p. 506; and HB. An illustration is in AR August 1934; OBD 1941–42, p. 117; and ISA 1938–39, p. 692. The Field building was renamed the LaSalle Bank building. Buildings previously on this site include the Home Insurance building (a plaque is in the Field building lobby), Porter Block, Edison, and Merchants Loan

Fig. 44. New Board of Trade, 1930

& Trust buildings. The Building Owners & Managers Association offices are here.

CHICAGOAN HOTEL, 1932–ca. 1966, at 67 W. Madison Street, was an addition to the Morrison Hotel, 23 stories high, on caissons. Holabird & Root were the architects and Verne O. McClurg was the engineer. A photograph is in HRHR Vol. 2, p. 330, under construction. The One First National Plaza building includes this site.

South: CENTURY OF PROGRESS (1933–34) buildings were of temporary — and some of unusual — construction. They are described and illustrated in WSE October 1932, August 1933, and August 1936 (skyride). Many photographs are in CAA and CCP. Vintage and contemporary bird's-eye views of Northerly Island and lakefront buildings are in ABOV, p. 12. Photographs are in HB and in LC, p. 164.

West: U.S. CUSTOMS HOUSE, built in 1932 at 610 S. Canal Street, at the southwest corner of W. Harrison Street, is 12 stories high. James A. Wetmore was the architect, with Burnham Brothers and Nimmons, Carr & Wright, associated architects. Photographs are in CPH, frontispiece, and ABOV, p. 42, scene to the right of the Post Office.

1932: Main Post Office: see U.S. Post Office of 1855.

North: SEARLE building, 1932–(1950 to 1990), at 215 W. Ohio Street, known as the Ohio building, was a four-story building. Henry C. Hengels was the architect. This building burned down and was rebuilt as a six-story building in 1932 (R. T. Sullivan, engineer). A photograph is in HB. This site is used for parking.

GOLDBLATT'S building, at 330–32 S. Wabash Avenue, 1934–(1950 to 1990), was eight stories high, on hardpan caissons. Graham, Anderson, Probst & White were the architects, and Magnus Gunderson was the engineer. This was originally the Davis Store building. The site is used for parking.

North: WGN STUDIO building, at 443–51 N. Michigan Avenue, on the southeast corner of E. Illinois Street, built in 1935 by the Chicago Tribune, is three stories high. Closed-end steel pipe piles were used. Howells, Hood & Fouilhoux were the architects, Leo J. Weissenborn was the associate architect, and Smith & Brown were the engineers. Photographs are in CNM, p. 86, and ILL, p. 72. The WGN Studio building is an addition to the Chicago Tribune Square complex.

North: CLARIDGE HOTEL, built in 1935 as the Tuscany Hotel, at 1244 N. Dearborn Street, is 10 stories high. Bank, Eaton were the architects for renovation and an addition in 1990.

1936: The Outer Drive extension and bridge were under construction, as was the Dearborn and State Street subway system, for which many buildings' foundations were improved, largely with caissons, and many buildings were condemned.

BENSON & RIXON building, at 230 S. State Street, on the southwest corner of W. Quincy Street, was built in 1937. It is six stories high, on a concrete mat foundation. A. S. Alschuler was the architect. A photograph of the predecessor building is in *Chicago Daily News,* March 28, 1937. Old "Quincy No. 9," three stories (?) high and 10 feet wide, was on the west portion of this site. The Benson & Rixon building is occupied by a McDonald's Restaurant.

North: KRAFT CHEESE CO. building, at 500 N. Peshtigo Court, on the southwest corner of E. Grand Avenue, was built in 1937. It is 5 to 10 stories high. Mundie, Jensen, Bourke & Havens were the architects and engineers. A photograph of the model is in ISA 1938–39, p. 392, and a photograph of the building is in CAA. The building was converted and renamed the Chicago Police Department building.

North: MOODY BIBLE INSTITUTE building, at 830 N. LaSalle Drive, built in 1937, is 12 stories high, on wood piles. Thielbar & Fugard were the architects and James B. Black the engineer. A photograph of the predecessor Moody Bible Institute building is in *Chicago Tribune,* February 17, 1940. The first building for the institute was built in 1873 at the northwest corner of W. Chicago Avenue and N. LaSalle Drive; a photograph is in LC, p. 79.

1937: A quintuple-foldout, panoramic view of the city from the Morrison Hotel Tower is in GMM.

North: ESQUIRE THEATER, built in 1938 at 58 E. Oak Street, was designed by William and Hal Pereira, architects. It was converted to six theaters and renamed the Esquire Center; Gelick, Foran were the architects. An article is in IA-C November 1991, p. 50. Photographs are in 1987 COF, p. 170; HB; RB March 25, 1978, p. 1; and *American Picture Palaces,* David Naylor, 1991, p. 174.

MONROE GARAGE, at 12 E. Monroe Street, built in 1940, is 10 stories high, on caissons. Louis Kroman was the architect and Benjamin Shapiro the engineer. In 1948 the foundations were reinforced in connection with the incorporation of this building into the Carson, Pirie, Scott & Co. store. A photograph is in CSA, fig. 185. DeJonghe's Hotel/Chicago Club previously occupied this site.

VON LENGERKE & ANTOINE building, at 9 N. Wabash Avenue, built in 1941, is six stories high, of reinforced concrete construction. Mundie, Jensen, Bourke & Havens were the architects and engineers. The building was erected on a parking lot. It was renamed the Lane-Bryant Store. A photo-

graph is in HB. The site was occupied earlier by a five-story portion of the Kesner building.

North: WESLEY MEMORIAL HOSPITAL, at 250 E. Superior Street, on the northwest corner of N. Fairbanks Court, completed in 1941, is 20 stories high, on wood piles. Thielbar & Fugard were the architects and James B. Black the engineer. A construction photograph is in *Chicago Tribune,* July 28, 1940. This is also known as the Wesley Pavilion, Northwestern University Memorial Hospital.

1941: A scene of N. Lake Shore Drive from the Palmolive building is in FC, p. 14.

1941–45: There was a virtual building construction hiatus during World War II.

1943: The subway system began operation.

North: CADILLAC building, at 40–66 E. Ontario Street, extending 300 feet from N. Rush Street to N. Wabash Avenue, was completed in 1946. The frontage on N. Rush Street is 109 feet (nos. 630–40) and on N. Wabash Avenue 149 feet (nos. 631–43). The building is five stories high, with a partial basement, of reinforced concrete construction, supported on 70-foot piles. Victor L. Charn was the architect. It was renamed the Steve Foley Cadillac building, 630 N. Rush Street. A photograph is in RB December 1, 1951. The building was converted in 1996 to mixed usage, including shops, offices, and an American culture museum, and renamed the Vitec building and the Sports Authority (Jordan Mozer, architect), and McClier Corp.

BASKIN store building, 1947–1994, at 137 S. State Street, at the northeast corner of E. Adams Street, was opened on December 15, 1947. It was five stories high, on 65-foot wood piles. Holabird & Root were the architects. A photograph is in *Daily News,* December 6, 1947, and WO, p. 25. A Unicom Thermal Technologies building occupies this site. The Adams-State building previously occupied this site.

1947: On Sunday noon, March 2, a gas explosion completely destroyed the old three-story brick building at 400–402 S. Wells Street (201–11 W. Van Buren Street), fronting 22.5 feet on S. Wells Street and 100 feet on W. Van Buren Street. The explosion occurred below the sidewalk near the center of the Van Buren Street side. Serious damage was done to several buildings in the neighborhood. Descriptions and photographs are in newspapers of the days following the explosion.

BOND building, at 234–48 S. State Street, 2–10 W. Jackson Street, and 11–19 W. Quincy Street, completed in 1949, replaced the old Hub building

(1883–1947). The frontage on S. State Street is 123 feet 10½ inches; on W. Jackson, 100 feet 1½ inches; and on W. Quincy, 50 feet. The building is six stories high, on 62-foot wood piles. The State and Jackson facades were faced with granite. The framing is of structural steel to the second floor and reinforced concrete above. Friedman, Alschuler & Sincere were the architects, with Morris Lapidus as associate architect. The building was refaced and converted to offices in 1981 and renamed the 10 W. Jackson Parkway building; Fujikawa, Johnson were the architects and CBM were the engineers. The U.S. Department of Justice, Immigration and Naturalization Service, occupies this building.

South: TOLL BUILDING NO. 2 of the Illinois Bell Telephone Company, at the southeast corner of S. Clark and W. Congress Streets, completed in 1948, is 11 stories high, supported on caissons to rock. It fronts 197 feet on Clark and 100 feet on Congress. Holabird & Root were the architects. A photograph is in *Chicago Tribune,* August 15, 1948. The building was renamed the Illinois Bell Central building, 523 S. Clark Street, in the South Loop Printing House Historic District/NR. A partial view is in ABOV, p. 82, with rooftop communications equipment.

1948: The "El" structure on North Wacker Drive was removed.

WOOLWORTH building, at 211–29 S. State Street, embraces the present Spalding building at 211–17 S. State Street with a frontage of 42.5 feet, and replaced with a three-story fireproof building the two five-story buildings at 219–23 and 225–29 S. State Street, which had frontages of 47.5 and 50 feet, respectively, making a total frontage of 140 feet, with a depth of 145 feet. The present Spalding building is on wood pile foundations, and its basement was lowered about six feet. The building was built in 1949. Shaw, Metz & Dolio were the architects and engineers. A photograph is in RB March 9 Bulletin, 1950. In early 1998, Woolworth has been reported to have vacated these buildings.

West: FLORSHEIM (Shoe Co.) OFFICES and FACTORY was built in 1949. The 130 S. Canal Street building (and 506 W. Adams Street to S. Clinton Street) is three and five stories high. Shaw, Metz & Dolio were the architects/engineers. Photographs are in GCA, p. 67; *Chicago Architects,* Stuart Cohen, 1976, p. 102; and HB. The building has been converted to lofts and condominiums and renamed Metropolitan Place.

1949: Construction of the State Street bridge and subsequent 50-foot widening of the street north of the river resulted in the removal of many small buildings on the west side of the street.

Period VI: From 1950 to 1998

The very slow pace of postwar construction picked up in the 1950s and strengthened in the 1960s. Heavy construction accelerated in the 1970s and 1980s with brief interruptions until peaking around 1990. The boom culminated — as did that of the late nineteenth century, although more intensely — in the early years of the century's final decade. The nearly 400 major new additions and structures, the economic obsolescence of old buildings, and a demand for more parking facilities caused several hundred demolitions of the subject buildings. Construction activity was accompanied by extensive major renovations not recorded here and by the functional conversion of scores of sound old buildings.

The new, broader city center was enriched by both new and expanded cultural facilities. Increased construction of residential, educational, medical, religious, and recreational / entertainment structures and the removal of most of the historical loft-industrial building stock afforded an enhanced urban way of life. The optimistic vision of institutional, real estate, and commercial entrepreneurs and their financial supporters ensured the place of Chicago as one of America's greatest cities.

The dramatic change and development of several of the city's downtown neighborhoods was influenced positively by major street improvements, with spreading and intensifying activity and density in every direction. The attention-drawing towers gave the thriving, energetic city a new skyline — in its major avenues, in the new riverfront from its mouth to Congress Parkway, and in the historic, miles-long lakefront facade.

Although the height of buildings had been constrained for several decades by earlier city ordinances, in 1973 the ingenuity of engineers made it possible to recapture the height record from New York City after 78 years. This was a reassertion of Chicago's early achievement in developing the nation's most celebrated construction type, the skeleton-framed skyscraper. Numerous technical advances have moderated construction costs so that the very tall structures that were formerly considered to be uneconomical have become practical as well as functional without posturing with spindly spires. Now the highest-*point* record holders worldwide, topped out in 1996, are the 88-story Petronas twin towers in Kuala Lumpur, Malaysia. These are 22 stories shorter than the Sears Tower (q.v.) but have 150-foot tips that reach about 22 feet higher than the Chicago landmark.

During Period VI, new concepts of employing bundled tubes, composite structures of steel and reinforced concrete, and higher-strength materials enabled the attainment of great heights economically. Refinements in many aspects of engineering design, materials, and processes contributed to cost savings and the sophistication of construction. The use of both high-strength steel and high-strength concrete and the employment of greater load-bear-

ing factors for soils in foundation design are noteworthy. Optimum spanning for more flexible office space, the amelioration of facade-loading problems, advances in the alleviation of wind forces, and the founding of very tall buildings on the shallower hardpan instead of on deep caissons to rock are among the developments of this period.

Structural steel framing was so prevalent in previous periods that basic structural types were not usually noted in this text. The highly remarkable growth in the employment of reinforced concrete makes it desirable to state the general construction type used in this period. Concrete is now commonly utilized for the entire structure of tall buildings, but frequently it is used for interior core enclosures and bracing walls in combination with peripheral steel framing as composite construction. The use of a reinforced concrete frame for the sixteen-story Ingalls building of 1901 in Cincinnati was highly innovative for its day, but in the past forty-eight years Chicago achieved new record heights time and time again with this adaptable material.

One can only generalize here about such all-important matters of structural advances. The reader who is interested in detail and in projections of new concepts for the future may refer to the extensive and authoritative books of the (worldwide) Council on Tall Buildings and Urban Habitat (CTBUH), to engineering journals for articles like that of structural engineer Don Belford in *Civil Engineering* for July 1972, or to the specialized technical literature about structural design.

North: 1350 N. ASTOR STREET CO-OP APARTMENT building, built in 1950 in the Astor Street Landmark District/CHALC, within the Gold Coast Historic District/NR, is 15 stories high. Ralph C. Harris was the architect. Photographs are in HB and in RB February 18, p. 1, and January 27, 1951, p. 34.

North: 101 E. ONTARIO STREET building, 1951–1995, at the southeast corner of N. Rush Street, was eight stories high. This was originally the American-Marietta building. Leichenko & Esser were the architects. A drawing is in RB December 1, 1951, p. 11. The space of the Arts Club of Chicago was designed by Ludwig Mies van der Rohe, architect. Major elements of the entry stairway were incorporated in a new Arts Club building by John Vinci, architect, in 1997. The 600 N. Michigan Avenue building includes this site.

North: 1350 and 1360 N. LAKE SHORE DRIVE apartment buildings, built in 1951, are 22 stories high. Loebl, Schlossman & Bennett were the architects, with Richard Bennett the designer. Photographs are in AGC, p. 159; RB Annual Review, January 25, 1958, p. 155 (advert.); and see appendix F. The Potter Palmer residence previously occupied this site.

North: 1335 N. ASTOR STREET CO-OP APARTMENT building, built in 1951 at the northeast corner of E. Banks Street, in the Astor Street Land-

mark District/CHALC, within the Gold Coast Historic District/NR, is 16 stories high. Leo S. Hirschfield was the architect. A photo is in RB January 28, 1950, p. 32.

North: *860 and 880 N. LAKE SHORE DRIVE APARTMENTS,* NR, CAL/ CHALC, built in 1952 at the southwest corner of E. Delaware Place, extending to E. Chestnut Street, are 26 stories, 270 feet high, of steel frame construction. Ludwig Mies van der Rohe was the architect, with Pace Associates and Holsman, Holsman, Klekamp & Taylor, associated architects; Frank J. Kornacker was the engineer. Photographs are in *Space, Time and Architecture,* Sigfried Giedion, 1941; CFB; AUS, p. 175, detail; GCA, p. 64; STL, p. 176, under construction; CH30, p. 55; TAA, with 14 references; *Form Givers at Mid-Century,* American Federation of Arts, 1959, p. 19; TBC, p. 240; *Horizons* magazine, April 1986; *Three Centuries of Notable American Architects,* ed. Joseph J. Thorndike, 1981, p. 271, at night; AF November 1952, p. 93; *Mies van der Rohe,* Arthur Drexler, 1960, figs. 81–84; MAC, p. 323, with plan; MEA Vol. 3, p. 193; PROC, p. 10; HB; SCS, p. 46; CSV, p. 119; CALP; and see appendix F.

North: 201 E. WALTON PLACE apartment building, built in 1952 at the southeast corner of N. Mies van der Rohe Drive, is 18 stories high. Known also as the Walton Promenade, it was renamed the Residence Inn By Marriott. Shaw, Metz & Dolio were the architects/engineers. Photographs are in TBC, p. 261; HB; RB April 14, 1951, p. 3.

North: 42 E. WALTON PLACE apartment building, built in 1952, is 13 stories high. It is also known as Walton Tower. Harry Weese was the architect and CBM the engineers.

ST. PETER'S CHURCH and FRIARY, built in 1953 at 110 W. Madison Street, is five stories high. Vitzhum & Burns were the architects. Photographs are in CCS, p. 197, and in 1987 COF, p. 69, partial photograph. The LaSalle Theater (not listed) previously occupied this site.

North: VETERANS ADMINISTRATION RESEARCH HOSPITAL, built in 1953 in the block bounded by E. Huron, N. McClurg, E. Erie, and N. Fairbanks Court, is 16 stories high. Schmidt, Garden & Erikson were the architects. It was renamed the V. A. Lakeside Medical Center. Photographs are in CAD and in ABOV, p. 21, scene west of the Furniture Mart.

North: 1530 N. STATE PARKWAY apartment building, built in 1953, is fourteen stories high. Shaw, Metz & Dolio were the architects/engineers.

155 N. WACKER DRIVE building, built in 1954 at the northeast corner of W. Randolph Street, is 10 stories high, of reinforced concrete construction. Holabird & Root were the architects. It was originally the Sinclair (Oil Co.) building. Photographs are in the *Chicago American* newspaper, April 24,

1958, part 2, p. 23; RB Annual Review, January 31, 1959, p. 16, and January 21, 1961, p. 1.

North: METROPOLITAN SANITARY DISTRICT building, built in 1954 at 100 E. Erie Street, at the northeast corner of N. Rush Street, is five stories high. Frank Finlayson was the architect, with Philip B. Maher as design consultant. The Cyrus McCormick residence occupied this site.

North: NATIONAL CONGRESS OF PARENTS AND TEACHERS building, built in 1954 at 700 N. Rush Street, at the northwest corner of E. Huron Street, is three stories high. Holabird & Root & Burgee were the architects. Photographs are in HB and in RB Annual Review, January 26, 1963, p. 24.

North: 1000 N. LAKE SHORE DRIVE building, built in 1954, is 23 stories high. Sidney Morris was the architect.

1954: North and South Wacker Drive was improved, including widening and double-decking, resulting in removal or refacing of many buildings.

ONE PRUDENTIAL PLAZA building, built in 1955 at 130 E. Randolph Street, is 42 stories, 601 feet high, the tallest building in the city when it was built. It is steel frame construction. Naess & Murphy were the architects. Photographs are in STL, p. 178; CNM, p. 209; ABOV, p. 50; GCA, p. 72; RB January 30, 1960, cover; PROC, p. 124; and CSV, p. 80. This was originally the Prudential building; see also Two Prudential building.

North: 850 N. DeWITT CONDOMINIUM building, built in 1955 at the southwest corner of N. Chestnut Street, is 22 stories high. Hirschfield & Pawlan were the architects. A photograph is in RB July 1954, p. 1.

North: 227 E. WALTON apartment building, built in 1956, between N. Mies van der Rohe Drive and N. DeWitt Place, is 13 stories high. Harry Weese was the architect. Photographs are in the first issue of IA-C September 1957, p. 19 and cover, and in CH30, p. 63.

North: 900 and 910 N. LAKE SHORE DRIVE apartment buildings, built in 1956 at the northwest corner of E. Delaware Place extending to E. Walton Place, are 28 stories, 260 feet high, of reinforced concrete construction. They are also known as the Esplanade Apartments. Ludwig Mies van der Rohe was the architect, with Friedman, Alschuler & Sincere as associated architects. Photographs are in COF, p. 76; CH30, p. 60; CAD, p. 165; PROC, p. 94; and see appendix F.

CHICAGO LOOP SYNAGOGUE was built in 1957 at 16 N. Clark Street. Loebl, Schlossman & Bennett were the architects, with Richard Bennett as the designer. The stained glass facade of 1960 was by Abraham Rattner. Photographs are in CFB, showing the interior, and CCS, p. 202.

AMERICA FORE (insurance group) building, built in 1957 at the northwest corner of W. Jackson Boulevard, is 14 stories high. Known also as the Continental Insurance building, it was renamed the 250 S. Wacker Drive building. Loebl, Schlossman & Bennett were the architects. Photographs are in IA-C September 1957; the *Chicago American* newspaper, April 24, 1958, part 2, p. 23; CMP, frontispiece view of the loop; RB May 17, 1958, p. 122; and January 31, 1959, p. 14. The 224–238 S. Market Street building previously occupied this site.

MUTUAL TRUST LIFE INSURANCE CO. building, 1957–ca. 1980, at 77 W. Wacker Drive, at the northeast corner of S. Wacker Drive and W. Monroe Street, was six stories high. Perkins & Will were the architects. Photographs are in IA-C September 1957, and RB Annual Review, January 16, 1959, p. 16. This site is used for parking. The west portion of the Old Farwell Block previously occupied this site.

North: CHICAGO SUN-TIMES (newspaper) building, built in 1957 at 401 N. Wabash Avenue, at the north bank of the Chicago River, is eight stories high. Naess & Murphy were the architects. It was also known as the Sun Times–Daily News building. A drawing is in IA-C September 1957. Photographs are in CFB; COF; ACMA, p. 174; and RB Annual Review, January 31, 1959, p. 13.

1957: The Chicago Commission on Architectural Landmarks was established. Federal Reserve Bank addition: see 1922.

JEWISH FEDERATION building, built in 1958 at 1 S. Franklin Street at the southeast corner of W. Madison Street, is six stories high. A. Epstein & Sons were the architect/engineers. Loewenberg & Loewenberg were associated architects. A drawing is in IA-C September 1957. The C. H. Henderson building previously occupied this site.

INLAND STEEL building, CAL, built in 1958 at 30 W. Monroe Street, at the northeast corner of N. Dearborn Street, is 19 stories, 250 feet high. It is steel frame construction, with 56-foot clear spans and an early use of steel piles. Skidmore, Owings & Merrill were the architects/engineers, with Walter Netsch and Bruce Graham the designers and Andrew Brown the engineer. Photographs are in CFB; AF April 1958, p. 88, and December 1973, p. 86; CANY, p. 52; COF; STL, p. 180; GCA, p. 69; CSA, fig. 192; ACMA, p. 170; AR April 1958, p. 169; *Bruce Graham*, Rizzoli, 1989, p. 16; CH30, p. 85; TBAR, p. 18; PROC, p. 32; SCS, p. 47; and *Office Buildings*, Architectural Record, 1961, p. 17. The Crilly building previously occupied this site.

BORG-WARNER building, built in 1958 at 200 S. Michigan Avenue, at the southwest corner of E. Adams Street, is 20 stories high. William Lescaze was the architect with A. Epstein, associated architect/engineer. Photographs

are in RB July 27, 1963, p. 2 (advert.); ABOV, p. 27, scene with identifying signage; and see appendix F. The Pullman building previously occupied this site.

North: SALVATION ARMY HEADQUARTERS building, ca. 1958–early 1990s, at 860 N. Dearborn Street, at the southwest corner of W. Delaware Street, was eight stories high. Skadberg-Olson were the architects. A drawing is in RB Annual Review, January 30, 1960, p. 18. The Park Newberry condominium building is under construction in early 1998 on this site.

North: 253 E. DELAWARE Place building, built in 1958 at the southeast corner of N. DeWitt Place, is 25 stories high. Hirschfield & Pawlan were the architects. It is also known as the Delaware East building.

1958: Chicago's "1980 Plan for the Central Area" was published.

North: 1150 N. LAKE SHORE DRIVE condominium building, built in 1959 at the southwest corner of E. Division Street, is 24 stories high. Hausner & Macsai were the architects and CBM the engineers. Photographs are in TBC, p. 264; GMM, p. 398; HB; and see appendix F.

North: 1445 N. STATE PARKWAY apartment building, built in 1959 at the southeast corner of E. Burton Place, in the Gold Coast Historic District/NR, is 28 stories tall. Philip Maher was the architect. A photograph is in TBC, p. 266; HB; RB Annual Review, January 28, 1961, p. 22.

North: 1540 N. STATE STREET apartment building, built in 1959, is 16 stories high. Christopher J. Chamales was the architect, with Shaw, Metz & Dolio as associated architect/engineers.

South: DAYS INN was built in 1959 at 540 S. Michigan Avenue, at the northwest corner of (72) E. Harrison Street. It is six stories high. Camburas & Theodore were the architects. Originally it was the Envoy Plaza Hotel and, later, the Ramada Hotel. A drawing is in RB Annual Review, January 31, 1959, p. 60.

CLARION EXECUTIVE PLAZA HOTEL, built in 1960 at 71 E. Wacker Drive, between N. Michigan and N. Wabash Avenues, is 40 stories, 340 feet high, the tallest reinforced concrete structure in the world at the time it was built. Milton Schwartz was the architect and Miller Engineering was the engineer. It was built as the Executive House and was later also known as the Executive Plaza Hotel. A description is in *Motels, Hotels, Restaurants and Bars*, Architectural Books, 1960, p. 189. Photographs are in ABOV, pp. 30 and 53 scenes; COF; and RB Annual Review, January 31, 1959, cover.

NATIONAL CASH REGISTER building, 1960–late 1970s, at 223 N. Michigan Avenue, was seven stories high. Naess & Murphy were the architects. A

photograph is in RB May 13, 1961, p. 28. The Boulevard Towers building includes this site.

North: 1440 N. STATE PARKWAY apartment building, built in 1960, is 20 stories high. Hausner & Macsai were the architects. It was renamed the Brownstone Condominium.

North: CARL SANDBURG VILLAGE, built 1960–1965, is bounded by N. Clark Street, N. LaSalle Drive, W. Division Street and W. North Avenue. The association address is 1355 N. Sandberg Terrace. The complex includes low-rise and high-rise buildings to 43 stories. Major "Houses" include Bryant-Alcott, Eliot, Faulkner, Kilmer-James, and Lowell House. Solomon & Cordwell were the architects and Alfred Benesch was the engineer. Photographs are in COF; CFB; GCA, p. 79; AGC, p. 167; STL, p. 217; CH30, p. 216; TBC, p. 299; and GMM, p. 394, bird's-eye view. The project includes the First St. Paul's Evangelical Lutheran Church, built in 1970 at 1301 N. LaSalle Drive, by Edward Dart; a photograph is in CCS and in CAD, p. 195.

North: BEST WESTERN LAKE SHORE DRIVE HOTEL, 1960–late 1980s, at 600 N. Lake Shore Drive, extending from E. Ohio to E. Ontario Street, was 12 stories high. Edward Steinborn was the architect. Originally the Lake Tower Inn, it was also called the Chicago Lake Shore Hotel. Photographs are in GMM, p. 469; RB January 30, 1960, p. 18, January 29, 1966, p. 102, Annual Review, January 28, 1967, p. 20, and January 27, 1968, cover, night scene. This site is vacant.

North: 30 E. ELM STREET apartment building, built ca. 1960, is 21 stories high. Solomon, Cordwell were the architects.

North: 33 E. CEDAR STREET apartment building, built ca. 1960, is 19 stories high. Louis R. Solomon was the architect.

1960: Harris Trust Bank additions: see 1911 Harris Bank. The first McCormick Place: see 1970 McCormick Place.

MORTON THIOKOL building, built in 1961 at 110 N. Wacker Drive, extending from W. Randolph to W. Washington Street, at the east bank of the Chicago River, is six stories high, of reinforced concrete construction. Graham, Anderson, Probst & White were the architects/engineers. It was originally known as the Morton Salt Co. building. Photographs are in ABOV, pp. 36 and 38, bird's-eye views; IA-C September 1957; GAPW; *Chicago American* newspaper, April 24, 1958, part 2, p. 23; and RB Annual Review, January 31, 1959, p. 13.

100 S. WACKER DRIVE building, built in 1961 at the southwest corner of W. Monroe Street, at the east bank of the Chicago River, is 21 stories, 244 feet

high, of reinforced concrete construction. Skidmore, Owings & Merrill were the architects/engineers, with Richard Lenke as engineering designer. It was built as the Hartford (Fire Insurance Co.) building. Photographs are in CFB; CSA, fig. 193; CH30, p. 46; RB Annual Review, January 28, 1961, p. 44, under construction; and PROC, p. 70. See also the 150 S. Wacker Drive building. The Farwell Block previously occupied this site.

111 W. JACKSON BOULEVARD building, built in 1961, extending from S. Clark to S. LaSalle Street, is 24 stories high, of reinforced concrete construction. A. Epstein was the architect/engineer. It was also known as the Trans Union building. A photograph of part of the building is in 1987 COF, p. 76. The Austin building previously occupied this site.

South: ESSEX INN, built in 1961 at 800 S. Michigan Avenue, at the southwest corner of E. 8th Street, is 15 stories high, of reinforced concrete construction. A. Epstein & Sons were the architects/engineers. It is also known as the Essex Motor Hotel. A drawing is in RB May 13, 1961, p. 28. The Bucklen building previously occupied this site.

West: (former) RAMADA INN, built in 1961 but vacant in 1995, at 506 W. Harrison Street at S. Clinton Street, is five stories high, of steel frame construction. Hausner & Macsai were the architects. It was also known as the Winfield Inn. A drawing is in RB June 29, 1961, p. 1.

North: FORUM HOTEL CHICAGO, built in 1961 at 525 N. Michigan Avenue, at the southeast corner of E. Grand Avenue, is 26 stories high. C. F. Murphy and Quinn & Christiansen were associated architects. It was an addition to the Medinah Club, built for the Sheraton Hotel. A photograph is in COF, p. 45.

North: John BLAIR building, built in 1961 at the southeast corner of E. Erie Street, is 11 stories high. It is also known as the 645 N. Michigan Avenue building. Photographs are in RB Annual Review, January 27, 1962, p. 16, and Annual Review, January 31, 1970, p. 149, and *Chicago Daily News,* June 19, 1975.

OUTER DRIVE EAST APARTMENTS building, built in 1962 at 400 E. Randolph Street, at the northeast corner of N. Field Boulevard, is 40 stories high. Pawlan & Reinheimer were the architects. A photograph is in GFC, p. 230, and IA-C February 1972, p. 15.

CNA CENTER (financial-insurance) buildings: the 1962 structure, at 55 E. Jackson Boulevard at the southeast corner of S. Wabash Avenue, is 24 stories, 333 feet high, of steel frame construction. C. F. Murphy was the architect, with Jacques Brownson as designer. The Continental National American building was also known as the Continental Center and was renamed

the CNA Plaza building. See also the Straus and the McCormick buildings. The 1973 south addition, at 325 S. Wabash Avenue, at the northeast corner of E. Van Buren Street, is 45 stories, 598 feet high, of high-strength steel frame construction, with 32-by-42-foot bays. Graham, Anderson, Probst & White were the architects/engineers. Photographs are in RNRC, 1962 building, following p. 128; COF; CFB; CSA, fig. 194; ABOV, pp. 17, 29, and 31 in bright red; CSV, p. 58; PROC, p. 59. A construction photograph is in CN November 22, 1971, p. 16. Trinity Church (not listed) and the Cable building previously occupied this site; Baldwin Piano, Averill, and Steinway Hall occupied the south portion.

29 N. WACKER DRIVE building, built in 1962 at the southeast corner of W. Washington Street, is 10 stories high. A. Epstein & Sons were the architects/engineers. It was planned as the Masonite building. Photographs are in HB and in RB May 27, 1961, p. 1.

North: MARINA CITY, built 1962–1967, 300 N. State Street, is at the north bank of the Chicago River and extends to N. Dearborn Street. This is a mixed-use complex including apartments, shops, theater, restaurants, exhibition and athletic space, offices, and a marina, with parking on the lower 20 stories. The two towers are 65 stories, 588 feet high, the tallest reinforced concrete buildings in the world when they were built. Bertrand Goldberg was the architect, with Frank Kornacker and Severud-Elsted-Kruger as the engineers. Photographs are in AR September 1963; CFB; COF, p. 178; ACMA, p. 174; ABOV, p. 55; AUS, p. 179; AF December 1973, p. 41; STL, p. 188, under construction; CH30, p. 70; WACH, p. 107; HAAW, p. 39; TBC, p. 199; IA-C June 1969, p. 23, balcony detail; MAC, p. 455, with plan; RB Annual Review, January 27, 1962, p. 15, under construction; ARCH March 1995, p. 59; BMT, following p. 242; *Developments in Structural Form*, Rowland Mainstone, 1973, p. 273; CRC, p. 102; and CSV, p. 106, detail.

North: 260 E. CHESTNUT STREET building, built in 1962 at the northwest corner of N. DeWitt Place, is 21 stories. A photograph is in RB June 12, 1975, p. 1.

North: PARK HYATT ON WATER TOWER SQUARE, 1962–1997, at 800 N. Michigan Avenue to the northeast corner of N. Rush Street, is 15 stories high. Hausner & Macsai were the architects, with CBM as the engineers. Photographs are in STL, p. 215, scene, uppermost stories at the left of the Water Tower, and RB May 18, 1963, p. 34.

North: 1550 N. LAKE SHORE DRIVE building, built in 1962 at the southwest corner of E. Division Street, is 36 stories high. Shaw, Metz & Dolio were the architects/engineers. A photograph is in HB, and a drawing is in RB Annual Review, January 28, 1961, p. 31.

1962: A triple-foldout aerial view of the city is in AF May 1963, p. 88.

U.S. GYPSUM building, 1963–1994, at 101 S. Wacker Drive, at the southeast corner of W. Monroe Street, was 17 stories, 220 feet high, of steel frame construction. Perkins & Will were the architects, with Alfred Picardi the engineer. Photographs are in COF; IA-C September 1985, p. 14; STL, p. 186; CH30, p. 91; PROC, p. 125; and SCS, p. 49. Buildings previously occupying this site include 129 S. Market Street, 131 S. Market Street, CB&Q, and Adams-Franklin building. The site is vacant.

South: CHICAGO POLICE DEPARTMENT CENTER building, built in 1963 at 1131 S. State Street, is 13 stories high. Paul Gerhardt was the architect. A drawing is in RB May 13, 1961, p. 12. It has been reported that a new center will be built beyond the central business district.

South: MERRILL C. MEIGS FIELD TERMINAL was built in 1963 on Northerly Island, Outer Drive and 1400 south. Consoer & Morgan were the architects. A photograph is in COF.

North: ASTOR TOWER CONDOMINIUM building, built in 1963 at 1300 N. Astor Street, at the northwest corner of E. Goethe Street, of reinforced concrete construction, is 22 stories high. Bertrand Goldberg was the architect. It was originally a hotel. It is in the Astor Street Landmark District/CHALC, within the Gold Coast Historic District/NR. Photographs are in COF; CH30, p. 67; *Architects on Architecture*, Paul Heyer, 1966, p. 51, at night.

North: 35 E. CHESTNUT STREET apartment building, built in 1963 at the southwest corner of N. Wabash Avenue, is 22 stories high. Hausner & Macsai were the architects. A photograph is in RB Annual Review, January 27, 1968, p. 104.

North: 430 N. MICHIGAN AVENUE building, built in 1963 at the northwest corner of E. Hubbard Street, is 11 stories high. Fred H. Prather was the architect. Known also as the Apollo Savings & Loan and as the Uptown Savings & Loan building, it was renamed the (National Association of) Realtors building. Photographs are in STL, p. 230, shown with the 444 N. Michigan Avenue building, and RB May 19, 1979, p. 1. The Music Corporation of America building previously occupied this site.

North: AMERICAN LIBRARY ASSOCIATION building, built in 1963 at 50 E. Huron Street, is five stories high. Holabird & Root were the architects.

North: 777 N. MICHIGAN AVENUE condominium building, built in 1963 at the southeast corner of E. Chicago Avenue, is 38 stories high. Shaw, Metz were the architects/engineers. A photograph is in STL, p. 164, scene, to the

right of Olympia Centre. The Winston Apartments previously occupied this site.

North: AMERICAN COLLEGE OF SURGEONS building, built in 1963 at 55 E. Erie Street, at the southwest corner of N. Rush Street, is eight stories high, of reinforced concrete construction. Skidmore, Owings & Merrill were the architects/engineers. See also the Nickerson House on the William Ogden residence site.

North: 535 N. MICHIGAN AVENUE condominium building, built in 1963 at the northeast corner of E. Grand Avenue, is 33 stories high. Raggie, Malitz were the architects, with William Schmidt the engineer. It is also known as the Michigan Terrace apartment building.

North: WESTIN HOTEL CHICAGO, built in 1963 at 909 N. Michigan Avenue, at the northeast corner of E. Delaware Place, is 17 stories high, with a 27-story addition in 1978. Shaw, Metz were the architects/engineers. It was originally the Continental Plaza Hotel. Photographs are in STL, p. 215, to the left of the base of the John Hancock building; AUS, p. 142, scene; and CSV, p. 24.

North: 247 E. CHESTNUT STREET building, built in 1963 at the southeast corner of N. DeWitt Place, is 25 stories high. A. Epstein & Sons were the architects. A drawing is in RB Annual Review, January 28, 1961, p. 15.

North: RITCHIE TOWER apartment building, built in 1963 at 1310–22 N. Ritchie Court, in the Gold Coast Historic District/NR, is 30 stories high. Barancik, Conte were the architects. A photograph is in RB October 5, 1963, p. 1.

North: 1300 N. LAKE SHORE DRIVE condominium building, built in 1963 at the northwest corner of E. Goethe Street, is 39 stories high. Gordon, Levin were the architects. Photographs are in RB May 12, 1973, p. 56, and ABOV, p. 237, at the right edge.

North: 1440 N. LAKE SHORE DRIVE condominium building, built in 1963, in the Gold Coast Historic District/NR, is 35 stories high. Hirschfield, Pawlan & Reinheimer were the architects. A photograph is in HB, and see appendix F.

North: BEST WESTERN RIVER NORTH HOTEL, built ca. 1963, at 125 W. Ohio Street, at the southeast corner of N. LaSalle Drive, is five stories high. Before 1986 it was known as Travelodge. It has been reported that the building incorporates part of a former ice house.

FEDERAL CENTER buildings, built from 1964 to 1991, in the block bounded by S. Dearborn, W. Adams, and S. Clark Streets, and W. Jackson

Boulevard, and adjoining blocks. The center includes a one-story post office at the southeast corner of W. Adams and S. Clark Streets. The JOHN C. KLUCZYNSKI building was built in 1974 at 230 S. Dearborn Street, at the northwest corner of W. Jackson Boulevard, 42 stories, 548 feet high, of steel frame construction, and the EVERETT McKINLEY DIRKSEN building was built in 1964 at 219 S. Dearborn Street, 30 stories, 368 feet high; both are of steel frame construction. Both buildings were designed by Ludwig Mies van der Rohe, architect, with Schmidt, Garden & Erikson, C. F. Murphy, and A. Epstein, associated architects/engineers. Photographs are in CFB; COF; AUS, p. 200; ACMA, p. 108; STL, p. 182; AR March 1965, p. 125; TBAR, p. 21; HB; PROC, p. 47; and CRC, p. 82. The RALPH H. METCALF building, built in 1991 at 77 W. Jackson Boulevard at the southeast corner of S. Clark Street, is 28 stories high, of reinforced concrete construction. Fujikawa, Johnson were the architects, with CBM the engineers. A photograph is in CST. Buildings previously occupying these sites include the Grace Hotel on the Metcalf building site and, on the others, the Dexter, Great Northern Hotel, Federal, Bedford/Owings, Majestic Hotel, Temple Court, and Bigelow House.

1 E. WACKER DRIVE building, built in 1964 at the southeast corner of N. State Street, is 41 stories, 522 feet high. Shaw, Metz were the architects/engineers. Originally the United of America building, it was also known as the United Insurance Co. building. Photographs are in STL, pp. 174, 198, and 282 with the Leo Burnett building, and HB. The American Institute of Steel Construction is located here.

North: ONE PLAZA condominium building, built in 1964 at the northwest corner of N. Michigan Avenue and E. Oak Street, is 57 stories, ca. 600 feet high, the tallest reinforced concrete building in the world at the time it was built. Sidney Morris was the architect. Photographs are in STL, p. 252, to the right of One Magnificent Mile; ABOV, p. 25, near the right edge of the scene; HB; RB Annual Review, January 30, 1965, p. 19, under construction; CRC, p. 23, and see appendix F.

North: HANOVER HOUSE apartment building, built in 1964 at 21 E. Goethe Street, in the Gold Coast Historic District/NR, is 18 stories high. Barancik, Conte were the architects. A photograph is in RB July 4, 1964, p. 1.

North: GALTER CARRIAGE HOUSE apartment building, built in 1964 at 215 E. Chicago Avenue, is 28 stories high, of reinforced concrete construction. Hirschfield, Pawlan & Reinheimer were the architects. It was originally called the Carriage House, and it is now a facility for Wesley Hospital nurses' training and apartments and doctors' residence. The building has been reported as incorporating a five-story garage that was built in the 1920s. Photographs are in HB and RB Annual Review, January 30, 1965, p. 19.

North: AMBASSADOR HOUSE condominium building, built in 1964 at 1325 N. State Parkway, at the southeast corner of E. Banks Street, in the Gold Coast Historic District/NR, is 25 stories high. Shaw, Metz were the architects/engineers.

North: 201 E. CHESTNUT STREET condominium building, built in 1964 at the southeast corner of N. Mies van der Rohe Drive, is 26 stories high. A photograph is in HB.

69 W. WASHINGTON STREET building, originally the Brunswick building, built in 1965 at the southwest corner of N. Dearborn Street, is 37 stories, 475 feet high, of reinforced concrete, tube-in-a-tube construction. Skidmore, Owings & Merrill were the architects/engineers. Bruce Graham was the designer and Fazlur R. Khan the engineer. Photographs are in AF April 1966, p. 28; COF; ABOV, p. 44; STL, p. 194; CH30, p. 96; *Bruce Graham,* Rizzoli, p. 36; PROC, p. 80; and BMT, following p. 242. The building was acquired by Cook County in 1996. Buildings previously occupying this site include Kendall, Chicago Title & Trust, Chicago Real Estate Exchange, and Stoner's Restaurant building.

West: 10 RIVERSIDE PLAZA building, built in 1965 at the southeast corner of W. Madison and S. Canal Streets, at the west bank of the Chicago River, is 22 stories, 285 feet high, of steel frame construction. This is a Gateway Center (No. 1) building. Skidmore, Owings & Merrill were the architects/engineers, with Bruce Graham the designer and Don Belford the engineer. Photographs are in STL, p. 223; CH30, p. 91; GMM, p. 459; RB November 21, 1964, p. 1, under construction; and PROC, p. 36.

West: UNIVERSITY OF ILLINOIS CHICAGO CIRCLE CAMPUS, 1965–1979, at S. Halsted and W. Harrison Streets, with many structures (to 28 stories high). Skidmore, Owings & Merrill were the architects/engineers, with Walter Netsch the designer. Associated architects for various buildings include C. F. Murphy, A. Epstein, Harry Weese, and Solomon, Cordwell & Buenz. It was renamed the Chicago Campus. Photographs are in *Architecture of SOM: 1963 to 1973,* 1974, pp. 224–38; ILL, p. 94; COF; AF September 1965, p. 21, December 1968, November 1970; PA October 1965, p. 222; CFB; ABOV, p. 104; CH30, p. 186; IA-C April 1969, p. 18, and March 1993, p. 52, about 1993 alterations (Daniel Coffey, architect); and AUS, p. 185.

North: BARCLAY CHICAGO HOTEL, built in 1965 at 166 E. Superior Street, at the north end of N. St. Clair Street, is 28 stories high. Joel R. Hillman was the architect. Originally offices and apartments, it was also known as the Regency-Orleans building. It was renamed the Summerfield Suites Hotel–Downtown Chicago. It was converted to a hotel in 1982. A photograph is in RB Annual Review, January 30, 1971, p. 136.

North: EQUITABLE (Life Insurance Co.) building, built in 1965 at 401 N. Michigan Avenue, on the eastern side of Pioneer Plaza at the north bank of the Chicago River, is 36 stories, 457 feet high. Skidmore, Owings & Merrill were the architects/engineers, with Don Belford the engineer and Alfred Shaw, associated architect. It is a continuous weld, orthotropic–steel frame structure. It is a Cityfront Center building. Photographs are in CFB; COF; CNM, p. 210; STL, p. 196; CH30, p. 225; RB Annual Review, January 30, 1965, cover, and January 28, 1967, cover; PROC, p. 38; and CSV, p. 51.

North: 222 PEARSON EAST building, built ca. 1965, at the northwest corner of N. DeWitt Street. Solomon, Cordwell were the architects. A drawing is in RB December 7, 1963, p. 1.

North: 1445 N. DEARBORN PARKWAY building, built in 1965, in the Gold Coast Historic District/NR, is six stories high. Alschuler, Wolfson were the architects. A drawing is in RB June 27, 1964, p. 1.

1966: Passage of the National Historic Preservation Act, Public Law 89-665, which was rooted in the Historic Sites Act of 1935 and the National Antiquities Act, ca. 1905.

RICHARD J. DALEY CENTER building, built in 1966, is on W. Washington Street in the block bounded also by N. Clark, W. Randolph, and N. Dearborn Streets. It is 31 stories, rising 662 feet. It is the largest all-welded steel frame and has the longest spans, 87 feet (48-foot bays), of any metallic-framed, multistory structure. C. F. Murphy was the architect, with Jacques Brownson, designer, and Loebl, Schlossman & Bennett and Skidmore, Owings & Merrill associated architects. It is also known as the Chicago Civic Center. Photographs are in CFB; COC; AUS, p. 189, plaza; GCA, p. 78; AF January 1966, p. 41, and October 1966, p. 33; PA October 1966, p. 244; CH30, p. 136; HAAW, p. 28; TBAR, p. 41; RNRC, p. 151, detail; HDM, pp. 18 and 30; and PROC, p. 61. Buildings previously on this site include 140 N. Dearborn Street, Cort Theater, Rawson, Colonial Restaurant, Washington-Dearborn, City Hall Square Hotel, U.S. Express, Fowler-Goodell-Walters Block, Hobbs, Grand Opera House, RKO Grand Theater, Reaper Block, and Henrici's Restaurant building.

CONNECTICUT MUTUAL building, built in 1966 at 33 N. Dearborn Street, at the southeast corner of W. Washington Street, is 25 stories, 348 feet high, of steel frame construction. Skidmore, Owings & Merrill were the architects/engineers, with Robert Serwatkiewicz the engineer. It was renamed the 33 N. Dearborn Street building. The street arcade was closed to increase shop space. Photographs are in IA-C June 1969, p. 20, facade detail, and PROC, p. 65.

Fig. 45. American Dental Association, 1966 (Courtesy Graham, Anderson, Probst and White)

HOME FEDERAL SAVINGS & LOAN building, built in 1966 at 201 S. State Street, at the southeast corner of W. Adams Street, is 15 stories high, of steel frame construction. Skidmore, Owings & Merrill were the architects/engineers, with Ivar C. Hillman the engineer. It was renamed the LaSalle Talman Bank building and the 11 E. Adams Street building. Photographs are in 1987 COF, p. 34, and RB June 30, 1990, p. 72. The Republic building previously occupied the site.

North: AMERICAN DENTAL ASSOCIATION building, built in 1966 at 211 E. Chicago Avenue, is 22 stories high, of steel and reinforced concrete construction (fig. 45). Graham, Anderson, Probst & White were the architects/engineers. A photograph is in STL, p. 264, left of Olympia Centre in scene, and RB Annual Review, January 30, 1965, p. 19, under construction.

North: PLAZA ON DEWITT condominium building, built in 1966 at 860 N. DeWitt Place, at the northwest corner of (260) E. Chestnut Street, is 44 stories, 395 feet high, of tubular frame reinforced concrete construction. Skidmore, Owings & Merrill, architects/engineers, with Bruce Graham as designer and Fazlur R. Khan the engineer. It is also known as the DeWitt-Chestnut Apartments. Photographs are in COF, p. 76, partial; ABOV, p. 22, west of the 860 N. Lake Shore Drive building; *Buildings and Concepts,* Myron

Goldsmith, 1987 pp. 15 and 91; *American Building Materials,* Carl Condit, 1971, p. 91; HB; and RB June 21, 1975, p. 1.

North: THE CARLYLE condominium building, built in 1966 at 1040 N. Lake Shore Drive, at the southwest corner of E. Cedar Street, is 40 stories high, of reinforced concrete construction. Hirschfield, Pawlan & Reinheimer were the architects, with CBM the engineers. Photographs are in 1987 COF, p. 218; TBC, p. 301; and see appendix F. The Borden mansion (RMNV, V26) previously occupied this site.

North: DAYS INN CHICAGO LAKE SHORE DRIVE, built in 1966 at 644 N. Lake Shore Drive, extending from E. Ohio to E. Ontario Street, is 33 stories, 330 feet high. Photographs are in RB Annual Review, January 27, 1968, cover, in a night scene; and GMM, p. 469, with the Furniture Mart.

ILLINOIS BELL TELEPHONE building, built in 1967 at 227 W. Randolph Street, at the southeast corner of N. Franklin Street, is 31 stories, 427 feet high, of steel frame construction. Holabird & Root were the architects/engineers. A photograph is in PROC, p. 126. Buildings previously on this site include the Morton and the Soden buildings.

South: 1130 S. MICHIGAN AVENUE building, built in 1967, is 43 stories high, of reinforced concrete construction. Loewenberg & Loewenberg were the architects, with William Schmidt as engineer. It is also known as the 1130 Apartments building. Photographs are in ABOV, p. 81, tallest building at the upper right; and RB Annual Review, January 27, 1968, p. 54.

North: JOHN FEWKES TOWER building, built in 1967 at 55 W. Chestnut Street, at the southwest corner of N. Dearborn Street, is 29 stories high. Harry Weese was the architect. A photograph is in CH30, p. 67.

SEVENTEENTH CHURCH OF CHRIST, SCIENTIST, built in 1968 at 55 E. Wacker Drive, of reinforced concrete construction. A drawing is in CA, p. 115. Photographs are in COF; CCS, p. 212; and HB. Harry Weese was the architect, the Engineers Collaborative the engineers.

South: WILLIAM JONES METROPOLITAN HIGH SCHOOL, built in 1968 at 608 S. State Street, at the southwest corner of W. Harrison Street, is seven stories high, of reinforced concrete construction. Perkins & Will were the architects/engineers. This was originally the William Jones Commercial High School.

West: 120 S. RIVERSIDE PLAZA building, built in 1968, in the block bounded by W. Monroe, S. Canal, and W. Adams Streets and the west bank of the Chicago River, is 22 stories high, of steel frame construction. Skidmore, Owings & Merrill were the architects/engineers, with Bruce Graham

the designer, and Don Belford the engineer. This is a Gateway Center (No. 2) building. A photograph is in STL, p. 223. The 1881 Union Passenger Station previously occupied this site.

North: 541 N. FAIRBANKS COURT building, built in 1968 at E. Grand Avenue, extending to (303) E. Ohio Street, is 30 stories, 404 feet high, of reinforced concrete construction. Harry Weese was the architect, and James Ruderman was the engineer. This was the first use in Chicago of tandem, two-story elevators. This building was originally the Time-Life building. Photographs are in AR September 1970, p. 20; STL, p. 202; HB; and PROC, p. 74.

North: 1524 N. ASTOR STREET building, built in 1968, in the Astor Street Landmark District/CHALC, within the Gold Coast Historic District/NR. I. W. Colburn was the architect.

North: PARK ASTOR building, built in 1968 at 1515 N. Astor Street, in the Astor Street Landmark District/CHALC, within the Gold Coast Historic District/NR, is 24 stories high. A photograph is in HB.

North: 230 E. ONTARIO STREET building, built in 1968, is 20 stories high.

ONE FIRST NATIONAL PLAZA building, built in 1969 on the north half of the block bounded by W. Madison, S. Clark, W. Monroe, and S. Dearborn Streets, is 60 stories, 850 feet high, of steel frame construction. Perkins & Will and C. F. Murphy were the associated architects. The south half of the block is a public plaza. Photographs are in IA-C July 1968, p. 6, September 1968, and June 1969, p. 50; AR September 1970; COF; AUS, p. 198; ABOV, p. 46; STL, p. 206; PROC, p. 93; and CRC, p. 107. A photograph is in CTCP, p. 44, in a view looking southwest to the Hartford building that includes the 1903 First National Bank building under construction and other buildings in the block. Photographs are in RB Annual Review, January 27, 1968, p. 20, under construction, January 25, 1969, p. 41, worm's-eye view, and Annual Review, January 1979 cover. Buildings previously occupying this block include Hawley, Hartford, Chicagoan Hotel, Montauk, Hamilton Hotel, Fuller Block, Morrison Block and Hotel, and Burnham's Oyster House (not listed here).

55 W. WACKER DRIVE building, built in 1969 at the southwest corner of (222) N. Dearborn Street, is 15 stories, 256 feet high, of reinforced concrete construction. C. F. Murphy was the architect and Otto Stark the engineer. Originally the Blue Cross, Blue Shield building, it was also known as the Ryan (Insurance Co.) building and as the Combined International Insurance building. Photographs are in *Office Building Design*, ed. Mildred Schmertz, 1975; IA-C December 1969; COF; STL, p. 192, with the Richard J. Daley Center.

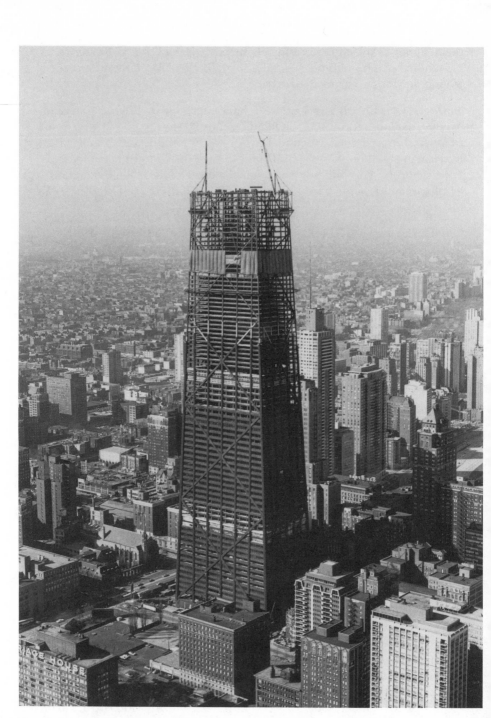

Fig. 46. John Hancock Center, 1969 (Photograph by McShane-Fleming Studios)

North: JOHN HANCOCK CENTER, built in 1969 at 875 N. Michigan Avenue, (175) E. Delaware Place (apartments), to E. Chestnut Street, is 100 stories tall (fig. 46). It reaches 1,127 feet high and 1,476 feet to the tip of the antennas, making it the tallest building in Chicago at the time of construction. It is an exterior-diagonalized, trussed tubular steel frame structure. Skidmore, Owings & Merrill were the architects/engineers, with Bruce Graham the designer, and Fazlur R. Khan the engineer. Paul Weidlinger and Amman & Whitney were consulting engineers. This is a mixed-use building including 29 floors of offices, 48 floors of apartments above, and shops and restaurants. Photographs are in AF July 1970, p. 36, and December 1973, p. 38; AR July 1970, p. 37; *Bruce Graham*, Rizzoli, 1989, p. 46; *Architecture of SOM: 1963 to 1973*, by Architectural Books, 1974, pp. 162–68; STL, p. 212; CH30, p. 103; WACH, p. 169; HAAW, p. 37; TBC, p. 201; HB; AUS, p. 193, detail; RB Annual Review, January 31, 1970, cover scene; PROC, p. 94; CRC, p. 106; and CMAG June 1970, p. 46, antennas. The 98 E. Chestnut Street building was previously on this site.

North: LATIN SCHOOL OF CHICAGO, built in 1969 at 1531 N. Clark Street, at the southeast corner of W. North Boulevard, is five stories high. Harry Weese was the architect. The Plaza Hotel previously occupied this site.

North: 1240 N. LAKE SHORE DRIVE apartment building, built in 1969 at the northwest corner of E. Scott Street, is 33 stories high, of reinforced concrete construction. Hausner & Macsai were the architects. See appendix F.

North: STREETERVILLE CENTER office and condominium building, built in 1969 at 233 E. Erie Street, is 26 stories high. Joel R. Hillman was the architect, CBM the engineers. It was also known as the Brittany.

North: LAKE POINT TOWER condominium building, built in 1969 at 505 N. Lake Shore Drive, at E. Illinois Street, just north of the Ogden slip, is 70 stories, 645 feet high, the world's tallest reinforced concrete building at the time of construction. Design architects Schipporeit-Henrich and Graham, Anderson, Probst & White, associated architects/engineers. William Schmidt was the engineer and Alfred Caldwell the landscape architect. The latter is the subject of *Alfred Caldwell: The Life and Work of a Prairie School Landscape Architect*, ed. Dennis Domer, 1997. Articles about the building are in AF October 1969; AR October 1969, cover and p. 123; RB January 25, 1969, p. 13, and cover, at night. Photographs are in COF; AUS, p. 183; STL, p. 204; CH30, p. 74; TBC, p. 346; HB; PROC, p. 50; CRC, p. 27; and ABOV, p. 68.

North: 640 N. LASALLE DRIVE building, built in 1969 in the block bounded also by W. Ontario, N. Wells, and W. Erie Streets, is six stories high. Alfred

Shaw was the architect, and Patrick Shaw was the designer. It includes Planet Hollywood, 633 N. Wells Street.

North: 1212 N. LAKE SHORE DRIVE condominium building, built in 1969 at the southwest corner of E. Scott Street, is 34 stories high. Barancik, Conte were the architects. A photograph of the lower stories is in IA-C September 1982, p. 39, and see appendix F. The Illinois Life building previously occupied this site.

North: ASTOR HOUSE apartment building, built in 1969 at 1340 N. Astor Street, in the Astor Street Landmark District/CHALC, within the Gold Coast Historic District/NR, is 31 stories high. Hirschfield & Reinheimer were the architects.

1969; A quintuple-foldout panoramic view of the city from the top of the Inter-Continental Hotel is in GMM.

150 N. WACKER DRIVE building, built in 1970 at the northwest corner of W. Randolph Street, at the east bank of the Chicago River, is 32 stories high, including five stories for parking. Joel R. Hillman was the architect. Photographs are in AGC, p. 38, scene, in the lower center; ABOV, p. 38, in the foreground; RB Annual Review, January 30, 1971, p. 160; and CSV, p. 48. The Sargent/Lind Block previously occupied this site.

South: McCORMICK PLACE, built in 1970 at 2300 S. Lake Shore Drive, is also known as the McCormick Convention Center and as McCormick Place-on-the-Lake. The first center at this site, 1960–1967 fire, was designed by Shaw, Metz & Dolio, architects/engineers; Victor Hofer and Ralph H. Burke, engineers; a photograph is in CFB. C. F. Murphy was the architect of the 1970 building, with Gene Summers, designer, and Sherwin Asrow, engineer. Photographs are in CFB; AUS, p. 195; CH30, p. 144; AR May 1971, p. 95; AF November 1971, p. 36; and CA, p. 12. An article about the 1987 exhibition addition is in ARCH March 1988, p. 100, and the "North" addition is in SEA, p. 71; IA-C September 1988, p. 43; COF, p. 257. A 1996 addition was made to the south on the site previously occupied by the McCormick Hotel; A. Epstein & Sons were the architects/engineers. The facility is also known as the Metropolitan Fair and Exposition building.

North: AMERICAN HOSPITAL ASSOCIATION building, built in 1970 at 840 N. Lake Shore Drive, at the northwest corner of E. Pearson Street, is 12 stories high. Schmidt, Garden & Erikson were the architects. A photograph is in ABOV, p. 22, on the north side of Lake Shore Park.

North: 500 N. MICHIGAN AVENUE building, built in 1970 at the northwest corner of E. Illinois Street, is 25 stories high, of reinforced concrete construction. Skidmore, Owings & Merrill were the architects/engineers, with Joseph Colaco the engineer.

North: 1 E. SCOTT STREET condominium building, built in 1970 at the southeast corner of N. State Parkway, is 24 stories high, of reinforced concrete construction. Dubin, Dubin, Black & Moutoussamy were the architects.

North: 1540 LaSALLE TERRACE condominium building, built in 1970 at the southwest corner of W. North Avenue, is 20 stories high.

1970: First St. Paul's Evangelical Lutheran Church: see Carl Sandburg Village, 1960.

150 S. WACKER DRIVE building, built in 1971 at the northwest corner of W. Adams Street at the east bank of the Chicago River, is 33 stories, 412 feet high, of reinforced concrete construction. Skidmore, Owings & Merrill were the architects/engineers, with Stanton Korista the engineer. This is a Hartford Plaza building; see also the 100 S. Wacker Drive building. Photographs are in *One Hundred Years of Architecture in Chicago*, Grube, Pran, and Schulze, 1977, p. 76, and PROC, p. 85. The Farwell Block previously included this site.

230 W. MONROE STREET building, built in 1971 at the northeast corner of S. Franklin Street, is 29 stories high. Perkins & Will were the architects. A photograph is in RB September 7, 1991, p. 7. The 222 W. Monroe Street building previously occupied this site.

TWO FIRST NATIONAL PLAZA building, built in 1971 at 20 N. Clark Street, is 31 stories, 407 feet high, of steel frame construction. C. F. Murphy and Perkins & Will were the architects/engineers. A drawing is in IA-C June 1969, p. 51. A photograph is in PROC, p. 66. The 36 S. Clark Street building previously occupied this site.

300 S. WACKER DRIVE building, built in 1971 at the southwest corner of W. Jackson Boulevard, at the east bank of the Chicago River, is 36 stories high, of steel and reinforced concrete construction. A. Epstein & Sons were the architects/engineers, with DeStefano & Goettsch, design associate architects. Photographs are in RB April 28, 1990, pp. 1 and 31. The 300–308 S. Wacker Drive building previously occupied this site.

ONE ILLINOIS CENTER building, built in 1971 at 111 E. Wacker Drive, is 29 stories, 389 feet high, of steel frame construction. The Office of Mies van der Rohe was the architect, and it was completed by Joseph Fujikawa, with Farkas, Barron, engineers. Photographs are in PGC, p. 48, worm's-eye view; STL, p. 209, LSCS, p. 33; RB January 3, 1970, p. 28, under construction (advert.); and PROC, p. 54.

West: ILLINOIS BELL TELEPHONE/AT&T building, built in 1971 at 10 S. Canal Street, at the southwest corner of W. Madison and S. Clinton Streets, is 25 stories high. Holabird & Root were the architects/engineers. A photograph is in IA-C November 1990, p. 44.

North: McCLURG COURT CENTER, built in 1971 at 333 E. Ontario Street, at the southwest corner of N. McClurg Court and extending to E. Ohio Street, includes two buildings 44 stories high. Solomon, Cordwell & Buenz were the architects, with Alfred Benesch the engineer. The complex includes apartments, a sports center, and a theater at 330 E. Ohio Street. Photographs are in STL, p. 216; 1987 COF, p. 181; and RB March 4, 1978, p. 2.

North: 1110 N. LAKE SHORE DRIVE building, built in 1971 is 39 stories, of reinforced concrete construction. Hausner & Macsai were the architects. A photograph is in HB, and see appendix F.

North: 625 N. MICHIGAN AVENUE office building, built in 1971 at the southeast corner of E. Ontario Street, is 27 stories high, of reinforced concrete construction. Meister & Volpe were the architects, with CBM the engineers. Photographs are in TBC and RB May 15, 1976, p. 28. Robert De-Golyer's 1919 Italian Court (not listed here) previously occupied this site.

North: 231 E. ONTARIO STREET building, built in 1971, is 14 stories high. Barancik, Conte were the architects.

North: 100 E. BELLEVUE PLACE condominium building, built in 1971, is 33 stories high. Barancik, Conte were the architects.

North: 1340 N. DEARBORN STREET apartment building, built ca. 1971, is 17 stories high.

North: 1344 N. DEARBORN STREET apartment building, built ca. 1971, is 19 stories high. Daniel Comm was the architect.

HEITMAN CENTRE building, built in 1972 at 180 N. LaSalle Street, at the southwest corner of W. Lake Street, is 40 stories, 410 feet high, of reinforced concrete construction. Harry Weese was the architect and CBM the engineers. Photographs are in TBC, p. 335; PROC, p. 75; and RB May 15, 1976, p. 28. The Northern Pacific building previously occupied this site.

MID-CONTINENTAL PLAZA building, built in 1972, also known as the 55 E. Monroe Street building, on the east side of N. Wabash Avenue and extending to E. Adams Street, is 50 stories, 580 feet high. Shaw Associates were the architects, with Patrick Shaw the designer. William Schmidt was the engineer. Photographs are in STL, p. 199, and TBC, p. 269. Buildings previously on this site include the 1873 (Eli) Williams, Revell, Tobey Furniture; a view of the Wabash Avenue block is in CIM, p. 326.

AMALGAMATED TRUST & SAVINGS BANK, built in 1972 at 100 S. State Street, at the southwest corner of W. Monroe Street, is five stories high. A. Epstein & Sons were the architects/engineers. The Pike Block previously occupied this site.

West: 222 S. RIVERSIDE PLAZA building, built in 1972 at the southeast corner of S. Canal and W. Adams Streets to W. Jackson Boulevard and to the west bank of the Chicago River, is 35 stories, 440 feet high, of composite steel frame and concrete tube construction. Skidmore, Owings & Merrill were the architects/engineers, with Hal Iyengar the engineer. The adjacent Mid-America Commodity Exchange building, built in 1971 at 444 W. Jackson Boulevard, is six stories high. Photographs are in 1987 COF, p. 149; STL, p. 222; *One Hundred Years of Architecture in Chicago*, Grube, Pran, and Schulze, 1977, p. 77; PROC, p. 66; and CE July 1972, p. 62, as Gateway 3.

North: One IBM PLAZA building, built in 1972 at 330 N. Wabash Avenue, between N. State Street and N. Wabash Avenue at the north bank of the Chicago River, is 52 stories, 695 feet high, of steel frame construction. The Office of Mies van der Rohe and C. F. Murphy were associated architects, with C. F. Murphy the engineer. Photographs are in STL, p. 210; ABOV, p. 55; *Architecture Plus* periodical September 1974, p. 62; and IA-C July 1972. Originally it was called the IBM building. The Central City Garage previously occupied the north part of this site.

North: 100 E. WALTON condominium building, built in 1972 at 100 E. Walton Place, is 44 stories, 386 feet high, of reinforced concrete construction. Dubin, Dubin, Black & Moutoussamy were the architects. A 1989 addition of eight stories for offices and shops was made by Sherman Gerber, architect. The building was also known as the Walton Colonnade building. Photographs are in PROC, p. 106, and RB Annual Review, January 27, 1973, p. 117.

North: 2 E. OAK STREET condominium building, built in 1972 at the N. Rush and N. State Street triangle, is 40 stories. Joel R. Hillman was the architect and CBM the engineers.

North: 200 E. DELAWARE CONDOMINIUM building, built in 1972 at the northeast corner of N. Mies van der Rohe Drive, is 34 stories high, of reinforced concrete construction. Dubin, Dubin, Black & Moutoussamy were the architects and CBM the engineers. A photograph is in RB May 6, 1972, p. 1. The 200 E. Delaware apartment building, constructed in 1915, previously occupied this site.

North: 40 E. CEDAR STREET condominium building, built ca. 1972, is 20 stories high. A photograph is in RB Annual Review, January 27, 1973, p. 119. The building is in the Gold Coast Historic District/NR.

North: 1339 N. DEARBORN STREET apartment building, built ca. 1972, is 15 stories high. Daniel Comm was the architect. A photograph is in RB April 7, 1973, p. 1. The building is in the Gold Coast Historic District/NR.

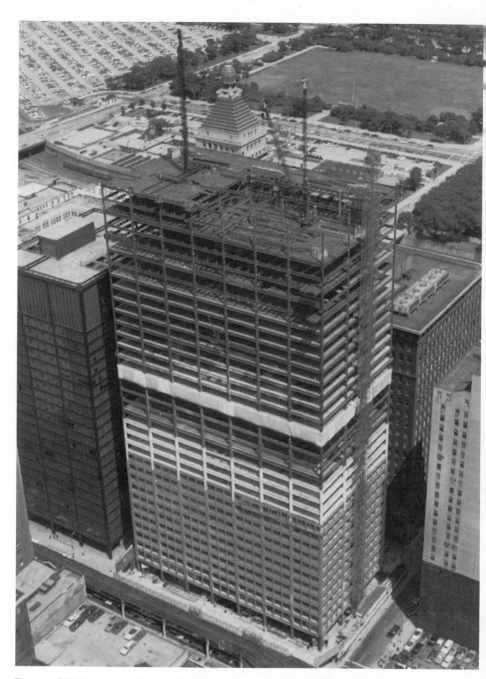

Fig. 47. CNA Center Addition, 1973 (Courtesy Graham, Anderson, Probst and White)

North: 1221 N. DEARBORN STREET apartment building, built ca. 1972, is 21 stories high. Daniel Comm was the architect. It is in the Gold Coast Historic District/NR and is also known as Dearborn Towers. A photograph is in RB April 21, 1973, p. 1.

North: 1330 N. DEARBORN STREET apartment building, built ca. 1972, in the Gold Coast Historic District/NR, is 16 stories high.

North: 1415 N. DEARBORN STREET apartment building is 28 stories high. Built ca. 1972, it is in the Gold Coast Historic District/NR.

200 W. MONROE STREET building, built in 1973 at the northwest corner of S. Wells Street, is 23 stories high. Welton Becket was the architect, Klein & Hoffman the engineers. The structure was also known as the National Surety (Corp.) building. A drawing is in RB June 2, 1973, p. 1. The 1879 Leiter (1) building previously occupied this site.

TWO ILLINOIS CENTER building, built in 1973 at 233 N. Michigan Avenue (to the east on East South Water Street), is 30 stories high. The Office of Mies van der Rohe was the architect and Joseph Y. Fujikawa the designer. The firm of Farkas, Barron was the engineer. The Massasoit House previously occupied a part of this site.

South: McCORMICK CENTER HOTEL, 1973–1993, at 451 E. Twenty-third Street, on the west side of S. Lake Shore Drive, was 25 stories high. A. Epstein & Sons were the architects/engineers. It was also known as the McCormick Inn. A photograph is in RB May 12, 1973, p. 114. The south addition to McCormick Place occupies this site.

North: SHERATON-PLAZA HOTEL, built in 1973 at 160 E. Huron Street, was renamed the Radisson Hotel and Suites. Located at the northwest corner of N. St. Clair Street, it is 40 stories high, of reinforced concrete construction. Hillman & Vagnieres were the architects. It was planned as the Westbury Hotel. A drawing is in RB April 28, 1973, p. 4. A photograph of the upper stories is in ABOV, p. 21, at the lower left.

North: 990 N. LAKE SHORE DRIVE condominium building, built in 1973 at the northwest corner of E. Walton Place, is 33 stories high, of reinforced concrete construction. Barancik, Conte were the architects. Photographs are in ABOV, p. 22, the white tower at the lower right, and RB June 10, 1972, p. 2; also see appendix F. The 242 E. Walton Place and the 936 and 942 Lake Shore Drive buildings previously occupied this site.

1973: CNA Center addition (fig. 47): see 1962 CNA Center building.

SEARS TOWER, built in 1974 at 233 S. Wacker Drive and including the block bounded also by W. Jackson Boulevard, S. Franklin, and W. Adams Streets, is

110 stories tall (see frontispiece). Skidmore, Owings & Merrill were the architects/engineers, with Bruce Graham, designer, and Fazlur R. Khan and Hal Iyengar the engineers. At 1,454 feet high, it was the tallest building in the world when it was built and until the twin towers of the Petronas K-L Towers in Kuala Lumpur, Malaysia, with 150-foot-high pinnacles and having only 88 stories, topped it by 22 feet in 1996. Cesar Pelli was the architect and Thornton-Tomasetti (now TT-CBM) were the engineers for the Malaysian building. The highest point of the Sears Tower, the antennas, is 1,787 feet high. The building's area is about 4,500,000 square feet in a steel framework of nine 75-foot-square bundled tubes of various heights. Most of the Sears offices have been relocated to new facilities in Hoffman Estates, Illinois. Articles are in AF December 1973, p. 24, and January 1974, p. 24; ENR August 26, 1971; *Architecture Plus* periodical August 1973, p. 56, bird's-eye view, on nearing completion; *Architecture of SOM: 1963 to 1973,* by Architectural Books, 1974, p. 170; and CMAG February 1994, cover and p. 51. Photographs are in COF; AUS, p. 201, scene; PGC, p. 6 and following p. 30; IA-C February 1973, p. 15, under construction; STL, p. 224; WACH, p. 149; HAAW, p. 40; TBC, p. 203; CST; PROC, p. 102; and RB Annual Review, January 1993, cover, nearing completion. Buildings previously on this site include 323 W. Adams Street, 320 W. Jackson Boulevard, Mercantile, Crest, Haskel, 212 S. Franklin Street, and 225–29 S. Market Street.

HYATT REGENCY CHICAGO hotel, built in 1974 at 151 E. Wacker Drive, at Stetson Avenue, is 36 stories high, of reinforced concrete construction. The East building addition, built in 1980, is 33 stories high, of reinforced concrete construction. A. Epstein & Sons were the architects/engineers for both buildings, in the Illinois Center complex. Photographs are in LSCS, p. 23, at the left side; STL, p. 208; TBC, p. 248; CST; and PGC.

AMOCO building, built in 1974 at 200 E. Randolph Street, at the northwest corner of N. Columbus Drive, is 82 stories, 1,136 feet high, a 194-foot-square tubular steel frame structure. This was originally the Standard Oil building. Edward D. Stone was the design architect, with Perkins & Will associated architects, and Alfred Picardi the engineer. Photographs are in CANY, p. 15; PGC, p. 11; ABOV, p. 17, and 50; STL, p. 218; ARCH October 1989, p. 26; *Smithsonian Guide to Historic America: Great Lakes,* 1989; CST; SEA, p. 22, recladding; PROC, p. 99; RB Annual Review, January 1993, nearing completion; CRC, p. 70; and CSV, pp. 66 and 209.

NORTHERN (TRUST) building, built in 1974 at 125 S. Wacker Drive, is 13 stories high. Perkins & Will were the architects. A photograph is in STL, p. 186, with the U.S. Gypsum building. The Old Farwell Block previously included this site.

North: MONTGOMERY WARD CORPORATE OFFICE building, built in 1974 at 535 W. Chicago Avenue, extending from N. Larrabee to N. Kings-

bury Street, is 26 stories high. Minoru Yamasaki was the architect. A photograph is in ABOV, p. 50.

North: THE WARWICK CONDOMINIUM building, built in 1974 at 1501 N. State Parkway, at the northeast corner of E. Burton Place, is 21 stories high, of reinforced concrete construction. Martin Reinheimer was the architect and Rittweger & Tokay the engineers. It was also known as the Prince Albert Warwick building. A drawing is in RB Annual Review, January 26, 1974, p. 114.

North: ASTOR VILLA condominium building, built in 1974 at 1430 N. Astor Street, in the Astor Street Landmark District/CHALC, within the Gold Coast Historic District/NR, is 20 stories high.

1974: Kluczynski building: see Federal Center, 1964.

CHICAGO METROPOLITAN CORRECTIONAL CENTER building, built in 1975 at 71 W. Van Buren Street, at the southeast corner of S. Clark Street, is 27 stories high. Harry Weese was the architect, Severud-Perrone-Bandel the engineers. The center is also known as the William J. Campbell U.S. Courthouse Annex and as the Federal Detention Center. Photographs are in IA-C September 1984, p. 50; PGC, p. 15 and following p. 30; HAAW, p. 157; CST; and CRC, p. 105. Buildings previously occupying this site include Hamilton, Pacific Block, and 75 W. Van Buren Street.

30 N. LaSALLE STREET building, built in 1975 at the southwest corner of W. Washington Street, is 43 stories high. Thomas E. Stanley was the architect/engineer. Photographs are in *New York Times Sunday Magazine,* April 6, 1975, p. 30, and IA-C No. 5, September 1982, p. 38. The 1894 Stock Exchange and the Union building previously occupied this site.

HARBOR POINT condominium building, built in 1975 at 155 N. Harbor Point Drive and E. Randolph Street, is 54 stories, 556 feet high, of reinforced concrete construction. Solomon, Cordwell & Buenz were the architects, with Alfred Benesch the engineer. It has been known as the Nobart Apartments. An article is in ENR August 14, 1975. Photographs are in CST and RB January 14, 1978, p. 1.

North: NEWBERRY PLAZA condominium building, built in 1975 at 1030 N. State Parkway, at the head of E. Bellevue Place, in the Gold Coast Historic District/NR, is 58 stories high. Gordon & Levin were the architects and CBM the engineers. A drawing is in RB May 13, 1972, p. 13.

North: 1555 N. ASTOR STREET condominium building, built in 1975 at the southeast corner of E. North Avenue, in the Astor Street Landmark District/CHALC, within the Gold Coast Historic District/NR, is 47 stories high. Solomon, Cordwell & Buenz were the architects; Alfred Benesch was

the engineer. A partial view is in ABOV, p. 57, at the upper left of the upper photograph. A photograph is in 1987 COF, p. 233.

North: HOLIDAY INN CHICAGO CITY CENTRE, built in 1975 at 300 E. Ohio Street, at the northeast corner of N. Fairbanks Court and extending to E. Ontario Street, is 27 stories, 225 feet high, of reinforced concrete construction. Robert Vagnieres Sr. was the architect and Rittweger & Tokay were the engineers.

North: 1530 N. DEARBORN STREET apartment building, built in 1975, is 26 stories high. It is also known as the Parkside. A drawing is in RB Annual Review, January 1975, p. 94.

North: 1516 N. STATE PARKWAY apartment building, built in 1975, in the Gold Coast Historic District/NR, is 21 stories high. A drawing is in RB Annual Review, January 1975, p. 105.

1975: Prentice Women's Hospital: see McKinlock Campus of Northwestern University, 1926.

West: HAROLD WASHINGTON SOCIAL SECURITY ADMINISTRA-TION building, 600 W. Madison and W. Washington, S. Jefferson, and S. Desplaines Streets, was built in 1976. It is 10 stories high, on pile foundations. Lester B. Knight was the architect/engineer. A photograph is in ABOV, p. 42, scene, to the left of the Presidential Towers buildings. Buildings previously occupying this block include J. W. Scoville and the Kuhn's and McEwan's Hotels (not listed here).

North: WATER TOWER PLACE and RITZ-CARLTON HOTEL, built in 1976 at 845 N. Michigan Avenue to N. Mies van der Rohe Drive and, for the hotel, 160 E. Pearson Street, is 74 stories, 859 feet high, the world's tallest (tubular) reinforced concrete building when it was built. Loebl, Schlossman, Dart & Hackl were the architects; Edward D. Dart, the designer; and Warren Platner, associated for retail spaces. C. F. Murphy was associated as engineer. This is a mixed-use project including the 180 E. Pearson Street condominiums, shops, and theaters. Photographs are in PGC, p. 9; GCA, p. 81, atrium; AF December 1973, p. 44; STL, pp. 118 and 215 with the John Hancock building; AR April 1976, p. 136, and October 1977, p. 99; IA-C October 1976, p. 6; TBC, p. 222; CST; PROC, p. 89; and *Interior Design* periodical November 1975, p. 90, under construction. Buildings previously on this site include the Pearson Hotel and the Rinn Apartments (not listed here).

North: 444 N. MICHIGAN AVENUE building, built in 1976 at the southwest corner of E. Illinois Street, is 38 stories (420 feet), of reinforced concrete construction. Perkins & Will were the architects, and CBM the engineers.

Photographs are in STL, p. 230; CST; RB February 3, 1979, p. 1, and September 25, 1993, p. 7. The *Chicago Tribune,* September 17, 1970, reported this was planned as the Educational Facilities Center.

North: ELM STREET PLAZA building, built in 1976 at 1130 N. Dearborn Parkway, at the southwest corner of W. Elm Street, in the Gold Coast Historic District/NR, is 34 stories high, of reinforced concrete construction. Gordon & Levin were the architects and CBM the engineers, with A. Epstein & Sons, associated.

1976: Harris Trust building addition: see 1911 Harris Bank.

North: APPAREL MART and HOLIDAY INN MART PLAZA building, built in 1977 at 350 N. Orleans Street, at the southwest corner of W. Kinzie Street at the north bank of the Chicago River at Wolf Point, is 23 stories high, of steel frame construction. Skidmore, Owings & Merrill were the architects/engineers; Don Belford was the engineer. The hotel occupies the upper eight stories. It has also been known as the Wolf Point Apparel Center and as Expocenter/Chicago. A drawing is in RB Annual Review, January 31, 1976, p. 88. A photograph is in ABOV, p. 33. The Davidson (Stone Co.) building previously occupied a portion of this site.

North: RIVER PLAZA apartment building, built in 1977 at 405 N. Wabash Avenue, at N. Rush and E. Hubbard Streets, is 56 stories high, of reinforced concrete construction. Gordon & Levin were the architects, CBM the engineers. Photographs are in PGC, following p. 30; STL, p. 174, at the right edge; ABOV, p. 30, at the left; TBC, p. 310; and CSV, p. 50. The 51–53 E. Hubbard Street building previously occupied this site.

North: CHICAGO MARRIOTT DOWNTOWN HOTEL, built in 1978 at 540 N. Michigan Avenue, in the block bounded also by E. Ohio and N. Rush Streets and E. Grand Avenue, is 46 stories high, of reinforced concrete construction. Harry Weese was the architect, CBM the engineers. Photographs are in PGC, p. 20; IA-C No. 5, September 1982, p. 38. The Michigan Square building previously occupied a part of this site.

North: DOWNTOWN COURT CLUB building, built in 1978 at 441 N. Wabash Avenue, at the northeast corner of E. Hubbard Street and extending to N. Rush Street, is seven stories high. Solomon, Cordwell & Buenz were the architects. The 56–62 E. Hubbard Street building previously occupied a part of this site.

1978: Westin Hotel addition: see Westin Hotel, 1963.

2 N. LASALLE STREET building, built in 1979 at the northwest corner of W. Madison Street, is 26 stories high, of reinforced concrete construction.

Perkins & Will were the architects, with Klein & Hoffman as engineers. Photographs are in STL, p. 231, and CST. The foundations of the LaSalle Hotel were reused for the new structure. The Oriental buildings previously occupied this site.

THREE ILLINOIS CENTER building, built in 1979 at 303 E. Wacker Drive, at the southeast corner of N. Columbus Drive, is 28 stories high (420 feet), of reinforced concrete construction. Fujikawa, Conterato, Lohan were the architects and Alfred Benesch was the engineer. Photographs are in SEA, p. 121, and STL, pp. 208 and 218. The site includes a fire station of 1982 by Fujikawa, Johnson, architects.

North: 21 E. CHESTNUT STREET condominium building, built in 1979, is 23 stories high. A photograph is in RB Annual Review, January 1979, p. 115.

North: 50 E. BELLEVUE PLACE condominium building, built in 1979, is 21 stories high, of reinforced concrete construction. Solomon, Cordwell & Buenz were the architects, with CBM the engineers.

1979: Health Sciences building, Northwestern University: see McKinlock Campus. The State Street Mall was opened.

XEROX CENTRE building, built in 1980 at 55 W. Monroe Street, at the southwest corner of S. Dearborn Street, is 40 stories, 496 feet high, of reinforced concrete construction. C. F. Murphy was the architect, with Helmut Jahn the designer and CBM the engineers. It was planned as the Monroe Centre building. Photographs are in STL, p. 233; PGC, p. 53, model; *Helmut Jahn,* Nory Miller, 1986, p. 76; *Skyscraper,* Paul Goldberger, 1982, p. 149, bird's-eye view; TBC, p. 338; PA December 1986, p. 88; CST; and PROC, p. 140. Buildings previously on this site include Howland Blocks 1 and 2, Westminster, Columbia Theater, and Inter-Ocean.

200 S. WACKER DRIVE building, built in 1980 at the southwest corner of W. Adams Street on the east bank of the Chicago River, is 32 and 38 stories, 470 feet high, of reinforced concrete construction. Harry Weese was the architect. It was also known as the Citicorp building. Photographs are in TBC, p. 358; CST; PROC, p. 135; *Tall Buildings,* ed. Lynn S. Beedle, 1984, p. 806. The Ryerson/Walker Warehouse previously occupied a portion of this site.

AVONDALE (S&L) CENTER building, built in 1980 at 20 N. Clark Street, at the northwest corner of W. Madison Street, is 35 stories high. A. Epstein & Sons were the architects/engineers. The Jarvis and the 6 N. Clark Street buildings previously occupied this site.

101 N. WACKER DRIVE building, built in 1980 at the northeast corner of W. Washington Street, is 24 stories, of steel frame construction. Perkins &

Will were the architects. Originally Wacker-Washington Plaza, it is also known as the Hartmarx (Hart, Schaffner & Marx) building. Photographs are in IA-C May 1988; STL, p. 270, to the right of the 123 W. Wacker Drive building; ABOV, p. 30, at the left edge; and CST. The Occidental building previously occupied this site.

COLUMBUS PLAZA apartment building, built in 1980 at 233 E. Wacker Drive (to the south on Stetson Drive), is 46 stories, 446 feet high, of reinforced concrete construction. Fujikawa, Conterato, Lohan were the architects, with Alfred Benesch the engineer. This is an Illinois Center building. A photograph is in PROC, p. 76, and STL, p. 208, scene.

South: DEARBORN PARK condominium buildings, built in 1980 at the northwest and the southwest corners of S. State and W. Ninth Streets, are 22 and 28 stories high. Gordon & Levin were the architects. Many other structures of the Dearborn Park development are up to 12 stories high. Scenes of Dearborn Park are in *Advances in Tall Buildings,* ed. Lynn S. Beedle, 1986, pp. 535–540. A photograph is in ABOV, p. 81, scene, at the center-left.

North: 233 E. ONTARIO STREET office condominium building, built in 1980, 25 stories high, of reinforced concrete construction. Hillman & Vagnieres were the architects.

North: 676 ST. CLAIR office building, built in 1980 at the northwest corner of E. Erie Street and extending to E. Huron Street, is 23 stories high. Skidmore, Owings & Merrill were the architects/engineers. A drawing is in RB May 20, 1978, p. 1, and a photograph is in RB March 30, 1985, p. 1. The St. Clair building of 1911 and the St. Clair Street building of 1912–1924 (not listed here), by Perkins, Fellows & Hamilton, previously occupied this site.

North: 65 W. DIVISION STREET office building, built in 1980 at the southeast corner of N. Clark Street, is seven stories high. Skidmore, Owings & Merrill were the architects/engineers. A photograph is in RB Annual Review, January 1979, p. 83.

North: 1100 N. LAKE SHORE DRIVE condominium building, built in 1980 at the northwest corner of E. Cedar Street, is 42 stories high, of reinforced concrete construction. Harry Weese was the architect and CBM the engineers. A photograph is in 1987 COF, p. 220, and see appendix F. The Marshall Apartments previously occupied this site.

1980: Hyatt Regency Chicago Hotel addition: see Hyatt Regency Hotel.

BOULEVARD TOWERS NORTH building, built in 1981 at 225 N. Michigan Avenue, at the southeast corner of E. South Water Street, is 19 and 24 stories high, of reinforced concrete construction. Fujikawa, Conterato,

Lohan were the architects; Alfred Benesch was the engineer. This is an Illinois Center building. An article is in ENR May 17, 1984. Photographs are in STL, p. 209, and PROC, p. 55. See also the Boulevard Towers South building. The Adams House 2 and the National Cash Register buildings previously occupied portions of this site.

33 W. MONROE STREET building, built in 1981 at the southeast corner of S. Dearborn Street, is 28 stories, 375 feet high, of steel frame construction. Skidmore, Owings & Merrill were the architects/engineers, Bruce Graham the designer, Hal Iyengar the engineer. Photographs are in TBC, p. 216; CST; AR November 1981, p. 122; and PROC, p. 132. Buildings previously on this site include American Express, Adams Express, Commercial Bank, and Sheppard Blocks 1 and 2.

North: 1410 N. STATE PARKWAY condominium building, built in 1981, in the Gold Coast Historic District/NR, is 27 stories high, of reinforced concrete construction. Solomon, Cordwell & Buenz were the architects and CBM the engineers.

North: ASBURY PLAZA apartment building, built in 1981 at 730 N. Dearborn Street, at the northwest corner of W. Superior Street, is 33 stories high, of reinforced concrete construction. George Schipporeit was the architect and Chris P. Stefanos the engineer.

North: MICHIGAN PLACE condominium building, built in 1981 at 110 E. Delaware Place, between N. Michigan Avenue and N. Rush Street, is 20 stories high. Solomon, Cordwell & Buenz were the architects and CBM the engineers.

North: HURON PLAZA apartment and office building, built in 1981 at 30 E. Huron Street, on the east side of N. Wabash Avenue and extending to E. Superior Street, is 56 stories high, of reinforced concrete construction. The offices occupy eight floors of the building. Gordon & Levin were the architects. Photographs are in *Analysis and Design of High-Rise Concrete Buildings,* American Concrete Institute, ed. Jaime Moreno, 1985, p. 172.

North: 1 E. SUPERIOR STREET building, built in 1981 at the southeast corner of E. State Street, is six stories high. Solomon, Cordwell & Buenz were the architects.

North: STATE TOWER condominium building, built in 1981 at 1230 N. State Parkway, is 23 stories high. Dubin, Dubin, Black & Moutoussamy were the architects.

North: 1330 N. LaSALLE DRIVE condominium building, built in 1981, was designed by Weimper & Balaban, architects.

North: 1120 N. LaSALLE DRIVE apartment building, built in 1981, is 19 stories high. Barancik, Conte were the architects.

North: MORNINGSIDE NORTH residence hall building, built in 1981 at 170 W. Oak Street, at the northeast corner of N. Wells Street, is 18 stories high. Barancik, Conte were the architects. The Morningside South residence hall building, built in 1978 at 171 W. Oak Street, is 12 stories high. The residence halls are Moody Bible Institute facilities.

ONE S. WACKER DRIVE building, built in 1982 at the southeast corner of W. Madison Street, is 40 stories high, of reinforced concrete construction. Murphy/Jahn were the architects, with Helmut Jahn the designer, and Alfred Benesch the engineer. Photographs are in *Chicago Stained Glass*, Erne R. and Florence Freuh, 1983, p. 91; ABOV, p. 36, to the right of the Civic Opera building; AR April 1981; *Helmut Jahn*, Nory Miller, 1986, p. 92; TBAR, p. 80; and CST. The M. D. Wells, Daily Times/Troescher, Hunter, Keith Brothers buildings previously occupied this site.

DORAL MICHIGAN PLAZA apartments, office, and market, built in 1982 at 155 N. Michigan Avenue, extending from E. Randolph to E. Lake Street, is 39 stories high, of reinforced concrete construction. Martin Reinheimer was the architect and Rittweger & Tokay the engineers. A photograph is in ABOV, p. 17, scene, to the right of the Stone Container building. Buildings previously on this site include the 1864 S. B. Cobb, S. D. Kimbark, and 159 N. Michigan Avenue buildings.

BUCKINGHAM PLAZA apartment building, built in 1982 at 360 E. Randolph Street, at the northwest corner of N. Field Boulevard, is 42 stories high, of reinforced concrete construction. Fujikawa, Conterato, Lohan were the architects. Alfred Benesch was the engineer. A photograph is in STL, p. 218, at the left edge of the scene.

1982: Board of Trade Annex building: see the Board of Trade, 1930. Newberry Library addition: see Newberry Library, 1892.

THREE FIRST NATIONAL PLAZA building, built in 1982 at 70 W. Madison Street, at the northwest corner of N. Dearborn Street, extending to the northeast corner of N. Clark Street, is 11 and 57 stories, 775 feet high, of steel and reinforced concrete construction. Skidmore, Owings & Merrill were the architects, Bruce Graham the designer. Photographs are in PGC, p. 54; ABOV, p. 46; TBAR, p. 58; *Bruce Graham*, Rizzoli, 1989, p. 94; CST; SEA, p. 81; and PROC, p. 160. Buildings previously on this site include the Ottawa, Harding Hotel, and Grant Hotel.

South: 1212 S. MICHIGAN AVENUE apartment building, built in 1982, is 30 stories, of reinforced concrete construction. Loewenberg-Fitch were the architects. A photograph is in ABOV, p. 81, at the upper right edge.

North: CHESTNUT PLACE apartment building, built in 1982 at 850 N. State Street, at the northwest corner of W. Chestnut Street, is 30 stories, of reinforced concrete construction. Weese, Seegers, Hickey, Weese were the architects and CBM the engineers. Photographs are in IA-C January 1984, p. 38; GCA, p. 91; ABOV, upper right red tower; and CST.

North: WALTON PLACE apartment building, built in 1982 at 221 E. Walton Place, is 21 stories high. Miller, Shelby & Anderson were the architects. A drawing is in RB January 7, 1978, p. 1.

North: STREETERVILLE 400 apartment building, built in 1982 at 400 E. Ohio Street, at the northeast corner of N. McClurg Court, is 52 stories high, of reinforced concrete construction. Gordon & Levin were the architects. Kolbjorn Saether was the engineer.

North: PARK LaSALLE apartment building, built in 1982 at 1000 N. LaSalle Drive, at the northwest corner of W. Oak Street, is nine stories high. Barancik, Conte were the architects. A photograph is in HB.

North: 1111 N. DEARBORN STREET apartment building, built in 1982 at the northeast corner of W. Maple Street, is 31 stories high. It is in the Gold Coast Historic District/NR. Barancik, Conte were the architects.

North: CONSTELLATION APARTMENTS building, built ca. 1982, 1555 N. Dearborn Parkway, at the southeast corner of W. North Avenue, is 26 stories high. A photograph is in HB.

MADISON PLAZA building, built in 1983 at 200 W. Madison Street, at the northwest corner of N. Wells Street, is 45 stories, 596 feet high, of tubular steel frame construction. Skidmore, Owings & Merrill were the architects/engineers, Bruce Graham the designer, and Fazlur R. Khan the engineer. Photographs are in *Bruce Graham*, Rizzoli, 1989, p. 98; STL, p. 249; 1987 COF, p. 88; TBC, p. 372; CST; and PROC, p. 158. The old Daily News building (ca. 1872) previously occupied a portion of this site.

320 N. MICHIGAN AVENUE office and suites building, built in 1983, originally planned for apartments, is 26 stories high, of reinforced concrete construction. Booth, Hansen were the architects. Photographs are in CANY, p. 26; STL, p. 244; and CST.

John NUVEEN (Co.) building, built in 1983, originally the 333 W. Wacker Drive building, in the "triangular" block bounded also by W. Lake and N. Franklin Streets, is 36 stories, 472 feet high, of steel frame construction. Kohn, Pedersen & Fox were the architects, William Pedersen the designer, with Perkins & Will as associated architects. Joseph Colaco (GCE of Illinois) was the engineer. Photographs are in PA October 1983, p. 78 and cover; IA-C

September 1983, including cover, and May 1984; STL, p. 24; CANY, p. 72; GCA, p. 90; ABOV, p. 34; *American Architects*, Les Krantz, 1989, p. 155; WACH, p. 146; CST; AR June 1981, p. 83; TBAR, p. 73; PROC, p. 146; SCS, p. 157; *KPF*, ed. Christian Norberg-Schulz, 1993, p. 10; and SEA, p. 112.

STONE CONTAINER building, built in 1983 at the northwest corner of E. Randolph Street, is 41 stories, 582 feet high, of reinforced concrete construction. A. Epstein & Sons were the architects/engineers, with Sidney Schlegman the designer. Originally the Associates Center building, it was also known as One Park Place and as the 150 N. Michigan Avenue building. Photographs are in STL, p. 246; CNM, p. 216; IA-C September 1982, p. 39, under construction, and May 1984, p. 30; PROC, p. 142; and CSV, pp. 31 and 45. The Crerar Library previously occupied this site.

HAROLD WASHINGTON COLLEGE, built in 1983 at 30 E. Lake Street, at the northwest corner of N. Wabash Avenue, is 12 stories high. Loewenberg & Loewenberg were the architects. It was formerly called Loop College. A photograph is in *One Hundred Years of Architecture in Chicago*, Grube, Pran, and Schulze, 1977, p. 128. The Leander J. McCormick Block previously occupied this site.

West: 300 S. RIVERSIDE PLAZA building, built in 1983 at the southwest corner of W. Jackson Boulevard and S. Canal Street, at the west bank of the Chicago River, is 22 stories high, of steel frame construction. Skidmore, Owings & Merrill were the architects. This is a Gateway Center (No. 4) building. Photographs are in STL, p. 222, and CST. See also the 10, 30, and 222 Riverside Plaza buildings.

West: 525 W. MONROE STREET building, built in 1983, from the southwest corner of S. Canal to S. Clinton Street, is 24 stories high. Skidmore, Owings & Merrill were the architects/engineers. It is also known as Monroe Place. A photograph is in CST.

North: (One) MAGNIFICENT MILE building, built in 1983 at 980 N. Michigan Avenue, extending from E. Oak Street to E. Walton Place, is 21 to 57 stories, 674 feet high, a reinforced concrete bundled tube structure. Skidmore, Owings & Merrill were the architects, with Fazlur R. Khan the engineer. Barancik, Conte were associated architects for the condominiums. The mixed-use building also includes offices and extensive retail spaces. Photographs are in IA-C May 1984, p. 24 and cover; AR March 1981, p. 126; PROC, p. 162; *American Architects*, Les Krantz, 1989, p. 95; STL, p. 253, scene; SEA, p. 88; and CST. See also article by Fazlur Kahn, in *Developments in Tall Buildings*, ed. Lynn Beedle, Council on Tall Buildings and Urban Habitat, 1985, p. 230, to whom Beedle's book is dedicated. Buildings previously on this site include the Weatherd (not listed here).

North: NEIMAN-MARCUS STORE, built in 1983 at 737 N. Michigan Avenue, at the northeast corner of E. Superior Street, is four stories high. Skidmore, Owings & Merrill were the architects/engineers, with Adrian Smith the designer. This is a part of the Olympia Centre project. A photograph is in STL, p. 265. The Sterling building previously occupied this site.

North: 111 E. CHESTNUT STREET condominium building, built in 1983, renamed the Elysees Private Residences, is 57 stories, 520 feet high, of reinforced concrete construction. Solomon, Cordwell & Buenz were the architects. This project adjoins the commercial Plaza Escada building. Photographs are in STL, p. 215, to the left of the Palmolive building; *Chicago Tribune,* Sunday, April 12, 1987, "Arts" section, p. 14, with the First Presbyterian Church; PROC, p. 107; and RB Annual Review, January 31, 1976, cover, to the right of the John Hancock Center.

North: 100 W. CHESTNUT STREET apartment building, built in 1983, is 30 stories high, of reinforced concrete construction. Weese, Langley, Weese were the architects and CBM the engineers. It is also known as the Clark/Chestnut Apartments.

North: 1418 N. LAKE SHORE DRIVE condominium building, built in 1983, in the Gold Coast Historic District/NR, is 29 stories high. Solomon, Cordwell & Buenz were the architects. Photographs are in 1987 COF, p. 215, and IA-C March 1985.

200 N. LaSALLE STREET building, built in 1984 at the northwest corner of W. Lake Street, is 30 stories high. Perkins & Will were the architects, with Wojciech Madeyski the designer. Photographs are in STL, p. 231; IA-C September 1985; and CST.

ONE FINANCIAL PLACE building, built in 1984 at 400 S. LaSalle Street, extending to S. Sherman Street, is 40 stories high. Skidmore, Owings & Merrill were the architects/engineers, with Bruce Graham the designer and John Zils the engineer. This complex includes the "five-story" (equivalent) Chicago (Midwest) Stock Exchange, straddling W. Congress Parkway; the 1982, eight-story Chicago Board of Options Exchange at 141 W. Van Buren Street, at the southwest corner of S. LaSalle Street; and the LaSalle Club Hotel. It is also known as the Exchange Center, 440 S. LaSalle Street. See also the 1997 Chicago Stock Exchange Extension building. Photographs are in STL, p. 262; TBC, p. 387; and CST. The LaSalle Street Station building previously occupied this site.

CHICAGO MERCANTILE EXCHANGE CENTER building, built in 1984, rising 530 feet at the east bank of the Chicago River, is 44 stories high, of reinforced concrete construction. The "ten-story" (equivalent) central trading floor structure is steel frame construction. Fujikawa, Johnson were

the architects. Alfred Benesch & Co. were the engineers. The exchange center is also known as the 30 S. Wacker Drive building. Photographs are in ABOV, p. 36; GCA, p. 133; STL, p. 251; IA-C November 1984, p. 17 (advert.); CST; SEA, pp. 95, 104; PROC, p. 137; and *Concrete International* (American Concrete Institute), December 1983, p. 18. See also the 1988 Mercantile Exchange Center addition. The Jewett and the 364–70 W. Monroe Street buildings previously occupied this site.

South: 2 E. EIGHTH STREET apartment building, built in 1984 at the northeast corner of S. State Street, is 29 stories high. Seymour S. Goldstein was the architect. A photograph is in RB March 9, 1985, p. 16.

North: 211 E. ONTARIO STREET building, built in 1984, is 18 stories high. Barancik, Conte were the architects. Photographs are in RB March 3, 1984, under construction, and June 29, 1985, p. 19.

North: ONTARIO PLACE building, built in 1984 at 10 E. Ontario Street, at the northeast corner of N. State Street, to (1) E. Erie Street, is 52 stories high, of reinforced concrete construction. Loewenberg-Fitch were the architects, with Barancik, Conte as associated architects. William Schmidt was the engineer. A drawing is in RB January 26, 1982, p. 1.

North: THE GRAND OHIO apartment building, built in 1984, at 211 E. Ohio Street, extends through to E. Grand Avenue. It is 26 stories high. Skidmore, Owings & Merrill were the architects/engineers, with Joseph Gonzalez as the designer. A photograph is in RB February 10, 1990, p. 2.

North: OLYMPIA CENTRE building, built in 1984, at 161 E. Chicago Avenue, is 63 stories, 690 feet high, of tubular reinforced concrete construction. Skidmore, Owings & Merrill were the architects/engineers, with Adrian Smith the designer. This is a mixed-use project including offices, the Residential Suites, and the 1983 Neiman-Marcus Store (q.v.), at 737 N. Michigan Avenue. Photographs are in 1987 COF, p. 185; STL, p. 264; CST; and PROC, p. 164. The Sterling building occupied part of this site.

1984: Northwestern University Law/American Bar Center; see McKinlock Campus. The Columbus Drive extension and bridge (SEA, p. 96) were constructed.

JAMES R. THOMPSON CENTER building was built in 1985, at 100 W. Randolph Street, in the block bounded also by N. LaSalle, W. Lake, and N. Clark Streets. It is 17 stories high, rising 308 feet, of steel frame construction. Lester B. Knight and C. F. Murphy were the associated architects. Helmut Jahn was the designer. It includes the Atrium Mall, 150,000 square feet of commercial space. It is also known as the State of Illinois Center. Articles are in IA-C March 1987, p. 54, and ARCH November 1985, p. 40. Photo-

graphs are in AR May 1987, p. 175; PA December 1985, p. 72; *American Architects,* Lee Krantz, 1989, p. 133; GCA, p. 87; STL, p. 238; ABOV, p. 45; SEA, pp. 84, 94; and PROC, p. 150. Buildings previously on this site include the Sherman Hotel, 192 N. Clark Street, Printer's Row, Astor Hotel, and the prefire Exchange building.

BOULEVARD TOWERS SOUTH building, built in 1985 at 205 N. Michigan Avenue, at the northeast corner of E. Lake Street, is 44 stories, 576 feet high, of reinforced concrete construction. Fujikawa, Johnson were the architects and Alfred Benesch & Co. the engineers. See also the Boulevard Towers North building. The site also provides for a future Boulevard East building fronting on N. Stetson Avenue. Photographs are in STL, p. 209; TBC, p. 252; and PROC, p. 55.

200 W. ADAMS STREET building, built in 1985 at the northwest corner of N. Wells Street, is 28 stories, of steel and reinforced concrete construction. Fujikawa, Johnson were the architects, Klein & Hoffman the engineers. It was also known as Equitec Tower and as the Bank of America building. A drawing is in RB May 11, 1985, p. 13. Buildings previously occupying this site include the 1888 200–206 W. Adams Street and 173–77 S. Wells Street buildings.

North: Richard PEPPER (construction) COMPANIES building, built in 1985 at 643 N. Orleans Streets, at the northeast corner of W. Ontario Street, is eight stories high, of steel frame construction. Loebl, Schlossman & Hackl were the architects and Schacht-Johnson the engineers.

North: HERMITAGE APARTMENTS ON HURON building was built in 1985 at 70 W. Huron Street, at the northeast corner of N. Clark Street, extending to W. Superior Street. The building is 26 stories high, of reinforced concrete construction. This was originally known as The Hermitage. Lisec & Biederman were the architects and Beer, Gorski & Graff the engineers.

North: DEARBORN PLACE apartment and office building, built in 1985, is located at 875 N. Dearborn Parkway, at the southeast corner of W. Delaware Place, opposite the southeast corner of Washington Square Park. The reinforced concrete building rises 26 stories. Loewenberg-Fitch were the architects, and the engineers were Structural Associates.

1985: Charlie Club addition: see Illinois Athletic Club.

203 N. LaSALLE STREET building, built in 1986 at the northeast corner of W. Lake Street, extending to N. Clark Street, is 27 stories, of reinforced concrete construction. Skidmore, Owings & Merrill were the architects/ engineers, with Adrian Smith the designer. It was planned as the Loop Transportation Center building. Articles are in IA-C September 1988, p. 21,

and November 1986, p. 34. Photographs are in GCA, p. 143; STL, p. 266; TBC, p. 408; and CST. Buildings previously occupying this site include the Marine, Merchant's Hotel, 120 W. Lake Street, and the Winston.

225 W. WASHINGTON STREET building, built in 1986 at the southeast corner of N. Franklin Street, is 27 stories high, of steel frame construction. Skidmore, Owings & Merrill were the architects/engineers, with Adrian Smith the designer and John Zils the engineer. Photographs are in IA-C May 1988; STL, p. 258; ABOV, p. 38, at the left edge; and CST. The Chicago Eye, Ear, Nose and Throat hospital previously occupied this site.

South: RIVER CITY, built in 1986 at 800 S. Wells Street, to W. Harrison and 12th Streets, at the east bank of the Chicago River, is 15 stories high, of reinforced concrete construction. This is a mixed-use project including low-rise apartments, shops, theaters, and a marina. Bertrand Goldberg was the architect. Photographs are in AGC, p. 149; STL, p. 191; 1987 COF, p. 138; CST; GCA, p. 104; and SCS, p. 258.

West: PRESIDENTIAL TOWERS apartment buildings (four), built in 1986 at 555, 575, 605, and 625 W. Madison Street to W. Monroe Street, with bridging through two blocks, S. Clinton to S. Desplaines Street. The buildings are 45 stories high, of reinforced concrete construction. Solomon, Cordwell & Buenz were the architects, with Chris P. Stefanos the engineer. Photographs are in IA-C November 1986; STL, p. 217; ABOV, pp. 41 and 42; TBC, p. 314; CST; SCS, p. 471; and CSV, p. 32. Buildings previously occupying this site include Plamondon and the Friend/15 S. Desplaines Street building (not listed here).

North: ONTERIE CENTER, built in 1986 at 441 E. Erie Street, extending through to 446 E. Ontario Street east of McClurg Court, is 12 and 60 stories, 570 feet high, of a diagonalized tubular concrete construction. Skidmore, Owings & Merrill were the architects/engineers, with Bruce Graham the designer and Fazlur R. Khan the engineer. This is a mixed-use project including offices, apartments, and shops. Photographs are in SEA, p. 72; AR Mid-August 1981, p. 78; and ENR April 1981. The Furniture Exhibition building previously occupied part of this site.

North: FCB (Foote, Cone & Belding) CENTER building was built in 1986 at 101 E. Erie Street, at the southeast corner of N. Rush Street. Rising 20 stories, the building is of reinforced concrete construction. Welton Becket was the architect. A photograph is in CST.

North: ORLEANS COURT apartment building, built in 1986 at 414 N. Orleans Street, at the northeast corner of (320) W. Illinois Street, is 22 stories high. Skidmore, Owings & Merrill were the architects/engineers.

Fig. 48. Manufacturers Hanover Plaza Building, 1987 (Photograph by McShane-Fleming Studios)

North: LASALLE CENTER office building, built in 1986 at 770 N. LaSalle Drive, at the southwest corner of W. Chicago Avenue, is eight stories high, of reinforced concrete construction. Alan Conn was the architect.

North: GOETHE TERRACE apartment building, built in 1986 at 1258 N. LaSalle Drive, at the southwest corner of W. Goethe Street, is 17 stories high, of reinforced concrete construction. Lisec & Biederman were the architects and Beer, Gorski & Graff the engineers. This was renamed the Place LaSalle building.

North: 445 E. OHIO apartment building, built in 1986, extending through the block to E. Grand Avenue, is 38 stories high. George Schipporeit was the architect; Chris P. Stefanos was the engineer. It was also known as Lake Shore Plaza. The structure is reinforced concrete.

1986: An addition was made to the Builders building (q.v.).

MANUFACTURERS HANOVER PLAZA building, built in 1987, renamed 10 S. LaSalle Street, at the southwest corner of W. Madison Street, is 37 stories high, a steel frame with a reinforced concrete core (fig. 48). It incorporates the lower four stories of the facade of the Otis building. Moriyama & Teshima were the design architects, with Holabird & Root, associated architects, and CBM the engineers. This was also known as the Chemical Trust Plaza building. Photographs are in IA-C November 1984, p. 55, and September, 1985, p. 22; CST; SEA, p. 66; *Process Architecture* no. 107, 1992; and SCS, p. 260.

190 S. LASALLE STREET building, built in 1987 at the northwest corner of W. Adams Street, is 42 stories (575 feet) high, a steel frame with a reinforced concrete core. John Burgee with Philip Johnson were the architects, Shaw & Associates the associate architects, and CBM the engineers. Photographs are in IA-C May 1988, p. 60; STL, p. 280; TBC, p. 363; SEA, p. 96; SCS, p. 9; *Philip Johnson–John Burgee: Architecture 1979–1985,* ed. Carleton Knight III and Robert A. Stern, 1989 rev. ed., intro., p. 153, and CMAG January 1985. Buildings previously on the site include National Republic Bank and the Schlosser Block.

FAIRMONT HOTEL CHICAGO, built in 1987 at 200 Columbus Drive, at the northwest corner of E. Lake Street, is 37 stories high, of reinforced concrete construction. HOK were the design architects, Fujikawa, Johnson, associated architects, and Alfred Benesch & Co. the engineers. This is an Illinois Center building.

West: NORTHWESTERN ATRIUM CENTER building, built in 1987 at 500 W. Madison Street, at the northwest corner of N. Canal Street to N. Clinton Street, is 40 stories, 590 feet high, of steel frame construction. Murphy/

Jahn were the architects, with Helmut Jahn, designer, and Thornton-Tomasetti the engineers. It was also known as One Northwestern Center. Photographs are in IA-C May 1988, p. 66; STL, p. 243; ABOV, p. 39; *Helmut Jahn*, Nory Miller, 1986, p. 10; CST; SEA, p. 79; AR December 1981, p. 62; and PROC, p. 154. A drawing is in TBAR, p. 21. The Chicago & Northwestern Railroad Station headhouse previously occupied this site, as did the Gault House and the Grand Central Hotel earlier.

North: QUAKER (Oats Co.) TOWER building, built in 1987 at 321 N. Clark Street, at the north bank of the Chicago River, is 35 stories high. Skidmore, Owings & Merrill were the architects/engineers, with Bruce Graham the designer, and John Zils the engineer. Photographs are in STL, p. 272; *American Architects*, Lee Krantz, 1989, p. 165; and CST. The Hiram Sibley Warehouse previously occupied this site.

North: HOTEL NIKKO CHICAGO, built in 1987 at 320 N. Dearborn Street, at the north bank of the Chicago River, is 20 stories high. HOK was the architect, with Masami Takayama associated, and CBM the engineers. Photographs are in STL, p. 272; ABOV, p. 55; IA-C September 1986, p. 33; and CST. A portion of this site was previously occupied by the 1909 Steele-Wedeles building.

North: 142 E. ONTARIO STREET office building, built in 1987, to the east of N. Michigan Avenue, is 18 stories high. Barancik, Conte were the architects.

North: 1212 N. LaSALLE DRIVE condominium building, built in 1987 at the northwest corner of W. Division Street, is 30 stories high, of reinforced concrete construction. James Loewenberg was the architect, and Structural Associates were the engineers. The building was renamed The LaSalle.

1987: McCormick Place addition: see McCormick Place. Morton building addition: see Morton building, 1896.

303 W. MADISON STREET building, built in 1988 at the southwest corner of S. Franklin Street, is 26 stories high. Skidmore, Owings & Merrill were the architects/engineers, with Joseph Gonzales the designer. Articles are in AR September 1989, p. 92, and IA-C May 1988, p. 54. Photographs are in STL, p. 259, and CST. The Commercial Trust building previously occupied this site.

123 N. WACKER DRIVE building, built in 1988 at the southeast corner of W. Randolph Street, is 30 stories high. Perkins & Will were the architects, with Ralph Johnson the designer. Photographs are in IA-C May 1988, p. 49; STL, p. 270; ABOV, pp. 34, 38; CST; and SCS, pp. 32, 261 (drawing). The Channon building previously occupied this site.

HARBOR TOWER NORTH apartment building, built in 1988 at 195 N. Harbor Drive, was renamed the Park Shore Condominiums. The building is 55 stories high, rising 519 feet, of tubular reinforced concrete construction. Fujikawa, Johnson were the architects and Alfred Benesch the engineer. This is an Illinois Center building. Photographs are in IA-C March 1991 (advert.) and in PROC, p. 166.

CHICAGO MERCANTILE EXCHANGE CENTER building addition was made in 1988, at 10 S. Wacker Drive, at the southwest corner of W. Madison Street, on the east bank of the Chicago River. Constructed of reinforced concrete, it is 44 stories tall, rising 530 feet. Fujikawa, Johnson were the architects and Alfred Benesch & Co, the engineers. This is a "twin" of the 1983 Exchange building. The C. H. Fargo building and the 1954 Wacker-Madison parking structure (not listed here) previously occupied this site.

North: LE MERIDIEN CHICAGO HOTEL was built in 1988 at 21 E. Bellevue Place, at the southeast corner of N. Rush Street, in the Gold Coast Historic District/NR. It is 23 stories high. MacKinlay, Winnaker, McNeil were the architects. It was renamed the Sutton Place Hotel.

North: OAKWOOD APARTMENTS building, built in 1988 at 77 W. Huron Street, at the southeast corner of N. Clark Street, is 25 stories high, of reinforced concrete construction. Metz, Train, Youngren were the architects and Don Belford the engineer.

North: 1133 N. DEARBORN STREET apartment building, built in 1988 at the southeast corner of W. Elm Street, in the Gold Coast Historic District/ NR, is 34 stories high, of reinforced concrete construction. Gordon & Levin were the architects and CBM the engineers.

1988: Burnham Park Plaza: see YMCA Hotel, 1915. Chicago Historical Society addition: see Chicago Historical Society, 1931.

AT&T CORPORATE CENTER building, built in 1989 at 227 W. Monroe Street, at the southeast corner of S. Franklin Street, is 16 and 60 stories, 885 feet high, of steel and reinforced concrete construction. Skidmore, Owings & Merrill were the architects/engineers, with Adrian Smith as the designer. See also the USG building. Photographs are in TBC, p. 412, and CST. The Butler Paper building previously occupied this site.

225 W. WACKER DRIVE building, built in 1989 at the southeast corner of N. Franklin Street, is 30 stories, ca. 390 feet high, of high-strength reinforced concrete construction. Kohn, Pedersen, Fox were the architects, with William Pedersen the designer and Perkins & Will as associated architects. An article is in ARCH February 1990, p. 78. Photographs are in STL, p. 142,

Fig. 49. 900 N. Michigan Avenue, 1989 (Photograph by McShane-Fleming Studios)

with the Engineering building, and p. 284; ABOV, p. 34; CST; *Kohn, Pederson, Fox,* ed. Warren A. James, 1993, p. 88; *KPF,* ed. Christian Norberg-Schulz, 1993, p. 83; and IA-C November 1987, p. 19. The Wabash building previously occupied the south portion of this site.

LEO BURNETT building, built in 1989 at 35 W. Wacker Drive, at the southeast corner of N. Dearborn Street, is 48 stories high, reaching 635 feet high, with a steel frame and a reinforced concrete core. Roche, Dinkeloo were the architects, with Shaw & Associates, associated architects, and CBM the engineers. Photographs are in STL, p. 174, with neighbors, and p. 282; IA-C January 1990, p. 36; and CST. The Dearborn-Lake Garage previously occupied this site.

SWISS GRAND HOTEL, built in 1989 at 323 E. Wacker Drive, is 44 stories tall, of reinforced concrete construction. Harry Weese was the architect and CBM the engineers. Photographs are in STL, p. 208, and CST. This is an Illinois Center building.

North: ONE EAST DELAWARE PLACE apartment building, built in 1989 at the southeast corner of N. State Parkway, is 6 and 36 stories high, of reinforced concrete construction. Loewenberg-Fitch were the architects, and Structural Associates were the engineers. A photograph is in IA-C March 1988, p. 23 (advert.).

North: 900 N. MICHIGAN AVENUE building, built in 1989, extending from E. Walton Place to E. Delaware Place and N. Rush Street, is 66 stories tall, 871 feet high (fig. 49). Steel framing was used for lower stories and reinforced concrete construction for the highest 36 stories. Eight- and 14-story structures adjoin the tower. Kohn, Pedersen, Fox and Perkins & Will were the architects, with William Pedersen the designer and Alfred Benesch & Co. the engineers. The mixed-use project includes The Tower offices, the Four Seasons Hotel (120 E. Delaware Place), and the Bloomingdale department store. Photographs are in CANY, p. 36; STL, p. 274; IA-C January 1990, p. 36; CST; *Kohn, Pedersen, Fox,* ed. Sonia R. Chao and Trevor D. Abramson, 1987, pp. 131, 198; PROC, p. 128; SEA, p. 50; and SCS, p. 354. The 900 N. Michigan Avenue building of 1927 and the 920 N. Michigan Avenue building previously occupied this site.

North: NBC TOWER building, built in 1989 at 200 E. Illinois Street and (454) N. Columbus Drive, at Mies van der Rohe Drive and the northwest corner of East North Water Street, is 4 and 40 stories high. Skidmore, Owings & Merrill were the architects/engineers, with Adrian Smith the designer and Stanton Korista the engineer. Photographs are in AGC, p. 119; IA-C January 1990, p. 40; STL, p. 276; ABOV, p. 54; CMAG January 1989; and CST.

Fig. 50. 200 N. Dearborn Street Apartments, 1990 (Photograph by McShane-Fleming Studios)

North: 1122 N. CLARK STREET apartment building, built in 1989 at the southwest corner of W. Elm Street, is 39 stories high. A. Epstein & Sons were the architects/engineers. It is also known as the Clark-Elm Apartments.

1990: Federal Reserve Bank addition: see Federal Reserve Bank, 1922. 100 E. Walton addition: see 100 E. Walton, 1972. Montgomery Ward Memorial: see McKinlock Campus of Northwestern Universty, 1926.

PAINE WEBBER TOWER building, built in 1990 at 181 W. Madison Street, at the southeast corner of S. Wells Street, is 50 stories high, 680 feet. The architect was Cesar Pelli, with Shaw & Associates, associated, and CBM the engineers. Photographs are in AF August 1991, pp. 100–107; ABOV, p. 47; TBC, p. 375; CST; CAD, p. 6; and SEA, p. 32. The Madison-LaSalle building previously occupied this site.

311 S. WACKER DRIVE building, built in 1990, in the block bounded also by W. Jackson Boulevard and S. Franklin and W. Van Buren Streets, is 51 and 65 stories, 970 feet high, of tubular high-strength reinforced concrete construction. Two additional buildings have been projected for this site. Articles are in *Concrete Construction,* January 1990, p. 5, and July 1994, p. 556; *Concrete Technology Today* (magazine of the Portland Cement Association), March 1994, on high-strength concrete. Kohn, Pedersen, Fox were the architects, Harwood K. Smith and Brockette/Davis/Drake associated, with Chris P. Stefanos, engineer. Photographs are in CST; CMAG February 1994, p. 52; *Kohn, Pedersen, Fox,* ed. Warren A. James, 1993, p. 101; ENR November 30, 1989, p. 25; AR February 1987, p. 126; PA January 1987, p. 46; and *KPF,* ed. Christian Norberg-Schulz, 1993, p. 105. Buildings previously occupying this site include 325 S. Market Street, 333–35 S. Market Street, 320–22 S. Franklin Street, 317–19 S. Market Street, 330–32 S. Franklin Street, and the Jackson-Franklin building.

CHICAGO BAR ASSOCIATION building, built in 1990 at 321 S. Plymouth Court, is 16 stories high. Tigerman, McCurry were the architects and CBM the engineers. Photographs are in ABOV, p. 51, beyond the Library Center; CST; and STL, model.

200 N. DEARBORN STREET apartment building, built in 1990 at the northwest corner of W. Lake Street, is 47 stories, of reinforced concrete construction (fig. 50). Lisec & Biederman were the architects and Beer, Gorski & Graff the engineers. Photographs are in IA-C January 1989, p. 22 (advert.); STL, p. 200, to the left and above the 55 W. Wacker Drive building; and CST. The General Clark Hotel and the Commercial (Hotel) building previously occupied this site.

TWO PRUDENTIAL PLAZA building, built in 1990 at 180 N. Stetson Avenue, is 64 stories tall, rising 995 feet, of high-strength reinforced concrete

Fig. 51. Morton International, 1990 (Photograph by McShane-Fleming Studios)

construction. The building is connected with the One Prudential Plaza building. Loebl, Schlossman & Hackl were the architects. Photographs are in ABOV, pp. 17, 50; STL, p. 179; and CST.

West: MORTON INTERNATIONAL building, built in 1990 at 100 N. Riverside plaza, extending from W. Randolph to W. Washington Street, at the west bank of the Chicago River, is 11 and 36 stories high and steel framed (fig. 51). Perkins & Will were the architects, with Ralph Johnson as the designer. Photographs are in AGC, p. 94; ABOV, pp. 38, 40; IA-C March 1991; ARCH May 1993, p. 94; CST; SEA, p. 42.

West: NORTHERN TRUST building, built in 1990 at 801 S. Canal Street, at the southeast corner of W. Polk Street, is eight stories high. Eckenhoff, Saunders were the architects and CBM the engineers. It was also known as the Canal Center building. Photographs are in IA-C July 1989, p. 66, and May 1991, p. 26.

North: THE CHICAGOAN apartment building, built in 1990 at 750 N. Rush Street, at the southwest corner of E. Chicago Avenue, is 37 stories high. Solomon, Cordwell & Buenz were the architects. A photograph is in CST.

North: 350 N. LaSALLE DRIVE building, built in 1990 at the southwest corner of W. Kinzie Street, is 15 stories high. Loebl, Schlossman & Hackl were the architects, with Wojiech Lesnikowski as consultant. It was planned as The Beacon of LaSalle Street building. Photographs are in CST and in RB June 29, 1991, cover.

North: AMERICAN MEDICAL ASSOCIATION building, built in 1990 at 515 N. State Street, in the block bounded also by N. Wabash and E. Grand Avenues and E. Illinois Street, is 29 stories high. Kenzo Tange was the design architect, with Shaw & Associates, associated architects, and CBM the engineers. A photograph is in CST.

North: 420 E. OHIO STREET building, built in 1990, is 41 stories high. Dirk Lohan was the architect and CBM the engineers.

North: CHICAGO PLACE building, built in 1990 at 700 N. Michigan Avenue, in the block bounded also by E. Superior, E. Huron, and N. Rush Streets, is 8 and 40 stories high. Skidmore, Owings & Merrill were the architects/engineers, with John Zils the engineer. Solomon, Cordwell & Buenz were associated architects for residential spaces. The mixed-use building includes (100 E. Huron Street) condominiums and a shopping mall. Photographs are in CST and in RB August 25, p. 1. Buildings previously occupying this site include the 700 N. Michigan Avenue building of 1929, 720 N. Michigan Avenue, and the Cyrus McCormick residence.

North: CITY PLACE BUILDING and HYATT SUITES HOTEL, built in 1990 at 678 N. Michigan Avenue, at the southwest corner of E. Huron Street, is 38 stories high, of reinforced concrete construction. Offices occupy the top 13 floors. The mixed-use project also includes The Residences. A photograph is in SEA, p. 47. Chris P. Stefanos was the engineer, and Loebl, Schlossman & Hackl were the architects. The hotel was renamed the Omni Suites Hotel, 676 N. Michigan Avenue. The Physicians building (not listed here) previously occupied a portion of the site.

North: GUEST QUARTERS SUITES CHICAGO HOTEL, built in 1990 at 198 E. Delaware Place, at the northwest corner of N. Mies van der Rohe Drive, is 30 stories high. Barancik, Conte were the architects. It was renamed the Doubletree Guest Suites Hotel. Photographs are in IA-C September 1990, p. 92 (advert.), and ABOV, p. 25, scene to the left of the John Hancock building. A drawing is in RB June 30, 1990, p. 21 (advert.). The 200 E. Delaware Place building previously occupied this site.

North: CRATE AND BARREL store, built in 1990 at 646 N. Michigan Avenue, is four stories high. Solomon, Cordwell & Buenz were the architects. Photographs are in IA-C November 1990, p. 16, and May 1993, p. 93 (advert.); CST; and AGC, p. 105.

North: 1250 N. DEARBORN STREET condominium building, built in 1990, in the Gold Coast Historic District/NR, is 24 stories high. Richard Neuman was the architect. A photograph is in *City Magazines,* Fall 1994, p. 31.

1990: Tarry Medical building: see McKinlock Campus of Northwestern University.

STOUFFER RIVIERE HOTEL, built in 1991 at 1 W. Wacker Drive, at the southwest corner of N. State Street, is 27 stories high. William B. Tabler was the architect, with Mann, Gin, Ebel & Frazier, associated architects. The hotel was renamed the Renaissance Chicago Hotel. The 220 N. State Street building previously occupied this site, as did the 1954 city "bird-cage" parking structure (not listed here) by Shaw, Metz & Dolio, at 11 W. Wacker Drive.

HAROLD WASHINGTON LIBRARY CENTER, built in 1991 at 400 S. State Street, in the block bounded also by W. Congress Parkway, S. Plymouth Court, and W. Van Buren Street, is 10 stories high, of steel and reinforced concrete construction. Hammond, Beeby & Babka, design architects by competition, and A. Epstein & Sons, associated architects/engineers. Photographs are in 1993 CFB, p. 58; ABOV, p. 51; *Whitney Guide to Twentieth-Century American Architecture,* Sydney LeBlanc, 1993, p. 200; TBC, p. 400; and CST. Buildings previously occupying this site include 400 S. State Street, 441–43 S. Plymouth Court, 445–47 S. Plymouth Court, and the Trocadero Theater (not listed here).

1 N. FRANKLIN STREET building, built in 1991 at the northeast corner of W. Madison Street, is 38 stories high. Skidmore, Owings & Merrill were the architects/engineers, with Joseph Gonzalez the designer. Photographs are in AGC, p. 86; CST; and CMAG February 1994, p. 52. The Galbraith building previously occupied this site.

1991: Ralph H. Metcalf Federal building: see the Federal Center, 1964. Burnham Court infilling: see Burnham building, 1924. Oceanarium addition: see Shedd Aquarium, 1929.

West: GREYHOUND BUS TERMINAL, built in 1991 at 650 W. Harrison Street and S. Desplaines Street, at the south side of the Eisenhower Expressway. Nagle, Hartray were the architects, with CBM the engineers. The building is of steel frame construction. A photograph is in AGC, p. 151, and SEA, p. 45.

West: 555 W. ADAMS STREET building, built in 1991 at the southwest corner of S. Clinton Street, is 10 stories high. McClier Corp. were the architects. It was also known as the Trans Union building.

North: 633 ST. CLAIR PLACE building, built in 1991 at the northeast corner of E. Ontario Street, extending to E. Erie Street, is 28 stories high. Loebl, Schlossman & Hackl were the architects, with CBM the engineers. A drawing is in STL, p. 293. Photographs are in TBC, p. 341, and CMAG February 1994, p. 53. The Popular Mechanics building previously occupied this site.

North: 401 E. ONTARIO STREET building, built in 1991 at the southeast corner of N. McClurg Court, is 49 stories high, of reinforced concrete construction. Nagle, Hartray were the architects, CBM the engineers. Photographs are in IA-C March 1989, p. 52, and CST.

North: NORTH PIER APARTMENT TOWER building, built in 1991 at 474 N. Lake Shore Drive, at the southwest corner of E. Illinois Street, on the north side of Ogden Slip, is 63 stories high, of reinforced concrete construction. Dubin, Dubin, & Moutoussamy were the architects, with CBM the engineers, and Florian-Wierzbowski, design consultants. This is a Cityfront Center building. A photograph is in ABOV, p. 54 scene. A portion of the Pugh Warehouses previously occupied this site.

North: CITYFRONT PLACE APARTMENTS, built in 1991 at 400, 440, and 480 N. McClurg Court, at the foot of Ogden Slip, comprises two 12-story and one 39-story buildings. Gelick, Foran were the architects and Chris P. Stefanos the engineer. This is a Cityfront Center project. Photographs are in IA-C January 1990, p. 29; ABOV, pp. 9, 54; PA July 1986, p. 104; and TBC, p. 386.

Fig. 52. R. R. Donnelley Center, 1992 (Photograph by Richard Binner, Fish Photography, Inc.)

North: PLAZA 440 apartments and COURTYARD BY MARRIOTT HOTEL, built in 1991 at 440 N. Wabash Avenue, at the northwest corner of E. Hubbard Street, is 50 stories high. Solomon, Cordwell & Buenz were the architects. The hotel, at 30 E. Hubbard Street, at the northwest corner of N. State Street, is 15 stories high. A small drawing is in CST. Buildings previously on this site include the 12–16, 18–20, and 22–24 E. Hubbard Street buildings.

North: EMBASSY SUITES HOTEL CHICAGO, built in 1991 at 600 N. State Street, in the block bounded also by E. Ohio, N. Dearborn, and E. Ontario Streets, is 11 stories high. Solomon, Cordwell & Buenz were the architects. It was also known as the Grand Royale Hometel.

CHICAGO TITLE and TRUST CENTER building, built in 1992, also known as 161 N. Clark Street, at the northeast corner of W. Randolph Street, is 13 and 51 stories high, rising 742 feet, constructed of steel and reinforced concrete. Kohn, Pedersen, Fox were the architects and Severud-Szegezdy the engineers. Photographs are in ARCH October 1992, p. 26; IA-C May 1993, p. 48; CST; AR October 1990, p. 87; *KPF,* ed. Christian Norberg-Schulz, 1993, p. 105; CE, on up/down construction, December 1993, p. 55; CMAG February 1994, p. 53; *Kohn, Pederson, Fox,* ed. Warren A. James, 1993, p. 105. Buildings previously on this site include a bus depot, the Ashland Blocks, and the Greisheimer on the northern part of the site, on which a second building is projected.

120 N. LaSALLE STREET building, built in 1992, extending through to N. Wells Street on Court Place, is 40 stories, of reinforced concrete construction. Murphy/Jahn were the architects, and Martin & Martin the engineers. This was planned as the Savings of America building. Photographs are in AGC, p. 82, upper stories; 1993 CFB, p. 94; CST; SEA, p. 39; and CMAG February 1994, p. 53. The Enterprise, Oxford building, and a rotating-elevator parking structure previously occupied this site.

R. R. DONNELLEY CENTER building, built in 1992, also known as the 77 W. Wacker Drive building, at the southeast corner of N. Clark Street, is 50 stories high, 668 feet, of tubular steel framing and a reinforced concrete core (fig. 52). Ricardo Bofill was the design architect, with DeStefano & Goettsch associated architects, and CBM the engineers. Drawings are in STL, p. 293; IA-C May 1993, p. 48; and CST. Photographs are in ARCH October 1992, p. 26; SEA, p. 24; *Ricardo Bofill,* Bartomeu Cruells, 1992, p. 142; and RB June 27, 1992, cover.

USG (United States Gypsum) building, built in 1992 at 222 W. Adams Street, at the northeast corner of (125) S. Franklin Street, is 34 stories high. Skidmore, Owings & Merrill were the architects/engineers, with Adrian Smith as designer and D. Stanton Korista as engineer. It is also known as the

AT&T/USG building, as part of the AT&T Corporate Center development. Photographs are in IA-C May 1993, p. 48; TBC, p. 415; CMAG February 1994, p. 52. Buildings previously on this site include the 222 W. Adams Street building.

West: HELLER INTERNATIONAL TOWER building, built in 1992, also known as the 500 W. Monroe Street building, at the northwest corner of N. Canal Street, extending to N. Clinton Street, is 45 stories high, reaching 600 feet. Skidmore, Owings & Merrill were the architects/engineers. Photographs are in CST; SEA, p. 16; and RB July 17, 1993. It is reinforced concrete construction.

West: CHICAGO-KENT COLLEGE OF LAW building, built in 1992 at 565 W. Adams Street, at the southeast corner of S. Jefferson Street, is 10 stories high. Holabird & Root were the architects. This is a branch of the Illinois Institute of Technology and includes the Stuart School of Business.

North: SHERATON CHICAGO HOTEL AND TOWERS, built in 1992 at 301 E. North Water Street, at the southeast corner of N. Columbus Drive, at the north bank of the Chicago River, is 40 stories high. Solomon, Cordwell & Buenz were the architects. It includes 14 stories of convention facilities.

North: PLAZA ESCADA building, built in 1992 at 840 N. Michigan Avenue, at the southwest corner of E. Chestnut Street, is four stories high. Lucien Lagrange was the architect and CBM the engineers. Drawings are in IA-C November 1992, p. 19, and CST. A photograph is in TBC, p. 402. The Michigan-Chestnut building previously occupied this site.

North: GOLD COAST GALLERIA building, built in 1992 at 111 W. Maple Street, at the southwest corner of (1010) N. Clark Street, is 35 stories high, of reinforced concrete construction. It includes apartments and offices. Loewenberg-Fitch were the architects and Structural Associates the engineers. A photograph is in RB June 29, 1991, p. 48.

North: 1320 N. LAKE SHORE DRIVE building, built in 1993 at the southwest corner of E. Banks Street, is 41 stories high. Jung/Brannen were the architects. See appendix F.

UNICOM THERMAL TECHNOLOGIES buildings include one built in 1994 on S. State Street, at the northeast corner of E. Adams Street. It is equivalent to about 10 stories, of steel frame construction. Eckenhoff, Saunders were the architects and TT/CBM the engineers. The Baskin Store previously occupied this site. Another building was constructed in 1996, in the block adjacent to the Congress Parkway between S. Wacker Drive and S. Franklin Street at W. Van Buren Street. It is 4 levels, about 60 feet high, of reinforced concrete construction. Eckenhoff, Saunders were the architects

and Chris P. Stefanos the engineer. A third facility is incorporated in the 1997 300 E. Randolph Street building (see below).

North: GRADUATE SCHOOL OF BUSINESS, UNIVERSITY OF CHICAGO, renamed the Eric Gleacher Center building, was built in 1994 at 450 Cityfront Plaza, at the north bank of the Chicago River. It is six stories high. Dirk Lohan was the architect and TT/CBM the engineers. Drawings are in IA-C July 1993, p. 22, and RB May 9, 1992, p. 1. A photograph is in *Chicago Tribune*, February 22, 1996, section 3, p. 2. The Mandel-Lear building previously included this site.

North: LOYOLA UNIVERSITY building, built in 1994 at 25 E. Pearson Street, at the southwest corner of N. Wabash Avenue, is 16 stories high. Holabird & Root were the architects, with Roy Solfisburg the designer. An article is in the *Chicago Tribune*, Sunday, September 15, 1994, arts section 13, p. 7.

1995: Additions on Navy Pier: see Municipal Pier/Navy Pier, 1916.

South: 1911 S. INDIANA AVENUE, built in 1995, is 10 stories high, of reinforced concrete construction. Gordon & Levin were the architects, with Kolbjorn Saether the engineer. It was built for the State of Illinois Department of Children & Family Services and comprises five stories of parking with offices above.

North: 1414 N. WELLS STREET condominium building, built in 1995, is six stories high. Pappageorge & Haymes were the architects.

West: GENERAL MAIL FACILITY, U.S. POST OFFICE, built in 1996 at 433 W. Harrison Street and the corner of S. Canal to W. Polk Streets, is eight stories high, of steel frame construction, and comprises about 1,000,000 square feet in area. Lester B. Knight was the architect/engineer.

North: MAPLE POINTE APARTMENTS building, built in 1996 at 150 W. Maple Street, at the northwest corner of N. LaSalle Drive, is 20 stories high. Barancik, Conte were the architects and Samartano & Co. the engineers.

North: MUSEUM OF CONTEMPORARY ART, built in 1996 at 220 E. Chicago Avenue, at the corner of N. Mies van der Rohe Drive and E. Pearson Street, is three stories high, of reinforced concrete construction. Josef Paul Kleihues was the design architect; A. Epstein & Sons were the associated architects/engineers. The Armory previously occupied this site adjoining Lake Shore Park.

North: 600 N. MICHIGAN AVENUE building, built in 1996, in the block bounded also by E. Ohio, N. Rush, and E. Ontario Streets, is four stories high, of steel frame construction. Beyer, Blinder & Belle were the architects. A drawing and construction photographs are in *Chicago Tribune*, January 24,

Fig. 53. 300 E. Randolph Street, 1997 (Courtesy Blue Cross, Blue Shield, and Robert Johnson, photographer)

1996, section 4, p. 1, and Sunday, February 4, 1996, real-estate section 16, p. 3, showing the building under construction. The building includes shops and theaters. The 100 E. Ohio Street, 101 E. Superior Street, and the John R. Thompson buildings previously occupied this site.

1996: The State Street Mall was returned to general vehicular use. See 1997 brochures: *A Year in Perspective,* Greater State Street Council, and *Vision for a Greater State Street: Next Steps,* Chicago Department of Planning and Development. McCormick Place South addition: see McCormick Place. South Lake Shore Drive was reconfigured to accommodate the "Museum Campus" comprised of the several lakefront museums.

South: McCORMICK/HYATT HOTEL, built in 1997, adjoining the west side of McCormick Place, is 32 stories high. A. Epstein and Sons were the architects/engineers. A drawing is in *North Loop News,* July 25, 1996, p. 1.

North: ARTS CLUB OF CHICAGO, built in 1997 at 201 E. Ontario Street, at the southeast corner of N. St. Clair Street, is two stories high. Vinci/Hamp were the architects. A drawing is in ARCH November 1995, p. 31.

North: CHICAGO MUSIC AND DANCE THEATER, built in 1997 at N. Fairbanks Court and E. North Water Street, is five stories high. Hammond, Beeby & Babka were the architects, CBM the engineers.

CHICAGO STOCK EXCHANGE EXTENSION building was built in 1997 at the northeast corner of S. LaSalle Street and W. Van Buren Street, extending to S. Clark Street. Fujikawa, Johnson were the architects. The Utilities building formerly occupied a portion of this site.

300 E. RANDOLPH STREET building for Blue Cross Blue Shield, built in 1997 at the northeast corner of N. Columbus Drive, is 30 stories, 411 feet high, of composite steel frame and reinforced concrete construction (fig. 53). The structure provides for vertical expansion of two increments of twelve additional stories, to 731 feet high. Dirk Lohan was the architect, with James Goettsch the designer. VOA did the interiors. A Unicom Thermal Technologies facility is incorporated in the building. An article by Blair Kamin is in *Chicago Tribune,* January 31, 1996, Tempo section, p. 1. A photograph is in the *Wall Street Journal,* "Developments" section, February 19, 1998.

1997: Symphony Center additions: see Orchestra Hall, 1905.

North: THE WHITNEY apartment building was built in 1997 at 1301 N. Dearborn Parkway, at the northeast corner of W. Goethe Street. It is 16 stories high, of reinforced concrete construction. Pappageorge & Haymes were the architects. A drawing (real estate advert.) is in *Chicago Tribune,* April 19, 1996.

North: ERIE CENTRE TOWER building was under construction in 1998 at 433 W. Erie Street. It is 23 stories high, of reinforced concrete construction. Pappageorge & Haymes are the architects.

North: 21 W. CHESTNUT PLACE condominium building was under constuction in 1998. It is 17 stories high, of reinforced concrete construction. Loewenberg Associates are the architects and Martin Finerty of Structural Associates the engineer.

North: CATHEDRAL PLACE apartment building was under construction in 1998 in the block bounded by W. Superior, N. State, and W. Huron Streets and N. Dearborn Parkway. It is 52 stories high. The architects are Loewenberg Associates, Kolbjorn Saether the engineer.

North: 1122 N. DEARBORN PARKWAY condominium building was under construction in 1998. It is 20 stories high, of reinforced concrete construction. Pappageorge & Haymes are the architects.

North: 33 W. HURON STREET condominium building was under constuction in 1998. It is 9 stories high. Pappageorge & Haymes are the architects.

North: PARK NEWBERRY AT DELAWARE PLACE was under construction in 1998 at 55 W. Delaware Place. It is 12 stories high. Loewenberg Associates are the architects and Martin Finerty of Structural Associates the engineer. The 1958 Salvation Army Headquarters building previously occupied this site.

North: PARK TOWER HOTEL AND CONDOMINIUM building, 67 stories high, was under construction in 1998 at 800 N. Michigan Avenue, extending to N. Rush Street. Lucien Lagrange is the architect and Chris P. Stefanos the engineer. The Park Hyatt Water Tower Inn previously occupied this site.

North: NORTHWESTERN UNIVERSITY MEMORIAL HOSPITAL buildings of various functions are under construction and expected to be completed in 1999. This group is in the block bounded by E. Huron, N. St. Clair, E. Erie, and N. Fairbanks Court. Ellerbe, Becket and HOK are the associated architects. A photograph is in *Real Estate Journal,* March 2, 1998, p. 14.

Appendix A. Locations of Buildings

In this appendix most existing buildings are listed street by street, from east to west, as a pedestrian would come upon them. Buildings on the east side of the north-south streets (odd numbers) are indented in the list. Buildings on east-west streets (odd numbers are on south side) that are not on a corner are given after the north-south street listing. Most demolished buildings are not listed except for (1) buildings noted in the text as having special significance but built before landmarks designation programs; (2) buildings that have been designated formally as landmarks; and (3) about ten demolished buildings that were built after 1949. Usually the present name is given first, with the year of construction in parentheses, followed by a slash (/) and the original or popular name for the building. Buildings not included in the text are acknowledged to exist simply by being given within brackets, with the designation "NI." The names of some of these buildings, as for all formally designated landmarks, are italicized.

NORTH LAKE SHORE DRIVE
—— North, 1600 north ——
1550 (1962)
1540 Co-Op Apts. (1925)
[*1516–30: three houses on Illinois Register,*
 NI]
1500 (1931)
—— Burton, 1500 north ——
1448 Apts. (1927)
1440 Condo (1963)
1430 (1928)
1420 (1929)
1418 Condo (1983)
1400 (1927)
—— Schiller, 1400 north ——
1350, 1360 (1941)
—— Banks ——
1320 (1993)
1300 Condo (1963)
—— Goethe, 1300 north ——
[*four houses, with 1516–30:* in *Lake Shore*
 Drive Landmark District, NI]

1242 (1929)
1240 Apts. (1969)
—— Scott ——
1212 Condo (1969)
1200 Condo (1912) / Stewart Apts.
—— Division, 1200 north ——
1150 (1959)
1130 (1910)
—— Elm ——
1120 (1925)
1110 (1971)
1100 (1980)
—— Cedar, 1100 north ——
1040: The Carlyle (1966)
—— Bellevue ——
1000 N. Lake Shore (23 stories) (1954)
One (Lake Shore) Plaza (57 stories)
 (1964)
—— Oak, 1000 north ——

EAST LAKE SHORE DRIVE
255: Drake Hotel (1929)

179: Drake Tower Apts. (1929)
181: Mayfair-Regent (1923)
199: The Breakers (1915)
209 (1924)
219 (1922)
229 (1918)

NORTH LAKE SHORE DRIVE
999 Co-Op (1912)
990 Condo (1973)
—— Walton ——
900 and 910 (1956) / Esplanade Apts.
—— Delaware, 900 north ——
860 and 880 (1952)
—— Chestnut ——
850: Lake Shore Center (1924) / Lake
 Shore Club
840: American Hospital Association
 (1970)
—— Pearson ——
(Lake Shore Park)
—— Chicago, 800 north ——
750: American Bar Center (1984)
—— Superior ——
Abbott Hall, Northwestern Univ.
 (1939)
—— Huron, 700 north ——
666: Lake Shore Place (1923,
 1926) / Furniture Mart
—— Erie ——
644: Days Inn Lake Shore Drive
 (1966) / Holiday Inn
—— Ontario ——
(vacant; site of 1960 Best Western Lake
 Shore Drive Hotel)
—— Ohio, 600 north ——
540 Lake Shore Drive Apts. (1910 and
 1919) / Lake Shore & Ohio and
 Borg
—— Grand ——
Navy Pier (1916) / Municipal Pier
—— Illinois, 500 north ——
505: Lake Point Tower (1969)
474: North Pier Apt. Tower (1991)
—— Ogden Slip and river ——

SOUTH LAKE SHORE DRIVE
*1300: Museum Campus; Field Museum
 (1912);*

*Shedd Aquarium (1929);
Adler Planetarium (1930)*
[Soldier Field, NI]
Meigs Field Terminal (1963)
2300: McCormick Place (1970), strad-
 dling the drive
 (site of 1960 / fire, McCormick Place
 and 1973 McCormick Hotel)
McCormick / Hyatt Hotel (1998)

RITCHIE COURT
Ritchie Tower (1963)
—— Goethe, 1300 north ——

NORTH ASTOR STREET
(one-way south)
—— North, 1600 north ——
 1555 Condo (1975)
 1515: Park Astor (1968)
 [1505 Condo, NI]
1524 (1968)
—— Burton, 1500 north ——
 [1445, NI]
1430: Astor Villa Condo (1974)
[1400, 17 stories, NI]
—— Schiller, 1400 ——
 *1365: Charnley-Persky Foundation
 (1892)*
 1335 Co-Op Apts. (1951)
1350 Astor Co-Op (1950)
1340: Astor House (1969)
—— Banks ——
 1325 Astor Banks Condo (1929)
 1301 Co-Op Apts. (1928)
[1310: John W. Root House (1887),
 HABS, NI]
1300: Astor Tower Condo (1963)
—— Goethe, 1300 north ——
 (Goudy Square park)
1260 Apts. (1931)
—— Scott ——
 1209 Condo (1926)
1210: Renaissance Condo (1897) / Mc-
 Connell Apts.
—— Division, 1200 north ——
Streeterville:

NORTH PESHTIGO COURT
—— Grand ——

510: Chicago Police Department
 (1937) / Kraft Cheese
—— Illinois, 500 north ——

NORTH McCLURG COURT
400 east (one-way north)
—— Huron, 700 north ——
 Lake Shore Place (1923) / Furniture
 Mart
Lakeside Medical Center (1953) / V. A.
 Hospital
—— Erie ——
 (parking)
 [Veterans Admin., 2 stories, NI]
[Arena / Chicago Riding Club, NI]
—— Ontario ——
 401 E. Ontario Apts. (1991)
 Streeterville 400 (1982)
McClurg Court Center (1971)
—— Ohio, 600 north ——
 (parking)
—— Grand ——
 (parking)
—— Illinois, 500 north ——
North Pier Terminal (1905) / Pugh
 Warehouses
—— Ogden Slip ——
400–800: Cityfront Place (1991)
—— North Water, 400 north ——

NORTH DeWITT PLACE
(one-way south)
233 E. Walton (1922)
900 Apts. (1924) / 230 E. Delaware
—— Delaware, 900 north ——
 Delaware East, 253 E. Delaware (1958)
237 E. Delaware (1922)
860: Plaza on Dewitt Condo (1963)
260 E. Chestnut (1962)
—— Chestnut ——
 247 E. Chestnut (1963)
 Worcester House (1926) / DeWitt
 Hotel
850 Condo (1955)
222 Pearson East (1965)
—— Pearson ——

NORTH FAIRBANKS COURT
300 east

Northwestern University Hospitals
 Tarry Medical (1990)
Wesley Pavilion (1941)
—— Superior ——
 Memorial Hospital (1929) / Passavant
Health Sciences Pavilions (1979)
Dental School
—— Huron, 700 north ——
 Lakeside Medical Center (1953) / V.
 A. Hospital
Northwestern University Hospital
 (1999)
—— Erie ——
 [301 E., 4 stories, NI]
240 E. Ontario (1910)
—— Ontario ——
 Holiday Inn Chicago City Centre
 (1975)
[Ontario Court, NI]
—— Ohio, 600 ——
 541 (1968) / Time & Life
 (parking)
—— Grand ——
 (parking)
—— Illinois, 500 north ——
 Chicago Music & Dance Theater
 (1997)
NBC Tower (1989)
—— North Water, 400 north ——
 Sheraton Chicago, Towers (1992)
Graduate School of Business, UC
 (1994)
—— Chicago River ——
Fairbanks Court becomes
North Columbus Dr.

NORTH COLUMBUS DRIVE
300 east
—— Wacker ——
 Three Illinois Center (1980)
Hyatt Regency Hotel (1974)
—— East South Water ——
 300 E. Randolph (1997)
Fairmont Hotel (1987)
Amoco (1974) / Standard Oil
—— Randolph ——

MIES VAN DER ROHE DRIVE
200 east (former Seneca Street)

(one-way north)
[210 E. Walton, 5 stories, NI]
—— Walton ——
Residence Inn By Marriott
(1952) / 201 E. Walton
200 E. Delaware Condo (1972)
Doubletree Guest Suites Hotel
(1990) / Guest Quarters
—— Delaware, 900 north ——
Raphael Hotel (1925) / 201 E. Dela-
ware
The Seneca (1926) / 200 E. Chestnut
—— Chestnut ——
201 E. Chestnut Condo (1964)
200 E. Pearson (1916)
Ritz-Carlton Hotel, Water Tower Place
(1976)
—— Pearson ——
Museum of Contemporary Art (1996)
—— Chicago, 800 north ——

NORTH ST. CLAIR STREET
200 east (one-way south)
—— Superior ——
(parking)
Archdiocese of Chicago
(1914) / Sargent
Sheraton Plaza Hotel (1973) / Radisson
Hotel
—— Huron, 700 north ——
Northwestern University Hospital
(1999)
676 (1980)
—— Erie ——
633 St. Clair Place (1991)
Motel 6 (1926) / Eastgate, Richmont
Hotel
—— Ontario ——
Arts Club of Chicago (1997)
Best Western Inn of Chicago (1928) / St.
Clair Hotel
—— Ohio, 600 North ——
[201 E. Ohio, 4 stories, NI]
(parking)
—— Grand ——
(parking)
[161 E. Grand, NI]
160 E. Illinois (1908) / Brokers

—— Illinois, 500 north ——
South of Chicago River:

STETSON AVENUE
—— Wacker ——
Hyatt Regency Hotel (1974, 1980)
—— East South Water ——
Columbus Plaza (1980)
—— East Lake, 200 north ——
Amoco (1974) / Standard Oil
180: Two Prudential (1990)
One Prudential (1955) / Prudential
—— Randolph ——
For easterly Harbor Drive and Field
Boulevard buildings, *see* East Ran-
dolph Street

NORTH MICHIGAN AVENUE
—— Oak, 1000 north ——
Drake Hotel (1920)
980: One Magnificent Mile (1983)
—— Walton ——
919 (1929) / Palmolive, Playboy
909: Westin Hotel (1963) / Conti-
nental Plaza
900 (1989) / Four Seasons Hotel, The
Tower
—— Delaware, 900 north ——
875: John Hancock Center (1969)
866: Fourth Presbyterian Church (1912)
—— Chestnut ——
845: Water Tower Place (1976)
840: Plaza Escada (1992)
—— Pearson ——
Chicago Avenue Water Tower (1869)
and Pumping Station, Visitors Center
820: Lewis Towers, Loyola U.
(1925) / 820 N. Michigan
[*814: Findlay Galleries/Perkins, Fellows &*
Hamilton Offices, 1917, CAL, NI]
800: Park Tower Hotel and Condo (un-
der construction)
—— Chicago, 800 north ——
777 Condo (1963)
737: Neiman Marcus store (1983)
(vacant)
[744: Banana Republic store, 1991, NI]
—— Superior ——

701: Allerton Hotel (1924)
700: Chicago Place (1990)
— Huron —
[679, NI]
[669: Nike Town store, NI]
678: City Place, Omni Suites Hotel
 (1990)
666: Terra Museum of Art
 (1926) / Helena Rubenstein
664: Terra Museum (1927) / Farwell
— Erie —
645: Blair (1961)
626: Woman's Athletic Club (1928)
— Ontario —
625 (1971)
[First Chicago Bank/Lake Shore Na-
 tional, NI]
600 (1996)
— Ohio, 600 north —
545 (1928)
535 Condo (1963) / Michigan Terrace
540: Chicago Marriott Downtown Hotel
 (1978)
— Grand —
525: Forum Hotel (1961) / Sheraton
 Hotel
505: Inter-Continental Hotel (1929) /
 Medinah Club
520 (1929) / McGraw-Hill
500 (1970)
— Illinois, 500 north —
443: WGN Studios (1935)
435: Tribune Tower (1923)
444 (1976)
430, Realtors (1963) / Apollo S & L
— Hubbard —
(Frontier Plaza open space)
401: Equitable (1965)
400: Wrigley (1921)
— Chicago River, E. Wacker —
333 (1928)
307: Old Republic (1925) / Bell
360 (1923) / London Guarantee
320 Offices and Suites (1983) / 320 Apts.
[300, ca. 1911, refaced 4 stories, NI]
— South Water —
233: Two Illinois Center (1973)
225: Boulevard Tower North (1981)

(site of National Cash Register, 1960)
205: Boulevard Tower South (1985)
230 (1929) / Carbide & Carbon
200 (1927) / Tobey
— Lake, 200 north —
155: Doral Michigan Plaza (1982)
180 (1927) / Harvester
168 (1911) / Federal Life, Maremont
150: Stone Container (1983) / Associ-
 ates
— Randolph —
*Chicago Cultural Center (1897) / Public Li-
 brary*
— Washington, 100 north —
30 (1914) / Michigan Boulevard
20 (1885) / 14 N. Michigan
6 (1899) / Tower, Montgomery Ward
— Madison, 000 base line —

SOUTH MICHIGAN AVENUE
8: Willoughby Tower (1929)
12: Chicago Athletic Association (1893)
18 (1898) / Gage
30 (1898) / Edson Keith & Ascher
University Club (1909)
— Monroe, 100 south —
104: Monroe (1912)
112: School of the Art Institute (1908) /
 Wollberg Hall /
Illinois Athletic Club
116: Lake View (1906) / Municipal Court
122 (1911) / People's Gas
— Adams, 200 south —
Art Institute of Chicago (1892)
200: Borg-Warner (1958)
*220: Orchestra Hall (1905) / T. Thomas
 Music Hall*
*224: Santa Fe Center (1904) / Railway Ex-
 change*
— Jackson, 300 south —
310 (1924) / Straus
318 (1885) / Richelieu Hotel, Karpen
332 (1909) / McCormick
— Van Buren, 400 south —
404: Chicago Club (1930) / Art Institute
410: Fine Arts (1886) / Studebaker
*430: Roosevelt University (1889) / Au-
 ditorium*

—— Congress, 500 south ——
504: Ramada Congress Hotel
(1893) / Congress Hotel
540: Day's Inn, Ramada (1960) / Envoy
Hotel
—— Harrison, 600 south ——
600: Columbia College (1907) / Fair-
banks Morse, Harvester
618: Spertus College (1913) / Petroleum
624: Columbia College (1908) / Blum
636: Blackstone Hotel (1909)
—— Balbo, 700 south ——
720: Chicago Hilton Hotel (1927) / Ste-
vens Hotel
—— 8th ——
800: Essex Inn (1961)
830 (1895) / YWCA Hotel
836 (1913) / Crane
—— 9th ——
910 (1911) / Standard Oil
[976, 5 stories, NI]
—— 10th ——
1006–12 (1904)
—— 11th ——
1100: Best Western Grant Park Hotel
(1891) / Ascot Grant Park Arms
Apts., vacant (1995)
1130 Apts. (1967)
[1154: Avenue Motel, NI]
—— 12th, Roosevelt ——
[1229: Grant View Apts., 6 stories, NI]
1255: Winton (1904)
1212 Apts. (1982)
[1240: Travel Inn, NI]
—— 13th ——
[1353, 8 stories, NI]
—— 14th to 16th ——
[1603, 6 stories, NI]
—— 17th to 18th ——
[1801, 6 stories, NI]
—— 19th ——
Second Presbyterian Church (1874)
—— 20th, Cullerton ——
[2001: Long Grove House, 1969, NI]
Studebaker (1910)
—— 21st ——
[27-story apt., NI]
[*2120: Chess Records, 1911, CAL,* NI]

(2135: site of *Lexington Hotel,* demol-
ished 1996)
—— 22d ——

SOUTH PRAIRIE AVENUE
(one-way south)
[*1801: Kimball House, NR,* NI]
1800: Glessner House (1886)

SOUTH INDIANA AVENUE
1855: Clarke House (1836)
—— 19th ——
1911 (1995)

NORTH RUSH STREET
—— Bellevue ——
21 E.: Sutton Place Hotel (1988) / Le
Meridien
40 E. Oak Condo (1928)
—— Oak, 1000 north ——
—— Walton ——
(parking)
900: 40 E. Delaware apts. (1926) / Mary-
land Hotel
—— Delaware ——
(parking)
Delaware Towers (1927) / 25 E. Dela-
ware
—— Chestnut ——
[Quigley Seminary, 103 E. Chestnut,
NI]
844: Railroad Retirement Bd.
(1923) / America Fore
—— Pearson ——
Lewis Towers, Loyola U. (1925) / 820
N. Michigan
Park Hyatt Water Tower Square
(1962)
—— Chicago, 800 north ——
(vacant)
750: Chicagoan Apts. (1990)
740: Crain Publishing (1926) / Method-
ist Book Concern
—— Superior ——
Chicago Place (1990)
700: PTA (1954)
—— Huron, 700 north ——
City Place (1990)

Metro. Sanitary District (1954)
St. James Cathedral (1856)
—— Erie ——
FCB Center (1986)
American College of Surgeons (1963)
630: Vitec (1946) / Cadillac
—— Ontario ——
600 N. Michigan (1996), site of
101 E. Ontario, Arts Club (1951)
616: Lenox House Suites Hotel (1927) /
Croydon
(parking)
—— Ohio, 600 north ——
Marriott Downtown Hotel (1978)
(parking)
—— Grand ——
(parking)
—— Illinois, 500 north ——
444 N. Michigan (1976)
(parking)
Downtown Sports Club (1978)
—— Hubbard ——
Wrigley (1921)
River Plaza apts. (1977)
—— Chicago River ——

NORTH WABASH AVENUE
Delaware Towers apt. hotel (1927)
—— Chestnut ——
844 N. Rush / America Fore
35 E. Chestnut Apts. (1963)
[Loyola University, NI]
—— Pearson ——
[Loyola Univ., NI]
[*40–52: St. Benedict Flats, CAL,* NI]
Loyola University (1994)
—— Chicago, 800 north ——
Holy Name Cathedral (1875)
—— Superior ——
Huron Plaza Apts. (1981)
720: Cass-Superior (1921)
—— Huron, 700 north ——
St. James Cathedral (1856)
American College of Surgeons
(1883) / Nickerson House
640: Cass Hotel (1925)
—— Erie ——
Vitec (1946) / Cadillac

[*Cable House, CAL,* NI]
(parking)
—— Ontario ——
(parking)
600: Medinah Temple (1912)
—— Ohio, 600 north ——
American Red Cross (1929) / Ameri-
can Bankers Insurance
(parking)
—— Grand ——
(parking)
American Medical Association (1990)
—— Illinois, 500 north ——
[443 N. Wabash, NI]
441: Downtown Court Club (1978)
444 (1880) / Dr. V. C. Price
440: Plaza 440 Apts. (1991)
—— Hubbard ——
405: River Plaza Apts. (1977)
420 N. Wabash Plaza (1914) / Western
News
(parking)
—— Kinzie, 400 north ——
401: Sun-Times (1957)
330: One IBM Plaza (1972)
—— Chicago River and E. Wacker ——
Seventeenth Church of Christ, Scien-
tist (1968)
—— South Water ——
225: Oxford House (1912) / Fisk
203 (1928) / Dearborn Bank
35 E. Wacker (1926) /Pure Oil
Harold Washington College
(1983) / Loop College
—— Lake, 200 north ——
185 (1927) / Medical Arts
(parking)
180, 1915 / Lemoyne
(parking structure)
—— Randolph ——
[139, NI; *see* WO, p. 21]
[137: Mossner store, NI]
[129: B. Dalton bookstore, NI]
125: Bauer store (1916) / Porter
115: Lord & Smith (1872)
111: Garland (1915)
Marshall Field store (1892)
—— Washington, 100 north ——

Pittsfield (1927)
21 (1875) / Shops
7 (1941) / Von Lengerke & Antoine
 store
5 (1910) / Kesner
25 E. Wabash (1914) / Field's Annex
16 (1912) / Stevens store
8 (1900) Mandel's store
— Madison, 000 —

SOUTH WABASH AVENUE

5: Mallers (1910)
19 (1882) Jewelers, Maxwell store
23: Charette store (1872) / 21–23 S.
 Wabash
27 (1872)
[29: Kroch's bookstore / Griffiths, NI]
37: School of the Art Institute
 (1903) / Champlain
29 E. Madison (1905) / Heyworth
10 (1897) / Silversmith
[18–28, NI; *see* WO, p. 19]
32–34 (1903) / Thomas Church, Car-
 sons
36: Carson's store addition (1927)
— Monroe, 100 north —
 Mid-Continental Plaza (1972) / 55 E.
 Monroe
 (site of *Revell building,* demolished
 1968)
27 E. Monroe (1913) / Goddard
Palmer House Hilton (1927)
30 E. Adams (1923) / Hartman
— Adams, 200 south —
 Symphony Center (1997)
 (229: site of *Edison Shop,* demolished
 1967)
 243: De Paul University (1916) / Lyon
 & Healy
(parking structure)
218: Pakula (1900) / McClurg, Ayer,
 Crown
226: Brainstorm Communications / Atlas
230: Starck (1927)
234: Starck Piano (1927)
28 E. Jackson (1910) / Steger
— Jackson, 300 south —
 CNA Plaza (1962) (site of

Cable building, demolished 1972)
 CNA addition (1973)
306: Lewis Center, De Paul U.
 (1917) / Kimball
[316, 5 stories, NI]
(parking structure)
— Van Buren, 400 south —
 421: Musical Arts (1924) / Fine Arts
 Annex
 425: Crown Center, Moss Center /
 Roosevelt U.
ROOSEVELT UNIVERSITY
 (1889) / AUDITORIUM
St. Mary's Church (1961)
[418: Prairie Avenue Bookshop, NI]
428 (1894)
434 (1886) / Richardson, Kimball
— Congress, 500 south —
 529–31 (1905) / Red Cross, Hoops
33 E. Congress, including
510: MacCormac College (1925) / Con-
 gress Bank
— Harrison, 600 south —
 Harrison Motor Hotel (1930) / Har-
 rison Hotel
 615: Harrison Parking (1930) / Elec-
 tric Garage
 623: Columbia College
 (1895) / Brunswick
610: South Loop Parking (1925) / Har-
 rison Garage
630: Wirt Dexter (1887)
— Balbo, 700 south —
[1 E. Balbo: Carter Hotel, NI]
— 8th, Polk —
 819: Loftrium (1909) / Munn
828: YMCA Hotel (1915), NR, and
 40 E. 9th: Burnham Park Plaza (1988)
 (site of *Plymouth Church,* demolished
 1970)
— 9th, Sam Cascio Drive —
900: Fairbanks Lofts (1906) / Fairbanks,
 Morse
— 10th, Taylor —
Scribcor (1912) / Gunther
— 11th —
 1139: Norbart (1905) / Henneberry
1104: Ludington (1871)

[1112: Liberty Engraving, 5 stories, NI]
[1130, 5 stories, NI]
1132: Advance Uniforms (1911) / Ryerson
1152: Roosevelt Budget Hotel (1892)
— 12th, Roosevelt —
[1255, NI]
[1259: South Loop Arts Apts., 6 stories, NI]
[1234: St. James Hotel, 7 stories, NI]
— 13th —
[1307, 6 stories, NI]
[*1323: (former) Coca-Cola, NR,* NI]
[1328: Filmworks Loft Condos, 10 stories, NI]
— 14th —
[1414: Public Storage, 7 storage, NI]

NORTH STATE PARKWAY
— North, 1600 north —
[Archbishop's house, 1880, HABS, NI]
1501: Warwick Condo (1974)
1550 Condo (1912)
1540 Apts. (1959)
1530 Apts. (1953)
1516 Apts. (1975)
Graham Foundation (1902) / Madlener House
— Burton, 1500 north —
1445 State Condo (1959)
1440: Brownstone Condo (1960)
[1419 Condo, NI]
1410 Condo (1981)
[1400 Apts., NI]
— Schiller, 1400 north —
[One E. Apts., 20 stories, NI]
[1350, NI]
— Banks —
1325: Ambassador House Condo (1964)
1301: Omni Ambassador East (1927)
1320 Apts. (1926)
1300: Radisson Plaza West (1919) / Ambassador West
— Goethe, 1300 north —
1255: The Churchill Apts. (1922)
6–12 E. Scott (1918)

[1260, 1929, NI]
— Scott —
1 E. Scott Condo (1970)
1230 Condo (1981)
1220: Canterbury Court Apts. (1928)
— Division, 1200 north —
10 W. Elm Apts. (1928)
— Elm —
1111 (1982)
[1118: Cedar Hotel, NI]
— Bellevue —
2 E. Oak Condo (1972)
1030: Newberry Plaza (1975)
[1000, NI]
— Oak, 1000 north —
— Walton —
(parking)
— Delaware, 900 north —
One E. Delaware Apts. (1989)
850: Chestnut Place Apts. (1982)
— Chestnut —
[Loyola U., NI]
— Pearson —
[Law School, Loyola U., NI]
— Chicago, 800 north —
733: Holy Name Cathedral (1875)
(parking)
— Superior —
1 E. Superior (1981)
(parking)
— Huron, 700 north —
— Erie —
Ontario Place (1984)
— Ontario —
601: Lambert Tree Studios (1894)
600: Embassy Suites Hotel (1991)
— Ohio, 600 north —
(parking)
— Grand —
515: American Medical Association (1990)
— Illinois, 500 north —
Courtyard By Marriott (1991)
6 W. Hubbard (1989)
— Hubbard —
Landquist (1885)
(parking)
400 (1873)

—— Kinzie, 400 north ——
One IBM Plaza (1972)
[Hertz, NI]
300: Marina City (1962)
—— Chicago River and Wacker ——
1 E. Wacker (1964) / United of America
ica
[6 E. Lake, 5 stories, NI]
Stouffer Reviere Hotel (1991)
—— Lake, 200 north ——
(State was a mall to Congress Parkway
from 1976 to 1996)
*177: Page Brothers, Loop End
(1873)/Burton*
175: Chicago Theater Center (1921)
190: ABC/WLS (1917) / State-Lake
162: Illinois Medical Training Center
(1924) / Butler
—— Randolph ——
111: Marshall Field store (1902)
("vacant") "Block 37" (site of *Kranz and
Bay State* buildings, demolished
1990)
—— Washington, 100 north ——
17 (1912) / Stevens store
1 (1912) / Mandel's store
32: RELIANCE BUILDING (1895)
20–30 (1928) / Woolworth
1 N. Dearborn (1905) / Boston Store
—— Madison, 000 ——

SOUTH STATE STREET
*1: CARSON, PIRIE, SCOTT store
(1900)*
39: Mentor, 1906
Chicago (1905)/Chicago Savings Bank
10–14: Kresge (1905)
26: Three Sisters store (1925)
32–34 (1922)
36: North American (1912)
—— Monroe, 100 south ——
Palmer House Hilton (1927)
127 (1920) / Waterman
Unicom Thermal Technologies
(1994)
100: Amalgamated Bank (1972)
114 (1926) / Richman Brothers store
120: Singer (1926)

—— Adams, 200 south ——
201: LaSalle Talman Bank
(1966) / Home Federal S & L
211–17: Woolworth (1916, 1949)
[Stuart's store, NI]
14 E. Jackson (1912) / Lytton store
202 (1915) / Century, Buck & Raynor
220: One Quincy Court (1913) / Consumers
sumers
(Quincy Court Plaza / vacated Quincy
Street)
230: McDonald's (1937) / Benson &
Rixon store
10 W. Jackson, Dept. of Justice
(1949) / Bond store
—— Jackson, 300 south ——
(a plaza on Komiss site)
De Paul Center (1912) / Goldblatt's,
Rothschild's
(Pritzker Park)
—— Van Buren, 400 south ——
*1: One Congress Center (1891)/Leiter II,
Sears store*
400: Harold Washington Library Center
(1991)
—— Congress, 500 south ——
(reported site of future De Paul University mixed-use building)
versity mixed-use building)
—— Harrison, 600 south ——
606: William Jones Metro High School
(1968)
—— Balbo, 700 south ——
East 7th Street Hotel (1930) / Carter
Hotel
2 East 8th Street Apts. (1984)
—— 8th ——
Dearborn Park Apts. (1980)
—— 9th to 11th ——
1121: Central Police Station (1928)
—— 12th, Roosevelt ——

SOUTH PLYMOUTH COURT
(one-way south; east side)
—— Jackson, 300 south ——
[19 W. Jackson, 5 stories, NI]
315: John Marshall Law School
(1911) / City Club
321: Chicago Bar Association (1990)

—— Van Buren, 400 south ——
Harold Washington Library Center
 (1991)
—— Congress, 500 south ——
 523–29: Peterson (1917)
 531: Mergenthaler Lofts (1886) / M.
 Linotype
 [substation, NI]
 Franklin (1887)
 537 Apts. (1892) / Terminals
 [555, NI]
—— Harrison, 600 south ——
 William Jones Metro High School
 (1968)
 621: Moser Lofts (1909) / Moser
 633: Pope Loft Apts. (1904) / Pope
 711: Plymouth Court Self Park (1927)
 731: Lakeside Loft Apts.
 (1897) / *Lakeside Press*
—— Polk, 800 south ——

NORTH DEARBORN PARKWAY
(one-way north)
—— North, 1600 north ——
 1555: Constellation Apts. (1982)
 1530 N. apts. (1975)
—— Burton, 1500 north ——
 1445 (1965)
 1415 Condo (1972)
 [1424: St. Chrysostom's Church (1893),
 NI]
—— Schiller, 1400 north ——
 [Racquet Club, 5 stories, NI]
 1339 Condo (1972)
 1366 Condo (1926)
 1344 apts. (1971)
 1340 apts. (1971)
 1330 apts. (1972)
 [*1308: Three Arts Club (1914) Holabird
 & Roche, CAL,* NI]
 1301: The Whitney (1997)
—— Goethe, 1300 north ——
 1221: Dearborn Towers Condo
 (1972)
 1260 (1929)
 1250 Condo (1990)
 1244: Claridge Hotel (1935) / Tuscany
 Hotel

—— Division, 1200 north ——
 1140 (1929)
 Chicago East Hotel (1927) / Wilmar
 Hotel
—— Elm ——
 1133 Apts. (1988)
 1117 (1927)
 1111 Apts. (1982)
 1130: Elm Street Plaza (1976)
 1122: Condo (under construction)
 [1118: Cedar Hotel, NI]
 1100 Apts. (1929)
—— Maple ——
 1001: Scholl College Podiatric Medi-
 cine,
 (1929) / YWCA
 1036 (1924) / Lansing Apts.
 1030 (1929) / Dearborn Plaza
 [*1012: Waller House, NR,* NI]
 [1000, 9 stories, NI]
—— Oak, 1000 north ——
 [Ogden School, NI]
 Newberry Library (1892)
—— Walton ——
 929: Scottish Rite Cathedral
 (1867) / Unity Church
 (*Washington Square Park, NR*)
—— Delaware, 900 north ——
 875: Dearborn Place Apts. (1985)
 Park Newberry Condo (under con-
 struction on the site of 1958 Salva-
 tion Army Headquarters)
—— Chestnut ——
 [839: Lakeside Hotel, NI]
 [867, NI]
 Lawson YMCA (1931)
 838: John Fewkes Tower (1967) / 55 W.
 Chestnut
—— Chicago, 800 north ——
 (parking)
 750: Asbury Plaza Apts. (1981)
—— Superior ——
 Cathedral Place (under construction)
—— Huron, 700 north ——
 [Porter Cancer Center, NI]
—— Erie ——
 Illinois Bell (1924) / Superior Ex-
 change

650 Apts. (1882) / Vendome Hotel,
 Raleigh Hotel
*632: Excalibur (1892) / Chicago Historical
 Society*
—— Ontario ——
Embassy Suites Hotel (1991)
(parking)
—— Ohio, 600 north ——
[a post office, NI]
—— Grand ——
515: Chicago Medical Society
 (1926) /
Portland Cement Association
[Illinois Bell, NI]
500: Boyce (1912)
—— Illinois, 500 north ——
[fire department, NI]
*Courthouse Place (1892) / Board of Health,
 Criminal Courts*
—— Hubbard ——
[415, 5 stories, NI]
(parking)
—— Kinzie, 400 north ——
Harry Caray's restaurant (1900) / Car-
 avetta
Marina City (1962)
(parking)
320: Hotel Nikko (1987)
—— Chicago River and W. Wacker ——
Leo Burnett (1989)
55 W. Wacker / Blue Cross
200 Apts. (1990)
—— Lake, 200 north ——
(parking)
159: Oliver (1908)
Delaware (1874) / Bryant
170–90: Michael Todd & Cinestage The-
 aters (1923) / Harris & Selwyn The-
 aters (reported future home of
 Goodman Memorial Theater)
—— Randolph ——
Only building in "vacant" "Block 37":
117: Commonwealth Edison substa-
 tion (1931)
(site of *McCarthy building*, demol-
 ished 1990)
Richard J. Daley Center (1966)
—— Washington, 100 north ——

33 (1966) / Connecticut Mutual
1 (1905, 1917) / Boston Store
69 W. Washington (1965) / Brunswick
10 (1923) / Covenant Club
Three First National Plaza (1982)
—— Madison, 000 ——

SOUTH DEARBORN STREET
7 (1902) / Tribune No. 3
Inland Steel (1958)
One First National Plaza (1969)
—— Monroe, 100 south ——
33 W. Monroe (1981)
(vacant)
Xerox Centre (1980)
140: Marquette (1895)
—— Adams, 200 south ——
219: Dirksen Federal (1964)
230: Kluczynski Federal (1974)
—— Jackson, 300 south ——
[33 W. Jackson Office Condo, NI]
Standard Club (1926) / 320 S.
 Plymouth
343: Fisher (1896)
MONADNOCK (1891, 1893)
—— Van Buren, 400 south ——
407: Old Colony (1894)
417: Plymouth (1894)
431: Manhattan Apts. (1890)
—— Congress, 500 south ——
[555, NI]
525: Old Franklin (1887)
537 Apts. (1892) / Terminals
500: Hyatt on Printer's Row
 (1896) / Morton and
530 S. Dearborn (1886) / Duplicator
542: Pontiac (1891)
—— Harrison, 600 south ——
607: Dearborn (1885)
[637: Grace Place (1915), NI, includ-
 ing
Grace Episcopal Church and
Christ the King Lutheran Church]
711–27: Donohue (1883)
600: Transportation Apts. (1911)
714: Rowe (1892)
720: New Franklin (1912)
—— Polk, 800 south ——

Dearborn Station Galleria (1883)/Polk Street Station and Dearborn Park Apts. (1980)

SOUTH FEDERAL STREET
(one-way south)
—— Jackson, 300 south ——
MONADNOCK (1891, 1893)
Union League Club (1928)
(parking structure)
—— Van Buren, 400 south ——
—— Congress, 500 south ——
Hyatt on Printer's Row (1896)/Morton
Pontiac (1891)
514–34: Illinois Bell Central (1910)/Wabash Exchange
—— Harrison, 600 south ——
Transportation Apts. (1911)
Rowe (1892)
New Franklin (1912)
700: Printer's Square (1910)/Borland Mfg.
—— Polk, 800 south ——

NORTH CLARK STREET
1601: Chicago Historical Society (1931)
—— North, 1600 north ——
1531: Latin School of Chicago (1969)
1501: Warwick Condo (1974)
Carl Sandburg Village (1960)
—— Burton, 1500 north ——
[30-story apt., NI]
Carl Sandburg Village
—— Schiller, 1400 north ——
Carl Sandburg Village
—— Goethe, 1300 north ——
Carl Sandburg Village
—— Division, 1200 north ——
65 W. Division (1980)
[1165 Apts., 5 stories, NI]
—— Elm ——
1122: Clark-Elm Apts. (1989)
—— Maple ——
Gold Coast Galleria (1992) [1011, NI]
104 W. Oak Apts. (1891)/Burlingham

—— Oak, 1000 north ——
Newberry Library (1892)
—— Walton ——
(Washington Square Park, NR)
—— Delaware, 900 north —— (parking)
100 W. Chestnut Apts. (1983)
—— Chestnut —— (parking)
800 (1901)/Bush Temple of Music, Chicago-Clark
—— Chicago, 800 north —— (parking)
—— Superior ——
Hermitage Apts. on Huron (1985) (parking)
—— Huron, 700 north ——
Oakwood Apts. (1988)
Wacker Apts. (1926)/Wacker Hotel
—— Erie —— (parking)
—— Ontario ——
[600: McDonald's, NI]
—— Ohio, 600 north ——
[a post office, NI]
—— Grand —— (parking)
512: One Grand Place (1875)/St. Regis Hotel
—— Illinois, 500 north —— (parking)
—— Hubbard —— (parking)
—— Kinzie, 400 north ——
350: Mesirow (1912)/John R. Thompson
321: Quaker Tower (1987)
320: Central Office (1913)/Reid, Murdoch
—— Chicago River and W. Wacker ——
R. R. Donnelley Center (1992)/77 W. Wacker
[McDonald's, NI] (parking)
203 N. LaSalle (1986)/Loop Transportation Center
—— Lake, 200 north ——
161: Chicago Title & Trust Center (1993)

James R. Thompson Center (1985)
—— Randolph ——
Richard J. Daley Center (1966)
County Hall (1911)
—— Washington, 100 north ——
Chicago Temple (1923) / Methodist
Church
Three First National Plaza (1982)
The Burnham Center (1913) / Conway
20: Avondale Center (1980)
—— Madison, 000 ——

SOUTH CLARK STREET
One First National Plaza (1969)
105 W. Madison (1929) / Chicago Real
Estate Board
16: Chicago Loop Synagogue (1957)
20: Two First National Plaza (1971)
100 W. Monroe (1927)
—— Monroe, 100 south ——
Bell Federal Savings (1906) / 79 W.
Monroe, Rector
72 W. Adams (1907) / Edison
Harris Bank (1960)
LaSalle Bank (1932) / Field
—— Adams, 200 south ——
Federal Center (1964)
Bankers (1927)
Bank of America (1924) / Continental
Bank
—— Jackson, 300 south ——
Metcalf Federal (1991)
111 W. Jackson (1961) / Trans Union
Stock Exchange Extension (1997)
—— Van Buren, 400 south ——
Chicago Metro Correctional Center
(1975)
[426: Ewing Annex Hotel, NI]
—— Congress, 500 south ——
Illinois Bell Central (1948) / Toll No. 2
547: The Columbian / Thom
536: Federal (1912) / Rand McNally
—— Harrison, 600 south ——
626: Dwight (1911)
650: Spectralith (1902) / Board of Edu-
cation
124 Polk Street Lofts (1912) / Rogers &
Hall

—— Polk, 800 south ——
Dearborn Park Apts. (1980)

NORTH LaSALLE DRIVE
—— North, 1600 north ——
[1555: Park Place North, NI]
1540: LaSalle Terrace Condo (1970)
[1512: Carling Hotel, NI]
[1500: Burton Place Condo, 1897, NI]
—— Burton, 1500 north ——
[1432: Paxton Hotel, NI]
Carl Sandburg Village (1960)
—— Schiller, 1400 north ——
Carl Sandburg Village
1301: St. Paul's Church
1330 (1981)
—— Goethe, 1300 north ——
1211 (1929) / LaSalle Towers
1258: Place LaSalle Apts. (1986)
[1232: Marshall Hotel, NI]
1212 LaSalle Condo (1987)
—— Division, 1200 north ——
[12-story apt., NI]
1140 (1928)
—— Elm ——
1133: Church of the Ascension
(1882)
[1136: LaSalle Street Church (1886),
NI]
1120 Apts. (1981)
1100 Apts. (1930)
Maple Pointe Apts. (1996)
—— Maple ——
[Annunciation Cathedral, NI]
1000: Park LaSalle Apts. (1982)
170 W. Oak: Morningside North (1981)
—— Oak, 1000 north ——
171 W. Oak: Morningside South
820: Moody Bible Institute (1927)
—— Chicago, 800 north ——
(parking)
[737: LaSalle Center, NI]
770: LaSalle Office Center (1986)
[730: Buhring, NI]
[720: HOJO Inn, NI]
—— Superior ——
721: Catholic Charities (1927)
[Central States Institute, NI]

—— Huron, 700 north ——
[676: LaSalle Corp., NI]
—— Erie ——
(parking)
640: Planet Hollywood (1969)
—— Ontario ——
(parking)
620: Sportmart (1894) / Chicago Flexible Shaft
[600: Ohio House Motel (1960), NI]
—— Ohio, 600 north ——
545: Best Western River North Hotel (1963) / Travelodge
540 (1880) / Ohio
(parking)
—— Grand ——
[505, NI]
[Anti-Cruelty Society, NI]
[Michael Jordan's, NI]
—— Illinois, 500 north ——
[435, NI]
—— Hubbard ——
415 (1888) / Hemlock
(parking)
—— Kinzie, 400 north ——
(parking)
350 (1990)
321: Central Office /(1913)Reid, Murdoch
(parking structure)
—— Chicago River and W. Wacker ——

NORTH LaSALLE STREET
221: LaSalle-Wacker, (1930)
203 (1986) / Loop Transportation Center
222 (1927) / Builders
200 (1984)
—— Lake, 200 north ——
James R. Thompson Center (1985)
180: Heitman Centre (1972) / LaSalle Plaza
160: State Judicial (1924) / Burnham
—— Randolph ——
121: City Hall (1911)
134 (1926) / Metropolitan
120 (1992) / Savings of America
100 (1929) / Lawyers

—— Washington, 100 north ——
33: American National Bank (1929) / Foreman National Bank
1: *American National Bank (1930)/1 N. LaSalle*
30 (1975) (site of *Stock Exchange,* demolished 1972)
2 (1979)
—— Madison, 000 ——

SOUTH LaSALLE STREET
11 (1915) / Roanoke
19 (1893) / Association, YMCA
29: Barrister Hall (1902) / Equitable
39 (1894) / New York Life
10: Manufacturers Hanover Plaza (1987) / 10 S. LaSalle
50: Northern Trust (1905)
—— Monroe, 100 south ——
Harris Trust (1976)
135: LaSalle Bank (1932) / Field (site of
Home Insurance (1885, demolished 1931)
120 (1928) / State Bank
190 (1987)
—— Adams, 200 south ——
209: ROOKERY (1888)
231: Bank of America (1924) / Continental Illinois Bank
208 (1914) / Continental National Bank
230: Federal Reserve Bank (1922)
—— Jackson, 300 south ——
Board of Trade (1930), at the head of LaSalle Street
111 W. Jackson (1961) / Trans Union
Chicago Stock Exchange Extension (1997)
—— Van Buren, 400 south ——
401: Traders (1914)/Fort Dearborn Hotel
417: Western Union (1919)
440: One Financial Place (1984) / Options Exchange,
including Chicago Stock Exchange, straddling Congress
—— Congress, 500 south ——
Federal (1912) / Rand McNally

—— Harrison, 600 south ——
601 (1912) / Rumely
619 (1903) / Brock & Rankin
701–03 (1913) / Linden
—— Polk, 800 south ——

SOUTH SHERMAN STREET
—— Harrison, 600 south ——
Patten (1905)
732: Printers (1908)
—— Polk, 800 south ——

NORTH WELLS STREET
(one-way south)
[1422: Cobblers Square, NI]
1414 Condo (1995)
 [*1327: Emmel, NR,* NI]
Morningside North (1981)
—— Oak, 1000 north ——
Morningside South
830: Moody Bible Institute (1937)
[800, NI]
—— Chicago, 800 north ——
—— Superior to Erie ——
640 N. LaSalle (1969)
—— Ontario ——
 [613: Olympia, NI]
—— Ohio, 600 north ——
 [545, NI]
—— Grand ——
 [501, NI]
[500, NI]
—— Illinois, 500 north ——
 [445, NI]
444: First Commonwealth (1900)
440 (1903) / Carpenter, Liquid Car-
 bonic
—— Hubbard ——
(parking)
 —— Kinzie, 400 north ——
Merchandise Mart (1929)
325: Helene Curtis (1912) / John
 Moir
—— Chicago River and W. Wacker ——
222 N. LaSalle (1927) / Builders
201: Tower (1930) / Trustees
Engineering (1928)
(parking)

—— Lake, 200 north ——
(parking structure)
Randolph Tower (1929) / Steuben
 Club
(parking)
—— Randolph ——
Bismarck Hotel (1926)
120 N. LaSalle (1992)
180 W. Washington (1929) / Equitable
205 W. Randolph, Phillips
 College / Randolph-Wells
Illinois Bell (1927) / Morton
—— Washington, 100 north ——
(parking)
40 (1874) / Washington Block
Madison Plaza (1983)
—— Madison, 000 ——

SOUTH WELLS STREET
Paine Webber Tower (1990) / 181 W.
 Madison
Northern Trust (1974)
200 W. Monroe (1975) / National Surety
 (site of
 *Leiter building ([1879], demolished
 1972)*
—— Monroe, 100 south ——
(parking)
180 W. Adams (1911) / Textile
Harris Bank (1898) / Williams
200 W. Adams (1985)
—— Adams, 200 south ——
208 S. LaSalle (1914) / Continental
 Bank
Federal Reserve Bank Annex (1957,
 1989)
(parking structure on the site of *Mar-
 shall Field Wholesale store,* 1887, de-
 molished 1930)
200 W. Jackson (1985)
—— Jackson, 300 south ——
Insurance Exchange (1912)
209 W. Jackson (1898) / McKinlock
316–26: Wells-Jackson Garage (1929)
330 (1927) / Insurance Center
—— Van Buren, 400 south ——
411: Dixon (1908)
[6-story, NI]

412: Vogue (1908)
—— Congress, 500 south ——
527: Hunter (1910)/Beloit
—— Harrison, 600 south ——
651: Regal Apts. (1908)/Regal
723: Swigart (1923)
725: Empire Paper (1914)
—— Polk, 800 south ——
801 S. Wells Loft Apts. (1912)/Polk-
Wells
800: River City (1986)

NORTH FRANKLIN STREET
[213 W. Chicago, NI]
—— Chicago, 800 north ——
[Dixie, NI]
[230 W. Superior, NI]
730: Central Arts (1915)
—— Superior ——
[301 W. Superior, Atrium, NI]
[280 W. Huron, Bauer, NI]
—— Huron, 700 north ——
[235 W. Huron Lofts, NI]
(parking)
—— Erie ——
223 W. Erie, North Branch Center I
(1899)/Smith Shoe
[222 W. Ontario Business Lofts, NI]
[303 W. Erie/Hanson (1907), NI]
—— Ontario ——
[Mike Ditka's, NI]
(parking)
—— Ohio, 600 north ——
[225 W. Ohio, NI]
[300 W. Grand Office Center, NI]
—— Grand ——
—— Illinois, 500 ——
229 W. Illinois (1876)/Roos,
Henshaw
[222 W. Hubbard, NI]
—— Hubbard ——
[223 W. Hubbard, NI]
400 (1918)/Union Special Machine
—— Kinzie, 400 north ——
Merchandise Mart (1929)
—— Chicago River and W. Wacker ——
225 W. Wacker (1989)
Nuveen (1983)/333 W. Wacker

—— Lake, 200 north ——
(a taxpayer)
(parking structure)
162 (1906)
310 W. Randolph (1872,
1927)/Randolph-Franklin
—— Randolph ——
Illinois Bell (1893)/Soden
130 (1924)/Parke, Davis
110: 300 W. Washington (1927)/Chi-
cago Mercantile Exchange
—— Washington, 100 north ——
225 W. Washington (1986)
1 (1991)
Telephone Square (1922)
—— Madison, 000 ——

SOUTH FRANKLIN STREET
(one-way north)
1: Jewish Federation (1958)
230 W. Monroe (1971)
303 W. Madison (1968)
(parking)
—— Monroe, 100 south ——
AT&T Corporate Center (1989)
USG (1992)
Harris Bank
300 W. Adams (1927)
—— Adams, 200 south ——
(parking)
Chicago City College (1904)/C & N W
Sears Tower (1974)
—— Jackson, 300 south ——
Brooks (1910)
(parking structure)
311 S. Wacker (1990)
—— Van Buren, 400 south ——
(site of *Meyer building*, demolished
1968)
Unicom Thermal Technologies (1996)
(*see* 1994)
—— Congress, 500 south ——

NORTH WACKER DRIVE
Nuveen (1983)/333 W. Wacker
—— Lake, 200 north ——
333 W. Lake (1898)/Franklin Mac-
Veagh

155 (1954) / Sinclair Oil
180 (1912) / Great Lakes
[160, NI]
150 (1970) / Randolph-Wacker
— Randolph —
123 (1988)
101 (1980) / Hartmarx
110: Morton Thiokol (1958)
— Washington, 100 north —
29 (1962)
(parking)
20: Civic Opera (1929)
— Madison, 000 —

SOUTH WACKER DRIVE
1 (1982) (site of *Hunter building*,
 demolished 1978)
(vacant site of 1957 Mutual Trust)
10 and 30: Chicago Mercantile Ex-
 change (1983, 1988)
— Monroe, 100 south —
(vacant site of 1963 U.S. Gypsum)
125: Northern Trust (1974)
100 (1961) / Hartford Plaza
150 (1971)
— Adams, 200 south —
223: Sears Tower, (1974)
200 (1980) / Citicorp
250 (1957) / America Fore
— Jackson, 300 south —
311 (1990)
300 (1971)
— Van Buren, 400 south —

RIVERSIDE PLAZA
on the west bank of the Chicago River
180: Morton International (1990),
between Randolph and Washington

NORTH CANAL STREET
(one-way north)
345: Fulton House (1908) / North
 American Cold Storage
— Fulton —
— Lake, 200 north —
165: One Northwestern Center
 (1922) / Butler Brothers
— Randolph —

111: River Center (1913) / Butler
 Brothers
— Washington, 100 north —
2 Riverside Plaza (1929) / Chicago
 Daily News
Northwestern Atrium Center (1987)
(and C&NW railroad station entrance)
— Madison, 000 —

SOUTH CANAL STREET
10 Riverside Plaza (1965)
Illinois Bell / AT&T (1971)
Heller International Tower (1992) / 500
 W. Monroe
— Monroe, 100 south —
120 S. Riverside (1968)
525 W. Monroe (1983) / Monroe
 Place
130: Florsheim (1949)
— Adams, 200 south —
222 Riverside Plaza (1972)
210: Union Station (1924)
— Jackson, 300 south —
300 Riverside Plaza (1983)
— Van Buren, 400 south —
Central Post Office (1932), straddling
 Eisenhower Expressway
(former) Ramada Inn (1961), vacant in
 1995
— Harrison, 600 south —
General Mail Facility (1996)
610: U.S. Custom House (1932)
— Polk, 800 south —
801: Canal Center (1991)

NORTH CLINTON STREET
(one-way south)
[216: Clinton-Fulton, NI]
— Lake, 200 north —
168 (1890)
[150: Erskine, NI]
— Randolph —
[Knight, 549 W. Randolph, NI]
— Washington, 100 north —
Northwestern Atrium Center
 (1987)
(parking)
— Madison, 000 —

SOUTH CLINTON STREET
AT&T (1971)
Heller International Tower (1992) /
 500 W. Monroe
Presidential Towers (1986)
—— Monroe, 100 south ——
Monroe Place (1983)
Florsheim (1949)
118: Baker Engineers (1886)
—— Adams, 200 south ——
Union Station (1924)
555 W. Adams (1991)
[550 W. Adams, 8 stories, NI]
—— Jackson, 300 south ——
Burlington (1911)
—— Van Buren, 300 south ——
[400: Gotham Lofts, NI]

NORTH JEFFERSON STREET
600 W. Fulton (1890) / Epstein
—— Fulton ——
 [217: Schwinn Bicycle, NI]
 [566 W. Lake, NI]
[216, NI]
—— Lake, 200 north ——
 [7-story loft, NI]
(parking)
—— Randolph ——
 [Werner, 6 stories, NI]
—— Washington, 100 north ——
(parking)
Harold Washington Social Security
 Admin. (1976)
—— Madison, 000 ——

SOUTH JEFFERSON STREET
Presidential Towers (1986)
—— Monroe, 100 south ——
(parking)
566 W. Adams (1900)
(parking)
600 W. Adams (1883) / Glessner
—— Adams, 200 south ——
Chicago-Kent Law, IIT (1992)
 [231: 7 stories, NI]
[216, 6 stories, NI]
600 W. Jackson (1912) / Otis Elevator
—— Jackson, 300 south ——

NORTH DESPLAINES STREET
[224: 6-story loft, NI]
—— Lake, 200 north ——
—— Randolph ——
[126: Catholic Charities, 6 stories, NI]
—— Washington, 100 north ——
Harold Washington Social Security
 Admin. (1976)
[651: Washington Square building, NI]
—— Madison, 000 ——

SOUTH DESPLAINES STREET
Presidential Towers (1986)
—— Monroe, 100 south ——
 [6-story loft, NI]
St. Patrick's Church (1856)
—— Adams, 200 south ——
(parking)
[200: 5-story loft, NI]
Greyhound Bus Terminal (1991) is
 along the south side of Eisenhower
 Expressway
University of Illinois Chicago Campus
 (1965) is south of W. Harrison
 Street and west of the Kennedy Ex-
 pressway

NORTH ORLEANS STREET
(ends at Division Street)
The Town & Garden Apartments (1929)
 are to the north at N. Sedgwick
 Street
[820, NI]
—— Chicago, 800 north ——
 [319 W. Chicago, NI]
[312 W. Superior, Gamma, NI]
[750: River North Concourse, NI]
—— Superior ——
 [311 W. Superior, North Branch, NI]
[340 W. Superior galleries, NI]
—— Huron, 700 north ——
325 W. Huron (1930)
—— Erie ——
643: Pepper Companies (1985)
343 W. Erie (1910) / Christies
—— Ontario ——
 [320 W. Ohio, Adlake, NI]

—— Ohio, 600 north ——
325 W. Ohio (1896)
—— Grand ——
Orleans Court Apts. (1986)
500: John Sexton (1917)
—— Illinois, 500 north ——
[Assumption Church, NI]
437: Martparc Centre (1989)
350: Kingsbury Center (1989)
—— Hubbard ——
[350: Mart Display, NI]
414: Orleans Plaza (1910) / Bradley
—— Kinzie, 400 north ——
Apparel Mart, Holiday Inn (1967)
—— Chicago River, Wolf Point ——

NORTH SEDGWICK STREET
[400 W. Superior, NI]
—— Superior ——
[NE corner Huron, 1893, NI]
—— Huron, 700 north ——
[400 W. Erie, NI]

NORTH HUDSON STREET
[430 W. Erie, NI]

NORTH KINGSBURY STREET
Montgomery Ward Corporate Office
(1974)
—— Superior to Erie ——
[308 W. Erie, NI]
[445 W. Erie Lofts, NI]
—— Ontario ——
[411 W. Ontario, NI]
[441 W. Ontario, Ontario Lofts, NI]
[River Bank Lofts, NI]
The Montgomery Ward Complex (1906) is
at Chicago Avenue and the east
bank of the river.

NON-CORNER BUILDINGS on
EAST-WEST STREETS
GOETHE
[61 E.: Goethe Shore Apts., NI]
21 E.: Hanover House (1964)

SCOTT
60–70 E. Condos (1917), at corner of
Stone Court
[65 E., 18 stories, NI]

DIVISION
[71 E.: Gold Coast Condo, NI]
[30 E. Apts., NI]

ELM
73 E. Condo (1928)
[30 E. Apts., NI]
18 E.: The Elms (1925)
[14 E. Apts., NI]
10 W. (1928)
14 W. Apts. (1927)

CEDAR
70 E. Apts. (1927)
40 E. Condo (1972)
[33 E., 19 stories, NI]
20 E. Condo (1925)

BELLEVUE
120 E.: *Fortnightly of Chicago (1892)* /
Bryan Lathrop House
100 E. Condo (1971)
50 E. Condo (1979)
33 E.: Chandler Apts. (1910)

OAK
[106 E., NI]
[58 E., NI]
58 E.: Esquire Center (1938) / Esquire
Theater
40 E. Condo (1928)

WALTON
232 E. Co-Op (1921) / 230 E. Walton
227 E. Apts. (1956)
222 E. (1920)
221 E.: Walton Place (1982)
220 E.: Two-Twenty Walton (1919)
210 E. (1927)
163 E.: Knickerbocker Hotel (1927)
100 E. Condo (1972) / Walton Colon-
nade
[Walton Office Centre, 7 stories, NI]
70 E. (1926) / Elizabeth Arden

DELAWARE
257 E. (1918)
[230 E. Condo, NI]
223 E. (1916)

211 E.: Delaware Apts. (1927)
110 E.: Michigan Place condo (1981)
105 E.: The Whitehall (1928)
20 E.: Talbott Hotel (1926)

CHESTNUT
222 E. (1928)
215 E.: Chatelaine Tower Apts. (1928)
111 E. Apts. (1983) / Elysees Res.
100 E.: Tremont Hotel (1926) / Mozart
 Hotel
21 E. Condo (1979)
19 W. Condo (1883) / residential
 hotel
21 W. Condo (under construction)

PEARSON
210 E. Condo (1927)

CHICAGO
215 E.: Galter Carriage House (1964)
211 E.: American Dental Association
 (1966)
161 E.: Olympia Centre (1986)
56–60 E. Amanda Apts. (1897)
[310 W., NI]

SUPERIOR
Wieboldt Hall, Northwestern Univ.
 (1926)
333 E.: Prentice Women's Hospital,
 Northwestern Univ. (1974)
166 E.: Barclay Hotel (1965) / Regency-
 Orleans / Summerfield Suites
215 W. (1913)

HURON
50 E.: American Library Association
 (1963)
33 W. Condo (under construction)
111 W. (1926) / Wacker Hotel

ERIE
441 E.: Onterie Center (1986)
233 E.: Streeterville Center (1969) / The
 Brittany
[33 W.: New Hampton Inn, NI]
[308 W., 7 stories, NI]
433 W.: Erie Centre Tower (under
 construction)

ONTARIO
446 E.: Onterie Center (1986)
233 E. (1980)
230 E. (1968)
211 E. (1984)
142 E. (1987)

OHIO
451 E.: *see* 540 N. Lake Shore
450 E. (1926) / Dunham
420 E. Apts. (1990)
232 E. (1916) / Pelouze
230 E.: Ohio Center (1916) / Pelouze
211 E.: Grand Ohio apts. (1984)
19 E.: Tokyo Hotel (1927) / Devonshire
 Hotel
15 E.: Ohio East Hotel
 (1926) / Berkshire Hotel

GRAND
445 E. Ohio, Lake Shore Plaza (1986)
57 W. (1913) / Remien & Kuhnert

ILLINOIS
11–15 E.: Kohnstamm (1900)
114 W. (1901) / Grommes & Ullrich
116 W.: Boyleston (1913)

HUBBARD
11–13 E. (1885)
[10 W., 5 stories, NI]
[25 W., 5 stories, NI]
[30 W., 5 stories, NI]
[333 W., Union Square Lofts, NI]

EAST SOUTH WATER
68 E.: Wacker Tower Office Center
 (1929) / Chicago Motor Club
65 E.: Southwater (1928) / Millinery
 Mart

EAST RANDOLPH
North Harbor Tower (1988) / Park
 Shore Condo (195 Harbor Drive)
Harbor Point Condos (1975) / Norbart
 Apts. (155 Harbor Point)
400 E.: Outer Drive East Apts. (1962)
360 E.: Buckingham Plaza (1982)
70 E.: Bowen (1872)

[62 E.: Flax, NI]
32 W. Randolph (1926)/New United Masonic Temple
(60 W.: parking structure, site of *Garrick/Schiller building*, demolished 1961)
180 W.: McDonald's (1872)/John Alston
310 W. (1872)/Randolph-Franklin
318 W.: Wellington (1908)/Mueller

WASHINGTON
166 W. (1872)/Central Bank
176 W.: "I Am" Temple (1916)/Elks Club
212–26 W.: Bell (1912)
215 W.: Hotel LaSalle Garage
310 W. (1906)
311–27 W.: Franklin Exchange, IBT (1917)

MADISON
110 W.: St. Peter's Church (1953)
120 W. (1906)/Brevoort Hotel
125 W. (1913)/Advertising

MONROE
12 E.: Carson Pirie Scott (1940)/Monroe Garage
22 W.: Majestic (1905)
[71 W.: Italian Village restaurants, NI]
111 W.: Harris Bank (1911)

ADAMS
Symphony Center (1904)/Chapin & Gore, 63 E. Adams
[17 W.: Berghoff Restaurant, NI]
176 W.: Midland Hotel (1927)/Midland Club
318 W. (1930)/Fashion Trades

JACKSON
23 E.: O'Malley, De Paul U. (1928)/Finchley store
20 E.: Douglas (1912)/Gibbons
216 W. (1899)

VAN BUREN
59 E. (1930)/Socony-Vacuum

21 E.: Isabella (1892)
210–14 W.: Van Buren (1893)

BALBO
60 E.: De Paul Reskin Theater (1911)/Blackstone Theater

9TH
[15 E.: Columbia Hotel, NI]

11TH
72 E.: Columbia College Theater Music Center (1928)/
Chicago Women's Club

RIVERFRONT BUILDINGS
WACKER DRIVE and, indented, north bank of the river
—— Lake Shore Drive ——
Swiss Grand Hotel (1989)
Three Illinois Center (1979)
 Sheraton Hotel and Towers (1992)
—— Columbus Drive ——
Hyatt Regency Hotel (1974 and 1980)
One Illinois Center (1971)
333 N. Michigan Avenue (1928)
 Chicago Music and Dance Theater (1997)
 U. Chicago Graduate School of Business (1994)
 Equitable (1965)
 (Frontier Plaza, Kinzie home site)
—— Michigan Avenue ——
360 N. Michigan Avenue (1923)/London Guarantee
75 E. Wacker (1928)/Mather Tower
Clarion Executive Plaza Hotel (1960)
Seventeenth Church of Christ, Scientist (1968)
 Wrigley (1920)
 River Plaza apartments (1977)
 Chicago Sun Times (1957)
—— Wabash Avenue ——
35 E. Wacker (1926)/Pure Oil
1 E. Wacker (1964)/United of America
 One IBM Plaza (1972)
—— State Street ——
Stouffer Reviere Hotel (1991)

Leo Burnett (1989)
 Marina City (1962)
 —— Dearborn Street ——
55 W. Wacker (1969) / Blue Cross
R. R. Donnelley Center (1992)
 Hotel Nikko (1987)
 Quaker Tower (1987)
 —— Clark Street ——
LaSalle-Wacker (1930)
 Chicago Central Office (1913) / Reid,
 Murdoch
 —— LaSalle Street ——
222 N. LaSalle (1927 and
 1986) / Builders

Helene Curtis (1912) / John Moir
 —— Wells Street ——
205 W. Wacker (1928) / Engineering
211 W. Wacker (1928) / Times
225 W. Wacker (1989)
 Merchandise Mart (1929)
 —— Franklin-Orleans Street ——
Nuveen (1983) / 333 W. Wacker
 Apparel Mart and Holiday Inn (1977)
 —— Wolf Point and north and south
 branching of the river ——

Appendix B. Architects and Engineers

The names rendered fully in capital letters are those of individual architects, engineers, or firms. Names rendered in capital and lowercase letters in subsequent entries are those of partners or associates of the previously named individuals or firms, or of the names of successor firms associated with those individuals or firms. Members of multiple-name firms are not listed separately from the full firm names. Architects and engineers who are not part of the names of firms are listed separately with a notation of their principal firm relationships. This appendix adds to the original edition's list of architects and engineers a few pre-1950 firms with their buildings. It also adds life data as known to the compiler, or simply notes "deceased"; no architects or engineers listed in the original book are known to be living at this writing. "*See*" references direct the reader to individuals and firms that appear elsewhere in this list, or to buildings in the text for which an individual or firm may have worked on additions or remodelings.

ABBOTT, FRANK B. (1856–dec'd)
 Keuffel & Esser, 1887
 North American Cold Storage Warehouse, 1908
ADDIS, IRVING
 see 215 W. Superior
ADLER, DANKMAR (1844–1900)
 see Burling & Adler (1871–1878)
 Central Music Hall, 1879
 Borden Block, 1880
 Rosenfeld, 1881
Adler & Co. (1880–1883)
 Rothschild, 1881
 Rosenfeld, 1881
 Brunswick, Balke factory, 1881
 Jewelers, 1882
 see RKO Grand Theater
 see Hooley's Theater
Adler & Sullivan (1883–1895)
 McVickers Theater 3, 1883
 Revell, 1883
 Grant Hotel addition

Ryerson, 1884
Troescher, 1884
Knisely, 1884
Kennedy Bakery, 1884
Columbia Theater remodeling, 1884
Scoville, 1885
Exposition remodeling, 1885
Ryerson Charities Trust, 1886
Springer, Bay State addition, 1887
Wirt Dexter, 1887
Ryerson, 1888
Auditorium, 1889
Felsenthal, 1889
Oakley, 1891
Chicago Cold Storage Exchange Warehouse, 1891
Charnley House, 1892
Schiller, 1892
Meyer, 1893
Chicago Stock Exchange, 1894
see Louis H. Sullivan

AHLSCHLAGER, FREDERICK (1858–
1905)
40 E. Hubbard St., 1894
46–54 E. Hubbard St., 1894
51–53 E. Hubbard St., 1894
56–62 E. Hubbard St., 1894
22–24 E. Hubbard St., 1901
AHLSCHLAGER, WALTER W. (1887–
1965)
Cass-Superior, ca. 1921
Putnam, 1922
Covenant Club, 1923
Woolworth, 1928
Medinah Club, 1929
Palmer House Garage, 1930
ALSCHULER, ALFRED S. (1876–1940)
John R. Thompson, 1912
Westminster, 1912
Rogers & Hall Co., 1912, 1914
Donohue Annex, 1913
Webster, 1913, 1929
Cunard, 1916
Pelouze, 1916
Apparel, 1917, remodeling
John Sexton, 1917/29
Henry Channon, 1920
Shops, ca. 1920, remodeling
Blum addition, 1922
Hartman, 1923
London Guarantee, 1923
Congress Bank, 1925
Furniture Exhibition, 1925
Michigan-Ohio, 1925
Adams-Franklin, 1927
Born addition, 1927
Chicago Eye, Ear, Nose & Throat Hos-
pital, 1927
Chicago Mercantile Exchange, 1927
South Loop Garage, 1927
Harvester, 1928
Finchley, 1928
Maurice L. Rothschild Store addition,
1928
Jackson-Franklin, 1929
Electric Garage, 1930
Harrison Hotel, 1930
Benson & Rixon, 1937
Alschuler, Alfred S., Jr. (1911–)

Alschuler & Friedman (1940–1946)
Friedman, Alschuler & Sincere
(1946–)
Alschuler, Wolfson
1445 N. Dearborn, 1965
ALTMAN-SAICHEK-ADAMS
see McKinlock
AMMAN, OTHMAR H. (dec'd), eng.
Whitney, Charles S. (dec'd), eng.
Amman & Whitney
see John Hancock
ANDERSON, H. A. (dec'd)
Orleans-Huron, 1930
ANDERSON, PIERCE (1870–1924)
see Graham, Burnham & Co. (part-
ner) (1912–1918)
see Graham, Anderson, Probst &
White (1918–1924)
ANIS, ALBERT (dec'd)
Randolph-Franklin, 1872
ARENSON, MICHAEL
see 1895 Brunswick
ARMSTRONG, JOHN ARCHIBALD
(dec'd)
Telephone Square, 1922
20 E. Delaware, 1926
ARMSTRONG, JOHN M. (dec'd)
Armstrong & Egan
Criminal Court & County Jail,
1874
ARMSTRONG, W. SCOTT (dec'd)
see Plymouth
ASROW, SHERMAN R., eng.
McCormick Place, 1970
ATWOOD, CHARLES BOWLER
(1849–1895)
see D. Burnham & Co. (partner, 1894–
1895)
see Reliance
see Fisher
AWSUMB, GEORGE (dec'd)
Chicago Engineer's Club, 1913,
remodeling

BAILOT & LAUCH
Berkshire Hotel, 1926
BANK, EATON
see Claridge Hotel

BARANCIK, RICHARD M.
 Conte, Ralph
Barancik, Conte (1950–)
Ritchie Tower, 1963
Hanover House, 1964
1212 N. Lake Shore, 1969
231 E. Ontario, 1971
100 E. Bellevue, 1971
990 N. Lake Shore, 1973
1120 N. LaSalle, 1981
Morningside North, 1981
1111 N. Dearborn, 1982
Park LaSalle Apts., 1982
211 E. Ontario, 1984
142 E. Ontario, 1987
Guest Quarters Suites Hotel, 1990
Maple Pointe Apts., 1996
see One Magnificent Mile, 1983
see Ontario Place, 1984
BARNETT, GEORGE D. (1815–
 1898)
 Haynes, John I. (dec'd)
 Barnett, Thomas P. (dec'd)
Barnett, Haynes & Barnett (St. Louis)
 Illinois Athletic Club, 1908
BAUER, AUGUSTUS (1827–1894)
 Charles F. Grey, 1868
Bauer & Co.
 Safety Deposit, 1870
Bauer & Loebnitz
 Firmenich, 1873
Bauer & Hill
 Foreman & Kohn Block, 1886
 see Carter & Bauer
BAUMANN, FREDERICK H. (1826–
 1921)
 see Burling & Baumann
Baumann, Edward (1838–1889)
Baumann & Baumann
 Shepard Block 1, 1869
 Culver, Page & Hoyne Warehouse,
 1870
 Central Union Block 1, 1871
 Ashland Block 1, 1872
 Metropolitan Block, 1872
 Bryan Block 2, 1872
 Winston, 1872
 Washington Block, 1874

Baumann & Lotz, mech. engs.
 Franklin, 1887
Baumann [Edward] & Huehl
 Chamber of Commerce 3, 1890
 see Harris W. Huehl
Baumann [Frederick] & Cady
 Bordeaux Hotel, 1891
 Kimball Hall, 1891
 Imperial Hotel, 1892
 see J. K. Cady
BEAUMONT, GEORGE (dec'd)
 Gunther, 1912
BECKET, WELTON D. (1901–1967)
 (L.A.)
 200 W. Monroe, 1973
 FCB Center, 1986
BEEBY, THOMAS (1941–)
 see Hammond, Beeby
 see Fourth Presbyterian Church
BEER, ROBERT H., eng.
 Gorski, Paul, eng.
 Graff, Howard, eng.
Beer, Gorski & Graff
 Hermitage Apts., 1985
 Goethe Terrace, 1986
 200 N. Dearborn, 1990
BEERS, MINARD LEFEVRE (1847–
 1918)
 Clay, William Wilson
 Dutton, Llewellyn B.
Beers, Clay & Dutton
 Ward, 1885
 Medinah, 1893
BEERSMAN, CHARLES G. (1888–
 1946)
 see Wrigley
BEIN, MORRIS I. (dec'd)
 1117 N. Dearborn, 1927
 40 E. Oak, 1928
 Dearborn Plaza, 1929
BELFORD, DON (1934–), eng.
 with SOM and with Metz, Train &
 Youngren
 10 S. Riverside, 1965
 120 S. Riverside, 1968
 Apparel Mart, 1977
 Oakwood Apts., 1988
 see Page Brothers building

BELLI & BELLI
 Old St. Mary's Church replacement,
 1992
 see 1833 note
BEMAN, SOLON SPENCER (1853–
 1914)
 Pullman, 1884
 Chicago Manual Training School,
 1884
 Studebaker, 1886
 Grand Central Station, 1890
 A. H. Andrews, 1890
 Studebaker, 1895
 Hamilton Club, 1904
BENESCH, ALFRED (1897–1981),
 eng.
 In practice from 1946
 Carl Sandburg Village, 1960–1965
 McClurg Court Center, 1971
 1555 N. Astor, 1975
 Harbor Point Condos, 1975
 Three Illinois Center, 1979
 Columbus Plaza, 1980
 Michigan Place, 1981
 1410 N. State, 1981
 Boulevard Towers North, 1981
 One S. Wacker, 1982
 Buckingham Plaza, 1982
 Chicago Mercantile Exchange, 1984,
 1988
 Boulevard Towers South, 1985
 Fairmont Hotel, 1987
 175 N. Harbor Tower, 1988
 900 N. Michigan, 1989
 Principals in 1996: Harold R. Sand-
 berg and Michael N. Goodkind
BENNETT, A. J. F. (dec'd)
 National Woolens, 1904
BENNETT, EDWARD H. (1874–1954)
 design with City of Chicago
BENNETT, RICHARD (1907–1997)
 see Loebl, Schlossman & Bennett
BERGER, JACK
 see 19 W. Chestnut conversion, 1984
BERLIN, ROBERT CARL (1853–1937)
 YMCA Hotel, 1915
Berlin, Swern & Randall (1919–1923)
 see Frank A. Randall

Berlin & Swern (1923–)
 YMCA Hotel addition, 1926
 H. H. McCormick Memorial YWCA,
 1929
BERNHARD, WILLIAM (ca. 1871–
 dec'd)
 14 W. Elm, 1927
 see Woltersdorf & Bernard
BEYER, JOHN H.
 Beyer, Blinder & Belle (N.Y.)
 600 N. Michigan, 1996
BILANDIC, NICHOLAS A., eng.
 with Holabird & Root
BLACK, JAMES B., eng.
 201 E. Delaware, 1925
 McGraw-Hill, 1929
 Trustees, 1930
 Moody Bible Institute, 1937
 Wesley Memorial Hospital, 1941
BOFILL, RICARDO (1939–) (Spain)
 American Medical Assoc., 1990
 R. R. Donnelley, 1992
BOLLENBACHER, JOHN CARLISLE
 (1884–1939)
 see Granger & Bollenbacher
BOOTH, LAWRENCE O. (1936–)
 Nagle, James L.
Booth, Nagle (1966–)
 Hartray, John F.
Booth, Hartray
 see Nagle, Hartray
Booth, Nagle & Hartray (1977–1979)
 Hansen, Paul
Booth, Hansen (1980–)
 320 N. Michigan, 1983
 see Donohue
 see 600 W. Adams
 see Morton addition
 see 566 W. Adams
 see Pugh Warehouse
 see John Moir Trust
 see Fort Dearborn Hotel
 see Borg
 see Farwell
BOYINGTON, WILLIAM W. (1818–
 1898)
 Massasoit House 1, 1857
 Sherman House 2, 1861

Crosby's Opera House, 1865
Lake Shore & Michigan Southern,
 and Chicago, Rock Island & Pa-
 cific Railway Depot, prefire
Chicago Avenue Water Tower, 1869
Metropolitan Hotel, prefire
Grand Pacific Hotel 1, 1871
Bowen, 1872
Farwell Hall, postfire
Fowler-Goodell-Walters Block, 1872
Gardner House, 1872
Leander J. McCormick Block, 1872
Richards, Shaw & Winslow Store,
 1872
Lake Shore & Michigan Southern,
 and Chicago, Rock Island & Pa-
 cific Railway Depot, postfire
Bowen, 1873
Exposition, 1873
Grand Pacific Hotel 2, 1873
McCormick Hall, 1873
Sherman House 3, 1873
Union Passenger Station, 1881
Wells Street Depot, 1881
600 W. Adams, 1883
Board of Trade 3, 1885
Royal Insurance, 1885
439–45 S. Clark, 1890
Columbus Memorial, 1893
BOYINGTON & WHEELOCK
 Wabash Avenue Baptist Church,
 1857
BRADLEY, CAPT. HEZEKIAH (dec'd),
 eng.
 Fort Dearborn (1816), rebuilt
BRAEGER, WILLIAM, eng.
 Wrigley, 1921, 1924
 Federal Reserve Bank, 1922
 Chicago Union Station, 1924
 Continental Illinois Bank, 1924
 Pittsfield, 1927
 State Bank, 1928
BRANSON, S. J. (dec'd), eng.
 Canterbury Court Apt. Hotel, 1928
 North Loop Garage, 1928
BRENNER, DANIEL (1917–1977)
 Danforth, George E. (1916–)
 Rockwell, H. P. Davis

Brenner, Danforth & Rockwell
 (1961–)
 see Madlener House
Danforth, Rockwell, Carow (1979–)
BROCKETTE/DAVIS/DRAKE, engs.
 (Dallas)
 311 W. Wacker, 1990
BROWN, ANDREW (dec'd), eng.
 with SOM
 Inland Steel, 1958
BROWN, FRANK ELAM (1888–dec'd),
 eng.
 Superior Exchange, 1924
 Sherman Hotel addition, 1925
 Sherman Hotel Annex, 1925
 Morrison Hotel Tower, 1925
 Palmer House 4, 1925/1927
 Tribune Tower, 1925
 Roanoke Tower, 1926
 Portland Cement Association, 1926
 Stevens Hotel, 1927
 Stevens Hotel Service, 1927
 Tobey, 1927
 Chicago Women's Club, 1928
 Times, 1928
 333 N. Michigan, 1928
 Michigan-Chestnut, 1929
 Passavant Hospital, 1929
 Chicago Daily News, 1929
 Chicago Motor Club, 1929
 Franklin Exchange addition, 1930
 see Smith & Brown, engs.
BROWNSON, JACQUES
 with SOM
BRUBAKER, C. WILLIAM
 with Perkins & Will
BRUSH, DANIEL H., JR. (dec'd)
 see Rapp & Rapp (1907–)
BUENZ, JOHN (1933–)
 see Solomon, Cordwell & Buenz
BURGEE, JOHN H. (1933–) (N.Y.)
 Johnson, Philip (1906–) (N.Y.)
 Burgee with P. Johnson (1969–)
 190 S. LaSalle, 1987
BURGEE, JOSEPH Z.
 see Holabird, Root & Burgee
BURKE, RALPH H. (dec'd), eng.
 see McCormick Place, 1970

BURLING, EDWARD (1819–1892)
Chamber of Commerce 1, 1865
Burling & Backus
St. James Cathedral, 1856
Burling & Baumann
Holy Name Cathedral 1, 1854
Burling & Adler (1871–1878)
Greenebaum, 1872
C. M. Henderson, 1872
166–68 W. Lake, 1872
Music Hall, 1872
Tribune 2, 1872
Dickey, 1873
Marine, 1873
Mercantile, 1873
Methodist Church Block, 1873
Unity Church rebuild, 1873
Burling & Whitehouse (1879–1892)
First National Bank 1, 1868
First National Bank 2, 1882
Samuel M. Nickerson residence, 1883
200–206 W. Adams, 1888
BURNHAM, DANIEL H. (1846–1912)
Root, John Wellborn
Burnham & Root (1873–1891)
Brunswick Hotel remodeling, 1873
Grannis Block, 1881
Montauk Block, 1882
CB&Q Office, 1883
People's Gas 1, 1883
Dexter, 1883
Calumet, 1884
Counselman, 1884
Art Institute, 1885
Insurance Exchange, 1885
Loan & Trust, 1885
Union Block, 1885
Phoenix, 1886
Commerce, 1886
Postal Telegraph, 1886
Sherman, 1886
Chemical Bank, 1889
Rookery, 1889
First Infantry Armory, 1890
Rand McNally, 1890
Reliance, 1890, 1895
Walker Store, 1890
Daily News, 1891

Herald, 1891
Monadnock Block (northern half), 1891
Great Northern Hotel, 1892
Masonic Temple, 1892
Woman's Temple, 1892
Burnham, Daniel Hudson (firm, 1891–1893)
Chief of Construction, World's Columbian Exposition, 1891–1893
Ashland Block 2, 1892
Marshall Field & Co., 1892
Majestic Hotel, 1893
Soden, 1893
Great Northern Office and Theater, 1895
Burnham, D. H. & Co. (1894–1912)
Reliance addition, 1895
Fisher, 1896
Illinois Trust & Savings Bank, 1896
Silversmith, 1897
Stewart 2, 1897
Franklin MacVeagh Co., 1898
Main Office (Illinois Bell) addition, 1899
Merchants Loan & Trust Co., 1900
Booth Cold Storage Co., 1901
Marshall Field & Co., 1902, 1906, 1907, 1914
First National Bank 3, 1903
Railway Exchange, 1904
Heyworth, 1905
Orchestra Hall, 1905
Carson, Pirie, Scott & Co., 1906
Edison, 1907
Mayer, 1910
Chamberlain, 1911
People's Gas Co. 2, 1911
Boyce, 1912
Field Museum of Natural History, 1912
Insurance Exchange, 1912
Otis Elevator, 1912
Polk-Wells, 1912
Stevens Store, 1912
Butler Brothers, 1913
Conway, 1913
Goddard, 1913

Continental National Bank, 1914
Marshall Field Annex, 1914
Lombard Hotel, 1914
Burnham, Daniel H., Jr. (1886–)
see D. H. Burnham & Co. (partner
 from 1910 to 1912)
Burnham, Hubert (1882–)
see D. H. Burnham & Co. (partner
 from 1910 to 1912)
see Graham, Burnham & Co. (1912–
 1917)
see Burnham Brothers, Inc. (1928–
 1933)
successor: Burnham Brothers and
 Hammond, Inc. (1933–)
Burnham Brothers
Burnham, 1924
Central Life, 1924
Dunham, 1926
Seneca Hotel, 1926
Bankers, 1927
Carson, Pirie, Scott & Co., 1927
Medical & Dental Arts, 1927
Engineering, 1928
Randolph-Wells addition, 1928
Carbide & Carbon, 1929
Loop Center, 1929
BURNS, JOHN J. (dec'd)
see Vitzhum & Burns
BURT, HENRY JACKSON (1873–
 1928), eng.
Crane Co., 1913
Fort Dearborn Hotel, 1914
Buck & Rayner, 1915
Franklin Exchange, 1917
John Crerar Library, 1920
Waterman, 1920
Apollo Theater, 1921
Illinois Life, 1921
Chicago Temple, 1923
Tower addition, ca. 1923
Rector addition, 1924
Stevens Hotel, 1927, consulting
 eng.

CADY, JEREMIAH K. (1855–1923)
see Baumann & Cady
see Handy & Cady

CALDWELL, ALFRED (1905–),
 land. arch.
see Lake Point Tower, 1969
CAMBURAS & THEODORE
Day's Inn, 1959
CANDELA, ROSARIO (dec'd) (N.Y.)
1500 N. Lake Shore, associated, 1931
CARR, GEORGE WALLACE (1879–
 dec'd)
see Nimmons, Carr & Wright (Carr &
 Wright in 1940s)
CARTER, ASA (dec'd)
Second Presbyterian Church, 1852,
 construction supt.
Carter & Bauer
St. Patrick's Church, 1856
Carter & Drake
Morrison Block 1, 1871
Carter, Drake & Wight (–1873)
Springer Block, 1872.
CHAMALES, CHRISTOPHER J.
1540 N. State, 1959
CHAPMAN, CASS (dec'd)
Lakeside 1, 1871
CHARN, VICTOR L. (dec'd)
Cadillac, 1946
CHARNLEY, F. L. (dec'd)
Kinsley, 1885
CHASE, FRANK D. (–1937), eng. &
 arch.
Starck, 1927
100 W. Monroe, 1927
Madison-LaSalle, 1927
Engineering, 1928
CHATTEN, MELVILLE C. (1873–1957)
see Perkins, Chatten & Hammond
Chatten & Hammond
200 E. Delaware, 1915
Lawson YMCA, 1931
CHESBROUGH, ELLIS S. (1813–after
 1879)
Chicago Avenue Water Tower, 1869
CHILDS, FRANK A. (dec'd)
Smith, William J.
Childs & Smith
McKinlock Campus, Northwestern
 University, associated, 1926
1448 N. Lake Shore, 1927

American Bankers Insurance, 1929
American Dental Assoc. remodeling
 1943
CLARK, EDWIN HILL (1878–dec'd)
 see Otis & Clark
CLAY, WILLIAM WILSON (1840–
 1926)
 Wilson Brothers, 1903
 see Beers, Clay & Dutton
 see Wheelock & Clay
CLEVELAND, L. D.
 Bonfield, 1872 dec'd
 State Savings Institution, 1873
COBB, HENRY IVES (1859–1931)
 Wellington Hotel, 1890
 Boyce, 1892
 Chicago Historical Society 3, 1892
 Cook County Abstract & Trust Co.,
 1892
 Newberry Library, 1892
 Chicago Athletic Club, 1893
 Hartford, 1893
 241–43 E. Illinois, 1894
 225–39 E. Illinois, 1895
 311 E. Illinois, 1897
 319–33 E. Illinois, 1899
 216 W. Jackson, 1899
 Caravetta, ca. 1900
 337–51 E. Illinois, 1902
 Chicago Post Office, 1905
 Frost, Charles F.
Cobb & Frost (1882–1898)
 Potter Palmer residence, 1885
 Chicago Opera House Block, 1885
 Bedford, 1890
COBB, OSCAR (1812–1900)
 Haverly's Theater, 1881
 Bucklin, 1884
COCHRANE, JOHN CROMBIE (1833–
 1887)
 Miller, Charles C.
Cochrane & Miller
 Chamber of Commerce 2, 1872
 Lord & Smith, 1872
 Galbraith, 1873
COFFEY, DANIEL P.
 see Goldblatt's Store
 see Chicago Theater

 see U. of Illinois Campus
COHEN, ELI W. (1927–), eng.
 Barreto, Renato (1925–retired), eng.
 Marchertas, Anthony (1923–), eng.
Cohen-Barreto-Marchertas/CBM
 (1956–1993)
 42 E. Walton, 1952
 1150 N. Lake Shore, 1959
 The Carlyle, 1966
 Streeterville Center, 1966
 625 N. Michigan, 1971
 Heitman Centre, 1972
 200 E. Delaware, 1972
 2 E. Oak, 1972
 Newberry Plaza, 1975
 Elm Street Plaza, 1976
 River Plaza, 1977
 Marriott Hotel, 1978
 Xerox Centre, 1980
 1100 N. Lake Shore, 1980
 1410 N. State, 1981
 110 E. Delaware, 1981
 Chestnut Place, 1982
 300 W. Chestnut, 1983
 Manufacturers Hanover, 1984
 190 S. LaSalle, 1987
 Hotel Nikko, 1987
 1133 N. Dearborn, 1988
 Swiss Grand Hotel, 1989
 Leo Burnett, 1989
 American Medical Assoc., 1990
 Canal Center, 1990
 Chicago Bar Assoc., 1990
 420 E. Ontario, 1990
 North Pier Apt. Tower, 1991
 Greyhound Bus Terminal, 1991
 Metcalf Federal, 1991
 401 E. Ontario, 1991
 633 St. Clair, 1991
 R. R. Donnelley Center, 1992
 Plaza Escada, 1992
 see Art Institute
 see Bond Store
CBM and Thornton-Tomasetti, engs.
 (N.Y.)
 as TT-CBM (1993–)
 U. of Chicago Graduate School, 1994
 Unicom Thermal Technologies, 1994

Chicago Music & Dance Theater, 1997

COHEN, EDWARD M.
see Mueller

COLACO, JOSEPH, eng.
Nuveen, 1983
see 500 N. Michigan

COLBURN, I. W.
1524 N. Astor, 1968

COMM, DANIEL
1344 N. Dearborn, 1971
1339 N. Dearborn, 1972
1221 N. Dearborn, 1972

CONANT, HOWARD
see First Commonwealth

CONDRON, THEODORE L. (1866–dec'd), eng.
Sinks, Frank F., eng.
Condron & Sinks
Studebaker, 1910
Condron & Co. (1912–1924)
Hamilton Club addition, 1920

CONN, ALAN
LaSalle Center, 1986

CONSOER & MORGAN
Meigs Field Terminal, 1963

COOLIDGE, CHARLES ALLERTON (1858–1936)
see Shepley, Rutan & Coolidge
Coolidge & Hodgson
Art Institute Ferguson Wing, 1958

CORDWELL, JOHN D. (1926–)
see Solomon, Cordwell

CRANE, C. HOWARD (dec'd)
Crane & Franzheim
Harris-Selwyn Theaters, 1923

CROWEN, SAMUEL N. (1872–1935)
Brokers, 1908
Textile, 1911
St. Clair, 1911
Tobey Furniture, 1912
Mergenthaler Linotype, associated, 1917
Lake Shore-Ohio, 1918
Willoughby Tower, 1929

CUDELL, ADOLPH A. (dec'd)
see Portland Block
Cudell & Blumenthal
Cyrus McCormick residence, 1879

DALSEY, HARRY I. (1891–1940)
Wilmar Hotel, 1927

DARRICK, ROBERT O. (St. Louis)
Central Chicago Garage, 1924

DART, EDWARD D. (1922–1975)
First St. Paul's Church, 1970
see Loebl, Schlossman & Dart

DAVIDSON, FRANK E. (dec'd)
Weiss, John W.
Davidson & Weiss, archs. & engs.
Thom, 1922

DECKER & KEMP
see 1903 Champlain

DeGOLYER, ROBERT S. (1876–dec'd)
(Italian Court noted under 625 N. Michigan)
200 E. Pearson Apts., 1916
Pearson Hotel, 1923
DeWitt Hotel, 1926
1420 N. Lake Shore, 1928
1242 N. Lake Shore, 1929
Stockton, Walter T.
DeGolyer & Stockton
1120 N. Lake Shore, 1925
1320 N. State, 1926
Ambassador East, 1927

DeSTEFANO, JAMES R.
Goettsch, James (1941–)
DeStefano & Goettsch
R. R. Donnelley, 1992
see 300 S. Wacker, 1971

DIBELKA, JAMES B. (1860–dec'd)
Flaks, Francis A. (dec'd)
Dibelka & Flaks
Randolph-Wells, 1914

DINKELBERG, FREDERICK PHILIP (1859–1935)
see Giaver & Dinkelberg
see Railway Exchange, 1904

DIXON, LAVALL B. (1834–dec'd)
Gibbs, 1872
Hamilton, Frederick B. (dec'd)
Dixon & Hamilton
Major Block 2, 1872
LaSalle, 1872
Windett, 1872

DOERR, JACOB F. (dec'd)
Doerr, John P. (dec'd)

Hyatt Regency West, 1974
Hyatt Regency East, 1980
Avondale Center, 1980
Stone Container, 1983
1122 N. Clark, 1989
Harold Washington Library, 1991
Museum of Contemporary Art, 1996
McCormick Place, 1996
McCormick/Hyatt Hotel, 1998
see Borg-Warner, 1958
see Federal Center, 1964
see U. of Illinois Campus, 1965
see 600 W. Fulton
ERIKSON, CARL A. (1888–dec'd)
see Schmidt, Garden & Erikson
ESSER, CURT A.
see Leichenko & Esser
EVANS, T. ARTHUR (dec'd), eng.
Wacker Drive chief engineer, 1924–
1926

FARKAS, BARRON, engs. (N.Y.)
One Illinois Center, 1971
Two Illinois Center, 1973
FELLOWS, WILLIAM KINNE (1870–
1948)
see Nimmons & Fellows
see Perkins, Fellows & Hamilton
Partner, Hamilton, Fellows & Nedved
FINERTY, MARTIN, eng.
Wevang, Lloyd, eng.
Structural Associates
Dearborn Place, 1985
1212 N. LaSalle, 1987
1 E. Delaware, 1989
Gold Coast Galleria, 1992
21 W. Chestnut, under construction
Park Newberry, under construction
FINLAYSON, FRANK
Metro Sanitary District, 1954
FISCHER, JOHN BAPTISTE (1875–
1951)
Monroe Theater remodeling
FITCH, MARVIN
Larocca, Frank
Fitch-Larocca
see American Furniture
see Lowenberg-Fitch

FLANDERS, JOHN J. (1848–1914)
Carter Harrison, 1882
Mallers, 1884
Zimmerman, William Carbys
Flanders & Zimmerman (1886–1898)
Kimball, 1892
Mallers, 1892
Van Buren, 1893
see 225 S. Market
see Zimmerman, W. C.
FLORIAN, PAUL G. A. (1950–)
Wierzbowski, Stephen (1953–)
Florian-Wierzbowski (1983–1994)
see North Pier Apt. Tower, 1991
FOLGERS, KENNETH W.
see Munn
FOLTZ, FREDERICK C. (dec'd).
Harrison Garage, 1925
Wells-Jackson, 1929
FOLTZ, FRITZ (1843–1916)
see Treat & Foltz
FOX, CHARLES ELI (1870–1926)
see Marshall & Fox
FRANCE, ROY (dec'd)
211–15 E. Chestnut, 1928
FRANZHEIM, KENNETH (dec'd)
233 E. Walton, 1922
see Crane & Franzheim
FRIEDMAN, RAPHAEL N. (1890–
dec'd)
see Alschuler & Friedman
Sincere, Edwin M.
Friedman, Alschuler & Sincere
(1946–)
Bond, 1949
see 900 N. Lake Shore, 1956
FROST, CHARLES S. (1856–1931)
Western Bank Note, 1891
McKinlock, 1898
Hibbard, Spencer, Bartlett, 1903
Borland Manufacturing, 1910, 1913
Borland addition, 1914
Municipal Pier, 1916
Granger, Alfred Hoyt
Frost & Granger (1898–1910)
(brothers-in-law)
LaSalle Street Station, 1903
C. & N. W. Ry. Office, 1904

Northern Trust, 1905
Henderson, Charles C.
Frost & Henderson
Northern Trust addition, 1928
FRYE, GILLAN & MOLINARO
see Orleans Plaza
FUCIK, EDWARD J. (dec'd), eng.
Steele-Wedeles, 1909, contr. supt.
FUGARD, JOHN REED (1886–1968)
see Allerton Hotel
Fugard & Knapp
60–70 E. Scott, 1917
229 E. Lake Shore, 1918
220 E. Walton, 1919
231 E. Delaware, 1920
222 E. Walton, 1921
230 E. Walton, 1921
210 E. Lake Shore Drive Hotel, 1923
Parke, Davis, 1924
20 E. Cedar, 1925
201 E. Delaware, 1925
see Eckland, Fugard & Knapp
FUJIKAWA, JOSEPH Y.
Office of Mies van der Rohe (1969–1975)
One Illinois Center, 1971
Two Illinois Center, 1973
Conterato, Bruno P.
Lohan, Dirk
Fujikawa, Conterato, Lohan/FCL (1975–1981)
Three Illinois Center, 1979
Columbus Plaza, 1980
Boulevard Towers North, 1981
Buckingham Plaza, 1982
Johnson, Gerald L.
Fujikawa, Johnson (1982–)
Chicago Mercantile Exchange, 1984
Boulevard Towers South, 1985
200 W. Adams, 1985
Chicago Mercantile Exchange, 1988
175 Harbor Tower, 1988
R. H. Metcalf Federal, 1991
see Bond Store
see Fairmont Hotel

GAMBRILL, CHARLES D. (dec'd)
Richardson, Henry Hobson

Gambrill & Richardson
American Express, 1873
GARDEN, HUGH MACKIE GORDON (1873–1961)
see Schmidt, Garden & Martin
see Schmidt, Garden & Erikson
see Grommes & Ullrich, 1901
see Madlener House
see 63 E. Adams
GCE OF ILLINOIS, engs.
see Seventeenth Church of Christ, Scientist, 1968
GELICK, MICHAEL
Foran, Walter J.
Gelick, Foran (1969–)
Cityfront Place, 1991
see Esquire Theater
GERBER, SHERMAN
see 100 E. Walton
GERHARDT, PAUL, SR. (1866–dec'd)
Hall Printing, 1908
Winston, 1916
Hearst addition
GIAVER, JOACHIM G. (dec'd), eng.
Silversmith, 1897
Merchants Loan & Trust Co., 1900
Railway Exchange, 1904
Heyworth, 1905
Orchestra Hall, 1905
Edison, 1907
Mayer, 1910
People's Gas Co. 2, 1911
Field Museum of Natural History, 1912
Insurance Exchange, 1912
Butler Brothers, 1913
Alfred Decker & Cohn, 1913
Goddard, 1913
Continental National Bank, 1914
Dinkelberg, Frederick Philip (dec'd)
Giaver & Dinkelberg, eng. & arch.
Jewelers, 1926
GIBSON, BAYARD K. (dec'd)
Central Cold Storage Warehouse, 1916
GILBERT, BRADFORD LEE (dec'd) (N.Y.)
I. C. Railroad Station, 1892

GOETTSCH, JAMES (1941–)
 with Murphy/Jahn
 see DeStefano & Goettsch
GOLDBERG, BERTRAND (1913–
 1997)
 Marina City, 1962
 Astor Tower, 1963
 Prentice Hospital, 1974
 River City, 1986
GOLDSMITH, MYRON (1918–1996)
 with SOM and C. F. Murphy
GOLDSTEIN, SEYMOUR S.
 2 E. 8th Apts., 1984
GONZALEZ, JOSEPH
 with SOM
GORDON, EZRA (1921–)
 Levin, Jack M. (1926–retired)
 Gordon & Levin
 Slawin, Gerry, now principal
 (1936–)
 1300 N. Lake Shore, 1963
 Newberry Plaza, 1975
 Elm Street Plaza, 1976
 River Plaza, 1977
 Dearborn Park Apts., 1980
 Huron Plaza, 1981
 Streeterville 400, 1982
 1133 N. Dearborn, 1988
 1911 S. Indiana, 1995
GRAHAM, ERNEST ROBERT (1866–
 1936)
 partner, Burnham & Co. (1904–
 1912)
 Graham, Burnham & Co. (1912–1917)
 Alfred Decker & Cohn, 1913
 Kimball, 1917
 Chicago Union Station, 1924
 Anderson, Pierce
 Probst, Edward
 White, Howard Judson
 Graham, Anderson, Probst & White
 (1917–)
 Western Union Telegraph Co., 1919
 Wrigley, 1921, 1924
 Federal Reserve Bank, 1922
 Continental Illinois Bank, 1924
 Straus, 1924
 Hibbard, Spencer, Bartlett & Co., 1926

Builders, 1927
Morton, 1927
Pittsfield, 1927
Standard Oil addition, 1927
Central Police Station & Courts,
 1928
Insurance Exchange Annex, 1928
State Bank, 1928
Civic Opera, 1929
Foreman National Bank, 1929
Marshall Field Apartments, 1929,
 consultants
Merchandise Mart, 1929
Shedd Aquarium, 1929
Chicago Historical Society, 1931
Field, 1932
U.S. Post Office, 1932
Goldblatts, 1934
226 S. Wells, 1934, remodeling
American Dental Assoc., 1966
Lake Point Tower, 1969
CNA Center, 1973 (*see* 1962)
Surman, Robert, principal (1992–)
GRAHAM, BRUCE (1925–)
 with SOM
GRANGER, ALFRED HOYT (1867–
 1930)
 see Frost & Granger
 Bollenbacher, John Carlisle
 Granger & Bollenbacher
 Chicago Club, 1930
GRAVEN, ANKER S. (dec'd)
 Mayger, Arthur G. (dec'd)
 Graven & Mayger
 Starck Piano, 1927
 21–23 S. Wabash, 1928, remodeling
 Lawyers, 1929
GREEN, JAMES G. (dec'd) (N.Y.)
 Hearst, 1911
GRISKELIS, RAYMOND P.
 Griskelis & Smith
 6 W. Hubbard, 1989
 see Brooks
 see 223 W. Jackson
GRUNSFELD, ERNEST ALLEN, JR.
 (1897–1970)
 Adler Planetarium, 1930
 see Klaber & Grunsfeld

GUENZEL, LOUIS (1860–dec'd)
Maryland Hotel, 1926
11 N. LaSalle, 1930
GUNDERSON, MAGNUS (dec'd), eng.
Straus, 1924
Morton, 1927
Central Police Station and Courts,
1928
Insurance Exchange Annex, 1928
Civic Opera, 1929
Foreman National Bank, 1929
Merchandise Mart, 1929
Shedd Aquarium, 1929
Chicago Historical Society, 1931
Field, 1932
U.S. Post Office, 1932
Goldblatts, 1934

HACKL, DONALD J.
see Loebl, Schlossman & Hackl
HALL, ERIC (dec'd)
Advertising, 1913
Atlas, 1930
Lawrence, Albin (dec'd)
Ratcliffe, H. E. (dec'd)
Hall, Lawrence & Ratcliffe
120 W. Lake, 1928
HALLBERG, LAWRENCE GUSTAVE
(1844–1915)
Vendome Hotel, 1882
Central Union Block 2, 1890
John Moir Trust, 1912
HAMILTON, FREDERICK B. (dec'd)
see Dixon & Hamilton
HAMILTON, JOHN L. (1878–dec'd)
see Perkins, Fellows & Hamilton
HAMMOND, CHARLES HERRICK
(1882–1969)
see Chatten & Hammond
see Perkins, Chatten & Hammond
see Burnham & Hammond
HAMMOND, JAMES W. (1918–1986)
Roesch, Peter H.
Hammond & Roesch
see St. James Cathedral
Beeby, Thomas H.
Hammond, Beeby (1971–1976)
Babka, Bernard

Hammond, Beeby & Babka (1976–)
H. Washington Library Center, 1991
Chicago Music & Dance Theater,
1997
see Art Institute, Rice addition
HANDY, FRANK W. (dec'd)
Cady, Jeremiah K.
Handy & Cady
Teutonic, 1893
HANSELMANN, HERMAN (dec'd)
America-Fore, 1923
HANSEN, PAUL
see Booth, Hansen
HARBOE, THOMAS G.
see McClier Corp.
HARKINS, CHARLES (dec'd), eng.
Seneca Hotel, 1926
Dunham, 1926
Medical & Dental Arts, 1927
Bankers, 1927
Loop Center, 1929
Carbide & Carbon, 1929
HARRIS, RALPH C. (dec'd)
Devonshire Hotel, 1927
HARRISON, FOUILHOUX & ABRA-
MOVITZ (N.Y.)
see Howells, Hood & Fouilhoux
HARTRAY, JOHN F., JR. (1930–)
see Nagle, Hartray
HARVEY, GEORGE LYON (dec'd)
Paper Mills, 1901
D. B. Fisk, 1913
HASBROUCK, WILBERT R.
Hunderman, Harry J.
Hasbrouck, Hunderman
Hasbrouck, Peterson
see Polk Street Station
see Rookery
see Manhattan
see Orchestra Hall
see Singer, 1926
HAUSNER, RICHARD
Macsai, John
Hausner & Macsai (–1975)
(1400 N. State, not listed)
1150 N. Lake Shore, 1959
1440 N. State, 1960
Ramada Inn, 1961.

Park Hyatt Hotel, 1962
35 E. Chestnut, 1963
1240 N. Lake Shore, 1969
1110 N. Lake Shore, 1971
HAVENS, GEORGE (dec'd), eng.
 see Mundie, Jensen, Bourke & Havens
HAWKES, THOMAS (dec'd)
 Girard, 1888
HEIDENRICH, E. LEE (dec'd), eng.
 Winton, 1904
HEIN, PETER (dec'd), eng.
 see Lieberman & Hein
HELLMUTH, GEORGE (dec'd) (St.
 Louis)
 Obata, Gyo
 Kassabaum, George (dec'd)
HOK
 Fairmont Hotel, 1987
 Hotel Nikko, 1987
HENDERSON, CHARLES C. (dec'd)
 Borland Manufacturing addition,
 1928
 see Frost & Henderson
HENDERSON (dec'd), eng.
 see Purdy & Henderson
HESSENMUELLER & MELDAHL
 Richelieu Hotel, 1885
HILL, BOYD (dec'd)
 see Huszagh & Hill
HILL, HENRY W. (1852–retired 1914)
 see Bauer & Hill
 Woltersdorf, Arthur F. (dec'd)
Hill & Woltersdorf (1894–1914)
 Thomas Church, 1903
 162 N. Franklin, 1906
 DeVoe & Raynolds, 1912
 see Page Brothers building
HILLMAN, IVAR C., eng.
 Home Federal, 1966
HILLMAN, JOEL R.
 Barclay Chicago Hotel, 1965
 Streeterville Center, 1969
 150 N. Wacker, 1970
 2 E. Oak Apts., 1972
 Vagnieres, Robert, Jr.
Hillman & Vagnieres (1970)
 Sheraton Plaza Hotel, 1973
 233 E. Ontario, 1980

HIRSCHFIELD, LEO S. (1892–dec'd)
 1335 N. Astor, 1951
 see Rissman & Hirschfield
 Pawlan, Harold
Hirschfield & Pawlan (1953–)
 850 N. DeWitt, 1955
 253 E. Delaware, 1958
 Reinheimer, Martin
Hirschfield, Pawlan & Reinheimer
 1440 N. Lake Shore, 1963
 Galter Carriage House, 1964
 The Carlyle, 1966
Hirschfield & Reinheimer (1966–1970)
 1340 N. Astor, 1969
 see Pawlan & Reinheimer
 see Reinheimer, Martin
HISS, PHILIP (dec'd) (N.Y.)
 Weeks, H. Hobart (dec'd)
Hiss & Weeks
 Elizabeth Arden, 1926
HODGKINS, HOWARD G. (dec'd)
 Pope, 1904
HOFER, VICTOR, eng.
 see McCormick Place
HOFFMAN, EDWARD S., eng.
 see Klein & Hoffman
 see Engineers Collaborative
HOLABIRD, WILLIAM (1854–1923)
 Holabird, John A. (1886–1945)
 Simonds, Ossian C.
Holabird & Simonds (1880–1881)
 Roche, Martin (1855–1927)
Holabird & Roche (1883–1928)
 Dearborn, 1886
 Caxton, 1890
 Pontiac, 1891
 Lathrop residence, 1892
 Venetian, 1892
 Congress Hotel Annex, 1893
 Monadnock Block (southern half),
 1893
 Champlain, 1894
 Old Colony, 1894
 A. M. Rothschild, 1894
 McCormick/Harvester/Powers, 1895
 Marquette, 1895
 Atwood, 1896
 McConnell Apartments, 1897

Price, 1897
Bailey (northern portion), 1898
Edson Keith, 1898
Ascher, 1898
Gage, 1898
320–22 S. Franklin, 1898
Poole Brothers, 1898/1912
Williams, 1898
Cable, 1899
Ayer, 1900
Mandel Brothers Store, 1900, 1905, 1912
Clow, 1902
Tribune 3, 1902
Brock & Rankin, 1903
Champlain, 1903
Liquid Carbonic, 1903
Hamilton, 1904
McNeil, 1904, 1911
Boston Store, 1905 to 1917
Chicago Savings Bank, 1905
Mercantile, 1905
Republic, 1905
Ryerson Warehouse, 1905
Fairbanks, Morse & Co., 1906
Maurice L. Rothschild Store, 1906, 1910
Brooks, 1907
Ohio, 1907
Bauer & Black, 1908
Oliver, 1908
Born, 1908
LaSalle Hotel, 1909
Moser, 1909
University Club, 1909
Brooks, 1910
Hart, Schaffner & Marx, 1910
McCormick, 1910
Wabash Exchange (Illinois Bell), 1910
American Medical Association, 1911/1922
City Hall & County, 1911
Ryerson, 1911
Sherman Hotel 4, 1911, 1920
Bell (Illinois Bell), 1912
Great Lakes, 1912
Monroe, 1912

North American, 1912
Otis, 1912
Moses, 1912
Rand McNally, 1912
Rothschild's Store, 1913
Crane, 1913
Reaper Block remodeling, 1913
Fort Dearborn Hotel, 1914
Buck & Raynor, 1915
Lumber Exchange, 1915
Republic, 1917
Franklin Exchange (I.B.Tel.), 1917
Hotel LaSalle Garage, 1919
Crerar Library, 1920
Waterman, 1920
Apollo Theater, 1921
Illinois Life, 1921
Vitagraph, 1921
Chicago Temple, 1923
Tower addition, 1923
Rector addition, 1924
Superior Exchange (Illinois Bell), 1924
Morrison Hotel Tower, 1925
Palmer House 3, 1925, 1927
Sherman Hotel addition, 1925
Sherman Hotel Annex, 1925
Portland Cement Association, 1926
Roanoke Tower, 1926
Stevens Hotel Service, 1926
Catholic Charities, 1927
Stevens Hotel, 1927
Chicago Women's Club, 1928
Temporary Board of Trade, 1928
Chicago Daily News, 1929
Palmolive, 1929
following Martin Roche's death:
 Root, John Wellborn, Jr.
Holabird & Root (1927–)
 Tobey, 1927
 333 N. Michigan, 1928
 Times, 1928
 Chicago Motor Club, 1929
 Michigan-Chestnut, 1929
 Passavant Hospital, 1929
 Board of Trade 4, 1930
 Buckingham, 1930

INGRAM, HORACE COLBY
 219 E. Lake Shore, 1922, associated
IYENGAR, SRINIVARA (HAL), eng.
 with SOM
 222 S. Riverside, 1972
 see Sears Tower
 33 W. Monroe, 1981

JAFFRAY, HENRY S. (dec'd)
Jaffray & Scott
 Commercial Bank, 1884
JAHN, HELMUT (1940–)
 (Germany)
 with C. F. Murphy
 see Murphy/Jahn
JENNEY, WILLIAM LE BARON (1832–
 1907), eng. and arch.
 Portland Block, 1872
 Lakeside 2, 1873
 Leiter, 1879
 Home Insurance, 1885
 Union League Club 1, 1886
 Manhattan, 1890
Jenney & Otis (1887–1889)
 Mundie, William Bryce (dec'd)
Jenney & Mundie (1891–1905)
 Ludington, 1891
 Siegel, Cooper/Sears, 1891
 Fair Store, 1892
 Isabella, 1892
 Association, 1893
 New York Life, 1894
 Fort Dearborn, 1895
 Grand Pacific Hotel, 1895
 remodeling
 Morton, 1896
 Trude, 1897
 Central Trust, 1900
 Equitable, 1902
 Jensen, Elmer C. (dec'd)
Jenney, Mundie & Jensen (1905–1907)
 Hoops, 1905
 Chicago Garment Center, 1905
 Lake View, 1906
 Kesner, 1910
JENNISON, E. S.
 Hale 1, 1870
 Hale 2, 1872

Clarke, Layton & Co., 1872
 Field & Leiter Store 2, 1873
JENSEN, ELMER C. (1870–dec'd)
 see Jenney, Mundie & Jensen (1905–
 1907)
 see Mundie & Jensen (1907–1936)
 see Mundie, Jensen, Bourke & Havens
 (1936–1944)
 see Mundie & Jensen (1944–1946)
 see Mundie, Jensen & McClurg
 (1946–)
JENSEN, JENS J. (1860–1951)
 300 W. Adams St., 1927
JOHNSON, GERALD
 see Fujikawa, Johnson
JOHNSON, LEWIS J., eng. (St. Louis)
 Steinway Hall, 1896
JOHNSON, PHILIP (1906–) (N.Y.)
 see Burgee with Johnson
JOHNSON, RALPH E. (1948–)
 with Perkins & Will (1976–)
 see 123 N. Wacker, 1988
 see McKinlock Campus
 see Morton International
JUNG/BRANNEN (Boston)
 1320 N. Lake Shore, 1993

KAHN, ALBERT (1869–1942) (Detroit)
 Standard Club, 1926
KAPLAN/MCLAUGHLIN/DIAZ (San
 Francisco)
 see Polk Street Station
KEELEY, PATRICK C. (1816–1896)
 (N.Y.)
 Holy Name Cathedral
KHAN, FAZLUR RAHMAN (1929–
 1982), eng.
 with SOM
 69 W. Washington, 1965
 DeWitt-Chestnut, 1966
 John Hancock, 1969
 Sears Tower, 1974
 211 E. Chestnut
 Madison Plaza, 1983
 One Magnificent Mile, 1983
 Onterie Center, 1986
KINGSLEY, GEORGE S. (dec'd)
 100 N. Dearborn, 1914

Loewenberg & Loewenberg
 Whitehall Apts., 1928, associated
 1130 S. Michigan, 1967
 H. Washington College, 1983
 see Jewish Federation
Loewenberg, James R. (1934–)
 1212 N. LaSalle, 1987
 Fitch, Marvin
Loewenberg-Fitch (1983–1994)
 1212 S. Michigan, 1982
 Ontario Place, 1984
 Dearborn Place, 1985
 1 E. Delaware, 1989
 Gold Coast Galleria, 1992
Loewenberg Associates (1993–)
 21 W. Chestnut, under construction
 Cathedral Place, under construction
 Park Newberry, under construction
LOHAN, DIRK (1938–)
 420 E. Ohio, 1990
 U. of Chicago Graduate School, 1994
 300 E. Randolph, 1997
 see Shedd Aquarium addition
 see Fujikawa, Conterato, Lohan
LUDGIN, JAMES G. (dec'd)
 see Klafter & Ludgin

MACBRIDE, E. EVERETT (dec'd)
 see Zimmerman, Saxe & MacBride
MACKINLAY, WINNAKER, McNEIL
 (Calif.)
 Le Meridien Hotel, 1988
MACSAI, JOHN
 see Hausner & Macsai
MADEYSKI, WOJIECH
 with Perkins & Will
 see 200 N. LaSalle
 see 350 N. LaSalle
MAHER, GEORGE W. (1864–1926)
 American College of Surgeons addi-
 tion, 1901
MAHER, PHILIP BROOKS (1894–
 dec'd)
 Farwell, 1927
 Women's Athletic Club, 1928
 1260 N. Astor, 1931
 1445 N. State, 1959
 see Metro Sanitary District

MANN, RICHARD P. (1936–)
 Gin, Jackson (1934–)
 Ebel, Walter H. (1943–1989)
 Frazier, Leotis K. (1934–)
Mann, Gin, Ebel, Ebel & Frazier
 (1977–)
 see Stouffer Riviere Hotel
MARSHALL, BENJAMIN HOWARD
 (1874–1944)
 Raymond Apartments, 1900
 Iroquois Theater, 1903
 Marshall Apartments, 1906
 Stewart Apartments, 1912
 Breakers, 1915
 1550 N. State Pkwy., 1918
 209 E. Lake Shore, 1924
 Drake Tower Apartments, 1929
 see Wilson & Marshall (1895–1902)
 Fox, Charles Eli
Marshall & Fox (1905–1924)
 McClurg, 1908, 1909, 1914
 Blackstone Hotel, 1909
 Steger, 1910
 Blackstone Theater, 1911
 Federal Life, 1911
 Karpen, 1911
 Gibbons, 1912
 999 N. Lake Shore, 1912
 Lytton, 1913
 Empire Paper, 1914
 Morrison Hotel 2, 1914
 Kaiserhof Hotel, 1915, addition
 Lyon & Healy, 1916
 Woods Theater, 1917
 Drake Hotel, 1920
 Rialto Theater, 1920
 Popular Mechanics, 1922
 John B. Murphy Memorial, 1926
MARTIN, EDGAR D. (1871–1951),
 eng.
 122d F. A. Armory, 1923
 see Schmidt, Garden & Martin
 see Pond & Pond, Martin & Lloyd
Martin & Martin, engs.
 120 N. LaSalle, 1992
MATZ, OTTO HERMANN (1830–
 1919)
 I. C. Railroad Station, 1856

Nixon, 1871
Constitution Block, 1872
Doggett, 1872
Criminal Courts, 1892
MAVEETY, R. H. (dec'd)
Telephone Square, 1922
MAYGER, ARTHUR G. (dec'd)
see Graven & Mayger
McBRIDE, R. E.
see Rogers & Hall
see Polk-Wells
McCARTHY, CHARLES A.
(dec'd)
see Rapp & Rapp
McCARTHY, JOSEPH W. (dec'd)
1540 N. Lake Shore, 1925, cnslt.
McCLIER CORP., developers
(1988–)
Harboe, Thomas G., arch.
555 W. Adams, 1991
see Reliance
see Fourth Presbyterian Church
see Cadillac
see Rookery
McCLURG, VERNE O. (dec'd), eng.
Palmolive, 1929
Board of Trade, 1930
Buckingham, 1930
Judah, 1930
Chicagoan Hotel, 1932
Henrotin Hospital, 1935
see Mundie, Jensen & McClurg
McKIM, CHARLES FOLLEN (1847–
1909)
Mead, William Rutherford (1846–
1928)
White, Stanford (1853–1906)
McKim, Mead & White (1872–)
(N.Y.)
Lathrop House, 1892
McLANAHAN, M. HAWLEY (dec'd)
see Price & McLanahan
McNALLY, FRANK (dec'd), eng.
Quinn, James Edwin (1895–dec'd)
McNally & Quinn, arch. & eng.
(1922–)
1366 N. Dearborn, 1926
70 E. Cedar, 1927

73 E. Elm, 1928
1100 N. Dearborn, 1929
1500 N. Lake Shore, 1931
MEISTER, GERALD
Volpe, Anthony
Meister & Volpe
625 N. Michigan, 1971
MELES, EDMUND J. (dec'd)
McCormick Hotel, 1927
MEREDITH, DAVID D. (dec'd)
Dearborn-Lake Garage, 1928
MERRILL, JOHN D. (1896–1969)
see SOM
METZ, CARL (ca. 1886–1970), eng.
see Shaw, Metz & Dolio
Train, Jack (1922–)
Youngren, Ralph (ca. 1924–)
Metz, Train & Youngren
Oakwood Apts., 1988
see Railway Exchange
see Brevoort Hotel
see John R. Thompson
MIES VAN DER ROHE, LUDWIG
(1886–1969)
860 N. Lake Shore, 1952
900 N. Lake Shore, 1956
Federal Center, 1964
see 101 E. Ontario
Fujikawa, Joseph Y.
Office of Mies van der Rohe (1969–
1975)
One Illinois Center, 1971
One IBM Plaza, 1972
Two Illinois Center, 1973
MILLER, CHARLES C. (dec'd)
see Cochrane & Miller
MILLER, HENRY (dec'd), eng.
Clarion Executive House, 1960
MILLER, SHELBY & ANDERSON
Walton Place Apts., 1982
MITTELBUSHER & TOURTELOT
see Auditorium
MOREY, CHARLES W. (1875–dec'd),
eng.
Randolph-Wells, 1914
Lombard Hotel, 1914
MORIYAMA, RAYMOND (1929–)
Teshima, Theodore

Moriyama & Teshima (1958–)
 (Toronto)
 Manufacturers Hanover Plaza, 1987
MORRIS, SIDNEY H. (dec'd)
 Vogue, 1908
MORRIS, SIDNEY H., Jr.
 1000 N. Lake Shore, 1954
 One (Lake Shore) Plaza, 1964
MOTT, ARTHUR D. (1869–dec'd)
 see Ritter & Mott
MOZER, JORDAN
 see Cadillac
MUELLER, PAUL (dec'd)
 with Adler & Sullivan (1886–)
MULLETT, ALFRED B. (Washington,
 D.C.)
 Post Office, 1879
MUNDIE, WILLIAM BRYCE (1863–
 1939)
 see Jenney & Mundie
 see Jenney, Mundie & Jensen
 Jensen, Elmer C.
Mundie & Jensen (1907–)
 Consumers, 1913
 Lemoyne, 1915
 Singer, 1926
 Union League Club 2, 1928
 Hiram Sibley Warehouse underpin-
 ning, 1945
MURGATROYD, A. J. (1881–1946)
 (N.Y.)
 Ogden, Palmer H.
Murgatroyd & Ogden
 Allerton Hotel, 1924
MURPHY, CHARLES F. (–1970)
Murphy, Charles F., Jr.
 Forum Hotel, 1961
 CNA Center, 1962
 R. J. Daley Center, 1966
 One First National Plaza, 1969
 55 W. Wacker, 1969
 McCormick Place, 1970
 Two First National, 1971
 One IBM Plaza, 1972
 Xerox Centre, 1980
 see Federal Center
 see U. of Illinois Campus
 see Water Tower Place

 see Northern Trust addition
 see Federal Reserve Bank addition
 see Naess & Murphy
Murphy, Charles F., Jr.
 Jahn, Helmut (Germany)
Murphy/Jahn (1981–)
 One S. Wacker, 1982
 J. R. Thompson Center, 1985
 Northwestern Atrium Center, 1987
 120 N. LaSalle, 1991
 see Board of Trade addition

Naess & Murphy (1946–)
 One Prudential Plaza, 1955
 Sun-Times, 1957
 National Cash Register, 1960
 see Federal Reserve Bank addition
 see Murphy, Charles F.
NAGLE, JAMES L. (1937–)
 Hartray, John F., Jr.
Nagle, Hartray (1979–)
 401 E. Ontario, 1991
 Greyhound Bus Terminal, 1991
 see Richelieu Hotel
 see Booth, Nagle
NAIR, R. SHANKAR, eng.
 see 900 N. Michigan
NEDVED, RUDOLPH J. (1895–dec'd)
 see Hamilton, Fellows & Nedved
NETSCH, WALTER A., JR. (1920–
 retired 1979)
 with SOM
NEUMAN, RICHARD
 1250 N. Dearborn, 1990
NEWBERRY, ROBERT T. (dec'd)
 Waller, 1922
NEWGARD, CARL T. (dec'd), eng.
 see Morey, Newgard
NEWHOUSE, HENRY L. (dec'd)
 Kinzie, ca. 1880
 Bernham, Felix M. (dec'd)
Newhouse & Bernham
 McVickers Theater 4, 1923
NIMMONS, GEORGE CROLL (1865–
 1947)
 Fellows, William Kinne
Nimmons & Fellows (1898–1910)
 Bailey (southern portion), 1898

Lesher, 1902
Stratford, 1902
Arthur Dixon, 1908
Railway Terminal, 1909
Nimmons, George Croll
Franklin, 1912
Reid, Murdoch, 1913
Adam Schaaf, 1916
Union Special Machine, 1918
Kelley, 1921
American Furniture Mart (eastern
portion) associated, 1923
American Furniture Mart (western
portion), 1926
Carr, George Wallace
Wright, Clark Chittenden
Nimmons, Carr & Wright (1928–)
North Loop Garage, 1928
NYDEN, JOHN A. (dec'd)
257 E. Delaware, 1918

OGDEN, PALMER H. (N.Y.)
see Murgatroyd & Ogden
OLDEFEST, EDW. G. (dec'd)
Williams, Theodore S.
Oldefest & Williams
Cass Hotel, 1925
211 E. Delaware, 1927
Lansing Apts., 1927
1211 N. LaSalle, 1929
OMAN, SAMUEL S. (1897–1943)
(N.Y.)
Lilienthal, Samuel
Oman & Lilienthal
Eastgate Hotel, 1926
St. Clair Hotel, 1928
OTIS, WILLIAM AUGUSTUS (1855–
1929)
Clark, Edwin Hill
Otis & Clark
Porter, 1916
OTTENHEIMER, HENRY L. (1868–
dec'd)
Steele-Wedeles, 1909
Stern, Isaac S.
Reichert, William
Ottenheimer, Stern & Reichert
Crerar Adams Warehouse, 1909

Norman, 1915
Elks Club, 1916
OWINGS, NATHANIEL A. (1903–
1984)
see SOM

PACE ASSOCIATES
see 860 N. Lake Shore
PALMER, C. M. (dec'd)
Honoré Block 2, 1872
PALMER, CHARLES (dec'd)
75 W. Van Buren, 1902
PAPPAGEORGE, George C. (1954–)
Haymes, David A. (1954–)
Pappageorge & Haymes
(1981–)
1414 N. Wells, 1995
The Whitney, 1997
Erie Centre Tower, under
construction
1122 N. Dearborn, under
construction
33 W. Huron, under construction
see 168 N. Clinton
see Lake View
see Western News
PARFITT BROTHERS (dec'd)
Tree Studios, 1894
PAWLAN, HAROLD
Reinheimer, Martin
Pawlan & Reinheimer
Outer Drive East Apts., 1962
see Hirschfield, Reinheimer
PELLI, CESAR (1926–) (Conn.)
181 W. Madison, 1990
see discussion of Sears Tower
PEREIRA, MORTON L. (dec'd)
Starck, 1927
Pereira, William (ca. 1909–)
Pereira, Hal
William & Hal Pereira
Esquire Theater, 1938
PERKINS, DWIGHT HEALD (1867–
1941)
In practice from 1893
Steinway Hall, 1896
Fellows, William Kinne
Hamilton, John L.

Perkins, Fellows & Hamilton (1911–1927)
Blakely, 1911
Chatten, Melville C.
Hammond, Charles Herrick
Perkins, Chatten & Hammond
Perkins, Lawrence (1907–1997)
Will, Philip
Perkins & Will, archs. & engs. (1935–)
Mutual Trust Life Ins., 1957
U.S. Gypsum, 1963
Wm. Jones Metro High School, 1968
One First National Plaza, 1969
230 W. Monroe, 1971
Two First National, 1971
Northern, 1974, 1976
444 N. Michigan, 1976
Two N. LaSalle, 1979
101 N. Wacker, 1980
200 N. LaSalle, 1984
123 N. Wacker, 1988
900 N. Michigan, 1989
Morton International, 1990
see McKinlock Campus
see Fair Store
see Mandel's Store
see Amoco
see Nuveen
see 225 W. Wacker
see Butler Brothers
PETERSON, JAMES
see Ohio
PICARDI, ALFRED, eng., retired
with Perkins & Will and SOM
U.S. Gypsum, 1963
Equitable, 1965
Amoco, 1974
PIERCE, OSBORNE J. (1830–dec'd)
Owings, 1889
PINGREY, ROY E. (dec'd)
see Shankland & Pingrey
PLATNER, WARREN (Conn.)
see Water Tower Place
POND, ALLEN BARTLIT (1858–1929)
Pond, Irving Kane (1857–1939)
Pond & Pond (1886–1925)
Stevens Art, 1898
Kent, 1903

Toll, Illinois Bell, 1908
City Club, 1911
Martin, Edgar D.
Pond & Pond, Martin & Lloyd (1925–1931)
Pond & Pond & Martin (1931–)
POST, CHESTER L. (1880–dec'd), eng.
see Condron & Post
POWERS, HORACE S. (dec'd)
Lesher, 1902, associated
PRATHER, FRED H.
Realtors, 1963
PRATHER, FRED V. (dec'd)
Transportation, 1911
PRICE, WILLIAM L. (dec'd)
McLanahan, M. Hawley
Price & McLanahan (Phila.)
Pennsylvania Freight Terminal, 1918
PRIDMORE, JOHN O. E. (1864–1940)
Chicago-Clark, 1901
Planters Hotel, 1910
PROBST, EDWARD (1870–1942)
partner, Graham, Burnham & Co.
see Graham, Anderson, Probst & White
PURCELL, WILLIAM GRAY (1880–1965)
Feick, George
Elmslie, George Grant (1871–1952)
with Adler & Sullivan from 1890
Purcell, Feick & Elmslie
Edison Phonograph Shop, 1912
PURDY, CORYDON T. (1859–dec'd), eng.
Boyce, 1892
Ellsworth, 1892
Columbus Memorial, 1893
Monadnock Block (southern half), 1893
Old Colony, 1894
see Wade & Purdy
Henderson, eng.
Purdy & Henderson, engs.
Marquette, 1895
Atwood, 1896
Bailey (northern portion), 1898
57 E. Jackson, 1899
Tribune 3, 1902

Born, 1908
LaSalle Hotel, 1909
Bell (Illinois Bell), 1912
QUINN, E. F.
Christiansen, R. T.
Quinn & Christiansen
Forum Hotel, 1961
QUINN, JAMES EDWIN (1895–dec'd)
see McNally & Quinn

RAEDER, HENRY (dec'd)
American Furniture Mart (eastern
portion), 1923
RAGGIE, RICHARD A.
Malitz, Gunther
Raggie & Malitz
535 N. Michigan, 1963
RANDALL, FRANK A. (1883–1950),
eng.
Warner, William H.
Randall & Warner, engs. (1914–1917)
YMCA Hotel, 1915
Berlin, Robert C.
Swern, Perry W.
Berlin, Swern & Randall, archs. & engs.
(1918–1923)
RANDALL, FRANK A. (1923–1947)
Delaware Towers, 1927
1400 N. Lake Shore, 1927
McCormick Hotel, 1927
Medinah Club, 1929
Lawson YMCA, 1931
Hiram Sibley Warehouse underpin-
ning, 1945
Randall & Sons (1947–1955)
RANDALL, GURDON P. (–1884)
Plymouth Congregational Church,
1867
Spaulding, 1872
RANDOLPH, SMITH MARTIN (1837–
1924)
310 W. Jackson, 1887
320 W. Jackson, 1880
RAPP, CORNELIUS W. (1860–1927)
Rapp, George L. (1878–1941)
Rapp, Mason G. (dec'd)
Rapp & Rapp (1907–)
State-Lake, 1917

Chicago Theater, 1921
Roosevelt Theater, 1921
100 E. Ohio, 1924
New United Masonic Temple & Ori-
ental Theater, 1926
Metropolitan Block & Bismarck
Hotel, 1926
Dearborn State Bank, 1928
see Christie's
RATCLIFFE, H. E. (dec'd)
see Hall, Lawrence & Ratcliffe
REBORI, ANDREW N. (1886–1966)
Roanoke Tower, 1926, associated
Elizabeth Arden, 1926, consultant
1325 N. Astor, 1929
Sterling, 1929
LaSalle-Wacker, 1930
see RKO Grand Theater
Rebori, Wentworth, Dewey & McCor-
mick
Fine Arts Annex, 1924
REICHERT, WILLIAM (dec'd)
see Ottenheimer, Stern & Reichert
REINHEIMER, MARTIN
The Warwick, 1974
Doral Plaza, 1982
see Hirschfield, Leo S.
see Pawlan & Reinheimer
RENWICK, EDWARD ANDERSON
(1860–1941)
Holabird & Roche partner
Holabird & Root partner
RENWICK, JAMES, JR. (1818–1895)
Second Presbyterian Church, 1852
RENWICK, RALPH (dec'd), eng.
14 N. Michigan, 1885
RICHARDSON, HENRY HOBSON
(1838–1886)
Glessner residence, 1886
Marshall Field Wholesale, 1887
see Gambrill & Richardson
see 1400 N. Lake Shore, noting for-
mer MacVeagh residence
RIDDLE, HERBERT HUGH (1875–
1930)
Mather Tower, 1928
RISSMAN, MAURICE B. (1894–1942)
Hirschfield, Leo S.

Rissman & Hirschfield
 Davis Hotel, 1927
 222 E. Chestnut, 1928
 Millinery, 1928
RITTER, LOUIS E. (1864–1934), eng.
 Manhattan, 1890
 with William Le Baron Jenney (–
 1892)
 with Jenney & Mundie (1892–1899)
 Mott, Arthur D.
Ritter & Mott (1899–1917)
 Monroe, 1912
RITTWEGER, WILLIAM (–1973),
 eng.
 Tokay, Nejat (–1986), eng.
Rittweger & Tokay (1966–)
 see Shedd Aquarium addition
 Erickson, Harold, principal, 1993–
 Warwick Condo, 1974
 Holiday Inn City Center, 1975
 Doral Plaza, 1982
ROBERTS, ELMER C. (dec'd)
 Hamilton Club addition, 1920
ROBERTS, JOHN W. (dec'd)
 Keith Brothers, 1872
 Pike Block, 1873
ROBINSON, ARGYLE E. (dec'd)
 Central Police Station, 1928, associ-
 ated
ROCHE, KEVIN (1922–) (Conn.)
 Dinkeloo, John G. (1918–1981)
Roche, Dinkeloo (1966–)
 Leo Burnett, 1989
ROCHE, MARTIN (1855–1927)
 see Holabird, Simonds & Roche
 see Holabird & Roche
ROESCH, PETER H. (1941–)
 see Hammond, Roesch
ROGERS, JOHN ARTHUR (dec'd)
 Ashland Block 2 addition
ROOT, JOHN WELLBORN (1850–
 1891)
 see Burnham & Root
ROOT, JOHN WELLBORN, JR. (1887–
 1963)
 see Holabird & Root
ROSNER, MAX (dec'd), eng.
 Northern Trust addition, 1928

ROY, VICTOR (dec'd)
 Ballard Block, 1873
RUBINOS, JACINTO E., eng.
 Rubinos, Teresa M., eng.
 Rubinos, Mesia
 see Municipal Pier
RUDERMAN, JAMES, eng.
 541 N. Fairbanks, 1968
RUSSELL, LEWIS E.
 Plymouth Court Garage, 1927
RUTAN, CHARLES HERCULES
 (1851–1914)
 see Shepley, Rutan & Coolidge
SAETHER, KOLBJORN, eng.
 Streeterville 400, 1982
 1911 S. Indiana, 1995
 Cathedral Place, under construction

SAMARTANO & CO., engs.
 Maple Pointe Apts., 1996
SAXE, ALBERT H.
 see Zimmerman
SCHACHT-JOHNSON, engs.
 Pepper Companies, 1985
SCHIPPOREIT, GEORGE D.
 (1933–)
 Asbury Plaza, 1981
 see Great Lakes
 445 E. Ohio Apts., 1986
 Heinrich, John C. (1938–ca. 1994)
Schipporeit & Heinrich (1965–1970)
 Lake Point Tower, 1969
SCHLACKS, HENRY J. (dec'd)
 Holy Name Cathedral 2 addition,
 1915
SCHLEGMAN, SHELDON
 with A. Epstein & Sons
SCHLOSSMAN, NORMAN J. (1901–
 1990)
 see Loebl & Schlossman
SCHMID, RICHARD GUSTAV (1863–
 1937)
 see Huehl & Schmid
SCHMIDT, RICHARD E. (1865–1958)
 In practice from 1887 to 1958
 Montgomery Ward, 1899
 Grommes & Ullrich, 1901
 Madlener House, 1902

THOMPSON, BENJAMIN (1918–)
 (Boston)
 see Municipal Pier
THORNTON, CHARLES H., eng.
 (N.Y.)
Thornton-Tomasetti, engs. (N.Y.)
 Northwestern Atrium, 1987
 see Board of Trade addition
 see CBM (TT-CBM)
TIGERMAN, STANLEY (1930–)
 McCurry, Margaret I.
Tigerman, McCurry
 Chicago Bar Association, 1990
TILLEY, THOMAS (dec'd)
 Chicago Museum
TRAIN, JACK (1922–)
 see Union Special Machine
 see Metz, Train
 see Conway
TRAVELETTI & SUTER
 40 E. Hubbard 1949, remodeling
TREAT, SAMUEL ATWATER (1839–
 1910)
 Foltz, Frederick
Treat & Foltz (ca. 1872–1897)
 Chicago Club, 1876
 Ontario Hotel, 1881
 Charles B. Farwell residence, 1882
 Richardson, 1886
 Frances, 1889

UFFENDELL, W. GIBBONS (1876–
 dec'd)
 115–21 N. Wells, 1919/39, remodel-
 ing
ULLMAN, MARVIN
 see 400 N. State

VAGNIERES, ROBERT, JR. (1932–)
 Holiday Inn, 1975
 see Hillman & Vagnieres
VAN OSDEL, JOHN MILLS (1811–
 1891)
 Wm. B. Ogden residence, 1837
 Mahlon D. Ogden residence, 1837
 Methodist Episcopal Church, 1845
 City Hall & Market, 1848
 Court House 2, 1848
 Tremont House 3, 1850

Rice Theater 2, 1851
Court House and City Hall 3, 1853,
 1858
Briggs House 1, 1856
Burley & Co., 1856
George Smith, 1856
Robbins 1, 1856
Frederick Tuttle, 1856
S. B. Cobb, 1864
Charles B. Farwell Store, 1869
Peter Page 1, 1869
Palmer House 1
University Hall (Univ. of Ill.)
Abram Gale, 1869
Drake-Farwell Block 1, 1870
Drake-Farwell Block 2, 1871
Gale & Block, 1871
Kendall, 1871
Palmer House 2, 1871
City Hall, 1872
S. B. Cobb, 1872
Dearborn Block, 1872
Drake-Farwell Block 3, 1872
Old Farwell Block, 1872
Fuller Block, 1872
Fullerton Block, 1872
Hawley Block, 1872
McCarthy, 1872
McCormick, C. H., 1872
Oriental, 1872
Peter Page 2, 1872
Robbins 2, 1872
Robbins (Lake & Wells), 1872
Tuttle, 1872
U.S. Express Co., 1872
Washington-Dearborn, 1872
Bridewell, postfire
Briggs House 2, 1873
City Hotel Block, 1873
Clifton House, 1873
Dyche, 1873
Foote Block, 1873
Kendall, 1873
McCormick Block 2, 1873
Page Brothers, 1873
Reaper Block, 1873
Saloon, 1873
Tremont House 4, 1873

WHITNEY, GEORGE B. (dec'd), eng.
 see Home Insurance, 1885
WIGHT, PETER BONNET (1838–
 1925)
 American Express, associated
 see Carter, Drake & Wight
WILCOX, W. H. (dec'd)
 Church of the Ascension, 1882
WILL, PHILIP (1906–1985)
 see Perkins & Will
WILLETT, JAMES ROWLAND (1831–
 1907)
 Williams, 1872
 Times, 1873
 12–16 E. Hubbard, 1885
WILLIAMS, THEODORE S. (dec'd)
 see Oldefest & Williams
WILSON, H. R. (1858–1917)
 Marshall, Benjamin Howard
 Wilson & Marshall (1895–1902)
 Powers, 1893, remodeling
 Illinois Theater, 1900
 Brevoort Hotel, 1906
WINCHELL, JOHN K. (dec'd)
 Bigelow House, 1871
WINSLOW, BENJAMIN E. (dec'd),
 eng.
 with Holabird & Roche (1905–1911)
WOLCOTT, RUSSELL (dec'd)
 14 N. Franklin, 1901
WOLTERSDORF, ARTHUR F. (1870–
 1918)
 Sargent, 1920s, remodeling
 Woltersdorf & Bernard (1919–1921)
 Tree Studio, 1921
WRIGHT, CLARK CHITTENDEN
 (1880–1948)
 see Nimmons, Carr & Wright

WRIGHT, FRANK LLOYD (1867–
 1959)
 see Studebaker, 1886
 see Rookery
 see Charnley House

YAMASAKI, MINORU (1912–1986)
 (Detroit)
 Montgomery Ward Office, 1974
YORK, A. J. (dec'd)
 Cleveland, 1872
 329 W. Monroe, 1872

ZARBELL, IVER C. (dec'd)
 Mueller, 1908
ZIC, MILTON
 see Maryland Hotel
ZILS, JOHN J., eng.
 with SOM
 One Financial Place, 1984
 225 W. Washington, 1986
 Quaker Tower, 1987
 Chicago Place, 1990
ZIMMERMAN, WILLIAM CARBYS
 (1859–1932)
 Inter-Ocean, 1900
 see Flanders & Zimmerman
 Saxe, Albert M.
 MacBride, E. Everett
 Zimmerman, Saxe & MacBride
 Arcade, 1913
 Zimmerman, Saxe & Zimmerman
 (1913–)

Appendix C. New Construction in Chicago

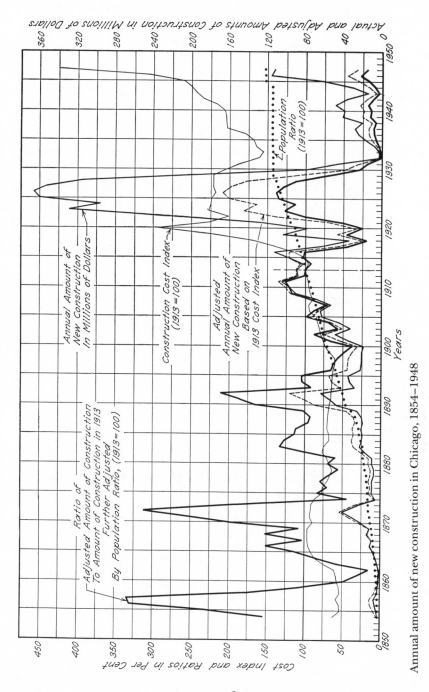

Annual amount of new construction in Chicago, 1854–1948

Table A.1. Annual Amount of New Construction in Chicago, 1854–1948

Year	Amounta	Cost Indexb,c	Adjusted Amount (millions)	Ratio of Adjusted Amounts	Ratio Adjusted for Populationc	Population Ratio
1854	$ 2,438,910	62	$ 3.9	4.3	153.6	2.80
1855	3,735,254	53	7.0	7.8	229.4	3.40
1856	5,708,624	54	10.6	11.8	330.5	3.57
1857	6,423,518	58	11.1	12.4	333.3	3.72
1858	3,246,400	53	6.1	6.8	178.0	3.82
1859	2,044,000	54	3.8	4.2	106.3	3.95
1860	1,188,300	57	2.1	2.3	49.6	4.64
1861	797,800	58	1.4	1.6	31.4	5.10
1862	525,000	61	0.9	1.0	17.0	5.87
1863	2,500,000	75	3.3	3.7	58.1	6.37
1864	4,700,000	86	5.5	6.1	84.8	7.19
1865	6,950,000	92	7.6	8.5	112.1	7.58
1866	11,000,000	95	11.6	12.9	150.5	8.57
1867	8,500,000	96	8.9	9.9	103.6	9.56
1868	14,000,000	96	14.6	16.3	152.2	10.71
1869	11,000,000	96	11.5	12.8	107.7	11.89
1870	20,000,000	89	22.5	25.1	197.6	12.70
		93				14.20
Oct. 9, 1871–						
Oct. 9, 1872	40,133,600	92	43.6	48.6	311.5	15.60
1873	25,500,000	92	27.7	30.9	191.4	16.14
1874	5,785,541	87	6.7	7.5	44.7	16.79
1875	9,778,080	77	12.7	14.2	83.5	17.01
1876	8,270,300	76	10.9	12.2	70.5	17.31
1877	9,071,050	70	13.0	14.5	79.4	18.26
1878	7,419,100	67	11.1	12.4	66.8	18.55
1879	6,745,000	64	10.5	11.7	56.0	20.88
1880	9,071,850	68	13.3	14.8	69.3	21.37
1881	8,832,305	71	12.4	13.8	60.2	22.93
1882	16,286,700	77	21.2	23.6	99.1	23.81
1883	22,162,000	75	29.5	32.9	133.6	24.63
1884	20,857,300	68	30.7	34.2	127.9	26.75
1885	19,624,100	68	28.9	32.2	114.0	28.24
1886	21,324,400	71	30.0	33.5	112.1	29.89
1887	19,778,100	71	27.9	31.1	96.3	32.28
1888	20,350,800	70	29.1	32.5	95.3	34.09
1889	25,065,500	69	36.3	40.5	102.0	39.71
1890	47,322,100	68	69.6	77.6	166.1	46.71
1891	54,001,800	66	81.8	91.2	186.9	48.79
1892	63,463,400	66	96.2	107.3	210.6	50.95
1893	28,517,700	65	43.9	49.0	92.1	53.22
1894	33,805,565	65	52.0	58.0	104.4	55.58
1895	34,920,643	64	54.6	60.9	104.9	58.05
1896	22,711,115	63	36.0	40.1	66.1	60.63
1897	21,690,030	61	35.6	39.7	62.7	63.32
1898	21,294,325	62	34.3	38.3	57.9	66.13

Table A.1. Continued

Year	Amount[a]	Cost Index[b,c]	Adjusted Amount (millions)	Ratio of Adjusted Amounts	Ratio Adjusted for Population[c]	Population Ratio
1899	20,857,570	68	30.7	34.2	49.5	69.07
1900	19,100,050	74	25.8	28.8	39.9	72.14
1901	34,911,755	77	45.3	50.5	68.1	74.21
1902	48,070,390	80	60.1	67.0	87.8	76.27
1903	33,645,025	82	41.0	45.7	58.6	77.92
1904	44,724,790	84	53.2	59.3	73.7	80.41
1905	63,455,020	87	72.9	81.3	98.6	82.47
1906	64,298,330	95	67.7	75.5	89.3	84.54
1907	54,093,080	96	56.3	62.8	72.5	86.61
1908	68,204,080	91	74.9	83.5	94.2	88.67
1909	90,558,580	94	96.3	107.4	118.4	90.74
1910	96,932,700	96	101.0	112.6	121.3	92.81
1911	105,269,700	97	108.5	121.0	126.7	95.53
1912	88,786,960	99	89.7	100.0	102.3	97.77
1913	89,668,427	100	89.7	100.0	100.0	100.00
1914	83,261,710	97	85.8	95.7	93.5	102.39
1915	97,291,480	100	97.3	108.5	103.4	104.66
1916	112,835,150	116	97.3	108.5	101.5	106.91
1917	64,244,450	141	45.6	50.9	46.6	109.14
1918	34,792,200	170	20.5	22.9	20.6	111.37
1919	104,198,850	224	46.5	51.9	45.7	113.61
1920	79,102,650	294	26.9	30.0	26.1	114.75
1921	125,004,510	226	55.3	61.7	51.3	120.28
1922	227,742,010	202	112.7	125.7	102.1	123.06
1923	329,604,312	228	144.6	161.3	128.1	125.91
1924	296,893,990	225	132.0	147.2	114.3	128.74
1925	360,794,250	224	161.1	179.7	136.6	131.51
1926	366,586,400	219	167.4	186.7	139.0	134.30
1927	352,936,400	222	159.0	177.3	129.3	137.14
1928	315,800,000	222	142.3	158.7	113.4	139.94
1929	202,286,800	222	91.1	101.6	71.2	142.71
1930	79,613,400	205	38.8	43.3	30.2	143.40
1931	46,440,130	185	25.1	28.0	19.5	143.47
1932	3,824,500	162	2.4	2.7	1.9	143.55
1933	3,683,960	156	2.4	2.7	1.9	143.63
1934	7,898,435	166	4.8	5.4	3.8	143.72
1935	17,120,947	169	10.1	11.3	7.9	143.81
1936	25,031,933	179	14.0	15.6	10.8	143.89
1937	28,806,443	204	14.1	15.7	10.9	143.98
1938	21,258,299	205	10.4	11.6	8.1	144.06
1939	41,597,282	205	20.3	22.6	15.7	144.15
1940	39,928,096	207	19.3	21.5	14.9	144.27
1941	49,151,997	216	22.8	25.4	17.6	144.40
1942	37,647,648	235	16.0	17.8	12.3	144.50
1943	15,607,975	244	6.4	7.1	4.9	144.59

Table A.1. Continued

Year	Amount^a	Cost Index^{b,c}	Adjusted Amount (millions)	Ratio of Adjusted Amounts	Ratio Adjusted for Population^c	Population Ratio
1944	31,648,547	250	12.7	14.2	9.8	144.67
1945	61,495,655	260	23.7	26.4	17.3	152.68
1946	116,382,777	303	38.4	42.8	28.0	152.90
1947	113,431,800	404	28.1	31.3	20.4	153.32
1948	147,942,400	456	32.4	36.1	23.3	154.96
Oct. 1948	high	471				

Note: The above data is extended to 1970 in *Chicago, 1930–1970*, by Carl W. Condit (1972), p. 306.

a. 1854–1932: from *One Hundred Years of Land Values in Chicago*, by Homer Hoyt (1933); 1833–1947: from Bell Savings and Loan Association and the annual reports of the Chicago Building Department.

b. The American Appraisal Company.　　c. 1913 = 100.

Table A.2. Chicago Building Permits, 1949–94

1949	$ 142 million	1972	$ 565 million
1950	246	1973	406
1951	205	1974	341
1952	166	1975	351
1953	227	1976	404
1954	237	1977	393
1955	285	1978	737
1956	330	1979	851
1957	346	1980	916
1958	374	1981	930
1959	287	1982	929
1960	425	1983	919
1961	409	1984	680
1962	317	1985	829
1963	338	1986	672
1964	374	1987	966
1965	294	1988	1,230
1966	506	1989	1,457
1967	299	1990	1,868
1968	524	1991	1,165
1969	560	1992	1,010
1970	395	1993	1,080
1971	730	1994	1,324

Source: Bell Savings and Loan Association

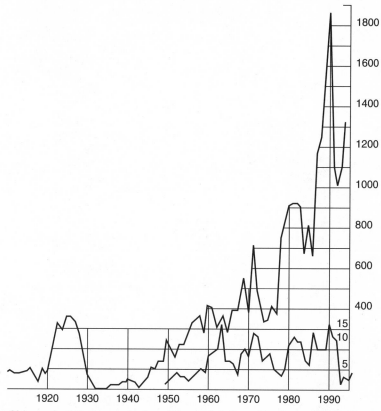

Chicago building permits in millions of dollars. The lower line indicates the number of buildings completed each year of Period VI for 325 of the documented buildings in the central area, exclusive of the University of Illinois campus facilities on the fringe.

Appendix D. The First Sub-Basement

Difficulties in the construction of the first sub-basement are set forth by Edward A. Renwick (EAR), as mentioned previously in the present account:

> Prior to 1890 the foundations of nearly all buildings in Chicago were floating foundations, i.e., spread foundations in which the areas of the foundations under the piers and columns were spread over a hard stratum [referred to above] of clay with an equal pressure . . . as nearly as possible. . . . In a building of 12 stories or more three or four inches of settlement was allowed for. . . .
>
> The use of piles had not been anticipated in the Loop district for the simple reason that no satisfactory method of driving piles had been discovered. The method then in use was to lift a four- or five-ton weight up to the head of the derrick and then release it, allowing it to strike from a distance of some 25 feet. The resulting vibration was excessive. . . . A little later a steam hammer for pile driving was devised and put into operation, giving a lighter blow with rapidity, causing the pile to penetrate the earth. Piles then began to be used in some places.
>
> In connection with the supporting of a party wall [at the west side] of the Stock Exchange building . . . General Sooy-Smith put in several caissons. I believe they were the first to be used in Chicago. They were wells sunk down to the underlying stratum of rock, 100 feet below the sidewalk, and filled with concrete.
>
> The next caissons were under the Old Colony building two or three years later, to support the south end of the building[,] which was sinking more rapidly than the rest of the structure. Sooy-Smith put down these caissons also. The importance of this step became manifest at once. From that date no sixteen-story building was erected without foundations being carried down 60 to 65 feet to "hardpan," a clay and gravel stratum extending from the limestone bedrock underlying Chicago up to this point. The larger buildings were generally carried down to bedrock.
>
> In the sinking of these early caissons it was found that the open wells had to be supported against enormous pressure. . . . It became important that, while sinking the caisson, the clay be supported against all possible movement until the well was filled with concrete.
>
> In 1901 we [Holabird & Roche] entered into a contract for the Tribune building to be erected on the southeast corner of Dearborn and Madison

streets. Mr. Robert Patterson, manager of the Tribune, was anxious that the presses be placed in the basement in order that the vibration from them need not be felt in the rest of the building. It was necessary, therefore, for head room for the presses, that the basement be approximately 33 feet below the sidewalk level. This had never been done in Chicago. Everyone was sure that, if this was done, the surrounding buildings, resting on floating foundations, would automatically fall into the excavation. Surrounding property owners were advised in writing by such firms as Burnham & Root, Adler & Sullivan, and W. L. B. Jenney that this would be the case. We were notified that the work would not be permitted — that we would be enjoined from cutting through the firm stratum of clay [at datum]. . . .

The contract was awarded to George A. Fuller. Purdy and Henderson, engineers, were awarded the contract for designing the structural steel and foundations, working under our [Holabird & Roche] direction.

The basement walls on the lot perimeter were built successfully under substantially the following specification.

A trench was dug down to the first hard stratum of clay and the sides lined with vertical planks, walers with jack screws three feet on centers vertically and four feet on centers horizontally, screwed up till they were tight. Then the excavation was continued about three feet more and the lagging set, walers inserted with jack screws, continuing by this method, maintaining constantly sufficient pressure to keep the sides set, with no movement of the clay. Concrete was put immediately in the bottom to keep the clay from coming up [and the trench filled].

As the excavation was dug inside these walls, jack screws were set up holding the walls without any movement until the excavations were complete and the floors of concrete [were] laid. Across the building[,] concrete struts were designed going in both directions, thus holding the bottom of the walls against any movement.

On the Dearborn street side of the Tribune building a gravity wall was put down to the depth of 12 or 14 feet. Their [Purdy and Henderson] engineers were confident that without carrying it down to the depth of the rest of the basement, the wall would be of sufficient size to resist pressure. Shortly after the wall was finished, it pushed in six or seven inches, damaging streetcar tracks, dropping the Dearborn street pavement six or seven inches, damaging electric cables, water pipes, sewers, etc. With this exception no damage was done [to surrounding buildings] and we were confident that had this wall been held as the other walls were [by the trench method] no damage would have occurred. . . . This was the first deep basement work to be used in Chicago. Out of it has grown the use of the basement, sub-basement and sub-sub-basement in the Loop district (EAR).

The cost of the original 12-story-and-attic Tribune building at 7 S. Dearborn street was 41.54 cents per cubic foot, including the architects' fee. The cost of the five-story addition in 1903 was 42.687 cents per cubic foot (EAR).

Appendix E. Foundations

Three publications about foundations and the soils and rock upon which they are based provide important additional information about the vital role of this buried part of construction developments. The following indexes refer to many specific structures that provide insights for understanding this part of construction, which is least discussed in building histories.

Frederick Baumann's 1873 work entitled *The Art of Preparing Foundations for All Kinds of Buildings, with Particular Illustration of the "Method of Isolated Piers," as Followed in Chicago* is quoted under "Isolated Footings" in part 1. Baumann's pioneering work is not indexed, but the author discusses many theories and "rules" on the pages indicated below:

The table of contents of Ralph Peck's 1948 *History of Building Foundations in Chicago,* abbreviated in the present text as HBF, does not refer to many Loop buildings discussed by Peck. The buildings and page numbers in Peck's book are:

History of Chicago Building Foundations, 1948–1983, Report No. 9, was issued in 1984 by the Chicago Committee on High-Rise Buildings. The report was written by Clyde N. Baker and John P. Gnaedinger, geotechnical principals of STS Consultants. The report is not indexed, but it notes methods or discusses central structures on the pages listed below. Ralph Peck's table of 57 buildings on spread foundations — 14 of which stand today — and his chart of the transition from shallow to deep foundations are included in the report under the heading "The Controversy" (over which to use).

Award Winning Structures, issued by the Structural Engineers Association of Illinois, has limited information about foundations but notes the use of caissons and foundation elements of buildings previously occupying the sites. That vol-

ume, which is abbreviated as SEA in the text of the present book, is not indexed for buildings. However, the buildings' importance and the construction photographs suggest the following listing of recent Chicago high-rise structures, with their page numbers.

Appendix F. Group Photographs

Kevin Lynch, writing in *Images of the City*, 1960, described the buildings along Michigan Avenue and Lake Shore Drive as the "unforgettable facade of Chicago on the Lake." Listed below are selected published "group views" of buildings facing Grant Park, from Harrison Street to Washington Street, and, lakeside, on North Lake Shore Drive, from Chicago Avenue to North Avenue. Formally designated landmarks are italicized.

MICHIGAN AVENUE, as shown in Robert Cameron's book *Above Chicago* (1992), pages 26 and 27, from Harrison Street: Ramada Congress Hotel, *The Auditorium/Roosevelt University,* Fine Arts and Annex, Chicago Club, McCormick/322 S. Michigan, Straus/Continental/310 S. Michigan, *Railway Exchange/Santa Fe Center* (the first building in the recent scene); next: *Orchestra Hall/Symphony Center* (beyond which are the upper stories of the *McClurg/Ayer/ Crown/Pakula/218 W. Wabash Avenue* building), Borg-Warner, *People's Gas/122 S. Michigan,* Lake View, Illinois Athletic Club/School of the Art Institute, Monroe, University Club/18 S. Michigan, *Edson Keith and Ascher/30 S. Michigan, Gage/18 S. Michigan Avenue,* Chicago Athletic Club, Willoughby, Tower/6 N. Michigan, 20 N. Michigan/Smyth/Lelong, and 30 N. Michigan/Michigan Boulevard. A small, similar scene is on the cover of *Wild Onions* (WO).

LAKE SHORE DRIVE, in ABOV, page 22, from Lake Shore Park to the north: American Hospital Association, Lake Shore Club/Northwestern University Lake Shore Center, *860 and 880 Lake Shore Drive Apartments,* 900 and 910 Lake Shore Drive, and 990 Lake Shore Drive. On page 25: 999 Lake Shore Drive, 229 E. Lake Shore Drive, 219 E. Lake Shore Drive, 209 E. Lake Shore Drive, 199 E. Lake Shore Drive, 181 E. Lake Shore Drive, 179 E. Lake Shore Drive, and the *Drake Hotel.* Similar scenes are in the 1987 edition of COF, p. 196, and in TBC, p. 188 (in 1929). In ABOV, page 23, north of the One Magnificant Mile building: One (Lake Shore) Plaza, 1000 Lake Shore Drive, The Carlyle, 1100 Lake Shore Drive, 1120 Lake Shore Drive, 1130 Lake Shore Drive (entrance at 40 E. Elm Street), 1150 Lake Shore Drive (curved facade), 1200 Lake Shore Drive/Stewart Apartments, 1212 Lake Shore Drive, 1240 Lake Shore Drive, 1242 Lake Shore Drive, *four houses* at Goethe Street, and 1300 Lake Shore Drive. See also CSV, page 36, to North Avenue, and p. 142. See TBC, p. 190, for pre-1926 apartments.

Appendix G. Some Tall Buildings

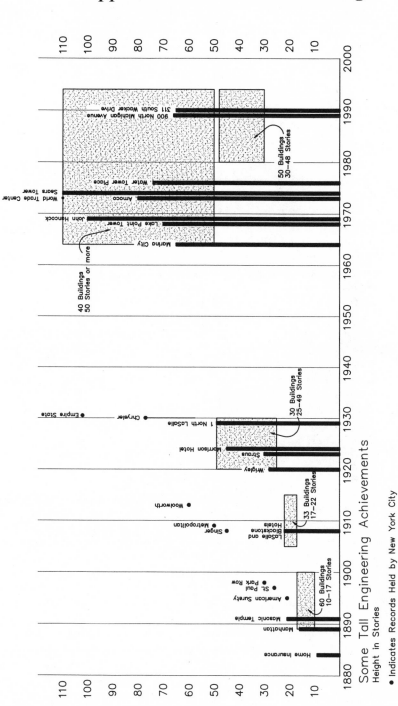

Some Tall Engineering Achievements
Height in Stories

• Indicates Records Held by New York City

477

Appendix H. "The Tall Building"

Convenience sanctions the tall building which necessity demands, and it has now come to stay, and to draw the most diligent and energetic population on the face of the earth nearer and nearer together, and thus facilitate its labors and expedite its business transactions.

In view of the great height, and consequent great weight, of our principal buildings, it is important that materials should be used in their construction so as to unite in the highest degree lightness and strength with the other qualities of good building materials. And so steel naturally came to the front with strongest sinews and head erect—too proud to bend—saying to the architect and engineer "Pile your mountain loads on my shoulders, and place them in the firm grip of my hands, and I will hold them for the centuries, though the storm wrestles with me and the earth quakes beneath my feet." The men of science accepted the proferred service, and the men of affairs poured out their money to pay for it. And as a great building now goes up, a gaunt skeleton of steel first rises aloft, which is gradually clothed from story to story, with its rigid flesh — stone and brick, tile and mortar; and with such integument it becomes a habitable edifice.

Acknowledging the elevator, saving us from . . . the old fashioned stairway, up and down which struggling humanity has been plodding its weary way through all the generations since past. In the very "nick of time," the elevator put in its appearance to make sixteen-story buildings *with it* more convenient than a four-story one had been *without it*. And "Presto Change!" each new building was planned higher than its predecessor.

From an address to engineering students, published in "The Technograph," University of Illinois, No. 6, 1891–1892, by Wm. Sooy Smith, consulting civil engineer and one of the pioneers in the solutions of problems attendant to the development of our office buildings, known widely for his deep foundations.

Appendix I. Future Builders

The achievements of some 160 years are prologue to an exciting future in Chicago. Youngsters of today will be tomorrow's guardians of what remains of the city's physical heritage. They will assume leadership in the adventures of tomorrow's building developments. Future skyscrapers will change to meet the needs of society and the advancements of science. They will not be outmoded by computer technology, communications magic — or the street congestion that existed even in horse-and-buggy days.

There will always be professionals who, having benefited by others' guidance, will be responsive to those seeking guidance. And there are many other avenues to prepare for being a part of the future. The easiest entree comes in the abundant literature about engineering and architecture. Besides experiencing great buildings and the visual pleasure of books like Cameron's *Above Chicago* and the *Chicago* books by Cromie and Visalli, young people can gain beginning knowledge and understanding through works such as: George Barr, *Young Scientist Looks at Skyscrapers,* 1963; Aylesa Forsee, *Men of Modern Architecture,* 1966 (includes the Auditorium); James C. Giblin, *The Skyscraper Book,* 1981 (includes the Rookery, Monadnock, Auditorium, and 860 Lake Shore Drive Apartments); D. Handlin, *American Architecture,* 1985 (includes Marshall Field Wholesale, Auditorium, and Monadnock); Gina Ingoglia, *Big Book of Real Skyscrapers,* 1989 (includes the Home Insurance); L. Edmond Leipold, *Famous American Architects,* 1972; Sigmund Levine, *Famous American Architects,* 1967; David Macaulay, *Underground,* 1976, and *Skyscrapers,* 1984 (drawings); C. E. Miller, *From Tepee to Towers,* 1967 (includes Carson's store, Reliance); Albert B. Parker, *You and Architecture,* 1965 (includes the Auditorium); John D. Randall, *Skyscrapers,* 1984, and *Treasures of American Architecture,* 1992 (a reference book for students that points to other works, including career-guidance books); Mario Salvadori, *Why Buildings Stand Up: The Strength of Architecture,* 1980; and Forrest Wilson, *Structure: The Essence of Architecture,* 1971.

Appendix J. Additional Bibliography

Some of these books contain additional illustrations of buildings that are referenced in the text. The buildings are given within parentheses in the list below.

American Federation of Arts. *Form Givers at Mid-Century.* 1959. (860 Lake Shore Drive)
American Portland Cement Manufacturers. *Factories and Warehouses of Concrete.* 1911. (Studebaker)
Architectural Annual. 1901. (Charnley House)
——. 1930. (Chicago Women's Club, American National Bank, Carbide and Carbon, McGraw-Hill, Passavant Hospital, 201 N. Wells Street, Adler Planetarium, Michigan Square, 700 N. Michigan Avenue, 1500 N. Lake Shore Drive)
——. 1931. (1301 N. Astor Street, 1210 N. Astor Street)
Architectural Record. *Motels, Hotels, Restaurants and Bars.* 2d ed., 1960. (Executive Plaza Hotel)
——. *Office Buildings.* 1961. (Inland Steel)
Beedle, Lynn S., ed. *Advances in Tall Buildings.* 1986. (Dearborn Park)
——. *Developments in Tall Buildings.* 1985. (Magnificent Mile)
——. *Tall Buildings.* 1984. (200 S. Wacker Drive)
Brooks, H. A. *The Prairie School.* 1972. (Grommes & Ullrich, Madlener House)
Bukowski, Douglas. *Navy Pier: A Chicago Landmark.* 1996.
Burchard, John, et al. *American Building.* 1961. (Carson's store)
Bush-Brown, Albert. *Louis Sullivan.* 1960. (Ryerson/Gray, Kingman & Collins, Chicago Cold Storage Warehouse, Carson's store)
Casari, Mario, ed. *New Chicago Architecture.* 1981. (Mergenthaler Linotype)
Chao, Sonia R., and Trevor D. Abramson, eds. *Kohn, Pedersen, Fox.* 1987. (900 N. Michigan Avenue)
Chicago Board of Education. *Chicago.* 1951. (600 W. Fulton Street)
Chicago Evening Post. *Book of Chicago.* 1911. (Virginia Hotel)
Chicago Official Visitors Guide. Chicago Convention and Tourism Bureau. Seasonally updated.
Chicago Tribune. *To the Tower.* 1924. (Tribune Tower)
Cohen, Stuart. *Chicago Architects.* 1976. (Stevens Art, Florsheim)
Condit, Carl. *American Building: Materials and Techniques from the First Colonial Settlements to the Present,* 1968, 2d ed. 1982. (Plaza On DeWitt, Grand Central Station)
——. *Rise of the Skyscraper.* 1952. (Keith Brothers)
Cromie, Robert. *Chicago.* 1948. (A. Haug photographs)
Cruells, Bartomeu. *Ricardo Bofill.* 1992. (R. R. Donnelley Center)

CTBUH books, including *Tall Buildings,* 1984; *Advances in Tall Buildings,* 1986; *High-Rise Buildings: Recent Progress,* 1986; *Proceedings,* e.g., International Conference on Planning and Design of Tall Buildings, 1973; "100 Tallest Buildings in the World," November 1994 (the latter list is given also in *Skyscrapers,* Judith Dupré, 1996).

Darling, Sharon. *Chicago Ceramics and Glass.* 1979, 1884. (Mallers, 10 W. Elm Street)

"Downtown Development" reports of surveys conducted since 1979 by the Center for Urban Affairs, Northwestern University, Mary Ludgin, and, since 1989, by the Chicago Department of Planning, Alicia Mazur (with extensive data).

Drexler, Arthur. *Mies van der Rohe.* 1960. (860 Lake Shore Drive)

Drury, John. *Old Chicago Houses.* 1941. (Nickerson House)

Duncan, Hugh Dalziel. *Culture and Democracy.* 1965. (Kennedy Bakery, Carson's store, Three Sisters)

Fireproof Building Construction: Prominent Buildings Erected by the George A. Fuller Company, 1904, reprint 1910.

Floyd, Margaret H. *Architecture after Richardson.* 1994. (Glessner House)

Frueh, Erne R., and Florence Frueh. *Chicago Stained Glass.* 1983. (1 S. Wacker)

——. *Second Presbyterian Church.* 1978.

Garczynski, Edward. *Auditorium.* 1890.

Giedion, Sigfried. *Space, Time and Architecture.* 1941. (860 Lake Shore Drive, Leiter, Fair Store, Montgomery Ward Complex)

Goldberger, Paul. *Skyscraper.* 1982. (Xerox Centre)

Goldsmith, Myron. *Buildings and Concepts.* 1987. (Plaza On DeWitt)

Graham, Bruce. *Bruce Graham of SOM.* 1989. (Inland Steel, 69 W. Washington Street, Hancock Center, 3 First National Plaza, Madison Plaza)

Greiff, Constance F. *Lost America: From the Mississippi to the Pacific.* 1972. (Monadnock, Charnley)

Grube, Oswald W., Peter C. Pran, and Franz Schulze. *One Hundred Years of Architecture in Chicago.* 1977. (150 S. Wacker Drive, 222 S. Riverside Plaza, Harold Washington College, 333 N. Michigan Avenue)

Hamlin, Talbot. *Architecture through the Ages.* 1949. (M. Field Warehouse)

Harrington, Elaine. *Glessner House: Story of a House.* 1978, 1992. (Includes Glessner's 1923 writing about his house)

Harris, Neil. *Chicago's Dream, a World's Treasure: The Art Institute of Chicago, 1893–1993.* 1993.

Hoak, Edward W., and Willis H. Church. *American Architectural Masterpieces.* 1930, 1992. (Tribune)

Holt, Glen E. *Chicago: A Historical Guide to the Neighborhoods.* 1978. (Victoria Hotel [1875], Doré Block)

James, Warren A. *Kohn Pedersen Fox.* 1993. (225 W. Wacker Drive, 311 S. Wacker Drive, Chicago Title & Trust Center)

Knight, Carleton, III. *Philip Johnson/John Burgee: Architecture 1979–1985.* 1989. (190 S. LaSalle)

Krantz, Les. *American Architects.* 1989. (Nuveen, Magnificent Mile, J. R. Thompson Center, Quaker Tower)

Larkin, Oliver W. *Art and Life in America.* 1949. (Marshall Field Warehouse, Monadnock, Charnley House)

LeBlanc, Sydney. *Whitney Guide, Twentieth Century Architecture.* 1993. (Harold Washington Library)

Lowe, David. *Thirty-two Picture Postcards of Old Chicago.* 1977. (Grand Pacific Hotel)

Maddex, Diane, ed. *Master Builders.* 1985. (Ludington)

Mainstone, Rowland. *Developments in Structural Form.* 1973. (Marina City)

McIlvaine, Mabel, comp. *Reminiscences of Chicago during the Civil War.* 1967.

Miller, Nory. *Helmut Jahn.* 1986. (Xerox Centre, 1 S. Wacker Drive, Northwestern Atrium Center, Board of Trade Annex)

Miller, Ross. *American Apocalypse: The Great Fire and the Myth of Chicago.* 1981.

Moreno, Jaime, ed. *Analysis and Design of High-Rise Concrete Buildings.* 1985. (Huron Plaza)

Naylor, David. *American Picture Palaces.* 1991. (Chicago Theater, Esquire Theater)

Norberg-Schulz, Christian, ed. *KPF.* 1993. (Nuveen/333 W. Wacker Drive)

Pacyga, Dominic A., and Ellen Skerrett. *Chicago, City of Neighborhoods.* 1986.

Perlman, Daniel H. *The Auditorium Building.* 1986.

Persons, Stow. *Evolutionary Thought in America.* 1956. (Carson's store)

Public Works Historical Society. *Chicago: An Industrial Guide.* 1991. (Union Special Machine, 500 W. Huron Street)

Randall, J. D. *Guide to Significant Chicago Architecture of 1872 to 1922.* 1958. (Carson's store, 218 S. Wabash Avenue, Edison Phonograph Shop)

Rand McNally central business district maps.

Real Estate Research Corp. *Tall Buildings in the U.S.* 1985.

Schmertz, Mildred, ed. *Office Building Design.* 1975. (55 W. Wacker Drive)

Schultz, Rima Lunin. *The Church and the City: A Social History of 150 Years at St. James Church, Chicago.* 1984.

Sexton, R. W. *The Logic of Modern Architecture.* 1929. (Passavant Hospital)

Skerrett, Ellen. *At the Crossroads: Old St. Patrick's Church and the Chicago Irish.* 1997.

Skidmore, Owings and Merrill. *Architecture of SOM: 1963–1973.* 1974. (University of Illinois Chicago Campus, Hancock Center, Sears Tower)

Smithsonian Guide to Historic America. Vol. 6, *The Great Lakes States.* 1989. (Amoco, Clarke House)

Sullivan, Louis. *Autobiography of an Idea.* 1956. (Ryerson/Walker Warehouse, Gage, and Carson's store)

———. *Kindergarten Chats.* 1947 edition. (I.C. Station, 1899 Tower, Downtown Parking Stations)

Szarkowski, John. *Idea of Louis Sullivan.* 1956

Thall, Bob. *Perfect City,* 1994

Thorndike, Joseph. *Three Centuries of Notable American Architects.* 1981. (860 Lake Shore Drive, Gage)

Turak, Theodore. *William Le Baron Jenney.* 1986. (Home Insurance)

Vinci, John. *Art Institute of Chicago: The Stock Exchange Trading Room.* 1977.

Wallin, Chad. *The Builders' Story.* 1966. (Chicago Tribune)

Woodward, Christopher. *Skidmore Owings and Merrill.* 1970. (Harris Trust Bank)

Wright, Frank Lloyd. *Genius and the Mobocracy.* 1971. (Gage)

Wright, Iovanna Lloyd. *Architecture: Man in Possession of His Earth.* 1962. (Garrick/Schiller)

Wright, Sylvia Hart. *Sourcebook of Contemporary North American Architecture.* 1989. (Northwestern University Prentice Women's Hospital)

Appendix K.
The Central Area Building Fact File

General knowledge (and future updating of this book) will be made more accurate and complete by voluntary submissions of information to the Central Area Building Fact File at the Ryerson and Burnham Library, Art Institute of Chicago. As each new Chicago building or addition is completed, it is requested that the architect or engineer prepare a street address form that includes the information below and send it to the library for general usage. The "Basic Information" is the most important. The secondary "Helpful Information" is of assistance in addressing inquiries. It would also be helpful for any party to submit "Amended Information" that adds data about a central Chicago building in this book or about a neglected building. It is expected that copies of appropriate Historic American Building Survey forms by the National Park Service will ultimately supplement this file.

The following are simplified uniform bases for the information requested:

1. *Construction years:* Give range, from initiation of excavation/foundations to substantial completion/major occupancy, e.g., 2001–2003.

2. *Height:* Number of stories from the principal sidewalk entrance. Note additional penthouse or more than one story below this grade. Height in feet, taken also from the main-entrance sidewalk level to the top of the roof of the highest enclosed space. A highest *point* may be noted for higher projections of spires, masts, decorative points, or sculpture, exclusive of flagpoles.

3. *Area:* Gross, out-to-out area of all enclosed spaces. Note exceptional/significant areas of roofed-only exterior space on roof or grounds. Net, rentable/usable area: taken from glazing and centers of interior subdivisions for public circulation and auxiliary/serving spaces, shafts, stairways, and mechanical/electrical rooms.

4. *FAR:* The floor area ratio of above-ground gross area to site area.

5. *Efficiency:* The ratio of rentable/usable area to the gross area. The notation of atria or roofed courts is helpful.

6. *Construction cost:* Excavation through building and site cleanup, exclusive of detached furnishings, special amenities such as art, fees for professional services, wrecking, financing, taxes, and ownership administration/management expenses.

Central Area Building Fact File, Ryerson and Burnham Library

Address-name of building: _____

 Corner, NE, etc.: _____

Name, if not by address: _____

Appears in Randall, *History of the Development of Building Construction in Chicago,* on p. _____, 1949 ed.; p. _____, 1999 ed.

Does not appear in Randall: _____

Basic Information

Other names: _____

Related building or group: _____

Primary function, or mixed: _____

Construction years: _____

Architect of record: _____

 Lead designer: _____

 Associated firm: _____

 Consultant: _____

Structural Engineer: _____

 Lead designer: _____

 Consultant: _____

Structural type, material: _____

 Foundation: _____

Height, in stories and feet: _____

Gross area, nearest 5,000 feet: _____

Helpful Information

Area (sq. feet): Site and FAR: _____

 Net and efficiency: _____

Dimensions: frontage, depth: _____

Dimensions: typical floor _____

Exterior/facade, material: _____

Parking provided: _____

Art: _____

Special/Notable: _____

Construction cost: _____

Developer, owner, or agent: _____

Published reference: _____

Photograph attached: _____

 Photographer: _____

Building(s) demolished: _____

Amended or Additional Information

Information correction: _____

Information addition: _____

Change to function, facade, other: _____

Demolished, year: _____

Further published reference: _____

Information submitted by: _____

Date: _____

Appendix L.
Additional Buildings

The first three buildings listed in this appendix were built in 1872 and should have appeared between the Hawley Block and the Roanoke building, on page 67 in this book.

PORTLAND BLOCK, 1872–1933, was at the southeast corner of N. Dearborn and W. Washington Streets. The building was seven stories high, on spread foundations. W. Le Baron Jenney was the architect. Pressed brick, then unusual, was used for the front, with stone trim. The design has been attributed to Adolph A. Cudell. Drawings are in CANY, p. 34, and SFO, p. 30. Photographs are in TBC, p. 35; *Chicago Tribune,* February 17, 1940; CIM, p. 574; and OBD for 1916, p. 201. A view of the building is in TYF; LO June 1873, p. 97; and RMNV, V20. An illustration of the building as built is in OBD 1901, p. 147. This building replaced another of the same name, five stories high, destroyed in the 1871 fire, a photograph of which is in CIM, p. 382, and an illustration of which is in a view of N. Dearborn Street given in CIJ (along with Tremont House 3). The 33 N. Dearborn Street building occupies this site.

STRATFORD HOTEL, 1872–1922, formerly the Gardner House and then the Leland Hotel, was at the southwest corner of S. Michigan Avenue and E. Jackson Street, fronting 120 feet on the former and 170 feet on the latter, and was wrecked to make way for the Straus building. It was six stories high. A photograph is in CIM, pp. 138, 371, and 445; CYT, pp. 39 and 43; RMNP; and IC Vol. 1. A view of the building is in CRT, opposite p. 12; HCA Vol. 3, p. 88; OYF, TYF; LO March 1872, p. 36; CAC, p. 48; STL, p. 66, with the Railway Exchange building; CIDL, p. 5; CTCP, p. 72; and RMNV, V4. W. W. Boyington was the architect. The home of Judge George Manierre had previously stood on this site (see photograph in CIM, p. 285).

John KRANZ (confectioners) building, NR, CLSI, HABS/photograph, ca. 1872–1990, at 126–32 N. State Street, was six stories high, on spread foundations. From its architectural similarity to the Bay State building, adjoining it on the north, it would seem that all but the south bay at 126 N. State Street was originally part of that building, with the two upper floors added later. See also the Bay State building. Photographs are in HDM, pp. 67 and 219. This "Block 37" site is vacant.

The buildings listed below were built in 1924 and should have appeared between the entries for Chicago Union Station and the American Dental Association building, on page 309 of this book.

North: 720 N. MICHIGAN AVENUE building, 1924–1982, at the southwest corner of E. Superior Street, formerly known as the Central Life building, was 16 stories high, on rock caissons. Burnham Brothers were the architects. An illustration is in OBD for 1941–42, p. 359; ISA 1923, p. 154; IA-C Vol. 26, No. 5, September 1982, p. 37; RB Annual Review, January 26, 1963, p. 92 (advert.); and LC, p. 91, scene. The Chicago Place building occupies this site.

North: 209 E. LAKE SHORE DRIVE building, built in 1924, is 18 stories high, on pile foundations. Benjamin H. Marshall was the architect. A photograph and a typical floor plan are in BW, p. 10. A photograph is in ISA for 1925, p. 566, and CYT, p. 59. It is a cooperative apartment building consisting of thirty-four apartments of fourteen rooms and seven baths each. Also known as The Breakers, it is in the East Lake Shore Drive District/CHALC. See appendix F.

North: CENTRAL CHICAGO GARAGE, 1924-(1950 to 1990), was 10 stories high, on pile foundations. Robert O. Darrick was the architect. The One IBM Plaza building includes this site.

North: LAKE SHORE CLUB, at 850 N. Lake Shore Drive, on the southwest corner of E. Chestnut Street, built in 1924, is 18 stories high, on wood piles. Jarvis Hunt was the architect. A photograph is in CIM, p. 450; COF, p. 76; ABOV, p. 22, south of 860 Lake Shore Drive building. It was converted to student housing and renamed the Northwestern University Lake Shore Center. See appendix F.

North: 100 E. OHIO STREET building, 1924–1995, at the northeast corner of N. Rush Street, was six stories high, of reinforced concrete construction. Rapp and Rapp were the architects. It had been renamed the DeFrees building. Photographs are in HB and in RB Annual Review, January 28, 1950, p. 65 (advert.). The 600 N. Michigan Avenue building includes this site.

North: ALLERTON HOTEL, at 701 N. Michigan Avenue, on the northeast corner of E. Huron Street, formerly known as Chicago Allerton House, was completed in 1924. Murgatroyd & Ogden of New York City were the architects, with John R. Fugard as associate. The building is 25 stories high, 360 feet, supported on rock caissons. A photograph is in HSM; CIM, p. 318; ISA 1924, p. 420; STL, p. 120; CNM, p. 123; and HB. An article is in AF May 1925, p. 313 and plate 58. It was being renovated in 1998–1999 and scheduled to reopen as a Crowne Plaza, owned by Holiday Inn.

Index of Buildings

Buildings having the same name are listed separately in this index, each distinguished by year of construction. The year of completion of buildings built since 1949 also is noted. The sequence of listing for address-number buildings is from north to south and from east to west, as they would appear to a pedestrian. The minor early depots and hotels that appear only in the 1893 Rand-McNally Views section are not included in this index.

Italicized building names indicate that each of these buildings has a main listing in the text. Names within brackets are those by which buildings also are or have been known, or are those of complexes with which the buildings are associated.

General Index

The general index does not include obscure parties briefly noted as tenants in the descriptions of buildings in the Rand-McNally Views section, and it omits references to street views in the Rand-McNally section; references to the latter are on pages 251 and 252, Keys to Maps of Views.

Designed by Copenhaver Cumpston
Typeset in 10/12 Baskerville
by Keystone Typesetting, Inc.
Manufactured by Thomson-Shore, Inc.